KU-329-937

Contents

Introduction

This book centers on the stage and the people who perform and work on and around it, people who practice different disciplines that merge to create an organically unified event, people who use different vocabularies within the context of English, yet create a living communication that sometimes transcends words.

Their special vocabularies represent a significant body of knowledge and experience. The variations from one discipline to another may seem obscure to an outsider, but they reveal fundamental differences between the arts. An actor and a dancer may each speak of *beats,* a lighting designer may change the *key,* but they are not thinking in musical terms. A musician may cite different kinds of *cadence* without touching on the progression of a poetic line.

We conceived and prepared this dictionary to make these differences understandable. Throughout the work we have imagined the presence of a cadre of performers and technicians in the background, each listening as we put definitions together, waiting to be shown useful meanings. We have tried not only to define each term accurately for those involved in a particular area of performance, but also to give some clue about its more subtle meaning to others who work differently. We want the book to be as practical and useful as possible for the performer and technician as well as for the student, the writer and the researcher.

We have maintained a general hierarchy of disciplines. Where a term applies to a specific discipline but not to others, we have named its category in the first line, as shown in "How to Use This Dictionary" (page ix). A term used only by actors is categorized as *Acting,* but actors will also find terms that apply to acting under the more general classification *Theater.* Similarly, some terms that apply only to *Vaudeville* are so identified, but other related terms, including the term *vaudeville* itself, appear under *Theater.*

There are terms that are used in several areas of performance with differences of meaning in each discipline. In such cases we have chosen to group those definitions by discipline in separated paragraphs. A scene designer, reading the definition for *toggle,* will find a reference to the term *flat,* which has different meanings in many unrelated categories but a specific meaning for the scene designer. Our grouping here is organized to make it easier to locate the context, in this case *stagecraft,* that will help.

Where a main entry occurs in different but closely related spellings, we have elected to bring the variations together as a multiterm main entry, as with *shofar* and *shophar,* and again with *tabor, taboret, taborin* and *tabret.* Where the differences of spelling are more extreme, we have entered a cross reference on a different page in the book. *Kookaloris,* for example, has a cross reference to the more common spelling *cookaloris.*

We have chosen to include certain terms and variations of meanings no longer in general use in modern performance because they provide background to definitions of other terms that are current or new. One example is the ancient term *chorus,* which has special meaning to experts in classical Greek and Asian theater, but also helps explain the significance of certain characters in modern plays. Another is *country dance,* which embraces a group of social dances in modern times, but stems from a mistranslation of *contra danse.*

Many slang and jargon entries have been included, some of which have become outdated but continue to appear in literature; some are in daily use and may or may not survive long

enough to become legitimate. Some are well understood intuitively but have not previously been honored with full definitions in print. Where necessary, we have provided historical information. In every case, we have tried to err on the side of inclusion rather than exclusion.

This dictionary contains terms that people involved in the performing arts may hear from time to time, whether or not they use these terms themselves. Because we have branched out into television, motion pictures and the recording industry, where technology, and therefore usage, can change from week to week, we have tried to include and explain terms the ordinary stage person may hear or read. We do not pretend to have covered these fields in depth since that would exceed the scope of this book. If a singer in a recording studio is working hard to use *head tones* and the recording engineer is having trouble because the voice lacks *highs*, the dictionary will help each to have some inkling of what the other is talking about. More often, it is the singer to whom we address the definitions.

Many entries in this dictionary originated in foreign languages. Some have kept their original meanings in international use; for others the meanings have changed. We have indicated the derivation in every case and have, where necessary, clarified usage when a foreign term has acquired a special meaning in its discipline. In the case of *gigue*, for example, we have traced its development into *geige* as a German name for an ancient violin, and have further pointed out that it is not related to the Irish word *jig*, even though one term sometimes substitutes for the other in musical practice.

A special class of words in Greek stem from Aristotle's essay *Poetics*, a work that is seminal for any modern study of drama. We have gone back to the original text and endeavored, with the help of scholars, to restore the precision of the original words in support of their usage in modern times.

We have been generous with cross references, direct citations of related terms and explanatory notes that will help you put a term in its proper context or delineate its limits. The ancient Japanese *Gigaku*, for example, is categorized under *Dance* and *Theater*, then described in the text as a form of *dance drama*—a cross reference. In time it evolved into *Bugaku*, for which we have another reference, and we have pointed out that it must not be confused with *Gagaku*, for which we include yet another cross reference.

Similarly, to define certain terms of modern times requires a network of references. *Heavy metal* stemmed from *hard rock* and makes use of *feedback, fuzztone, reverb* and the *wah-wah pedal*, all of which are cross references that add detail to the meaning.

When you use this dictionary, we hope that you will check many such references not only for a more precise understanding of a term, but also because they may lead you into unexpected areas and provide a context beyond that of the definition you seek.

This is a book of evolving traditions. In a sense, performers have been practicing their arts in the same way since the dawn of history. For centuries they have taught each other, using concepts that seem as current as today's newspaper; in some cases not even the words have changed. It is exciting, perhaps sobering, for modern students to realize that performers in other cultures and at other times faced problems and found solutions similar to their own. We have cited an occasion when an actor in the classical theater of ancient Greece used *emotion memory* in almost the way a modern student of "The Method" would today, but he used a physical prop to bolster his concentration where the modern actor would focus more intently on an inner vision. We know that such development and increased understanding will go on in the future; we have compiled this dictionary to help keep the process fluid as terms continue to change superficially without necessarily losing their fundamental meanings.

We hope that these terms, fundamental to the performing arts, will help connect performers not only to their colleagues in other fields of performance, but to their ancestors and their progeny.

Acknowledgments

Among the people who have given us encouragement and authoritative information for this dictionary, Goddard Winterbottom and Maurice Edwards have been extremely helpful. Winterbottom, a retired editor of the *Encyclopedia Brittanica*, and Edwards, retired artistic director of the Brooklyn Philharmonic, each of whom has an extensive list of credits as actor and/or director in theater and a thorough knowledge of languages, have provided many valuable historical and linguistic details. Actress Lin Kosy and Sean McEntee, a stage and lighting technician, sharpened our understanding of the technical jargon and slang of modern professional theater. We have also taken advantage of the goodwill of many in the crafts unions who have helped pin down some terms with precision.

In the realm of ballet and modern dance, we are grateful for a detailed and careful review by Diana White of the New York City Ballet and Christian Claessens, of the Netherlands. Sally Schmertz, formerly of the Washington Ballet, also reviewed the dance portions of the text.

We have benefited from the comments and suggestions of Frank Ezra Levy, a composer and cellist who is fluent in several European languages, for his review and criticism of more than 2,000 music terms. Both Abraham Silverman, a busy New York composer, arranger and woodwind player, and Nicholas Varchaver, a bassist, reviewed drafts and provided background and insight into the rapidly evolving language of jazz and popular music.

No modern dictionary, particularly one that must be supported by research into unconventional and illusive sources, could be complete without the insights of the fine librarians who have helped us.

And above all, this work has gained strength and accuracy from the careful reading and sharp insight of our editor Susan Schwartz, the lexicographer Richard Spears and our agents, Nicholas Smith and Andrea Poldolsky, all of whom worked with us through thick and thin.

How to Use This Dictionary

1. The entry word or phrase appears in **boldface** type.

2. Pronunciation, if necessary, appears next in *italics* in parentheses.

3. The word's etymology and/or language origin, if appropriate, appears next in brackets.

4. The appropriate category of performing arts is next, in *italics*.

5. The definition follows.

6. Cross references appearing within or at the end of the entries are in SMALL CAPITAL letters.

Pronunciation Guide

These conventions are intended to give an English speaker the information needed to produce an approximate rendering of the non-English entries in this dictionary. Most of the symbols are easy to interpret, but some require additional explanation.

eu A sound similar to the vowels in English *get* or *met* but pronounced with the lips pursed or rounded.

ü A sound similar to the vowel in English *feet* pronounced with the lips pursed or rounded.

ay A vowel sound pronounced the same as the long *a* sound in the English words *play, gray* and *say*.

nh A symbol used to mark heavy nasalization of a preceding vowel. (The symbols *n* and *h* are not pronounced. Nasalization means that more of the sound exits through the nose than through the mouth.) The symbol **onh** stands for a sound that is a heavily nasalized version of the vowel *o*. The symbol **enh** stands for a sound that is a heavily nasalized version of the vowel of *cat*. The symbol **anh** stands for a heavily nasalized version of the *a* in *father*.

Note: In some transliterations of Japanese words (that have high and low tones rather than accents), we have elected to indicate a syllable that the Japanese pronounce with a low tone as if it were an accented syllable.

A

a *Music* 1. The sixth tone of the SCALE of C major. 2. The KEY of which the note A is the TONIC. In the FIXED-DO SYSTEM, A is LA.

THE NOTE A

AA *Theater* Acting area.

ABA form *Dance, Music, Theater* The form of any musical, dance or dramatic composition that consists of an initial section, a differing middle section followed by a repeat of the initial section. Also called TERNARY FORM.

A & B rolls *Motion pictures* In 16-mm film editing, two parallel rolls of edited and synchronized ORIGINAL film, with SHOTS in proper order and with BLACK LEADER alternating between them so that overlaps of scenes, where necessary for FADES, DISSOLVES and the like, can be accomplished in the printing process without cutting the original.

a battuta (*ah bah-TOO-tah*) [Italian] *Music* Literally, to the beat. The same as A TEMPO.

Abbey Theatre A theater on Abbey Street in Dublin. It became the home of the Irish Dramatic Society, founded in 1904 by three playwrights, Yeats, Synge and Lady Gregory, who were its first directors.

Abend musik (*AH-bent moo-ZEEK*) [German] *Music* Evening music.

above *Theater* 1. Upstage, *i.e.*, further from the audience in relation to someone who is downstage. 2. On a platform over the main stage. In Elizabethan times the stage often included a high platform at the rear that could represent a window, a balcony or other scenic elements.

above the line *Motion pictures* Describing that part of a production budget that covers major contracts for the author, composer, choreographer, stars, screen writer(s), director and the like, many of whom will own a share of the picture, and any actors' contracts that require individual negotiation. Such costs generally are not covered by union SCALES. *See also* BELOW THE LINE.

absolute music Music with no extra-musical implications or influences such as lyrics or story lines.

absolute pitch *Music* 1. Pitch expressed precisely in terms of its name and the octave in which it occurs, as well as its frequency in Hz (HERTZ). 2. The ability to recognize or reproduce a precise pitch. *See also* PERFECT PITCH, RELATIVE PITCH.

abstract ballet A ballet composed of pure dance movements, without a plot or guiding program. *See also* ABSTRACT DANCE.

abstract dance Any dance work composed of pure dance movements, without a plot or guiding program, including not only ballet, but all forms of dance such as TAP, JAZZ DANCE, MODERN DANCE, etc.

abstract music Music that has no underlying narrative, dramatic meaning or literary idea, or that is not designed to suggest a mental picture. The opposite of PROGRAM MUSIC. Most SONATAS and SYMPHONIES are abstract, as is most instrumental music in CONTRAPUNTAL form.

abstract set *Theater* Any set designed with definite acting areas and levels, but without realistic detail. The degree of abstraction may range from simple darkness with illumination only on the actors themselves, to elaborate constructions of fantastic shapes, using unusual materials and complex lighting. What matters is that the set is general and suggestive of the relationships and distance between characters, rather than specific and expressive of their actual surroundings, and that it helps the audience achieve AESTHETIC DISTANCE. In amateur and experimental theater where budgets are, by definition, low, the set may be designed in an abstract manner simply because it will be cheaper to build. *See also* SPACE STAGE, UNIT SET.

absurdism *See* THEATER OF THE ABSURD.

Academy Awards *Motion pictures* A series of awards presented annually in the spring by the ACADEMY OF MOTION PICTURE ARTS AND SCIENCES to the people who created or participated in producing the best of several categories of pictures exhibited during the previous calendar year. The first awards were presented in the 1927–1928 season for Best Picture (*Wings*), Best Actor (Emil Jannings), and Best Actress (Janet Gaynor).

academy leader *Motion pictures* A standard LEADER approved by the ACADEMY OF MOTION PICTURE ARTS AND SCIENCES for silent films running at 16 frames per second. *Compare* SOCIETY LEADER.

Academy of Motion Picture Arts and Sciences Founded in Hollywood, California, in 1927, the Academy set certain technical standards for the industry, *e.g.*, the proportions of the motion picture screen (*See* ASPECT RATIO), and established the annual ACADEMY AWARDS.

Academy of Television Arts and Sciences Founded in 1948, it is one of several unions and other organizations, such as AGMA, AFTRA, IATSE, SMPTE, NABET, etc., involved in the annual presentation of the EMMY awards.

a cappella (*ah kah-PELL-ah*) [Italian] *Music* Literally, in chapel. Describing vocal music intended to be sung without instrumental accompaniment. A chorus that sings *a capella* may accomplish a purity of harmonic tuning that does not occur when it is accompanied by an equal-tempered instrument. *See* TEMPERAMENT.

a capriccio (*ah kah-PREET-choh*) [Italian] *Music* Literally, at whim.

accelerando (*ah-chehl-eh-RAHN-doh*) [Italian] *Music* Accelerating.

accent *Lighting* Added illumination to make a particular detail of a scene brighter and more prominent than its surroundings, thereby increasing the sense of three-dimensional form in a scene. *See* KEY LIGHT, PIN SPOT, SPOTLIGHT.

> *Music* 1. Loudness or emphasis added to a specific note to make it more prominent. One of the major components of musical rhythm. *See* AGOGICS. 2. To play a specific note louder than others, thus giving it prominence. *See also* ATTACK.

> *Music notation* *See* ACCENT MARK.

> *Speech* 1. Vocal emphasis of one syllable, word or phrase that gives it prominence over another. The relation between accented and unaccented syllables in words is one of the components of the rhythm of speech. 2. Any nonstandard mode of pronunciation, particularly one that suggests a character is from a specific region. 3. To add intensity to a unit of speech.

accent light *Lighting* 1. Any beam of light focused within a more generally illuminated area to add brightness to part of that area, *e.g.*, the light from a small spotlight focused on an actor's face. 2. The instrument that produces such a light. *See also* KEY LIGHT, PIN SPOT, SPOTLIGHT.

accent lighting Lighting with varying degrees of brightness, designed to emphasize specific features in a scene.

accent mark *Music notation* The mark, usually >, placed near the head of a note to indicate that it should be accented in performance.

accessory action *Acting* An actor's gesture or vocal tone that is not wholly natural to the character and the situation of the moment, *i.e.*, any conventional or stylized action, such as taking a theatrical stance to deliver a speech, or BOXING a word because it will have significance later.

acciaccatura (*ah-chee-ah-ka-TOO-rah*) [Italian] *Music* Literally, crushing. A dissonant GRACE NOTE one half step above the principal note, played at the same time and instantly released. Common in music of the late Baroque period, the 17th and 18th centuries.

accidental *Music notation* A sign indicating a temporary change of pitch, (sharp, flat or natural), placed just before a single note of music. Generally, the sign is valid for all subsequent notes on that line or space within that single measure, but not in following measures. *See also* CHROMATIC SIGN, KEY SIGNATURE.

accolade 1. (*AH-koh-layd*) [English] *Music, Theater* An outpouring of praise in critics' reviews of a show. 2. (*ah-koh-LAHD*) [French] *Music notation* *See* BRACE.

accompaniment *Music* Music that provides support for soloists, dancers or a chorus. Accompaniment may consist of simple chords on the beat in appropriate harmonies, or it

may be harmonically and rhythmically elaborate. The accompaniments of Mozart, Beethoven, Schubert and other composers are not secondary to the melodies they support, but integral parts of the whole composition. *See also* BACKUP.

accompanist *Music* An instrumentalist, usually a pianist, who plays the accompaniment for dancers, soloists or a chorus.

accompany *Music* To play the ACCOMPANIMENT for other performers.

accordatura (ah-kor-dah-TOO-rah) [Italian] *Music* Proper adjustment of the sounding parts of a string instrument (e.g., tuning the strings in PERFECT FIFTHS) so that with normal FINGERING they produce tones precisely tuned in relation to each other. *Compare* SCORDATURA.

accordion *Music* A large, box-shaped instrument hung from the shoulders or supported on a stand consisting of a bellows, which the player expands or squeezes to force air through sounding reeds. The right hand plays melodies on a short KEYBOARD; the left selects harmonies and bass notes from an array of buttons. Some accordions are electrically powered and do not require movement of the bellows. *See also* BUTTON ACCORDION, CONCERTINA, MELODEON.

acetate *Lighting* Colored, transparent plastic sheet that can be cut and fitted into a COLOR FRAME for use as a color filter for stage lights.

achromatic lens *Lighting* A lens constructed to focus all the different colors contained in a light accurately on the same target. If such differences were not corrected, the image projected by the lens would show rings of individual colors around the edges where none should appear.

achy breaky *Dance* A dance craze of the early 1990s, inspired by Billy Ray Cyrus's song "Achy Breaky Heart."

acid rock *Music* A style of ROCK music born on the West Coast in the 1960s that created effects reminiscent of the psychedelic experience produced by the drug LSD (lysergic acid diethylamide), also known as "acid." It was designed more for listening than dancing. SYNTHESIZERS, FEEDBACK and FUZZTONE were used, as well as modal sounds, unchanging harmonies and exotic instruments such as the SITAR and the OUD. Also called psychedelic rock. *See also* TRANCE MUSIC.

acoustic Having to do with the physics of sound.

acoustical cloud *Music, Theater* A panel of plywood or other stiff, sound-reflecting substance, hung near the ceiling of an auditorium in a position that will reflect back toward the audience sound that would otherwise be lost in the structure. Clouds are shaped and placed with great care to "tune" concert halls that would otherwise have poor ACOUSTICS. Their shape and position can be arranged to treat different parts of the musical spectrum differently, dulling overly prominent BASS tones, for example, while reflecting HIGHS.

acoustic bass *Music* 1. A DOUBLE BASS of the violin family whose sound is made audible by the resonance of its body rather than by electronic means, though the sound it produces may be amplified electronically. *See also* ELECTRIC BASS GUITAR. 2. A double set of bass pipes in a PIPE ORGAN that are sounded in pairs, each pair controlled by a single pedal, and so tuned that their COMBINATION TONES create a deeper tone than either of the individual pipes can produce. Since very deep tones would otherwise require very large pipes, this technique saves space.

acoustic guitar *Music* A GUITAR whose sound is made audible by the resonance of its body, not by electronic means (though the sound it produces may be amplified electronically). *Compare* ELECTRIC GUITAR.

acoustician A scientist or technician who works with physical sound, who may assist architects and renovators to improve the quality of sound in a theater or concert hall.

acoustic instrument *Music* Any instrument whose sound is wholly physical and not produced by electronic means, whether or not the sound is subsequently amplified. Generally acoustic instruments have some physical means, such as a sounding board, for enhancing their sound.

acoustics 1. The science and technology of physical sound. 2. By extension, the quality, balance and clarity of sound as heard by the audience during performance.

acrobat *Circus* A performer who specializes in gymnastic feats. *See also* TUMBLER.

Dance (derogatory) A dancer who emphasizes physical agility to the detriment of art.

acrobatic dance A style of movement lying somewhere between dance and sport, that emphasizes physical skill and gymnastic feats involving contorted movements, usually performed to fast-paced music.

act *Theater* 1. A major formal segment of a play, opera or ballet that may be further subdivided into scenes. 2. A short, rehearsed scene or musical number, complete in itself, that one or several performers play routinely within a variety show. 3. To perform a ROLE.

actable *Theater* Capable of being acted. Said of a SCRIPT that contains material that actors can capably work with on stage.

act break *Theater* The period between acts of a play, opera or ballet. *See also* ENTR'ACTE.

act call *Theater* Notice to the cast that it is time to assemble for rehearsal or performance of the next act.

act change *Theater* Any SET change between acts.

act curtain *Theater* A curtain behind the main curtain, drawn to signify the end of an act. *See also* SCENE CURTAIN.

act drop *Theater* A DROP, sometimes painted, hung directly behind the MAIN CURTAIN.

act-drop scene *Theater* Any scene that ends with the lowering of the ACT DROP.

acted prologue *Theater* A PROLOGUE involving dialogue between two or more characters of the play, frequently played in front of the ACT CURTAIN.

acting *Theater* Performing in a play before an audience or before a camera as someone other than oneself. Reacting intentionally and in a controlled manner to imaginary stimuli, and expressing an inner significance and dramatic meaning of those stimuli and that reaction in performance; the supreme art of establishing a complete SUSPENSION OF DISBELIEF and making the drama happen within the minds of the audience by means of actions and/or words. There are techniques for all the elements of acting including both the physical (e.g., diction and movement) and the psychological (e.g., memory and belief), and there are specialized techniques for acting in different media (e.g., plays, ballet, motion pictures, television, puppetry or vaudeville). Acting itself is interpretive in the sense that an actor portrays a character in a stylized context such as a play or a dance. It is creative in the sense that at its best it establishes the character in the mind of the viewer as a being quite separate from the actor who plays it. Acting has been the object of philosophical study and technical development around the world since long before the time of Aristotle who, in his *Poetics*, wrote about its psychological and cultural aspects in the 4th century B.C. In the ancient theatrical traditions of Java, Japan, India and China, about which Aristotle knew nothing, vocal and physical techniques were codified in elaborate detail and have been taught consistently for more than 2,000 years in a philosophical context. The European styles of acting, from the Renaissance on, stemmed partly from medieval religious plays that kept classical practices alive for a time, partly from the traditions of folk festivals, and partly from COMMEDIA DELL'ARTE. In the 19th and 20th centuries the psychological foundations that Aristotle discussed began to be reinterpreted in the light of modern philosophies with the plays of Anton Chekhov, Henrik Ibsen, Eugene O'Neill, Bertolt Brecht, and others, and the teachings of directors such as Konstantin Stanislavski and John Gassner, the designers Gordon Craig, Mordecai Gorelik and Robert Edmond Jones, and the scholar Francis Fergusson. Although this brief discussion of acting has focused for simplicity on its most fundamental aspects, it is important to keep in mind that those fundamentals are all present in comedy, tragedy, mystery or burlesque. The suspension of disbelief that is necessary for an audience watching *Macbeth* is in no way different from that required of moviegoers watching Charlie Chaplin or children watching a magician. *See* KABUKI, METHOD, NOH.

acting area *Theater* Any one of several areas in the SET that can become a center of action for actors and of attention for the audience. The director considers them as individual areas for BLOCKING. The lighting designer defines each area by lighting. Similarly, the set designer may organize the set to suggest different kinds of space in each. Not to be confused with STAGE AREAS, which are specific areas on the stage, regardless of the set that occupies them.

acting-area flood *Lighting* A floodlight that illuminates the ACTING AREA.

acting company *Theater* An organized group of performers, directors, designers and coaches who work together to rehearse and perform a play. They may be part of, but are distinct from, a larger company that includes the theater, administration and management.

acting edition *Theater* The published version of a play that has been specifically prepared in format and in text, including stage directions, for practical use by actors during rehearsals. *Compare* SIDES.

acting text *See* ACTOR'S SCRIPT, SIDES.

acting time *Theater* The actual time required to perform each act of a play from beginning to end.

acting version *See* ACTING EDITION.

acting zone *Lighting* The portion of the entire stage that actors can occupy and be seen and heard by the audience. *See also* SIGHT LINES.

action *Acting* 1. Any physical movement by actors. 2. The unspoken combination of motivations, mental processes and tendencies of his or her character that an actor senses in a role at a given moment and seeks to communicate in performance. The psychic focus that gathers a character's wants and needs together and steers them in the direction of the plot. Aristotle uses the Greek word *praxis*; practice in the sense of basic action in life, an inner process that is the expression of a character's rational personality. *See also* GIVEN CIRCUMSTANCES.

Motion pictures When spoken by a director, an instruction to actors to begin the scene. *See also* SPEED.

Music The mechanism that causes the sounding part of any keyboard instrument to produce sound when a KEY is pressed. There are actions in the PIANO, HARPSICHORD, CELESTA, ORGAN and ACCORDION.

Theater 1. The dramatic progress of a scene or of the PLOT. 2. The mental processes and motives that contribute to the underlying movement of the plot and the effect of inner forces driving the characters of a play in pursuit of their wants, needs and desires.

actor *Theater* One who performs a role in a play.

actor-director *Theater* An actor who also directs the play.

actor-manager *Theater* An actor who also manages the affairs of a company.

actor-proof *Theater* Said of a play so well composed and prepared, or so laced with theatrical spectacle, that it cannot be ruined by incompetent actors.

Actors' Equity Association A labor union of professional actors, founded in New York in 1913 to provide job protection, bargaining power and mutual support. *See also* AFTRA, AGVA, SAG.

actors' rehearsal *Theater* Any rehearsal that does not involve the technical, dance or musical aspects of the scene.

actor's script *Theater* A SCRIPT specifically prepared for the use of an actor, often in a typographical format that distinguishes one character's lines from another's more clearly than an ordinary text and includes extra space in the margins for actors' notes. *See also* SIDES.

Actors Studio An association of actors in the form of a professional school, founded in New York City in 1947, now the primary source of training based on the principles of the STANISLAVSKI METHOD.

actress *Theater* A woman who acts.

actron *Acting* New York slang for an unemployed actor working part-time as a word processor or computer operator on the midnight shift, as distinguished from those who work days as waiters, etc.

act tune *Theater* Music as an ENTR'ACTE, especially when it includes a significant musical theme for the play.

act wait *Theater* The actual period of time between acts.

act warning *Theater* Notice to the cast and crew that an act is about to begin. In some theaters, the notice is signaled with a bell or a blinking light. In others, the stage director or assistant speaks through the backstage intercom system.

AD *See* ASSISTANT DIRECTOR.

adagietto (*ah-dah-ZHYEH-toh*) [Italian] *Music* 1. Somewhat slow. 2. To be played quite slowly, but not as slow as ADAGIO. 3. A slow piece, not quite as slow as an adagio.

adagio (*ah-DAH-zhyoh*) [Italian] *Music* 1. Slow. 2. To be played quite slowly. 3. A slow movement. *See also* LARGO *and* LENTO.

adagio dance 1. A dance performed to slow music. 2. Dance exercises calculated to develop balance, sense of line, and poise through a variety of slow movements. 3. In BALLET, the first section of the classical PAS DE DEUX.

adagissimo (*ah-dah-GEE-see-moh*) [Italian] *Music* Extremely slow, much slower than ADAGIO.

adaptation The rewriting of a work into some other form, *e.g.*, the rewriting of a short story as a play, a spoken play as a MUSICAL or an OPERA, or a piece of chamber music as a jazz dance accompaniment. The motion picture *Silk Stockings*, with Fred Astaire and Cyd Charisse, was a musical adaptation of *Ninotchka* with Greta Garbo. *Compare* REMAKE.

ad curtain *Theater* A painted drop behind the main curtain. In some theaters of the recent past, especially VAUDEVILLE houses, it was painted with advertising.

added attraction *Vaudeville* An ACT or a STAR brought in temporarily to enhance box-office appeal.

à deux (*ah DEU*) [French] *Music* As two, two together. (Also written in Italian as A DUE.) In a choral or instrumental part with two independent voices singing or playing different notes, À DEUX indicates that from that point on both voices must sing (or play) the same line. Unfortunately, composers have also used the term to indicate the opposite, where a single voice becomes two. More precise terms are available, *e.g.*, IN UNISON and DIVISI.

à deux bras (*ah DEU brah*) [French] *Ballet* Literally, with both arms. With the arms stretched forward, palms facing down, and the arm farther from the audience held higher than the other.

ad lib *Acting* Abbreviation of the Latin *ad libitum*, at liberty. 1. Any response or comment freely invented at the moment. 2. To invent lines not supplied in the script in the course of the performance.

Music 1. To be played at whatever pace, or in whatever manner the player wishes at the moment. 2. A passage invented at the moment of playing, usually consisting of a variation of a previously played theme, *i.e.*, an IMPROVISATION.

à droite (*ah DRWAHT*) [French] *Ballet* To the right.

a due (*ah DOO-eh*) [Italian] *See* À DEUX.

advance man *Circus* A representative of the circus management who visits the towns where the circus will perform well ahead of time, making all necessary legal, lodging and business arrangements. *Compare* BILLING AGENT, TWENTY-FOUR-HOUR MAN.

Theater A publicist or agent who travels ahead of the COMPANY to prepare the theater, arrange accommodations and begin publicizing the performance.

advance notices *Theater* Critics' early reviews of a new play or new production, usually based on having seen out-of-town tryouts or previews.

advance sale *Theater* Tickets sold by mail, by subscription or at the box office before the show opens.

aeolian harp *Music* A sound box with tuned strings that produce musical tones when the wind blows through them.

aeolian mode *Music* One of the eight CHURCH MODES, represented on the piano keyboard as the scale consisting wholly of white notes in the octave from A to A.

aerialist *Circus* An ACROBAT who performs spectacular feats high above the floor on trapezes or wires, sometimes swinging or leaping from one to the other. *See* HIGH WIRE, TIGHTROPE.

Theater An actor or acrobat who performs while suspended in a hidden harness on supposedly invisible wires high above the stage floor.

aerophone *Music* A categorization including any musical instrument that sounds when air passes through it, *e.g.*, BRASSES, WOODWINDS.

aesthetic distance *Acting* The subtle feeling of separation from the events depicted in a drama that makes it possible to be aware of its deeper meaning and/or its beauty. This separation is intentionally supported, in the works of many playwrights, by artifices such as abstract sets and highly stylized costuming. The ancient Greeks accomplished it with masks and choral odes. It allows the operagoer to hear the beauty of *Dido's Lament* in Henry Purcell's *Dido and Aeneas*, without being overwhelmed by the grief Dido feels as she dies. Richard Wagner emphasized it with the DOUBLE PROSCENIUM of the *Festspielhaus* at Bayreuth. Igor Stravinsky insisted that the text (by Jean Cocteau and J. Danièlou) of his dramatic cantata *Œdipus Rex* be sung in Latin to enhance its mythic quality. Many modern productions achieve it with symbolic props and stark lighting. Contrary to what one might infer from the term, aesthetic distance is the element that allows the viewer to experience drama, that gives drama its immediacy and power.

affective memory *Acting* The memory of an emotional experience in the past stimulated by a similar experience in the present: the foundation of the actor's technique of consciously establishing an emotional context by recalling an analogous personal experience and constructing a character through remembered actions and responses. *See also* EMOTION MEMORY, STANISLAVSKI SYSTEM.

affettuoso (*ah-feh-too-OH-zoh*) [Italian] *Music* Full of affection, tenderly.

AFM *See* AMERICAN FEDERATION OF MUSICIANS.

a-440 *Music* The pitch of the note A in the octave above MIDDLE C tuned to sound at 440 Hertz (HZ), the international standard reference for musical pitch.

AFTRA *See* AMERICAN FEDERATION OF TELEVISION AND RADIO ARTISTS.

à gauche (*ah GOHSH*) [French] *Ballet* To the left.

agent A person who represents performers, directors, writers and other artists in their dealings with managers and producers.

agitando (*ah-gee-TAHN-doh*) [Italian] *Music* Becoming agitated.

agitato (*ah-gee-TAH-toh*) [Italian] *Music* Agitated, hurried.

agitprop (*AH-zheet-prop*) *Theater* Agitation and propaganda; an international movement among playwrights in the 1920s and 1930s to make theater more relevant to what they saw as the urgent needs of the people. Part of the pervasive anticapitalist movement in western Europe in that period.

AGMA *See* AMERICAN GUILD OF MUSICAL ARTISTS.

agogics *Music* A term proposed by the musicologist Hermann Riemann in 1884, to distinguish the subtleties of tempo from the dynamics of music. It denotes modifications of tempo such as RALLENTANDO, ACCELERANDO, TEMPO RUBATO, dwelling on a note or a rest, pausing briefly for breath, holding at a FERMATA, etc., that lend musical expressiveness and suppleness to a performance.

à gogo [French] *Cabaret* Literally, as much as you like. Frequently included in the names of night clubs such as *Whiskey à Gogo*. *See* GOGO DANCER.

agon (*AH-gon*) [Greek] *Theater* Literally, contest or struggle. The conflict of motives and dramatic purpose between the PROTAGONIST and ANTAGONIST in classical Greek drama that initiates the basic ACTION of the PLOT. The tension of inner action in a plot that is introduced in the PREMISE and dealt with in the DEVELOPMENT.

agonist [Greek] *Theater* An actor in classic Greek drama who contests with fate. *See also* ANTAGONIST, DEUTERAGONIST, PROTAGONIST.

agrément (*ah-gray-MANH*) [French] *Music* Literally, an agreeable thing. Usually plural. *See* ORNAMENT.

AGVA *See* AMERICAN GUILD OF VARIETY ARTISTS.

à haute voix (*ah OHT vwah*) [French] *Music* At the top of the voice. Open.

ailes de pigeon (*ehl deu pee-ZHONH*) [French] *Ballet* Literally, pigeon's wings. In ballet, a difficult step requiring a leap off one leg with the other thrown upward, followed by alternating beats and changes of the legs in air. Also called *pistolets* (*pee-stoh-LAY*).

air *Music* A melody or song.

air bearings *Stagecraft* Commercially manufactured bearings that may replace casters on the bottom of a stage wagon. When compressed air is forced into the bearings, through tubing hidden in the piece, it flows out to form a thin cushion of air that lifts the piece a fraction of an inch off the floor. It can then be moved across the stage with very little effort.

air brush *Stagecraft* A scene painter's tool similar to a house painter's sprayer but capable of much finer control.

air check *Television* A videotaped copy of a television program, taken from the broadcast signal rather than directly in the studio, for verification or portfolio purposes.

air link *Television* A transmission linkage by high-frequency radio between a REMOTE pickup and the main studio. *See* FEED. *Compare* LANDLINE, SATELLITE LINK.

aisle *Theater* A passageway among the seats in the auditorium.

aisle sitter *Theater* One who sits in a seat at the end of a row, therefore "on the aisle," so that he or she can leave quickly when the show ends, as must a critic who has to rush back to write for a late-night broadcast or next day's newspaper.

à la hauteur (*ah lah oh-TEUR*) [French] *See* HAUTEUR, À LA.

à la quatrième devant (*ah lah KAH-tree-em deu-VANH*) [French] *Ballet* A position in which the dancer faces the audience, arms extended to the side, with either foot in FOURTH POSITION front on the ground or raised to the fourth position front in the air. One of the POSITIONS OF THE BODY in the CECCHETTI METHOD.

à la quatrième dèrrière (*ah lah KAH-tree-em deh-ree-AIR*) [French] *Ballet* The reverse of À LA QUATRIÈME DEVANT, with the foot in FOURTH POSITION back on the ground, etc., one of the POSITIONS OF THE BODY in the CECCHETTI METHOD.

alarums and excursions *Acting* Much shouting and seemingly disorganized activity on stage with actors entering and exiting, running here and there, flailing away with various weapons as if there were a battle. A stage direction that appears in many of Shakespeare's history plays.

à la seconde (*ah lah seu-GOND*) [French] *Ballet* 1. Indicating that the foot should be put in SECOND POSITION, or that a movement should be performed in the second position in the air. *See also* EN SECONDE. 2. One of the POSITIONS OF THE BODY (CECCHETTI METHOD) in which the feet are in second position with the toe of one foot pointed and the arms extended to the side.

Alberti bass *Music* A style of writing bass lines for early keyboard instruments, particularly associated with Mozart and his contemporaries. The player's left hand keeps up a continuous pattern of figures based on appropriate TRIADS while the right hand plays the melody.

album *Music* A packaged recording available for sale to the public. When recordings first came out, long musical works required more than one disc and were therefore sold in bound albums. Though manufacturers developed long-playing records and eventually CDs, the term persists even when there is only one disc in the package. When there are several discs, the package that used to be an album is called a box.

al coda *Music* An instruction to the player to move directly to the CODA without repeating any intervening passages.

aleatory music A style of late 20th-century avant-garde music intentionally lacking in controlled order, with each individual part performed completely at the player's whim without direct relation to any unifying tempo. *See also* CHANCE MUSIC.

alegrias (*ah-lay-GREE-ahs*) [Spanish] *Dance* An old Flamenco dance from Spain, in 3/4 or 6/8 time, considered one of the most elegant and refined in the Spanish repertoire.

alert *Theater* 1. A notice in the light-cue sheet that a new set-up of dimmers must be prepared for a CUE that will come up shortly. 2. A note or symbol in the script to warn actors and crews to be prepared for a cue. 3. A stage manager's notice to actors and crew to be prepared for a cue or a new scene.

Alexandrine *Theater* 1. A line of verse containing twelve syllables. 2. The formal verse of classical French theater.

al fine (*ahl FEE-neh*) [Italian] *Music* To the ending. An instruction to a musician to continue to the point marked *fine*, which is the end of the piece. *See also* AL CODA, DA CAPO, DAL SEGNO.

alignment *Ballet* The position of the entire body with every part in balance and in proper placement (vertical relationship to every other part), *e.g.*, with the pelvis balanced precisely over the supporting leg. Also called placement.

aliquot part *Music* That part of the whole that is an exact divisor of the whole, *i.e.*, the division of a vibrating string that produces the sound of one of the string's natural HARMONICS.

alla breve (*ah-lah BREH-veh*) [Italian] *Music* At a pace measured by half-notes, using half-notes as the basic beat. In some music, particularly marches, the TIME SIGNATURE for a four-beat measure consists not of numbers but a capital C for "common time." For *alla breve* the time signature is sometimes indicated by a vertical line through the C and is called CUT TIME.

alla gitana (*ah-lah gee-TAH-nah*) [Italian] *Music* Literally, like a gypsy. In rhapsodic style that exaggerates emotions by alternating between the slow, sweeping rhythms and wildly rapid passages typical of gypsy music. *See also* ALLA ZINGARESE.

alla marcia (*ah-lah MAHR-chee-ah*) [Italian] *Music* At the pace and in the style of a march.

allargando (*ah-lahr-GAHN-doh*) [Italian] *Music* Broadening, slowing the TEMPO and sometimes gradually increasing the volume.

alla tedesca (*ah-lah teh-DESS-kah*) [Italian] *Music* Literally, in the German manner. A term once used to mean "in the style of an ALLEMANDE," then later "in the style of a German WALTZ."

alla zingarese (*ah-lah zin-gah-REH-seh*) [Italian] *Music* In the gypsy style. *See also* ALLA GITANA.

allegory *Playwriting* A play, or part of a play, that represents reality indirectly by means of a story told in spiritual terms or the terms of a mythical world, but that parallels events in the real world. *See also* FABLE.

allegretto (*ah-leh-GREH-toh*) [Italian] *Music* 1. To be played at a tempo slightly slower than ALLEGRO, but faster than ANDANTE. 2. A piece or a movement wholly in that tempo.

allegro (*ah-LEH-groh*) [Italian] Literally, lightly.

Dance A composition consisting of movements, particularly leaps, jumps and turns in the air, performed at a fast or fairly fast tempo.

Music 1. Briskly. To be played at a rapid pace, less fast than PRESTO, but faster than ALLEGRETTO. 2. A piece or movement wholly in that tempo.

alleluia (*ah-leh-LOO-yah*) [Hebrew] *See* HALLELUJAH.

allemande (*ah-leh-MAHND*) [French] *Dance* A 16th-century round dance in German style, elements of which can be found in American SQUARE DANCE.

Music In 17th- or 18th-century instrumental music, part of a SUITE.

alliteration *Playwriting* The practice of repeating the same initial sound in several words of a phrase or sentence, frequently used by dramatists to add theatrical effect. In Peter Quince's *Prologue* to the play-within-the-play of Act V of *A Midsummer Night's Dream*, Shakespeare makes fun of the technique with the line, "Whereat with blade, with bloody blameful blade / he bravely breach'd his boiling bloody breast."

alliterative *Playwriting* Describing lines composed with ALLITERATION.

allongé (*ah-lon-ZHAY*) [French] *Ballet* Elongated, extended, outstretched.

all'ottava (*ahl-oh-TAH-vah*) [Italian] *Music* At the octave. An octave higher than written, usually, unless the word BASSA follows to indicate an octave lower. Abbreviated as 8va.

all-star *Theater, Vaudeville* Describing a cast of performers all of whom are very famous.

alpenhorn [German] *Music* A wooden horn without keys or valves, several feet long and straight, used by Swiss and German herdsmen in alpine regions because its signal can be heard at great distances.

al segno (*ahl SEH-nyo*) [Italian] *Music* An instruction to the musician to go to the sign and continue playing from that point.

alt (*ahlt*) [Italian] *Music* High, in the highest REGISTER.

altered chord *Music* A chord with one or more tones raised or lowered from the pitch that would be appropriate in the prevailing KEY.

alternate *Theater* A player who stands ready if necessary to fill the role assigned to another. *See also* BACKUP, UNDERSTUDY.

alternating cast *Theater* Said of a production with two casts who play on alternate dates so that each may have some time off during a LONG RUN.

alternative theater Any form or style of theater unlike that which prevails, and which therefore supplies an alternative for audiences. *See* AGITPROP, LABOR THEATER, THEATER OF THE ABSURD.

althorn (*AHLT-horn*) [German] *Music* An ALTO HORN.

altissimo (*ahl-TEE-see-moh*) [Italian] *Music* Literally, highest. As high as possible.

alto *Music* Literally, high. 1. A voice in the middle range, between SOPRANO and TENOR. In the 16th and 17th centuries an alto voice was considered high because it was sung by a male. In modern times it is considered low because it is usually sung by a female. 2. Another name for the VIOLA. 3. In JAZZ, the alto SAXOPHONE.

alto clef *Music notation* The clef that defines MIDDLE C as the center line of the five-line STAFF most suitable to cover the range of altos. The VIOLA CLEF.

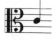

ALTO CLEF
(MIDDLE C)

alto horn *Music* A brass instrument similar in shape to the BARITONE horn, but smaller. It plays in the alto REGISTER.

alto saxophone *Music* The third highest of the saxophones, a TRANSPOSING INSTRUMENT in E-FLAT, frequently assigned the main melodic line within a choir of saxophones. Among jazz musicians, it is called, simply, an alto.

AM *Broadcasting* AMPLITUDE MODULATION.

Theater Assistant manager.

amateur show *Theater* An evening of songs, dances and short skits prepared and performed by amateurs competing for a prize that may range from cash to an appearance in a more important show. Although most amateurs compete for fun, the amateur show has also served as a springboard for professionals and stars.

Amati (*ah-MAH-tee*) [Italian] *Music* A violin made by Niccolò Amati, the most famous member of a family of violin makers in Cremona, Italy, during the 16th and 17th centuries, or by either of his sons. Many of his and his sons' violins and other instruments are still in daily professional use, treasured by their owners. Both Guarneri (*see* DEL GÈSU) and STRADIVARIUS were his pupils.

ambient light *Theater, Motion pictures* The general light on the set when the stage lights are not on.

ambient noise *Audio* The general noise existing in the studio area, not usually noticed unless a recording is in progress, but extremely important to the recording engineers. Even in what seems to be a very quiet studio, microphones pick up such sounds as the hum of electrical equipment, airplanes overhead and the movement of air through air-conditioning ducts. *See also* ROOM TONE.

Ambrosian chant *Music* A style of liturgical chant developed for the Catholic Church during the time of Saint Ambrose, who lived in Milan, Italy, during the 4th century.

American Federation of Musicians The national labor union, founded in 1896, to which most professional instrumentalists in the United States belong.

American Federation of Television and Radio Artists The national labor union to which most professional performers in television and radio belong, founded in 1937 as AFRA. The T was added in 1952. AFTRA's jurisdiction parallels that of the Screen Actors Guild (*See* SAG) in motion pictures.

American Guild of Musical Artists The national labor union, founded in 1936, to which most professional singers belong.

American Guild of Variety Artists The national labor union, founded in 1939, to which most professional variety entertainers belong.

American National Theater and Academy An association created by Congress in 1935 for the support and encouragement of theater. It became inactive during the 1980s.

American organ *Music* A small reed organ, with wind supplied by a bellows operated by the player's feet. Common in middle-class parlors in the 19th century. Also called a HARMONIUM.

American plan seating *Theater* An arrangement of the seats of the HOUSE in several blocks, no more than fourteen in one row, with radial aisles between and usually with one or two CROSSOVER aisles. It is distinguished from CONTINENTAL SEATING, which has no radial aisles except along the outside walls and therefore requires more space between rows to allow the audience to move around. *Compare* THREE-ROW-VISION SEQUENCE.

American Society of Composers, Authors and Publishers The original performance rights management organization for music in the United States, founded by composer Victor Herbert and others in 1914. It collects performance fees from performing organizations and broadcasters and distributes them proportionately to its members. *See also* BMI, SECAM, SESAC.

American Theater Wing An organization founded in 1917 by a group of actors to aid war relief by bringing professional actors to perform in hospitals and camps. After World War I it became dormant, but it was revived in 1939, and was again active during World War II. It is best known for its annual award for distinguished achievement in theater, the Antoinette Perry Award or TONY.

amp *Audio* Abbreviation for AMPLIFIER.

AMPAS *See* ACADEMY OF MOTION PICTURES ARTS AND SCIENCES.

ampere *Lighting* The basic unit of electrical current, commonly referred to as an amp or amps.

amphitheater A circular or semicircular theater with seats arranged in concentric arcs or circles around the stage. The classical Greek and Roman theaters were amphitheaters.

amplifier *Audio* A unit that adds power to an electronic signal, thus adding volume to the resulting sound.

amplitude modulation *Audio* The electronic medium through which all radio broadcasts were originally transmitted, by which the pattern of increasing and decreasing power in the steadily modulating radio wave carried the sound signal. *Compare* FREQUENCY MODULATION.

amps *Lighting* Amperes, used to express the total capacity of a circuit or of an electric system, as in "this board handles 200 amps."

anacreontic *Music* A verse form attributed to the very ancient Greek poet Anacreon (6th century B.C.) who composed love songs. The melody used for the national anthem of the United States was originally a drinking song, "To Anacreon in Heaven."

anacrusis *Music* Literally, before the CRUSIS. The last BEAT of a preceding MEASURE that leads over the BARLINE into the CRUSIS, which is the first beat of the next measure. A term made most specific in DALCROZE EURYTHMICS. An UPBEAT. *Compare* METACRUSIS.

anagnorisis (*ah-nahg-noh-REE-sis*) [Greek] *Theater* The moment of RECOGNITION in any classical Greek tragedy; the critical moment that occurs after the DISCOVERY and precedes the REVERSAL OF CIRCUMSTANCES.

analog format *Audio* The recording technique invented by Thomas Alva Edison that converts the vibrations of sound in air directly to ridges and valleys in a groove on the surface of a spinning cylinder. When the cylinder is replayed, a needle running in the groove responds to the ridges and valleys with physical vibrations that are amplified to reproduce the original sound. Although the means of amplification has changed over the years, the basic technique remained in use until digital recordings were developed in the 1970s.

anamorphic lens *Motion pictures* Any lens that alters the ratio between vertical and horizontal dimensions. A typical anamorphic lens reduces horizontal dimensions during the shooting of what is intended to become a wide-screen film, so that the width of the image will fit within the available width of the frame. When projected through a matching lens, this compressed width is enlarged to the original ratio. CINEMASCOPE, PANAVISION and some others are trade names for anamorphic lens systems. Not the same as wide-angle lens. *See* ASPECT RATIO.

anchor *Broadcasting* The principal person seen and/or heard during a news or sports broadcast, often also responsible for coordinating the appearances of various participants.

Stagecraft 1. A weight or a piece of hardware used to keep a piece of scenery in place on the stage floor. 2. To secure a flat or a piece of scenery to the stage floor. *See* PIG, SANDBAG, STAGE SCREW, WAFER.

andamento (*ahn-dah-MEN-toh*) [Italian] *Music* A section of a FUGUE in which the subject has been extended beyond its original statement.

andante (*ahn-DAHN-teh*) [Italian] *Music* Literally, walking. 1. At an easy walking TEMPO. 2. A MOVEMENT composed to be played at that pace.

andantino (*ahn-dahn-TEE-noh*) [Italian] *Music* 1. Somewhat faster than ANDANTE. 2. A MOVEMENT composed to be played at that pace.

angel *Theater* A generous financial BACKER of a production.

anglaise (*ahn-GLEHZ*) [French] *Dance* Literally, English. 1. A country dance popular in the 17th and 18th centuries. 2. Part of an instrumental SUITE, usually in rapid DUPLE TIME.

angled flat *Stagecraft* A FLAT set at any angle other than parallel to the PROSCENIUM.

angled wings *Stagecraft* WINGS set at any angle other than parallel to the PROSCENIUM.

angle iron *Stagecraft* A short, flat strip of steel bent to form a right angle and fastened with screws into an inside corner at the back of a FLAT to stiffen the frame.

angle shot *Television* A shot made from an unorthodox point of view, e.g., with a tilted camera, to lend interest to an otherwise ordinary shot.

angle wing *Stagecraft* A WING made of two FLATS joined together vertically and placed at either side of the stage with one flat parallel to the curtain line and the other slanting upstage toward an imaginary vanishing point. To create a street scene, the designer may stand three angle wings along each side of the stage, their front surfaces painted to look like the sides of houses, their angled surfaces in false perspective as housefronts. Not to be confused with an ANGLED WINGS.

Anglican chant *Music* A style of liturgical singing developed at Canterbury and Salisbury in England during the early Middle Ages.

animal dances 1. Dances of ancient origin in many different styles from all over the world, probably stemming from the hunter's tactic of disguising his body with animal skins, feathers, etc., and deceiving his prey by mimicking its movements. Similar camouflage and animal-like gestures were used in celebrations following a successful hunt. 2. An American dance style built on movements that mimic animals, usually performed to ragtime music. Popular in the early 20th century, some examples are the BUNNY HUG, BUZZARD LOPE and TURKEY TROT.

animate *Motion pictures* To suggest lifelike movement of images by creating a controlled sequence of pictures on separate frames (at standard motion picture speed, 24 frames per second) showing every position the subjects of the images would go through in real motion.

animation *Motion pictures* 1. The process of making a motion picture from prepared stills. 2. A motion picture made from animated stills.

animation stand *Motion pictures* Basically, a worktable with a motion picture camera mounted on rails above it, aimed directly at the table upon which an animation camera operator places stills to be individually photographed to make up an animated sequence. In practice, animation stands are extremely complex, allowing nearly unlimited manipulation of many images at many depths on the table and of camera movement. In feature films where titles and other images require simple animation, the stand is often called a ROSTRUM.

animato (*ah-nee-MAH-toh*) [Italian] *Music* Animated, in a brisk manner.

animator *Motion pictures* An artist who calculates the necessary moves and then draws, paints, sculpts or electronically creates the images that make up an animated motion picture. An animator always determines how the moves will be made, but does not always actually create all the IN-BETWEENS.

Annie Oakley *Theater* A ticket in which a hole has been punched, *i.e.*, a free ticket. Named after a woman sharpshooter of Buffalo Bill's Wild West Show (early 1900s) who became famous by shooting holes through tickets held by willing persons standing several yards away. *See also* COMP.

announce booth *Television* A soundproof booth, *e.g.*, at a baseball game, to house announcers and their monitoring equipment.

announcer *Broadcasting, Television* One who talks directly to the audience about the show or the news but is not necessarily an actor in the cast. *See also* NARRATOR.

answer *Music* The second appearance of the theme of a FUGUE, following the first (the SUBJECT).

answer print *Motion pictures* A test print of a completed motion picture made from the ORIGINAL or the INTERNEGATIVE, giving the laboratory and the film director an opportunity to check that colors have been correctly balanced in the laboratory's TIMING process. Once an answer print has been approved, final RELEASE PRINTS may be made and sent to theaters.

ANTA *See* AMERICAN NATIONAL THEATER AND ACADEMY

antagonist [Greek] *Acting* In classical Greek tragedy the character who responds to the PROTAGONIST. *See also* AGONIST, DEUTERAGONIST.

anthem *Music* A hymn or song of praise, a descendant of the Latin MOTET. Its usage dates back to the English Protestant Church of the 16th century.

anticipate *Acting* To react to a line or ACTION CUE that has not yet been given.

Music To sound the next tone of a melodic line before the other voices have reached the harmony of which it will become a part.

anticipation *Music* The practice of anticipating.

anticlimax *Theater* The RESOLUTION of minor situations in the PLOT after the major plot situation has been resolved.

anticulinary theater A term coined by playwright Berthold Brecht to describe his more serious plays, which he considered too disturbing to see after—or before—a good meal.

anti-hero *Acting* The hero of a play, but one who displays few of the conventional attributes of a hero.

antilude *Music* The last movement of a work that comes after the climax of the previous movement and contrasts with its mood.

Playwriting A scene that comes after the climax and, because its content and mood are entirely different from what went before, tends to calm or answer its effect. *Compare* ANTICLIMAX.

antiphon *Music* Literally, answering sound. A liturgical chant coming before or after an important passage, usually including responses of one voice to another. The term is sometimes applied to other minor sections of the MASS.

antiphonal *Music* Originally describing the character of liturgical ANTIPHONS, but in modern times describing works for separated choirs who answer or echo each other in successive passages of music. Palestrina's *Stabat Mater* is an example.

antiphony *Music* The echoing and responsive quality of antiphonal music. The practice of composing or performing such compositions.

antistrophe *Acting* The responding or answering stanza (*i.e.*, second, fourth, sixth, etc.) of a STROPHIC ODE in classical Greek drama.

anvil *Music* A blacksmith's anvil used as a percussion instrument. It emits a very loud clang when struck with a heavy sledge by a strong percussionist.

apache dance *Cabaret, Dance* A sensuous couple dance popular in Paris during the 1920s and later, full of violent moves, performed originally by what the Parisians considered members of the criminal class, whom they called *apaches*.

apart *Acting* An instruction to an actor to step with another actor to another part of the stage and speak, as if confidentially, lines that the audience, but not the other characters, are supposed to hear. *Compare* ASIDE.

aperto (*ah-PEHR-toh*) [Italian] *Music* Literally, open. 1. Clear, in broad style. 2. In music for the FRENCH HORN it indicates unstopped tones.

aperture *Lighting, Motion pictures, Television* The diameter of the opening of a lens through which light may pass, expressed as a ratio related to the focal length of the lens. *See* ASPECT RATIO.

aplomb [from French] *Acting, Dance* Self-possession and poise expressed in the vertical position of the body. The ability to hold one's balance while keeping the weight of the body correctly centered. The French word "plomb" refers to the lead weight on a string used by surveyors to establish a true vertical line.

Appalachian Mountain Dance Originally Celtic, a country dance whose principal SET is the KENTUCKY (or TENNESSEE) RUNNING SET, later mixed with CONTRAS and developed into the SQUARE DANCE.

apparent light source *Lighting* A point onstage, such as a reading lamp on a bedside table, which seems to the audience to be the source of illumination for the scene, though the light actually comes from stage lights. Called a "practical" in motion picture lighting. Similar to a MOTIVATING LIGHT. *Compare* ARBITRARY LIGHT.

apparition scene *Theater* A scene during which a ghost appears. *See also* APPEARANCE TRAP.

appassionato (*ah-pah-syoh-NAH-toh*) [Italian] *Music* 1. Passionately. 2. An impassioned piece.

appear *Theater* 1. To perform in a show or concert. 2. To enter into a scene. 3. To reveal oneself during a scene without a formal entrance, as does the Ghost in *Hamlet*.

appearance *Acting* 1. An actor's presence on stage as part of a show. 2. An actor's entrance into a scene.

appearance trap *Stagecraft* A TRAP in the stage floor through which an actor may suddenly appear. Such a trap may be fitted with an elevator to enhance its suddenness. *See also* GHOST TRAP.

appear opposite (someone) *Acting* To play one of two leading roles in a play.

apple *Television* A box placed on the floor, out of sight of the camera, to support a short actor or announcer.

appoggiatura (*ah-paw-gee-ah-TOO-rah*) [Italian] *Music* Literally, a leaning note. A brief tone, not part of the harmony with which it sounds, played on the BEAT in place of an expected tone and quickly resolving into it. Not the same as a GRACE NOTE, which comes before the beat.

apprentice *Theater* A temporary member of the acting company who is learning the craft and who intends to become a full professional after a specified period. In regional theater an apprentice expects little or no pay and works for a short period such as a summer or one season.

apron *Theater* An area of the stage floor in front of the main curtain, deep enough for actors to play on. *See also* RAMP, THRUST STAGE.

apron stage *Theater* A stage with an APRON.

a punta d'arco (*ah POON-tah DAR-koh*) [Italian] *Music* At the point of the BOW. An instruction to the string player when the composer wishes the particular lightness of sound that this placement of the bow produces.

aquacade *Theater* 1. An elaborate production similar to a musical REVUE in which swimmers and divers perform in a pool. It was popular at large state and national fairs during the 1940s, but had its roots as a popular indoor entertainment as early as the 18th century. 2. A name sometimes used for a special theater built for a swimming show.

aquadrama *Theater* A play designed to be performed by actors swimming in a pool.

arabesque (*ah-rah-BESK*) [French] *Ballet* A dancer's basic pose with one arm extended forward, the opposite leg backward, and the body extended to form a long curved line arching from the fingertips to the toe of the working leg. The arabesque takes many forms; *à deux bras* (both arms extended forward), *à la demi-hauteur* (with the working foot halfway between the floor and a horizontal position in the air), ALLONGÉE (in a horizontal line from fingertips to toes), *allongée à terre* (extended on the ground), *à terre* (on the ground with one leg extended in fourth position, toe pointed), *en promenade* (with a slow turn in arabesque position), FONDUE or *pliée* (with the knee of the supporting leg bent), *voyagée* (traveling with small hops, with the supporting knee bent), etc.

Music A name used by composers of the 19th century and later as a title for certain graceful piano solos.

arbitrary light *Lighting* A light that has no apparent justification in the story of a scene, inserted for purely theatrical or aesthetic reasons. *Compare* APPARENT LIGHT SOURCE, MOTIVATED LIGHT, PRACTICAL.

arbor *See* COUNTERWEIGHT ARBOR.

arc, arc light *Lighting* A powerful light, frequently a SPOTLIGHT placed at the rear of the house, whose source of light is a continuous spark between carbon electrodes that require constant adjustment during operation, rather than a tungsten filament. *See also* BRUTE.

arc follow-spot *Lighting* A very bright FOLLOW-SPOT that uses a carbon spark for its light source. Its beam, which is usually highly visible and comes from a great distance behind the audience, adds theatrical effect by highlighting a single actor on stage with great brilliance in the surrounding darkness.

arch form *See* TERNARY FORM.

archlute *Music* A LUTE with two sets of tuning pegs, one for the fingered strings, the other for the bass strings.

arco [Italian] *Music* 1. Short for *coll'arco*, with the bow. To be played with the bow, not with the fingers as in PIZZICATO. 2. The string player's bow.

area lighting General lighting for an acting area.

arena stage *Theater* A stage without backdrop or wings, surrounded by the audience.

arena theater A THEATER IN THE ROUND, with seats all around the stage.

argument *Theater* An outline of the situation of the plot and how it will be worked out in the play, printed at the beginning of the script or in the printed program for the audience to read, or spoken by an actor before the curtain opens. Not the same as PROLOGUE.

arhythmic *Music* Structurally without rhythm. Said of a passage that seems to move in a completely pulseless time-frame.

aria [Italian] *Music* Literally, an air. An extended lyrical vocal solo, usually part of an opera or choral work.

aria da capo (*AH-ryah dah KAH-poh*) [Italian] *Music* An ARIA in ABA form, *i.e.*, an aria whose ending repeats its beginning.

arietta (*ah-ree-YET-tah*) [Italian] *Music* Literally, a little ARIA.

ariose (*ah-ree-OHZ*) [French], **arioso** (*ah-ree-OH-zoh*) [Italian] *Music* 1. Melodious, like an aria. 2. A richly melodious piece.

Aristotle's terms *See* ELEMENTS.

Arlecchino (*ahr-leh-KEE-noh*) [Italian] *Theater* Harlequin, the tricky one, a major character in COMMEDIA DELL'ARTE, who wears a costume of very bright colors in a diamond pattern and carries a sword. Arlecchino was originally the local hero of carnivals in Bergamo and always, in Italian productions, speaks in the dialect of that city.

arm cyclorama *Stagecraft* A DROP made in three panels designed to provide a three-sided background for a scene. Its side panels hang from hinged extensions at each end of the BATTEN. When it is FLOWN, the sides are folded against the back so that they will not interfere with lighting and other drops in the FLIES. When in place on stage, these arms are unfolded by their RIGGING LINES to provide side panels and background for the scene.

arm puppet *See* HAND PUPPET.

arpeggiando (*ahr-peh-gee-AHN-doh*) [Italian] *Music* An instruction to the string player to use a bouncing bow-stroke over broken chords. *Compare* PIZZICATO, SPICCATO.

arpeggiate *Music* To play as an ARPEGGIO that which has been written on the page as an ordinary CHORD.

arpeggiation *Music* The conversion of ordinary chords into ARPEGGIOS.

arpeggio (*ahr-PEH-gee-oh*) [Italian] *Music* The notes of a chord played in succession (instead of simultaneously) with an upward or downward sweep, usually on a HARP or KEYBOARD instrument.

arpeggione (*ahr-peh-gee-OH-neh*) [Italian] *Music* A stringed instrument the size of a VIOLONCELLO, shaped somewhat like a GUITAR, without a SOUND POST, and having six strings tuned like a guitar.

arrange *Music* To reorchestrate or rework a piece of music for a new combination of instruments or voices.

arrangement *Music* A version of a piece of music reworked for a different combination of instruments or voices or for a different situation, with alterations and the development of variations in both melody and harmony, interesting modulations and transpositions, new countermelodies and new rhythmic patterns.

arranger *Music* One who reworks a tune or a piece of music into a new form, or resets it for different instruments or voices.

arrière, en *See* EN ARRIÈRE.

Ars Antiqua *Music* A term used by European composers during the late 14th century in France and Italy to distinguish the old style (late 13th century) from their own which they called *Ars Nova*. The *Ars Antiqua* featured ecclesiastical contrapuntal music based on PLAINSONG, which was a new development in its time. *Ars Nova* carried this development further, with more complex rhythmic phrasing and freer POLYPHONY. The style of notation developed similarly in that period, but without as profound a difference. Modern scholars continue to use both terms as convenient labels for each century.

aspect ratio *Motion pictures, Television* The ratio of the width of the aperture (or the screen) to its height. The Academy of Motion Picture Arts and Sciences determined the ratio for the standard movie screen and the FRAME of the film that played on it to be 1.33 to 1 (width to height), the proportions used also for broadcast television. Standard wide-screen movies are projected with a frame that is 1.85 to 1, which appears commonly in television as the LETTERBOX FORMAT. *See also* CINEMASCOPE, PANAVISION.

aspirate *Acting* 1. Produced by the breath. 2. A vocal sound produced by a relatively sharp breath, *e.g.*, the sound of *h* or an initial *t*. 3. To speak a sound with audible breath.

assai (*ah-SIGH*) [Italian] *Music* Literally, very. Often confused with the French *assez* (quite, or somewhat), even by such composers as Beethoven. Both meanings are common.

assemblé (*ah-sawm-BLAY*) [French] *Ballet* A jump, often preceded by a preparatory step, ending with both feet together. It has many variations and can be performed EN AVANT, EN TOURNANT, SOUTENU, etc.

assembly *Motion pictures* A nearly complete version of a motion picture, or a segment of it, accompanied with some of the elements of its SOUND TRACK, giving the editor and director a general impression of what the picture will look like before more refined editing.

assistant conductor *Music* A conductor who assists the chief conductor by leading sectional rehearsals and the like, and who stands ready to take the chief conductor's place in an emergency.

assistant director *Theater* One who assists the director of a production by helping with the details in a large rehearsal or shooting session or by directing preliminary or partial rehearsals while the director is busy with larger or more advanced ones. In large stage productions the assistant director (in opera, the assistant stage director) makes note of every direction or change made by the director during rehearsals, then monitors all subsequent rehearsals and the performance to make sure they are properly executed. The assistant director's notes become the official record of the production and are referred to if the production is revived. *Compare* STAGE MANAGER.

Motion pictures, Television With some directors, an assistant has specific secondary responsibilities in the production of a film or taping for television. With others, the assistant takes notes and handles offstage details. *See also* TECHNICAL DIRECTOR.

assonance *Acting* Similarity of sound, distinguished from rhyme. A poetic device used by dramatists to give extra color to lines or to hint at ideas that are not being directly expressed in the words. *See also* ALLITERATION.

atelier (*ah-tel-YAY*) [French] A studio or workshop for painters, sculptors, dancers or CRAFTS people.

a tempo [Italian] *Music* At (the original) pace. An instruction to resume the TEMPO that was in effect before the preceding passage.

à terre (*ah TAIR*) [French] *Ballet* On the ground, with the working foot touching the floor, as distinguished from EN L'AIR. Also called *par terre*. *See also* TERRE À TERRE.

at liberty *Acting* Unemployed.

atonal *Music* Literally, without tone. Used to describe music that does not follow a system based on KEY or MODE. Not the same as DISSONANT.

atonality *Music* The lack of a tonal center or key system. The style of musical composition that is not based upon a tonal center. The tones do not gravitate around a central note but seem individually to float free in musical space. *Compare* HARMONIC, POLYTONAL, TONAL.

at rise *See* DISCOVERY.

à trois (*ah TRWAH*) [French] *Music* As three. Three together. Depending on the musical context, three who have been singing or playing separate lines now playing the same line, or the reverse: three on the same part changing to three separate lines.

attacca (*ah-TAH-kah*) [Italian] *Music* Attack, *i.e.*, continue the next section of the piece immediately.

attacca subito (*ah-TAH-kah SOO-bee-toh*) [Italian] *Music* Strike the next note or chord suddenly.

attack *Music* 1. The manner of initiating a sound, particularly with a wind instrument or the voice. Precision of attack distinguishes a good ensemble or chorus from a sloppy one. 2. The prompt, forcible initiation of a tone without audible preparation.

attitude (*ah-tee-TÜD*) [French] *Ballet* A dancer's pose with one leg raised, with the knee bent and turned out. The pose has many variations according to the position of the body vis-à-vis the audience, or the placing of the arms, and can be performed À DEUX BRAS, CROISÉE DERRIÈRE, ÉFFACÉ, EN TOURNANT, etc.

attraction *Circus, Motion pictures, Music, Theater* A performer with a good BOX OFFICE NAME that can be featured in advertising to draw a large crowd.

aubade (*oh-BAHD*) [French] *Music* Pleasant music meant to be performed in the early morning. *Compare* NOCTURNE, SERENADE.

audience dress *Acting* A rehearsal in costume in the presence of an audience.

audience number *Acting* A routine the audience responds to very well.

audience participation show *Theater, Television* *See* HAPPENING, PARTICIPATION SHOW.

audience-proof *Theater* A play that will work well on stage no matter how dull and unresponsive the audience seems at the beginning.

audio [from Latin, "I hear"] The portion of any electronic system that carries sound.

audio console A CONSOLE with an array of electronic controls designed to modify the volume and quality of sound in any multichannel sound system. A typical console may have the capacity of controlling dozens of channels.

audio control 1. A soundproof room with large windows and an audio control console where an audio director and engineers can work in isolation from extraneous sound while maintaining visual contact with performers and others in the studio. 2. The section of a television studio's CONTROL CONSOLE that controls the audio system.

audio creep An audio engineer's subconscious tendency during a very long and difficult recording session constantly to adjust recording LEVELS slightly upward. The result is that TRACKS recorded late in the session are incompatible with those recorded at the beginning, thus requiring a tedious rerecording session.

audio mix The process of merging two or more audio recordings into one. In traditional motion picture technique, this occurs in a modified screening room where the director and engineers can see the film (*i.e.*, the visual portion) on a screen and hear all the different parts of the sound track IN SYNC with it. They create the composite sound track by rerecording from its separate elements, adjusting balances and equalizing tones the way they want them. In modern technique, the same general procedure takes place with the components of the film in video and audio magnetic format. Not the same process as a VIDEO MIX. *See also* MIX-DOWN.

audio spectrum *Acoustics* The entire range of frequencies that can be heard by the human ear, from about 15 HZ to about 18,000 HZ. The tones of the piano range from about 55 HZ to about 7,000 HZ. Most people can detect tones in the highest range when they are young, but the ability diminishes as they grow older. The tones above the top notes of the piano, though they are difficult for most people to identify, are crucial as the HARMONICS of lower tones; their presence and the balance between them determine the TIMBRE of all instruments and voices.

audio tower A high scaffolding that supports very large LOUDSPEAKERS for outdoor concerts.

audition A hearing for the purpose of filling positions in a cast, chorus or orchestra. *See also* CALL, CASTING CALL, CATTLE CALL, TRYOUT.

auditorium beams *Lighting* BEAM LIGHTS aimed at the stage from the auditorium.

augmentation *Music* The widening of an INTERVAL, or the lengthening of a melodic line.

augmented *Music* 1. Said of a MAJOR or a PERFECT INTERVAL that has been widened by raising its high note or lowering its low note a SEMITONE. 2. Said of a melodic line, especially a FUGAL SUBJECT, that has been lengthened in development by increasing the time-value of its notes, *e.g.*, by making each quarter note a half note, etc.

aulos (*OW-lohs*) [Greek] *Music* A flute with two pipes bound together, sounded simultaneously by blowing into the tips through oboe-like reeds. The aulos appears in illustrations from long before the time of the classical theater in Greece. It was considered the instrument of passionate emotion and was associated with Dionysius. *See also* KITHARA.

ausdruck, ausdrucksvoll (*OWS-drook, OWS-drooks-fol*) [German] *Music* Expression, expressively.

Austrian curtain *Stagecraft* A CONTOUR CURTAIN drawn up so that all its lifting cords move at the same speed and arrive at the same height, with identical looping drapes between them at equal distances from the floor. *Compare* VENETIAN CURTAIN.

auteur (*oh-TEUR*) [French] *Motion pictures* The author, in the sense of chief creator of a film, often the person who conceived, wrote and directed it. The concept is central to the philosophy of the French NEW WAVE movement set forth in the periodical *Cahiers du Cinéma* in the 1950s. It became the guiding creed of the great French directors of that era, including François Truffaut, Jean-Luc Godard and Claude Chabrol.

authentic cadence *Music* A CADENCE consisting of a DOMINANT chord resolving into the TONIC. *See also* DECEPTIVE CADENCE, PERFECT CADENCE, PLAGAL CADENCE.

authentic instruments *See* PERIOD INSTRUMENTS.

autograph *Music, Theater* An authentic manuscript in the composer's or playwright's handwriting.

autoharp *Music* A small instrument with strings like a harp and a sound board parallel to the strings (like a ZITHER), played with a PLECTRUM or by plucking with the fingers. A mechanism mounted over the strings can be pressed by the player to dampen all the strings except those wanted for a particular harmony at a particular time.

auxiliary tone *Music* A tone above or below the principal tone of the moment, briefly played after it and followed in turn by the principal tone. An embellishment. *See also* ORNAMENT.

available *Theater* Unemployed, ready to be auditioned or cast.

available light *See* AMBIENT LIGHT.

avant, en *See* EN AVANT.

avant-garde (*AH-vanh GARD*) [French] The innovators and experimenters among composers, choreographers, filmmakers, playwrights and theater companies, noted for their willingness to try unorthodox works and use unorthodox techniques.

a vista scene change *Stagecraft* A change of scenery that takes place in full view.

axe *Music* 1. In JAZZ, any player's instrument. 2. In ROCK MUSIC, a guitar.

axial movement *Dance* Movement taking place around an axis on the stage, *i.e.*, around an individual dancer or group of dancers.

B

b *Music* 1. The seventh tone of the scale of c, one WHOLE TONE above A. 2. The TONALITY of which the note B is the TONIC. In the FIXED-DO SYSTEM, B is TI or SI.

baby *Lighting* Any small light, usually a 750-watt SPOTLIGHT.

baby grand *Music* The smallest of the grand pianos, any GRAND PIANO less than 65 inches in overall length.

baby legs *Motion pictures* A low camera tripod.

baby spot *Lighting* Any very small spotlight, used to provide accent lighting when the fixture itself must be hidden from the audience's view either behind a TEASER or among the FOOT-LIGHTS. *See also* CHASER, INKY.

bacchanal *Dance* Any wild, drunken dance. Traditionally a revel in honor of the Greek god Bacchus, also called Dionysius, the god of wine, celebrated in preclassical times in the Mysteries at Eleusis. Also referred to as Bacchic Dances. *See* DIONYSIA.

Bach trumpet *Music* A modern TRUMPET with very high range, in the third octave above MIDDLE C, created in the late 19th century to play parts originally composed for the CLARINO, *e.g.*, in the *Brandenburg Concertos* and the *Magnificat* of Johann Sebastian Bach.

back *Music* On any stringed instrument the bottom surface, away from the strings, that provides a good part of its resonance and enhances the sound. With the exception of some DOUBLE BASSES that have flat backs, the backs of instruments of the VIOLIN FAMILY are rounded.

Theater 1. The rear wall of the stage. 2. To provide financial support for a production.

back batten *Stagecraft* The BATTEN farthest from the PROSCENIUM.

back beat *Music* In JAZZ or ROCK, an emphasis on the off-beat, *e.g.*, on the second and fourth beats of a 4/4 measure.

back cloth *Stagecraft* Any curtain or DROP hung across the back of the stage.

backdrop *Stagecraft* The DROP across the back of the set, sometimes painted to represent a distant landscape, the sky or an architectural wall appropriate to the scene. *See also* CYCLORAMA.

backer *Theater* One who contributes, lends or invests money to help pay for a production.

background *Theater* The initial situation facing the characters in a drama as the first scene opens. It contains the basis of the conflict (AGON) between the characters with which they will begin to deal in the DEVELOPMENT of the plot, that Aristotle in his definition of the processes of drama calls the EPITASIS. *Compare* GIVEN CIRCUMSTANCES. *See also* ELEMENTS.

background music *Motion pictures* Music intended to accompany, but not intrude upon, a scene. When movies were silent, exhibitors hired pianists (or organists, in richer theaters) to play appropriate music to help define the mood or enhance the excitement of what was happening on the screen. When sound tracks became integral parts of films, the tradition continued and acquired a new justification: to cover extraneous noises, DROP OUTS, and changes of ROOM TONE that would otherwise distract the audience. Not the same as INCIDENTAL MUSIC.

background projection *Lighting* A scene providing the background of the set projected on a BACKDROP or a CYCLORAMA. Such projections are very common in motion pictures, showing the passing scenery outside an automobile window, for example, when the scene of the driver and the passenger is actually shot within the studio.

background scene *Acting* A scene, early in the first act of a play, providing background information about its characters and the plot.

backing *Stagecraft* 1. Any material applied to the back of a flat to give it stiffness or render it opaque. 2. Any scenic element, such as a DROP or a FLAT, placed outside an opening in the set, such as a window or a doorway, to provide background suitable to that scene.

Theater Financial support for a production.

backing light *Lighting* 1. Illumination on the BACKING elements of the scene. 2. The instrument and lighting circuit that provides such illumination.

backing strip *Stagecraft* A strip of lights in a metal housing hung or mounted on a stand to provide realistic illumination inside a doorway, or to focus on a piece of scenery that would otherwise look dark.

backing track *Music* A tape recording of the rhythm section of a dance or ROCK band, used as BACKUP for a RAP performer.

backlight *Lighting* 1. Light from a small, hidden source illuminating the edges of a subject from behind. Not the same as background lighting, nor fill light. 2. To illuminate from behind. *See* ACCENT, HALO, HIGHLIGHT.

backlighting *Lighting* The practice of lighting from behind the subject, to create various effects including ACCENT, HALO and HIGHLIGHT.

back of the house *Theater* Behind the audience.

back painting *Stagecraft* The practice of painting a few wide, criss-crossed lines on the back of a flat to prevent its surface from wrinkling as the paint on the front dries, or to render it opaque.

back pipe *Stagecraft* The PIPE hanging farthest from the PROSCENIUM. The BACK BATTEN.

back projection *Lighting* Any image or scene projected from behind on a BACKDROP or a CYCLORAMA.

backstage *Theater* 1. Behind the PROSCENIUM, out of sight of the audience. 2. Describing everything the audience is not meant to see, including the space and paraphernalia behind the set and the people (and their activities) who do not appear as actors, including designers, builders, stagehands, coaches, directors, producers and the like.

backstage crew *Stagecraft* All the stagehands, gaffers, costume and makeup people who work backstage during the show but do not appear onstage as actors. Often called the RUNNING CREW.

backstage staff *Stagecraft* Everyone who works backstage during the operation of the theater, including the technical supervisors, designers, directors and crews, makeup artists, dressmakers, wigmakers, wardrobe assistants, even the guards, doorkeepers and security people, but not including the management, the box office clerks, ushers and other front-of-house workers.

backup *Acting* An actor who stands ready to step into a role in case of emergency. *See* ALTERNATE, UNDERSTUDY.

Music 1. In popular music or JAZZ, a musician or COMBO who accompanies a soloist. *See* SIDE MAN. 2. A vocalist or group who closely accompanies a LEAD SINGER. 3. To accompany a soloist or a lead singer. 4. To play a secondary solo in close relationship to the lead soloist's melody.

Recording 1. A duplicate recording, made simultaneously with the ORIGINAL, as insurance against loss or damage to the first. Also called a protection copy or a SAFETY. 2. To make a duplicate recording for those purposes.

backup group *Music* 1. In popular music or JAZZ, a COMBO that accompanies a soloist during the soloist's improvisations. 2. A group of vocalists who sing in harmony with the soloist.

backup musician *Music* Any instrumentalist who accompanies a soloist or plays a secondary solo part in close relationship to the lead. Also referred to as a SIDEMAN.

back wall *Theater* The structural wall that forms the back of the stage.

badinage (*bah-dee-NAHZH*) [French] *Music* *See* BADINERIE.

badinerie (*bah-dee-neh-REE*) [French] *Music* A little dance in duple time with much teasing and playfulness between the parts, frequently included among the optional group of movements within dance suites of the 18th century. One of the most famous of these occurs in the *Suite in B Minor* by Johann Sebastian Bach.

baffle *Audio* 1. A flat surface placed within a LOUDSPEAKER enclosure to control the quality of its sound. 2. A moveable panel in a recording studio, placed between instruments that are being recorded on separate tracks, to prevent the sound of one instrument from being picked up by the microphone recording the other.

Lighting *See* BARN DOORS, COOKALORIS, FLAG, SHUTTER, SPILL RINGS.

bag *Stagecraft* 1. A weight, usually a bag of sand, attached to the end of a rigging line to counterbalance whatever hangs from the other end, or laid against the base of a flat to hold it in place. 2. To attach a sandbag or other weight to a line, or place it against the bottom of a flat, to prevent unwanted movement.

Motion pictures A sandbag used to hold a part of the set in place during a shoot. On location in wet places, it may be filled with gravel instead of sand.

bagatelle [French] *Music* Literally, a little thing. A short, often playful composition in one movement, often for a keyboard instrument.

bag line *Stagecraft* A rigging line attached to a SANDBAG.

bagpipe *Music* A wind instrument consisting of a mouthpiece through which the player fills a bag with air which then flows out continuously through pipes that produce musical tones by means of reeds. Various forms of the instrument have existed for at least 3,000 years, and are still in use in many parts of Europe and Asia. The common Scottish bagpipe has from two to four SINGLE-REED pipes, that produce the continuous DRONE so characteristic of Scottish bagpipe music, and a DOUBLE-REED CHANTER that plays the melody. The music of the bagpipe is distinctive, and its drones supply such a strong accompaniment to the melody that it is almost never heard with any instrument other than more bagpipes. Several bagpipes playing together create a formidable sound, ideal for outdoor use. Perhaps for this reason they have been the instrument of choice for military use in Scottish and Irish regiments. For many a British veteran, the sound of the bagpipe brings up vivid images of a stalwart piper leading his regiment into battle. In the United States bagpipe bands play at many military or quasi-military events, such as the funeral of a firefighter who died in the line of duty. *Compare* MUSETTE.

baile (*bah-EE-leh*) [Spanish] *Theater* An entertainment performed between acts of a 17th- or 18th-century play, usually consisting of dance, poetry and music. *Compare* ENTR'ACTE.

balalaika (*bah-lah-LYE-kah*) [Russian] *Music* A stringed instrument with a triangular body somewhat like a GUITAR, but with a longer, thinner neck. The player often accompanies the melody with chords strummed in very rapid rhythm. Balalaikas are made in several sizes with different ranges, enabling small balalaika orchestras to be formed.

balance *Lighting* The adjustment of focus, color and intensity of individual lights that either eliminates noticeable lines of different brightness between general and specific lights on the set or establishes them for dramatic effect.

Music 1. The adjustment of loudness between different instruments or sections of the orchestra, or between the different voices of a vocal ensemble or choir, that produces the desired overall tone. 2. The selection and placement of singers in a vocal ensemble or choir that results in a smooth blend so that the voices "sound as one."

Television The color intensity of the primary color circuits in a video camera in relation to each other. A proper adjustment reproduces colors exactly. *See* WHITE BALANCE.

balancé (*bah-lanh-SAY*) [French] *Ballet* Literally, balanced. A rocking, balancing step executed in place, from side to side, or traveling across the stage, usually in 3/4 time.

balançoire (*bah-lanh-SWAHR*) [French] *Ballet* A swinging movement, performed from the FOURTH POSITION front EN L'AIR to the fourth position back en l'air, passing through FIRST POSITION, or vice versa. Sometimes called *battement en cloche*.

bal champêtre (*bahl shawm-PET-reu*) [French] *Dance* A rustic French BALL held out of doors.

balcony *Theater* An area of seats above the main floor. Sometimes small sections of more expensive seats or a line of private BOXES occupies a narrow architectural balcony, but are called LOGES or MEZZANINE to distinguish them from cheaper balcony seats.

balcony beam *Lighting* A BEAM LIGHT installed in the balcony.

balcony box *Theater* A small, semienclosed area at each end of a balcony nearest the stage, with a few seats that can frequently be rented as a unit for families or other small groups of theater patrons.

balcony light *Lighting* A stage light placed on the front edge or in the ceiling of a balcony to illuminate the stage and/or the main curtain from the front. *See also* BEAM LIGHT, FOLLOW SPOT.

balcony lighting The illumination of the stage and/or the main curtain from BALCONY LIGHTS.

balcony operator *Stagecraft* A technician stationed in the balcony to operate BALCONY LIGHTS or any other stage devices that may have been installed there.

balcony rails *Lighting* An array of pipes installed on the balcony to accommodate BEAMS and other stage light fixtures.

balcony stage *Theater* A stage with a smaller acting area above the main stage upon which actors may appear in scenes that require such a difference of height, *e.g.*, the balcony scene in Shakespeare's *Romeo and Juliet*.

bald wig *Costume* A flexible rubber or plastic shell made to fit over and completely conceal an actor's hair, and dyed or painted to match the skin color so he or she appears to be bald.

ball *Dance, Music* 1. A large social gathering at which couples dance. 2. A staged scene based upon such an event, *e.g.*, in Act II of *Die Fledermaus* by Johann Strauss.

ballad *Music* 1. A narrative song, frequently telling a tale of high adventure, unrequited love, revenge or retribution. 2. In jazz and popular music, a slow song with or without a vocal.

ballade *Music* In the 15th century, a somewhat formal narrative song in three STANZAS unaccompanied or with simple accompaniment. Gradually composers elaborated on the original concept, emphasizing musical mood and dramatic suggestion and slowly eliminating

the vocal line until, by the time of Chopin and Brahms, the term came to mean a romantic, programmatic work for solo piano.

balladeer *Music* A singer (sometimes also the composer) of ballads.

ballad farce *Theater* A musical play consisting of a series of comic ballads strung together to tell a silly, sometimes satirical tale.

ballad opera *Music* A musical drama told in ballads and spoken scenes. A famous example is *The Beggar's Opera* by Pepusch and Gay.

balladry *Music* The art and practice of composing and singing ballads.

ballad stanza *Music* A stanza standard in BALLADES of the 15th century and later, with a rhyme scheme: *a-b-a-b-c-d-refrain* (sometimes with a double REFRAIN).

ballata (*bah-LAH-tah*) [Italian] *Music* A popular form of vocal music in Italy during the 14th century, not related to the old French BALLADE. *See also* ARS NOVA, VIRELAI.

ballerina *Ballet* A principal female dancer in a ballet company. *Compare* BALLET MISTRESS.

ballet The classical form of theatrical dance, with scenery and music, performed in costume by dancers specially trained in its complex technique. Ballet began as entertainments in the courts of France and Italy during the 15th century, when dancers were called upon to amuse guests with dances that were popular at the time. Many of these events celebrated significant occasions, such as a royal birth, a wedding or a diplomatic visit, with dances specially composed around appropriate themes. By the 16th century, sequences of dances were being woven around all kinds of story lines, gradually developing into dramatic entertainments performed by a professional class of trained dancers. The first modern integrated theatrical dance-drama, an extravagant five-hour show with orchestra, singers, magnificent scenery and lighting effects was *Le Ballet Comique de la Reine,* presented to the Queen of France, Catherine de Medici in October, 1581, during the reign of Henry II. Ballet reached an early peak in the time of Louis XIV, a capable amateur who sometimes took part on stage himself. In his artistically blessed court during the early 1700s, the composer Jean-Baptiste Lully wrote nearly thirty ballets, establishing the high style of ballet we know today. During this period, Lully and the playwright Molière (Jean-Baptiste Poquelin) collaborated in the creation of the *comédie-ballet,* which united the dance form with the stage play and operatic productions. Many individual dances originally created for formal presentation at this time became popular in social dancing as well. Among these are the BOURRÉE, GAVOTTE, MINUET, PASSEPIED and RIGAUDON. From Versailles and Paris, ballet spread to other European cities during the 18th century. In the 1800s its center of development was first Vienna, and later the court of the tsars in St. Petersburg. There, ballet had another period of magnificence when its movements were choreographed to the music of Rimsky-Korsakov, Tchaikovski, Borodin and others. Russian ballet reached its modern peak in the first third of the 20th century under the direction of the impresario Sergei Diaghilev with music by many great composers including Igor Stravinsky and Sergei Prokofiev. In that same period, Isadora Duncan and later Martha Graham and others developed innovative techniques rather than follow the traditional movements of classical ballet and established the many styles

that collectively form MODERN DANCE. But ballet, as a special form of theatrical dance-drama, continues to flourish in modern times, with modern composers and choreographers continuing and expanding its techniques.

ballet blanc (*bah-lay BLANH*) [French] Literally, white ballet. Ballet in which the women dancers wear white TUTUS, as in *Swan Lake, Giselle* and *Les Sylphides*.

ballet d'action (*bah-lay dahk-SYONH*) [French] Literally, ballet of action. Ballet in which the movements are designed to illustrate a story or theme, with music chosen afterward to fit each episode in the development. It is distinct from an older style of ballet in which music was selected first, and movements set to it afterward.

ballet d'école *See* DANSE D'ÉCOLE.

ballet de cours (*bah-lay deu KOOR*) [French] Literally, ballet of the court. A lavish 16th-century entertainment introduced by Catherine de Medici at the French court, involving scenery, music and elaborate dances performed by ladies of the court. The dance figures were later developed and codified in the system of techniques known as DANSE D'ÉCOLE.

ballet master/mistress A member of a ballet company who is responsible for teaching the choreography of a new piece, conducting rehearsals and often giving classes to dancers.

balletto [Italian] *Music* A popular 17th-century form of madrigal with dance-like rhythms, sometimes with a refrain that can be danced while singing nonsense syllables such as *fa-la-la*.

balletomane *Ballet* A person with a passion for ballet. A fan.

ballet shirt A short-sleeved pullover worn by dancers to avoid chills when offstage and not actually dancing.

ballet slipper A soft, close-fitting, leather or canvas shoe worn by male and female dancers, for dancing on DEMI-POINTE. *Compare* POINTE SHOE.

ballet suite *Music* A concert suite made of music for a ballet.

ballo (*BAH-loh*) [Italian] *Dance* In 15th-century Italy, a term applied to the mimic dances performed by aristocrats at social gatherings.

ballon (*bah-LONH*) [French] *Ballet* Literally, balloon. A ballet dancer's ability to stay in the air during a jump, to be buoyant, to display elasticity while jumping.

ballonné (*bah-lonh-NAY*) [French] *Ballet* Literally, filled with air. A step in which the working leg is extended straight and then drawn back in a round movement with the knee bent.

ballotté (*bah-lot-TAY*) [French] *Ballet* Literally, tossed from side to side. Describing a rocking step, or series of steps in which one leg is exchanged for the other with the knees bent, performed EN ARRIÈRE or EN AVANT.

ballroom *Dance* A relatively large room set aside for social dancing.

ballroom dance Social dancing in couples. The better known ballroom dances include the CHARLESTON, FOXTROT, LINDY HOP, MERENGUE, PASO DOBLE, RUMBA, SAMBA, TANGO, WALTZ and others.

bally *Carnival, Circus* 1. To perform out in front of the building, or the sideshow tent, in order to attract customers to see the show. 2. To go out ahead of a traveling show to advertise performances.

ballyhoo *Carnival, Circus* All the extravagant advertising and clamor that introduces a performer or a performance.

bal masqué (*bahl mah-SKAY*) [French] *Dance* A fancy-dress or costume ball at which the dancers wear masks. Masked balls were all the rage in the 17th and 18th centuries in Venice, Paris and Vienna. The favorite mask was the DOMINO, which provided a degree of anonymity without hiding one's attractiveness and gave dancers opportunities to flirt seemingly without risk of complications. There were occasions when someone's true identity would be suspected and, in extreme cases, blood might flow. Giuseppe Verdi's opera *Un Ballo in Maschera* deals with an assassination committed at such an affair, and *Die Fledermaus,* by Johann Strauss, uses it in magnificent comedy.

bamboula *Music* A simple form of TAMBOURINE once used in the music of African American groups in Louisiana and in the West Indies.

banana *Vaudeville* A comedian. *See also* TOP BANANA.

band *Music* 1. Any organized group of instrumentalists gathered to perform music together. 2. Short for WIND BAND, MARCHING BAND. *See also* JAZZ BAND.

band car *Circus* A railroad car that carries the musicians of the circus band and their instruments from town to town during their seasonal tour. *See also* BANDWAGON.

Theater A stage wagon carrying a band on stage.

band man *See* BANDSMAN.

bandonion, bandoneon *Music* Originally a type of CONCERTINA, created in Germany in the mid-1800s, that became popular in Argentina as an instrument for the TANGO. Its design is similar to the BUTTON ACCORDION.

bandora [Italian] *Music* A fretted stringed instrument of the 16th century with pairs of strings in the bass range. Not to be confused with the BANDURA.

band parts *Music* The individual sheets on which each instrumentalist's part is printed.

band shell *Stagecraft* A doubly curved surface that provides a back wall behind a BAND or an ORCHESTRA to focus its sound toward the audience during an outdoor concert. Some band shells are permanent buildings and may contain dressing rooms and other facilities

for the players. Most are portable, made in demountable sections for easy transportation from park to park.

bandsman *Music* An instrumentalist who plays in a band.

bandstand *Music* A platform on which a band can play in concert performances or for a dance.

bandura *Music* A Ukrainian instrument of up to 25 metal strings, somewhat like a large lute, held in the lap and played in an almost vertical position.

bandwagon *Circus* A wagon made to carry the band. One of the fancy wagons in the grand CIRCUS PARADE that precedes and advertises the series of performances; a grand place to be seen riding if one is a member of the troupe.

banjo *Music* An instrument of four, five or more gut or metal strings stretched the length of a long NECK (with or without FRETS) over a BRIDGE that stands on the parchment surface of a shallow, one-headed DRUM that forms its body. It is plucked with a PLECTRUM or strummed, and because of the drumhead it has a penetrating "twangy" tone. It is an important instrument in African American FOLK MUSIC and early JAZZ, and may have come originally from West Africa, brought by slaves to the United States. The instrument of most modern banjo players is the FIVE-STRING BANJO.

banjorine *Music* A BANJO tuned a PERFECT FOURTH higher than usual.

bank *Lighting* 1. An array of DIMMERS or their controls in a rack. *See* DIMMER BANK, PRESET. 2. A set of lights aimed in the same general direction and controlled as a unit.

Music An array of organ pipes of a particular TIMBRE.

bar *Dance* *See* BARRE.

Music notation A vertical line at the end of a measure, denoting the transition between the last beat of that measure (UPBEAT, ANACRUSIS) and the first beat of the next (DOWNBEAT, CRUSIS).

barbershop harmony *Music* Close harmony for a BARBERSHOP QUARTET, using chromatically moving seventh chords and augmented or diminished sixths with many passing chords, perfectly suited to the romantic, nostalgic songs that are most popular with such groups.

barbershop quartet *Music* A group of four or more singers who sing in close harmony without accompaniment. The tradition began with amateur groups in barbershops, and has expanded to a national pastime with its own publications, competitions and organization: SPEBSQSA (Society for the Preservation and Encouragement of Barbershop Quartet Singing in America).

barcarole, barcarolle [French] *Music* A gentle song whose accompaniment evokes the feeling of a gently rocking boat. Derived from songs sung by Venetian gondoliers, barcaroles developed into romantic compositions for concert and opera. One of the more famous is the Barcarole from Jacques Offenbach's opera *The Tales of Hoffman*.

bard *Music* Originally a Celtic poet who sang his own poems in a time when such works were not often written down. Some accompanied themselves on a form of harp. Many of their songs were epics, telling tales of heros and great events in history. *See also* RHAPSODIST.

bareback *Circus* Riding on a horse without a saddle.

bareback rider *Circus* An acrobat who performs gymnastic feats while riding a horse around one of the rings in a circus.

baritone *Music* Literally, low tone. 1. Pertaining to the range generally covered by the BASS CLEF, from G_1 to B (*See* OCTAVE NAME SYSTEM). The range of the male voice of medium low range, below TENOR and above BASS. 2. A singer who sings in that range. 3. A brass instrument with that range.

baritone clef *Music notation* A special use of the C-CLEF, placed to define the top line of the staff as MIDDLE C, or of the F-CLEF placed to define the center line as F.

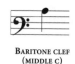

BARITONE CLEF
(MIDDLE C)

barker *Carnival, Circus* A person who stands on a raised platform outside a SIDESHOW booth and shouts to passersby to lure them in.

barline *Music* *See* BAR.

barn dance 1. A social evening of American folk dances, chiefly SQUARE DANCES led by a CALLER, that was often held to celebrate the completion of a newly built barn. Typically the band would be a single fiddler. In Tennessee mountain tradition, there was often a four- or five-piece string band with violin, two banjos, perhaps a guitar and a WASHTUB BASS. 2. A couple dance, usually lively (like a SCHOTTISCHE) in 4/4 time performed in a barn.

barn doors *Lighting* A set of two (sometimes four) adjustable flat steel plates, painted black on both sides, mounted on a frame that fits on the front of a spotlight to narrow the beam or to control SPILL. When out of use, the whole arrangement can be folded flat and efficiently stored.

barney *Motion pictures* A removable weatherproof cover for a motion picture camera, usually made of somewhat sound-absorbent material, and with provision for reaching the camera controls while the cover is in place. *Compare* BLIMP.

barnstorm *Theater* To tour the countryside with a theatrical production, perhaps without having previously arranged a definite itinerary.

barn theater A theater built into the shell of a barn.

Baroque organ *Music* One version of the multikeyboard organ developed in the late 17th and early 18th centuries, with ranks of pipes of different TIMBRES that could be selected for use by actuating STOPS. Although its stops allowed many complex combinations of timbres, the Baroque organ is commonly distinguished from others by the predominance of natural harmonics among its stops.

barre (*bahr*) [French] *Dance* A horizontal rail, firmly mounted at a convenient height (usually 42 inches above the floor) along the wall of a dance studio so that dancers may rest a hand on it to help control balance, or grasp it for support during practice.

barre exercises *Dance* A series of physical exercises specifically designed to make use of the BARRE.

barrelhouse *Music* A style of early-20th-century American JAZZ originating in New Orleans, performed by solo piano players or small groups in an unpretentious and spontaneous manner. It had to be strident enough to be heard above the clamor of a cheap drinking establishment.

barrel organ *Music* A portable mechanical ORGAN, common on the streets of many cities during the late 18th and early 19th centuries, usually mounted on a handcart, operated by turning a crank. Tunes and their accompaniment are determined by a system of cogs on a removable cylinder that control the release of air pressure through a set of REEDS. Different cylinders produce different tunes; with them an operator may satisfy requests to a certain degree. Also known as a street piano or piano organ.

barrel turn *Ballet* A difficult jump, usually performed by a male dancer, with the legs extended as in a split in the air and the back arched, followed by a rapid turn on the ground. Also called the *coupe jeté en tournant.*

baryton *Music* An 18th-century instrument with six or seven strings played by a BOW and seven to ten strings vibrating sympathetically behind the NECK. The most famous baryton player, an amateur, was Prince Nicholas Esterhazy, Haydn's patron, whose fame rests not on his playing but on the fact that Haydn wrote music for him. *See also* BARITONE.

base *Makeup* The first layer of makeup to be applied, consisting of cream that will remain soft to aid removal after the show. The base can be tinted to provide a proper color for the role.

base light *See* FILL LIGHT.

basic situation *Acting* The set of relationships and events that exists in the plot at the beginning of the play or scene. *See also* AGON, ARGUMENT.

bass (*bayss*) *Music* 1. The lowest line of music in any piece. 2. The lowest voice or instrument in any ensemble. 3. The male voice of lowest range. 4. A bass viol, DOUBLE BASS, string bass or an ELECTRIC BASS GUITAR. 5. A TUBA.

bass clef *Music* The CLEF that defines the line F below MIDDLE C. The F-CLEF.

BASS CLEF
(MIDDLE C)

bass drum *Music* A large drum of very low, indeterminate pitch sounded by striking with a soft stick, *i.e.,* a stick with a padded head, that provides a heavy beat.

basse danse (*bahs dahns*) [French] *Dance* Literally, low dance. A court dance originating in 14th-century France, using simple steps performed by pairs of dancers, with the feet kept low. *Compare* HAUTE DANSE.

basset horn *Music* An 18th-century version of the CLARINET in the alto range.

bassist *Music* One who plays the DOUBLE BASS.

basso (*BAH-so*) [Italian] *Music* One who sings BASS.

basso cantante (*BAH-so kahn-TAHN-teh*) [Italian] *Music* Literally, singing bass. A bass voice with a strong upper REGISTER, into the baritone range. *Compare* BASSO PROFUNDO.

basso continuo (*BAH-so kon-TEEN-oo-oh*) [Italian] *Music* Literally, continuing bass. A method of writing a continuous accompaniment in a kind of shorthand first devised in the 17th century. The composer writes a single bass line with the understanding that it will be played by at least two instruments, a solo bass instrument playing the line itself and a keyboard instrument improvising harmonies and ornamentation upon it. *See also* FIGURED BASS.

bassoon *Music* A large DOUBLE-REED instrument of low range. It has a distinctive TIMBRE, and it is frequently called upon in musical scenes to accompany comic characters. *See also* CONTRABASSOON.

basso ostinato (*BAH-so os-tee-NAH-toh*) [Italian] *Music* Literally, obstinate (or persistent) bass. A musical figure in the bass line that repeats without change through a section of a piece.

basso profundo (*BAH-so pro-FOON-doh*) [Italian] *Music* Literally, deep bass. A bass voice with strength in the lowest REGISTER. *Compare* BASSO CANTANTE.

bass viol *Music* In the 17th century, the VIOLA DA GAMBA. In modern usage, another name for the DOUBLE BASS.

bastard amber *Lighting* Amber with a slightly pinkish cast. The color of a GEL frequently used in lighting to help make the skin of white actors look normal on stage.

baton [French] *Music* Literally, stick. 1. A little white stick with which an orchestral conductor defines the beat and the pace of the music. 2. A much larger shiny metal stick used by the leader of a marching band to define the beat, but not always the measure.

baton twirler *Circus, Music* A person who marches ahead of a marching band performing spectacular tosses and twirls with a three-foot, decorated metal BATON as visual accompaniment, not actually conducting the music. *Compare* DRUM MAJOR.

battement (*BAHT-manh*) [French] *Ballet* Literally, a striking. A beating movement of the bent or extended leg, having a great variety of forms identified by specific descriptives such as *grand* (large, *See* BATTEMENT, GRAND), *petit* (small), *arrondi* (rounded), *dégagé* (disengaged), *en cloche* (like a bell), etc. *See also* BATTEMENT TENDU.

battement, grand (*grahn BAHT-manh*) [French] *Ballet* An exercise designed to facilitate the TURN-OUT by loosening the hip joints, that can be performed in several ways. With both knees straight and the body kept quiet but not rigid, the working leg is raised into

the air from the hip and then lowered, with attention focused on controlling the downward movement.

battement tendu (*BAHT-manh tanh-DÜ*) [French] *Ballet* Literally, beating stretched. An exercise designed to force the insteps outward. Without lifting the toes from the floor, the working foot slides from FIRST or FIFTH POSITION to SECOND or FOURTH position, reaching POINTE TENDU, then returning to the starting position. A *battement tendu* is generally performed at the beginning and end of a GRAND BATTEMENT.

batten *Stagecraft* A long, strong, stiff wooden strip or steel pipe, usually suspended horizontally above the stage and stretching its entire width, to which curtains and drops may be attached. Battens can be lowered to a convenient height above the floor for attachment of set pieces or raised high enough into the FLIES so that the attached pieces are out of the audience's sight. In a typical theater there are four sets of battens; the first is just behind the MAIN CURTAIN, and the rest in order behind that, with the fourth just in front of the CYCLORAMA. In large theaters there may be many more, in small theaters, fewer. A batten may also be slipped into the seam at the bottom of a drop to supply an even bottom line, or slipped into a horizontal line of S-HOOKS across the backs of a line of FLATS to keep them straight. If necessary, battens can be suspended at angles other than horizontal. *See also* DOUBLE BATTEN, PIPE, RIGGING, FLY TOWER.

batten clamp *Stagecraft* A clamp designed to fasten rigging lines or lighting fixtures to a batten, or to fasten two battens firmly together.

batten hook *Stagecraft* *See* KEEPER.

battening batten *Stagecraft* A relatively short wooden strip used to hold the tops of two FLATS at a specific distance from each other.

batten light *Lighting* A light hung on a BATTEN. In consideration of safety, batten lights are not usually allowed to become very hot, therefore they are not usually very brilliant.

batter head *Music* The drumhead that the drummer beats, usually the top head of the drum.

batterie (*bah-TREE*) [French] *Ballet* A term applied to any and all movements in which one foot or leg beats against the other, or both feet beat against each other.

Music The percussion section of an orchestra.

battu (*bah-TÜ*) [French] *Dance* Literally, struck. Any step or movement ornamented with a BEAT. Also called *pas battu*.

battuta (*bah-TOO-tah*) [Italian] *Music* The principal beat, especially the beat at the beginning of a measure. *See also* A BATTUTA.

batuque (*bah-TOO-keh*) [Portuguese] *Dance* Any of several Brazilian round dances of African origin, with syncopated rhythms sometimes enhanced by the dancers' hand-clapping or striking handheld instruments. Ancestor of the SAMBA and the very cosmopolitan MAXIXE.

bayonet base *Lighting* A cylindrical base of a light bulb with small studs protruding from its sides that fit into properly spaced slots in a socket. When the bulb has been inserted into the socket and given a quarter turn, it locks in place with the filament of the bulb lined up properly for clear projection.

bazooka *See* KAZOO.

beam *Lighting* 1. A horizontal LIGHT PIPE built into the structure of the ceiling of the HOUSE, or along the front of a balcony, to support spotlights and other light fixtures where they can illuminate the stage from the front. 2. Any light fixture powerful enough to project intensely onto the stage from the back of the house, a balcony or its ceiling. *See* BALCONY BEAM, BALCONY SPOT, BEAM LIGHTS, FOLLOW-SPOT.

Music notation A horizontal stroke written to connect the ends of the stems of EIGHTH NOTES, SIXTEENTHS and the like (*i.e.*, connecting their FLAGS together), to make their relationship within beats easy to recognize.

beam angle *Lighting* The angle of the centerline of a beam of light compared to the horizontal stage floor. *See also* BEAM SPREAD.

beam border *Lighting* A beam light clamped to a BORDER LIGHT support.

beam light *Lighting* A light that projects a narrow beam of very high intensity by means of a parabolic reflector and without a lens. It is generally placed in the back of the house or in the DOME, where it can illuminate the stage from a more convenient angle than if located overhead. Beam lights may also be placed behind the set to simulate sunlight coming through windows, or for similar uses.

beam projector *Lighting* A light fixture with a high-powered lamp, a reflector and a lens that focuses a relatively intense beam of light on the stage from some distance. *See* BEAM LIGHTS.

beams *See* BEAM LIGHTS.

beam shaper *Lighting* Any device that shapes the edges of a beam of light, such as BARN DOORS, GOBOS or LENSES, all of which are usually mounted directly on the light fixture.

beam spread *Lighting* The angle of divergence between the edges of a beam of light.

bear trap *Motion pictures, Stagecraft* A heavy-duty spring clamp used to hold cables or other objects in place. In England, also called a gaffer grip.

beat *Acoustics* An audible pulse that results from the simultaneous sounding of two tones of close, but not identical, pitch. If this beat is rapid enough, *i.e.*, when the fundamental tones that produce it are of very high pitch, it can be heard as a tone. Beats may also be heard in the overtones of two tones sounding simultaneously. *See also* COMBINATION TONE, HARMONICS.

Acting 1. In the STANISLAVSKI METHOD, an actor's intuitive feeling of pace that affects the timing and tone of speech and of movement on stage. *See* OFFSTAGE BEAT. 2. In classical poetic works, such as Greek drama (in Greek) and much of the Elizabethan and classical

French theater, the beat is as specific a unit as the beat of music and dance. In prose and in freer variations of speech and sentence structure of 20th-century plays, and in silent moments, the beat is far less definable, yet is subjectively present. A sensitive actor knows that the beat of one performance feels different from that of another, even though it cannot be measured.

Dance During a jump, a movement in which one leg strikes the other, or in which the legs cross while in the air.

Music 1. The fundamental pulse of a measure that defines the meter upon which rhythmic patterns are built or, by extension, the rhythmic patterns themselves, as in "a Latin beat." *See* CRUSIS, DOWNBEAT, PACE, RHYTHM, SUBDIVISION, UPBEAT. 2. To mark time with movements of the hand or BATON. *See* CONDUCTING.

beat box *See* DRUM MACHINE.

beater *Music* The short stick with which a percussionist strikes the instrument. A drumstick.

bebop *Music* A style of JAZZ originated by Charlie Parker, Thelonius Monk, Dizzy Gillespie and others in the 1940s, characterized by very fast, complex melodic improvisations, startling harmonies and odd leaps, frequently in two-part COUNTERPOINT. The word *bebop* is loosely onomatopoetic, indicative of constantly changing accents and comes from the practice of working out a musical idea with verbal sounds. The music tends to be tighter and more dense than earlier jazz styles, with a harsher sonority, and irregular spacing of piano chords. Also referred to as "bop." *Compare* MODERN JAZZ.

bedroom farce *Theater* A farce whose subject matter is concerned chiefly with love affairs. The style has been very popular in the 20th century, especially in England.

beep *Motion pictures* A brief tone, commonly ¹⁄₂₄th of a second at 100 hz, which marks the nine-foot point on a standard LEADER before the brief section of black leader that introduces the picture.

"beginners" *Acting* A British stage manager's call to the actors who are to begin a scene to take their positions on the stage.

beguine (*beh-GEEN*) [French West Indian] *Dance* A ballroom dance based on the rhythm of a BOLERO; a variation of the FOXTROT.

behind *Acting* Behind the curtain or the scenery, not visible to the audience. Actors generally prefer the term UPSTAGE to indicate someone who is standing in back of them on the stage.

belaying pin *Stagecraft* A round steel or wooden stake that can be driven into a hole in a PINRAIL to provide a firm anchoring point for the operating end of a rigging line.

bel canto [Italian] *Music* Literally, beautiful song. A lyrical style of singing of the 18th century and later, highly appropriate to the great operas of Mozart, Rossini and others, less so to the more declamatory style of Wagner. In *bel canto*, beauty of tone and brilliance of articulation are considered more important than emotional expression.

belief *Acting* An actor's ability to put aside any consciousness of, or response to, the physical and social environment—the reality—of the moment and to concentrate on emotional memories and re-creation of the character during a scene. *See also* EMOTIONAL MEMORY, SUSPENSION OF DISBELIEF. *Compare* OFFSTAGE BEAT.

bell *Music* 1. A special form of cast-metal gong, hollow and tapered, open at its large end and sounded by striking with a CLAPPER. Its ringing tone is distinctive, because it contains a great many audible PARTIALS (*See* HARMONIC SERIES). In an orchestra, bells occur in two forms: the GLOCKENSPIEL, which produces the higher register, and ORCHESTRAL BELLS which produce the lower, like CHURCH BELLS. 2. The wide opening of a brass instrument farthest from the mouthpiece, where the sound emerges.

bell tree *Music* A stack of small bells of graduated size, nested closely together by their centers along a straight rod with the largest at the bottom, the smallest on top. When stroked with another metal rod, the tree produces a shimmering scale of high ringing tones. *See also* WIND CHIME.

belly *Music* On a stringed instrument such as the VIOLIN, the upper surface over which the strings are stretched.

belly dance Any dance of Middle Eastern origin, usually performed by women, in which the movement centers in the abdominal muscles.

belly laugh *Theater, Vaudeville* 1. A rich, loud, satisfying laugh. 2. By extension, the joke or line that elicits such a laugh.

below *Acting* 1. Downstage in relation to someone who is upstage. 2. Under the stage.

below the line *Motion pictures* The major part of a production budget that covers the expected costs of all guild and union personnel including actors and technicians, equipment, sets and locations, editing and finishing. It does not include stars and other major participants whose remuneration is ABOVE THE LINE and subject to individual negotiation, frequently including a share of the profits of the picture and other financial settlements.

belt, belt out *Music* In cabaret and musical comedy, to sing very loudly and clearly, with strong ATTACKS.

bemol (*beh-MOLL*) [German] *Music notation* 1. Flat, as in *A bemol*, A-FLAT. 2. The flat symbol. *See* FLAT (*Music notation*).

bend *Music* 1. In JAZZ, to initiate a tone off pitch and slide to the correct pitch or, alternatively, to begin on pitch and slide away from it. 2. Any tone played in such a manner. The bend is somewhat similar to the classical appoggiatura and acciaccatura, but performed with a quick DIMINUENDO and leading or falling away directly into the next note. Also called SCOOPING. It has been used by brass and wind players and by singers since the 1940s. Among its virtuosi was the alto sax player Johnny Hodges.

Benedictus [Latin] *Music* Literally, blessed. A principal section of the liturgical MASS.

benefit *Concert, Theater* Any public performance, the proceeds of which will be given to a particular artist, organization or charity.

Benesh notation *Dance* Also called *Choreology*, a form of dance notation developed by the English painter Rudolf Benesh and his wife, dancer Joan Benesh, in the 1950s. Similar to music notation, the Benesh Dance Notation System is based on a system of five lines onto which symbols are written to indicate body position and movements. It has been used extensively in England and is considered one of the more effective dance notation methods. *See also* LABANOTATION.

berceuse (*bear-SEUZ*) [French] *Music* A lullaby.

bergamasca [Italian], **bergamasque** (*BEHR-ga-mahsk*) [French] *Dance* Any of several dances from the neighborhood of Bergamo, in the Italian Alps. It developed into a folk dance for couples, combining the WALTZ and circle dance and became popular in the rest of Europe and in England during the 16th and 17th centuries.

Music A performance of dances, or a suite of music, in the style of a BERGAMASQUE. Among the many composers who incorporated the style into their music have been Johann Sebastian Bach, in the QUODLIBET at the end of his *Goldberg Variations*, and Claude Debussy in his *Suite Bergamasque*.

best boy *Motion pictures, Television* Assistant lighting technician. When there is a team of assistant GAFFERS, the best boy is their chief. In some productions, the term is used for an assistant GRIP, and in some where multiple crews work, there may be several best boys. The term has been in use in theaters since Elizabethan times.

between acts, between engagements *Acting* Unemployed, usually used ironically.

b-flat man *Music* 1. A trumpet player who cannot transpose at sight, so that everything played comes out in the trumpet's natural key of B-flat. 2. By extension, any instrumentalist of mediocre ability.

bias *Recording* A signal of constant, very high frequency upon which the electronic signals of audio or video program content are superimposed and without which a tape recording would not be possible.

big apple *Dance* A party dance popular in the late 1930s. A form of JITTERBUG danced in groups, with couples arranged in a large circle executing figures such as the LINDY HOP, SHAG, TRUCKING, etc., according to the instructions of a caller.

big band *Music* The most popular form of American dance band in the 1930s and 1940s, led by Count Basie, Benny Goodman, Fletcher Henderson, Duke Ellington, Tommy Dorsey, Glenn Miller, Woody Herman and others. In contrast to JAZZ BANDS with their individual players, big bands had choirs of saxophones, trumpets and trombones in addition to piano, rhythm guitar and TRAPS. They performed at dances, college PROMS and in concerts. Sometimes they used HEAD ARRANGEMENTS, but more often their ARRANGEMENTS were written out in full and the arrangers themselves became stars.

big hand *Theater* A loud round of applause.

big time *Acting, Music* At the top of the profession, with national fame.

big top *Circus* 1. The large tent that contains the main acts of the circus. 2. A metaphor for circus itself. *See* UNDER THE BIG TOP.

bill *Theater* Short for PLAYBILL.

billing *Circus* Putting up posters and distributing flyers to advertise a circus that will soon arrive in town. *See* PAPER.

Motion pictures, Theater The position of an actor's name on the marquee or in the advertising for the show. An actor's relative importance in the production is often defined by the billing. *See* TOP BILLING.

billing agent *Circus* An employee of the circus company who travels a week or two ahead of the circus to make sure the town where it will next appear has been sufficiently papered with advertising. Not to be confused with the ADVANCE MAN or TWENTY-FOUR-HOUR MAN.

binary form *Music* A two-part musical form in which the two sections form a pair built on similar musical material. In a common analogy, the first section "asks a question" and the second "answers it." The first may state a theme and repeat it, coming to a new KEY (usually the DOMINANT) at its end; the second develops the material of the first and comes back to the original key at its end. An important outgrowth of binary form is the SONATA FORM or the classical SYMPHONY. *Compare* TERNARY FORM.

binaural *Recording* Through two channels of sound. In a binaural recording, two microphones pick up the sound of the performance from different perspectives, as the ears do. Each delivers what it hears to an individual channel for recording. When these channels, still separated and played back through HEADPHONES, are presented to the ear, the listener's mind recombines them as a FUSION that closely resembles the three-dimensional presence of the performers. When they are presented through LOUDSPEAKERS, the effect seems the same, but in fact their separation is slightly less pure. Because of this, the word *binaural* is often restricted to the effect of complete separation, heard through headphones, to distinguish it from true STEREOPHONIC quality in which the two channels each convey all the sound, but with a different balance between them.

bird *Theater* An ugly, rasping, nonvocalized sound made by intensely vibrating lips, used to disparage a performer. A BRONX CHEER, a RASPBERRY.

bis (*bis*) [French and Italian] Literally, again. A second time. Repeat. *See also* ENCORE.

bit *See* BIT PART.

bite a cue *Acting* To respond too quickly to a cue. To interrupt another actor's line, thus ruining the timing of the upcoming cue.

bitonal *Music* Having two tonalities, *i.e.*, in two keys at the same time. Said of music in which two contrapuntal lines or parts are written in different keys. *Compare* POLYTONAL.

bitonality *Music* The practice of writing two different voices, or different lines, in different keys. *Compare* POLYTONALITY.

bit part *Acting* A small part with very few lines to say. The only smaller part is a WALK-ON, which has no lines at all.

bit player *Acting* An actor who specializes in BIT PARTS.

biz Short for BUSINESS as in "the biz." *See* SHOW BIZ.

black and tan *Vaudeville* A vaudeville act in BLACKFACE.

black bottom *Dance* A dance popular in the late 1920s, characterized by vigorous Caribbean- and African-style hip movements that were considered risqué by the older generation.

black box *Lighting, Recording* Any unit in an electronic system that performs a specific function, such as amplification or equalization, the interior details of which are not germane to the understanding of the whole system.

Theater A theater consisting of an enclosed space in which seats for the audience and acting areas for performance can be freely placed at any time in any configuration desired by the producers. Typically the walls and ceiling of the space are painted dark, often black, and the ceiling is fitted with a grid sufficient to support lights and scenery as needed in any position.

black comedy *Acting* Comedy with morbid, sardonic or sinister implications.

blackface *Makeup* Facial makeup designed to create the stereotypical look of a black person. To be distinguished from careful makeup to accomplish that purpose without the stereotypical quality.

blackhat *Motion pictures* A villain, the one who wears the black hat, especially in low-budget old-fashioned WESTERNS.

black leader *Motion pictures* An opaque strand of film. Its primary use occurs in the 16mm film editing process of setting up A & B ROLLS. The NEGATIVE CUTTER splices black leader to the end of a shot on the A roll, to prevent any interference with the second shot that comes up on the B roll at that point. *See* LEADER (*Motion pictures*).

black light *See* ULTRAVIOLET LIGHT.

blackout *Lighting* An instantaneous and complete cutting of the lights over the entire stage.

Vaudeville A SKIT, sometimes just a line or two, with a funny PUNCH LINE followed instantly by a blackout of the lights.

blackout switch *Lighting* A master switch that cuts off all the lights on the stage.

blacks *Stagecraft* A set of DROPS, always including wings, sometimes also a black BACKDROP, that establishes the acting area of the stage when there is no set on it. Any performer tends to stand out vividly against such a background, and the audience forgets the DROPS are there. Blacks are the simplest and least distracting of all settings.

black theater 1. The body of theatrical literature concerned with African American culture and the black experience. 2. A style of theater built on the illusions that become possible when actors wearing bright colors and bright makeup over parts of their bodies play in front of black BACKDROPS, so that the bright parts seem to the audience to float in space, and the black parts are invisible. Developed to a high degree in the Czech production *Laterna Magika* that visited the United States in the 1950s and 1960s, directed by Alfred Radok. *Compare* ULTRAVIOLET LIGHT.

black wax *Makeup* Wax that can be applied on the visible face of a tooth to make it invisible to the audience.

bladder *Circus, Vaudeville* An inflated bag carried by a clown who squeezes it from time to time to make a startling noise like a RASPBERRY.

blank verse *Acting* Nonrhyming stanzas of IAMBIC PENTAMETER. The standard verse form of Elizabethan playwrights including Shakespeare.

blare *Music* The sound of brass instruments played very loudly. When blare becomes blast, musical tone has been lost.

bleed *Stagecraft* The intermingling, intentional or not, of colors painted or dyed edge-to-edge while they are still wet. *Compare* SPILL.

bleep *Recording* A high-pitched sound recorded over and obliterating an offensive word. The bleep preserves the timing of the recording where cutting out the piece of tape that contains the word would not and might therefore be jarring to the listener. The bleep also lets the audience know that an offensive word was there, thus preserving the audience's belief that the recording is authentic.

blend *Lighting* 1. To adjust the colors and intensities of light from several sources so that the illuminated surface appears uniformly lit. 2. The quality of color that results from BLENDING.

Makeup 1. To modify the color of makeup by skillfully mixing its ingredients. 2. To smooth out contrasts in the finished mask by adding powder. 3. The effect that results from these processes.

Music 1. To adjust the sounds of many voices in a chorus by selecting particular singers and altering the placement of singers on the stage. 2. To modify the loudness and quality of tones and standardize the pronunciation of vowels and consonants so that all the voices of a chorus or a vocal ensemble will have the same characteristic sound. *See also* BALANCE. 3. The fusion of sound that results from these processes.

blender *Makeup* 1. A BASE added to colors to reduce their individual contrast. 2. A powder added after other makeup has been applied, to soften the contrasts between different areas. 3. A cloth band built into the front edge of a wig and tinted to match the color of the makeup on the face of the actor who wears it.

blend in *Acting* To become an integral part of the FOCUS group on stage.

Music For a CHORISTER, to adjust the tone and volume of one's voice so that it becomes a non-distracting part of the ensemble's overall tone.

blending *Lighting* The art and practice of adjusting the positions, intensities and colors of individual light fixtures so that illumination on the stage will appear smooth and even to the audience.

Makeup The art and practice of smoothing areas of different pigments over each other to eliminate any sharp contrasts that would appear artificial.

blending light *Lighting* Any light of a color and intensity that, when focused on areas already lighted from other sources, tends to soften any hard edges and make a smooth, imperceptible transition from one area to another.

blimp *Motion pictures* A soundproof covering or case fitted around a motion picture camera (or any other noisy device) that permits its operation on a SOUNDSTAGE without risk of its noise being picked up by microphones. Some cameras are advertised as "self-blimped," which means only that the soundproofing material has been integrated into the design of its standard case. *See also* BARNEY, ICEBOX.

blinder *Lighting* Any brilliant light aimed directly at the audience to prevent people from seeing whatever is behind the source. Vaudeville stage designers sometimes put bright lights around the PROSCENIUM to blind the audience during blackouts, adding immeasurably to their effect.

blind recording *Lighting* The process of entering a new light cue into the memory of the CONTROL BOARD while another scene with its own lighting is in progress, *i.e.,* setting up a lighting cue without actually seeing its effect.

blobby *Lighting* Uneven, unblended.

block *Acting* To cut off the audience's view of another actor.

Stagecraft An assembly of one or more pulleys (SHEAVES) in a wood or steel casing, through which RIGGING LINES may be passed enabling DROPS and SET PIECES to be FLOWN.

Theater To arrange actors and define their general movements in specific acting areas during a scene before considering the detailed actions they may perform in those scenes. Once the director has blocked the scene, the lighting director will be able to set up LIGHTING PLOTS.

Television To arrange the initial positions of both actors and cameras and determine their movements for a scene.

block chord *Music* A chord that can be moved up or down the scale without changing its general quality. *See also* PARALLEL MOTION.

blocked joint *Stagecraft* A joint between two FLATS at right angles to each other, made firm by screwing each flat to a block of wood placed inside the corner between them.

blocking *Theater* 1. The process of assigning general positions for actors for each major section of a scene. *See* BLOCK. 2. The general plan of the positions of actors from scene to scene. *See also* CAMERA BLOCKING.

blocking notes *Acting* Notes written into the director's and actors' scripts to remind them of the BLOCKING when they become involved in more elaborate rehearsals.

blocking rehearsal *Acting* A rehearsal during which the director determines the BLOCKING for one or more scenes, or reviews previously assigned blocking to see that it works as desired.

block out *Stagecraft* 1. To make a general plan for a set or an individual scene. 2. To lay out a general color scheme for BACKDROPS and other pieces before deciding on paints and lighting.

blocks *See* WOOD BLOCKS, TEMPLE BLOCKS.

blond *Lighting* Slang term for a 2,000-watt incandescent light. Referred to also as a 2K (two kilowatts).

bloop, blooper *Acting* An error on stage, either in lines or in movements.

blow lines *Acting* To forget one's lines during a scene.

blow the show *Acting* To leave the production while it is still running without giving notice.

blue *Acting* 1. Sorrowful. 2. Sexually suggestive.

 Music 1. Having the qualities of BLUES. 2. Feeling sad.

blue beat *See* SKA.

blue-eyed soul *Music* SOUL MUSIC composed or performed by a white musician.

bluegrass *Music* A style of country music that people associate with Kentucky, the Bluegrass State. Typically composed for and performed by one or two singers who play their own acoustic STEEL-STRUNG GUITARS, sometimes backed up by BANJO and DOUBLE BASS, sometimes also with a MANDOLIN, all acoustic. The singers practice a "high mountain style" with a slightly nasal quality and pronounce words in the accent of the region.

blue note *Music* A note that gives an otherwise unstyled melody its BLUES quality. Typically, a blue note is a flatted (minor) THIRD or SEVENTH played over a major TRIAD, or a melodic tone clashing with a simultaneous major third or major seventh in the chord.

blues *Music* A style of American vocal and instrumental music, the ancestor and the heart of JAZZ, one of the great African American cultural achievements. Based on chords of the TONIC, DOMINANT and SUBDOMINANT, it is characterized by a generally forlorn tone, created not only by the lyrics but also by the bending or flatting of MAJOR THIRDS, SIXTHS and SEVENTHS into MINORS and by heavy rhythms, originally too slow for dancing but more recently played at any tempo, in phrases of 12 measures (in place of the more common 8 or 16). Blues developed out of the solo laments and work songs of poor blacks in the South after the Civil War, and are not closely related to spirituals that were frequently happy, faster and generally sung by choirs. Because the words were usually mournful and brief, often cutting off long before the end of a musical phrase, solo musicians developed the practice of "filling in" the ends of phrases with short, contrasting figures they called RIFFS. The first blues to become national favorites were composed by Jelly Roll Morton in 1905 and W. C. Handy in 1912. In modern-day jazz, the blues are no longer as slow, and, they make use of many harmonic alterations, as did

Charlie Parker in *Blues for Alice*, but they usually retain the 12-measure phrasing. *See also* DELTA BLUES, CHICAGO BLUES.

blues harp *Music* A HARMONICA, also called a diatonic harmonica; an instrument used in BLUES, FOLK MUSIC and occasionally in JAZZ. The available tones consist of a single scale, with several additional notes below and above the scale that have a chordal relationship to it.

blue sky filter *Motion pictures* A camera filter that absorbs a portion of the blue light coming into the lens. Used when shooting outdoors or from an aircraft to reduce the oversupply of blue reflected from the sky that would look unnatural in the developed film.

BMI *See* BROADCAST MUSIC INCORPORATED

board *Broadcast, Lighting, Recording* Any control board.

board operator *Broadcast, Lighting, Recording* The technician who operates the board and who is ultimately responsible for the smooth running of the show or recording.

boards *Theater* 1. The wooden floor of the stage. 2. The stage as a place to work, the setting for an actor's career.

board set-up *Electronics, Lighting* The manner in which the CONTROL BOARD has been prepared to run a show or a recording. The initial settings of DIMMERS or audio POTS.

boat show *Theater* A show staged on a boat, *e.g.*, on a Mississippi riverboat.

boat truck *Stagecraft* Any very low platform on hidden wheels capable of supporting an actor or two and elements of scenery in controlled movement across the stage floor during a scene. The swan that glides across the set to Lohengrin near the end of Wagner's opera floats on a boat truck.

bobbinet *Stagecraft, Lighting, Motion pictures* A nearly invisible fabric with a hexagonal mesh used to create a haze effect. *See* THEATRICAL GAUZE.

Bocane (*boh-KAHN*) [French] *Dance* A courtly dance of the 17th century in 2/4 time.

bocca chiusa (*BAW-kah KYOO-zah*) [Italian] *Music* Literally, mouth closed. An instruction to singers to hum with closed lips. (Humming is also possible with lips open, which produces quite a different sound.)

bodkin *Costume* In Elizabethan times, a needlelike dagger named after the long, sharp pin used by women to keep their hair in place and by men to fasten a cape over the shoulder.

body alignment *Acting* The stance of an actor's body in terms of the direction it is facing, though the eyes may be looking in a different direction.

body double *Motion pictures* A person whose body, but not necessarily face, resembles an actor's sufficiently to allow substitution when the actor cannot, or will not, do the scene. Typically, a substitute in a nude scene. *Compare* DRESS DOUBLE, STAND-IN.

body position *Acting, Dance* One's stance on stage, as distinguished from the moves or gestures that may develop from it. *See also* POSITIONS OF THE BODY.

body scene *Burlesque* A rather large scene in a BURLESQUE show with two comedians, a STRAIGHT MAN, chattering women, and a very old or very young character (or both), all in costume with PROPS.

boff *Theater* A loud laugh.

boffo *Theater* Said of a big box-office success, especially of a COMEDY or MUSICAL.

bolero (*boh-LEH-roh*) [Spanish] *Dance* An energetic Spanish dance performed by a soloist or a couple to a relatively slow three-beat measure with intricate syncopations within the beats. Often accompanied by castanets and by the dancers' own voices synchronized with strong accents here and there. There is also a Cuban-style bolero with the same characteristics, but danced to a duple measure.
Music The music for the Spanish bolero.

Bolshoi Theater Literally, large theater. A 700-seat theater in Moscow used for all kinds of performances. Its ballet company is known for its rigorous preservation of the traditions of classical Russian ballet, in contrast to the more inventive programming of the company in St. Petersburg.

bomb *Theater* 1. In the United States, a spectacular failure. In England, a spectacular success. 2. To fail in the United States or triumph in England.

bombardon (*bawm-bahr-DONH)* [French] *Music* The TUBA of lowest range, similar to the SOUSAPHONE.

bombs *Music* In jazz, very strong accents or small explosions of sound played on the bass drum, often when least expected.

bone *Jazz* Slang term for TROMBONE.

bones *Music* A handheld percussion instrument introduced by African American musicians. It consists of a pair of flat strips, perhaps six inches long, made of hardwood or ivory (hence "bones"), and held in one hand, separated by one finger and tapped by the others to create a rapid clicking like the sound of castanets.

Bones *Vaudeville* Properly, MR. BONES. One of the END MEN in a MINSTREL SHOW who plays the BONES. The other end man is MR. TAMBO.

boneyard *Theater* A storage area for scenery that may not be used again.

bongo *Music* A small, tapered, round wooden drum from Cuba, with a single head perhaps six to nine inches in diameter, of high but indeterminate pitch. Usually constructed in pairs, providing two contrasting tones. The player holds a pair between his knees and plays them with his fingers and thumbs. In orchestral use, bongos may be racked four in a line and mounted on a stand.

Boogaloo *Dance* A solo dance popular in the 1960s, based on BOOGIE-WOOGIE rhythms, in which the feet brush or tap across each other.

boogie-woogie *Music* A jazz style based on a heavy chordal bass OSTINATO in eighth notes, extremely popular in the 1940s. It originated as a JAZZ piano style in Chicago twenty years earlier. A typical boogie-woogie bass line consists of a one-measure figure, constantly repeated in the tonic key, then in the subdominant, etc., following the 12-measure phrasing of BLUES.

book *Theater* The SCRIPT of a play, as distinguished, in the case of a MUSICAL, from its LYRICS.

book ceiling *Stagecraft* A stage ceiling made up of two FLATS hinged together like the covers of a book and rigged so that they fold up when they are drawn up into the FLIES, or open horizontally when they are lowered to become the ceiling of a small BOX SET. If the set is so large that a book ceiling would be too deep for flats (*i.e.*, if the flats are too wide to be transportable), a ROLL CEILING or a combination of the two styles usually solves the problem.

booker *Motion pictures* A person who negotiates with DISTRIBUTORS and arranges for films to be delivered to the EXHIBITOR for public showing. Not the same as AGENT.

book flat *Stagecraft* A flat constructed of two flats hinged together lengthwise with a DUTCHMAN to conceal the jointure. When in use, a book flat is open and is usually much wider than other flats on the set. When closed it resumes normal size and can be stored along with all the others without posing space problems. *See also* BOOK CEILING.

booking *Music, Theater* An engagement for a performance or a role, usually negotiated by an AGENT.

book number *Theater* A musical NUMBER that carries the plot along, *e.g.*, any of the love songs or choreographed fights in Leonard Bernstein's score for *West Side Story*.

book show *Theater* A play that may or may not have music, but that consists primarily of spoken dialogue.

book wing *Stagecraft* A WING that can be folded lengthwise, constructed like a BOOK FLAT. *See also* ANGLE WING.

boom *Audio, Motion pictures* A long telescoping tube, usually mounted at its center of balance on a wheeled stand, strong enough to support a microphone or a small spotlight above a set and out of sight of the camera or viewer but near the actors. *Compare* CRANE, JIB.

boom arm *See* BOOM.

boomerang [Aboriginal Australian] *Stagecraft* A wooden platform on casters with two or three levels on which scene painters stand while painting scenery. Each level has a shelf at a convenient height to hold paint cans and brushes.

Lighting 1. A large circular frame holding GELS of several different colors that can be mounted in place of ordinary gels in front of a light and turned, sometimes by a motor, to

provide constantly changing colors. 2. A vertical LIGHT PIPE carrying spotlights or floods, freestanding or suspended from the gridiron behind the TORMENTORS.

boom mike *Audio* A microphone attached to the upper end of a BOOM and operated by an audio technician. The boom operator places the mike near the person who is speaking or singing, but out of sight of the camera. *Compare* SHOTGUN, PARABOLIC REFLECTOR MIKE.

boom operator *Audio* A technician who operates the BOOM MIKE.

boom shot *Motion pictures, Television* Any shot requiring a BOOM.

boom spot *Lighting* A SPOTLIGHT mounted at the upper end of a BOOM. Usually mounted on a movable stand, the spotlight is often placed in a fixed position so that its projected light will not shake visibly and distract the viewer. *See also* ACCENT LIGHT.

boondocks, boonies [from Tagalog] *Theater* Any place far out of town, beyond the suburbs. *See also* STICKS, TANK TOWN.

booth *Audio* 1. A small soundproof room within which an actor or announcer may sit while recording a VOICE-OVER. It has a large window for visual communication with the AUDIO DIRECTOR during the recording. Sometimes called an ICEBOX. 2. A CONTROL BOOTH.

Stage lighting A CONTROL BOOTH situated near the ceiling at the BACK OF THE HOUSE or on a balcony where the LIGHTING DIRECTOR has a clear view of the show as the audience sees it.

Theater The BOX OFFICE, particularly at a CARNIVAL.

booth lights, booth spots *Lighting* Spotlights mounted inside a booth at the BACK OF THE HOUSE or in a BALCONY.

booth stage *Circus* A small stage built into a stall as at an outdoor fair, from about the 17th century. Precursor of the SIDE SHOW.

bop *Music* *See* BEBOP.

bopper *Music* 1. A musician who can improvise in BEBOP. 2. A devotee of BEBOP.

border *Stagecraft* A short DROP of full stage width, hung from a BATTEN to define the height of the visible stage and mask the battens behind it. In older theaters, the border just behind the main curtain hangs from the first batten *i.e.*, IN ONE, and is called the first border. The next, IN TWO, is the second border, and so on. In large modern theaters there may be more, and their numbers cease to define acting areas on the stage. If a border is painted, it is named appropriately as SKY BORDER, CEILING BORDER, etc. Borders differ from TORMENTORS in that they may be changed for different scenes, whereas tormentors, though they may be designed to represent part of the set, remain unchanged throughout the play or even the season. *See also* LEG DROP, TAB. *Compare* TEASER.

Lighting A light or a strip of lights hung behind a BORDER.

border batten *Stagecraft* The BATTEN from which a BORDER hangs.

border light *Lighting* A light fixture, usually a strip of lights within a metal trough hanging behind a BORDER. The open side of the trough has color frames for each lamp.

border light cable *Lighting* The cable that connects border lights with the control CONSOLE.

border pipe *Stagecraft* A light pipe that supports BORDER LIGHTS.

border strip *Lighting* A unit containing a number of lights, suitable to be hung from a BORDER PIPE.

Bordoni *Lighting* Trade name for a line of heavy-duty DIMMER systems installed in many large theaters and opera houses, whose dimmers are high-capacity transformers capable of controlling great amounts of power with less heat than other kinds of circuitry.

born in a trunk *Acting* Said of an actor whose parents were also actors and who, thereby, got an early start in the profession.

borscht belt, borscht circuit *Theater* A cluster of hotels and vacation resorts in the Catskill Mountains, north of New York City. They cater to what was once a predominantly Jewish clientele and provide entertainment by stand-up comics, singers and dancers along with tremendous meals, many of which include the variety of beet soup known as borscht. *See also* CHINA CIRCUIT.

bosom mike *Audio* A wireless MICROPHONE hidden within the blouse, bodice or jacket of a singer.

bossa nova [Portuguese] *Dance, Music* Literally, new bag. A SAMBA-like dance form, popular in the 1960s, that combines Brazilian and American jazz rhythms. One famous example is the song *The Girl from Ipanema*.

Boston *Dance* A type of slow waltz of American origin in which the partners turn in circles in several directions and pause on, or slightly stretch the first beat of each measure. European name for the HESITATION WALTZ.

bottleneck guitar *Music* An acoustic guitar with steel strings tuned to the pitches of a major TRIAD ("slack-key" tuning). The term also refers to the method of playing used by many blues guitarists in imitation of the wailing sound of the HAWAIIAN GUITAR, achieved by fretting the strings with a smoothed-off bottleneck fitted over the finger, or with a flat knife or piece of metal, held across the strings. Experts in this technique were Albert King and Duane Allman, among others. *See also* STEEL GUITAR.

bottom batten *Stagecraft* 1. A BATTEN slipped into the seam along the bottom edge of a DROP, to keep the drop in position and prevent any unwanted movement that might be caused by an actor crossing quickly behind it. 2. A batten tied to the bottom edge of a heavy drop and attached to TRIP LINES by which it can be hauled up into the FLIES along with the top of the drop.

bottom billing *Theater* The worst place for an actor's name on a poster or a playbill, signifying a lack of importance to the company.

bottom rail *Stagecraft* The horizontal piece that forms the bottom of a FLAT.

bounce card *Motion pictures* A reflective panel placed off-camera to reflect a small amount of light to shadowy areas such as eye sockets. Also called a FILL CARD. *Compare* BUTTERFLY.

bounce drop *Stagecraft* A DROP made of highly reflective cloth or painted in somewhat shiny light colors so that it will reflect light indirectly into a scene when illuminated from a hidden source. Good for scenes in SILHOUETTE, for example.

bounce light *Lighting* The light that falls on its subject indirectly, by being reflected from a BOUNCE CARD, BOUNCE DROP or similarly reflective surface. In theaters, bounce light is used often to illuminate the back of a SCRIM, to create a misty effect. In motion pictures, especially close-ups, it helps fill the shadows by adding diffuse, relatively flat light.

bouncing ball *Music, Motion pictures* An animated image of a ball that bounces along the line of song lyrics projected on a movie screen, enabling the audience to sing the words in proper rhythm to the accompaniment of "the mighty Wurlitzer" organ. The technique was popular in the early days of DOUBLE FEATURES, to fill the time while the projectionist changed reels.

bourdon (*boor-DONH*) [French] *Music* 1. A long sustained tone or tones, used as a DRONE. Not the same as BURDEN, and only distantly related to FAUXBOURDON. *Compare* PEDAL POINT. 2. A STOP on the organ.

bourrée (*boo-RAY*) [French] *Ballet* 1. A series of rapid, small steps on POINT in FIFTH POSITION that enables the dancer to move quickly across the stage as if gliding. 2. To perform such a series of steps. Not the same as PAS DE BOURRÉE.

Dance A 16th-century peasant dance from the Auvergne in France, in which skipping steps are performed by couples facing each other. Also performed, in quick duple time, by professional dancers as an element of French BALLET DE COUR.

Music A musical form based on the dance, used by composers beginning in the late 1600s. It was used often by Lully, Bach and Rameau as one movement of a SUITE.

bout (*bowt*) [from the French word for "end," but pronounced as in English] *Music* 1. Either of the gracefully formed rounded ends of the body of an instrument of the violin family, called upper bouts (near the fingerboard) and lower bouts (the widest part), separated by the middle bouts (the indented waist). The bouts are formed by the RIBS. 2. The tip, or non-adjustable end of the BOW.

bow *Music* A slightly curved stick of Pernambuco wood, with horsehairs stretched in parallel with its length, with which a stringed instrument player makes sustained musical tone emerge from the instrument. At the end of the bow close to the FROG is a small screw mechanism that adjusts the tension of the hairs.

Theater The actor's acknowledgment of applause, which can be anything from a slight nod of the head, to a deep bend of the body, but does not frequently involve a bended knee. *See also* BREAK A LEG.

bowing(s) *Music* 1. The technique of playing a stringed instrument with a bow. 2. The markings in a string instrument part that direct the musician to use the bow in a specific manner as an element of phrasing.

bow snap line *Stagecraft* A string stretched taut between the ends of a bowed stick. A scene painter rubs the line with chalk, lays it across a piece of scenery, pulls the line at its center and lets it snap back against the surface, producing a straight line that can be used as a guide in painting.

box *Acting* To pause very briefly before speaking a word, then again after it, thus focusing the attention of the audience on that word. A theatrical convention and a typical example of ACCESSORY ACTION.

Theater A small booth with a private entrance and six or eight chairs situated in the balcony of a theater and separated from its neighbors by walls.

box boom *Lighting* A vertical LIGHT PIPE in an auditorium, *e.g.*, in vacant balcony BOX SEATS. Such light pipes are sometimes constructed in architectural recesses high on the walls of the HOUSE that are open to the stage, so lighting fixtures will be shielded from the view of the audience.

boxing *See* BOX (*Acting*).

box interior *Stagecraft* A setting made to look like an interior room with walls and a ceiling. *See* BOX SET.

box office *Theater* The theater office where tickets are sold. By extension, the sale of tickets cited as one measure of a production's success with the public. *See also* GATE.

box office clerk *Theater* A person who works in the box office.

box office manager *Theater* The manager of the box office.

box office name *Theater* A performer whose famous name in a PLAYBILL helps sell tickets.

box office poison *Theater* A performer of doubtful reputation whose name in a PLAYBILL drives potential ticket buyers away.

box office star *See* BOX OFFICE NAME.

box seat *Theater* One seat in a BOX; therefore a very good seat from which to see the show and, if the box is on the side of the house, to be seen by the rest of the audience.

box set *Theater* A set constructed with three walls and a ceiling, instead of open WINGS, A BACKDROP and no ceiling.

box teaser *Stagecraft* A boxlike arrangement of sheets of fireproof, opaque material designed to conceal from the audience a light fixture that is situated within the set. Box teasers are frequently necessary in sets built out on THRUST STAGES or in ARENA THEATERS, where the audience can see the stage from three or four directions.

B picture *Motion pictures* During the mid-20th century, a motion picture made at a major American studio with a small budget and without major STARS, and rented at a flat rate instead of a share of the receipts to play as the lesser half of a DOUBLE-FEATURE at neighborhood theaters. Ironically, because B pictures were less important to the MOGULS who made the decisions at big studios, they provided an opportunity for directors to exercise their creativity and produce some high-quality films. FILM NOIR was one of the products of this situation.

brace *Music notation* A heavy line, sometimes bow-shaped, drawn at the left of a SCORE to join two or more STAFFS, thereby indicating that they are closely related, *e.g.*, as right and left hands for a pianist, or the voices of a choir.

Stagecraft See STAGE BRACE.

brace clamp *Stagecraft* A clamp mounted on the telescoping section of an adjustable STAGE BRACE to secure it in position.

brace cleat *Stagecraft* A CLEAT with a hole in it (or a ring welded to it), attached to one of the STILES of the back of a flat. It receives the U-shaped hook at the upper end of a STAGE BRACE.

brace hook *Stagecraft* A U-shaped hook at the upper end of a STAGE BRACE designed to fit into the hole of a BRACE CLEAT to permit quick attachment or release of a stage brace.

brace jack *Stagecraft* A triangular frame, approximately two-thirds the height of a FLAT and hinged to it so that it can be folded away when the flat is not in use. When it is unfolded, a FOOT IRON at the bottom can be fastened to the floor with a STAGE SCREW.

brace rail *Stagecraft* A strip of wood of the same dimensions as a RAIL or a TOGGLE, placed diagonally across a corner of a large FLAT to give it extra strength and rigidity, and to provide a high attachment point, if necessary, for a second BRACE CLEAT.

brace weight *Stagecraft* A weight, often a bag of sand, placed on the low end of a STAGE BRACE to hold it in place on the floor during the scene.

bracket light *Lighting* A light fixture mounted on a bracket instead of a LIGHT PIPE or a stand.

brail *Stagecraft* 1. A line attached to a FLOWN piece of scenery and pulled horizontally when the piece is dropped, to move it into a position on the set that cannot be achieved by straight vertical hanging. 2. A rigging line for a BRAIL CURTAIN. 3. To hang a rigging line for either purpose.

brail curtain *Theater* Any curtain fitted with RIGGING LINES (lifting cords) that pass through rings sewn every few feet along straight lines reaching from the top to the bottom of the backing, so that the curtain will gather in graceful folds as it is drawn up. There are several versions: *See* AUSTRIAN CURTAIN, CONTOUR CURTAIN, VENETIAN CURTAIN.

brake drum *Music* A percussion instrument consisting of an automobile brake drum without extraneous fittings, played by striking with a metal hammer to produce a very loud clang.

branle [from French *branler*, to shake] *Dance, Music* A court dance dating from the 12th century in which a line of swaying dancers performs to alternating rhythms, fast and slow. There are many regional variations. By the early 18th century, it was the formal dance that opened every court ball, with the king and queen leading. Also known in England as brawl.

brass *Music* Brass instruments collectively. The brass sections (trumpets, horns, trombones and tubas) of the orchestra considered as a single unit.

brass band *Music* A band consisting entirely of brass instruments and percussion, quite popular in England and in other areas of the world settled by Europeans.

brass quartet (quintet, sextet, etc.) *Music* 1. A performing group consisting of four (five, six, etc.) brass instruments. 2. The music composed or arranged for such a group.

"bravo" (*BRAH-voh*) [Italian] *Music, Theater* Literally, brave one. The audience's traditional shout of praise for an especially good performance. It is proper to use the feminine form "brava" when the performer is a woman.

bravura (*brah-VOO-rah*) [Italian] *Music* Literally, courage, brilliance, spirit. A passage in any piece of music characterized by florid lines and strong rhythms demanding great brilliance in performance.

brawl *See* BRANLE.

break *Music* 1. The point within the range of the voice, or of any instrument, where the TIMBRE of its sound changes. *Compare* COMMA, WOLF. 2. In JAZZ, an effect in which all accompaniment briefly ceases, letting a soloist fill in the time until the accompaniment picks up again. The same as STOP TIME.

Stagecraft To roughen a painted surface.

Theater 1. The end of an act or scene. 2. A period of rest between periods of rehearsal. *See also* TAKE FIVE. 3. Said of the scheduled time for the end of a performance: "The play breaks at 11:15 p.m."

break a leg *Acting* 1. The traditional good-luck wish in American theater, where to speak the words "good luck" ensures the opposite. 2. To take so many bows that your knees break. *See also* MERDE, TOY-TOY.

break an act, break up an act *Vaudeville* To destroy an act by separating the team that performs it.

breakaway *Stagecraft, Motion pictures* 1. A PROP or a piece of scenery that is designed to be broken into pieces during the show. Some breakaways are designed so that they can be put together again for the next performance or TAKE. 2. Any supposedly fragile prop, such as a bottle, constructed of very flimsy material that can be smashed on cue and shattered dramatically but harmlessly, for example, on an actor's head. Breakaway bottles are made of wax that makes so little noise in breaking that a more believable sound has to be added by a SOUND MAN, a FOLEY OPERATOR or an EDITOR.

break character *Acting* To put aside one's awareness of the character being played and speak or act as oneself, thereby erasing the AESTHETIC DISTANCE that permits an audience to accept an actor's theatrical illusion.

break dancing *Dance* A style of acrobatic solo street dancing popular in the 1980s, notable for complex footwork, spinning headstands and gymnastic maneuvers requiring great agility and skill.

breakdown *Dance* A noisy, rollicking folk dance of the mid-19th century.

break down *Stagecraft* 1. To take the set apart. *See* STRIKE. 2. To separate the parts of any large piece of scenery so that it may be removed from the stage. *See* DEMOUNTABLE DOOR, DEMOUNTABLE WINDOW.

breakdown scenery *Stagecraft* Scenery constructed in several pieces that can be separated from each other for convenience in transporting and/or storing. *See* DEMOUNTABLE DOOR, DEMOUNTABLE WINDOW.

break even *Theater* To recover the cost of the production through ticket sales.

break-even point *Theater* The point at which ticket sales equal the amount spent on the production, expressed either as dollars or as a date during the RUN.

break in *Theater* To play a new production, perhaps out of town, ahead of its scheduled run, so that adjustments can be made and everything finely tuned before the official opening when critics will be reviewing. *See* PREVIEW, TRYOUT.

break up *Acting* 1. To lose concentration, especially by laughing when the character portrayed is supposed to remain serious. 2. To destroy the meaning of a scene by reacting to it in a manner that is inappropriate to the script. To laugh, for example, when someone misspeaks a line.

break-up lens *Motion pictures* A camera lens that reproduces a single image as an array of many identical images.

breeches role *Acting* A male role played by a woman, *e.g.*, Octavian in Hofmannsthal's play (and Richard Strauss's opera) *Der Rosenkavalier.*

breve (*BREH-veh*) [Italian] *Music notation* Literally, brief. A musical note, twice as long as a WHOLE NOTE or semibreve, half the duration of a LONGA, used only occasionally in modern music. When time-based musical notation was first developed in the Middle Ages, the breve was considered a brief note, defining what modern musicians would call the beat of the measure. After 400 years of notational development, it has become the longest note still in occasional use. Also called a DOUBLE WHOLE NOTE.

bridge *Acting* A passage of dialogue or stage BUSINESS that provides a logical transition between major dramatic events in a scene or allows time for offstage preparation for the upcoming scene.

Broadcasting A passage of music, sound effects or dialogue that provides a transition or psychological separation between two segments of a program, or two reports in a news program, or allows time for preparation of an upcoming segment.

Music 1. A thin carved sheet of hardwood designed to support and hold apart from each other the taut strings of a stringed instrument and transmit their vibrations to its BELLY where they become audible tone. The bridge of the VIOLIN, VIOLA or VIOLONCELLO rests firmly on the belly nearly over the SOUND POST, so that both the belly and the back of the instrument resound to the tone. The bridge of a DOUBLE BASS differs from the others in that only the end (or "foot") under the highest string is near the sound post, while the other touches the belly a few inches away from it, causing the response of the belly to be slightly different from that of the back. 2. In musical composition, a passage composed to effect a transition between one section of a piece and another. 3. In any standard 32-bar popular song, the third eight-bar phrase, which is different from the others, *i.e.,* B in the AABA form. Also called the RELEASE.

Puppetry A raised platform behind the stage and concealed by its backdrop where puppeteers may stand while operating MARIONETTES.

Stagecraft A platform that can be raised above the stage and among the FLIES, strong enough to support stage hands or technicians while they hang DROPS, paint scenery and install or repair equipment.

Lighting A steel platform suspended above the stage, strong enough to support heavy fixtures and the lighting technicians who install and maintain them. Also called a LIGHT BRIDGE.

bridge clamp *Lighting* A large, strong two-piece clamp designed to support a light fixture on a light bridge. A BRACKET CLAMP.

bridge crew *Lighting* Technicians assigned to work on a BRIDGE.

bridge lights *Lighting* Lights attached to a BRIDGE.

bridge operator *Stagecraft, Lighting* A technician who controls the raising and lowering of a bridge.

bridge position *Stagecraft, Lighting* The position of the BRIDGE upstage of the MAIN CURTAIN, *i.e.,* IN ONE. It is also sometimes called the TEASER position.

bridge spot *Lighting* A spotlight installed on a BRIDGE.

brindisi (*BRIN-dee-see*) [Italian] *Music* A jovial drinking song, as "Libiamo!" ("Let us drink!"), in Verdi's opera *La Traviata.*

bring down the house *Theater* To cause such tremendous applause that the roof of the theater might fall in.

bring in *Lighting* To light a light, or a group of lights, in the sense of raising their power from zero with a DIMMER. *See also* BUMP ON.

Stagecraft To lower (*e.g.,* a DROP) into the set.

bring up *Lighting* To increase the brightness of a light or a group of lights. *See also* BUMP UP.

brisé (*bree-ZAY*) [French] *Ballet* Literally, broken. A step that starts with one leg brushing out, then a jump off the other foot, followed by a small BEAT of the legs in midair that breaks the movement. It ends with a landing on both feet.

brisé volé (*bree-ZAY voh-LAY*) [French] *Ballet* Literally, flying break. Like the simple BRISÉ, but landing on one foot. It can be performed EN AVANT and EN ARRIÈRE.

broad *Lighting* 1. A 2,000-watt floodlight. 2. An array of floodlights (often nine) set into a wide metal reflector shaped like an open box and mounted on a LIGHT PIPE or a stand. Also called a NINE-LIGHT.

Broadcast Music Incorporated An association of composers, authors and publishers who broke away from ASCAP, during a period in 1939 when negotiations between ASCAP and broadcasters had broken down, to form a separate performing-rights management organization, which they thought would be more appropriate to the upcoming era of recordings and television. BMI and ASCAP are the largest such organizations in the United States.

broadside *Theater* An advertisement for a show printed on one side of a large sheet. *See also* FLYER.

Broadway *Theater* 1. The theater district in New York City, centered at Times Square where the street named Broadway crosses Seventh Avenue, quite near TIN PAN ALLEY. 2. A style of commercial musical theater that developed there, characterized by its self-assured, brash extravagance and a high degree of professionalism.

brogue *Acting* An Irish accent.

broken color *Stagecraft* Color painted on a relatively wide surface such as a FLAT, which has been broken up with small spots or streaks of another color to give it the appearance of roughness, as, for example, the surface of a concrete wall.

Bronx cheer *Acting* A very loud, insulting RASPBERRY or BIRD.

brush *Makeup* A moustache.

Ballet To extend the working leg forward, with the toe brushing along the floor, to a pointing position.

brushes *Dance* In MODERN DANCE, an exercise intended to strengthen the ankles, calves and thighs. It is performed in a standing position, often at the BARRE, with the leg straight, the toe brushing the floor in a forward motion and the heel brushing the floor on return.

Music Metal drumsticks with heads made of wires about six inches long, bundled at one end and spreading at the other somewhat like a whiskbroom, that produce a much softer sound than drumsticks with wooden heads. When out of use, the wires can be retracted into the handles, which are hollow for that purpose. When the drummer strokes the drum with brushes, instead of striking it, the sound is a soft swish or whisper.

brush lining *Stagecraft* Lines painted in scenery with a brush, *i.e.,* wide enough to be seen by the audience and having some degree of shadowing or roughness to add three-dimensional quality.

brush up *Acting* To refresh an actor's memory of a role.

brush-up rehearsal *Acting* A rehearsal called at some point during the run of a show, or after the show has been off the stage for a short period, expressly for the purpose of refreshing the actors' memories of LINES and BLOCKING and, especially in the case of musicals, to tighten up cues. *Compare* PICK-UP REHEARSAL.

brute *Lighting* An extremely powerful (225-ampere, or 10,000-watt) carbon-arc lamp.

bubble dance *Cabaret, Vaudeville* A dance performed by a nude or nearly nude dancer with large, hand-held balloons partly screening the dancer's body. *Compare* FAN DANCE.

Buck and Wing *Dance* A lively turn-of-the-century tap dance, probably inspired by African American and Irish CLOG DANCES, performed in wooden-soled shoes with much clicking of the heels and hopping.

bucklebuster *Vaudeville* A tremendously funny joke or comic act. *See also* BELLY LAUGH, BOFF.

buffa *See* OPERA BUFFA.

buffo (*BOO-foh*) [Italian] *Music* Literally, a jest. Comic, as a comic role in opera, usually sung by a BASS.

buffoon *Acting* A comic character, frequently a stylized role played by a man.

Bugaku (*boo-GAH-koo*) [Japanese] *Dance, Theater* A formal court dance or dance-drama of 7th-century Chinese and Indian origin, performed by groups of four, six or eight male dancers of the Japanese Imperial Household. It is characterized by slow, stately repeating steps in the four cardinal directions. For Bugaku plays, performers wear elaborately carved and painted wooden masks that may have moveable parts. *See also* GIGAKU.

Music The music that accompanies Bugaku dancers. Distinguished from GAGAKU, which is similar in style but does not accompany dancers.

bugle *Music* A treble brass instrument of the CORNET family, shaped like a trumpet but with no valves, capable therefore of playing only the natural harmonics of its fundamental tone. Most frequently used as a military signaling instrument. *See* TAPS, TATTOO.

build *Acting* To add tension in one's performance as a means of increasing the audience's feeling of anticipation.

Makeup To increase three-dimensional relief and/or color by adding more material.

building crew *Stagecraft* The people who build the sets.

build on *Acting* To pick up another actor's expression of dramatic tension and add to it.

build up *Theater* To coach an actor for a leading part.

> *Playwriting* 1. To develop the plot, or develop a character. 2. To prepare for a character's first entrance by introducing background information in the initial scenes of a play.

> *Theater* 1. To increase the size of the audience by handing out free tickets. 2. To publicize the production and its stars before opening night. *See also* PAPER THE HOUSE.

build-up *Makeup* Thickness added to a face by means of makeup.

built *Stagecraft* Constructed, instead of painted to simulate construction.

built set *Stagecraft* A self-standing set architecturally constructed, as contrasted with a setting suggested by painted flats and drops.

bulerias (*boo-leh-REE-ahs*) *Dance* A Spanish FLAMENCO dance that is rather fast and merry.

bulldog *See* LINE GRIP.

bull fiddle *Music* Slang term for a DOUBLE BASS.

bullfrog *Acting* An actor with a deep, resonant speaking voice.

bullroarer *Music* A device of ancient origin that produces a roaring, buzzing noise. Its sound is more like that of an airplane propeller than an animal roaring, because it is produced by whirling a short wooden slat at the end of a string.

bump *Dance* 1. A provocative movement, beloved of BURLESQUE and vaudeville dancers, in which the pelvis is propelled forward. 2. A dance that enjoyed brief popularity in the 1970s, in which couples bumped their hips against each other.

bump and grind *Vaudeville* A lascivious style of dance characterized by a BUMP and a circular movement of the hips.

bumper *Lighting* A metal hoop placed around a hot lighting fixture to prevent any nearby cloth drops or other flammable objects from touching it.

> *Stagecraft* Any object placed to act as a stop for a moving platform on the stage.

bump on *Lighting* To turn stage lights on suddenly by bumping the handle of the DIMMER rather than smoothly pushing it.

> *Recording* To turn music or a sound effect on suddenly by tapping its GAIN CONTROL upward.

bump up *Lighting* To increase the brightness slightly by "bumping" the dimmer.

> *Recording* To increase the volume of a sound effect slightly by tapping its GAIN CONTROL.

bunny hug *Dance* A ballroom dance of the early 1900s performed to RAGTIME music, characterized by a close embrace between the partners, considered scandalous at the time. *See also* ANIMAL DANCE.

Bunraku (*boon-RAH-koo*) [Japanese] *Puppetry, Theater* The traditional puppet theater of Japan, developed in the late 1600s and performed on a full-size stage. Characters are represented by almost life-size bodiless dolls with wooden heads, their moving parts covered by elaborate costumes. Fully visible to the audience, the principal puppeteer is also costumed, while two assistants wear black clothing to conceal themselves. A narrative is chanted by one speaker to the accompaniment of a single three-stringed guitar (SAMISEN).

burden *Music* A REFRAIN, especially the repeating refrain of an Elizabethan dance or folk song.

burlecue *Vaudeville* Slang for BURLESQUE.

burlesque *Theater* 1. A style of theater that mocks society by imitating it with comedy, music and dance. 2. A play or scene that mocks a person or an event.

Vaudeville A style of entertainment featuring jokes, songs and dances, most of which are sexually suggestive, sometimes with STRIPTEASES, FAN DANCES and the like.

burlesque queen A STRIPPER.

burletta [Italian] *Theater* Literally, a little jest. In Europe in the 18th and 19th centuries a little comic play, especially one that has BURLESQUE quality, with songs and dances.

burn in *Motion pictures* To superimpose an image on a film by exposing it with white light which overwhelms any other image. Typically credits and subtitles are burned in because they are added after the film has been completed. When possible, however, editors plan ahead so that they can make those items clearer by shooting them in color with black or white outlines to ensure that they separate visually from the background. In television, the same result is achieved with a CHARACTER GENERATOR.

burnt cork *Makeup* Black makeup, achieved by burning a piece of cork (from a wine bottle, for instance) and applying it when cool. It gives a smudgy, smoky quality, useful for beards and heavy mustaches.

burnt sugar *Stagecraft* The liquid in a stage drink—caramelized sugar mixed with water—that looks like whiskey but has no alcoholic content and will not discommode an actor.

burthen *Music* The Elizabethan spelling for BURDEN.

bury the show *Theater* To put the sets and costumes in storage when the run of the show is over.

business *Acting* Small but significant bits of action on stage, such as tamping out a cigarette, rearranging the pillows on a sofa, brushing off a little dandruff, etc., all directed or improvised for purposes such as focusing the audience's attention or establishing the audience's sense of elapsed time. Often business makes a scene more lifelike.

business cue *Stagecraft, Lighting* A CUE for lights, sound, stage effects and the like, as distinguished from a cue for an actor.

business manager *Theater* The administrative and financial manager of the theater and/or the production company, the person responsible for business arrangements such as union contracts, salaries and wages, supplies, rentals and the like. Not the same as PRODUCER or MANAGER.

business prop *Acting* Any prop required for stage BUSINESS, such as a cigarette that must be tamped out, pillows that must be rearranged on a sofa, etc.

busk *Acting, Circus* To perform on the street or in public places for money, *e.g.,* by passing the hat.

busker *Acting, Circus* A street actor who performs for tips. The name seems to have come from buskin, a type of boot with very high lifts built into the sole and heel (*see* COTHURNUS), once worn by tragic actors to give them a larger-than-life appearance on the stage.

buskins *Costume* Knee-length socks, highly ornamented with gold embroidery, a vestige of a kind of boot once worn by actors in Roman theaters in classical times. *See also* COTHURNUS.

bust shot *Television* A shot showing the subject from the waist up. Also called a chest shot.

Butoh (*boo-TOH*) [Japanese] *Theater* A theatrical performance art, born of the despair and confusion of post-Hiroshima Japan.

butterfly *Motion pictures* A large square translucent panel, often made of nylon or a similar synthetic fabric, up to about 4 × 5 feet, mounted on a stand, that can be placed between the sun and the subject, or in front of a very powerful FLOODLIGHT to diffuse its beam, so that the scene is evenly illuminated. In a typical situation, with a daytime scene being shot at night inside a house, the flood and its butterfly, outside, simulate the even brightness of daylight at all the windows.

button accordion *Music* An ACCORDION without a keyboard, with an array of buttons, each producing a single tone. The player plays chords by pressing several buttons at once. *See also* BANDONION.

butt splice *Motion pictures* A SPLICE prepared by cutting the film or tape straight across.

buyout *Motion pictures, Television* A contract by which a producer acquires all the rights to a PROPERTY, a musical score or a performance, leaving the writer, composer or performer with a cash settlement but no ROYALTIES or RESIDUALS.

buzzard lope *Dance* An American ANIMAL DANCE popular in the 1890s, in which the principal activity was grinding the hips. Possibly of African origin, it is supposed to have been inspired by the antics of the turkey-buzzard. *See also* TURKEY TROT.

byplay *Acting* Any little exchange of dialogue or stage BUSINESS, or both, that has little to do with the main action but that may provide a sidelight on it or remind the audience of a subplot. An example might be a private, silent exchange between lovers while other characters are speaking.

Byzantine chant *Music* Liturgical chant in the Greek Orthodox Church. *See also* PLAINSONG.

Byzantine notation *Music notation* A wholly melodic notation consisting of Arabic symbols that indicate how a melodic line must move in steps or leaps rather than how its tone at any moment may relate harmonically to another tone. One symbol indicates "the same note," another "a step up," and another "two steps in succession down" and so forth. In the Byzantine system, duration and rhythm depend on the words being sung, which is entirely appropriate for a system that is melodic in its structure. The continuity of Byzantine notation is unbroken as far back as the 9th century, and music written in earlier versions (even from long before that period) can be deciphered and sung. Some scholars have extrapolated from this tradition to make an educated guess at how classical Greek drama and epic verse, which were both sung, may have sounded in their own time—not at all the stiff syllabification that used to be thought correct, but something much closer to Arabic and other Middle Eastern folk music.

C

c *Music* 1. The first note of the scale of C, a MAJOR SIXTH below A. 2. The KEY of which the note C is the TONIC. In the FIXED-DO SYSTEM, C is DO. *See also* MIDDLE C.

C *Music* 1. The symbol for COMMON TIME. In modern scores, particularly scores for marching band, C replaces the normal numerical time signature 4/4. When it appears with a vertical line through it, it indicates CUT TIME (*see* ALLA BREVE), in which the half-note takes the basic beat. These symbols did not derive from the letter *C* in abbreviation of the words *common* or *cut*, but came into fashion in the early days of time-based music notation, around the 14th and 15th centuries, when "perfect time" (4 LONGAS per measure) was represented in liturgical music by a full circle, cut time (2 longas, or 4 breves) by part of that circle, *i.e.*, C. The symbol has lived on, though the practical durations of the written notes have changed. 2. In modern VOCAL SCORES, C is used also to indicate the CONTRALTO voice.

cabaret (*kah-bah-RAY*) [French] 1. A restaurant or nightclub with entertainment featuring skits, monologues and songs of political satire, with much of the material drawn from current events. 2. The style of music performed in a cabaret that generally includes songs expressive of nostalgia and disillusionment, usually performed by a woman with a pianist or small combo as BACKUP. The style is typified in the songs composed by Kurt Weill with lyrics by Bertolt Brecht, and the songs recorded by Edith Piaf. *See also* TORCH SONG.

cable *Audio* Any insulated bundle of electrical conductors, usually shielded against electronic interference from outside, designed to carry audio signals between electronic units, *e.g.*, between studio microphones and control console, or between control console and recording equipment.

Lighting A flexible, insulated, three-conductor line, or a group of such lines enclosed in an insulating case, designed to carry electrical power from STAGE POCKETS to LIGHTING INSTRUMENTS. It has a male PIN CONNECTOR that fits into the stage pocket, and a female that accepts the line from the instrument.

Television 1. The bundle of conductors that carries the VIDEO and AUDIO signals from the camera to the CONTROL ROOM 2. The bundle of conductors that carries the broadcast signal from the broadcasting station to the viewer's home. 3. Collectively, the nationwide system of networks that distribute their programs to the public by wire.

cable clamp *Lighting* Any clamp used to hold a cable firmly in place along a BATTEN, a pipe batten or a wall.

cabriole (*ka-bree-OHL*) [French] *Ballet* A lively step in the air, with the lower leg beaten against the upper leg. It is performed EN AVANT, DERRIÉRE and À LA SECONDE in various positions of the body.

caccia (*KAH-chyah*) [Italian] *Music* Literally, a chase or a hunt. A little piece for two or more voices in which the voices imitate and follow each other both musically, somewhat like a CANON, and in words. The texts of the earliest examples frequently deal with hunting and village scenes. Similar to the English CATCH.

cachucha (*kah-CHOO-chah*) [Spanish] *Dance* A solo Spanish dance in triple time from Andalusia, to music somewhat like the bolero, sometimes accompanied by CASTANETS.

cacophony [from Greek] *Music* Literally, bad sound. Harsh, disordered noise, not to be confused with DISSONANCE that may be harsh but is constructed of orderly musical tones.

cadence *Acting* 1. The flow of accents and tones of speech in the syllables of a spoken line, not necessarily in repetitive beats. 2. The falling tone of speech that indicates the end of a phrase or a sentence.

Music 1. A harmonic sequence, implied or realized, that brings a section or an entire piece of music to an end. Cadences serve as signposts to orient the listener within a musical framework. To modern ears, the clearest example of cadence occurs at the end of any simple piece of music as a chord of the SUBDOMINANT or DOMINANT resolving into the TONIC. The cadence from the dominant is called AUTHENTIC, while that from the subdominant is PLAGAL. Each is a PERFECT CADENCE because each moves to the TONIC and therefore brings the piece or the section to a definite end. If, however, either resolved to a nontonic chord, the resolution would be called a DECEPTIVE CADENCE. Beethoven's First Symphony begins with a SEVENTH CHORD, exactly like the onset of a cadence, but follows it with another, then another, then launches the themes of the piece. 2. The rhythmic pattern of drums played as, or in imitation of, an accompaniment for marching.

cadenza (*kah-DEN-zah*) [Italian] *Music* A more or less elaborate passage, sometimes improvised, sometimes carefully composed, that interrupts the steady flow of phrasing during or just before the end of a piece of music, and gives the performer (or soloist, if the piece is a CONCERTO) a chance to invent variations on the themes of the work and develop them in a personal way. *See also* BRAVURA, BREAK.

caesura (*seh-ZOO-rah*) [Latin] *Acting* A break in the rhythmic flow of a metrical line marked sometimes, but not always, by punctuation as in "I think, therefore I am" (Descartes).

Cajun music Energetic dance music associated with the descendants of French-Canadians driven out of Acadia (now Nova Scotia) in 1755 who settled in the bayou region of southern Louisiana. It is most often performed by fiddles, guitars and a small rhythm section. *See also* ZYDECO.

cakewalk *Dance* An African American dance involving much strutting or prancing, performed in informal competition by couples as a promenade or march, with a cake as a prize for the most inventive dancers. Possibly the source of the expression "take the cake," meaning to outdo everyone else.

cake-walk *Dance* To dance in the exaggerated high-stepping fashion of the CAKEWALK.

calabash *Music* A rattle consisting of a hollow gourd partially filled with dry seeds that makes a distinctive sound when shaken. A percussion instrument frequently found in Latin American dance bands.

calcium light *Lighting* An extremely bright white light produced by lime brought to incandescence with an electric arc. Used in theaters in the late 19th and early 20th centuries for brilliant spotlighting from the back of the house. *See also* ARC LIGHT, FOLLOW SPOT.

call *Acting* 1. A gathering of actors at a specific time and place for a specific event such as CASTING or rehearsal. 2. The announcement of such an event, stating when and where it will occur and who is required to attend.

callback *Acting* 1. An invitation to an actor who has been through an initial CASTING call to come back for a second, usually more demanding audition. 2. An audience's demand for another CURTAIN CALL.

call board *Acting* A bulletin board backstage, perhaps near the stage door, displaying a detailed schedule of upcoming rehearsals and performances.

call boy, call girl *Theater* A stage manager's assistant, one who goes around to all the dressing rooms to give actors their 30-minute, 15-minute and 5-minute warnings.

caller *Dance* One who calls the figures for a country dance, who instructs the dancers to perform specific steps or patterns, particularly in the American SQUARE DANCE.

calliope (*kah-LYE-oh-pee*) *Circus* A large pipe organ powered by steam pressure and built into a MERRY-GO-ROUND or mounted on its own gaudy wagon so that it can be dragged around town in a circus parade. Because of the way its sound is generated and the type of music generally played on it, the calliope is imitated in a few concert scores to suggest the circus itself.

call out *Theater* To applaud and demand that a performer come out from behind the curtain to take another bow, perhaps even to speak.

call sheet *Theater* A list of upcoming rehearsals, particularly such a list compiled for a specific actor or other participant.

call the act *Theater* A stage manager's instruction to the CALL BOY/GIRL to notify actors that they should take their places for the next act.

call time *Theater* The time for which a CALL is scheduled.

calypso *Dance, Music* A style of popular song-dance native to the West Indies, particularly Trinidad, and distinguished by its easy rhythms and simple dance movements, the use of STEEL DRUMS, CONGAS and MARACAS, and its often satirical, gossipy or narrative lyrics.

cambiata (*kahm-bee-AH-tah*) [Italian] *Music* Literally, changed. An ornament in which the melody approaches a principal tone by first sounding its upper, then lower (or *vice versa*) neighboring tones.

cambré (*kahm-BRAY*) [French] *Ballet* Literally, arched. A ballet movement with the body bent from the waist toward the back or to the side.

cam card *See* CAMERA CARD.

camel walk *Dance* An ANIMAL DANCE of the 1920s performed to RAGTIME.

cameo *Acting* A small but significant role involving little or no interplay with other members of the cast, that occurs briefly and only once or twice in a play. Stage cameos permit a visiting star to make an appearance in a play or a film without actually going through all the rehearsals and without having to stay backstage the rest of the evening. In films, cameos may be filmed elsewhere, apart from the studio or other shooting locations.

camera blocking *Motion pictures, Television* The process, during a special rehearsal, of practicing the SET-UPS and moves that must be made with the camera during a SHOOT. After the first camera-blocking rehearsal, a full DRESS REHEARSAL occurs with all the camera set-ups and moves taking place in real time.

camera card, cam card *Television* A large card on which titles, credits or other such information has been printed to be shot by the camera. Also called a flip card.

camera chain *Television* A single television camera together with all the equipment required to run it and connect it to the videotape recorder, including cables, camera controls, monitors and power supply.

camera performance *Acting* A performance designed to look wonderful through the camera.

camera right, camera left *Television* To the right or the left of the frame, from the camera's point of view. The opposite of stage right, stage left.

Camerata, la *Music* A little group of literary and musical friends who gathered regularly at Count Bardi's palace in Florence, Italy, around 1580 to discuss aesthetics and poetry. Among them were the poet Ottavio Rinuccini, the composers Vincenzo Galilei (father of the great astronomer and scientist), Giulio Caccini and Jacopo Peri. The group at Count Bardi's was once thought to have invented opera. In fact they did more to protect the concept of madrigal comedy. Opera came out of meetings of another Florentine group of intellectuals to which Rinuccini, Caccini and Peri also belonged, that met at the home of Jacopo Corsi. Their first opera was performed there during the pre-Lenten carnival of 1598.

camp *Acting* 1. A style of acting with ludicrously extravagant suggestions of emotion and meaning, as in revivals of late-19th-century American melodramas. Camp, to be successful, requires sophisticated technique and is not the same as HAM. 2. To act in a highly exaggerated style, to "camp it up."

campanile (*kahm-pah-NEE-leh*) [Italian] *Music* A bell tower.

campanology *Music* The art and practice of bellringing. *See* CHANGE RINGING.

campy *Acting* Having the quality of camp, ludicrously exaggerated in style.

can *Motion pictures* A lightproof container for film stock that is also used for exposed film to protect it from light on its way to the laboratory for development. Used figuratively ("the scene is in the can") to mean that shooting is complete and satisfactory for that scene.

Canaries *Dance* A 16th-century couple dance from the Spanish Canary Islands, in rhythm somewhat like the GIGUE. Once danced around a corpse, it evolved into a dance-pantomime of courtship.

canary *Vaudeville* Slang term for a female singer, usually one who works with a dance band.

cancan *Dance* A 19th-century French QUADRILLE in 2/4 time, boisterous and high kicking, in which professionals scandalized spectators by revealing their legs and petticoats. The cancan is said to be the descendant of an old fertility dance from southern Brittany.

cancel *Lighting* To get rid of a shadow by filling it with the right amount of light, or to reduce an unwanted effect of color by adding another color to counteract it.

cancrizans [from Latin: to move backward] *See* CRAB CANON.

candle power *Lighting* A measure of the intensity of a source of light expressed as a multiple of that emitted by a standard candle. It has been replaced by more reliable units such as the LUMEN. *See also* LUX.

C & W *See* COUNTRY-AND-WESTERN.

canned *Music* Said of recorded music originally composed for some other purpose, used as background or as sound effect. The opposite of ORIGINAL MUSIC.

canon *Music* A piece of music for two or more voices (or instruments) characterized by strict imitation of the line of one voice by each of the others. A ROUND. A typical example is the little canon "Row, Row, Row Your Boat." More elaborate canons appear in larger instrumental works. A canon is usually relatively short, with little formal development, and it is always to be distinguished from a FUGUE, which usually develops beyond strict imitation.

cans *Audio* Headphones, usually big ones designed to keep out AMBIENT NOISE so that engineers and musicians wearing them can hear specific sounds very clearly. Necessary in recording, for example, when musicians are synchronizing to a CLICK TRACK or when an actor must hear another's cue clearly in the midst of what would otherwise be overwhelming sound.

cantabile (*kahn-TAH-bee-leh*) [Italian] *Music* Literally, singing. In a singing manner, with the melody smoothly emphasized.

cantata *Music* A piece in several movements for solo voices and/or chorus and instruments. Cantatas are frequently based upon secular dramatic or narrative texts, and are distinguished from ORATORIOS, which are always based on religious subjects, are more formally dramatic in content and usually much longer.

canticle *Music* A relatively short liturgical text meant to be sung.

canto (*KAHN-toh*) *Music* 1. A song, a melody. 2. The leading voice, usually the soprano, in music of the Renaissance.

canto fermo (*KAHN-toh FEHR-moh*) [Italian] *Music* *See* CANTUS FIRMUS.

cantor *Music* 1. The chief singer in a synagogue who leads the music and performs the chants and other liturgical solos as required in the service. 2. The leader of singers in a German Protestant church, the choirmaster or director of music.

cantus firmus (*KAHN-tus FEER-mus*) [Latin] *Music* Literally, firm song. A strong melody derived from ancient PLAINSONG and used as the basis (often the bass line) for a choral composition in a church service. The cantus frequently appears as a long melodic line, in notes of long duration, supporting relatively florid variations and counter-melodies in the other voices. It has been used in that way since the 11th century.

canvas *Circus* 1. The heavy cloth formerly used to make circus tents, now frequently replaced by synthetic materials. 2. The circus itself.

Stagecraft 1. Heavy linen or duck cloth stretched over wooden frames to make flats or hung from battens as drops. 2. To cover a flat in preparation for painting it.

canzona (singular) (*kahn-ZOH-nah*), **canzone** (plural)(*kahn-ZOH-neh*) [Italian] *Music* Literally, song. 1. The name given to some Italian lyrical poems of the 13th through 17th centuries, and to solo or choral musical settings of such poetry. 2. In the 16th and 17th centuries, instrumental music that grew out of the CHANSONS of Josquin des Prez and others. Often in several sections or movements, the canzone were written with a homophonic or contrapuntal treatment and often in livelier rhythms.

canzonet, canzonetta [Italian] *Music* The diminutive of CANZONA, a short, light vocal work. Also, a name given to some MADRIGALS and short instrumental and organ pieces of the 16th and 17th centuries.

capacity *Theater* The size of the house, expressed as the total number of its seats.

cap and bells *Costume* The symbolic costume of the court fool in medieval times.

capo (popularly pronounced *KAY-poh*) *Music* Short, Americanized form of CAPOTASTO.

capotasto (*kah-po-TAHS-toh*) [Italian] *Music* A metal bar that can be clamped across the strings of a guitar or other stringed instrument, defining the length of all the strings and their pitches so that the instrument can be played in a higher key without changing fingering. *See also* STEEL.

capriccio (*kah-PREE-choh*) [Italian] *Music* Literally, caprice. A short, informal, sometimes humorous piece of music whose themes and styles develop one from the other. *See also* FANTASIA.

capriccioso (*kah-pree-CHOH-zoh*) [Italian] *Music* Capriciously, freely, at the player's whim.

caption *See* CRAWL, SCROLL, SUPER. *See also* BURN IN, CLOSED CAPTIONING.

car *Circus, Stagecraft* Any basket, box or piece of scenery designed to be FLOWN carrying one or two actors. *See also* DEUS EX MACHINA.

carbon arc *Lighting* A brilliant white light produced by an electrical arc between carbon electrodes, powerful enough to flood the stage from a fixture at the back of the house. *See* ARC LIGHT.

carbon arc spotlight *Lighting* A carbon arc light with a spotlight lens, built to cast a brilliant light on a single actor or a small group from the back of the house. The basic unit of the FOLLOW-SPOT.

card *See* CUE CARD.

carillon *Music* A set of large church bells tuned to the CHROMATIC SCALE, mounted in an open tower and played by means of a keyboard installed in a room just below. Until recently, the connection between keyboard and bells was wholly mechanical, requiring the player to slam the keys with both fists clasped together in order to make any sound at all. That method has given way to electronically actuated beaters. Since whatever sound the bells make can be heard for miles, students practice on a simulator with weighted keys attached to a set of miniature bells.

carilloneur (*kah-ree-onh-NEUR*) [French] *Music* One who plays the CARILLON.

carioca *Dance* A form of SAMBA made suitable for ballroom dancing.

carmagnole (*kahr-mahn-YOL*) [French] *Dance, Music* Dating from 1789, a wild dance by a chain of dancers involving a GALOP and resembling a FARANDOLE. It sprang into existence almost spontaneously during the extended celebrations of the fall of the Bastille at the beginning of the uprisings that led to the French Revolution.

carmina (*kahr-MEE-nah*) [late Latin, *carmen, carminis*] *Music* Literally, a song. A term used by the mid-20th-century German composer Carl Orff in the title of his *Carmina Burana*, a choral work based on Latin texts of medieval songs. The name of Bizet's opera *Carmen* (1875) comes from the same root.

carnival 1. A time of feasts and merrymaking, so named from the ancient custom in Roman Catholic countries of a day of merrymaking on the last Tuesday (MARDI GRAS) before Lent. The word derives from the Latin *carne levare*, "to take the meat away." 2. A festive traveling show with many SIDESHOWS and amusement arcades, exciting rides and audience-participation contests and games. *See also* CIRCUS.

carny *Carnival* 1. *Short for* CARNIVAL. 2. A member of the carnival staff.

carol *Music* A simple, gentle song for Christmas. Carols were not always associated with Christmas, but generally were happy songs celebrating a sacred subject.

carousel, carrousel *Carnival* *See* MERRY-GO-ROUND.

carpenter *Motion pictures, Stagecraft* A craftsperson who builds SETS.

carpenter batten, carpenter pipe *Stagecraft* A BATTEN or pipe with TRIM CHAINS in place ready for hanging DROPS or SET PIECES.

carpenter's room *Stagecraft* The carpenter's storage room for tools and materials backstage.

carpenter's scene *Stagecraft* Any scene played before a SCENE CURTAIN that is intentionally noisy to mask the bangs and bumps of a scene change going on behind it.

carpet hoist *Stagecraft* 1. A special hoist used to lower very heavy DROPS, such as carpets, to the floor of the stage and to hold in that position in spite of the COUNTERWEIGHTS attached to the other end of the RIGGING LINES while the carpet is detached and put in place on the floor. 2. A strong rigging line, placed so that it can be attached quickly to the rigging, holding heavy counterweights to prevent them from moving while a heavy drop is being removed and put in place on the stage.

carpet pin *Stagecraft* A nail driven partway into the stage floor, leaving enough head above the floor to accept one of the grommets used to hold a carpet in position during a scene.

carriage and frame system *See* CHARIOT AND POLE SYSTEM.

carry *Acting* To reach the ear and/or eye of the audience and be understood.

carry a scene *Acting* To maintain the pace and effectiveness of a scene and hold the audience's attention so that it gets across to the audience with all its meaning.

carry it off *Acting* To succeed in reaching the hearts and minds of the audience.

cart *Broadcasting* Short for CARTRIDGE.

Stagecraft *See* DOLLY, WAGON.

cartridge *Audio* A protective container and mounting for a STYLUS in the TONE ARM of a PHONOGRAPH. The cartridge contains a crystal, or sometimes an inductive coil, that converts the motions of the stylus into electrical impulses. These impulses then travel through wires to the electronic circuitry of the machine that converts them into sound.

Broadcasting A plastic-cased audio tape, usually containing a short prerecorded message such as a commercial or a public-service announcement, set up so that it can play that message on the air precisely on cue. *Compare* CASSETTE.

cartwheel *Circus* An acrobatic feat in which the performer throws himself or herself sideways into a handstand and continues to rotate without break to an upright standing position.

cassation *Music* A piece of instrumental music composed for outdoor performance, similar to a DIVERTIMENTO or an orchestral suite. Popular in the time of Haydn and Mozart.

cassette *Video/Audio recording* A plastic case containing a video or an audio tape permanently mounted on internal reels, ready for recording or playback in a machine designed to handle it. *Compare* CARTRIDGE.

cast *Acting* 1. The group of actors who will play the roles in a play, opera, ballet or film. 2. To select actors for individual roles in a play or a motion picture.

castanets [Spanish] *Music* Literally, little walnuts. A pair of wooden shells, attached to the thumb and a finger of each hand, that produce a loud, hollow clicking sound when tapped by the fingers. FLAMENCO dancers commonly provide their own percussive acccompaniment with the sound of their heels on the floor and two pairs of castanets, one in each hand.

caster piece *Stagecraft* Any unit of equipment or scenery mounted on casters.

caster plank *Stagecraft* A single board mounted on casters to form a very low conveyance on stage, used for moving units of the set on or off stage during scene shifts. If there is more than one board, the caster piece becomes a WAGON. If it is large enough to support an actor or two and some elements of scenery and is used on stage during a scene, it becomes a BOAT TRUCK.

caster stand *Audio, Lighting* Any stand for lights, microphones or speakers mounted on casters.

casting *Theater* The process of selecting actors and/or assigning roles in a production.

casting agent *Theater* A person who represents the production company and performs the first round of CASTING for a production.

casting call *Theater* A public notice to actors to audition for roles in a production. *See also* CATTLE CALL.

casting couch *Theater* A couch said to exist in a casting director's office as a convenience for interviewing an INGÉNUE.

casting director *Theater* A member of the production team responsible for casting a show.

casting office *Theater* An office set up for the process of casting productions, most frequently occupied by a CASTING AGENT rather than a CASTING DIRECTOR.

Castle walk *Dance* A slow, graceful ballroom dance originated and made popular by the exhibition ballroom dancers Vernon and Irene Castle before World War I.

cast list *Theater* The official list of actors who have been selected and the roles to which they have been assigned in a production.

cast of characters *Theater* A list showing the names of the characters in a particular play, sometimes accompanied by a word or two describing their relationship. In a playbill this list includes the names of the actors assigned to each role. *Compare* COMPANY LIST.

castrato (*kah-STRAH-toh*) [Italian] *Music* A male singer whose high singing voice during early youth has been artificially preserved by surgical emasculation before puberty. Such singers were celebrities in the 18th and early 19th centuries. The last known famous castrato died in the early 1900s.

cast to type *Acting* Selected for a role because of appropriate physical or behavioral characteristics, *e.g.,* choosing a large, bearded man with a gruff voice to play a mountaineer. *See also* TYPECAST.

cat *Jazz* Originally, a jazz musician or member of a dance band. Louis Armstrong is said to have brought the term into jazz slang in the early 1920s. In more modern usage, "cat" can apply to a jazz fan or to any person, particularly one who "swings" musically.

catastasis (*kah-TAH-stah-sis*) [Greek] *Theater* Literally, a standing fast. *See* CONFRONTATION OF FATE, ELEMENTS.

catastrophe [from Greek] *Theater* Literally, downturning. The collapse of dramatic tension occurring after the CLIMAX of a tragedy (or, in Aristotle's terms, just after the CATASTASIS), when the PROTAGONIST has confronted fate and either conquered or been overwhelmed by it. *See* ELEMENTS.

catch *Music* A short ROUND for two or three EQUAL VOICES with apparently innocent words which, when sung, occur in a new order with a sometimes satirical and/or scandalous meaning. Popular from the time of Shakespeare. *See also* CACCIA.

catch flies *Acting* To perform any action on stage, *e.g.,* gazing at the audience with one's mouth agape, that intentionally or not distracts the attention of the audience from the primary FOCUS.

catharsis *Theater* Literally, a cleansing. The emotional release that comes with the resolution of dramatic tensions at the end of a drama, one of Aristotle's seven necessary components of TRAGEDY. Aristotle describes it as purgation, purification and clarification, the processes that resolve PITY AND FEAR, which he calls the fundamental emotions of tragedy.

cattle call *Motion pictures, Television* A casting call for extras, with few specific requirements.

catwalk *Stagecraft* A bridge high above the stage that permits technicians to reach LIGHTING FIXTURES, BATTENS and PIPES in the FLIES.

cavalcade *Circus* A parade of horses. By extension, any festive procession, as a "cavalcade of stars."

cavatina (*kah-vah-TEE-nah*) [Italian] *Music* Literally, a little thing drawn out. A short song, properly composed on a single sentence sung without repeats. A pretty little song in an opera of the 18th or 19th century. *See also* ARIETTA, CANZONETTA.

c-clamp *Stagecraft* A strong, adjustable steel clamp shaped like the letter C. It is used by electricians to attach cables or small light fixtures to BATTENS. *Compare* G-CLAMP.

c clef *Music* A clef that centers on the line representing MIDDLE C. Its shape derives from an ornate version of the gothic letter C which has a central decoration that serves as a pointer. When the pointer defines middle C as the middle line in a five-line staff, it is called the viola clef. When it defines

C-CLEF
(MIDDLE C)

the fourth line, it becomes the tenor clef, though that function is frequently fulfilled in modern publications by a treble clef with a subscript 8.

CD *Recording* Short for COMPACT DISC.

CD player *Audio* A machine that plays recordings made on COMPACT (optical) DISCS.

Cecchetti Method (*cheh-KEH-tee*) [Italian] *Ballet* A method of teaching classical ballet technique devised by the Italian ballet master Enrico Cecchetti, one of the greatest teachers in ballet history. It includes practice of the five basic POSITIONS OF THE FEET and arms, THE POSITIONS OF THE BODY, etc., and a strict routine of exercises set for each day of the week.

ceiling *Stagecraft* A flat, or a series of flats, constructed, painted and hung horizontally to look like a ceiling in a BOX SET. *See also* BOOK CEILING, ROLL CEILING, BOOK FLAT, LOUVRED CEILING.

ceiling beam *Lighting* A beam light mounted in a SLOT in the ceiling of the auditorium, where it can be focused on the stage from a distance. Similar to BALCONY BEAM.

ceiling border *Lighting* A BORDER LIGHT installed on the balcony where it can illuminate the stage and/or the closed curtain from the front.

ceiling lights *Lighting* Light fixtures mounted in the ceiling of the auditorium, frequently in a slot that conceals them from the view of the audience but allows them to be aimed at the stage.

ceiling piece *Stagecraft* Any drop or other piece of scenery designed to be a ceiling in a scene. *See* BOOK CEILING, ROLL CEILING.

ceiling slot *See* SLOT.

cel, *also* **cell** *Animation* A transparent plastic sheet, often imprinted with the outlines of a motion picture (or television) screen and with alignment holes punched along one edge, upon which an animation artist paints an image showing the position of a character (or of any shape) at a single instant during a moving sequence. Not the same as GEL. *See also* ANIMATION, IN-BETWEENS.

Celastic *Makeup, Stagecraft* Trade name for a plastic-impregnated fabric that can be cut and shaped in any form and applied to the face or used to make three-dimensional PROPS. In modern use as makeup, it has been supplanted by LATEX.

celesta (*cheh-LES-tah*) [Italian] *Music* A keyboard instrument whose delicate, bell-like sound is produced by an array of tuned metal bars struck by hammers, much like the action of a piano. It is the direct descendant of the orchestral GLOCKENSPIEL. A famous example of its use occurs in the *Dance of the Sugarplum Fairy* in Tchaikovski's *Nutcracker Suite. See also* DULCITONE.

cellist *Music* One who plays the VIOLONCELLO.

cello *Music* Short for VIOLONCELLO.

cembalo (*CHEM-bah-loh*) [Italian] *Music* A keyboard instrument whose sound is produced by plucked strings, an ancestor of the 18th-century HARPSICHORD. In modern orchestral performances of old music, a harpsichordist plays the cembalo part.

cement mixer *Vaudeville* (derogatory) An unskilled dancer, particularly inept at performing with GRINDS.

cent *Music* One 100th part of a standard (*i.e.,* tempered) SEMITONE. A piano tuner's unit of measurement. *See* EQUAL TEMPERAMENT.

center *Acting* Center stage. *See* STAGE AREAS.

center door *Theater* A door at the center of the back of the set.

center entrance *Acting* Any entrance in the center of the back of the set.

centering *Acting, Dance* Localizing within one's body the seeming source of one's energy as an actor or dancer.

center line *Acting, Stagecraft* 1. An imaginary line from the center of the BACKDROP to the center of the FOOTLIGHTS, defining the center of the stage. 2. An imaginary line defining the center of a beam of projected light.

center of interest *Television* The point on the screen where a viewer is expected to focus his attention at any given moment during a scene.

Theater *See* FOCUS.

center opening *Stagecraft* Describing curtains or sliding flats designed to open at a central point and move simultaneously to each side.

center overlap *Stagecraft* 1. The closure of stage curtains drawn together so that they overlap, leaving no accidental opening. 2. By extension, the arrangement of traveling supports that carry one edge of the curtain beyond the other so that they overlap when closed.

center practice *Dance* Used as a verb: to practice BARRE exercises in the center of the practice room, away from the barre, the movements that require concentration on balance, turns, jumps, etc.

center stage *Acting* 1. Any position along the center line. 2. Symbolically, the most important position during any scene. *Compare* UPSTAGE (*Acting*).

central stage *Theater* A stage surrounded by its audience. *See* ARENA STAGE.

cesura (*cheh-ZOO-ra*) [Italian] *See* CAESURA.

cha-cha *Dance* A popular Cuban dance, a descendant of the MAMBO, consisting of two slow and three quick steps performed to a strong Latin American beat. It was created in the mid-1950s.

chaconne (*shah-KON*) [French] *Dance* A slow, dignified French dance in triple time, with slow gliding steps and crossing of the feet. It was performed at the court of Louis XIV.

 Music A slow piece in triple time built as a series of variations upon a continuously repeating theme. Despite many scholarly attempts to distinguish the chaconne from the PASSACAGLIA, with theories that one usually repeats its theme as a melody in the bass while the other develops it as a sequence of harmonies within the body of the piece, the fact is that composers have used the terms interchangeably. Also called a *ciaccona*.

chain *Television* *See* CAMERA CHAIN.

chain anchor *Stagecraft* A bar, usually made from a wooden two-by-four, placed across a gap in the GRIDIRON, and with a hole in its center. A chain passes upward through the hole, and is held there with a heavy nail through one of its links while a light fixture or a piece of scenery is hung below.

chaîné (*sheh-NAY*)[French] *Dance* Literally, chained. A series of short rapid turns performed in a straight line or a circle, on POINTS or on DEMI-POINTES.

chain hanger *Stagecraft* Any adjustable chain attached to a horizontal LIGHT PIPE for the purpose of hanging lighting fixtures at various heights above the stage.

chain pocket *Stagecraft* A depression in the stage floor concealing an eyebolt to which a chain may be firmly attached.

chalumeau (*SHAH-lü-moh*) [French] *Music* 1. The French name of two ancient instruments: the shawm, an ancestor of the OBOE, and another woodwind instrument of the 17th and 18th centuries, an ancestor of the CLARINET. 2. The lowest range of the clarinet. The clarinet's tone in its chalumeau range is particularly smooth in soft passages.

chamber concert *Music* A concert of chamber music.

chamber music Music composed for a small ensemble of a very few solo instruments, once intended for private performance in the home, or in a space with more intimacy than the normal concert hall.

chamber opera *Music* An opera intended for performance in a small space, with a small cast, usually without chorus, and accompanied by a keyboard instrument or small ensemble.

chance music Music composed according to the rules of chance, where the first notes of a melody, for example, are chosen by throwing dice. The American composer John Cage composed several works according to the Chinese game of chance called *I Ching*. *See also* ALEATORY MUSIC.

change *Costume* Any change of costume during a show.

 Stagecraft Any change of scene.

changement, changement de pieds (*shanh-zheu-MANH deu pee-AY*) [French] *Ballet* Literally, change of feet. A jump in which the feet change position. Starting in FIFTH

POSITION, right foot forward, the dancer springs into the air (off both feet) and lands in the fifth position with the left foot forward.

changement battu (*shanh-zheu-MANH bah-TÜ*) [French] *Ballet* A CHANGEMENT in which the legs are beaten lightly together in the air before the change of position takes place.

change ringing *Music* A style of bell ringing that developed in English churches where bells had to be sounded by pulling their individual ropes to swing them back and forth. Since church bells are made of heavy cast bronze, it takes some strength and agility to ring them. Because they swing back and forth in their own time, like pendulums, the bell ringer must synchronize his leap to pull the next rope at just the time that its attached bell is starting its return swing. A complete series of swings is a PEAL. To ring changes, a performer pulls the ropes in numerical succession over and over again, advances by one position with each cycle (*i.e.,* with each peal), creating a joyous chaos of bells.

changing strings *Music* Moving the BOW from one string to another without sounding unwanted tones between them. Since the strings of a violin, viola, violoncello or double bass are held up by an arched bridge, the bow normally contacts only one at a time. To move from one string to its neighbor involves nothing more than a change of angle of the bow. But to move from one string past its neighbor to a third requires lifting the bow so that it does not touch the intervening string, which is somewhat more difficult. Changing strings without a perceptible break in musical sound is, therefore, a technique the violin student practices with diligence.

changing tone *Music* A tone that is not part of the harmony of either a preceding chord or the next, but serves as a bridge between them. *See also* APPOGGIATURA.

channel *Audio* 1. Any single audio circuit and its controls. 2. Any single magnetic track on a strand of tape. STEREOPHONIC recordings are made in channels, distinguished as right or left. SURROUND SOUND has two or more pairs of right and left channels. Most musical recordings are made originally on as many channels as there are types of instruments and/or voices; a 24-channel recording, with all the channels on a single strand of tape, is fairly common. Some of these channels may carry the sound of individual drums in a set of TRAPS, others may carry the sound picked up by contact microphones on guitars, or the direct-wired output of electronic synthesizers. All of these eventually go into a MIX to be sorted out, balanced and rerecorded onto the two or more channels that can be played as stereophonic or surround-sound tracks.

Broadcasting, Television The portion of the airwave (electromagnetic) spectrum assigned by the government to a specific broadcasting station.

Lighting Any single circuit that is independently controlled, including its DIMMER, its CABLE and its LIGHTING FIXTURE.

channel iron *Stagecraft* A steel strip with a U-shaped cross section, of such size that it can be attached with screws under the bottom RAIL of a FLAT to provide a stiff, strong base so that the flat may be skidded across the stage (*See* SKATE A FLAT) without risk of its breaking at the bottom. *Compare* SILL IRON.

chanson (*shahn-SONH*) [French] *Music* Literally, song. A type of early MADRIGAL or simple song with repeating verses, often composed for several voices or for solo voice with accompaniment. Chansons developed in France and Italy around the 14th century. *See also* CANZONA.

chant *Music* 1. A liturgical song, or monodic (*i.e.*, one part predominating) intonation of a prose text. In church services, the Psalms and CANTICLES are generally treated as chants, though they may be spoken as CHORAL SPEECH rather than actually sung. 2. The style of liturgical intonation of prose texts without a musical rhythmic structure other than that of spoken words. 3. To sing in a chanting manner, *i.e.*, syllable by syllable, without a rhythmic scheme except the PROSODY of the words themselves.

chanter *Music* The little pipe that plays the melody of a BAGPIPE. The chanter has a double reed like an OBOE and finger holes like a RECORDER. Its sound is produced by a steady flow of air from the bagpipe's windbag. *See also* MUSETTE.

chantey [from French, *chanter*, "to sing"] *Music* A sailor's chantlike tune with short stanzas and vigorous rhythms, used as a means of synchronizing heavy hauling, *e.g.*, weighing anchor or raising a mainsail.

chapel organ *Music* 1. Any organ situated in a chapel. 2. A subordinate organ situated in one of the chapels of a large church. In modern times, such an organ is controlled by the main keyboard of the primary instrument, which permits the organist in some churches, where the chapel is not acoustically isolated from the main body of the church, to use the chapel organ for echo effects and the like during a service in the main church.

character *Acting* 1. The person being portrayed in an actor's role. 2. The sum of all the conscious and unconscious devices an actor uses to create the illusion of being that person.

Theater The second most essential ingredient of DRAMA, according to Aristotle, following PLOT.

character actor *Acting* An actor who specializes in roles of a particular type. Some actors may choose to concentrate on such roles because of challenges they frequently present. Others may be forced into the choice because of physical or other limitations, *e.g.*, an actor with a strong foreign accent must stick to roles where the accent would be appropriate. Some character actors have achieved stardom, as did Victor McLaglen, an Irishman with a heavy brogue, who starred in John Ford's 1935 film *The Informer*.

character comedy *Acting* Comedy in the form of plays or vaudeville skits that explores the possibilities of humor.

character dance Generally, the folk or popular dances of many nations. More specifically, a dance in a particular style and using a particular technique not associated with classical dance, such as the Hungarian CZARDAS.

character development *Acting* An actor's conscious application of styles of movement and speech together with mannerisms, facial expressions, body language, bits of BUSINESS and TIMING that construct in the mind of the audience a convincing portrait of the personality being represented in a role and of that personality's responses to the events of the plot.

character generator *Television* An electronic device that inserts lines of text, such as credits and subtitles, into a recorded picture. The operator types and formats the text on a computer keyboard. The electronic system codes the image of the text digitally and integrates it with the coding of the picture. *Compare* BURN IN.

characterization *Playwriting* A playwright's and/or director's realization of a character within the dialogue of a play, achieved by language and accent, the establishment of a point of view, the character's relationship with others and the way the character reacts to situations in the plot.

character lines, character makeup Makeup designed to emphasize the lines and shadows that indicate a particular type of personality and to simulate age, worry, anger or other states of being that the audience may interpret as hints about the personality being represented.

character part, character role *Theater* Any secondary role in which the personality type is more important than any individuality of character; the gravedigger in Shakespeare's *Hamlet*, for example, or any of the townspeople in Thornton Wilder's *Our Town*.

character play *Theater* A play based on the relationship between the different characters, rather than on their actions. *The Gaolgate* (1906) by Lady Gregory is an example.

character prop *Stagecraft* A prop carried by an actor or placed in the set to add background detail to a character being portrayed. In Samuel Becket's *Waiting for Godot* the rope around Pozzo's neck is an example. *Compare* PERSONAL PROP.

chariot and pole system *Stagecraft* In theaters of the 17th century, a simple system of low, wheeled platforms guided by slots across the stage floor and pulled by endless ropes, hidden in the slots, that coiled around long, wooden cylinders offstage. Each platform had two or more poles (sometimes ladders) mounted vertically, to which flat pieces of scenery could be attached. There were two such WAGONS to each set of ropes, arranged so that when one was in view, the other was out of sight in the wings. With a set of three or four such pairs, an entire stage setting could be changed in seconds merely by cranking the offstage cylinders to shift the chariots. If the scenery pieces are hung on framework instead of poles, it is called a carriage and frame system.

chariot stage *Stagecraft* In medieval times, a stage built on a wheeled platform. These were common in the processions of the guilds in England, in which each guild traditionally presented its MYSTERY PLAY about the life of Christ. *See* PAGEANT.

charisma *Acting* A performer's personal magnetism; the ability to project a sense of authority, or to inspire enthusiasm or devotion. *See also* STAR QUALITY.

charivari (*shah-ree-vah-REE*) [French] (In English, pronounced as *shiv-ah-REE*) *Dance* Literally, uproar. A large, noisy dancing party, particularly in Louisiana where French is still spoken.

Charleston *Dance* An energetic ballroom dance popular among flappers and their partners in the 1920s, performed with side-kicking steps on the beat against vigorously syncopated music in rapid 4/4 time. Said to have been created in South Carolina by the African American dock workers of Charleston.

Charleston cymbals, Charleston machine *Music* A matched pair of large cymbals, mounted horizontally on a stand with their concave sides facing each other and their edges touching. The sound is ideal as an off-the-beat accent in dance music. It first became popular in the 1920s when the CHARLESTON was all the rage. *See also* HI-HAT.

chart *Music* 1. The musical SCORE of an ARRANGEMENT of a popular song or jazz composition. 2. The weekly published list of best-selling recordings (usually plural). 3. To write an arrangement.

chase *Motion pictures* Any sequence in a motion picture that consists of pursuit. The excitement of the chase was discovered early in the history of motion pictures and became a staple of the first WESTERNS and gangster movies, with the hero risking life and limb to catch or to escape from the villain.

chase music *Motion pictures* Exciting music to accompany a CHASE scene. One of the most famous examples is Rossini's *Overture to William Tell*, used in many real and satirized chases.

chaser *Lighting* A small spotlight used as a FOLLOW-SPOT.

Vaudeville 1. The last act on the BILL. 2. The music played after the show, while the audience is leaving.

chaser lights *Lighting* Strips of little lights that flash on and off in a mechanically controlled sequence that produces an illusion of rapid movement of light and dark along the line. Often used for the borders of a MARQUEE.

chassé (*shah-SAY*) [French] *Ballet* Literally, chased. A sliding ballet step done in a series, in various poses, in which one foot "chases" the other out of position.

chaunt (*shawnt*) *Music* The Chaucerian English spelling of CHANT.

cheat *Acting* To move surreptitiously in order to correct one's position on stage or to prepare for an upcoming CUE.

Lighting 1. To adjust the setting of a DIMMER so slightly or so gradually that the audience will not be aware of the change. *See also* TAP CUE. 2. To weight the FALL of a light to one part of a scene, as in "Cheat that light a little to the left." 3. To bring up all the lights surreptitiously when the star of the show enters for the first time.

Television To place the camera in an unusual position to lend excitement to the shot.

check chain *Stagecraft* A short chain used to tie a BATTEN to a fixed anchor to limit its movement. A pair of check chains can be attached to a curtain batten to prevent any accidental lowering of the curtain beyond the point where its lower edge touches the floor.

cheesecake *Vaudeville* Any tableau, scene or publicity photo designed to show off a woman's pretty legs.

cherry picker *Motion pictures, Television* A large crane carrying a level platform for the camera, its operator and an assistant.

chest of viols *Music* In the 17th century, a partitioned chest containing a matched set of six VIOLS.

chest register *Music* The lowest register of the female voice. Singing teachers used to think the voice was "produced"—*i.e.,* resonated—in different parts of the upper body: head for high notes, throat for the middle and chest for low. Though they continue to use the terms to help their students control their vocal sounds, the idea itself has been generally discredited.

chest shot *Television* A shot showing the subject from the waist up. Also called a BUST SHOT.

chew the scenery *Acting* To overdo the expression of emotion by exaggerating vocal changes and gestures beyond credibility. *See* HAM.

Chicago blues *Music* A JAZZ style associated with the city of Chicago, characterized by the use of ROCK instruments such as the ELECTRIC GUITAR, etc., made famous by the blues singer and guitarist Muddy Waters.

Chicago style *Music* A style of JAZZ, loosely characterized by the prominence of the tenor saxophone in melody ensembles and by the marked personal styles of players who wished to improve on the New Orleans style popular in the 1920s.

chicken *Dance* A solo dance in vogue in the 1950s, a take-off on the LINDY HOP.

chief electrician *Stagecraft* The technician responsible for all electrical operations and in charge of all who work with electrical equipment. Not the same as LIGHTING DIRECTOR.

chimes *Music* Tuned metal tubes that ring with a bell-like sound. Orchestral chimes hang from a rack in the order of a chromatic scale of about two OCTAVES, from F to f^1 (See OCTAVE NAME SYSTEM). The player strikes at the top rim with a wooden hammer covered in leather.

chimney *Lighting* A vent built into the housing of a lighting fixture to permit air to circulate through it and prevent overheating.

china circuit *Theater* A tour among very small towns, especially Pottstown, Pottsville and Chambersburg, Pennsylvania, where the main industry was the manufacture of glazed tableware or other vitrified household necessities.

Chinese temple blocks *See* TEMPLE BLOCKS.

chin piece *Costume* Slang for a beard.

chin rest *Music* A smooth, carved piece of wood firmly clamped to a VIOLIN or VIOLA at its large end, shaped to provide a comfortable rest for the performer's chin yet leave the violin free to resonate.

chitarrone (*khee-tah-ROH-neh*) [Italian] *Music* An instrument of the Renaissance, the largest of the LUTE family, with a very long neck and 18 strings. Seven of these stretch the length of the neck and are tuned to resonate when the shorter strings are played (*See*

SYMPATHETIC VIBRATION). The 11 remaining strings of more convenient length are stretched over frets and can be fingered to play melodies and harmonies somewhat like the strings of a GUITAR. *See also* ARCHLUTE.

choir *Music* Any blended group of similar instruments (clarinet choir, brass choir) or voices (women's choir, men's choir, mixed choir). CHOIR implies a more tightly composed and blended group than CHORUS.

choirboy *Music* A boy who sings in a CHOIR and is distinguished from other males by the fact that, because of his youth, his voice has not yet dropped out of the SOPRANO or ALTO RANGE.

choirgirl *Music* A young woman who sings in the choir, distinguished from other female singers only by the youthful TIMBRE of her voice.

choirloft *Music* A space on a high level at the back or the front of a church or synagogue where the choir performs during the service. In the 16th-century Ducal church of San Marco in Venice there are four choir lofts, facing each other at the church's crossing and connected with narrow bridges.

choirmaster *Music* The leader of the choir.

choir organ *Music* 1. A relatively small organ situated in or near the choir loft and used as accompaniment for the choir. 2. One MANUAL of a large church organ, with its own set of stops consisting in general of those most suitable as accompaniment for the choir.

choker *Stagecraft* 1. A rope tied to a locking rail on the onstage side of a counterweight operating line to provide fine adjustment after a set piece has been lowered into place. 2. A block and tackle attached to a COUNTERWEIGHT ARBOR to provide fine adjustment after a set piece has been put in place onstage.

chops *Music* 1. A slang term for a brass player's lips, which can tire during prolonged or strenuous playing to the point that the EMBOUCHURE collapses, making it almost impossible to play properly. This collapse leads the hardworking brass player to complain about "busting my chops." The term has been extended to mean the technical ability of any player on any instrument. 2. In JAZZ and ROCK, the term has come to mean any musician's technical prowess, especially the ability to play fast.

choragus *See* CHOREGUS.

choral *Music* Pertaining to a CHORUS.

choral drama *See* CHORAL THEATER.

chorale *Music* 1. A relatively short, homophonic choral piece or hymn. 2. A somewhat formal name for a secular CHOIR.

chorale prelude *Music* A prelude, frequently for organ solo, composed upon the theme of a CHORALE.

choral ode *Theater* A formal scene performed by a singing and dancing chorus in a classical Greek tragedy. *See* ODE, STASIMON.

choral prelude *See* CHORALE PRELUDE.

choral reading *Theater* A reading by many voices in unison.

choral score *Music* A score showing the vocal lines for chorus (and soloists, if appropriate), usually with a keyboard accompaniment for rehearsal purposes. A VOCAL SCORE.

choral speaking *Theater* The act of speaking together as a chorus. In some revivals of the choral dramas of ancient Greece, the odes are rendered by choral speaking, in a cautious attempt to indicate, if not to reproduce, what may have been the effect of their singing in ancient times.

choral theater Musical theater in which a singing chorus plays the primary dramatic role, with individual roles played by single members of the chorus. Not the same as OPERA or MUSICAL COMEDY, in each of which the chorus serves chiefly as background for individual roles. Not to be confused with musical compositions in which a narrator tells a dramatic story with the accompaniment of a chorus. The great tragedies of classical Greece were choral dramas. A modern example is Benjamin Britten's *Saint Nicholas*.

chord *Music* A harmonious combination of several musical tones sounded together.

chordal *Music* Pertaining to chords, having the quality or producing the effect of chords.

chord chart *See* CHORD SHEET.

chord off, chord on *Vaudeville* To play a chord loudly as a performer leaves or enters the scene.

chord of the sixth *Music* A TRIAD in its FIRST INVERSION, *i.e.,* with its THIRD as its lowest tone, its FIFTH next, and its ROOT on top, a SIXTH above the bass—hence the name. A chord of the sixth with C as its root consists of E - G - C.

chord of the third *Music* Another name for CHORD OF THE SIXTH, based on the fact that the THIRD of the TRIAD is its lowest note.

chordophone *Music* A scholarly term for any instrument whose sound is produced by plucking, striking or scraping taut strings.

chord organ *Music* An electronic organ with preset chords built into its system, to make it easier for nonmusicians to play simple melodies with limited chordal accompaniments.

chord sheet *Music* A small sheet of paper with CHORD SYMBOLS, used by a SIDEMAN as the basis of an improvised accompaniment to a particular tune. Also called a chord chart. Having such a basic structure, the player may improvise passing chords or substitute chords around and between those specified in the sheet, to give the accompaniment a richer,

more personal flavor (*See* CHORD SUBSTITUTION). For the dominant chord G^7, in the key of C, for example, the player may substitute a D^{b7}, (D-flat-F-A-flat-B) as a variation.

chord substitution *Music* A jazz technique dating from the BEBOP era, still practiced today, in which improvising players replace one chord with another that is harmonically related.

chord symbol *Music* Any combination of letters and numbers that provides a quick reminder of the construction of a chord in a CHORD SHEET, *e.g.*, C^7 to indicate a major-minor seventh on C (C-E-G-B-flat), or Ddim to indicate D-diminished (D-F-A-flat-B-flat).

choregus (*kor-REH-gus*) [from Greek, transliterated into Latin] *Music* The person responsible for organizing and financing, but not training or leading, the chorus for the annual festival of drama in classical Greece. A choregus was appointed by the government each year, an honor for which the appointee had to be rich and competent. *Compare* CORYPHAEUS.

choreograph *Dance* To compose a dance, particularly a theatrical dance such as a BALLET.

choreographer *Dance* One who choreographs.

choreographer-in-residence *See* ARTIST-IN-RESIDENCE.

choreographic *Dance* Pertaining to dance.

choreography *Dance* The process of composing a dance, particularly a theatrical dance or a BALLET. Until the development of photography and then LABANOTATION it was difficult, if not impossible, to make a record of choreography.

choreology *Dance* *See* BENESH DANCE NOTATION SYSTEM.

choreutics *Dance* An analysis of form in movement, a complex system based on the laws of harmony in space and the laws of motion as they apply to all types of dance. Developed by Rudolf von Laban. *See also* LABANOTATION, EUKINETICS.

choric *Music* Having to do with or written for CHORUS.

chorine *Vaudeville* A CHORUS GIRL.

chorister *Music* A musician who sings choral music. The technique of a chorister is somewhat different from that of a solo singer, hence the use of the specialized term in professional circles.

choroscript *Dance* A generic term for dance notation. *See* BENESH NOTATION SYSTEM, LABANOTATION.

chorus *Music* 1. A performing group of singers with more than one singer to each part. 2. The REFRAIN of an American popular song.

chorus boy *Vaudeville* A male dancer in the CHORUS LINE.

chorus girl *Vaudeville* A female dancer in the CHORUS LINE.

chorus line *Vaudeville* The chorus of dancers/singers in a vaudeville show, typically appearing in a line across the width of the stage, often with arms interlocked, performing high-kicking dance steps.

chorus shirt *Musical Comedy, Vaudeville* A T-shirt or a light pullover worn for warmth during chorus stage rehearsals instead of the costume that will be worn in the performance. *See also* BALLET SHIRT.

chroma *Lighting* The specific color intensity of a particular light.

chroma key *Motion pictures, Television* A color-separation process to enable a subject to be placed within a separately shot background. In a simple example, the subject is shot against a monochromatic color background (usually blue), then placed within the other shot while suppressing the background color with a filter.

chromatic scale *Music* A SCALE made up entirely of SEMITONES.

chromatic sign *Music* Any of the signs for semitonal adjustment of a note. An ACCIDENTAL.

chronicle play *Theater* A play based on history, particularly a specific era or a monarch's reign. There are several by Shakespeare including *The Life and Death of King John*, and the first and second plays about *Henry I*. Both August Strindberg and Maxwell Anderson have written modern chronicle plays.

church bells *See* CARILLON, ORCHESTRAL BELLS.

church mode *Music* Any of the MODES used in church music, particularly in Ambrosian and Gregorian chant and in polyphonic works up to the 15th century. They are commonly given Greek names and the system is sometimes called Greek Modes, although the modes actually used in Greek music are quite different. To understand their differences in modern terms, each mode can be represented by playing a SCALE of one octave on the white keys of the piano starting and ending on different notes. Thus, from D to D represents the Dorian mode, E to E the Phrygian, F to F the Lydian, G to G Mixolydian, A to A Aeolian, and C to C Ionian. For musicians it is important to keep in mind that a scale is only a collection in convenient sequential form of the tones that make up a mode. It is the mode that gives music its harmonic structure. Also called ecclesiastical mode.

ciaccona (*chah-KOH-nah*) [Italian] *See* CHACONNE.

cimbalom, cymbalom *Music* A large DULCIMER used in Hungarian dance bands and by gypsies, and featured in the *Hary Janos Suite* by Zoltán Kodály. It is played with wooden hammers.

Cinemascope *Motion pictures* Trade name for a system of shooting and presenting movies on a WIDE SCREEN with an aspect ratio (proportions) of 2.35 to 1. The proportions can be achieved without changing the standard 35mm width of motion picture film or the standard position of the sound track by using an ANAMORPHIC LENS that compresses the wide image for both shooting and projection.

cinema, the *Motion pictures* 1. The art and business of motion pictures. 2. A local motion picture theater. *See also* MOVIES, THE.

cinema verité (*SEE-nay-mah veh-ree-TAY*) [French] *Motion pictures* A style of moviemaking that emphasizes spontaneity and creates the appearance of real situations, whether or not they are in fact real. In some cases there are no precise rehearsals of scenes. It is distinguished from DOCUMENTARY in that it remains a medium of fiction. What happens before the camera may be based on reality, improvised in some part, and may be shot in nonstudio situations using AMBIENT LIGHT (and with ambient noise, etc.), but it is still a story, a work of creative art. Some of its techniques, such as the HANDHELD camera, have been adopted in more formal moviemaking.

Cinerama *Motion pictures* Trade name for a system of presenting extremely wide-screen movies that had a brief success just after World War II. It was developed first as a method of teaching army officers the battle tactics of artillery. Three cameras were bolted together so that each covered one third of the total viewing area, 140° wide (the average view of a normal human being). When projected by a gang of three projectors set up in the same relationship in the center of a training facility, the total view amounted to all an artillery officer could possibly see without turning his head. The image seemed, therefore, to be overwhelmingly real. The first movies made with this system exploited its possibilities in breathtaking airviews of the Alps, heart-stopping rides on rollercoasters, and the like. Unfortunately such realism in a series of views is not the same as the inner emotional reality of a meaningful movie, and the Cinerama process became a footnote in movie history.

circa (*SEER-kah*) [Latin] *Music* Literally, around, approximately. In tempo markings as a prefix to the number of beats per minute, *circa* indicates that adjustment is acceptable.

circle *Acting* In the STANISLAVSKI METHOD, an imaginary circle conceived by an actor as a shield against any distraction that might intrude on his/her concentration.

 Theater The mezzanine or any balcony designated as more expensive seating, as the DRESS CIRCLE.

circle of fifths *See* CYCLE OF FIFTHS.

circle of fourths *See* CYCLE OF FOURTHS.

circuit *Theater* A standard route for traveling shows. *See also* BORSCHT BELT, CHINA CIRCUIT.

circular breathing *Music* A technique of inhaling through the nostrils while the mouth, temporarily isolated from the lungs, is still exhaling an excess of air previously supplied to it. Much prized by virtuoso FLAUTISTS and trumpeters when they must play very long phrases without a break, or hold a single note over an extended period. Both the flautist James Galway and the jazz trumpeter Dizzy Gillespie are famous for their circular breathing abilities.

circus A spectacular variety show featuring animal acts, acrobatics, aerialists and clowns who perform in one or more rings, frequently in an arena or an enormous tent. Even older than the theater, the circus has existed in some form for nearly 5,000 years. One

of the best known of all ancient circus acts was bull-leaping, practiced 4,500 years ago and memorialized in designs on pottery from that period. The circus in modern times is usually a traveling show that plays for a few days and nights in each town or city it visits. The largest of them moves by railroad in its own train, carrying everything with it. When the company arrives, ROUSTABOUTS set up the tent. Then the animals, the band, and all the acts march through the town in a great, gaudy parade. Elephants go first, wearing headpieces and blankets festooned with bright metal and glass decorations. The band rides in its BANDWAGON, playing show tunes and marches. The clowns follow, each IN CHARACTER, stumbling along the street. When such a large company performs, it fills two or three rings instead of one, with something exciting going on in each ring all the time. Probably the most famous circus promoter was P. T. Barnum, whose circus flourished in the United States during the late 1800s and expanded to become Barnum and Bailey's. Touted as the Greatest Show on Earth, this circus still plays nearly a century later. Among the most famous acts in Barnum's circus were Jumbo, the largest elephant ever seen; Tom Thumb, one of the smallest people; and Jenny Lind, one of the greatest sopranos of all time. Smaller one-ring circuses sometimes achieve great fame because of their specialties and exotic SIDESHOWS. Not every circus has animals. Among the most successful in the 1990s: *Le Cirque du Soleil*, an elegant show that features clowning, pantomime and acrobatics based on classical European traditions.

ciseaux (*see-ZOH*) [French] *Ballet* Literally, scissors. A jump in which the legs open to a wide SECOND POSITION in the air, like the movement of scissor blades.

cithara (*si-TAH-ra*) [From the Greek, Kithara] *Music* See KITHARA.

citronella circuit *Theater* The summer theater touring circuit, where insect repellants such as citronella are necessary.

cittern *Music* An ancient stringed instrument somewhat like a LUTE, similar to a small GUITAR with seven strings and a flat back.

City Dionysia *Theater* The great festivals of drama in Athens from the 6th to the 4th centuries B.C. See DIONYSIA.

civic theater A theater operated or partly supported by a municipality. It houses touring shows, concerts and the like and provides a showcase for local companies, musical organizations and civic affairs.

clamp *Lighting, Motion pictures* Any device with a light-fixture mounting-stud attached to enable the placement of lights in places where a stand or a LIGHT-PIPE cannot be located, either for lack of room or because the stand would show in the shot.

clapper *Motion pictures* An occasional name for the CLAPSTICK mounted on a SLATE, or for the assistant who wields it before the camera when a scene is about to be shot.

Music A metal tongue, hanging loosely inside a bell, that strikes the side of the bell and makes it ring when the bell is swung back and forth.

Theater See CLAQUEUR.

clapstick *Circus* *See* SLAPSTICK.

Motion pictures A brightly painted little stick, hinged along the top edge of a SLATE, that can be lifted at one end and then smartly smacked against the slate to produce both the loud sound and the visual image that an EDITOR will use later to SYNCHRONIZE the separately recorded SOUND TRACK to the visual film. In modern practice, the clapstick has been replaced by an electronic signal. *See also* DOUBLE SYSTEM, START MARK, SYNCHRONIZATION.

claptrap *Stagecraft* A TRAP in the stage floor, specially designed with springs and levers for very rapid opening and closing, to permit an actor to appear or disappear with dramatic suddenness.

claque *Theater* A group of people in the audience who are there for the specific purpose of applauding a particular actor who is either their friend or their employer. *See* CLAQUEUR.

claqueur (*klah-KEUR*) [French] *Theater* A member of a CLAQUE.

clarin *Music* A small brass trumpetlike instrument sometimes used in Mexican MARIACHI bands. One of the descendants of the 16th- and 17th-century CLARINO.

clarinet *Music* Any of several wind instruments consisting of a straight tube (not having a conical bore) with a mouthpiece containing a single reed. Clarinets are related to SAXOPHONES (that have conical tubes), and all the DOUBLE-REED instruments such as the OBOE and BASSOON. Because of its straight bore, the clarinet produces a distinctive tone in which odd-numbered PARTIALS are prominent. Its lowest register, the CHALUMEAU, played softly, is smooth and warm like that of no other instrument. Clarinets came into frequent use with Mozart who composed brilliant works for the instrument. The modern orchestra includes a choir of clarinets and bass clarinets; JAZZ and DANCE BANDS feature them as solo instruments. Although clarinets, especially for school or marching band use, may be made of metal, most orchestral clarinets are made of grenadilla wood or the plastic ebonite.

clarinetist *Music* One who plays the CLARINET.

clarino *Music* 1. An ancient instrument, forerunner of the BUGLE, CORNET and TRUMPET, in orchestras of the times of Monteverdi and Bach (17th and 18th centuries). Like a bugle it had no valves with which to play different notes, but when played in its highest register (where its natural harmonics provided many tones per octave) a virtuoso could perform florid music. It was this capability of the clarino that allowed Bach and others to compose solos in very high registers that challenge the very best trumpeters even today. *Compare* BACH TRUMPET. 2. The highest register of the CLARINET.

clarion *Music* A keyless TRUMPET (or BUGLE) with a curved or round tube, popular in England during ancient times.

clash *Music* The sound of a CLUSTER on the piano.

classic *Dance, Music, Theater* Any work of such excellence and enduring quality that it stands as an example of workmanship and beauty to all who aspire to similar greatness.

classical ballet, classic ballet With reference to ballet, the word *classical* or *classic* is somewhat arbitrary, indicating style, structure and technique rather than a particular cultural period. Classic ballet conforms to a specific framework originating in the 19th century and includes, for example, the formal PAS DE DEUX. It is not necessarily seen as the opposite of romantic ballet, where the defining elements are content and period rather than structure and style.

classical drama *Theater* In its strictest sense, Greek drama of the period between 534 and 336 B.C. and including the works of Aeschylus, Sophocles, Euripides and Aristophanes and, less strictly, extended to Roman drama of the next few centuries, including Terence and Seneca. French scholars give the works of Corneille and Racine this distinction. In England other terms are more favored, such as ELIZABETHAN for the works of Marlowe, Shakespeare and others, and RESTORATION for the high style of Congreve, Dryden, Sheridan and their contemporaries.

classical music A term loosely indicating music of any era that is thoroughly composed for concert or opera performance, as distinguished from the many popular forms such as FOLK MUSIC, JAZZ, ROCK AND ROLL, etc.

classicism *Dance* The aggregation of gestures, expressions and steps based on the five absolute positions of the DANSE D'ÉCOLE, performed in a style of unmannered nobility and purity.

Music From the point of view of scholars of music history, a term of convenience categorizing the style of music by composers who flourished before the age of romanticism, *i.e.*, the music of such composers as Bach, Handel and Haydn, before the work of Mozart and Beethoven became so different that it could no longer be contained in the term.

Theater The styles of classical dramatists such as Corneille, Racine, Dryden and others who worked in strictly defined verse forms, as compared with Molière, Sheridan and their contemporaries, who subordinated form to emotion and story.

classicist One who studies or creates works of art in imitation of classical styles.

clave beat *Music* In popular music, a regular rhythmic figure played by the claves and consisting of two measures constantly repeated. There are several patterns based on a simple pair of measures.

CLAVE BEAT (TYPICAL)

claves (*KLAH-vehs*) [Spanish] *Music* Literally, keys. A pair of hardwood sticks, approximately seven inches long and ¾ inch in diameter, played by striking them together to produce a piercing, dry clack of very high, indeterminate pitch. Used in many Latin American dance bands to emphasize every beat. The player frequently uses these short, fat sticks to strike other percussion instruments as well.

clavicembalo (*klah-vee-CHEM-bah-loh*) [Italian] *Music* Literally, a keyed CEMBALO. The older word for HARPSICHORD.

clavichord *Music* A small KEYBOARD instrument with strings like the (larger) HARPSICHORD, that produces its sound by striking and pressing against the strings with a small, chisel-shaped pin (called the TANGENT) actuated by, and fastened to, each key. A good clavichord is contained in a finely wrought rectangular wooden box that can be laid on any convenient table. The player opens the box at one side, exposing a short keyboard of four to four and a half octaves. The strings (usually made of wire) are stretched from left to right, at right angles to the line of each key and damped at the right end. The only part of the string that sounds is the segment between the tangent and the other end, which is not damped. Pitch is determined only approximately by the actual length of the string. It is the place where the tangent strikes and presses against the string that accomplishes the fine tuning. Since the pressure of the tangent also raises the string, slightly increasing its pitch, an experienced player can create subtle dynamic and harmonic effects that are impossible on a harpsichord or piano. Indeed, it is possible to play music of the 17th and 18th centuries with artificially raised or lowered intervals, creating a suggestion of untempered tuning. (*See* TEMPERAMENT.) The clavichord's sound is so soft and ethereal that the instrument cannot be heard by an ordinary concert audience unless it is amplified, which most discriminating listeners find undesirable. For this reason, and because many people cannot hear the niceties of modified intonation, clavichord recitals are quite intimate affairs.

clavicylinder *Music* A keyboard instrument of the late 1700s whose sound was produced by suspended wood, metal or glass rods rubbed by a glass cylinder when moved by the keys.

clavicytherium *Music* A HARPSICHORD or SPINET with its strings stretched upward in a vertical box behind the keyboard. It was popular in Europe during the 17th and 18th centuries, and required a space with a high ceiling. *Compare* GIRAFFE.

clavier (*klah-vee -AY*) [French], (*klah-FEER*) [German] *Music* Literally, an array of keys. A keyboard, hence a keyboard instrument. During the 18th century, the term was used loosely to designate a CLAVICHORD. In its German spelling (*klavier*) in the 19th century, it was similarly used for the PIANO.

clear *Acting* To get off the stage before the curtain or lights go up for the next scene.

 Lighting 1. A GEL having no color. 2. To move all the lighting controls to the "off" position.

 Stagecraft 1. To remove everything (or everybody) from the stage. 2. To disentangle rigging.

clearance *Motion pictures, Television* Written permission to use a trade-named product, copyrighted material or a private person's picture in a motion picture or television broadcast. Also called a RELEASE.

clearer *Stagecraft* A stagehand who clears the stage after the show to prepare it for the next event.

clearing pole *Stagecraft* A long wooden pole, sometimes fitted with a short crosspiece at the end, with which a stagehand can clear a line of rigging that has become entangled with another.

clear leader *Motion pictures* A transparent strand of film. *See* LEADER (*Motion pictures*).

clear the frame *Motion pictures, Television* A director's order to clear everybody and every object that does not belong in a shot from the area the camera will see.

cleat *Stagecraft* An iron plate fastened to the frame of a flat so that it protrudes an inch or two beyond the wood of the framing to provide a tying point or a firm anchor for a LASH LINE or a point of attachment for a STAGE BRACE. *See* BRACE CLEAT, FLAT CLEAT, LASH CLEAT, STOP CLEAT.

cleat bar *Stagecraft* A strong wooden piece across the back of a FLAT to which a cleat may be attached.

cleat line *Stagecraft* A piece of rigging tied to or wound around a CLEAT.

clef [from French] *Music notation* Literally, key. The symbol placed at the beginning of a STAFF that defines the musical tones that are related to that staff. Each of the clefs in general use was derived from a letter of the alphabet, and each is placed to indicate a particular line of the staff as the line named with that letter. Thus the TREBLE CLEF evolved from the letter *G*, and points out the line G above MIDDLE C with a little spiral in its center. The BASS CLEF, formerly the letter *F*, points out F below MIDDLE C with the two little dots, which are all that remains of the original letter's horizontal bars. The C CLEF was originally a simple letter *C*, but after generations of decorative evolution it has turned almost completely inside out. It points out MIDDLE C with its central angle.

clew *Stagecraft* 1. A metal plate, to one part of which several rigging lines are attached so that they can all be raised or lowered at one time by a single line attached to the opposite part. A clew, for example, permits a CEILING FLAT to be raised or lowered with a single action. 2. A reinforcement sewn into the bottom edge or a corner of a curtain or a drop to permit the attachment of a rigging line. 3. To pull up the bottom edge of a curtain or a drop and lift it out of sight without having to raise the BATTEN from which it hangs.

cliché (*klee-SHAY*) [French] *Acting* Any banal or stereotyped mannerism.

click track *Music* A special sound track on which a series of audible beats or clicks has been recorded. The beats may represent, for example, the footsteps of an actor on screen, or the tempo of something spoken or sung during a previous shooting session, to which new material is to be synchronized. Musicians listen to the click track through headphones and then, at a specific count, begin to play exactly in time. Rock musicians often use it to keep an even beat. Click tracks may also be set up for a solo musician recording his or her own accompaniment and OVERDUBBING a solo or for actors taking part in a DUBBING session, to help them synchronize their syllables with the scene. *See also* LIP SYNC.

cliffhanger *Motion pictures, Television* 1. Any show in series form that ends with a scene of unresolved suspense, keeping the audience in a state of anticipation for the next episode. 2. Any tale of high adventure, pursuit or confrontation, that keeps the audience in suspense until the very last moment.

climax *Theater* The moment of greatest dramatic tension in a play, followed by the resolution of the plot. In tragedy, it corresponds roughly to the moment Aristotle identifies as the CATASTASIS. *See also* CONFRONTATION OF FATE.

climax curtain *Stagecraft* In theater of past centuries, when plays often ran to five or more acts the last of which was usually after the climax, the close of the next-to-last act.

clip a cue *Acting* To speak too soon, thus cutting off an essential CUE so that whatever action follows becomes unmotivated and therefore illogical. *See also* STEP ON A LAUGH.

cloak-and-dagger *Motion pictures, Theater* Describing a role, a play or a motion picture of dark suspense and intrigue, particularly involving espionage.

clog dance A type of TAP DANCE from England and Ireland, performed in hard-soled or wooden shoes.

clogging *Dance* A style of stepping alternately on the heel and toe in each beat of a fast KENTUCKY RUNNING SET, performed by dancers wearing high-heeled boots, often with TAPS attached.

close *Acting* The ending of a scene or an act. Sometimes an ending consists of a formal device such as a rhymed couplet. Sometimes it is a distinct change of BEAT (in the actor's sense of that term) or of subject matter. Sometimes it is a heightened resolution of dramatic tension. In any case, the close is a moment that can be worked out in the actor's mind and given special treatment as an event different from the main body of the scene or act.

Theater To end the run of a production. *Compare* FOLD.

closed-captioning *Television* A system for providing SUBTITLES on the screen for deaf viewers. To see the words, viewers activate special decoders installed in their television receivers.

closed-circuit television A television system restricted to a specific situation, not broadcast to the public. In opera, for example, closed-circuit television, consisting of a camera focused on the conductor and a monitor visible backstage, permits an offstage singer to synchronize with the conductor who is otherwise out of sight. Such a circuit is routinely set up in large theaters so that everybody backstage, from actors to lighting technicians, can see and hear cues that are necessary to their individual roles or functions.

closed position *Acting* Any position with the back turned toward the audience.

Ballet The FIRST, THIRD or FIFTH POSITION of the feet.

closed rehearsal *Acting* Any rehearsal not open to visitors.

closed turn *Acting* A turn toward upstage, away from the audience.

close harmony *Music* Harmony characterized by four-note chords in which each of the top three is no more than a PERFECT FOURTH apart from the next. *See also* BARBERSHOP HARMONY, CLOSE POSITION.

close in *Acting* An instruction to actors to move closer together on stage.

close-in curtain *Stagecraft* A curtain that closes by drawing together toward the center line of the stage.

close-in drop *Stagecraft* A drop in two pieces that can be stored out of sight in the wings or brought into view by being drawn together toward the center line of the stage.

close position *Music* The distribution of tones in any chord of four voices, in which the upper three are separated from each other by intervals of a perfect fourth or less. In vocal music, the difference between close and OPEN POSITION is quite noticeable, because the more prominent HARMONICS of tones in close position tend to interfere acoustically with each other more than in open position. Close position gives special warmth to certain styles of vocal music such as BARBERSHOP HARMONY.

closet drama *Theater* A drama intended for private reading, but not for the stage.

close-up *Motion pictures* Any SHOT taken from a position close to its subject so that the subject fills most of the screen and its surroundings are off screen. It is abbreviated CU. *See also* EXTREME CLOSE-UP, IN TIGHT, LONG SHOT, TWO-SHOT.

closing notice *Theater* An official notice put up by the management to inform the actors and members of the staff that the show will close on a certain date. Union rules generally require that such a notice be posted two weeks before actual closing.

cloth *Stagecraft* Short for any border, drop or floor covering made of cloth.

cloth cyclorama *Stagecraft* A CYCLORAMA made of cloth. The advantage of cloth is that a large cyclorama, higher and wider than the stage itself, can be rolled up for storage. The disadvantage is mainly acoustic: a cloth cyclorama tends to absorb sound, whereas a plaster, plastic or wood surface tends to reflect it toward the audience.

cloth dutchman *Stagecraft* A narrow strip of cloth glued over the division between two FLATS to conceal a joint.

cloud *See* ACOUSTICAL CLOUD.

cloud border *Stagecraft* A BORDER painted to look like clouds in the sky.

cloud machine *Stagecraft* A fan-driven source that produces a vapor that will look like cloudy air or fog when it passes over the stage. *See also* STEAM CURTAIN.

clown *Acting* 1. The fool or JESTER in an Elizabethan play. 2. An actor who plays a ridiculous or absurdly comic role, often in a bizarre costume, using pantomime and SIGHT GAGS. The art of the clown has a long history, reaching at least as far back as the SATYR PLAYS that were part of the Greek DIONYSIA. It has been developed through the ages by street performers such as the PHYLAKES and BUSKERS, in folk plays such as the British PAGEANTS and above all in the COMMEDIA DELL'ARTE. Among 20th-century masters of the art are Emmett Kelly, Charlie Chaplin, Buster Keaton, Red Skelton and Danny Kaye. 3. To do funny things on stage, especially when humor seems contrary to the main action of the scene.

Circus An actor and/or acrobat who performs comic acts, usually in PANTOMIME, with or without absurd props, wearing an outrageous costume and exaggerated makeup.

clown white *Makeup* White greasepaint intended as a base for the clown's entire face. There was a time when the base was zinc white, but since that was found to be toxic it is no longer in use.

cluster *Music* Any group of three or more tones that are adjacent in the scale and are sounded as one. Henry Cowell astounded an audience in Moscow in the 1930s by playing clusters on the piano with his whole forearm. Other composers since have put clusters to very good use in music, not always for their clashing effect, but sometimes for an effect of untuned softness.

coach *Acting, Music* 1. One who advises a performer on how to solve a technical problem. A typical example is the coach who teaches an actor to fence so that he may play Cyrano with flair. Other coaches work on matters of speech, ensemble playing, rhythm, singing, posture and the like. 2. To advise an actor or musician in the proper practice of specific techniques in performance.

co-ax (*KOH-ax*) *Electronics* Abbreviation for coaxial, *i.e.,* COAXIAL CABLE.

coaxial cable *Electronics* Cable consisting of two conducting elements, one of which is made of woven metal entirely enclosing a plastic covering that, in turn, entirely encloses and provides a precise separation from the other conductor, the whole being protected by an insulating outer skin. Coaxial cable carries audio and video signals coherently from one location to another. Any other type of cable operating at such high frequencies would allow the signals to leak out or extraneous signals to leak in, causing interference that would make everything incoherent.

coda [Italian] *Ballet* 1. In the classic PAS DE DEUX, the third section, following the variations. 2. The FINALE of a CLASSIC BALLET, when the principals appear on parade before the audience.

Music Literally, tail. An ending section that comes after several repeating sections of a composition and may be different in thematic content from them, signaling that the piece is coming to a close. *See also* CADENCE.

code The official regulations that stipulate the requirements of architecture, electrical installation, scene construction and general safety in a theater or concert hall.

code generator *Motion pictures, Television* An electronic device that embeds a TIME CODE in the video signal for editing purposes.

codetta *Music* Literally, a little tail. A relatively short transitional passage between entries of the subject and its answer in a FUGUE or, in SONATA FORM, a short passage at the end of the EXPOSITION after which the piece continues.

co-director *Motion pictures* One who directs in collaboration with another director. Sometimes the director handles all the shooting sessions in one location, and the co-director those in another.

codpiece *Costume* A bit of cloth hanging from the belt of an actor who is dressed as a pantless peasant in medieval times, meant to conceal his private parts. *Compare* G-STRING.

cold house *Theater* An unresponsive audience.

coliseum Variant spelling of COLOSSEUM.

collapse *Stagecraft* Any prop or piece of scenery designed to fall apart on cue, *i.e.,* when triggered by an invisible string or other device. *Compare* BREAKAWAY.

coll'arco (*kohl-AHR-koh*) [Italian] *Music* In stringed instrument playing, with the bow. *Compare* COL LEGNO, PIZZICATO.

collegium musicum [Latin] *Music* A name derived from the ancient name of the papal choir in Rome, now typically used by organizations devoted to the preservation and performance of classical forms and techniques of music.

col legno (*kol LEHN-yoh*) [Italian] *Music* Literally, with wood. An instruction to string players to strike the strings with a bouncing motion using the stick of the violin bow rather than the hairs. *Compare* SPICCATO.

color *Music* 1. The degree of ornamentation in a melodic line. *See* COLORATURA 2. The degree of harmonic richness in a sequence of harmonies, such as the use of chords of the seventh, ninth and so on. 3. The exploitation of differences of TIMBRE in an orchestrated work. 4. The play of differences in timbre effected by using different STOPS on an organ.

coloratura (*koh-loh-rah-TOO-rah*) [Italian] *Music* Literally, coloring. 1. Describing a brilliant style of singing, characterized by rapid, florid passages requiring outstanding vocal agility, usually composed for the highest soprano voice. 2. A SOPRANO with a light, flexible voice who specializes in the coloratura style.

color bars *Television* A test pattern consisting of an array of wide vertical bars showing the primary colors of each element of the video tube plus white and black, and a horizontal stripe across the bottom providing color and other information in coded form. With the pattern showing on the screen, a technician can adjust the set's controls to produce all colors correctly. *See also* TEST PATTERN, WHITE BALANCE.

color boomerang *See* BOOMERANG (*Lighting*).

color box *Lighting* A boxlike attachment to the front of a SPOTLIGHT, which contains a selection of color filters that can be mechanically slid into the beam of light, one after the other, serving the same purpose as a COLOR BOOMERANG.

color circuit *Lighting* One of several separate circuits, each supplying power to the lamps of a specific color in the footlight units.

color filter *Lighting* A transparent filter, especially one made of glass, used to color the beam projected onto the stage from any LIGHTING INSTRUMENT. Typically, it fits inside a frame attached in front of a FLOODLIGHT or on individual FOOTLIGHTS. *See also* GEL.

color frame *Lighting* A slotted metal frame, mounted in front of the lens of a light fixture, made to hold COLOR FILTERS, DIFFUSERS or MASKS.

color temperature *Lighting* The degree of white light produced by a source, expressed in terms of degrees KELVIN (K). A wholly objective measure of the color of light, used by cinematographers and television engineers. A light that is richer in reds (*i.e.*, at the lower end of the spectrum) is of a lower color temperature than another light rich in blues (at the high end). Sunlight lies between 5,000 and 20,000K; motion picture lighting, in general, strives for 3,200K.

color wheel *See* BOOMERANG (*Lighting*).

Colosseum [Latin, from Greek] *Circus* Literally, a place for a giant. A large stone arena in Rome, built while Vespasian was in power and the Roman Empire seemed to control the whole world (70 B.C.). It was the scene of gladiatorial combats, animal fights and staged massacres including mass sacrifices of early Christians. The name has been borrowed (and misspelled as COLISEUM) for many large municipal arenas and showplaces ever since.

col sopra (*kohl SOH-prah*) [Italian] *Music* Literally with the one above, *i.e.*, an instruction to an instrumentalist to coordinate closely with the instrumentalist playing the line next above in the score. Not to be confused with COME SOPRA.

combination curtain *Stagecraft* A curtain that can be opened or closed horizontally or raised into the FLIES.

combination tone *Acoustics, Music* A musical tone apparently, but not physically, produced by the interference of sound waves of two loud tones of high register. It is not an acoustical event, but a physiological phenomenon caused by the structure of the cochlea (the inner ear). When the ear hears two high tones, the inner ear (cochlea) also seems to hear a third tone whose frequency is approximately the difference between the frequencies of the real tones. Such DIFFERENTIAL TONES were first accurately described by the violinist Giuseppe Tartini in 1714, and used by him to teach his students how to control DOUBLE-STOPS. SUMMATION TONES, much more difficult to hear, were discovered by the physicist Herman von Helmholtz. Combination tones are an important part of the effect that makes a change in harmony feel like motion, one of the enigmas that makes music seem alive. They also provide the tones one thinks one is hearing from an organ with ACOUSTIC BASS. *See also* HARMONIC SERIES.

combo *Music* A small group of players, the equivalent in JAZZ of a chamber music ensemble.

comeback *Theater* A renewed success in show business for a performer or director after a period of unemployment or mediocre work.

comedian *Acting* One who plays comic parts, especially a solo performer who improvises comic situations and acts them out. *See also* CLOWN, STAND-UP COMIC.

comedic *Acting* Having to do with comedy.

Comédie Française, La (*lah ko-may-DEE franh-SEZ*) [French] *Theater* One of the most important theaters in Paris, La Comédie Française houses everything but operas.

comedienne *Acting* A female comedian. In the 1990s the term has been supplanted by the generic use of COMEDIAN.

comedietta [Italian] *Theater* A brief comic scene.

comedist *Theater* One who writes comedies.

come down *Acting* An instruction to the actor to move DOWNSTAGE.

comedy *Theater* Generally, a funny play. The word, however, has had more subtle meanings in the past and in certain contexts. It used to be said that if a TRAGEDY was a play that ended with the hero dying (which was seldom true), then a comedy had to be a play in which the hero came out alive. Comedy can occur in all kinds of plays including tragedy and is always in one way or another funny; tragedy, on the other hand, does not often appear within a comedy. The ancient Greeks symbolized the art of theater with an image of two masks, one laughing, the other crying; anyone playing a comedy, or a comic part, wore the funny one.

comedy of character *Theater* Comedy that depends for much of its effect on the characters involved, and less on comic action or clowning.

comedy of manners *Theater* Comedy set in a context of overly polite society, as in RESTORATION plays and the works of Molière.

come-on *Acting* An implied, unspoken invitation from one character to another.

come sopra (*KOH-meh SOH-prah*) [Italian] *Music* As above, the same as before. Not to be confused with COL SOPRA.

comet tail *Video* A brief trail of light across the screen following the rapidly moving image of a bright light in surrounding darkness. The cause is partly the slow reaction of the phosphors that coat the inside of some television screens. The brighter the scene, the less often one sees comet tails.

comic muse *Theater* In ancient Greece, the MUSE Thalia, one of the nine daughters of Zeus.

comic opera *Theater* 1. Any opera based on a comedy. 2. A happy opera with many speaking parts and interspersed with songs and dances. *See also* MUSICAL COMEDY, OPERA BUFFA.

comic relief *Theater* A comic scene that follows a scene of intense drama, giving the audience a respite from whatever misery the preceding scene may have evoked and allowing them to recover before the next tragic moment. Shakespeare used comic relief in many of his tragedies.

comma *Music* The difference in pitch between two notes of the same name that have been arrived at by different sequences of harmonic movement. *See* COMMA OF DIDYMUS, COMMA OF PYTHAGORAS, HARMONIC SERIES. This difference is meaningful in music, because it demonstrates that the entire system upon which music is based is mathematically irrational and capable of infinite variation. Another symptom of the same effect occurs the

moment one tries to build harmonies on a short sequence of pure-tuned bass notes. Careful analysis of the chords reveals that if the harmonies are each in PURE TUNING, notes that have the same name at different times in the sequence have different frequencies. *See also* EQUAL TEMPERAMENT.

command performance Any performance mounted upon orders of the king or queen for their edification and amusement. Shakespeare's *The Merry Wives of Windsor* was first performed under these conditions. By extension, any performance ordered by a head of state or a very important personage.

comma of Didymus *Music* The tiny but audible difference of pitch that occurs when building a series of four perfectly tuned FIFTHS to arrive at a tone that has the same name as the FIFTH HARMONIC of the FUNDAMENTAL tone but not the same frequency (pitch). *See* TEMPERAMENT. *See also* OCTAVE NAME SYSTEM.

comma of Pythagoras *Music* The tiny but audible difference in pitch that occurs when building a series of seven perfectly tuned OCTAVES on a fundamental tone to arrive at a note that has the same name but not the same frequency as the last of 12 perfectly tuned FIFTHS built on the same tone. This discrepancy, which was discovered by Pythagoras, is proof of the infinitesimal differences that occur in all harmonic progressions, that give music its feeling of movement. *See* TEMPERAMENT. *See also* OCTAVE NAME SYSTEM.

commando cloth *Motion pictures* A heavy, opaque, fireproof fabric, similar to DUVETINE, used as a FLAG to block outside light from the SET.

commedia dell'arte (*ko-MEH-dya del-AR-teh*) [Italian] *Theater* Literally, the comedy of art. The theater of masked comedy, performed by professional companies of actors in Italy as early as the 1550s. Commedia grew out of local folk plays and improvised entertainments that were popular traditions in many Italian towns. It first flourished in Venice. Commedia troupes were the first independent professional acting companies in Europe and the first to include women as actors. From the outset there were STOCK CHARACTERS, developed from local carnival figures of various towns. Among them were Brighella, the shrew from Breschia; Volpone, the old fox from Venice; and ARLECCHINO, the trickster and clown from Bergamo. The plays mounted for the Duke of Mantua and other major patrons were comic variations improvised on a few standard themes. There were often an aged father, his unmarried daughter, two suitors (one handsome and the other ugly but rich), a teacher, a lawyer and so on. And there was always Arlecchino who turned everything on its head. Commedia emphasizes physical comedy and elaborate PANTOMIME. It influenced the greatest dramatists of the Renaissance, including Lope de Vega, William Shakespeare and Molière. It is still performed in its original magnificence by companies in Venice, Milan and other cities. Commedia dell'arte is an important part of the foundation of modern acting and the modern theater. Modern companies, such as the Piccolo Teatro of Milan, still improvise their performances on the basis of sketchy scenarios and incorporate ideas and situations based on the latest news of the day, exactly as their predecessors did for centuries. There have been schools of commedia in Europe from time to time and famous teachers, including Ètienne Ducroux, who flourished in Paris in the mid-1900s. Its modern international revival began when the French mime Marcel Marceau visited Padua in 1949 and asked Carlo Mazzone-Clementi, a young member of the troupe in Venice, to be his partner. Mazzone, who

had worked for nine years with Jacques Lecoq, later founded the first professional school of commedia in America at Blue Lake, California, and cofounded another in Copenhagen, Denmark. Both schools carry on the authentic tradition to this day.

commercial *Television* Short for commercial message. An advertisement on television. *See* SPOT. *Compare* PROMO.

commercial sound *Music* The general style of any popular music that has been commercially successful in the past.

commercial theater The theater business, established and managed for the purpose of making money.

commission 1. A contract for the creation of a work of art in theater, music, dance or design, accompanied by an advance payment of royalties and, usually, with a guarantee of performance. 2. To contract with an artist for the creation of a work and to make a payment for it in advance.

common time (common measure, common meter) *Music* A rhythmic scheme built on measures of four beats each.

community sing *Music* A gathering of townspeople for the purpose of singing together. Some sings have been organized as regional affairs, some have been commercially sponsored. The grand tradition in the United States had its beginnings at 19th-century community picnics, often held at the time of the harvest moon.

community theater 1. A building devoted to shows and movies for local audiences. 2. A mostly amateur company that produces plays on a more or less regular basis for local audiences.

comos *See* KOMOS.

comp *Jazz* To accompany or fill in around a soloist, typically with chords.

Theater A complimentary ticket. A free ticket.

compact disc *Recording* A digitally recorded disc.

company *Dance, Theater* The professional personnel of the production organization. An organized team of performers and supporting personnel who stay together to present many productions over a period of time, as distinguished from a company brought together for a single production. *See also* ACTING COMPANY, BALLET COMPANY, DANCE COMPANY.

company call *Theater* A rehearsal involving the entire company.

company crew *Theater* The crew who are regular employees of the company, as distinguished from those who are hired on a part-time or temporary basis or who are visiting as part of a touring company.

company list *Theater* The official list of members of the acting company.

company manager *Ballet, Dance, Motion pictures, Theater* The business manager of the company.

company photo call, company picture call *Theater* A meeting scheduled on stage, like a rehearsal, but for the purpose of making publicity pictures of the whole company, usually in costume.

company rehearsal *Theater* A rehearsal involving the entire company.

company switch *Lighting* The switch that controls the main source of electric power for the stage, *i.e.,* the switch connected to the power company.

complementary rhythm *Music* Any rhythmic pattern made up of OFF-BEATS or unaccented subdivisions that are not the principal beats of the passage.

complication *Theater* A term sometimes used by scholars of theater as a translation of Aristotle's term DÉSIS. *See* ENTANGLEMENT.

compose *Acting* To relax (oneself) so as to be alert and physically ready for the next action.

 Dance, Music Literally, to place together. To create a formal work of art. The word is used to suggest what a painter does in shaping the image or the scene, but in dance, music and theater its meaning has to do with the creation of form in space and time.

composer *Music* One who creates a piece of music.

composer-in-residence *See* ARTIST-IN-RESIDENCE.

composite *Acting* An 8" × 10" photographic print containing CONTACT PRINTS of photos of the actor in different poses, roles and/or situations. A print from which the actor can choose his or her best shots for submission to casting agents. *Compare* GLOSSY.

composition *Dance, Music* 1. The manner in which the formal elements of a work of art are put together. 2. Any work of art, particularly a work constructed in the context of time, as a piece of music or dance.

compound interval *Music* Any musical interval larger than an octave. The first four compound intervals are sufficiently common to have names: ninth, tenth, eleventh and twelfth. The rest must be referred to as "an octave and a minor sixth," "two octaves and a major third," etc. Intervals of an octave or less are called SIMPLE INTERVALS.

compound time, compound meter *Music* Music with measures containing multiples of duple or triple elements (*e.g.,* 9/8 which has three groups of three

COMPOUND TIME

eighth-notes), or combinations of duple and triple (*e.g.,* 5/4, which can be construed as 2/4 plus 3/4, or 3/4 plus 2/4). In recent times composers have developed a time signature to account for such differences, as shown in the illustration. *Compare* SIMPLE TIME.

comprimario (*kom-pree-MAH-ree-oh*) [Italian] *Music* Literally, with the first. An opera singer who specializes in important male roles that are secondary to the leading role. By extension, that class of roles.

computer-assisted lighting system A lighting system activated by a computer-based control system that permits the lighting designer to preset the entire LIGHT PLOT and run the show by monitoring what is going on and making only minor timing adjustments as necessary to synchronize with the actors. Since the light plot is stored on a disk, it is possible also to save it for future performances.

computer music Music that has been composed as computerized functions, not merely notated by means of a computer. To be distinguished from ELECTRONIC MUSIC that makes use of electronically developed sounds, but is not the product of functions in sound and in time created by formulas set up on a computer. *See also* IRCAM.

con [Italian] *Music* With.

con amore (*kon ah-MOH-reh*) [Italian] *Music* Literally, with love. Warmly, ardently.

con brio (*kon BREE-oh*) [Italian] *Music* Literally, with verve. Vivaciously, brilliantly, vigorously.

concentration *Acting* The practice of controlling one's thoughts and avoiding outside stimuli to find a symbol or a memory that will help sensitize one to the emotional content and action of a role and to the sources that will help project its meaning and emotion into the minds of the audience.

concert *Music* A public or private musical performance of significant length, usually by an ensemble or an orchestra. *See also* RECITAL.

concertante (*kon-chehr-TAHN-teh*) [Italian] *Music* Literally, playing together (*i.e.,* in concert). Describing a work to be played by several soloists together, with or without orchestral accompaniment. *Compare* CONCERTO GROSSO.

concert border *Stagecraft* A border installed for a musical performance. A concert border adjusts the opening of the PROSCENIUM to proportions that seem more appropriate to a concert. It also may be made of different material than a regular theater border, to help control or modify the acoustics of the stage for concert purposes. *See also* CONCERT SET.

concert goer *Music* One who regularly attends concerts.

concert grand piano *Music* A large GRAND PIANO, generally one that is at least nine feet long. The length allows the bass strings to be aligned away from, instead of at an angle and beneath, the trebles.

concertina *Music* A small instrument like an ACCORDION with round or hexagonal ends, and generally with buttons instead of a KEYBOARD. It is a very popular instrument in folk dance and as backup for a singer in England, Italy, France and Spain.

concertino (*kon-chehr-TEE-noh*) [Italian] *Music* Literally, a little concert. 1. A short instrumental work with a soloist or soloists, usually in one movement. 2. The group of soloists in a CONCERTO GROSSO. *See also* RIPIENO.

concertize *Music* To play concerts. To specialize as a soloist.

concert master *Music* The chief performing member of an orchestra, usually the first violinist, sitting in the FIRST CHAIR (*i.e.*, near the conductor and nearest the audience at the first DESK), who is responsible for musical management of the string section and, usually, of the whole orchestra. The position has nothing to do with nonmusical management, but involves responsibilities such as getting everybody tuned up before a concert and deciding on bowings for the music being played. The concert master also plays, ex officio, the solo violin sections of a piece if there is no specially designated soloist present. It is the concert master who stands up before the concert begins and directs the oboist to sound an A to which the entire orchestra may tune up. In England, the concert master is called the LEADER.

concerto (*kon-CHEHR-toh*) [Italian] *Music* In general, a symphonic work featuring an instrumental soloist. There are exceptions, however; Béla Bartók composed a *Concerto for Orchestra* (1944); others have featured solo parts so deeply integrated with the orchestra that one cannot call the work a concerto in the traditional sense, *e.g., Harold in Italy* (1834) by Hector Berlioz, with a solo VIOLA throughout.

concerto grosso [Italian] *Music* An instrumental work, often in more than one movement, featuring several soloists (CONCERTINO) who play individually and together with the accompaniment of an orchestra (RIPIENO).

concert pitch *Music* The pitch to which all instruments are normally tuned for a concert. The whole gamut of audible pitches that have been tuned to their proper individual relationships with A-440. By extension, being at concert pitch is also used loosely to indicate complete readiness for any kind of performance, whether or not musical. *See also* STANDARD PITCH.

concert reading *Music* Any performance of a work, such as an opera, composed for stage presentation but performed as a concert piece without sets, lights, with only leading roles played (sometimes) in costume, and minor roles taken by chorus members. Performers' actions are necessarily limited to simple indications and gestures, such as turning to face each other in appropriate scenes.

concert set *Stagecraft* A stage set designed for use during concerts. It usually provides a hard-surface CYCLORAMA to reflect sound toward the audience, and sometimes a hard-surface ceiling and wings for the same purpose. The lights are also adjusted to provide proper illumination for musicians on stage. *See also* SHELL.

concert tour *Music* A tour by one or more musicians performing concerts at scheduled stops.

concord *Music* Literally, agreement. Harmony, the quality of being IN TUNE.

concrete music *See* MUSIQUE CONCRÈTE.

condensed score *Music* A SCORE of an instrumental work, reduced from the FULL SCORE of an orchestral or band work, written at CONCERT PITCH on a few lines with words inserted at appropriate places to indicate which instruments are represented. Also called a short score. A condensed score is easier for an unpracticed CONDUCTOR to read, and requires fewer pages than a full score. *Compare* MINIATURE SCORE, PARTICELLO, REDUCTION, VOCAL SCORE.

con dolore (*kon doh-LOH-reh*) [Italian] *Music* Literally, with grief. Sadly, grieving.

conduct *Music* To lead musicians in the performance of a musical work, using a BATON or the hands to set the TEMPO, define the BEAT and to indicate dynamic shadings.

conductor *Music* One who leads a musical ensemble using a BATON or the hands to set the TEMPO, define the BEAT and indicate dynamic shadings.

conflict *Acting* The ideas and actions in the PLOT that create and intensify dramatic tension in a work of drama. *See also* AGON, ARGUMENT.

conform *Motion pictures* In traditional film editing, to cut and assemble the ORIGINAL so that it precisely matches the edited WORKPRINT of a film. The final process in POST-PRODUCTION, coming after the MIX.

conformed original *Motion pictures* In traditional film editing, the two fully edited strands (A & B ROLLS) of the ORIGINAL, which are, in fact, the visual part of the motion picture itself, all others being copies or prints. The conformed original is used only sparingly, first with the mixed sound track added to make the ANSWER PRINT, then to make MASTER DUPLICATES from which many RELEASE PRINTS can be struck off. In modern practice, with the editing process based on digital coding, the shots included in the (video) workprint are selected by a computer-controlled processor, and printed in sequence from the intact original.

confrontation of fate *Theater* The moment of the highest degree of dramatic tension, the CLIMAX of the action of the drama that directly precedes the resolution of the plot. One of the essential moments in formal tragedy that Aristotle calls CATASTASIS. *See also* ELEMENTS.

con fuoco (*kon foo-OH-koh*) [Italian] *Music* Literally, with fire. Brilliantly, impetuously.

conga *Dance* A Cuban social dance popular in the 1930s, performed by a long chain of people, each holding the waist of the person in front and doing a one-two-three-kick step to Latin American music. In 2/4 time, its rhythmic pattern has a strong syncopation (the kick) in every second measure.

conga drum *Music* A single-headed drum, played with both hands. Of African origin, the conga came to this country through South America, and is a staple of South American and Central American bands. It is a long, tubular drum originally made of wood but now often of fiberglass, held vertically between the knees or supported vertically in multiple-drum sets before a standing player. The drumskin diameter varies from 9.5 to 11.5 inches, which produces a tone roughly in the range of the low part of the TREBLE CLEF, just below the range of their close relatives, BONGOS.

connector *Lighting* Any of several devices used to attach electrical conductors to each other. *See* PIN CONNECTOR, STAGE PLUG, TWIST-LOCK CONNECTOR.

connector box *Lighting* A large metal box, containing connectors each of which is the terminus of a cable bringing power for stage lights. Several of these are often permanently placed in convenient positions around the stage or among the flies. When lights are installed they are plugged into the connector box. *See also* STAGE POCKET.

connector strip *Lighting* A strip of stage connectors to which power lines for lights may be attached.

conservatory A school that trains candidates to become teachers or performers in the performing arts. The word connotes a place dedicated to the preservation of tradition, which is appropriate for the performing arts because so many of their techniques are nonverbal and must be taught through example and practice.

console *Audio, Motion pictures, Lighting, Television* A specialized desk in which a system of electronic controls has been installed for the operation of electrical or electronic equipment such as microphones, video cameras, the sound system, stage lights or stage machinery. Depending upon what is to be controlled, the console may be built into a booth at the back of the house, in the balcony or elsewhere, where the operator can best see the results of the operation. It may also be made portable to take care of temporary needs.

console unit *Audio, Lighting, Stagecraft, Television* A CONSOLE or part of a console that controls a single specific function in the production.

consonance *Music* The harmonious agreement of the tones of a chord or an interval. The essential factor in consonance is the degree of audible conflict between the first few HARMONICS of each of the fundamental tones. If the fundamental tones are a THIRD or a FIFTH apart, for example, their first few harmonic tones tend not to clash as much as if the fundamentals were a SECOND, or a FOURTH apart. In the history of music, chords have sometimes been considered dissonant when they were first introduced, but have gained acceptance in the course of time. When Beethoven started his First Symphony with a seventh chord, some considered it brash and dissonant. *See* HARMONICS.

consonant *Music* Having the quality of consonance.

con sordino (*kon sor-DEE-noh*) [Italian] *Music* With a MUTE. An instruction to an instrumentalist to use a mute for the upcoming passage.

con spirito (*kon SPEE-ree-toh*) [Italian] *Music* With spirit, vigorously.

contact *Lighting* Either of two metal (usually copper) parts of an electrical connector or a switch that can be separated to cut off the current, or brought together to restore it.

contact improvisation *Dance* Any dancer's exercise that requires physical contact with another.

contact mike *Audio, Music* A microphone designed to pick up sound by direct contact with the surface of an instrument. Contact mikes are common with stringed instruments especially in ROCK bands, fairly common for drums in recording sessions, but not often used for brasses or woodwinds. Also called a pick-up.

contact print *Acting* A photographic print made directly from the negative, without enlargement. Actors collect contact prints of their publicity shots in order to keep them on file for future selections. *See* COMPOSITE.

contemporary music 1. Music recently composed. 2. Music in the style that is popular at the present time.

contemporary style Style as practiced at the present time. That which was recently, but is no longer actually contemporary, usually acquires a different name, such as op art, serialism, or expressionism.

continental cyclorama *Stagecraft* A rolling CYCLORAMA, also called traveling cyclorama. *See* MOVING PANORAMA.

continental seating *Theater* An arrangement of seats in the auditorium without radial aisles except at the ends of rows, and without CROSSOVERS, but with enough space between rows to allow the audience to move into and out of their seats without difficulty. *Compare* AMERICAN PLAN SEATING, THREE-ROW-VISION SEQUENCE.

continuity *Motion pictures* 1. The visual relationship of the first FRAME of an incoming scene to the last frame of what preceded it. Good continuity requires that the location of the CENTER OF INTEREST of the outgoing frame coincides with that of the incoming frame, so that the eye does not suddenly see something the mind cannot comprehend. It also requires that objects visible in the outgoing scene remain unchanged and in their logical places, *e.g.,* that an actor does not suddenly reach for a green telephone when it was beige before and already in her hand. 2. Short for continuity clerk.

continuity clerk *Motion pictures, Television* A member of the production crew whose job it is to check for errors of visual continuity during the SHOOT. This person frequently uses instantly developed STILLS (*see* POLAROIDS) to make a permanent record of each scene so that continuity can be established when a new shot will be taken at another date. *See also* SCRIPT CLERK.

continuity sheets *Motion pictures, Television* A complete, written record of the details of the beginning and ending of each shot in a production, as noted by the continuity clerk.

continuo *Music* 1. A continuous accompaniment built upon a bass line with harmonies improvised (or prepared beforehand) by the instrumentalist. *See* BASSO CONTINUO. 2. The group of instrumentalists who play the continuo part. Their instruments commonly include a keyboard (harpsichord, organ or piano) and a violoncello, bassoon or other bass instrument.

contortionist *Circus* A gymnast who entertains the audience by twisting his or her body into seemingly impossible positions and shapes.

contour curtain *Stagecraft* A form of BRAIL CURTAIN with several individually controlled lifting ropes passing through vertical lines of ring guides every few feet for its entire width. When it is raised, the sections between the ropes form great looping folds of cloth. It is called a contour curtain because the lines can be drawn up independently to different heights and the cloth can be made to drape in different ways, *i.e.*, with different contours. *See* AUSTRIAN CURTAIN, TABLEAU CURTAIN, VENETIAN CURTAIN.

contour piece *Stagecraft* A flat that has a shaped profile. Contour WING FLATS, for example, may be used to indicate the edge of a forest. Others, horizontal and low, may be made to look like a stone wall against a distant view painted on the backdrop.

contra *Dance* An American country dance, a 17th-century forerunner of the SQUARE DANCE, with elaborate figures performed by SETS of couples facing each other, often in lines or a square pattern. The name refers to the position of the dancers opposite or "counter" to each other.

contrabass *Music* The DOUBLE BASS.

contrabassoon *Music* The double-bass BASSOON.

contraction/release *Dance* A style of movement associated with the MODERN DANCE technique of Martha Graham, requiring active use of the entire body. Contraction occurs after exhaling, when energy is diminished. Release is defined as the moment after taking a breath, when the body feels at its lightest.

contractor *Music* The union representative, usually one of the musicians, present at every rehearsal, recording or performance in which union musicians take part.

contradance, contradanse *Dance* An English choral dance of the 17th century, performed by couples facing each other or by men and women in circles. Introduced into France about 1710, it developed into the COTILLION and QUADRILLE, among others.

contralto *Music* The female voice of lowest range.

contra octave *Music* The octave below C_1. The lowest octave on the piano. *See* OCTAVE NAME SYSTEM.

contrapuntal *Music* Having the form and function of COUNTERPOINT.

contrapuntist *Music* One who composes COUNTERPOINT.

contrary motion *Music* The movement of voices toward or away from each other during a passage of music. *See* VOICE-LEADING.

contra tenor *See* COUNTERTENOR.

contredanse *See* CONTRADANCE.

contretemps (*konh-treu-TANH*) [French] *Ballet* Literally, against time. A ballet step off the musical BEAT.

contrivance *Playwriting* Any sequence of actions introduced into the PLOT that is basically implausible or requires a manipulation of events that would be unlikely or even impossible in real life.

control *Acting* Any performer's ability to use technique efficiently without losing concentration during the performance.

Electronics Any electronic instrument that controls the volume of power or its frequency range in an audio or video circuit.

Lighting Any electronic instrument that controls dimmers that in turn control the power delivered to a lighting circuit.

Puppetry Any device, including the human hand, used to hold and manipulate the strings that effect the movements of a MARIONETTE.

control board *Audio, Lighting, Stagecraft* Any array of controls mounted together as a unit for convenience in operation. The control board is usually understood to be portable, whereas a CONSOLE is more often permanently installed.

control board operator *Audio, Lighting, Stagecraft* A technician who operates a control board during the show.

control booth *Theater* A relatively small soundproof booth containing a control CONSOLE and with a large window through which operators and directors can see what is going on in rehearsal or performance. In a theater, the booth for lighting and/or audio control is usually placed at the back of the house or on a balcony where it provides the same view of the stage that the audience has. Wherever it is situated, the control booth also has an intercom that allows the operators and director to communicate with performers and technicians backstage. *Compare* CONTROL ROOM.

control circuit *Electronics* Any circuit that carries signals from a control board to whatever device is being controlled, *e.g.,* to the DIMMERS.

control console *See* CONSOLE.

control room *Audio, Television* A soundproof room containing all the controls necessary for recording the performance going on in a recording studio. A control room is usually a permanent part of the architecture of the studio. It has very large double (*i.e.,* soundproof) windows giving the operators and director(s) inside a wide view of the entire studio area, and it has both intercom facilities and quick physical access through sound-isolating vestibules for communication with the studio. *Compare* CONTROL BOOTH.

convention *See* THEATRICAL CONVENTION.

conversation-piece *Theater, Motion pictures* A play or motion picture in which most of the action of the plot is carried forward in dialogue between actors.

convertible set *Stagecraft* A set that, with the slightest of physical moves, presents a different scene. *See also* UNIT SET.

cookaloris *Lighting* Any masking device made of heat-resistant material and mounted in front of a light source, which produces shadow patterns or creates a dappled effect on the lighted surface. Also called cookie, kook, kookaloris, cuke.

cookie *See* COOKALORIS.

cool colors *Lighting* Blues and greens, for example, as distinguished from reds and oranges. *See* MCCANDLESS METHOD.

cool jazz *Music* The style of JAZZ made popular in the 1950s by the tenor saxophonist Lester Young in contrast to the hot sound of contemporary jazz and the big-band sound of Coleman Hawkins. Further developed by Miles Davis and others, it is characterized by relaxed rhythms, thoughtful melodic improvisation and more contained, refined expressiveness.

co-producer One who collaborates in the financing and management of a production.

copyist *See* MUSIC COPYIST.

copyright The legal right to restrict the copying of any original written or recorded work. According to the copyright law in effect in the United States in the 1990s, this right is inherent in the act of creating the work in the first place, *i.e.,* the creator has the right to restrict copying the moment anything is put down on paper or onto a computer disk or has been "fixed" in a recording. The right is, for obvious reasons, unenforcible until the existence of the work has been registered in a timely fashion with the United States Copyright Office. Once registered, the right remains valid until 50 years after the death of the creator unless it has been otherwise assigned. A work made for hire is the property of the person or corporation who hired it, and since a corporation does not necessarily die, its right is limited to 75 years from the date of registration. *See also* CLEARANCE, RELEASE, RIGHTS.

cor [French] *Music* Horn, particularly the FRENCH HORN.

cor anglais (*kor anh-GLAY*) [French] *See* ENGLISH HORN.

cork opera *Vaudeville* A musical show in BLACKFACE. *See also* MINSTREL SHOW.

cork-popper *Theater* A great performance, a great opening or closing night, a perfect time to open the champagne at a company party.

corn *Theater* Anything trite, overly simple and/or sentimental.

corner block *Stagecraft* A block of plywood set into the corner of a FLAT to give it more rigidity.

corner brace *Stagecraft* A strap of wood or metal fastened across the corner of a flat to ensure its rigidity. *See also* BRACE RAIL.

corner trap *Stagecraft* A TRAP in the stage floor near either downstage corner.

cornet *Music* 1. A brass instrument similar to a TRUMPET but stubbier, with a shorter tube and a slightly less brilliant tone. Common in brass bands. 2. A STOP on the organ that produces a sound approximating that of a cornet.

cornet à pistons (*kor-nay ah pee-STONH*) [French] *Music* A CORNET.

cornetist *Music* One who plays the CORNET.

cornett *Music* An ancient wind instrument made as an octagonal tube of wood, with six finger holes. Because of its soft tone, it was still in use far into the time when other, more versatile wind instruments became available. Bach used it in several cantatas. Not to be confused with the brass CORNET, which is an entirely different instrument. The cornett was the ancestor of the SERPENT, and of other later soft-voiced wooden bass instruments.

cornetto *Music* The old Italian spelling for either the CORNET or the CORNETT.

coro [Italian] *Music* CHORUS.

corps de ballet (*kor deu bal-LAY*) [French] 1. The company of ballet dancers of any particular theater. 2. The ensemble of nonsoloists in a ballet company.

corpse *Theater* Slang for a show that died in performance.

corrente (*kor-REN-teh*) [Italian] *Dance, Music* The Italian form of the COURANTE.

cortége (*kor-TEZH*) [French] *Dance, Music* A solemn, ceremonial procession.

corybant *Ballet* A dancer playing the role of a mythical Greek sprite who dances and pretends to play delightful music in attendance to a goddess.

corybantic *Ballet* Having the happy and wild character of a corybant.

coryphaeus (*ko-ree-FEH-yus*) [Greek] *Theater* Literally, at the head, the leader, the one who holds the leash. The chorus master in classical Greek theater; the person who actually trained, rehearsed and directed the chorus for classical Greek tragedies and comedies. The word is derived from a Greek word having to do with heads, not from the inherently different word for chorus. *Compare* CHOREGUS.

coryphée (*koh-ree-FAY*) [French] *Ballet* A member of the Russian Imperial Ballet whose position ranked between that of soloist and member of the CORPS DE BALLET. More recently, a leading dancer of the corps de ballet.

co-star *Motion pictures, Theater* 1. A star who plays one of the leading roles in a production. 2. To play one of the leading roles in a production.

costume *Theater* The clothes a performer wears while acting on stage, including wigs and other accessories needed to establish the character being portrayed and/or the historical period.

costume crew *Theater* The seamsters and seamstresses, wardrobe keepers and wig managers who take care of the costumes for a production, see to the fittings and assist actors in dressing.

costume designer *Theater* The artist who sets the style of costumes for a production and may, at times, design them.

costume fitting *Theater* A meeting between an actor and the costume crew during which the actor's costume is modified as necessary for a proper fit.

costume master, costume mistress *Theater* The chief of the costume crew.

costume part *Acting* A role characterized by its costume, usually a role that requires several changes of elaborate costumes.

costume play *Acting* A play characterized by elaborate costumes. Frequently a historical play set in some grand setting, such as the English or French courts of the 17th century, Victorian or Edwardian England or Vienna in the 1890s.

costume plot *Theater* A schedule of all the costumes to be used in a performance, which shows when they must be prepared, put on and put away.

costume prop *Stagecraft* Any prop worn or carried to complete the visual effect of a costume, *e.g.,* a walking stick for an Edwardian gentleman, or a bow and arrows for Robin Hood.

costumer *Stagecraft* One who makes a costume.

costume rehearsal *Theater* A rehearsal called for the purpose of trying out costumes and allowing the actors to get used to them.

costumier (*kos-tü-mee-AY*) [French] *Stagecraft* A costume maker.

costuming *Theater* All the costumes in the production and their general style.

cothurnus [from Greek] *Acting* A solemn, tragic style of acting in the 16th to 18th centuries characterized by grand gesture, a sonorous voice and heavy, elaborate costumes.

Costume A style of costume (including high boots with lifts built into the soles and heels) worn by actors in heroic roles during the 16th and 17th centuries. The word comes from the Greek word for BUSKIN.

cotillion *Dance* A French CONTRADANCE, ancestor of the modern SQUARE DANCE, popular in England in the early 1700s and usually executed by four couples. Later introduced in the United States, it was in great demand as a dance and as a game with penalties. In modern usage the cotillion is a formal ball for young women being introduced to society.

cotillon (*koh-TEE-yonh*) [French] *Dance* *See* COTILLION.

cotton rod *Music* A short, stainless steel rod with a piece of cotton attached at one end, used by flautists to clear excess moisture from the tube of the flute. The rod also serves as a measuring device to determine the correct position of the cork inside the headpiece that affects the tuning of the flute. Also called a tuning rod.

cou-de-pied, sur le (*sür leu KOO deu pee-YEH*) [French] *Ballet* Literally, neck of the foot or ankle. A position in which one foot wraps around the other ankle, with the heel forward and the toe behind.

count-down *Television* The technical director's spoken count over the intercom, usually from 5 or 3 to 1, giving all the people on the set a precise cue for action.

counter *Acting* To move in a direction opposite to another actor's move, to avoid any situation in which either would be masked from the view of the audience or to keep the stage picture in balance.

counter focus *Theater* An arrangement of actors' positions on stage that provides a secondary FOCUS for the audience. *See* BLOCKING.

counterplot *Theater* A SUBPLOT, particularly one that seems contrary to the main plot and thereby adds to the dramatic tension.

counterpoint *Music* The art of composing music of two or more melodic lines that weave together in a variety of ways and yet form a unified piece of music. Counterpoint developed in the time of Lassus and Palestrina in the 16th century, and reached its highest peak with the work of Johann Sebastian Bach in the 1700s. *See also* CANON, FUGUE.

counterpoint lighting A style of stage lighting that allows constant, fluid changes of the color and intensity of all the individual lights within each scene, synchronized with the movements of the actors and variations of mood within the play. Light cues in this style consist of initial settings for the scenes, followed by many combinations of continuous, timed changes of individual dimmers as action continues during the scene. It is the opposite of DISCRETE LIGHTING that moves, cue by cue, from one fixed state to another fixed state.

countertenor *Music* A tenor with an extremely high range of natural voice, well into the treble clef and in the range of the female ALTO, though the male voice in that range has a perceptibly different TIMBRE than the female. Much vocal music of the 16th and 17th centuries includes a part for a countertenor.

counterweight *Stagecraft* A weight attached to one end of a rigging line to balance the dead weight of a CURTAIN, DROP or scenery at the other end that would otherwise be unmanageably heavy. In practice, the counterweight system consists of a steel frame (the COUNTERWEIGHT ARBOR) that accepts as many PIGS or WAFERS (the weights) as needed to balance the load. This arbor is raised or lowered by an endless OPERATING LINE that can, when in final position, be locked with a ROPE LOCK.

counterweight arbor, counterweight carriage *Stagecraft* An assembly consisting of a steel frame that slides in a vertical channel placed against the structural wall of the stage, is raised or lowered by an OPERATING LINE and is attached to rigging lines that

are, in turn, attached to scenery. The frame carries a number of weights (PIGS or WAFERS) that almost, but not quite, counterbalance the weight of any piece of scenery at the other end of the lines. The total weight is kept slightly less than the weight of the scenery to ensure that the scenery will descend slowly if the line is left loose. An endless OPERATING LINE raises or lowers the counterweight and, conversely, the scenery.

counterweight system *Stagecraft* A system of counterweights built into the stage rigging of large theaters to balance the weights of pieces of FLOWN scenery. The weights are slabs of iron (PIGS or WAFERS) that fit into a COUNTERWEIGHT ARBOR as needed.

counterweight track *Stagecraft* A channel built against the wall of the stage to guide and contain a COUNTERWEIGHT ARBOR as it moves up and down during set changes, to keep it from tangling with rigging lines and to protect people from accidental injury.

country-and-western, country, C & W *Music* Once called HILLBILLY MUSIC, the name was changed to country-and-western in the 1940s and shortened in the 1970s to country. A style of American popular music characterized by melodic and dance motifs based on rural folk music of the western, midwestern and southern United States, performed by small bands in which STEEL-STRING GUITARS, PEDAL GUITARS and solo FIDDLE predominate, and with lyrics that tend to have a regional content and flavor. *See also* BLUEGRASS.

country dance *Dance, Music* Social group dancing dating from ancient times, consisting of square dances, hoedowns and the like, and including many different kinds of line dances with groups facing each other and interweaving from time to time. A mistranslation of CONTRA.

count the house *Theater* To assess the size of the audience by seeing how many empty seats are left or counting the number of tickets taken in.

count the rack *Theater* To count the number of tickets sold by counting the presumably fewer numbers left on the rack of unsold tickets.

coup (*koo*) [French] *Theater* Literally, a hit or a blow. A surprising success, a triumph expressed in the published remarks of the critics.

coup de théâtre (*koo deu teh-AH-treu*) [French] *Acting* A successful dramatic device that overwhelms and pleases the audience.

coup d'oeil (*koo DEU-ee*) [French] *Theater* Literally, a glance of the eye. A quick visual event on stage.

coupé (*koo-PAY*) [French] *Ballet* Literally, cut. An intermediary ballet step that displaces one foot with the other as preparation for another step. There are many coupés; DESSOUS (below), DESSUS (above), JETÉ (tossed), etc.

couple-dance Any dance performed in couples. *See also* BALLROOM DANCE.

couplet *Acting* A two-line statement, usually in rhyme. Used frequently by Shakespeare and others as a CLOSE.

courante (*koo-RAHNT*) [French] *Dance* Literally, running. A dance form that originated in France and Italy during the 16th century and is characterized by rapid running steps in duple time (in the French courante) or triple time (in the Italian CORRENTE).

Music A movement in keyboard suites by Bach and others, based on the dance.

couronne, en *See* EN COURONNE.

courtroom drama *Theater* A play whose setting is a courtroom and whose principals include at least an attorney and a judge with, most often, a jury. *Inherit the Wind*, by Jerome Lawrence and Robert E. Lee, was one such piece.

court theater The theater of any royal or princely court, the most famous example of which is the theater of Versailles where Molière's plays were first performed.

couru (*koo-RÜ*) [French] *Ballet* A running step usually executed as preparation for a GRAND JETÉ, to build up power and momentum.

cove light *Lighting* A light fixture hidden in a depression in the wall or ceiling.

Covent Garden *Music, Theater* The Royal Opera House on Bow Street in London, England, the site of an ancient convent garden. The original theater opened in 1732, was destroyed by fire in 1808 and again in 1856, and has been rebuilt and enlarged each time. It is now the home of the Royal Opera and the Royal Ballet.

cover *Acting* 1. An actor who stands ready to step into a role on a moment's notice in case the incumbent becomes incapacitated. 2. To obscure the audience's view of another actor by standing in the way. *Compare* UPSTAGE.

Music In popular music or jazz: 1. To perform or record songs by other composers or groups. 2. To attempt to duplicate the arrangement or performance of a recording. 3. As a noun, as in "they played a cover."

cover flat *Stagecraft* Any FLAT that is intended to conceal part of the stage structure, *e.g.,* a small triangular flat painted to look like a wall that conceals the wooden supports under stairs.

cover gun *Stagecraft* A gun loaded with blanks, kept backstage in readiness to be fired in case the actor's prop weapon on stage fails to go off.

cover scene *Playwriting* Any scene designed to take enough time to convince an audience that an offstage action is really taking place, or to allow sufficient time for some real action (which the audience is not supposed to be aware of) to happen, *e.g.,* while an actor changes a costume.

cover shot *Motion pictures, Television* A wide shot including the entire scene, shot for safety to provide the editor with material to substitute if needed. A particular kind of CUTAWAY.

cover up *Acting* The act of improvising a distraction to take the attention of the audience away from a missed cue.

crab canon *Music* A CANON in which the second voice expresses the theme of the first voice backwards. Josef Haydn carried this idea to extremes in some of his music, notably in one of a set of ten canons on texts of the Ten Commandments from the New Testament. Also called *canon cancrizans.*

crab dolly *Motion pictures, Television* A DOLLY that can move forward and backward, like any other, but also sideways. Since free-turning wheels would be treacherous in a studio situation, most crab dollies are motorized and the direction of their wheels is under tight control.

crab the turn *Acting* To spoil another actor's action, *e.g.,* by moving so that it occurs in the wrong direction or failing to react to it.

cradle *Stagecraft* Any STRUCTURE, FLOWN or fastened in place in the FLIES, that will support something movable in that position, *e.g.,* the metal structure around a COUNTERWEIGHT ARBOR, a tilting box that can be seesawed back and forth to drop simulated snowflakes into the set, or a sling (like a bosun's chair) built to support a technician working among the lighting fixtures.

crafts *Motion pictures, Theater* All the technicians in the production, including carpenters, stagehands, electricians and audio and video engineers. Usually they are members of CRAFT UNIONS.

craft union *Motion pictures, Theater* Unions whose members form the technical staffs of productions. *See* CRAFTS.

crane *Motion pictures, Television* A derrick mounted on a large dolly, designed to carry a camera and its crew at various heights in various places in the studio during a shooting session, in almost perfect silence and with no perceptible vibration.

crane operator *Motion pictures, Television* The technician who operates the crane carrying a camera crew, according to the director's orders that come through HEADPHONES from the CONTROL BOOTH.

crane shot *Motion pictures, Television* A shot taken from a crane.

crash box *Stagecraft* A steel or wooden box full of metal and glass debris that will produce a convincing crashing sound when properly dropped or shaken.

crash cymbal *Music* A 14- or 18-inch CYMBAL made much thinner than other cymbals, used for heavy accents. In a marching band the player holds a pair of crash cymbals, one in each hand, and brings them together in a vigorous diagonal sweep to produce the crashing sound.

crash machine *Stagecraft* A machine designed to toss a built-in CRASH BOX around to produce the sound of an automobile accident without putting the people backstage in danger.

crawl *Motion pictures, Television* A string of words that moves across the bottom of the screen, often superimposed on the picture, to give the audience a message. Not to be confused with a SCROLL, which moves upward.

create a part, create a role *Acting*　To establish the basis for acting a role for the first time. In practice, the actor who first plays a given role in professional theater gets credit as the creator of that role even when someone else plays it subsequently in the movies or on television.

credit *Acting*　Official recognition in the program or on the screen of an actor in a specific role, or an author, composer, arranger, choreographer, designer or other functionary in the production.

credit list *Theater*　The official list of all the people in a production, together with their functions.

credits *Acting*　An actor's list of roles played and the productions played in.

Motion pictures, Television　The list of all the people who took part in the production together with the functions they performed, as well as all the specialized cameras, film stock and other equipment used, that appears (usually as a SCROLL) at the end of the show.

Credo (*KRAY-doh*) [Latin] *Music*　Literally, I believe. A major part of the MASS.

creep *Audio*　*See* AUDIO CREEP.

creepie-peepie *Television*　A small, handheld video camera.

creme makeup *Makeup*　Any makeup with an oil or water base.

crepe (crepe hair) *Makeup*　False hair that can be shaped and attached to an actor's face to provide him with a beard.

crescendo (*kreh-SHEN-doh*) [Italian] *Music*　Literally, grow or increase. 1. Growing louder. 2. A gradual increase in volume of sound. 3. A

CRESCENDO

musical symbol consisting of a pair of diverging lines indicating that the associated notes are to grow louder. The opposite is DECRESCENDO.

crew *Stagecraft, Motion pictures*　Stagehands and technicians as a group.

crisis *Theater*　The point at which the main conflict of a play, having reached its greatest tension, resolves. From the Greek word *krisis*, decision.

crit *Acting*　Short for criticism. *See* CRITS.

critic　A journalist or broadcaster who reviews performances and publishes or broadcasts opinions about them.

critique　A detailed technical assessment of a performance.

Acting　A director's NOTES, discussed at the end of a rehearsal, assessing each actor's effectiveness and suggesting changes. *See also* CRITS.

crits *Acting* 1. A director's NOTES to the cast after a rehearsal, pointing out problems and suggesting changes. 2. Critics' published or broadcast reviews of a performance.

croisé (*krwah-ZAY*) [French] *Ballet* Literally, crossed. A pose with the body at an oblique angle to the audience, with the WORKING LEG crossed in front or in back.

croisé derrière (*krwah-ZAY der-ree-AIR*) [French] *Ballet* A position with the body at an oblique angle to the audience, with the WORKING LEG (toe pointed) extended back in FOURTH POSITION on the ground, or raised up to fourth position in the air. One arm is curved above the head on the side of the supporting leg and the other extended to the side. One of the POSITIONS OF THE BODY in the CECCHETTI METHOD.

croisé devant (*krwah-ZAY deu-VANH*) [French] *Ballet* The reverse of CROISÉ DERRIÈRE, with the working leg (nearer the audience) extended or raised forward instead of back, and the position of the arms reversed accordingly. One of the POSITIONS OF THE BODY in the CECCHETTI METHOD.

cromorne *See* CRUMHORN.

crook *Music* A removable portion of the tube of any brass instrument, shaped like the letter *U*, that can be adjusted for tuning. Instruments with valves usually have small crooks associated with each valve that add length to the column of air passing through the instrument when the valve is pushed, lowering its tone accordingly. The most visible of all crooks is the TROMBONE's slide.

croon *Music* In American popular music, particularly during the 1930s and 1940s, to sing a love song in a quiet, romantic manner.

crooner *Music* A singer (usually male) of popular songs who specializes in CROONING. Bing Crosby was one of the most famous, but there were many others during the 1930s and 1940s.

cross *Acting* 1. A movement across the stage. 2. To cross the stage.

cross fade *Lighting* To dim one light or circuit while increasing another as a single lighting cue.

cross fader *Lighting* A DIMMER that controls two circuits at the same time, reducing one and increasing the other.

cross in *Acting* To cross in front of another actor, moving toward the center of the stage.

cross light *Lighting* To set up a lighting fixture so that its beam crosses the stage to illuminate an area beyond the center line, *i.e.,* at an angle nearer to horizontal.

crossover *Theater* 1. Any passageway behind the set that permits an actor to cross from one side of the stage to the other without being seen. 2. Any aisle between, and parallel to, the rows of seats in the auditorium that permits members of the audience to move from one side of the HOUSE to the other without stepping over each other. *See also* AMERICAN PLAN SEATING, CONTINENTAL SEATING.

crossover album *Music* Recorded music that appeals to an unexpectedly large audience, such as a RAP album that arouses interest and enthusiasm among people who like JAZZ and might not normally enjoy the rap style.

cross relation *Music* The harmonic or melodic coincidence of a given tone and its augmented or diminished octave, *e.g.,* a melodic leap from G to g# (an augmented octave), or a harmonic ambiguity consisting of a major triad with a minor tenth added. Sometimes called "false relation."

cross rhythm *Music* *See* POLYRHYTHM.

crosstalk *Audio* Unwanted leakage of audio signal between two different audio circuits, so that each carries not only its own signal but a little of the other's.

crotales (*kroh-TAH-lehs*) [Spanish] *Music* Small cymbals with a high bell-like sound, played in pairs by clashing one against another. Modern crotales are cast in bronze and range from c^2 to e^4 (*see* OCTAVE NAME SYSTEM). They are also called antique cymbals, or finger cymbals.

crotchet *Music notation* The British name for the QUARTER NOTE. Oddly, the word derives from the French *crochet* (*kroh-SHAY*) for hook, because of confusion arising from the use of a flag (*i.e.,* a hook) on its stem in ancient notation, like the modern eighth note.

crowd *Music* *See* CRWTH.

Crucifixus (*kroo-chee-FICK-soos*) [Latin] *Music* A part of the Roman Catholic MASS, describing the crucifixion and burial of Christ, often treated by composers as an important section of a musical mass.

crumhorn *Music* A small, OBOE-like instrument of the 15th and 16th centuries, shaped like the letter *J*. It was very popular with ecclesiastical painters as an appropriate instrument for painted angels to play. Unlike the oboe, its double reed is enclosed in a mouthpiece so that the player's lips cannot touch it. Because of this, its tone is unvarying, much like the tone of a reed stop on the organ.

crusis *Music* The main accent of a musical measure, represented as the beat written just after the BARLINE. The DOWNBEAT. *Compare* ANACRUSIS, METACRUSIS, UPBEAT.

crwth (*krooth*) [Welsh] *Music* An ancient instrument of six strings, played with a BOW.

crystal sync *Motion pictures* A speed control system that maintains synchrony between a camera and a tape recorder, once they have been started IN SYNC, by controlling the frame speed of the camera and the recording speed of the tape recorder with absolute precision, based on the (very high) frequency of vibration of a crystal built into the control systems of each machine. Once started (*see* SLATE) the camera and the tape recorder will stay aligned throughout a SHOT without need for interconnecting wires. *See also* DOUBLE SYSTEM.

csárdás *See* CZARDAS.

CU *Motion pictures* Abbreviation for CLOSE-UP.

cuadro flamenco (*KWAH-droh flah-MENK-oh*) [Spanish] *Dance* Literally, Flemish (*i.e.,* gypsy) quarter. A DIVERTISSEMENT once danced by gypsies living in the caves of Andalusia in southern Spain, characterized by gradually increasing tempo and intensity of movement.

cucaloris, cuckaloris, cucoloris *See* COOKALORIS.

cue *Acting* 1. A signal: a spoken line, gesture or some other event on stage to which an actor responds with action or speech. 2. To signal to an actor to take the next line or action.

Music 1. A short excerpt from another PART, usually appearing before an entrance or a long rest, giving an instrumentalist a precise reference in the music with which to coordinate the entrance. 2. A signal that may be a spoken line, a gesture, an event on stage or sometimes a beep in the conductor's HEADPHONES, to start playing a specific piece of music. *See also* MUSIC CUE.

Lighting A notation in the lighting director's script to make a specific change in lighting, *e.g.,* to DIM or to BRING UP a circuit. *See also* WARNING CUE.

cue bite *Acting* An actor's mistake, anticipating or reacting too quickly to a cue. To "step on a CUE."

cue biter *Acting* An actor who frequently anticipates CUES.

cue-bound *Acting* Said of an actor who habitually needs frequent prodding to react to CUES.

cue capacity *Lighting* The maximum number of lighting changes that can be PRESET and handled in sequence by a control system.

cue card *Acting* A large card, held by someone out of camera view but within the actor's view, displaying the actor's lines for a specific SHOT.

cue feeder *Acting* A person on or off stage, often not the prompter, who whispers cues to a CUE-BOUND actor.

cueing *Broadcasting* The process of aligning a recording so that it will be ready to play when its time comes.

Motion pictures The process of aligning the various strands of picture and audio recording (*i.e.,* one or many sound tracks) so that they will play IN SYNC during the process of EDITING or MIXING.

cue light *Stagecraft* A small light, hidden from the view of the audience but visible to the proper person on or back stage, that can be switched on to give that person a CUE. Sometimes a cue light will be switched on as a WARNING CUE and then switched off as the cue itself. Such lights are most frequently set up to cue specific functions, such as to open or close the main curtain, to bring up or to dim the house lights, or to start the music.

cue lines *Acting* The individual lines an actor needs to react to during performance, hence the lines, or parts of lines, that can be read to that actor during the learning process, to help in memorizing a role.

cue list, cue sheet *Audio* A detailed, numbered list of SOUND EFFECTS and MICROPHONE activations for a show, showing their timings, levels, relationship to lines in the script and other necessary details.

Music A detailed, numbered list of music CUES for a show, motion picture or video recording, showing timings, dynamics and all necessary details for precise synchronization with whatever occurs on stage or screen.

Stagecraft A detailed, numbered list of CUES required for a specific function (*e.g.,* lighting, curtain pulling, prop handling, sound effects, scene shifts), numbered and in chronological sequence.

Lighting A list of all the lighting CUES required for a show, including the cue number, its timing in seconds and all necessary details of circuits, DIMMERS and other items to be controlled, keyed to cue numbers that are marked into the script.

cue-struck *Acting* Said of an actor who is suddenly struck speechless on stage, having a critical lapse of memory of what to say or do at a specific CUE.

cue tape *Stagecraft* An audio tape containing music and/or sound effects for a show, in proper order and each preceded by a bright white leader so it can be CUED UP during the performance.

cue up *Audio, Broadcasting* To place a recorded tape or disc in position so that it will play the right sound at the right intensity and speed immediately when it is switched on.

cuke *See* COOKALORIS.

cumulative form *Dance* The form of any dance that is characterized by building up more and more movement from a relatively simple beginning, or by adding more and more dancers as the work progresses.

cup-and-saucer drama *Acting* Any play whose action consists mainly of conversation over tea or coffee.

curtain *Stagecraft* Although there may be many fabrics draped here and there on the stage, the term generally refers to the main curtain opened (or raised) at the beginning of the act or play and closed (or lowered) at the end. By extension, the end of the act or play.

curtain call *Acting* A reappearance of an actor or the cast in front of the closed curtain after the end of the play to receive the applause of the audience. *See also* BOW, BREAK A LEG, CURTAIN PAGE.

curtain cue *Stagecraft* A cue to the CURTAIN OPERATOR to open the curtain at the beginning of an act, or to close it at the end. It may also be the cue for CURTAIN MUSIC. *See also* SLOW CURTAIN.

curtain cyclorama *Stagecraft* A cloth curtain hung across the entire width of the stage, at the back.

curtain grip *See* CURTAIN OPERATOR.

curtain guides *Stagecraft* Metal channels that guide a curtain as it opens or closes.

curtain line *Acting* The line that tells the audience and the curtain operator that the play is over. The last line of the act or play. *See also* COUPLET.

Stagecraft An imaginary line across the stage floor that the curtain will touch when it is closed.

curtain man *Stagecraft* *See* CURTAIN OPERATOR.

curtain music *Theater* Music chosen or composed for a show's ending.

curtain operator *Stagecraft* A stagehand who opens or closes the stage curtain on cue.

curtain page *Stagecraft* A stagehand who walks behind the leading edge of the curtain, out of sight of the audience, to guide it as it moves toward the center and to be ready to pull it back enough to let the actors go out, one by one, for curtain calls. There may be two curtain pages, one for each side of the stage.

curtain pull *Stagecraft* 1. The act of opening or closing the curtain. 2. The person who opens or closes the curtain.

curtain raiser *Theater* A scene or short play performed before the main attraction. Some curtain raisers are mere skits, designed to WARM UP the audience. They are performed in front of the curtain, hence the name.

curtain routine *Stagecraft* The sequence of CUES and moves by which the curtain is opened or closed in a specific production.

curtain scene *Acting* The final scene that ends an act or a play. It usually includes lines that wrap up loose ends in the plot and indicate to the audience that an ending is taking place.

curtain set *Stagecraft* A setting defined by curtains and cloth DROPS instead of construction or ordinary FLATS.

curtain shutter *Lighting* A thin metal sheet installed at the focal plane of a SPOTLIGHT which can be adjusted to shape the beam or black it out.

curtain speech *Acting* 1. An actor's last speech just before the final curtain of the act or the play. 2. An actor's speech, in character in front of the curtain, after the end of the play.

curtain time *Theater* The scheduled time for a performance to begin.

curtain warmers *Lighting* Lights, usually FOOTLIGHTS, in front of the main curtain, brought up to quiet the audience and focus their attention on the stage just before the play is to begin.

curved cross *Acting* Crossing in front of another actor in a curving line.

cushion time *Theater* Extra time included in a production schedule to allow for unforeseen delays in constructing the set.

cut *Acting* 1. A line, or several lines in a sequence, eliminated from the script. 2. The point in the script where a cut has been made. 3. To eliminate lines from a script.

Audio 1. A director's order to stop recording. 2. Any single segment of program material included in a completed recording. 3. A single piece of magnetic tape containing recorded material. 4. To record, *i.e.,* to "cut a disk." Derived from the fact that recordings, in their early days, consisted of tracks actually carved into a spinning disk by a stylus.

Motion pictures 1. A director's order to stop shooting. 2. In traditional film editing, the act of cutting a strand of film and its related sound track. 3. A piece of film or sound track that has been deleted. 4. A particular version of a finished film, as determined by the way it has been edited, *e.g.,* the director's cut. 5. Any single SHOT in a sequence. 6. To EDIT a film by eliminating unwanted portions and cueing in desired shots in their proper order.

Television 1. A director's order to stop recording. 2. To end a shot by switching away from it. If the show is being broadcast or taped in REAL TIME, a cut necessarily consists of switching directly to something else, to a different camera's scene or another prerecorded tape.

cutaway *Motion pictures* A WILD SHOT taken during a shooting session (but not necessarily called for in the script) that may come in handy during the editing process as a device to cover a camera shift or any other unwanted sight, during the scene. A typical cutaway shows the face of actor B, ostensibly listening while actor A talks, and it will have been shot separately, perhaps without A's presence anywhere on the set. Cutaways become necessary, for example, when an editor cuts out one phrase in a sentence spoken by A, and finds in the corresponding visual strand that A's head seems to jump where the cut was made. Only the insertion of a cutaway can cover such a JUMP CUT.

cut drop *Stagecraft* A DROP with openings cut into it, to allow the audience to see other drops hung behind it, creating a three-dimensional effect. The openings are often reinforced with theatrical net. The drop may be cut irregularly to represent openings in foliage, or in straight lines for architectural vistas. *See also* LEG DROP.

cut in *Motion pictures* To replace part of a shot with something else, such as a CUTAWAY.

cut line *Stagecraft* A rigging line that holds the FIRE CURTAIN in the FLIES behind the proscenium, but which can be cut instantly in case of emergency, letting the curtain drop into position.

cutoff *Lighting* The edge of the beam of a focused light, especially a light that has been shaped by BARN DOORS or a COOKALORIS. The gaffer locates the cutoff of a specific light by FLAGGING it with a hand in the beam.

cut of the gate *Theater* A share of the GROSS.

cut-out *Lighting* 1. Any shaped opening in a GEL or a COOKIE. 2. Any light mask with an opening cut into it. *See also* WHITE SHADOW.

Stagecraft Any shaped opening in a FLAT, a LEG DROP or an array of flats.

cut-out setting *Stagecraft* A setting framed by a CUT-OUT.

cut step *Dance* A step in place to permit a change of weight to the other foot.

cutter *Lighting* See FLAG.

 Motion pictures, Television An editor.

cut the buck *Dance* To dance the BUCK AND WING.

cutting contest *Music* A competitive sequence in a JAZZ performance or a JAM SESSION during which individual musicians or groups attempt to outdo each other in improvisations.

cut to the chase *Motion pictures* A metaphorical instruction to stop beating around the bush and get to the exciting material. *See* CHASE.

cut wing *Stagecraft* A wing with a shaped edge that, when painted, will suggest a setting such as a garden.

cyc, cycs, cyke Short for CYCLORAMA.

cycle *Theater* A series of related plays having to do with the development of a particular idea, such as the chronology of the Kings of England in Shakespeare, or the story of Agamemnon's family in the plays of Sophocles.

cycle of fifths *Music* A progression of harmonies whose ROOTS move by intervals of a FIFTH, from C to G, to D, to A and so on. For the sake of practicality, every second change is actually inverted (*i.e.*, goes down a FOURTH instead of up a fifth), but the harmonic effect is unchanged. In music notation, twelve such moves brings back the original harmony, but in acoustic reality that is only true with an EQUAL TEMPERAMENT. Also called circle of fifths.

A CYCLE OF FIFTHS BUILT ON C
(WITH ENHARMONIC ADJUSTMENT)

cycle of fourths *Music* A progression of harmonies whose roots move at intervals of a fourth; from C to F, to B-FLAT and so on. For the sake of practicality, every second change is inverted, going down a fifth, instead of up a fourth, but the harmonic effect is unchanged. In music notation, twelve such moves brings back the original harmony, but in acoustic reality that is only true with an EQUAL TEMPERAMENT. Also called circle of fourths.

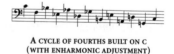

A CYCLE OF FOURTHS BUILT ON C
(WITH ENHARMONIC ADJUSTMENT)

cyclorama *Stagecraft* The visible surface across the rear of the set, generally curved and carefully lighted to hint that it is endless. Not to be confused with the rear wall of the stage.

cyclorama arms *Stagecraft* Short BATTENS hinged to each end of a main batten and carrying the side panels of a triple-panel cyclorama. *See* ARM CYCLORAMA.

cyclorama base *Stagecraft* 1. The bottom of the CYCLORAMA. 2. A pit or trough along the bottom of the cyclorama containing lights, hidden from the audience, that illuminate it.

cyclorama borderlight, floods, footlights, overheads *Lighting* Lights placed and aimed to bathe the cyclorama in light without unwanted shadows from other items in the set.

cyclorama set *Stagecraft* Any set designed to include a CYCLORAMA.

cymbal *Music* A disk of metal, shaped as a shallow dish, designed to produce a clashing tone of indeterminate PITCH when struck with a DRUMSTICK or other beater. The best cymbals are made of brass wire, carefully laid in a tight spiral of a single thickness, fused together and formed by pressing on a spinning lathe. Most have a raised dome in the center. Individual cymbals are usually mounted singly on vertical stands, and arranged according to size and, therefore, to tone. The smallest cymbals that produce a ringing tone of definite pitch instead of a clash are called CROTALES. Large cymbals range up to 16, 20, even 24 inches in diameter. The largest of all, 30 to 36 inches in diameter, are TAMTAMS, shaped without the dome but with a rounded edge that adds a different quality to what is, because of their very large size, a deep tone. *See also* SIZZLE CYMBAL, RIDE CYMBAL, HI-HAT, CRASH CYMBAL.

cymbalom *See* CIMBALOM.

Czardas (*CHAHR-dahsh*) [Hungarian] *Dance* A Hungarian folk dance dating from the Middle Ages, consisting of a slow movement and a fast one in 4/4 or 2/4 time. In ballet it is referred to as a CHARACTER DANCE.

D

d *Music* The second note of the scale of C, a MAJOR SECOND above C and a PERFECT FIFTH below A. The KEY of which the note D is the TONIC. In the FIXED-DO SYSTEM, D is RE.

D *Theater* DOWNSTAGE. *See* STAGE AREAS.

da capo (*dah KAH-poh*) [Italian] *Music* Literally, from the head, *i.e.,* from the beginning. An instruction to the player to go back to the beginning of the piece, or the section just played, and repeat it. The DA CAPO section usually ends with a DOUBLE BAR indicating the end of the portion to be repeated. If that point is not the final measure of music, the original instruction will read "da capo AL CODA" or "AL FINE." If the instruction "da capo" occurs at the end of a FIRST ENDING, it is understood that the player will repeat the section and end with the SECOND ENDING. *Compare* DAL SEGNO.

dailies *Motion pictures* The first WORKPRINTS made from ORIGINALS shot the day before. In traditional production of a motion picture it is standard procedure for the director and, usually, the editor to take time every morning to see all the uncut footage shot the day before, just as it comes from the laboratory (as a time-coded WORKPRINT in either film or video form). Armed with a SHOTLIST and a LOG of yesterday's shooting session, they make preliminary selections among the many TAKES to be used in the film. Also called rushes.

Dalcroze Eurythmics *Music* A fundamental approach to the study of music through the integration of three kinds of nonverbal experience: the physical (kinesthetic) experience of RHYTHM, the acoustical and tonal experience of SOLFÈGE, and the experience of spontaneous musical creation through IMPROVISATION, named for the Swiss composer and music educator Émile Jaques-Dalcroze. The first complete school of music based on it was established in New York City in 1915. Because it is based on the constant interaction of rhythmic movement, aural perception and improvisation, it is a holistic approach to music education and provides incomparable training in ENSEMBLE, basic not only to musicians and dancers but also to actors and all performers.

dal segno (*dahl SEN-yoh*) [Italian] *Music* Literally, from the sign. An instruction to go back to the place marked with the symbol shown below and repeat the passage until the expression AL CODA or the word FINE appears, or to the last written measure of music.

SIGN (SEGNO)

damper *Music* A small felt pad that the mechanism of the piano or harpsichord lowers onto the string when the player's finger lifts off the KEY, or the player releases the SUSTAINING PEDAL. It deadens the vibration of the string, causing its sound to cease.

damper pedal *See* SUSTAINING PEDAL.

Dampit *Music* Trade name for a humidifying device consisting of a small cloth bag shaped to fit inside the sound box of a violin or viola, containing a water-absorbing material that, when dampened, will help keep the instrument from drying out during a rehearsal or concert in air-conditioned space.

dance 1. Movement of the feet and body in a rhythmic manner, especially to music. 2. A formal composition of bodily movements in a defined space and with a structure in time. *See* BALLET, MODERN DANCE. 3. A social gathering for the purpose of dancing. *See* BALL, BARN DANCE, FOLK DANCE. 4. To move the body in a formal manner in a defined space in coordination with rhythmic patterns or music. Dance has been a major form of artistic expression since the earliest times. Classical Greek drama was performed by three actors and a chorus of singing dancers. During the Middle Ages, dance was not only popular among ordinary people, it was also an important element of entertainment in the otherwise stony atmosphere of the castles of the nobility. In the 14th and 15th centuries, creators and directors of dance in various courts became celebrities. Many have left detailed choreographic descriptions from which modern dancers can re-create their compositions with some precision. But the music they danced to, for which notation was not as well developed, is only indirectly known. Dance in the particular theatrical form we know as ballet reached a peak at Versailles in the court of Louis XIV, where Jean-Baptiste Lully and other great composers wrote for it. Social dancing entered a golden age in Vienna with Carl Maria von Weber's *Invitation to the Dance* in 1815, and achieved international popularity with the magnificent waltzes of Johann Strauss (both senior and junior).

Music 1. Any piece of music based upon repeating rhythmic patterns and phrases that can be related to the natural movement of the human body. 2. A musical composition based upon a dance, *e.g.,* the GAVOTTE, MAZURKA, PASSEPIED, WALTZ. *See also* SUITE.

dance band *Music* A band that provides the music for social dances. *See also* BIG BAND. *Compare* JAZZ BAND.

dance company A group of dancers who perform regularly together, and their supporting personnel.

dance director *Musical comedy* One who stages the dance portions of REVUES, MUSICAL COMEDIES and the like, not necessarily the CHOREOGRAPHER.

dance drama *Dance, Theater* A drama in the form of dance, with a PLOT worked out in movement, often with PANTOMIME. Not the same as a play with dances. Dance dramas have been created in many styles, including BALLET and MODERN DANCE. *See also* GIGAKU.

dance form *Music* Any musical form based on rhythmic patterns and phrases that have been, or could be, related to the natural movements of the human body dancing.

dance hall A public establishment that offers its customers dancing space, music and refreshments for a modest admission fee.

dance notation Any system of notation that provides both a way to record choreographic events and ideas, and a way to read them with sufficient accuracy to re-create the dance that was so recorded. There are two well-known systems in present use: LABANOTATION and BENESH DANCE NOTATION SYSTEM. *See also* CHOREUTICS, CHOROSCRIPT.

dance of death *Theater* A symbolic scene in a medieval MYSTERY PLAY in which the Angel of Death, before whom rich and poor are equal, appears as a rotting corpse or a skeleton, perhaps carrying a scythe as his CHARACTER PROP, and leads his victim(s) away to the netherworld. It was a popular subject for painters of the 15th and 16th centuries because it allowed so many opportunities to depict sinners of all kinds paying for their misdeeds. Similar scenes have appeared often in ballets, plays and movies; sometimes the Devil, represented as a fiddler, plays a vigorous accompaniment. A recent example appears in the final sequence of Ingmar Bergman's film masterpiece *The Seventh Seal.* Also called DANSE MACABRE, TOTENTANZ.

dancer *Dance* One who dances, particularly one who performs in dance.

dancing mat *See* TAP MAT.

danse d'école (*DANHS day-KOL*) [French] *Ballet* The academic ballet techniques attributed to the dancer and dancing master Pierre Beauchamps in the late 1600s. Beauchamps expanded and developed the movements of traditional French society dances (*see* BALLET DE COUR) into a method based on the five POSITIONS OF THE FEET and the TURN-OUT.

danse macabre (*danhs mah-KAH-breu*) [French] *See* DANCE OF DEATH. The French name refers to the biblical Maccabaeus.

danseur (m) (*danh-SEUR*), **danseuse** (f) (*danh-SEUZ*) [French] *Ballet* A dancer. *See also* PREMIER DANSEUR.

danseur noble (*danh-SEUR NOH-bleu*) [French] *Ballet* 1. A dancer of princely roles. 2. A leading dancer skilled in the classical style.

danza (*DAN-tsah*) [Italian] Dance.

dark *Theater* Closed. Said of a theater with no production running, hence no lights in the marquee.

dark change *Stagecraft* A change of scene with the stage wide open to the audience, but with stage lights and house lights off.

darken *Acting* To play the role or the scene more somberly, perhaps more ominously.

day-for-night *Motion pictures* An old technique for shooting scenes in daylight that would look like nighttime scenes when projected on the screen. In the early days of motion pictures, the emulsion on a strand of film required a relatively long period of exposure to light to register any sort of image. Since it moved through the camera (then) at about one foot (16 frames) per second, dark scenes simply would not come out. Since cameras were not motorized, movie directors hit on the idea of shooting such scenes in bright daylight UNDERCRANKED, *i.e.*, with the camera operator cranking the film through as slowly as he could without losing his steadiness.

The actors would then go through the scene in equally slow motion, taking several seconds, for example, to make a simple gesture of the arm. Thus the exposure on each frame was long enough to register with a very small lens opening, making everything a bit underexposed, *i.e.,* murky. When projected at ordinary speed the audience was too interested in the story to notice any unintended jerkiness on the screen.

day set *Stagecraft* A stage setting for the opening act of the evening's performance, put in place during daylight hours.

db *Audio* Short for DECIBEL.

DBO *Lighting* Abbreviation written into the stage manager's and lighting director's cues indicating a DEAD BLACKOUT.

DC *Acting* Downstage center. *See* STAGE AREAS.

D. C. *Musical notation* Abbreviation for DA CAPO.

dead *Audio* Said of an audio circuit that carries no signal whatsoever. Disconnected.

Stagecraft Said of scenery and/or PROPS that can be removed and stored because they are no longer required.

dead act *Theater* An act that completely fails to interest the audience.

dead air *Audio* A period of time during which the only sound to be heard through loudspeakers or headphones is the barely perceptible hiss of their electrical circuitry. In the early days of radio, dead air indicated that the broadcasting station was malfunctioning. In modern times dead air still comes across as a disturbing DROP-OUT of the signal, which editors of film and video correct by the insertion of ROOM TONE.

dead area *Lighting* An inadequately illuminated area of the stage. *Compare* DEAD SPOT.

dead blackout *Lighting* A period of time when the stage is completely dark, when the stage lights and the house lights are turned off. Sometimes abbreviated to DBO.

dead cue *Acting* A precise cue. A cue that requires exact synchronization, *e.g.,* a cue for a DEAD BLACKOUT at the instant an actor speaks his final word. *Compare* EMPHATIC CURTAIN.

dead fold *Costume* A way of draping a full skirt so that the fabric falls straight down.

dead-front board *Lighting* Any control board whose front panel (where the operator will actually handle the controls) has no power circuits and is therefore safe to touch.

dead-front plug *Lighting* A PLUG (or a socket) that has no exposed metal on its front surface that might be a source of danger.

dead-hang, dead-hung *Stagecraft* To hang a DROP, a curtain or a FLAT directly from a BATTEN without any RIGGING that would permit it to be raised or lowered.

dead house *Acoustics* A theater in which music and voices on stage are muffled and difficult to understand because of sound-absorbent construction in the SET or the HOUSE. A dead house has no RESONANCE.

Theater A completely unresponsive audience.

dead line *Acting* The imaginary line on the stage floor beyond which the audience cannot see action taking place.

Audio Any audio cable that is out of the circuit and therefore carries no signal.

Lighting Any lighting circuit disconnected from the source of power.

Stagecraft Any rigging line firmly tied down so that the attached scenery or drop cannot be raised or lowered.

dead man switch *Lighting* Any switch that cuts off electrical power automatically if its operator's hand is taken away.

dead march *Music* A slow, solemn march appropriate for use during a funeral. A CORTÉGE.

dead-on *Stagecraft* Said of any piece of scenery that has been placed exactly on its proper spot.

dead pack *Stagecraft* Any group of FLATS, temporarily stacked backstage, that will no longer be needed during the performance. *Compare* LIVE PACK.

deadpan *Acting* Expressionless, especially when something hilarious is going on.

dead season *Theater* Any period during which the theater is expected to be idle, such as winter for an outdoor theater. *Compare* DARK, OFF SEASON.

dead side *Audio* The low-response side of any directional microphone.

dead spot *Acting* A position on stage from which an actor's voice cannot easily be heard by the audience.

Audio Any part of the ACTING AREA that is inadequately MIKED.

Lighting A relatively small area in the scene that is inadequately lit.

dead stack *See* DEAD PACK.

dead stage *Dance, Theater* 1. A stage with no set in place. 2. A stage with inadequate resonance. Resonance in the set is important to actors, and in the floor is critical not only to dancers, especially tap dancers, but also to actors in pantomime and in several classical styles. The proper stage for the Japanese NOH, for example, is carefully constructed of tightly fitted boards, very much like the sounding board of a grand piano, and reverberates like an enormous drum.

dead-tied *Stagecraft* Said of any curtain, DROP or piece of scenery that is tied in place and cannot be moved by pulling RIGGING.

déboulé (*day-boo-LAY*) [French] *Dance* Literally, rolled over. A fast turn from one foot to the other, with a rolling movement. Often performed in a series, in a circle or in a straight line.

début (*day-BÜ*) [French] The first public appearance of a performer.

decay *Acoustics* The natural rate at which a sound diminishes to inaudibility after it has ceased being generated. There are two ways in which this happens. One is decay, the rate at which a reverberating source, such as the string of the piano, comes to rest after it has been actuated. The other is the rate at which the echo of any sound dissipates within a theater or concert hall, more accurately described as REVERBERATION TIME.

deceptive cadence *Music* Any CADENCE that resolves to an unexpected chord. A common example is a cadence starting with a MAJOR-MINOR SEVENTH chord on C that one expects to resolve into an F-MAJOR chord but resolves to D-MINOR instead.

decibel *Audio* Literally, one-tenth of a bel. A bel is a unit of the power of sound, named after Alexander Graham Bell. The decibel is therefore the convenient unit for measuring sound power (or pressure) at the ear as a ratio compared to a sound at the threshhold of audibility; its symbol is db. Normal conversation in a quiet interior room, for example, ranges around 60 db. City traffic at a busy intersection is around 75 db.

deck *Audio, Television* An audio tape or videotape recording machine.

 Stagecraft The floor of the stage.

deckhand *Stagecraft* Theatrical argot for a STAGEHAND.

declaim *Acting* To speak one's lines in an inappropriately loud, almost ritualistic, sing-song fashion.

declamatory *Acting* Overly loud and pompous, in a sing-song fashion.

décor (*day-KOR*) [French] *Stagecraft* The decorative style of a setting, including the design of its furniture and the coordinated style of its stage props, considered apart from the set itself.

decrescendo (*deh-kreh-SHEN-doh*) [Italian] *Music* Literally, decreasing. Gradually becoming softer. The opposite of CRESCENDO.

DECRESCENDO

dedans, en *See* EN DEDANS.

deejay [from DJ, the initials for disk jockey] *Broadcasting* A person who plays recordings of popular music over the air, frequently granting special requests from the listeners.

défilé (*day-fee-LAY*) [French] *Ballet* Literally, parade. A glorious presentation and parade of the Paris Opéra ballet company on stage, designed for special occasions, in which the entire CORPS DE BALLET appears and marches in strictly ordered groups or as soloists, depending on their individual places in the company hierarchy.

definition *Motion pictures, Television* The sharpness of perceivable detail in any shot.

dégagé (*day-gah-ZHAY*) *See* PAS DÉGAGÉ.

degauss *Audio, Television* To demagnetize, effectively erasing, a recorded tape.

dehors, en *See* EN DEHORS.

delay line *Audio* An electronic circuit in a recording or playback system that delays part of a signal briefly (perhaps only part of a second) and then sends it on, often at slightly lower volume than the original so that it sounds like an ECHO. By this means a recording made in an ordinary small studio can be altered to sound like a performance in a great hall. Formerly referred to as an echo chamber, or echo line.

delay time *Audio* The length of the period of delay produced in a DELAY LINE.

del Gesù (*del JEH-zoo*) [Italian] *Music* A violin made by Giuseppe Bartolomeo Guarneri, one of the master violin makers of Cremona, some of whose violins are still in use. *See also* AMATI, STRADIVARIUS.

delivery *Acting* The manner in which an actor speaks on stage, a combination of diction, timing and vocal resonance.

Delsarte method *Acting* A complete method of acting in which every gesture on stage and every element of an actor's DELIVERY is thoroughly and rationally analyzed and described. It was developed in France in the 19th century by François Delsarte.

Delta blues *Music* A BLUES style linked to the Mississippi Delta, usually performed solo and characterized by the use of a STEEL GUITAR played with a slide or STEEL. Some of the pioneer bluesmen in the style are Elmore James, Robert Johnson and James Cotton.

deluge curtain *Stagecraft* A large, perforated water pipe mounted above and in parallel with the main curtain of a theater that can, in an emergency, deliver a heavy spray of water to soak the curtain thoroughly so that it will not ignite if there is a fire onstage. *See also* WATER CURTAIN.

demi-plié (*deu-mee plee-AY*) [French] *Ballet* A half-bending of the knees. *See also* PLIÉ.

demi-pointes (*deu-mee-PWENHT*) [French] *Ballet* On the toes, but not on the tips of the toes, *i.e.*, on the balls of the feet. *See also* POINT.

demisemiquaver *Music* In Britain, a thirty-second note.

demotic *Acting* The popular style of pronunciation, as distinguished from scholarly style. The term generally applies to pronunciation in modern performances of classical Greek drama, that were plagued for years during the 19th century with an academically acceptable style of pronunciation that did not scan, *i.e.*, did not fall naturally from the tongue with smooth phrasing. Demotic pronunciation, though it may be less than authentic, does seem to scan in most of the plays.

demountable door, demountable window *Stagecraft* A PRACTICABLE door or window, mounted in an appropriate frame that is part of a constructed FLAT in such a manner that it can easily be separated from the flat for storage. *See* BREAKDOWN SCENERY.

denouement (*day-noo-MANH*) [French] *Theater* The dramatic RESOLUTION of the tensions of the plot after the CLIMAX of the play. In his discussion of tragedy, Aristotle uses a stronger expression, LYSIS, a deliverance. *See also* ANTICLIMAX.

depth of field *Motion pictures* The range of distance from foreground to background that will appear to be in focus through a given lens at a given focal setting. A measure of effectiveness that has particular importance for lenses which focus at long distance, such as telephoto lenses. A lens with little depth of field will pick out, for example, one or two people in a distant crowd but leave the images of the others quite fuzzy. With more depth of field, more people will be in focus.

depth stage *Theater* Any stage with exceptional usable depth behind the PROSCENIUM but not necessarily much acting area in front of it.

derma wax *Makeup* A soft wax used to build up facial thickness under makeup.

derrière (*deh-ree-EHR*) [French] *Ballet* Literally, behind, in back. Indicating a movement, step or placement of the arm or leg in back of the body. Also, some steps performed derrière have the working foot closed in back.

dervish *See* WHIRLING DERVISH.

descant, discant *Music* Generally, a vocal or instrumental line, freely written and ornamented, that accompanies and sounds above the main vocal line.

design *Costume* The costume designer's set of sketches for the costume makers (and, if appropriate, wig-makers) to follow, showing how the costumes for each role in the production should look after patterns have been worked out.

Lighting The lighting director's plan for lighting the stage, showing placement, GEL colors and aiming positions for lighting fixtures for the entire show but not their schedule of use from scene to scene, which is the function of the LIGHTING PLOT. *See also* BLOCKING.

Stagecraft The set designer's general plan from which precise working drawings can be made for building the set.

designer *Stagecraft* One who designs the sets, lighting or costumes for a production.

designer-in-residence *See* ARTIST-IN-RESIDENCE.

désis (*DHAY-sis*) [Greek] *See* ENTANGLEMENT.

desk *Music* A music stand in an orchestral setting. One desk commonly serves two string players playing the same part, or a single wind or other instrumentalist playing an individual part. In theaters with orchestra pits, the desk has its own shaded lamp that permits the musician to read the music when the house lights are down.

dessous (*deu-SOO*) [French] *Ballet* Literally, under. With the working foot passing behind the supporting foot.

dessus (*deu-SÜ*) [French] *Ballet* Literally, over. With the working foot passing in front of the supporting foot.

détaché (*day-tah-SHAY*) [French] *Music* With separate movements of the BOW, with each tone separated from its neighbor. The opposite of LEGATO but not the same as STACCATO.

detached *See* DÉTACHÉ.

détourné (*day-toor-NAY*) [French] *Ballet* Literally, turned aside. A pivoting turn on both feet toward the foot in back, thereby reversing the position of the feet.

deus ex machina (*DEH-us ex MAH-kee-nah*) [Latin] *Theater* Literally, god from machine. Any inexplicable event that saves the situation at the last moment in a play. In the classical Greek and Roman theater, an actor cast as one of the benevolent gods would be lowered into the scene in a little gondola or basket and would magically carry away the hero or the villain. The same idea became a cliché of 19th-century American melodramas, when the hero would burst into the scene waving the paid-up mortgage on the family homestead just in time to save the pretty girl from marrying the villain.

deuteragonist [Greek] *Theater* Literally, the second actor, one who takes secondary roles in classical Greek theater. Not the same as ANTAGONIST, who opposes the PROTAGONIST. *See also* COMPRIMARIO.

devant (*deu-VAHN*) [French] *Ballet* Literally, in front. Indicating a movement, step or placement of the leg or arm in front of the body.

development *Music* The composer's process of working with a previously stated theme, adding new ideas to it, and creating new interrelations between its elements. One of the defining characteristics of both FUGUE and SONATA FORM is the development section that follows the statement of its theme(s).

Theater 1. The process of filling in previously unknown details of a role, or of the plot. 2. The process of revealing the basic situation of the plot during the opening scene(s) of a play, through dialogue and action. *Compare* DIRECT EXPOSITION. 3. In classical Greek drama, the actions and dialogue during which the conflict (agon) initiated in the opening scenes create EPITASIS (stretching and straining) that expand in complication and complexity and lead inexorably through a REVERSAL OF CIRCUMSTANCES to the CONFRONTATION WITH FATE.

développé (*day-vel-lo-PAY*) [French] *Ballet* Literally, developed. The unfolding of the WORKING LEG by drawing its foot up to the knee of the supporting leg and slowly extending it to an open position in the air, as for an ARABESQUE. Développés are performed in several positions, with the hips held level and square to the direction in which the body faces.

DGA *See* DIRECTORS GUILD OF AMERICA.

diabolus [Latin] *Music* Literally, the devil. The TRITONE (AUGMENTED FOURTH or DIMINISHED FIFTH), an interval that was considered dangerous in medieval and early contrapuntal music because it produced tension that seemed to demand a resolution against the regular harmonic flow of the piece.

diagonal cut *Audio* A cut made at a slant across a strand of magnetic tape. A splice made with a diagonal cut will not be heard as a click when the TRACK is played back. *Compare* STRAIGHT CUT.

dialect *Acting* Any style of speech with strong regional pronunciation and vocabulary.

dialogue *Theater* Generally, the spoken lines of any play. More particularly, lines spoken in scenes with more than one actor. Although the word, strictly defined, indicates that only two actors will speak, in modern usage there is no such limit. *Compare* MONOLOGUE, SOLILOQUY.

dialogue track *Motion pictures* A sound track containing only the dialogue spoken by actors during the SHOOT. All other sounds, usually music and sound effects, are recorded at separate recording sessions on other tracks. *See* DOUBLE-SYSTEM, M & E TRACK.

diamond horseshoe *Theater* The first balcony of a large, richly appointed theater, frequently decorated with gilt and lavish carving, sometimes designed with BOXES. The DRESS CIRCLE.

dianoia [Greek] *Theater* Thought and meaning, along with skill, the third most important ELEMENT of formal drama as defined in Aristotle's *Poetics*.

diapason *Music* The fundamental STOP of the organ, its PRINCIPAL.

diapason normal pitch *See* CONCERT PITCH.

diaphragm *Audio* The sensing element within a microphone.

Lighting *See* IRIS.

diapositive *Lighting* 1. A GEL with several areas of different colors arranged to produce an image in those colors (usually intentionally vague) when projected on the setting. Not the same as a COLOR BOOMERANG. 2. A photographic transparency intended for projection as part of the scenery on stage.

diatonic scale *Music* Any scale that rises from its ROOT or TONIC note to its OCTAVE in seven steps, of which five are WHOLE TONES and two SEMITONES. The actual sequence of whole tones and semitones determines the kind of scale. In general, any scale that begins with two whole tones is a MAJOR SCALE. Any scale that begins with one whole tone followed by a semitone is a MINOR SCALE.

dichroic filter *Lighting* A coating on a lens or a reflector, intended to cut down the amount of heat transmitted through it, *i.e.,* to cool the beam without perceptible change of color. A dichroic filter transmits one color of light and reflects another.

Television A filter that separates the red, green and blue components of the shot so that they can be rebalanced in the camera.

dichroic lens *Lighting* A lens with a dichroic coating.

dichroic reflector *Lighting* A reflector with a dichroic coating inside the housing of a flood-light or spotlight.

diction *Acting* Clarity of speech, particularly the clear pronunciation of consonants. Diction and projection are the most important factors that make a spoken or sung line intelligible to the audience. Since the stage, by definition, is set apart from the audience, clarity requires far more emphasis in performance than in daily life. Stage actors and singers learn to exaggerate their diction when they are in performance. One famous coach used to say, "Use more teeth!"

Theater One of Aristotle's six essential elements of drama. Besides the actor's clarity of speech, his term includes the playwright's art and science of PROSODY. It is the language and its form with which the playwright carries on the PLOT.

didactic drama *Theater* Drama that teaches, including not only plays that recreate historical events for the edification of audiences, but also plays written especially to instruct, such as the little skits that appear on television to teach children how people relate to one another in ideal situations, or full-length dramas intended to teach people about social and political ideas. Among the great dramatists who practiced didacticism were Aristophanes, George Bernard Shaw and Clifford Odets.

die *Acting* To pause in confusion on stage, having failed to get any reaction from the audience.

died *Acting* Said of a line, a scene or even a play that completely failed to get a reaction from the audience.

differential dimming *Lighting* Simultaneous dimming of more than one circuit with two or more dimmers operating at different speeds so that the overall color of the scene is, or is not, altered as its intensity changes. This capability, for example, allows the lighting director to turn the stage briefly red as all the lights fade out at the end of Mozart's opera *Don Giovanni*. Also called PROPORTIONAL DIMMING.

differential tone *See* COMBINATION TONE.

diffuse *Lighting* To spread and defocus, *i.e.,* soften, a beam of light so that its effect is more subtle in the scene.

diffuser, diffusing filter *Lighting* Any device or material fitted in the COLOR FRAME or placed in front of a light fixture to diffuse the emitted light. *See also* COOKALORIS.

diffuse reflection *Lighting* The softened effect of a light that illuminates a surface indirectly after reflecting from another surface. *See* BOUNCE LIGHT.

dig *Music* A JAZZ slang term meaning to understand completely, to empathize with.

digital *Electronics* Said of any control or recorded signal that is transmitted in binary form, *i.e.,* as groups of pulses that can be read as coded numbers by the receiving or reproducing

equipment. Digital signals can be transmitted at extremely high speed and are not vulnerable to changes of meaning when the carrying signal is disturbed. Modern audio and video recordings are digital, and in motion picture film editing, most visual and audio tracks are digitally coded for synchronization purposes.

digital recording *Audio* A recording in which the shapes of sound waves in air have been converted to a stream of billions of digitally coded signals and impressed in that form on a magnetic tape or an optical disc. Each digital signal consists of a coded series of pulses, like a series of ones and zeros (*e.g., 10110, 01001, 11101*) that have the advantage over other kinds of electronic signals in that they do not change their effect if the medium carrying them is disturbed by noise of any kind. Hence a digital recording can always reproduce its original sound in full fidelity, no matter how old and worn the tape or disc that carries it may become.

dim *Lighting* To reduce the power of a lighting circuit by degrees, thus making the illumination less than before. (*See* DIM DOWN, DIM OUT.) Also, conversely, to raise it, making things brighter. (*See* DIM IN, DIM UP.)

dim down *Lighting* To reduce somewhat the power of a lighting circuit.

dim in *Lighting* To introduce light into the set gradually.

diminish *See* DIMINUENDO.

diminished *Music* Said of a PERFECT INTERVAL that has been reduced by a SEMITONE, or a SEVENTH by a WHOLE TONE.

diminished chord *Music* Any chord with its FIFTH and, usually, its THIRD lowered by a SEMITONE.

diminished fifth *Music* An interval of the FIFTH that has been lowered by one semitone, *e.g.,* C-G-flat. Also known as a TRITONE.

diminished seventh *Music* The interval of a seventh lowered by two semitones, *e.g.,* C-B-double flat. In EQUAL TEMPERAMENT this interval is equivalent to a MAJOR SIXTH.

diminished seventh chord *Music* A SEVENTH CHORD consisting of a MINOR THIRD, DIMINISHED FIFTH and DIMINISHED SEVENTH, *i.e.,* entirely of MINOR THIRDS, *e.g.,* B-D-F-A-flat.

diminuendo [Italian] *Music* Literally, diminishing (in volume). The same as DECRESCENDO.

dimmer *Lighting* An electrical device that controls the amount of power flowing in a lighting circuit. In older theaters, a dimmer consisted of a variable transformer with contact points moved by an insulated handle. In newer theaters, the dimmers are actuated by electromechanical devices operated by knobs or small sliding controls mounted in the electrician's control console, so that the dimmers themselves, which can be quite large and develop a lot of heat, can be placed elsewhere backstage in a safe and temperature-controlled booth of their own.

dimmer bank *Lighting* An array of dimmers under remote control. In most theaters the dimmer bank is placed away from busy areas backstage, sometimes in a booth by itself, and is connected to the CONTROL CONSOLE by cables. The output of the dimmers goes to a PATCH BOARD where the various lighting circuits can be plugged in as indicated by the LIGHTING PLOT. *See also* PRESET.

dimmer board *Lighting* *See* DIMMER BANK.

dimmer channel *Lighting* The three electrical circuits, input (from the power supply), control (control circuit) and output (power to the lighting fixture), associated with a single dimmer.

dimmer pack *Lighting* A small, portable control board connected to and controlling a DIMMER BANK.

dimmer room *Lighting* A room backstage, off limits to the busy cast and crew, containing the DIMMER BANK. Since dimmers, especially in large theaters, develop a lot of heat, this room is frequently ventilated separately.

dim out *Lighting* To reduce the power in a lighting circuit slowly but completely.

dim up *Lighting* To increase the power in a scene slowly, as a whole or area by area. To BRING UP the scene.

dinner theater In general, a theater combined with a restaurant where the audience comes for both dinner and a show. In a few dinner theaters, the stage and tables are in the same room. In others, the dining room is separate from the theater. In most dinner theaters, shows tend toward light musicals, vaudeville and murder mysteries in which audiences may often participate. A few present more serious plays.

Dionysia [from Greek] Secret annual festivals, said to have been founded by Orpheus in very ancient times to honor Dionysus (Bacchus), the ancient Greek god of wine and of ecstasy. The *Orphic Mysteries* at Eleusis (pronounced *Elevsis* by the Greeks). The Dionysia may have been the source of the DITHYRAMB, originally a song in honor of Bacchus that was developed into a much more elaborate combination of accompanied song and choric dance in STROPHIC FORM, a possible precursor of what became the CHORAL ODE in Greek drama. Although the rites are mentioned obliquely by many contemporaries some of whom hinted at wildly orgiastic dancing, the exact nature of the Dionysia is unknown. They certainly contributed to the development of what we know as theater. An offshoot of the Dionysia was the CITY DIONYSIA, which took place in celebration of the onset of spring in Athens during late March and early April from about 554 to about 336 B.C. During these festivals, the great classical plays of Aeschylus, Sophocles, Euripides and Aristophanes were produced. At its height, the festival presented three days of tragedies and one day with a series of five comedies, the last of which was usually a SATYR PLAY. The most ancient form, the DITHYRAMB, was also revived at this time.

dip *Lighting* A brief dimming of light.

direct To instruct performers and guide them in the process of preparing for a performance. *Compare* CHOREOGRAPH, COACH, CONDUCT, PRODUCE.

direct beam projector, direct beams *See* BEAM LIGHT.

direct control *Lighting* Control by direct physical means, *e.g.*, control of a dimmer by moving its handle, rather than operating a knob on the CONTROL CONSOLE to send a signal to move an automated dimmer.

direct control switchboard *Lighting* Any switchboard whose controls directly effect changes in the amount of power being delivered to lighting circuits, in contrast to one that sends a controlling signal to automated dimmers.

direct emphasis *Theater* BLOCKING that focuses the audience's attention on a single actor or specific group of actors.

direct exposition *Theater* The process of supplying background information about the characters and/or the plot of a play through DIALOGUE or in a SOLILOQUY. *Compare* DEVELOPMENT.

direct focus *See* DIRECT EMPHASIS.

direction *Dance* 1. Any of eight basic directions in which a dancer may move from a specific position on stage. They are high, low, up, down, to the right, to the left, forward and backward. 2. A dancer's standing position in relation to the audience.
Motion pictures, Theater The instructions of a DIRECTOR in preparing for a performance.

directional lighting Lighting from a single direction.

directional mike *Audio* A microphone designed to pick up sound coming from a specific direction and repress sound from any other direction. *See* PARABOLIC REFLECTOR MICROPHONE, SHOTGUN MICROPHONE. *Compare* LAVALIERE, MOUSE, OMNI-DIRECTIONAL MICROPHONE.

directions of the body *See* POSITIONS OF THE BODY.

director One who directs the preparation of a stage performance or a motion picture. The person artistically in charge. *See also* CHOREOGRAPHER, CONDUCTOR, PRODUCER. *Compare* BALLET MASTER, COACH, CONCERTMASTER, METTEUR EN SCÈNE, RÉGISSEUR.

director of photography *Motion pictures* The chief camera operator or supervisor of camera operators, who determines the lighting set-up, specifies camera positions and movements together with the lenses, lens openings (apertures) and filters to be used for each shot, and determines the way each shot is to appear within the FRAME. In some productions, the film director takes on some of these responsibilities.

Directors Guild of America An American union of motion picture directors, assistant directors, production managers, production assistants, *et al.,* founded in the 1930s, expanded to include the television industry in 1947.

direct profile position *Dance* Two dancers facing each other at a 90° angle to the center line of the stage.

dirge *Music* A mournful piece of music, frequently a slow march, for a funeral.

dirtbag *Motion pictures* Slang for a weight consisting of a BAG filled with sand, dirt or gravel.

disappearing footlights *Lighting* Footlights built into boxlike strips that can be retracted into a trough along the front of the stage, leaving a surface that may or may not become flush with the stage floor and is strong enough for actors to walk on.

disbelief *Acting* 1. Inappropriate awareness of one's physical environment during a play. 2. The audience's inability to accept the plot and illusion that form the material of any play. *See* SUSPENSION OF DISBELIEF.

disc, disk *Audio* 1. The flat round plate upon which a recording has been imprinted (or etched, as the case may be). 2. Any recording. *Compare* COMPACT DISC.

Stagecraft *See* TURNTABLE.

discant *See* DESCANT.

disco *Music* 1. Short for DISCOTHÈQUE. 2. A style of dance music popularized in discothèques, characterized by a steady sixteenth-note drumming pattern.

discothèque (*dis-coh-TEK*) [French] *Music* A dance hall where music is provided entirely from recordings played by a DEEJAY through loudspeakers. In the 1970s and 1980s, such music tended to be of a particular style characterised by a constant 2/4 beat in a long series of eight-measure phrases, with simple rhythmic lyrics sung by two or three voices. The style has been preserved for posterity in several shows and films of the period, one of the most notable being *Saturday Night Fever*, starring John Travolta. *Compare* ROCK AND ROLL.

discovered at rise *Acting* Onstage and in view of the audience when the curtain rises (or when the lights dim up).

discovery *Theater* 1. The moment in a performance when the set and characters first become visible to the audience, after the curtain has risen or the lights have been brought up on the scene. Also called *at rise*. 2. The moment when an important, previously unrecognized truth that will later cause a complete REVERSAL OF FORTUNE is made clear.

discrete cue *Lighting* A lighting cue that involves the activation of a group of lighting circuits controlled as a single unit. *See* DISCRETE LIGHTING.

discrete lighting A style of stage lighting based upon dimmer settings handled as DISCRETE CUES, with no individual changes while each setting is in use. The opposite of COUNTERPOINT LIGHTING, in which constant, fluid changes go on within scenes, coordinated with the movements of actors and changes of mood within the play. The PRESETS for discrete lighting are activated in sequence, whereas the presets for counterpoint lighting are only the initial settings as the scene opens, and will be altered more or less continually throughout the scene.

diseur (m) (*dee-ZEUR*), **diseuse** (f) (*dee-ZEUZ*) [French] *Music* Literally, a speaker. A soloist who speaks, rather than sings, with musical accompaniment.

disguise *Stagecraft* Makeup and costume that make a character look like someone else.

dished floor *Theater* A HOUSE floor that rises from front to back and to each side, giving it the shape of a shallow bowl.

disk *Audio* *See* DISC.

 Stagecraft *See* TURNTABLE.

disk dimmer *Lighting* A dimmer in the shape of a disk, so that its operation will consist of circular, rather than straight linear movement.

disk jockey *See* DEEJAY.

dissolve *Lighting* 1. The operation of simultaneously dimming out one scene while dimming in another. A common example is the dimming of a scene in front of a SCRIM while bringing up what is behind the scrim, invisible to the audience until that moment, or changing daylight into sunset. 2. To dim out one scene while dimming in another.

 Motion pictures 1. The relatively gradual replacement (in two or three seconds) of one scene on the screen by another. The film editor accomplishes this by overlapping the end of the outgoing scene with the beginning of the incoming, then instructing the laboratory to make a timed fade-out on the one, matched to a timed fade-in of the other. *Compare* CUT. The television MIXER accomplishes the effect by fading out one scene while fading in the other that is already running IN SYNC. *Compare* STRAIGHT CUT. 2. The editorial process of setting up the gradual replacement of one scene by another.

distortion *Audio* Any disturbance that renders an electronic SIGNAL less intelligible than its original source. Distortion occurs when an audio signal is too powerful for the system that carries it. A signal can be distorted by increasing its volume beyond the limits of the circuit. Speech becomes distorted to the point of unintelligibility if the speaker shouts too loudly into the microphone. In an electronic circuit, music becomes NOISE if the LEVEL is too high. Sometimes distortion is desired, as when a HARD ROCK guitarist uses a FUZZ BOX.

 Motion pictures Any exaggeration of size, shape or apparent distance in a scene caused by the intentional (or unintentional) misuse of a lens. A typical and intentional distortion might be to exaggerate the size of a comic actor's nose in a tight CLOSE-UP shot using a wide-angle lens.

distribution *Motion pictures* The business organization through which a motion picture is made available to exhibitors.

 Lighting The system of PATCHES and CABLES through which controlled power is delivered to light fixtures in the theater or on the motion picture SET.

dithyramb [from Greek] *Music* An elaborate choric ode. A song (*ode*) with dancers (*choros*), known to have originated in the ancient Greek DIONYSIA, possibly the source of the SATYR PLAY that was the usual closing piece during the Dionysia, and of the CHORAL ODE that became the characteristic feature of all classical Greek drama.

ditty *Music* A happy little tune, something to hum or whistle for pleasure.

diva (*DEE-vah*) [Italian] *Music* Literally, goddess. A female singer with a superb voice, an opera star.

divertimento (plural, **divertimenti**) [Italian] *Music* An entertaining piece of music, sometimes in several movements and including dance movements, for a small orchestra or ensemble.

divertissement (*dee-ver-teess-MANH*) [French] *Dance* A group of short dances called ENTRÉES, sometimes included as part of a CLASSIC BALLET.

Music Literally, a diversion. *See* DIVERTIMENTO.

Theater A short entertainment, complete in itself, particularly one played in front of the ACT CURTAIN between the acts of a play. An ENTRE'ACTE.

divided *See* DIVISI.

divided setting, divided stage *Theater* A stage set depicting two or more related scenes simultaneously, *e.g.,* the interior of a room and an outdoor garden.

divisi (*dee-VEE-see*) [Italian] *Music* Literally, divided. A composer's instruction to the players who have been reading the same melodic line together IN UNISON, to divide and perform the double notes of the next section separately. *Compare* A DUE.

Dixieland *Music* An exuberant style of JAZZ that originated in New Orleans during the early 1900s, characterized by simultaneous improvisations by several soloists in a small band, typically a trumpet, a clarinet, a trombone, a bass and a drummer. Dixieland musicians played, often outdoors, at parades and at every conceivable social occasion from births to weddings to funerals. One of the best-known pieces of Dixieland music is the joyous song "When the Saints Go Marching In." In the old days a street band played such hymns marching back from a funeral, happy because of their feeling that the late departed soul was released from the burdens of worldly life. Also called two-beat jazz because of the custom of accenting the second and fourth beats. *See also* TAILGATE.

DJ *See* DEEJAY.

DL *Acting, Stagecraft* Downstage left. *See* STAGE AREAS.

DLC *Acting, Stagecraft* Downstage left center. *See* STAGE AREAS.

do (*doh*) *Music* The first syllable in the system of SOLMIZATION. In the FIXED-DO SYSTEM, it represents the note C. In MOVABLE DO it represents whatever tone is the root of the scale in use. DO replaced the original syllable UT, which music teachers in the mid-1600s considered unsingable.

dock *Stagecraft* 1. A space backstage where FLATS can be stored, sometimes fitted with guide rails to allow orderly storage and retrieval. 2. The loading dock backstage where trucks can back up to deliver or take away large pieces of scenery.

dock doors *Stagecraft* Special doors leading directly into the backstage area from the street, wide enough and high enough to permit large pieces of sets to be moved into and out of the theater.

docu-drama *Audio, Television* A fictional re-creation of a historical or current event with little authentic documentary material included, but with great attention paid to historical accuracy.

documentary *Audio, Motion pictures* Any recorded audio program or motion picture that depicts current or historic events as they happened, with voices and/or pictures of the actual participants involved. Since events in history cannot always be presented in live recordings or motion picture footage, the term has been stretched slightly to include re-creations that combine new material taken at the actual locations with stills, and/or re-creations of the events of the time and the voices of the people. *Compare* DOCU-DRAMA.

documentary theater Plays that have been written as re-creations or realistic interpretations of historical or contemporary events.

dodecaphonic [from Greek] *Music* Literally, having twelve tones. Said of music composed in accordance with various theories based upon an assumed harmonic equality between the twelve tones of the equal-tempered system. *See also* DUODECUPLE SCALE. *Compare* ATONAL, TWELVE-TONE SYSTEM.

dodge *Lighting* To control the spread and the contrast of light by means of reflectors, DIFFUSERS, UMBRELLAS, BUTTERFLIES or FLAGS.

dog *Stagecraft* A STAGE SCREW.

Theater Slang for a thoroughly bad play.

dog and pony show *Circus* A very small traveling show consisting of a showman, his performing dog and the pony that the showman may or may not ride during the performance. In contemporary business parlance, the term describes the routine presentation made by a traveling salesperson.

Dolby sound *Audio* Trade name for a noise-reduction system used in audio tape recording.

dolce (*DOHL-cheh*) [Italian] *Music* Literally, sweet. Sweetly, gently, warmly.

dolly *Motion pictures* A small platform on wheels built to carry a camera and its crew smoothly and silently during a shoot, often moved by a DOLLY GRIP. In a studio the dolly is usually motorized and can be steered in any direction. When the crew is ON LOCATION it is often necessary to lay down tracks for the dolly to ride on to keep its operation smooth. *See also* CRAB DOLLY, CRANE, TRUCK SHOT.

Stagecraft Any small platform on wheels suitable for carrying a load, *e.g.*, an OUTRIGGER or a TIP JACK built to support a piece of scenery on casters so that it can be moved easily during a scene shift. Not the same as a WAGON.

dolly grip *Motion pictures* A GRIP who moves and steers a camera DOLLY when the script demands complex shooting operations that require the camera operator's entire attention. Along with the camera operator, the dolly grip rehearses the moves that will be required in the shot and executes them at the proper times.

dolly shot *Motion pictures, Television* Any shot made from a moving dolly. To be distinguished from TRACK SHOT and TRUCK SHOT, which are special cases.

doloroso (*doh-loh-ROH-soh*) [Italian] *Music* Literally, painfully. Sadly, dolorously.

dome *Theater* The ceiling of the HOUSE, usually constructed as an architectural dome so that it can bear the weight of suspended lighting fixtures for the house and the BRIDGES that must support the weight of BEAM LIGHTS and the technicians who focus them on the stage.

dominant *Music* 1. Describing the harmonic tension of any chord that demands resolution into the TONIC chord of its key. 2. By extension, describing the harmonic function of a passage or an entire section of a piece of music written in a key that is the dominant of the central key of the piece. 3. In harmonic analysis, the name of the fifth tone of the scale. 4. The chord built upon that tone. *See also* DOMINANT SEVENTH.

dominant seventh *Music* A MAJOR-MINOR SEVENTH chord (a major triad with a MINOR SEVENTH added) built on the DOMINANT, that demands resolution to the TONIC or SUBMEDIANT chord of its key. In the key of C, for example, G-B-D-F.

dominate a scene *Acting* To control the effect of a scene by (1) standing where all the other members of the cast must turn away from the audience in order to respond, (2) speaking at a level and pace that requires the other members of the cast to modify their styles to match, and/or (3) timing one's cue lines to force other actors to accommodate them. These and any other tricks an actor may use can be infuriating to the rest of the cast. A director may request, however, that similar devices be employed judiciously when the effect will be right for the particular scene.

domino *Costume* A mask covering only the eyes, very popular in Venetian society in the 15th and 16th centuries and later in France, for men and women who wanted to conceal their identities at masked balls. The domino is the foundation for many masks used in COMMEDIA DELL'ARTE. Some are very elaborate, giving fantastic character to the natural face without concealing it completely. *See also* BAL MASQUÉ.

donkey *Stagecraft* An electric winch used backstage to raise or lower heavy DROPS or scenery.

donut *Lighting* A type of mask for a stage light, consisting of an opaque sheet with a relatively large hole in its center that is slipped into a COLOR FRAME at the focal point of a SPOT-LIGHT to reduce the diameter of its beam. *See also* IRIS.

doodlesack *See* DUDELSACK.

door button *Stagecraft* A stage screw placed unobtrusively in the stage floor at the point where a PRACTICABLE DOOR must stop its swing, or to prevent a FLAT from moving out of place.

door flat *Stagecraft* A FLAT with a large, uncanvassed opening built into it, reaching to the stage floor. Since a wooden BOTTOM RAIL would not be appropriate in a doorway, it is replaced by a SILL IRON or a SADDLE IRON. The opening may be left unfilled, or be fitted with attachment points to accommodate a built-up door frame with a practicable door.

door frame unit *Stagecraft* A FLAT with a practicable door frame built into it, into which a door may be fitted for the show.

door stop *Stagecraft* A strip of wood nailed along the opening edge of the STILE that forms the frame of a door in a DOOR FLAT to prevent the door from swinging too far when it closes.

Dorian mode *Music* The MODE based on the second tone of the major scale. On the white notes of the piano the Dorian is the mode that has D as its TONIC, and A its DOMINANT.

dos à dos (*doh ah DOH*) [French] *Dance* Back to back.

dosido (*DOH-see-doh*) [American] *Dance* In American SQUARE DANCE, when the caller calls for a dosido, the man from each couple goes to the center of the square, dances around the other back to back and then resumes his original place, taking four measures in all. When the men have completed the move, their partners do the same, for a total of eight measures. In the KENTUCKY RUNNING SET, the first and third couples often perform the move together as couples, then the second and fourth.

dot *Music notation* A dot placed immediately to the right of the head of any note, indicating that the note must continue to sound half again its normal duration. Thus a dotted quarter note is to sound as one and one-half quarters, etc. *See also* DOUBLE DOT.

do the bends *Acting* To take a bow while the audience applauds.

dotted *Music notation* Said of any note followed by a DOT.

dotted rhythms *Music* The class of rhythms characterized by beats subdivided into long-short combinations. *See* SKIP. *See also* SCOTCH SNAP.

double *Acting* 1. An actor who plays two or more different roles in one play or performs in two different shows in one night. 2. An understudy.

Motion pictures An actor who looks (with makeup) enough like another to take the other's part, especially in scenes that might be difficult or impossible for the other actor. *See also* BODY DOUBLE, DRESS DOUBLE, STAND-IN.

Music To play more than one instrument during a SESSION.

Stagecraft Describing PROPS that can be used to dress two or more different scenes. The chairs for a scene in a lawyer's office, for example, may reappear later in a different scene in a hospital waiting room.

double act *Vaudeville* Any act developed and performed by a team of two actors.

double bar *Music notation* A BARLINE consisting of two parallel lines, close together. The double bar usually indicates a division between two different sections of a piece. It does not indicate that a pause should occur at that spot, but only that a new section is beginning. Sometimes it is accompanied by a new tempo indication. *Compare* REPEAT BAR.

double bass *Music* Of the bowed string instruments in the modern orchestra, the one of lowest range. The standard double bass with four strings has a written range down to E_1 and sounds one octave lower than written. (*See* OCTAVE NAME SYSTEM.) Many modern basses have five strings, the lowest of which goes another third down, to C_1. Also called CONTRABASS.

double bassoon *Music* The lowest in range of the DOUBLE-REED INSTRUMENTS of the orchestra, whose range is a perfect fourth lower than that of the double bass, reaching B_2-flat. Also called CONTRABASSOON.

double batten *Stagecraft* A wooden BATTEN constructed of two spliced strips between which a curtain or a drop may be permanently clamped. Also called a sandwich batten.

double bill *Theater* Two plays playing in sequence at a single performance for the price of one.

double cast *Acting* A production played at alternate performances (or alternate weeks) by alternate CASTS.

double counterpoint *Music* A form of COUNTERPOINT that permits the positions of the melodic lines (one higher, the other lower) to be exchanged without producing unwanted harmonic clashes.

double-deck drop *Stagecraft* A DROP of twice the normal height. If such a drop has been painted to show two different scenes, it can be dropped partway for the first and the rest of the way, into a slot in the floor, for the second. Similarly, if it is painted for a single scene of great height, it can be raised out of such a slot with great dramatic effect as is done with the Christmas tree in many productions of Petipa's ballet *The Nutcracker*.

double dot *Music notation* Two dots placed horizontally in line just to the right of any note to indicate that the tone should be extended 75 percent longer, *i.e.*, half the note's original value for the first dot, and half of that for the second. Thus, a double-dotted QUARTER NOTE is equal to a quarter note, an EIGHTH and a SIXTEENTH.

double feature *Motion pictures* A program of two motion pictures, one a FEATURE and the other a B PICTURE, running continuously all day and evening at a neighborhood theater.

double flat *Music notation* An ACCIDENTAL that indicates that the following note is to be sounded two SEMITONES lower than written.

DOUBLE FLAT

double fugue *Music* Any fugue with two contrasting SUBJECTS that may be treated separately at first, then combined.

double-hung *Lighting* Said of a scene lighted by the McCANDLESS METHOD but with warm and cool colors hung together on the light pipes providing both general and specific lighting on each side, enhancing the three-dimensional quality of light on the actors. Sometimes called the double-McCandless method.

double in brass *Circus, Vaudeville* Originally said of an actor or performer who plays in the orchestra when not acting or singing on stage. By extension, any actor who fills two roles, or who performs additional important functions in the company, such as coaching the apprentices.

double octave *Music* The interval between two tones two OCTAVES apart.

double plot *Playwriting* A PLOT with two related story lines, main plot and subordinate plot, that work out simultaneously.

double proscenium *Stagecraft* A stage framed by two prosceniums, one set a few feet behind the other, to increase the impression of AESTHETIC DISTANCE between the events of the play and the minds of the audience. This design was strongly favored by Richard Wagner for his *Festspielhaus* at Bayreuth because, in the composer's view, it emphasized the impassable gulf between gods in the scene and mere mortals who watched.

double quartet *Music* 1. An ensemble of eight singers or instrumentalists, two of each category, *e.g.,* two sopranos, two altos, two tenors and two basses; or two violins, two second violins, two violas and two cellos. They may perform as eight individuals or as two quartets, depending on how the piece is composed. 2. A piece of music composed for a double quartet.

doubler *Music* 1. A musician who plays more than one instrument during a recording session or in a concert, usually a performer who specializes in doubling within a family of instruments such as WOODWINDS or BRASSES. 2. A SIDEMAN in a DANCE BAND who specializes in playing more than one instrument, and can be called in to supply the extra line on short notice at a higher union SCALE than the ordinary musician.

double-reed instrument *Music* Any instrument of the OBOE family, including the ENGLISH HORN, BASSOON, DOUBLE BASSOON and others. Its mouthpiece is a pair of carefully shaped reeds, bound together back to back around a ferrule that fits into the top of the instrument so the reeds will vibrate smoothly when the player blows through them. Reeds cause the column of air inside the instrument to vibrate, and the keys of the instrument determine the frequency of that vibration, *i.e.,* the PITCH of the note. Double-reed instruments are much older than those, like the CLARINET and SAXOPHONE, that have single reeds. Double reeds have been known in the Middle East for at least 4,800 years. Unlike single-reed instruments, double-reeds do not require a mouthpiece. *See also* AULOS.

double sharp *Music notation* An ACCIDENTAL indicating that the note following must be sounded two SEMITONES higher than written.

DOUBLE SHARP

double stage *Stagecraft* An ELEVATOR STAGE with two sets mounted one above the other, so that a complete change can be effected rapidly by raising or lowering the whole system.

double stop *Music* 1. A combination of two tones played simultaneously on a bowed string instrument. 2. To bow on two strings at the same time producing two-note chords.

double-system *Motion pictures* The system of recording synchronized sound on a recording device separated from, but synchronized with, the camera. This system permits editing of sound and picture separately, so that, for example, errors may be corrected or other sound may be added to the track for dramatic effect. Until the double system became possible, a cut made in the actual film also eliminated the sound at that point (and vice versa). (*See* SINGLE-SYSTEM.) In double system, sound and picture are recorded and edited on completely independent strands and can be cut individually, so that nothing is lost. They are digitally coded so they can be synchronized in editing, and are put together for the RELEASE PRINT only after all editing has been completed.

double take *Acting* 1. An actor's surprised, sudden, second reaction to another's line or gesture. 2. A specific gesture of the head consisting of a turn to respond, but blandly, to another actor's presence followed by a nonchalant turning away, then a sudden, excited turn again to react with a new emotion to what the cue really meant. *See* TAKE.

double time *Music* Twice as fast as before.

double-tongue *Music* With a wind instrument, to sound notes, *e.g.,* SIXTEENTHS or THIRTY-SECONDS, in rapid succession by moving the tongue as though pronouncing ta ka ta ka. Not the same action or effect as FLUTTER-TONGUE. *Compare* TRIPLE-TONGUE.

double up *Acting* To perform as a DUO.

double whole note *Music notation* A note of the duration of eight quarter notes. Called a BREVE in the earliest period of time-based musical notation.

DOUBLE WHOLE NOTE

douse *Lighting* To cut off a brilliant beam of light completely and rapidly using a metal shutter. The metal shutter is necessary, particularly with arc lights, so that the effect will be immediate, without residual glow.

down *Acting* DOWNSTAGE. *See* STAGE AREAS.

downbeat *Music* The first beat of any measure. The main accent of the measure, its CRUSIS. *See also* ANACRUSIS, UP BEAT.

downbow *Music* 1. To pull the bow downward across the string from the nut toward the tip. Composers and/or conductors call for a downbow at times because its effect can be different from that of an UPBOW. 2. A mark in the SCORE, indicating that a particular note is to be played as a DOWNBOW.

DOWNBOW

down center *Theater* Downstage center. *See* STAGE AREAS.

down-fade *Lighting* To fade certain specified circuits partially within a scene. *See* DIM DOWN.

down front *Theater* Downstage, in front of the curtain line.

downlight, downlighting *Lighting* Light aimed straight down on the acting area. Also called top light, top lighting.

downstage *Theater* 1. Toward the front of the stage, *i.e.,* toward the audience. The term came into use when stages more frequently were RAKED (slanted downward toward the audience). 2. The entire front portion of the stage. *See* STAGE AREAS.

downstage center, downstage left, downstage left center, downstage right, downstage right center *See* STAGE AREAS.

DP *Motion pictures* Abbreviation for DIRECTOR OF PHOTOGRAPHY.

DR *Theater* Downstage right. *See* STAGE AREAS.

drag *Acting* To play a scene slowly by holding back in lines and action so that it begins to lose its coherent feeling of PACE.

Costume, Makeup A woman's costume and makeup on a male actor who is said to be "in drag."

dragging *Stagecraft* Applying color to a FLAT by pulling a dry brush (*i.e.,* a brush with drier than normal pigment) across the canvas, to produce an uneven effect.

drag the cue *Acting* To hold back on delivering or reacting to the cue, momentarily slowing the pace of the scene.

drama [from the Greek verb meaning "to do"] *Theater* An enactment in theatrical form of a significant event or relationship in life involving stress and conflict. These events develop into the complications and entanglements that lead to a climax of dramatic tension and its resolution. *See also* COMEDY, TRAGEDY.

dramatic Having the quality of DRAMA, implying an action demanding deep emotional involvement. To be distinguished from THEATRICAL, which does not necessarily involve the deeper emotions.

dramatic action *Acting* The basic working out of the ideas and conflicts in a PLOT.

dramatic irony *Acting* A secondary meaning within the spoken lines of a scene that seems not to be apparent to the characters on stage, but which the audience understands perfectly. An excellent example is the extended sequence of actions in which Œdipus, who has exiled himself to avoid fulfilling a prediction that he will murder his father, meets a stranger on the road, confronts him and murders him, not knowing that the stranger is his own father.

dramatic lighting Lighting that goes far beyond what would seem natural in a given scene to emphasize the emotional implications of the PLOT, *e.g.,* bright background lighting, which can make a foreground figure seem dark and threatening.

dramatic metaphor *Theater* An author's use of setting and situation to emphasize a deeper meaning in a scene. The cold night in the opening scene of Shakespeare's *Hamlet* not only satisfies the needs of the scene itself, but also characterizes Hamlet's situation in the court.

dramatic monologue *Acting* Any performance by a single actor of a play or scene with a plot that develops and comes to a climax.

dramatic opera *Music* An opera on a serious theme with a plot that develops and comes to a climax.

dramatic rights *Theater* The legal and/or contractual right to perform a play that is covered by copyright or to adapt a copyrighted nontheatrical work for performance. *See also* GRAND RIGHTS, SUBSIDIARY RIGHTS.

dramatics　The art and practice of theatrical performance considered as a course of study or as extracurricular activity in a high school.

dramatic soprano *Music*　A SOPRANO voice capable of great dramatic expressiveness, powerful enough to be heard over an orchestral accompaniment. *Compare* LYRIC SOPRANO.

dramatic structure *Theater*　The structure within the PLOT that carries the story through all the stages of drama to its climax and ending. The skeletal framework of the action and emotional progress of the plot, not including those details necessary only to give body to the characters or to supply verisimilitude to the settings. *See also* MYTHOS.

dramatic tension *Theater*　One of the most important components of drama: the strain and conflict that develop between characters, or between characters and circumstances, whether on the surface or hidden. Dramatic tension intensifies as the play moves toward its climax, and dissolves when the resolution occurs. *See also* AGON, CATASTASIS, CATASTROPHE, CLIMAX, ENTANGLEMENT.

dramatic unity *Theater*　According to Renaissance scholars of theater, extrapolating inaccurately upon Aristotle's principles in his essay *Poetics*, a good play must have unity of time, place and subject and must bring all these elements into coherence. *See* UNITY OF PLOT.

dramatis personae *Theater*　1. The list of roles, with or without little descriptive remarks about each, at the beginning of a SCRIPT. 2. The same list, with names of the cast members playing the roles, printed in the program for the production.

dramatist *Theater*　One who writes DRAMAS.

dramatization *Theater*　The retelling of a story, or re-creation of an event in action and dialogue like a DRAMA.

dramatize *Theater*　To tell in theatrical terms, using action, setting and dialogue, a story that has a beginning, middle and end.

dramaturge *Theater*　Literally, one who works on dramas, *e.g.,* a member of a theater company who reads scripts and reports on their potential production values and requirements. *Compare* DOCTOR.

dramaturgy *Theater*　The act or process of working on a drama, *e.g.,* studying its production requirements, analyzing potential problems and suggesting solutions.

drape *Stagecraft*　1. Any large piece of cloth used to form the sides or background for a scene. *See also* ARM CYCLORAMA, BLACKS. 2. Any piece of cloth hung more or less loosely or gathered in pleats or folds over a piece of furniture or some part of the set.

drapery border *Stagecraft*　A cloth BORDER hung with gathers or pleats in the set.

draw *Theater*　The attracting power of an actor's name or an author's play or of a particular production as measured by its box office TAKE.

draw curtain *See* BRAIL CURTAIN, TRAVELER CURTAIN.

drawing card *Theater* A star or a show with BOX OFFICE appeal.

draw line *Stagecraft* The rigging line that draws the curtain.

DRC *Acting* Downstage right center. *See* STAGE AREAS.

Drehtanz (*DREH-tants*) [German] *Dance* A turning dance of German origin, ancestor of the LÄNDLER and the WALTZ.

dress *Acting* 1. Costume, in general. 2. Short for DRESS REHEARSAL. 3. To provide all the costumes for a production.

Stagecraft *See* DRESS THE SET.

dress circle *Opera* The first rows of the balcony, where spectators have an excellent view of the stage and a chance to be seen by the rest of the audience.

dress double *Motion pictures* An actor who substitutes for another in dangerous or difficult situations, wearing the primary actor's costume. A typical situation would be a scene requiring an acrobatic stunt that the primary actor cannot or should not do.

dresser *Acting* An assistant from the costume department who helps an actor into costume and makeup before the show and out of it later, and facilitates quick changes when required between scenes or even during one. In the opera *Manon Lescaut*, a dresser must be in costume on stage to help Manon make a fast change, called for in the LIBRETTO, in full view of the audience.

dress extra *Motion pictures* An EXTRA wearing the style of costume demanded by the script, who appears for the sole purpose of lending character to the scene by means of that costume. *See also* SUPER.

dressing room *Theater* 1. A small room backstage where an actor can change into and out of costume in privacy. 2. A somewhat larger room backstage where several actors, members of the chorus or dancers, may change without interference from the public. *See also* TIRING ROOM.

dressing table *Theater* A small table fitted up with a large mirror and a great deal of light for the convenience of an actor putting on makeup. Standard set-up for the dressing table includes a three-section mirror ringed by a dozen bare light bulbs.

dress parade *Theater* A procession of actors, each in full costume, staged for the benefit of the costume designers, wardrobe manager, director and the actors themselves to check out the costumes and make any last-minute changes before dress rehearsals begin.

dress plot *Stagecraft* The WARDROBE MANAGER's schedule of all the costumes needed for the show, listed in order of their appearance on stage, with the names of the characters and the actors who play them listed and, if appropriate, the times during the show when the actors must make costume changes.

dress rehearsal *Acting* A rehearsal in full costume.

dress the house *Theater* To give out free tickets at the last moment so that the house will not look undersold when the show begins. *Compare* PAPER THE HOUSE.

dress the set *Stagecraft* To complete the setting by putting all necessary furniture in place, and adding all the decorative touches and/or TRIM PROPS called for by the set designer.

dress the stage *Theater* A director's instruction during rehearsal to all the actors in a scene to arrange themselves better on the stage and particularly to move out of positions that obstruct the audience's view.

droite, à *See* À DROITE.

drone *Music* Any tone or chord that sounds without change of pitch throughout several measures, a section or an entire piece of music. Some drones consist of an OPEN FIFTH in the bass as in a MUSETTE. The BAGPIPE's larger pipes provide a continuous drone in the bass as accompaniment for the CHANTER. By contrast one of the characteristics of Japanese GAGAKU is a high-pitched drone far above the rest of the music.

drop *Stagecraft* Any curtain, BACKDROP, WING or piece of scenery made of cloth and suspended from a BATTEN.

drop clamp *Stagecraft* A clamp used to secure the bottom of a DROP to prevent it from moving during a scene.

drop curtain *Stagecraft* Any curtain that is lowered into view from the FLIES whether or not it can also, on occasion, be drawn apart or drawn to close.

drop in *Stagecraft* To lower a piece of scenery into view on stage.

drop light *Lighting* A lighting fixture, commonly consisting of a bare bulb, that can be hung by its own wire somewhere on the stage to provide light for crews to work by.

drop off *Audio* To lose intensity of sound because of a malfunction in the recording.

drop-out *Audio* Any period of complete silence in a recording, no matter how brief. *Compare* DEAD AIR.

drop pocket *Lighting* An insulated metal box installed among the FLIES containing the receptacles for dimmer circuits into which lighting fixtures hung in the flies can be plugged.

drop scene *Stagecraft* Any setting consisting of cloth DROPS instead of FLATS and constructed pieces.

drop stage *Stagecraft* An ELEVATOR STAGE.

drum *Music* In a generic sense, the drum is a percussion instrument consisting of a membrane (the DRUMHEAD) stretched taut over the end of a hollow cylinder and struck by a

stick (DRUMSTICK). Cylindrical drums may be tapered (*see* CONGA), and may be open or not at the end opposite the drumhead. Some have two drumheads, one at each end (*see* BASS DRUM, SNARE DRUM) and some are shaped like bowls with only one (*see* TIMPANI). If there are two, the one to be struck is called the BATTER HEAD. There are also primitive drumlike instruments made from hollowed logs with an open slit in the center of one side that permits the log to resonate when it is struck. Properly speaking these are called IDIO-PHONES to distinguish them from true drums or MEMBRANOPHONES.

drumbeat *Music* The sound of a drum, usually understood as a regular pulse, a continuing beat.

drumhead *Music* The membrane, usually made of animal skin, stretched taut over the rim of a DRUM.

drum machine *Music* An electronic SYNTHESIZER that produces the tones of many different kinds of drums. It can be amplified and played in a live concert by tapping the symbolic images of the various drumheads that are printed on the face of the instrument and serve as its "keys." It can also be used in combination with a computer-based notational program to compose drum parts for orchestral music, and to play back such previously composed parts fully integrated with the orchestra. Among synthesizing equipment available in the late 1990s, the drum machine is the simplest and most reliable and has the most realistic effect.

drum major *Music* The marching leader of a MARCHING BAND. In a parade, or any other ceremonial outdoor occasion, the drum major marches ahead of the band wearing a brilliant uniform with a high military hat, carrying a four- or five-foot long decorated baton with which to set the beat and to direct marching maneuvers, and usually accompanied by TWIRLERS. The conductor of the band usually conducts only the rehearsals and does not march.

drummer *Music* One who plays the drum.

drummer's throne *Music* A drummer's swiveled, backless seat. Since the days of the BIG BANDS (the 1940s) the drummer sometimes uses one of his instrument cases as a seat. Some are heavily encrusted with false mother of pearl and other decorations, hence the descriptive term. The best thrones are comfortable, with adjustable height, and swivel easily to allow the drummer to reach all his or her instruments easily during performance. The term seems to have come into general use first among JAZZ musicians in the 1920s and 1930s, perhaps suggested by the fact that the drummer in a small band sat higher and looked more important than any of the other players.

drumroll *Music* A continuous, smooth, roaring sound made by bouncing the drumsticks continuously and rapidly on the taut DRUMHEAD. When the drum has SNARES, its roll takes on a more crackling TIMBRE. The drumroll is a favorite device to introduce a master of ceremonies in vaudeville, or to add to the excitement when a circus aerialist begins a death-defying swing high in the rigging of the tent. Many different styles of drumrolls are included in the basic RUDIMENTS.

drumstick *Music* A beater with which a drummer strikes a drum. Generally, the term refers to the standard stick used in playing a snare drum or a side drum, made of hardwood with a small knob at its tip called a bead. *See also* MALLET.

Drury Lane A street in London just south of the British Museum, the site of the Drury Lane Theatre, first opened in 1663. Many of the greatest names in theater played there, including David Garrick, Mrs. Sarah Kemble Siddons and Edmund Kean. The theater is now used primarily for big MUSICALS.

dry *Acting* Unable to remember the lines while on stage during the scene.

dry brushing *Stagecraft* Applying color to a flat with a damp or nearly dry brush, *i.e.*, using dry, or nearly dry pigment for visual effect.

dry color *Stagecraft* Any pigment purchased in powder form. *See also* DRY BRUSHING.

dry recitative *Music* A passage in an OPERA or an ORATORIO in which a soloist tells part of the story of the work by singing the words in a melodically limited style, often intoning many syllables on a single note in rhythms that imitate natural speech. The keyboard accompaniment is limited to simple chords as punctuation at the ends of verbal phrases and a simple CADENCE at the end of the whole passage. *See also* RECITATIVE.

dry run *Television* A RUNTHROUGH of a scene without costumes and with no cameras.

dry up *Acting* To forget one's lines on stage during the performance.

DS *Theater* Abbreviation for DOWNSTAGE.

D. S. *Music* Abbreviation for DAL SEGNO.

DSC *Theater* Abbreviation for DOWNSTAGE CENTER. *See* STAGE AREAS.

dual role *Acting* Two roles in the same production played by one actor.

dub *Audio* 1. An unmodified duplicate of an audio recording. 2. To duplicate an audio recording directly without any modification. A dub is to be distinguished from a MASTER DUPLICATE or any other specialized copy that has been rebalanced or modified in some way. 3. To record a VOICE-OVER or other new sounds for a preexisting sound track.

Motion pictures 1. To add new sound track to or replace an existing track in a motion picture, *e.g.*, to replace a foreign language DIALOGUE TRACK with a new track recorded in English. 2. In POST-PRODUCTION editing, to copy a recorded sound on SPROCKETED MAGNETIC TAPE to preserve the original recording intact (*e.g.*, when it must be preserved in a SOUND EFFECTS LIBRARY), or to permit using it in more than one place in the picture.

Dubarry pink *Lighting* A color developed under the direction of playwright and manager David Belasco to ensure that the bright red hair of the star in his play *DuBarry* would look natural in stage lighting. *See also* BASTARD AMBER.

dubber *Audio* A recording machine set up to make direct copies of recorded tapes or of magnetically recorded ORIGINAL sound tracks.

ducat, ducket *Theater* Slang for a ticket of admission.

duct tape *See* GAFFER TAPE.

dudelsack [German, from Czech] *Music* The BAGPIPE.

duet *Music* A piece for two players with or without accompaniment. In piano music the term can mean either a piece for two players at one piano (a piece for FOUR HANDS), or for two players at separate pianos.

dulcet *Music* An organ STOP of sweet, soothing tone.

dulcimer *Music* 1. An instrument with an array of tuned strings stretched over a SOUND BOARD and played with two wooden HAMMERS, a distant ancestor of the piano. Medieval dulcimers were fairly small instruments with ten or more strings. Modern composers (Igor Stravinsky, Zoltán Kodály and others) have used them for color in large orchestras, and the innovative American composer Harry Partch constructed and played several with 40 or more strings, tuned in MICROTONES. *See also* CIMBALOM.

dulcitone *Music* A CELESTA whose tone is produced by tuning forks that give a sound sweeter than would the metal bars normally used.

dulling spray *Stagecraft, Television* A clear spray that can be applied to any surface on the set to reduce unwanted shine or reflection.

dumb show *Acting* A PANTOMIME usually played within a normal (spoken) scene, intended to convey the meaning of a larger scene or even of the whole play in an indirect or metaphorical manner.

dumka, dumky (*DOOM-kah, DOOM-kee*) [Ukrainian] *Music* A dancelike instrumental piece based on Slavonic folk ballads, characterized by sudden changes of mood and pace.

dummy *Acting* A VENTRILOQUIST's doll, articulated so that it can seem to sit on the performer's lap, and with facial controls hidden in its body operated from behind by the ventriloquist's hidden hand.

Costume A dressmaker's form in the size and shape of a particular actor upon which costumes may be adjusted for correct fit.

dump *Music* An English dance form of the 16th and 17th centuries, sorrowful in character, that used simple tonic-dominant harmonies in simple 4/4 rhythms.

duo *Acting* 1. Any act or skit for two performers. 2. A team of two actors who perform together.

Music Any piece for two instrumental soloists or two singers of equal importance, with or without accompaniment.

duodecuple scale *Music* A scale consisting of 12 semitones, each of which is considered an independent tone and none of which is considered a chromatic alteration of another. *See also* DODECAPHONIC.

duologue *Acting* 1. A composition for two speakers. 2. A sequence played within a scene by two actors whose lines are not supposed to be heard by the others in the scene. 3. A dialogue. The word, however, is more limiting than dialogue. Only two can speak a duologue.

duple *Music* 1. Having two beats per measure. 2. Subdivided into two half-beats.

duple rhythm *Music* Any rhythm based on two beats or subdivisions of a single beat into two parts.

duple skip *Music* In Eurythmics, a SKIP containing two equal steps on each foot, as in left-left, right-right. The physical experience of performing such a skip, and comparing it to that of a triple skip, is a fundamental example of the musical experience of rhythm.

duplet *Music* Any melodic figure in which two notes of a given value replace and require the same period of time as three. A duplet is identified in music with a horizontal bracket or a slur, and the figure *2* over the two notes. *See also* TUPLET.

duple time *Music* A musical METER based on two beats per measure.

duplex *Lighting* A connector with two PLUGS and/or two outlets. *See also* QUAD BOX, SPIDER, THREEFER.

dur (*du-er*) [German] *Music* Major, as in *a-dur* = A MAJOR.

duration *Music* 1. The length of time that a tone should sound in a measure of music, usually expressed in terms of note, *e.g.,* QUARTER NOTE, HALF NOTE, etc. 2. The length of time required to perform a piece, usually expressed in minutes.

durchkomponiert (*durkh-kom-poh-NEERT*) [German] *Music* Literally, through-composed. Said of a composition that has no repeating passages, nor any exact recapitulations of them, but has been composed throughout. The opposite of STROPHIC FORM. An example is *La Marseillaise* by Rouget de Lisle.

dutchman (plural, **dutchmans**) *Stagecraft* 1. A strip of cloth glued over the gap between two adjacent flats and painted along with them so that the surface will appear unbroken. 2. On a RAKED STAGE a wedge placed under one corner of a flat to raise it to a level position. *See* FOX WEDGE, JIGGER.

Duveteen, Duvetine, Duvetyn *Motion pictures* Trade names for a heavy, opaque, fireproof fabric, similar to COMMANDO CLOTH, used as a FLAG to block light from the SET.

dwell *Acoustics* The length of time a sound remains audible after the player has ceased playing it, *e.g.,* the length of time the strings continue to vibrate. *See also* DECAY. Not the same as REVERBERATION TIME.

dynamic marks *Music notation* Words, abbreviations and/or symbols written above or below the staff to tell the player the degree of loudness or softness that should be applied to the passage so marked. Symbols and their associated words include *f* (FORTE) for loud,

p (PIANO) for soft, *mf* (MEZZOFORTE) for medium loud, *mp* (MEZZOPIANO) for medium soft, *ff* (FORTISSIMO) for very loud, *pp* (PIANISSIMO) for very soft, and so on. Other dynamic markings indicate how changes should occur, such as CRESCENDO and DIMINUENDO.

dynamics *Music* The element of musical expression that concerns the volume of sound produced, the contrasts between loudness and softness and the manner by which these contrasts are made to occur. A composer or an editor may suggest dynamics for a particular piece with DYNAMIC MARKINGS, which the player interprets in performance. *Compare* AGOGICS.

E

e *Music* The third note of the scale of C, a MAJOR THIRD above C and a PERFECT FOURTH below A. The TONALITY of which the note E is the TONIC. In the FIXED-DO system, E is MI.

Eagle Rock *Dance* An ANIMAL DANCE that enjoyed some popularity in the early 1900s, performed to RAGTIME.

eagle-tail dance A Cherokee Indian dance of the late 1700s and early 1800s, designed to encourage the spirit of war in the younger generation.

ear *Acting* The ability to hear and accurately reproduce national or regional dialects and/or rhythms in speech.

Music The ability to perceive differences between musical tones. A person with a good ear can, for example, remember a melody, hear the inner voices of a composition, understand the movements of harmonies, and so on. Usually a person with a bad ear cannot carry a tune with any degree of accuracy.

ear training *Music* The process of learning to hear and analyze music melodically and harmonically, and to reproduce it according to one's particular talent. Ear training and RHYTHM together constitute the most fundamental process in the study of music. A person's ear is trained through courses (*See* SOLFÉGE, SOLMISATION) of listening to and remembering intervals, melodic phrases and harmonies, learning how to write them down accurately and to reproduce them by reading (SIGHT-SINGING).

ebony *Music* A deep black hardwood from India and Sri Lanka once prized by instrument makers but largely replaced by other materials that are lighter and less difficult to work with, such as Pernambuco wood and certain plastics.

écarté (*ay-kar-TAY*) [French] *Ballet* Literally, separated, spread wide apart. A position with the body at an oblique angle to the audience, with the working leg (nearer the audience) pointed in SECOND POSITION on the ground or raised to second position in the air. The arm on the side of the working leg is raised and the other arm extended to the side. One of the POSITIONS OF THE BODY in the CECCHETTI METHOD.

écart, grand *See* SPLIT.

ecclesiastical modes *See* CHURCH MODES.

ecdysiast *Vaudeville* A striptease dancer. The term was coined by the famous curmudgeon and social critic H. L. Mencken from *ecdysis*, a technical noun from Greek meaning "the process of getting out," or "shedding," as when a snake sheds its skin.

échappé (*ay-shah-PAY*) [French] *Ballet* Literally, escaped, slipped. The level spreading of the feet from a closed position to an open position starting with a spring from both feet (SAUTÉ) or from a raising of the body (RELEVÉ) on POINTS or DEMI-POINTES, ending in SECOND or FOURTH POSITION, then returning to FIFTH POSITION.

echo *Audio* Any audio signal that resounds within an audio circuit, constantly diminishing with each repeat. Undesirable echo can occur accidentally when there is CROSSTALK within the circuit. It can also be created intentionally through a DELAY LINE, when the audio engineer wishes to imitate the sound of a larger hall than was actually used during an original recording. *See also* RESONANCE, REVERBERATION.

echo chamber *See* DELAY LINE.

eclogue *Music* Originally a lyric poem in the form of a pastoral dialogue between two people. In the 16th century the eclogue developed into a staged scene with music and must surely have been known to the little group of composers in Florence (*see* CAMERATA) who tried to re-create Greek drama but invented opera instead.

Écossaise (*ay-koh-SEZ*) [French] *Dance* Literally, Scottish. An early 19th-century contradance in quick 2/4 time, not exclusively Scottish but popular in England and France and particularly in Vienna where Beethoven and Schubert composed short pieces in the form. The dance was performed in two lines and was often accompanied by BAGPIPES.

ECU *Motion pictures* Abbreviation for EXTREME CLOSE-UP.

edge numbers *Motion pictures* In traditional motion picture practice, a series of multidigit numbers photographically imprinted along one edge of motion picture film by its manufacturer or ink-printed on the ORIGINAL later in the laboratory. The numbers have no meaning in themselves, except that they are in numerical sequence. They enable an EDITOR or a NEGATIVE CUTTER to match the print or WORKPRINT precisely to the original at any time. In modern motion picture production, the function of edge numbers has been taken over by digital coding embedded in both the sound track and the video workprint. *See* TIME CODE.

edit *Audio* 1. A single strand of recorded audio tape cut by an editor for insertion in a recorded sequence. A CUT. 2. To organize many separately recorded sections of a performance into a single, coherent recording of the piece.

Motion pictures 1. A single SHOT, together with its synchronized sound track, cut by an editor for insertion in its proper place in a sequence. A CUT. 2. To organize individual shots and their synchronized sound tracks into a coherent sequence.

Video 1. A single shot (consisting of both visual and audio tracks) that has been inserted into a sequence by a video editor. Although a video editor works by rerecording, and never

actually cuts a tape, a single edit often is called a CUT. 2. To assemble a sequence by switching between several synchronized video recordings and rerecording the selected shots in a chosen order.

editor *Audio, Motion pictures, Television* One who EDITS. The person who cuts and reorganizes the various takes of any film or recording to create the desired sequence.

éffacé (*ay-fah-SAY*) [French] *Ballet* Literally, effaced. A POSITION OF THE BODY at an oblique angle to the audience with the WORKING LEG stretched out away from the body. *See also* ÉCARTÉ, ÉPAULEMENT.

éffacé devant (*ay-fah-SAY deu-VANH*) [French] *Ballet* A variant of CROISÉ DEVANT in which the leg farther from the audience is pointed in FOURTH POSITION front, etc., with the higher arm raised on the side of the supporting leg. One of the POSITIONS OF THE BODY in the CECCHETTI METHOD.

effect *Audio* 1. Any artificially produced sound in a recording, *e.g.*, the effect of horses walking, produced by striking a surface with hollow bowls (or halves of coconuts). *See* FOLEY RECORDING. 2. Any alteration of a recorded sound for dramatic purposes. Effects include audio fades and dissolves, or changes of timbre as, for example, when a well-recorded voice is rebalanced to emphasize its HIGHS and deemphasize its lows, so that it sounds as if it were coming through telephone wires or an airborne communication circuit.

Motion pictures In general, any alteration of a picture during the editing phase, *e.g.*, FADES and DISSOLVES. *See also* SPECIAL EFFECTS.

Stagecraft Any event, such as thunder and lighting, rain or explosions, simulated visually and/or aurally on stage by workable means. Some effects demand considerable preparation of the set, *e.g.*, rain, with pipes in the flies to deliver the water on cue and troughs in the floor to catch it so that it doesn't run out over the ORCHESTRA PIT. The sound of rain, on the other hand, may be nothing more than an audio recording.

Theater Any impression or illusion produced in the minds of the audience by the means available to actors, *e.g.*, when a small group of actors backstage murmur loudly to create the impression that they are a large crowd.

Video Any artificially produced alteration of a video recording during either the SWITCHING or the editing process, including FADES, WIPES, DISSOLVES and the like.

effect head *Lighting* Any device attached in front of a light fixture for the purpose of creating an EFFECT. *See also* FLICKER WHEEL.

effects The totality of editing alterations or artificially produced sights or sounds used in any branch of the performing arts. *See* STAGE EFFECTS, SOUND EFFECTS, SPECIAL EFFECTS, VISUAL EFFECTS.

effects machine *Theater* Any machine (not an audio recording) that artificially produces a sound or visual effect on stage. Such machines include, for example, the THUNDER RUN, CRASH BOX and LIGHTNING EFFECT.

effects track *Motion pictures* The individual sound track that carries the sound effects, as distinguished from the DIALOGUE TRACK and the MUSIC TRACK. Since there are usually many different sounds, originally from different sources, that must be synchronized and rerecorded to create a realistic audio environment, the effects track begins as many tracks, becoming a single track after a MIX or a series of MIX-DOWNS in the sound editing process. *See also* M & E TRACKS.

eight-ball *Audio* Slang term for a small, omnidirectional microphone.

eighth *Music* 1. Short for EIGHTH NOTE. 2. The interval of one OCTAVE.

eighth note *Music* Half a QUARTER NOTE.

EIGHTH NOTE

eighty-eight *Music* Slang term for the piano, which has 88 keys.

Eisteddfod (*eh-STETH-vod*) [Welsh Gaelic] *Music* Literally a sitting, or meeting. An annual gathering of Welsh BARDS and choirs during the 19th and 20th centuries in imitation of similar gatherings in early times.

EL *Acting* An abbreviation for enter left, *i.e.,* from STAGE LEFT, written as a CUE into an actor's script.

élancé, élancée (*AY-lahnh-SAY*) [French] *Ballet* A descriptive ballet term indicating that a step should be executed in a darting manner.

electric bass (guitar) *Music* A solid-body instrument with four strings (approximately 36 inches long) tuned like those of a DOUBLE BASS, first made in the early 1950s by Leo Fender, who dubbed it the "precision bass." The instrument is held horizontally (like the guitar) and supported by a strap over the shoulder. When played, string vibrations are picked up by electromagnets that convert them to electrical signals channeled through tone modifiers, an amplifier and finally a LOUDSPEAKER. The electric bass has become an essential part of pop and ROCK music performance.

electric guitar *Music* A guitar with steel strings and a solid body in place of the hollow re-sounding body of the acoustic guitar. Its sound is picked up and amplified directly from electronic sensors (not microphones) associated with each string. Not the same as a STEEL-STRUNG GUITAR or an amplified ACOUSTIC GUITAR. The electric guitar normally has volume and balance controls built into the body that can greatly modify the tone of the instrument. Some performers have made special use of the instrument's electronic capabilities, as did Jimi Hendrix with his technique of controlled FEEDBACK (*see* FUZZ BOX).

electrician *Lighting* A technician who works with lighting and power, but not audio, circuits.

electric organ *Music* An organ whose sound is produced by electronic means through loudspeakers. *Compare* PIPE ORGAN, REED ORGAN.

electronic music Music produced wholly electronically, as distinguished from music that is constructed from recordings of the sounds of normal instruments and voices. When composers first began to experiment in electronics after 1945 when tape recording first came

into general use, much of their product consisted of standard musical harmonies and melodies produced in weird, electronic TIMBRES. Although a piece of music may be created wholly by electronic means and yet sound completely traditional, the term is now understood in its pure sense to mean nontraditional composition in which harmonics, tonality and rhythm are converted into electronic concepts, sounding completely unlike acoustically produced music. *Compare* COMPUTER MUSIC.

electrophone *Music* A scholarly term for any of the class of musical instruments whose sound is produced by, or made audible by, electronic means. Among them are the ELECTRIC GUITAR and electronic instruments such as the THEREMIN, the ONDES MARTENOT and all SYNTHESIZERS.

elegy *Music* A sad, lyrical, commemorative piece. A lament for the dead.

element *Theater* A single, discrete event or situation within a scene that is an essential part of the dramatic movement into the next such event, *e.g.*, in Goethe's *Faust* when the stray dog comes up to Faust on the street and Faust, later in the scene, decides to take him home.

elements *Acting* The fundamental components of acting, including enunciation, vocal projection, gesture, timing and characterization.

Lighting The light fixtures, dimmers, control boards or other units that are parts of a lighting circuit.

Music The fundamental components of music, including HARMONY, MELODY and RHYTHM.

Theater The six formative components of every drama, defined and discussed by Aristotle in his *Poetics*. They are, in order of importance: PLOT (the action of the story), CHARACTERS (who exist to create the action), diction (language, the expression of their thoughts in words), thought (the power of saying what can be said), melody (*i.e.*, music, beauty, the greatest of all pleasures) and spectacle (the least important). He also lists the *processes* of drama, often referred to by their Greek names: PROTASIS (premise), EPITASIS (development of stress or tension), PERIPETEIA (reversal of circumstances), CATASTASIS (confrontation of fate) and CATASTROPHE (collapse of dramatic tension). In yet another enumeration, he mentions the essential sections of the classical Greek comedy and tragedy: PROLOGUE, PARODE (the first statement of the CHORUS), EPISODE, STASIMON (the second statement of the chorus) and EXODE. Beyond these formal lists, he also used many words that have special meanings in the context of his philosophy. Among them are ANAGNORISIS (recognition), DÉSIS (entanglement, enchainment), MIMESIS (creative imitation), MYTHOS (fundamental story), PATHOS (suffering or calamity) and PRAXIS (practice in the sense of how one practices one's life).

elevation *Dance* A dancer's ability to perform high leaps and jumps, and to remain in the air for a brief moment (called BALLON), creating the impression that the body is in flight.

elevation sight lines *See* VERTICAL SIGHT LINES.

elevator stage *Stagecraft* An entire stage floor that can be raised into view from below with its SET and CAST in place. Probably the most outstanding modern example is in the Metropolitan Opera House in New York City, where four complete sets can be mounted at the

same time: the main elevator stage (the full stage is 101 feet wide by 80 feet deep), two side stages either of which can be rolled into the center, and an elevator stage behind the main stage that can be used as part of an extremely deep scene when raised to the level of the main stage or rolled in to replace it.

ellipsoidal reflector *Lighting* A shaped reflector built into a lighting instrument that has no lens and focuses the light through spill rings sharply into the set. With nothing to absorb the light, it is brighter than it would be with a lens. Usually it has a color frame at its focal plane. *Compare* LINNEBACH PROJECTOR.

ellipsoidal spotlight *See* LEKOLIGHT.

elocution *Acting* An actor's style and manner of speech, including diction (for clarity), projection (for audibility beyond the proscenium), pronunciation (for characterization), articulation, pitch, rhythm and general control of quality and level (strength) of voice. Elocution is usually understood as ideal speech, but an actor's actual DELIVERY on stage will be modified from the ideal to make a characterization believable.

ELS *Motion pictures* Abbreviation for EXTREME LONG SHOT.

embellishment *See* AUXILIARY TONE, ORNAMENTATION.

emboîté (*om-bwah-TAY*) [French] *Ballet* Literally, boxed or fitted together. A boxed-in step or type of JETÉ often executed in a series, with the feet held as close together as possible. It is performed moving UPSTAGE or DOWNSTAGE, EN TOURNANT, on POINTS, etc.

embouchure (*OM-boo-shür*) [French] *Music* Literally, mouthpiece. 1. The shape and size of the opening of the lips while blowing into the mouthpiece of a wind instrument. A player's "lip." 2. The mouthpiece of a woodwind or brass instrument excepting those that have double reeds. *Compare* CHOPS.

embryo *Lighting* A spotlight so small it can be held in the hand. Also called an INKY, for incandescent, to distinguish it from an ARC or HALOGEN LIGHT. It has a FRESNEL LENS and can be hidden among the footlights to highlight an actor close to the front of the stage, or hidden within some part of the set for a similar purpose.

emcee *Cabaret, Vaudeville* 1. Short for the MASTER OF CEREMONIES, the MC. 2. To perform the duties of a master of ceremonies.

emergency lights *See* SAFETY LIGHTS.

emergency rope *Stagecraft* A rope that will instantly release the FIRE CURTAIN when cut. A CUT LINE.

Emmy *Television* An award for excellence in programming, production or acting on television, given annually since the early 1950s by the Academy of Television Arts and Sciences (for the East) and the National Academy of Television Arts and Sciences (for the West). The name came from the nickname for an image orthicon camera tube, called an immy.

emote *Acting* To display too much emotion during a scene. *Compare* CAMP, CHEW THE SCENERY, HAM.

emotion memory *Acting* An actor's memory of a specific personal experience and the emotion felt at the time, used to help achieve the BELIEF necessary to play a scene. The term comes from the teaching of Konstantin Stanislavski, but actors have been known to make use of the principle since at least the 4th century B.C. when an actor playing in *Electra*, a play by Sophocles, being required to carry an urn supposedly filled with the ashes of Electra's brother, substituted another urn carrying the real ashes of his own son who had recently died. The grief he expressed was impressive; it came from the memory of his own emotion. The way he accomplished it, however, violated another essential principal of the craft of acting: to move an audience, an actor must not weaken his or her performance by being overly moved. *See also* AFFECTIVE MEMORY, STANISLAVSKI SYSTEM.

emphatic curtain *Acting, Stagecraft* A singularly strong ending line or action that is the cue for quickly dropping the curtain.

emphatic figure *Acting* The dominant character in a scene, placed at the main FOCUS of the scene.

en arrière (*anh ah-ree-AIR*) [French] *Ballet* Literally, backward, indicating that a step is to be performed moving away from the audience. The opposite of EN AVANT.

en avant (*anh ah-VANH*) [French] *Ballet* Literally, in front, indicating that a step is to be performed moving toward the audience. The opposite of EN ARRIÈRE.

enchaînement (*anh-shen-MANH*) [French] *Dance* Literally, linkage as in a chain. A chain or combination of movements that make up a complete dance phrase.

Music See VOICE-LEADING.

enchainment *See* ENTANGLEMENT.

encore (*anh-KOHR*) [French] Literally, again. 1. What the audience shouts to request that the performer repeat what has just been done, or at the end of a concert to request another piece. 2. A work performed after the formal concert program ends. 3. A short piece of music or, for an actor, a sketch or a monologue that has been prepared for performance in case the audience does call for more.

en couronne (*anh koo-RUN*) [French] *Ballet* Literally, in the shape of a crown. A position with the arms held above the head and slightly curved.

en dedans (*anh deu-DANH*) [French] *Ballet* Literally, inside. Describing the inward circular motion of the legs or arms, toward the supporting leg from back to front. Also, a turn toward the supporting leg. The opposite of EN DEHORS.

en dehors (*anh deu-OR*) [French] *Ballet* Literally, outside. Describing the outward circular motion of the legs and arms away from the supporting leg. Also, a turn away from the supporting leg. The opposite of EN DEDANS.

Music In the foreground, more prominent. An instruction to the player to play slightly louder than the others in the ensemble.

endless runner *See* MOVING PANORAMA, TREADMILL STAGE.

end man *Vaudeville* Either of two stock characters, MR. BONES (who played the BONES) or MR. TAMBO (with a TAMBOURINE), who sat at either end of the little semicircle of black-face actors and exchanged jokes and repartee with the INTERLOCUTOR between musical numbers.

energy *Acting* An actor's intensity of DELIVERY and of action during a performance. Energy does not necessarily manifest itself as speed of action and movements, but as intensity of concentration and of relationship with other actors in the scene.

en face (*anh FAHS*) [French] *Ballet* Literally, opposite, facing the audience.

engagement *Acting* A scheduled and contracted appearance or series of appearances in a single theater. *Compare* GIG.

engine *Stagecraft* A WINCH or other device that provides the physical power to move a WAGON on the stage, or to lift scenery into the FLIES. It differs from a MACHINE in that the machine moves on its own, whereas an engine is fixed in place, usually in the WINGS or on the GRID, and moves something else.

engineer *Audio* An electronic technician qualified to operate the entire recording system.

Lighting A technician with special knowledge who is authorized, sometimes officially licensed, to supervise and/or operate electrical circuits and controls.

English horn *Music* A DOUBLE-REED INSTRUMENT much like an OBOE in appearance but larger, with its mouthpiece set at a convenient angle toward the player's lips instead of straight, and with a bulbous section at the bottom that forms the BELL. The alto voice of the oboe family, it is a transposing instrument in the key of F. Only its name is English, having been mistranslated from the French *cor anglais*, angled horn.

English National Opera *See* SADLERS WELLS.

English style *Dance* A form of BALLROOM DANCE that developed in England after World War I and reached its zenith with the English slow FOXTROT. Characterized by smooth gliding steps, with great emphasis on erect carriage. Also called INTERNATIONAL STYLE.

enharmonic *Music* Said of a note that can be written in more than one way, depending on its harmonic treatment. In equal temperament, a chord that normally contains a G-sharp, for example, may be written with an A-flat instead, because the composer has established a harmonic context in which the change is appropriate.

en haut (*anh OH*) [French] *Ballet* Literally, on high. With the arms held above the head. *See also* EN COURONNE.

en l'air (*anh LEHR*) [French] *Ballet* Literally, in the air. A movement done off the ground. The opposite is PAR TERRE.

enlèvement (*anh-lev-MANH*) [French] *Ballet* Literally, carrying away. Describes the lifting of a dancer into the air by her male partner, in a pose or step.

en promenade (*anh pro-meu-NAHD*) [French] *Ballet* In a walk. Not to be confused with PROMENADE.

en seconde (*anh seu-GOHND*) [French] *Ballet* In SECOND POSITION. Also written as À LA SECONDE.

ensemble (*anh-SENHBL*) [French] *Dance* Literally, together. A number of dancers, not necessarily soloists, performing together as a coherent group.

 Music 1. The quality of togetherness in performance. 2. A company or group of players or singers performing together, usually without a conductor, as in CHAMBER MUSIC.

ensemble theater The art and practice of theatrical production as a close-knit company whose individual actors take leading or supporting roles in a REPERTORY of several plays, in contrast to companies organized for single productions whose actors perform single roles.

Ent. *Acting* Enter, or entrance. An abbreviation in a stage director's or an actor's script indicating an entrance.

entanglement *Theater* A translation of DÉSIS, Aristotle's term for everything that happens as the plot of drama develops, the enchainments and complications that beset its characters until the main character's REVERSAL OF CIRCUMSTANCES (PERIPETEIA). Everything after that point to the end of the play he calls EPITASIS.

enter *Acting* To walk into the visible area of the stage. A STAGE DIRECTION in the actor's script.

enter above *Acting* A STAGE DIRECTION in several Elizabethan plays; to enter on the top level of a two-level stage. Stages of that period frequently included two levels, and the playwright could use the higher level as an upper room in the house (the balcony scene from *Romeo and Juliet*), or a place for the king and the court to watch a play-within-the-play. Actors got there by climbing offstage stairs.

en tire-bouchon (*anh TEER-boo-SHONH*) [French] *Ballet* Literally, like a corkscrew. A position on POINT with one leg raised, the thigh in SECOND POSITION and the toe of the raised leg touching the knee of the supporting leg. A PIROUETTE executed in this position suggests the movement of a corkscrew.

en tournant (*anh toor-NANH*) [French] *Ballet* A term specifying that a step or movement, *e.g.,* ASSEMBLÉ or FOUETTÉ, should be performed while the body turns.

entr'acte (*anh-TRAKT*) [French] *Theater* 1. Between acts, an intermission. 2. A short piece of music or a theatrical sketch intended for the entertainment of the audience while the curtain is closed and stagehands are changing the set. *See also* BAILE.

entrance *Acting* The action of walking into a scene.

Stagecraft Any door, gateway, or simple opening through which an actor can enter the scene.

entrance cue *Acting* Another actor's line or any event on stage that signals the moment for an actor to enter the scene.

entrance light *Stagecraft* A special lamp backstage that can be switched on by the stage manager or an assistant to indicate an ENTRANCE CUE. In some theaters' practice, the light is switched on as a WARNING, then off as the precise CUE.

entrance line *Acting* A line spoken by an actor upon entering the scene.

entrance round *Theater* A round of applause that greets an actor on entering the scene. Common and sometimes appropriate in 18th- and 19th-century operas (and their modern productions) and in other shows in which stars are the main attraction.

entrance strip *Lighting* A strip of lights inside an entrance, illuminating the area within it.

entrechat (*anh-treu-SHAH*) [French] *Ballet* Literally, caper. A rapid crossing and recrossing of the legs before and behind each other while the dancer is in the air. In the various ENTRECHAT figures, numbered from 2 to 10, the even-numbered finish with both feet on the ground, while the odd-numbered end on one foot.

entrée (*anh-TRAY*) [French] *Dance* Literally, entrance. 1. The entry of a dancer or a group of dancers on stage to execute a NUMBER in a DIVERTISSEMENT or at the beginning of a grand PAS DE DEUX. 2. The number itself.

entrelacé (*anh-treu-lah-SAY*) [French] *Ballet* Literally, interlaced. *See* TOUR JETÉ.

environmental theater An alternative style of theater in which audience and actors mingle. In some manifestations, the actors surround the audience, in others the audience may walk from place to place, even outside the building, to watch scenes in different locations. *Compare* EPIC REALISM.

épaulé (*ay-poh-LAY*) [French] *Ballet* Literally, shouldered. A pose with the dancer at an oblique angle to the audience, with one shoulder turned forward (chin over the forward shoulder) and the other shoulder turned back. The leg nearest the audience is extended back on the ground or in the air, while the corresponding arm extends forward. One of the POSITIONS OF THE BODY in the CECCHETTI METHOD

épaulement (*ay-pohl-MANH*) [French] *Ballet* 1. The placing of the shoulders that gives a finishing touch to many movements. 2. A movement of the torso from the waist upward, in either of two basic POSITIONS OF THE BODY, with the legs crossed (CROISÉ) or open (EFFACÉ).

epic *Motion pictures* A movie on a heroic, usually historical, theme with a large cast, many important stars and grand settings.

epic realism *Theater* The depiction of stark social reality as practiced by Bertholt Brecht and others in the German theater of the 1920s and 1930s. An American example is the play *Waiting for Lefty* by Clifford Odets, which is set in a union hall. The audience has to imagine that they are members at a tense meeting at which a strike is being considered.

epic theater A style of theater put forward by the director and educator Erwin Piscator in New York during the 1940s and 1950s, emphasizing realism rather than illusion in acting and presentation and designed to leave its audience in an open-ended situation with conflicts unresolved.

epilogue [from Greek] *Theater* Literally, upon the word. A speech or a short scene after the play has ended, commenting on the meaning of the play or recounting how its characters continued their lives after its conclusion.

episode [from Greek] *Music* A subsidiary passage in a piece of music, such as the freestyle passage between the first statement and response of a FUGUE and its restatement or development later.

 Theater A single, complete event within a play or a scene. An event made to carry the plot or add substance to its characters, but that is secondary to the main action of the play and is complete in itself.

episodic Said of any work that is built of episodes, each more or less complete in itself.

epitasis (*eh-pee-TAH-sees*) [Greek] *Theater* Literally a straining, a stretching. One of the processes described by Aristotle, coming after the PREMISE and including all the complex action and DEVELOPMENT of the plot until it reaches its maximum intensity at the CONFRONTATION OF FATE. In modern thinking, development tends to be restricted to the expansion of ideas that occurs early in a drama, whereas Aristotle's epitasis continues to grow until the climax. *See also* ELEMENTS.

epithalamion (*eh-pee-tha-LAH-mee-on*) [Greek] *Music* Literally, at the bridal chamber. In Greek drama, a CHORAL ODE sung to the bride before the wedding.

epode (*EH-pohd*) [Greek] *Playwriting* Literally, end song. The third STANZA of each three-part sequence of a formal ODE in classical Greek drama, following the STROPHE and the ANTISTROPHE. The strophe sets up the material of the sequence, the antistrophe responds to it and the epode ends it.

epos (*EH-pos*) [Greek] *Theater* In classical Greek theater, the meaning or substance of a speech. In modern usage the word has lost such specificity and is used by scholars to mean any poetic material suitable for development as epic poetry.

equalization *Audio* The process of modifying the complex electronic signal of a recording so that it (1) reproduces the sound of the voices or instruments originally recorded as accurately as possible or (2) produces an effect needed for a dramatic situation. Equalization usually involves the adjustment of relative balance of loudness between various portions of the spectrum of the signal. The audio engineer accomplishes this by adjusting the relative LEVELS (volumes) of different portions of the audio range of the recording, *e.g.*, reducing or increasing some of the

HIGHS or LOWS until, to the ear, it sounds right. A new recording is then made at those settings. This delicate process is highly vulnerable to AUDIO CREEP. *Compare* MIXING.

equalize *Audio* To modify the quality of a recording by adjusting the LEVELS of its HIGHS and LOWS. *See* EQUALIZATION.

equalizer *Audio* A subsystem, built into a recording or PLAYBACK system, that provides an array of controls for each channel of sound coming through the system. Each of the controls can reduce the volume of one part of the spectrum of its channel to alter the sound it produces, *e.g.*, reducing higher portions (HIGHS) in relation to lower portions (LOWS) to create a less strident tone. *See* EQUALIZATION.

equal temperament *Music* A system of tuning any instrument of fixed pitches, such as a keyboard instrument, so that every SEMITONE is acoustically of equal size with every other semitone. For convenience, the OCTAVE, which is an acoustically specific interval, has been arbitrarily divided into 1,200 units, called CENTS. One equal-tempered semitone is therefore equal to 100 cents. This system approximates what the human ear expects to hear closely enough so that the mind can accept changes of KEY that would otherwise require a vastly expanded keyboard. The system came into use during Johann Sebastian Bach's lifetime, and he composed 48 preludes and fugues (*The Well-Tempered Clavier*) using all 12 keys, major and minor, in celebration.

equal voices *Music* Voices of the same range singing in harmony (not in unison). A convenient term indicating that a choral work is written for women's voices only, men's voices only, children, or (occasionally) for mixed voices of the same range.

equestrian *Circus* One who performs on horseback.

equestrienne *Circus* A woman who performs on horseback.

Equity *See* ACTORS' EQUITY ASSOCIATION.

ER *Acting* Enter right, *i.e.*, from STAGE RIGHT. An abbreviation written as a CUE into an actor's script.

escape ramp *Stagecraft* A ramp built behind any high platform within the SET and out of sight, allowing an actor to leave the stage at that height without having to come back down in view of the audience.

establish *Acting* To provide the audience with enough information to make the character and the situation being represented clearly understood within the period of an actor's first scene.

Motion pictures To compose the basic shot (usually near the opening) of any sequence so that the entire environment of the sequence is visible and can be understood at the outset. To make an ESTABLISHING SHOT.

establishing shot *Motion pictures* The basic view that encompasses the entire area of the scene, so that the audience will not become disoriented when close-ups and changes of point of view occur as the scene develops. An establishing shot for a romantic scene at a

dance, for example, would use a wide-angle lens to show most of the ballroom and the people dancing. The establishing shot does not necessarily have to be the first of every scene, but it usually occurs early enough to prevent the audience from losing track of where they are. *See also* KEY DRAWING.

estampie (*eh-stam-PEE*) [French] *Dance* Descended from a Frankish "stamping" dance that provided the name. By about the 12th century, it had become a sedate couple dance performed at court, led by personages of the highest rank.

esthetic distance *See* AESTHETIC DISTANCE.

étendre (*ay-TANH-dreu*) [French] *Ballet* Literally, to stretch. One of the seven basic MOVEMENTS in dance.

ethnic music The indigenous music and musical style of a particular people, *e.g.,* American JAZZ, Caribbean CALYPSO, or Japanese GAGAKU. Some ethnic styles involve tonalities and modes quite different from European classical tradition as does, for example, the music from India that is based on MICROTONES and complex rhythmic patterns.

étoile (*ay-TWAHL*) [French] *Ballet* Literally, star. A term used to designate the highest-ranking dancers of the Paris Opéra.

étude (*ay-TÜD*) [French] *Music* Literally, study. A musical composition suitable for concert performance, based upon a specific problem of instrumental technique and designed to give the student practice in its solution. Not the same as finger exercises. The 24 études by Frédéric Chopin are perennial favorites of concert pianists.

etwas (*ET-vas*) [German] *Music* Literally, somewhat or moderately, as in *etwas bewegt* (moderately fast), *etwas langsam* (somewhat slow).

eukinetics [from Greek] *Dance* Proper, *i.e.,* natural and beautiful, bodily motion.

euphonium *Music* A BRASS INSTRUMENT of the same range as the BARITONE but with a deeper, mellower tone similar to that of the TUBA.

euphony [Greek] *Music* Literally, good sound. Pleasing concord, general harmoniousness.

eurhythmic [from Greek] *Music* Having a pleasing rhythm. The term has taken on a more specific meaning with the study of EURHYTHMICS.

Eurhythmics [from Greek] *Music* A holistic method of studying music through the physical experience of rhythm, the aural experience of solfege and the integrating experience of improvisation, developed during the early 1900s by the musical educator and composer Émile Jaques-Dalcroze and introduced to the United States in 1915. *See* DALCROZE EURHYTHMICS.

eurhythmy [from Greek] *Music* Smooth, pleasing rhythmic motion. A term used to describe a style of simple, flowing bodily movement to lend visual interest to choral performance, having no specific relation to eurhythmics.

eutony [from Greek] *Dance* The relaxed and harmonious condition of the body when all its tensions are under control.

evensong *Music* The musical form of the early evening service of the Anglican church, corresponding to VESPERS in the Roman Catholic rite.

excursions *See* ALARUMS AND EXCURSIONS.

exercise *Dance, Music, Theater* Any relatively short, repetitive sequence of physical or mental actions designed to help a performer prepare in body and mind for a performance.

exeunt [late Latin, the plural form of the verb "to leave"] *Acting* A stage direction from Shakespeare's time, still in use, telling the several actors who have just been speaking to leave the scene.

exeunt omnes [late Latin plural] *Acting* Literally, go out all. A stage direction for all actors to leave the scene.

exhibitor *Motion pictures* One who exhibits motion pictures to the public, *i.e.,* a theater owner.

exit [Latin singular] *Acting* Literally, go out. 1. Leave the scene. 2. The act of leaving the scene.

 Stagecraft A door or other opening through which actors can leave the scene.

 Theater A door that leads the audience out of the theater.

exit cue *Acting* Any CUE, such as a line of dialogue or some other event on stage, that defines the moment when a specific actor must leave the scene.

exit lights *Theater* Special lights in the HOUSE, permanently illuminated, that identify safe exits for the audience in case of emergency.

exit line(s) *Acting* The line(s) spoken by an actor when leaving the scene.

exodos [Greek] *Theater* The final scene of a classical Greek comedy or tragedy consisting of a CHORAL ODE and a procession off the stage. *Compare* EPILOGUE.

exotic dancer *Vaudeville* 1. A dancer, usually female, who performs ethnic or pseudo-ethnic dances in Middle-Eastern, Balinese or Hawaiian style and costume. 2. Euphemism for a STRIPTEASE or GOGO DANCER.

experimental theater Any style of theater that breaks from tradition. A theater that features productions using ideas and techniques that are more or less untried elsewhere, *e.g., Einstein at the Beach,* as produced and directed by Robert Wilson with music by Philip Glass.

exploded box set *Stagecraft* A stage set similar to a BOX SET, but with sides, backdrop and ceiling separated from each other, creating a stylized version of reality that was popular among European stage designers of the early 20th century.

exponential horn *Audio* A large LOUDSPEAKER in the shape of a conical horn that grows exponentially to whatever maximum size is physically possible in a given situation. It can deliver loud sound at greater distances than most other shapes.

exposition *Music* The first section containing the statement of themes in a composition in SONATA FORM or in a FUGUE.

Theater The process of presenting all necessary background information about characters and plot in the first section of a play.

expression *Acting* An actor's manner of DELIVERY, partly suggested in the author's words, partly established by the actor through the technique of acting. The author may go to some length to instruct the actor with directions written into the script, but how the actor deals with these suggestions finally determines the expressiveness of the scene in the minds of the audience.

Music The emotional component of music, communicated to the listener not only by the character of the composition, but also by the manner in which it is performed. A composer suggests expression in the notes themselves by choices of KEY or MODE, PACE, DYNAMICS, the interplay between harmonies and melodies, instrumentation and many other factors. The performer expands and interprets all these suggestions, hoping to communicate the composer's intent.

expressionism *Theater* An antirealistic, antinaturalistic movement in European and American theater during the 1920s, emphasizing a struggle for spiritual renewal, and characterized by EPISODIC plays in which scenes and actions followed each other in a sequence not always based on logical cause and effect, with stylized acting and cubistic and surrealistic set designs. One work that survived the era is August Strindberg's *Dream Play*.

expression marks *Music* Symbols and/or words written above or below the STAFF of any piece of music, to instruct the performer about how individual notes, measures, melodies or passages should be played. Expression marks fall into several categories: DYNAMICS, TEMPO, PHRASING, ARTICULATION, BOWING for string players, symbols for terms like LEGATO and STACCATO, as well as indicators of mood (CON AMORE) and style (ALLA GITANA).

extempore acting *See* COMMEDIA DELL'ARTE, IMPROVISATION.

extended control *Lighting* Any control situated away from the main CONSOLE.

extended stage *See* THRUST STAGE.

extending brace *See* EXTENSION BRACE.

extension *Ballet* A dancer's ability to raise and hold the WORKING LEG in the air at any angle from the body.

extension brace *Stagecraft* A telescoping STAGE BRACE, intended to be placed diagonally between a FLAT and the stage floor to hold the flat upright, constructed in two pieces that slide against each other so its length can be adjusted to fit the situation.

extension stand *Lighting* A length of pipe that can be clamped to a LIGHT PIPE or vertical stand to support a lighting fixture in a position beyond its normal reach.

exterior, exterior scene *Motion pictures* Any scene depicting the outdoors, whether it is actually shot there or in the studio.

extra *Acting* A person hired to appear in a scene as one of a crowd, but with no specific role to play. An extra may be required, along with everybody else, to shout or scream on CUE during the scene. If the extra is required to shout solo, he or she is considered a BIT PLAYER and paid accordingly. *See also* SPEAR CARRIER, SUPERNUMERARY, WALK-ON.

extravaganza *Vaudeville* Any elaborate, basically frivolous, show with lots of comedy, music and dancing.

extreme close-up *Motion pictures* A close-up taken from an extremely small distance away, *e.g.*, showing only the eyes of the subject, not the entire head. Its abbreviation is ECU.

extreme long shot *Motion pictures* A shot taken from a great distance away, showing the subject as a relatively small part of a wide expanse. Its abbreviation is ELS.

eye level *Acting* The level determined by an actor's line of sight while looking at the back of the HOUSE, the first row of a low balcony or the mezzanine.

F

f *Music* The fourth note of the scale of C, a PERFECT FOURTH above C and a MAJOR THIRD below A. The TONALITY of which the note F is the TONIC. In the FIXED-DO system, F is FA.

fa *Music* 1. In the FIXED-DO system, the note F. 2. In the MOVABLE-DO SYSTEM, the fourth note of the scale in use. *See* SOLMIZATION.

fable *Theater* The planned structure of the PLOT, a term used by Aristotle to distinguish the underlying intrigue of the plot from the argument, *i.e.,* to distinguish the plan in structural terms (the FABLE) from the actual actions to be performed by the named characters.

fabliau (*fah-blee-YOH*) [French] *Music* In the Middle Ages, a musical entertainment.

face, en (*enh FAHS*) [French] *Ballet* Literally, facing, opposite. A dancer's position facing the audience.

face lace *Makeup* A slang term for artificial facial hair.

fadagh (*FAH-dakh*) [Irish Gaelic] *Dance* A LONGWAYS DANCE of ancient Irish origin, led by a trio of dancers connected to each other by handkerchiefs and followed by couples similarly connected. Each couple passes in turn under the leaders' handkerchiefs, executing several figures before returning to its original position. Also known as the *rinnce fada*, it was accompanied by the IRISH HARP or BAGPIPES.

fade *Audio* To reduce the volume of the signal gradually, so that the audience is not aware of any sudden change.

Lighting To decrease the intensity of light by means of a DIMMER.

Motion pictures A dimming-out of the scene, specified by the editor during the editing phase and carried out by the laboratory during the final printing process.

Television A dimming-out of the scene, called for by the director and carried out by the SWITCHER during the recording, or by the VIDEO MIXER during the editing process.

fade in *Audio* To increase the volume of the signal from silence, gradually.

Lighting To DIM IN.

Motion pictures To increase the brightness of the picture gradually from nothing. A FADE-IN is specified by an editor's mark in the WORKPRINT or by coding in a digital control track, and actually accomplished by the laboratory during the ANSWER-PRINT phase.

Television To increase the brightness of the picture gradually from nothing, accomplished during the recording process, or by the VIDEO MIXER later.

fade-in *Lighting* A gradual increase of light, starting in darkness.

fade out *Audio* To decrease the volume of the signal gradually to silence.

Lighting To DIM OUT.

Motion pictures To decrease the brightness of the picture gradually to nothing. A FADE-OUT is specified by an editor's mark in the WORKPRINT or by coding in a digital control track, and actually accomplished by the laboratory during the ANSWER-PRINT phase.

Television To decrease the brightness of the picture gradually to nothing, accomplished during the recording process, or in a video MIX later.

fade-out *Lighting* A gradual decrease of light, ending in darkness.

fader *Television* A control on the console that performs a FADE.

fade rate *Lighting* The rate of change for a FADE to take place, usually expressed in seconds on the CUE SHEET.

fader wheel *Lighting* A master control that causes all the active dimmers to FADE at the same time. *Compare* PROPORTIONAL DIMMER.

fade time *Lighting* The period of time designated by the director for a FADE to take place.

fado (*FAH-doh*) [Portuguese] *Music* Dating from the mid-1800s, the popular songs and ballads of the cafes and cabarets of Portugal, usually accompanied by guitar or small instrumental groups.

failli (*fah-YEE*) [French] *Ballet* Literally, failed. A movement starting with a bound forward in FIFTH POSITION and, after several movements in the air, ending in FOURTH POSITION and DEMI-PLIÉ, performed on one count.

fake *Music* An abbreviated version of a popular song, with only the melody and CHORD SYMBOLS for a single refrain written out, so that a pianist can "fake" a harmonization or a bass part for the song and perform it at length without previous practice.

Stagecraft *See* BREAKAWAY.

fake a curtain *Acting* To force an encore or a BOW whether or not the audience actually calls for it.

fake book *Music* A compilation of FAKES for use in various situations, built upon popular tunes or sequences of chords. Performers frequently compile their own. Fake books were once published without payment of royalties to the copyright owners whose songs were represented, and were illegal. They have been replaced since the 1960s with *The Real Fake Book* and other similar titles, by publishers who adhere to copyright law.

fake map *Costume* A slang term for a MASK.

fake up *Acting* To improvise a line or a bit of BUSINESS.

fa-la *Music* Any 16th-century song or madrigal with its chorus built on a text consisting of fa-la-las, *e.g.,* Thomas Morley's MADRIGAL "Now is the Month of Maying."

fall *Lighting* The way the light from a light fixture illuminates an area of the set; the product of its direction, intensity and color, whether it blends into other areas or has sharp edges, etc.

fall guy *Circus, Vaudeville* A character who is the butt of jokes and tricks in a comic routine, played by a CLOWN in the circus or the THIRD BANANA in vaudeville.

falling action *Theater* The action that follows the CLIMAX of the play and carries the story to its logical ending. *See* RESOLUTION.

falling flap *Stagecraft* A section of a piece of scenery, such as the top half of a FLAT, hinged so that it can be dropped quickly to reveal a new scene painted on its other side.

fall-recovery *Dance* In MODERN DANCE, the relationship, and its consequences, between opposing forces of balance and imbalance as seen in the simple shifting and changing of a dancer's weight. A term much used by the American dancer Doris Humphrey, but probably originating with the German theoretician Rudolf von Laban.

false blackout *Theater* A very brief BLACKOUT to indicate that time has passed.

false cadence *See* DECEPTIVE CADENCE.

false proscenium *Stagecraft* A second PROSCENIUM somewhat smaller than the main proscenium and placed behind it to make the stage look smaller, as for a classical opera that would appear incongruous on an enormous stage. It is called a hard proscenium if it is constructed, or soft if it is a painted DROP.

false relation *See* CROSS RELATION.

falsetto [Italian] *Music* A style of singing in a range higher than one's natural range, accomplished by temporarily restricting the larynx so that it produces PARTIALS instead of fundamental tones. The result is less loud than the full voice, but may be perfectly acceptable for quiet high notes. Many high passages intended for falsetto appear in vocal works of the 17th and 18th centuries. Not the same as the voice of the CASTRATO, which is much louder and not produced by temporary laryngeal control.

fan dance *Vaudeville* Any solo dance performed by a nude or nearly nude dancer using large fans for concealment.

fan dancer *Vaudeville* One who performs a FAN DANCE.

fandango *Dance* An ancient Spanish dance based on two-measure phrases in TRIPLE TIME performed by a couple playing castanets, beginning slowly and gradually increasing in speed and intensity.

fanfare *Music* A brilliant musical salute or signal composed of vigorous tunes often based on TRIADS, usually played by BRASS INSTRUMENTS with military drums.

fanny bump *Dance* A couple dance popular in Harlem in the early 1900s, performed to RAGTIME.

fantasia *Music* Any composition in free form, not based on a traditional or classical form.

fantastic realism *Acting* A term coined by Eugene Vakhtangov, a director and a colleague of Stanislavski in the Moscow Art Theater in the 1920s, to describe a style in which actors mine their own experience for the truth of their character's emotions, and then augment the memory by theatrical means so that they stimulate a powerful response in the audience.

fantasy *See* FANTASIA.

fantasy makeup *Theater* Any makeup that changes a character into something completely different, *e.g.*, the ass's head for Bottom the Weaver, in Shakespeare's *A Midsummer Night's Dream.*

fantoccini (*fahn-to-CHEE-nee*) [Italian] *Puppetry* Literally, little dolls. 1. Puppets operated by hidden strings or wires, MARIONETTES. 2. Marionette shows. 3. Life-size figures, actually large marionettes, manipulated on stage as part of a live production.

farandole *Dance* An ancient French folk dance from Provence performed by a long chain of dancers following a leader and holding hands, to the music of PIPE and TABOR. It may have descended from an ancient Greek song-dance.

farce *Theater* A light, sometimes satirical play based on a silly situation that develops with comic and/or absurd twists. The characters in a farce tend to be stereotypes rather than more complex representations of real people.

farceur (*fahr-SEUR*), **farceuse** (*fahr-SEUZ*) [French] *Theater* 1. A playwright who writes farces. 2. An actor in a farce. 3. A jokester.

farruca (*fah-ROO-cah*) [Spanish] *Dance* An energetic Spanish gypsy dance from Andalusia. Manuel de Falla composed one for the ballet *The Three-Cornered Hat. See* FLAMENCO.

farthingale *Costume* A voluminous skirt, tight at the waist and held far out from the lower body by a light framework. A HOOPSKIRT.

fast curtain *Stagecraft* A curtain closed as quickly as possible. *Compare* EMPHATIC CURTAIN.

fat *Acting* Slang term describing a good, effective, piece of BUSINESS, or a good ROLE.

fauxbourdon (*FOH-boor-donh*) [French] *Music* Literally, false *bourdon*, understood as "false bass." An ancient technique first used in the 13th century for enhancing the relatively undecorated sound of PLAIN CHANT by adding a second voice, generally a SIXTH below the main voice. The term has been applied very loosely to a modern practice of composing choral music in CLUSTERS, related to the ancient style only in the fact that all the voices more or less follow the same melodic line.

f-clef *Music* A clef originally based on the shape of the letter *f* as it was written in music during the period when notation was just being invented, about 1,000 years ago. The two short horizontal strokes, which have gradually degenerated into two dots, one above the other, identify the position of the note F below MIDDLE C. *See* BARITONE CLEF, BASS CLEF.

F-CLEF

feather dusting *Stagecraft* The process of painting with a wide, loose brush (like a feather duster) and almost dry pigment to create a mottled effect on the scenery.

feature *Motion pictures* 1. The main attraction. 2. Any full-length film produced for the commercial market, distinguished from a SHORT. The term is generally understood to describe a full-length film with a fictional story, but there have been DOCUMENTARY features, such as the classic *Nanook of the North* by Robert Flaherty.

feed *Acting* To support the effect of another actor's next line by delivering the preceding line in a manner that prepares the audience for it. *See also* PROMPT.

Broadcasting, Television 1. A transmission circuit designed to bring a program or news material from a remote location into the studio. It uses an AIR LINK, LANDLINE or SATELLITE LINK. 2. News or program material brought in from outside the studio by transmission from a remote location. 3. To supply video material from a remote location to the studio through an air link, landline or satellite link.

feedback *Audio* Reverberation within an audio system, produced by feeding part of the output of an amplifier into its own input. If such a connection occurs accidentally, as when a MICROPHONE is too close to the LOUDSPEAKER carrying its sound, such a reverberation can build up in less than a second to a level that can do damage to the loudspeakers and the ears. On the other hand, in controlled conditions, as in the reverberation circuits sometimes used in ROCK music (*see* FUZZ BOX), it can produce a raucous but manageable effect.

feeder *Acting* One, usually another actor rather than the PROMPTER, who feeds lines from the wings to an actor who is substituting and is therefore less familiar with the play than others in the cast.

Broadcasting *See* FEEDER LINE.

feeder line *Acting* A spoken line intended to be delivered in such a manner that it sets up the audience for an effective response to another actor's next line.

Broadcasting The cable or satellite link that brings program material into the studio from a remote location.

feel of the house *Acting* A sense of connection, or lack of it, with the audience.

feel the part *Acting* To be comfortable in the role, to have a sense of understanding the character being represented.

feel the rope *Circus, Stagecraft* To test the rigging for tautness.

feierlich (*FIRE-likh*) [German] *Music* Solemnly, ceremoniously, proudly.

female impersonator *Vaudeville* A male performer who acts and dresses on stage like a woman. *Compare* BREECHES ROLE.

feminine cadence *Music* Any CADENCE that resolves off the beat or on a weak beat of the measure. *Compare* APPOGGIATURA.

fence *Acting* To perform a duel with foils, as do Hamlet and Laertes near the end of Shakespeare's *Hamlet*. Actors often take fencing lessons not only to learn how to play such scenes, but also to develop alertness and the ability to move with precision and style on stage.

fencing *Acting* The art of dueling with FOILS. One of the basic techniques necessary for actors performing in classical plays.

Fender *Music* Trade name for a type of ELECTRIC GUITAR originally designed and manufactured by Leo Fender: the instrument of choice among modern rock-and-roll guitarists. The Fender guitar differs from other electric guitars in the arrangement of its tuning capstans, placed on one side of the NECK away from the player's body.

Fender bass *Music* An ELECTRIC BASS GUITAR built by the Fender company.

fermata (*fair-MAH-tah*) [Italian] *Music notation* Literally, a stop. A symbol indicating that the note or chord below it is to be held longer than its normal length, slowing the pace of the music temporarily.

FERMATA

fermé (*fehr-MAY*) [French] *Dance* Literally, closed. With both feet in a closed position, as in the FIRST, THIRD and FIFTH POSITIONS.

festival Any gala series of performances planned to celebrate a particular style, period or artist. One of the more famous is the Edinburgh Festival in Scotland that embraces all the performing arts.

festival theater Any theater designed for gala performances with large audiences. *See* FESTSPIELHAUS.

Festspielhaus (*FEST-shpeel-hows*) [German] *Music* Literally, festival play house. A large opera house in Bayreuth, Germany, built especially for performances of the operas of

Richard Wagner, and introducing many innovations designed by or for that composer, such as a DOUBLE PROSCENIUM, and a screened covering over the orchestra pit so that the very large orchestra could be heard but not seen during the opera.

ff *Music* Symbol for FORTISSIMO, *i.e.*, very loud.

fff *Music* Symbol for FORTISSISSIMO, even louder than FORTISSIMO.

f-hole *Music* Either of the two f-shaped holes in the TABLE of any instrument of the violin family. They exist partly to "let the sound out," which might easily be accomplished with round holes as in a GUITAR or a LUTE, but their odd shape also serves to dampen the reverberations after the bow has been lifted from the strings, a necessary effect in violin music. Attempts to vary their shape have invariably weakened that damping function.

fi (*fee*) *Music* The SOLMIZATION syllable for F-sharp in the FIXED-DO SYSTEM, or for the sharped FOURTH of any scale in the MOVABLE-DO SYSTEM.

ficta *See* MUSICA FICTA.

fiddle *Music* Colloquial name for the VIOLIN.

fiddler *Music* An informal name for anyone who plays the VIOLIN, especially one who plays for a BARN DANCE, SQUARE DANCE or HOEDOWN, or who specializes in that style of playing.

field *Television* Half the scanning cycle of the television FRAME. The system scans two fields for each frame using alternate (interlaced) scanning lines. Because of the persistence of vision of the human eye, the viewer sees a complete picture.

field angle *Motion pictures* The angle that encompasses the FIELD OF VIEW of a particular lens. *See also* WIDE-ANGLE LENS, TELEPHOTO LENS, ZOOM LENS.

field diameter *Motion pictures* The diameter of the FIELD OF VIEW, regardless of its focus.

field music Music composed for a MARCHING BAND, or intended to be performed out of doors.

field of view *Motion pictures* The entire area within the frame of the lens of a camera, whether in or out of focus. *See also* DEPTH OF FIELD.

fife *Music* A small, keyless wind instrument, roughly similar to a FLUTE, with nine holes on one side including one to blow across and four for the fingers of each hand, plus a tenth hole on the opposite side that raises all the tones one OCTAVE. The fife is used by marching groups of fifers and drummers, a fife and drum corps.

"fifteen minutes" *Theater* A stage manager's warning to the cast and crew that the show will begin in fifteen minutes.

fifteenth *Music* The musical interval of two OCTAVES, *i.e.*, fifteen scale steps.

fifth *Music* The interval of five scale steps, with the bottom note counted as one. *See also* AUGMENTED FIFTH, PERFECT FIFTH, DIMINISHED FIFTH.

fifth business *Acting* A minor role with very little to do on stage, but nevertheless essential to the PLOT.

fifth position *Ballet* A basic position with one foot immediately in front of and parallel to the other, the big toe of the back foot reaching the heel of the front foot. One of the five basic POSITIONS OF THE FEET.

Music The fifth position of the string player's left hand, at the bottom of the neck of the instrument. *See* POSITIONS.

figure *Dance* Any physical movement with a recognizable pattern that repeats, regularly or from time to time, in the course of a dance. Some dance figures consist only of patterns of movements for the feet, as in the WALTZ, though others may consist of body movements, such as the TANGO or the stylized gestures of the arms in Balinese ritual dance.

Music *See* MOTIF.

figured bass *Music notation* A system of shorthand developed in the 17th century to assist a keyboard player in accompanying other instruments or voices. In this system, the bass line of the music appears with numerals, written under the bass notes, that indicate the appropriate harmonies. From these, the player can improvise an accompaniment based on those harmonies. Thus, if the note in the bass is C and has the numerals 6 and 4 under it, the player can add tones corresponding to those intervals (A and F) and work them into the accompaniment. In some cases, the unadorned bass line is played by a cellist (*see also* BASSO CONTINUO), while the keyboard player fills in the harmonies.

filament image *Lighting* The image of the filament of the bulb of a SPOTLIGHT that appears (usually unwanted) in sharp focus on some part of the SET.

fill *Lighting* Illumination designed to supply general lighting within the set, to soften shadows and the edges of brighter accented spots and blend the key and secondary lighting of the scene. *See also* WASH.

Television Extra program material available during a broadcast to fill time if necessary.

fill card *See* BOUNCE CARD.

fill in *Acting, Dance, Music* To step in to replace a missing performer.

Lighting To add general light here and there within the scene to brighten dark spots and make everything look evenly illuminated.

fill-in date *Theater* A date left open in the calendar to allow for an added performance if the need should arise.

fill-light *See* FILL.

film clip *Television* A segment of motion picture film used as an insert in a live television program.

film noir (*feelm NWAR*) [French] *Motion pictures* Literally, black film. Originally a genre of low-budget American films, B PICTURES, photographed in black and white, that were produced without the close attention of studio MOGULS who concentrated on keeping more expensive pictures within the strict limits of Hollywood's artistic conservatism. The result of this inattention was a series of innovative motion pictures depicting the world in a stark manner, often projecting an atmosphere of depression and cynicism and focusing on the seamier side of inner-city life. Eventually it became so successful that its budgets were raised and actors and directors could build their careers in the style. The term seems originally to have been coined by a French film critic, writing in the international periodical *Cahiers du Cinéma* in the mid-20th century. One of the most successful of the type is *Double Indemnity*, starring Fred MacMurray, Barbara Stanwyck and Edward G. Robinson. A more recent example is *L.A. Confidential*, which was nominated for several Academy Awards in 1998.

filter *Lighting* Any GEL or other translucent medium that can be placed in or in front of a lighting instrument to modify its intensity and/or color.

filter frame, filter holder *Lighting* A special frame fitted in front of a lighting instrument to hold a FILTER. *Compare* COLOR FRAME.

fin *Lighting* A sheet of metal welded to the lamp housing of any lighting instrument to help dissipate heat.

fin (*fenh*) [French] *Motion pictures* Literally, end. The word that appears at the end of a French motion picture to indicate that it has ended.

finale (*fee-NAH-leh*) [Italian] *Music* Literally, ending. 1. The ending section of a piece of music. 2. The last NUMBER in a ballet, an opera or a musical play.

fine (*FEE-neh*) [Italian] *Motion pictures* Literally, end. The word that appears at the end of an Italian motion picture to indicate that it has ended.

Music Literally, end. A MEASURE that appears within the body of a piece of music rather than at the end of the movement or the piece, marked *fine* to indicate that it is the proper ending. This situation may occur, for example, when the piece is in A-B-A form, and the second A section is not separately written out. *See also* DA CAPO, DAL SEGNO, SECOND ENDING.

finger *Music* To assign numbers or symbols to the notes of passages in a piece of music, particularly keyboard music, to suggest to the performer which fingers may be best to use in performance.

fingerboard *Music* A hardwood strip over which the strings of a stringed instrument are stretched. It provides a surface against which the performer's finger may press the strings in performance. Fingerboards on instruments of the violin family are smooth. On other instruments such as the BANJO, GUITAR OR MANDOLIN, they are FRETTED as were the LUTE and VIOLA DA GAMBA in earlier centuries.

finger cymbals *See* CROTALES.

fingered *Music* Said of any piece of music to which FINGERING instructions have been added.

finger exercises *Music* Short, repetitive works designed to provide practice in a specific technique, *e.g.,* playing in parallel thirds, ARPEGGIOS or DOUBLE STOPS.

fingering *Music* 1. Any symbols or numbers added to a piece of music to suggest which fingers to use in performance. 2. Any particular style or system of assigning fingers to notes in a piece of music, as in "Brahms's fingering" for a piano work, or "Ysaÿe's fingering" for a violin piece.

finger turns *Ballet* Turns in which a female dancer is supported in a series of movements by her partner, who extends his arm above her head with one finger pointing down. Grasping the finger helps her to maintain proper balance and posture while turning on one foot, as in a PIROUETTE.

finger wringer *Acting* An actor who habitually expresses concern or emotional tension on stage by wringing the fingers. Often derogatory.

fioritura (*fee-yor-ee-TOO-rah*) [Italian] *Music* Literally, flowering. The ORNAMENTATION of any piece of music, but most especially of an 18th-century ARIA.

fipple flute *Music* A flute played by blowing through a small MOUTHPIECE that steers the air over a hole in the side of the instrument.

fire curtain *Theater* A noncombustible curtain, usually quite heavy, hung just inside the PROSCENIUM. It can be lowered when the stage is not in use as a precaution to prevent or delay the spread of fire. It can also be dropped quickly in an emergency by cutting its safety line. *Compare* WATER CURTAIN.

fireplace flat *Stagecraft* A FLAT built like a DOOR FLAT, but with an opening the size of a fireplace instead of a door. It may have a mantelpiece painted on its canvas surface, or a three-dimensional mantelpiece unit placed in front of the opening and lashed to the flat.

first batten *Stagecraft* The BATTEN hung just behind the PROSCENIUM.

first billing *Theater* Star billing, with an actor's name appearing in large type ahead of the name of the play. *Compare* TOP BILLING.

first border *Stagecraft* Any border hung from the FIRST BATTEN, *i.e.,* from the batten immediately behind the PROSCENIUM. *Compare* TORMENTOR.

first chair *Music* The chair occupied by the leader of any orchestral section. *See also* CONCERTMASTER.

first desk *Music* In the first violin section of an orchestra, the desk nearest the conductor, and the two players who sit at it.

first electric *Lighting* The first LIGHT PIPE. *See also* BRIDGE POSITION.

first ending *Music* In a passage that will be repeated, the final measure(s) of the first play-ing, that will be replaced by a SECOND ENDING when the repeat comes to its end. *See also* FINE.

first entrance *Acting* 1. The first door, or first opening on each side of the stage. 2. An actor's earliest appearance in the show.

first inversion *Music* The position on the STAFF of any TRIAD when its THIRD is the lowest note, *e.g.,* for a triad with C as its root, E - G - C. *Compare* ROOT POSITION, SECOND INVERSION.

first night *Theater* Opening night, the first official performance of a particular production, though there may previously have been PREVIEWS and/or TRYOUTS. The real importance of first night is that all the changes and adjustments that seemed necessary during previews will now be complete, and critics may base their reviews on what is now in final form. First night is usually a more gala affair than subsequent performances.

first night list *Theater* The company's list of important contributors, critics and other guests who must be invited to attend the first performance, partly because the company and the actors are grateful for their support, but also because the company wants to make sure there is an adequate audience when critics are present and that as many celebrities as pos-sible lend their glamour to the occasion.

first pipe *Lighting* The first LIGHT PIPE, hanging directly behind the proscenium.

first position *Ballet* With the heels touching each other and the feet turned out completely to form a straight line. One of the five basic POSITIONS OF THE FEET.

 Music 1. On a string instrument, the position of the left hand at the far end of the FIN-GERBOARD nearest the PEGS. 2. On a trombone, the "home position" of the slide, fully con-tracted. *See* POSITIONS.

fish dance A couple dance popular in the late 1950s, somewhat like the SLOW DRAG, per-formed to ROCK music.

fish, fish dive *Ballet* 1. Preceded by a lift, a position in which the female dancer is lifted by her partner and held in a horizontal position with her back arched, her head and arms up, her stomach resting on his knee with one leg extended behind, the other knee bent. 2. Preceded by a lift, a position in which the dancer is held by her partner above his head, in an almost vertical diving position with her back arched, legs extended behind and pointed feet crossed. *See also* TEMPS DE POISSON.

fish-eye lens *Motion pictures* A lens capable of accepting an image from an extremely wide angle, up to 180°.

fishing *Acting* Speaking whatever comes into mind while hunting for one's next LINE on stage.

fish tail *Dance* An erotic ANIMAL DANCE of the early 1900s, performed to RAGTIME music and characterized by hip-grinding movements.

fitch *Stagecraft* A stage painter's small brush, on the order of ¼ inch to ½ inch wide.

five *See* SENIOR.

"five minutes" *Theater* A STAGE MANAGER's warning to the cast and crew that the next act will begin in five minutes.

five-string banjo *Music* A BANJO with five strings, the standard instrument for American banjo music. Its fifth string, played by the thumb, provides a high drone while the player works out harmonies and the outlines of melody with rapid fingering on the other four

c tuning G tuning

FIVE-STRING BANJO TUNING
(STANDARD MUSICAL NOTATION)

strings. Tuning is variable, depending on the style of music the player prefers. The American folk singer Pete Seeger tunes his banjo in C, many others use the tuning in G. In each case, the drone is the fifth string. Notation for banjo players consists of what appears to be a musical STAFF, but is actually a representation of the strings of the instrument, with numbers representing fingerings instead of notes representing tones. The above illustration, however, shows tuning as normal musical notes, with the numbers indicating which string plays each one.

five-string bass *Music* A DOUBLE BASS with five strings instead of the usual four. The fifth string is a recent addition to the instrument and provides a much deeper bass for the modern orchestra. It is tuned to C_2, which is written as C_1, since the double bass is a TRANSPOSING INSTRUMENT. *See also* OCTAVE NAME SYSTEM.

five-three chord *Music* A TRIAD in ROOT POSITION as indicated in FIGURED BASS notation. The figures indicate that its top note is a FIFTH above the bottom, and its middle note a THIRD.

fixed board *Lighting* A control board permanently placed, usually the board that controls the HOUSE LIGHTS.

fixed-do system *Music* A system of teaching SIGHT-SINGING in which the syllables (DO, RE, MI, FA, etc.; *see* SOLMIZATION) invariably apply to specific notes, no matter what the key. Thus DO is always C, RE is always D and so forth. *Compare* MOVABLE-DO SYSTEM.

fixed points *Dance* A set of visible points on the stage or in the practice room used as references for the dancer's location during performance or exercises. In practice, dancers or coaches assign numbers to the corners and sides, or centers of each side, of the practice space. On stage, the corners, the center of the backdrop and of the back of the HOUSE, similarly numbered, serve the same purpose. Dancers use the numbers to identify the direction of a pose or a step, or to indicate how far the body must turn.

fixture *Lighting* Any LIGHTING INSTRUMENT.

flag *Lighting* 1. Any opaque, nonreflective device, usually a piece of heavy cloth, placed to prevent unwanted spill from a light. 2. To wave a hand in the beam coming from a light, so that one can see where it falls on the set.

Motion pictures 1. Any sheet of opaque, nonreflective material placed between a light source and a camera lens to prevent excess light from entering the lens. A flag is generally two or three feet square and mounted on or hung from its own stand allowing its placement to be adjusted so that its shadow does not fall on the part of the set visible to the camera. 2. Any large piece of opaque, nonreflective material, sometimes several yards wide, used to block outside light from the set, *e.g.,* by covering windows. *See also* COMMANDO CLOTH, DUVETYN.

Music notation A short horizontal stroke at the end of the stem of any black musical note, reducing the note's relative duration by half. Since a black note with no flag is a QUARTER NOTE, a single flag makes it an EIGHTH NOTE, a double flag a SIXTEENTH, triple a THIRTY-SECOND and so on.

Stagecraft A marker on an OPERATING LINE indicating the position to which it should be drawn in a scene.

flageolet *Music* An ancient wooden pipe played by blowing gently into one end. Similar to the RECORDER.

flam *Music* 1. A drummer's generic term for any of several kinds of beat consisting of one or more quick GRACE NOTES and a principal note. *See* RUDIMENTS. 2. In specific use, the term *flam* indicates one grace note. When there are more, it becomes a RUFF.

flamenco *Dance* The name for a gypsy from Seville, and describing the nonformal Spanish dances associated with gypsies. Once accompanied only by singing and hand-clapping, in modern flamenco guitars have been added. The excitement of flamenco comes largely from the inventiveness and intensity of the individual dancers. *See also* ALEGRIAS, BULE-RIAS, FARRUCA, SOLEARES, TANGO, ZAMBRA and ZAPATEADO.

Music An emotional, tragic style of song that originated in Andalusia, with elaborate ornamentation characterized by chromatic alterations within a very limited range, sung passionately with guitar accompaniment.

flash act *Vaudeville* 1. A good solo in front of the chorus. 2. A traveling act with its own scenery and PROPS, not necessarily a regular part of a specific show.

flashback *Motion pictures* A short glimpse into the past interpolated within a scene to provide the background for the main scene, or to illustrate someone's memory of an incident that has been mentioned in the main scene.

Vaudeville A turnabout in a comic act when the STRAIGHT MAN turns the comic's laugh into his own.

flash box *Stagecraft* An open metal box containing a small amount of lycopodium powder (flash powder) triggered by an electric spark that flares instantly to produce a flash of light on CUE.

flash effect *Stagecraft* Any device that produces a flash of light on CUE. *See* FLASH BOX, FLASH POT.

flash frame *Motion pictures* A single isolated blank FRAME in a film, usually at the start of a SHOT and caused by overexposure as the camera accelerates to proper speed at the beginning of operation. It is too brief to be seen by unpracticed eyes, nevertheless it can spoil a carefully composed shot. If a film director wants the audience to perceive the effect there must be five or six such frames.

flash pot *Stagecraft* A small box loaded with magician's flash powder and black gunpowder (to produce smoke), all of which is triggered by a fuse wire heated by an electrical circuit. It burns furiously but does not explode because the ingredients are not confined.

flash powder *Stagecraft* Lycopodium powder, sometimes known as magician's flash powder.

flat *Audio* Unvarying in amplitude or volume of response. An audio system is said to have a flat response if it delivers sounds of all pitches with equal amplification. The term derives from the flat appearance of the graphic curve of response of such a system, following a testing procedure that consists of inputting a signal that varies from the lowest to the highest audible pitch with unchanging volume. The broader the flat part of the curve, *i.e.*, the more pitches the system delivers with equal volume, the more authentic its reproduction of the sound will be. Flatness is normally described in DECIBELS of difference, *e.g.*, "plus or minus 2 db." *See also* ACOUSTICS, Hz, EQUALIZATION.

Acting Monotonous, with unvarying tone, unemotional, inexpressive.

Dance A shoe with little or no heel.

Lighting Describing an even distribution of light that produces no contrast between different areas in the SET, thus diminishing the modeling effect of shadows, making the SET look shadowless.

Music 1. Below the indicated PITCH. A tone is flat when it sounds lower than the pitch indicated by its position on a line or space of the STAFF. 2. Said of a voice or instrument that produces tones lower in PITCH than they should be. *See* TUNING, HARMONICS. 3. In guitar music, the forefinger of a guitarist's left hand used in place of a CAPO, when a capo is not readily available. The player presses the finger firmly as a STOP across all the strings of a guitar to raise all the strings at once to a HIGHER RANGE. 4. To sound a note at lower pitch than indicated, or lower than previously sounded. A note so sounded is said to be flatted.

Music notation A symbol indicating that the note that immediately follows on the same line or space of the staff is to sound a semitone lower in pitch than normal.

FLAT (A-FLAT)

Stagecraft A large, portable vertical panel, constructed of canvas stretched over a light wooden frame and appropriately painted, that becomes part of the SET when placed on the stage. A typical wooden frame consists of a top and a bottom RAIL with vertical STILES at each side and a horizontal TOGGLE RAIL across its center point. If the flat is very high, there will be another toggle. The top and bottom rails are held rigid by plywood CORNER BLOCKS, sometimes assisted by long wooden corner braces (BRACE RAILS). Toggles are fastened to the stiles with wooden KEYSTONES to assure stiffness. Canvas (usually muslin) is stretched over one face, nailed to the back of the outside frame, then painted as needed for the scene. A flat often has a LASH LINE attached at its top through a hole in one of its corner

blocks and one or two CLEATS down the near stile to the bottom rail, where the line can be tied off at another cleat. Two flats can be lashed together by looping the line quickly around the cleats on both flats, then tying it off at the bottom of one of them. *See also* DOOR FLAT, HARD FLAT, PROFILE, SADDLE IRON, SILL IRON, WINDOW FLAT.

flat cleat *Stagecraft* A CLEAT made of a flat strip of steel fastened to one of the STILES of a FLAT to act as a STOP to keep an adjacent flat precisely in line.

flat man *Stagecraft* A stagehand who moves flats. A GRIP.

flautist *Music* One who plays the FLUTE. Also flutist.

fleshings *Costume* Flesh-colored tights that look like the naked body in stage lights.

flexible theater *See* BLACK BOX (*Theater*).

flic-flac [French slang] *Ballet* A flicked or whipping gesture, somewhat like the FOUETTÉ, used as a connecting movement.

flicker wheel *Lighting* A disk mounted in the color frame of a SPOTLIGHT and turned by hand or by a motor to provide a flickering effect on the SET.

flicks *Motion pictures* The movies; they used to flicker all the time when they were silent and passed through the projector at 16 FRAMES per second instead of the SOUND SPEED of 24.

flied *Stagecraft* Having been hung in the FLIES.

flies *Stagecraft* The volume of space above the stage that has been fitted with a system of BRIDGES and PIPES to hold lighting equipment, and battens and rigging by which CURTAINS, CYCLORAMAS, DROPS and pieces of SCENERY may be hoisted up and out of sight or lowered to the stage for use during a scene.

flip card *Television* A CAMERA CARD placed on a stand in front of the camera and flipped out of the way after it has been shot.

flipper *Stagecraft* A FLAT hinged to another flat, or a partial flat with a cut-out edge hinged to anything, so that it can be flipped into view.

float down *Stagecraft* To lower a FLAT to a face-down position on the stage floor by stopping its bottom edge with the foot and letting it fall freely into a cleared area backstage, cushioned by air. *See also* WALK A FLAT.

floating floor *Stagecraft* A stage floor separated by joists from the actual floor of the building so that it will be less rigid than the underlying floor and more suitable as a dance or acting surface.

floating stage *Stagecraft* A movable stage. *See* ELEVATOR STAGE, WAGON STAGE.

flood *Lighting* 1. A FLOODLIGHT. 2. To widen the beam of a floodlight by moving its lamp nearer its lens. *Compare* SPOT DOWN.

floodlight *Lighting* Any light that illuminates a wide area. A floodlight may not have a lens, but if it does it is often a FRESNEL LENS that can be adjusted to make the beam wider or narrower. *Compare* SPOTLIGHT. *See also* SCOOP.

floor cloth *Stagecraft* A cloth painted to resemble a floor appropriate to the scene being played, stretched flat and held in place by grommets that fit over PEGS fixed in the stage floor.

floor electrician *Lighting* An electrician who works primarily with the lights installed on stands on the stage floor, rather than those in the FLIES or on the GRID.

floor manager *Television* The person present on the set who works with camera operators and others to fulfill the orders of the DIRECTOR who sits in the CONTROL ROOM watching monitors and speaking through the intercom.

floor mike *Audio* A small microphone placed on the floor of the stage with or without a stand. Some floor mikes are designed either to pick up the sounds of feet in a dance performance or, by being BLIMPED, to pick up voices without the sounds of feet. *See also* MOUSE.

floor operator *Lighting* A technician who works on the stage floor and within the SET, rather than on the GRID or the back of the house.

floor peg *Stagecraft* Short pegs placed in the stage floor to hold carpets, FLOOR CLOTHS or any other piece of a set firmly in place during a scene.

floor plan *Stagecraft* A diagram of the SET, showing the placement of every item of scenery and furniture for each scene.

floor plate *Lighting* A metal plate covering a FLOOR POCKET when it is not in use.

floor plug *Lighting* A plug designed to fit into a POCKET in the stage floor to provide power for a lighting fixture or any other electrical device that may be situated in the visible area of the set.

floor pocket *See* STAGE POCKET.

floor show A show with dance, music and often comedy acts staged in a night club, with the audience sitting at tables.

floor-work *Dance* In modern dance, a series of exercises done on the floor as a warmup for technique class or for a performance.

floozie *Acting* A stock character role; a gaudy, cheaply dressed, flirtatious woman. *See also* VAMP.

flop *Theater* Any production that fails to attract an audience.

flop sweat *Acting* The intense discomfort felt by any performer who believes the show is dying on stage.

flounce *Makeup* Eyelash liner on the lower eyelids, applied to exaggerate the eyes and counteract any flattening effect of bright stage lights.

flourish *Music* A short burst of trumpets and/or drums. *See also* FANFARE, STING.

flown *Stagecraft* Said of any piece of scenery that has been hung on RIGGING and hoisted up into the FLIES.

flown in *Stagecraft* Said of any part of the SET that has been lowered onto the stage from the FLIES.

flue pipe *Music* One of two classes of organ pipe; the other is the REED PIPE. The flue pipe is cylindrical, with a conical section at its base through which the wind (the flow of air) enters, and a rectangular opening, the flue, cut into the side of the pipe at the point where the conical section joins the cylinder. At the edge of the flue the wind passes through a narrow slit that directs it as a sheet of air across the flue, much like the airflow in a tin whistle. The flue causes the sheet of air to resonate and the length of the pipe determines the frequency of reverberation, creating a musical tone. An organ tuner adjusts the pitch of a flue pipe by altering its length with a metal sleeve fitted over the top, and regulates the quality of its tone by delicate adjustment and by trimming the edges of the flue.

fluff *Acting* 1. A line misspoken during a scene. 2. To misspeak a line on stage.

flügelhorn (*FLÜ-gl-horn*) [German] *Music* A brass instrument similar to the TRUMPET but of somewhat larger bore and with a shorter tube. It has the same range but a less brilliant tone that sounds best in the lower part of its register.

flush footlights *Lighting* Footlights placed in a trough at the front of the stage so that they will shine on the curtain and on any actors who are standing fairly far downstage, but will not be seen by or obstruct the view of the audience.

flute *Music* A wind instrument of TREBLE range shaped like a pipe and played by blowing across a hole near one end while closing other holes with finger tips and/or keys in various combinations along its length. Also called the side-blown or transverse flute. The flute is one of the oldest of all musical instruments, and was one of the two most important instruments used for musical accompaniment in classical Greek drama. In modern times it is used as a solo instrument, and as one of the chief treble voices in the orchestra. It has a smooth tone, distinctive in that it has no strong PARTIALS. *See also* FIPPLE FLUTE, PICCOLO.

flutist *Music* A FLAUTIST.

flutter-tongue *Music* A technique used by players of BRASS INSTRUMENTS and the FLUTE, but difficult on instruments that have reeds; the tongue is held fairly close to the teeth and allowed to flex freely while the breath blows into the instrument. The flexing is rapid, much like that produced when one rolls one's Rs in proper Italian pronunciation. It produces a distinctive, strident vibrating tone. *Compare* TRIPLE-TONGUING.

fly *Stagecraft* To attach a piece of scenery to rigging and hoist it up above the stage.

fly bridge *Stagecraft, Lighting* A permanent bridge built among the FLIES to support technicians while they work with the lights or other equipment at that level.

fly catcher *Acting* Said of any actor who distracts the audience by staring helplessly this way or that with the mouth wide open, having forgotten what to say or do next or having lost concentration while others are acting.

fly control side *Stagecraft* The side of the stage where the rigging lines are anchored, and controls for hoists and the like are situated.

fly crew *Stagecraft* The crew of stagehands and technicians who work with the rigging that operates the FLIES.

fly curtain *Stagecraft* A curtain mounted on a BATTEN that can be raised or lowered as a unit like any other piece of scenery, whether or not it can also be drawn open or closed horizontally.

flyer *Circus, Theater* A single sheet of paper, usually letter size, printed on both sides with pictures of stars and acts and advertisments for upcoming performances. Flyers are often left in hotel lobbies, drugstores, airports and other places where people may pick them up. *See also* AERIALIST, HIGH FLYER, PAPER.

fly floor *Stagecraft* In large theaters and opera houses, a deck that is part of the architectural structure of the building, built high above the stage with integrated BRIDGE structures providing access to the BATTENS and PIPES that constitute the FLIES.

fly gallery *Stagecraft* A walkway along a side wall of the stage above the stage floor where an operator can manipulate the OPERATING LINES that control the drops and scenery hung in the FLIES. In a typical installation a LOCKING RAIL runs the length of the walkway next to the operating lines holding the ROPE LOCKS that can be clamped to each line to hold it firmly in its desired position. *See also* LOADING GALLERY.

fly in *Stagecraft* To lower a piece of scenery from the FLIES into position on the stage.

flying *Acting* Playing a role while apparently floating in the air, hanging in a harness suspended from nearly invisible steel wires.
 Stagecraft Having been raised into the FLIES, ready for use.

flying bridge *Stagecraft* Any bridge hanging from the GRIDIRON above the stage.

flying trapeze act *Circus* A spectacular act that consists of aerialists swinging from trapeze to trapeze at a great height above the floor of the circus, usually with a partner. A 19th-century French AERIALIST, Jules Léotard, is credited with the earliest development of the act.

fly ladder *Stagecraft* A ladder permanently installed against one wall of the stage, providing access to the top of the FLIES.

fly loft *See* FLY FLOOR, FLY GALLERY.

flyman *Stagecraft* A stagehand or lighting technician who specializes in handling equipment in the FLIES. A RIGGER.

fly plot *Stagecraft* A schedule of cues that direct the operation of the FLIES during a performance.

flyrail *Stagecraft* On a small stage, a rail built into the wall of the stage to which rigging lines may be anchored. On a large stage, the flyrail is somewhat above the stage floor, below the FLY GALLERY, and anchors the line of sheaves through which the operating lines that control the positions of COUNTERWEIGHT ARBORS pass.

fly rope *Stagecraft* Any operating line that controls the position of any curtain, drop or piece of FLOWN scenery.

fly rope lines *Stagecraft* OPERATING LINES hanging from the GRIDIRON and in reach of stagehands on the stage floor.

fly space *Stagecraft* The space above the stage that contains the FLIES.

fly tower *Stagecraft* That part of the theater building built higher than the HOUSE to contain the stage and its FLIES.

FM *See* FREQUENCY MODULATION.

focus *Acting* The actor or group of actors at the center of attention on stage. *See also* BLOCKING.

 Lighting 1. The adjustment of lenses that produces a sharp image on the SET. 2. To adjust the focal length of a SPOTLIGHT by shifting either the LAMP itself, the lens and/or the projection slide in front of it so that it projects a clear, sharp image on the set.

focus lamp *Lighting* An auxiliary lamp within a lighting fixture designed to provide just enough light so that a technician can aim it during the preparation of the set without turning on the high-powered lamp that would make the instrument too hot to touch.

focus puller *Motion pictures* A member of the camera crew who has sole responsibility for keeping the image in focus while the distance between the camera and its subject changes, as in a DOLLY or TRUCK SHOT. In such a situation, focus cannot conveniently be maintained by the camera operator because he or she cannot see the focus-ring settings while watching the image through the viewfinder.

fog machine *Stagecraft* Any device, such as a container of dry ice, that can be activated on CUE to provide a thick cloud of harmless vapor on the set.

FOH *Theater* Abbreviation for FRONT OF THE HOUSE.

FOH controller *Lighting* The console containing the dimmer controls for the FOH LIGHTS.

FOH lights *Lighting* All the stage lights placed by the lighting designer in the FRONT OF THE HOUSE, including BALCONY SPOTS, BEAMS and WARMERS, but not necessarily the FOOTLIGHTS, in front of the main curtain.

foil *Acting* A thin and flexible fencing weapon with a blunt point, much used on stage in simulated duels.

fold *Theater* To close the show. Derived from the circus, where to close the show meant folding the tent.

folding jack *Stagecraft* A light, triangular frame hinged to the back of a FLAT so that it can be swung out as a brace to hold the flat in a vertical position on stage.

Foley artist *Motion pictures* One who devises methods to create the sound required in a FOLEY OPERATION.

Foley editor *Motion pictures* An editor who edits the sound tracks produced by a FOLEY OPERATION and matches them to the WORKPRINT.

Foley operation *Motion pictures* The operation of re-creating and synchronizing sounds for a film or video recording that, for whatever reason, were not recorded or were not satisfactory during the actual shoot. It was first developed by an American sound editor, Jack Foley. Certain sounds, *e.g.,* cloth being torn, a chair scraping on the floor, people swimming, are difficult to record realistically during a SHOOT. They must be created later and mixed into the sound track. In a typical LOCATION SHOT, for example, the scene may show several people walking through high grass and talking together. The sound recorded IN SYNC during the shot would necessarily be restricted to the conversation, which would be transmitted to the recorder by WIRELESS MIKES that cannot pick up the swishing of the grass. It becomes necessary then to re-create the outdoor ambient sound and the specific swishing of the grass to match the visible steps of the actors. This re-creation requires that the Foley operator go outdoors with a FOLEY WALKER or two to record and OVERDUB all the different sounds required and to SYNCHRONIZE them with the filmed event on the editing table.

Foley recording *Motion pictures* The sound track produced in a FOLEY OPERATION.

Foley walker *Motion pictures* An actor who walks on a suitably prepared surface, with the right shoes on and at precisely the pace that will synchronize with the image (usually visible on a monitor), so that the sounds of the steps can be recorded, edited and SYNCHRONIZED to that picture to replace the real sounds which, for whatever reason, cannot be heard on the original sound track.

folía (*foh-LEE-ah*) [Italian] *Dance* A 15th-century carnival dance of Portuguese origin. Sometimes known as a fool's dance, it was performed by masked figures and accompanied by CASTANETS.

Music A style of music consisting of continuous variations derived from old folk-dance melodies (not known to be related to the Portuguese *folía*), used by many composers of the 17th and 18th centuries.

foliage border *Stagecraft* A border cut and painted to resemble foliage.

folio *Theater* A large, bound printed script of a play, especially a play by Shakespeare, frequently the oldest known version. A folio is printed with two pages on each side of a PRINTER'S SHEET that is then folded in half once to show four pages in finished form.

folk dance Dance originating in and developed by people of a particular ethnic, regional or racial group working together without direction from a choreographer. In use since the 18th century, the term takes note of the difference between the dances of peasants and working people, and those of the aristocracy. Most folk dances have been handed down from one generation to another and subjected to many changes along the way. BALLROOM and theatrical dancing have borrowed from folk dance. The POLKA and the CZARDAS of Central Europe, the Cuban RUMBA and the American SQUARE DANCE are among the better-known types.

folk music Music of mainly rural origin, created by individuals rather than groups, and passed from one generation to another by hearing rather than reading. Folk music belongs to the entire community, and its oral traditions are constantly being changed by the performers who learn it. Unlike classical or popular music, it is almost never notated and is played or sung by nonprofessionals. It is not necessarily entertainment, but may provide an accompaniment for work or ritual events, and in some cultures serves as social commentary, as a chronicle of daily life or the retelling of history. Folk music genres also include short narrative songs (ballads), songs of love and loss, songs to accompany games, children's lullabies, and a large body of instrumental music for dancing. Elements of folk music have been used to great effect by composers of classical music over the centuries, and in the 20th century have merged with popular music in forms such as COUNTRY-AND-WESTERN, FOLK-ROCK, RHYTHM AND BLUES, etc.

folk-rock *Music* A style used mainly by American performers, a blend of folk melodies with the heavy beat and other elements of commercial ROCK AND ROLL. First heard in 1965 when folk singer/composer Bob Dylan startled a concert audience by appearing with a rock band and abandoning his acoustic guitar for an electric guitar.

folk singer *Music* One who makes a career of singing FOLK SONGS.

folk song *Music* Any traditional popular song of unknown origin that is associated with a particular social or regional group. *See also* FOLK MUSIC.

follies *Vaudeville* Any lavish music and dance show, with or without comic acts.

follow-cue *Lighting* Any CUE that so closely follows another that it has no individual cue number. In effect, it becomes the second part of a two-part cue.

follow-focus *Motion pictures* The operation of keeping a camera in proper focus while it, or its subject, moves. *See also* FOCUS PULLER.

follow-shot *Motion pictures, Television* Any shot in which the camera—handheld, mounted on a dolly, a truck or a crane—moves along with the subject.

follow-spot *Lighting* A brilliant SPOTLIGHT usually placed in the rear of the HOUSE or a BALCONY and mounted so that it can be turned and tilted to follow and highlight the movements of a person on stage. *See also* ARC LIGHT.

follow spotter *Lighting* A technician who operates a FOLLOW-SPOT during the show.

follow-through *Acting* The specific actions and/or spoken lines that establish continuity between scenes.

fondu (*fon-DÜ*) [French] *Ballet* Literally, melted. Bending the knee of the supporting leg to lower the body. A PLIÉ on one leg.

fool *Acting* A CHARACTER ROLE in the theater from very ancient times until the present, including Elizabethan plays and COMMEDIA DELL'ARTE. Sometimes a court jester, as in Shakespeare's *King Lear*, sometimes a seeming idiot of mystical power, as in Mussorgsky's opera *Boris Godunov*. *Compare* CLOWN.

fool's cap *See* CAP AND BELLS.

footage *Motion pictures* A generic expression for any length of exposed motion picture film. Used frequently by editors. *See* STOCK FOOTAGE LIBRARY.

foot-candle *Lighting* The amount of light emitted by a standard candle falling on a square foot of surface one foot away.

foot iron *Stagecraft* 1. A short iron strap projecting a few inches out from the bottom end of a STAGE BRACE, with a hole through which a STAGE SCREW can be inserted to fasten the brace to the floor. 2. A strap hinge attached to a bottom corner block of a FLAT so that its loose end can unfold to lie flat on the floor where it can be fastened in place with a STAGE SCREW.

footlight baby, footlight spot *Lighting* A very small SPOTLIGHT mounted among the footlights where it can highlight a person or a part of the set from below without being seen by the audience. *See also* INKY.

footlights *Lighting* Any light at floor level in front of the curtain.

footlight strip *Lighting* A unit of the FOOTLIGHT TROUGH.

footlight trough *Lighting* A trough in front of the curtain, usually the width of the stage, containing the FOOTLIGHTS. In some theaters the footlights can be retracted into the floor and covered with removable sections of flooring.

foots *Lighting* Short for FOOTLIGHTS.

forestage *Theater* The area in front of the curtain. Also called the APRON, though FORESTAGE implies something larger. *See also* THRUST STAGE.

forestage canopy *Stagecraft* A construction high above the APRON in front of the main curtain providing structural support for lights and often built as a scenic frame appropriate to the show.

forestage elevator *Stagecraft* An elevator installed in the stage APRON where it can lift an orchestra or a scene into view while the curtain is closed. It is frequently designed to operate in several sections, individually or in combinations.

forestage gridiron *Lighting* A GRIDIRON installed in front of the proscenium and against the ceiling where it can support lights or FLIES.

forestage lift *Stagecraft* British term for FORESTAGE ELEVATOR.

forlana *See* FURLANA.

formal stage *Theater* A stage with a permanent, nonrepresentational SET usually consisting of steps, entrances, platforms and ramps that can be used by actors in many kinds of scenes.

forte (*FOR-teh*) [Italian] *Music* Literally, strong. Loud, loudly, represented by the symbol *f*.

fortepiano (*FOR-teh pee-AH-noh*) [Italian] *Music* Literally, loud-soft. One of the old names for the PIANO. It has come back into use to designate a piano built in, or in the style of, the early 1800s. Fortepianos tend to have a lighter and less sonorous tone than do modern pianos and are considered by some to be more appropriate to the performances of piano music of that era.

fortissimo (*for-TEE-see-moh*) [Italian] *Music* Literally, strongest. Very loud, represented by the symbol *ff*.

fortississimo (*for-tee-SEE-see-moh*) [Italian] *Music* Even louder than fortissimo, represented by the symbol *fff*.

forzando (*fort-ZAHN-doh*) [Italian] *Music* Literally, strengthening. Forcing, accenting, represented by the symbol *fz*. *See* SFORZANDO.

fouetté (*fweh-TAY*) [French] *Ballet* Literally, whipped. A whipping motion of the raised foot or of the working leg, or a brisk whipping around of the body. Fouettés are executed in many ways, such as À TERRE, BATTU, (grand) ÉFFACÉ, EN TOURNANT, RACCOURCI, etc.

fouling pole *Stagecraft* A long, light pole used by a stagehand or a technician to reach and help disentangle snagged rigging lines.

four hands *Music* Describing a duet composed for two players at a single piano, as distinguished from music for two pianos.

four-line octave *Music* In the OCTAVE NAME SYSTEM used in older books, the highest octave of the piano, beginning with C three octaves above middle C. It was written out as c''''. In some more modern books including this dictionary, that octave begins with c^3.

fourth *Music* The interval of four scale steps with the bottom note counted as one. *See also* AUGMENTED FOURTH, DIMINISHED FOURTH, PERFECT FOURTH.

fourth chord *Music* Any chord built of FOURTHS instead of the THIRDS that comprise the TRIAD, SEVENTH, NINTH, etc. Fourth chords were not considered chords at all until modern times, but were called dissonances, acceptable only as transient meetings of voices in the process of becoming normal, triadic chords. They are, however, commonly treated as stable chords in the music of Igor Stravinsky, Paul Hindemith and others since about 1920.

fourth position *Ballet* A position with the feet parallel and the toe of one foot in front of the heel of the other foot, separated by the distance of one short step, called CROISÉ. An alternative is the fourth position OUVERTE, with the feet in FIRST POSITION separated by the distance of one short step. Both are considered basic POSITIONS OF THE FEET.

Music *See* POSITIONS.

fourth wall *Theater* An imaginary wall between an audience and the actors in a BOX SET.

foxtrot *Dance* Originally, a fast-trotting RAGTIME dance associated with the music-hall entertainer Harry Fox around 1914. It evolved into a more sedate social dance for couples, and survives in various forms to this day. The British version was called the SAUNTER.

fox wedge *Stagecraft* A DUTCHMAN shaped to conceal any gap between the bottom rail of a flat and the surface of a raked stage floor.

fp *Music* An instruction to the player to sound the next note or the next chord loudly, then immediately continue playing quietly.

frame *Lighting* *See* COLOR FRAME.

Motion pictures, Television 1. A single image on the film. 2. The borders of that image. 3. The time that image remains visible, *i.e.*, ¹⁄₂₄th of a second at SOUND SPEED, or ¹⁄₃₀th of a second in American broadcast television. 4. To adjust the camera so that the image it photographs is well composed within its borders.

frame brace *Stagecraft* A triangular frame built onto the back of a FLAT to keep it in a vertical position. *See also* FOLDING JACK.

frame count *Motion pictures* The precise length of a shot on film expressed as the number of frames it contains. In the United States, film moves through the camera at the standard (sound) speed of 24 frames per second (25 in Europe). In films shot for television, it moves at 30 fps. The frame count is used directly by animators, or it can be translated with great precision into seconds so that a composer may plan music to fit the shot.

framed drop *Stagecraft* A large cloth drop fastened to a wooden frame. Because of its size, the frame is hinged and the cloth is attached by nailing on top and bottom and lacing on the sides, so that it can be partially collapsed and rolled up around its folded frame for transportation. A framed drop is convenient as a lightweight BACKDROP with window and door openings that would be heavier and more expensive to move if it were assembled as built-up set pieces. *See also* FRENCH FLAT.

frame line *Motion pictures* 1. An imaginary line in a movie SET, showing the limit of the camera's view. Actors adjust their movements accordingly. 2. An undesirable black line that appears at the top or the bottom of the screen when the frame is improperly adjusted in the projector.

frame speed *Motion pictures, Television* The speed with which images succeed each other in a motion picture or television broadcast, expressed in frames per second or fps. Early silent motion pictures ran at 16 frames per second, because that seemed convenient when

16 frames equaled one foot of film. It was not sufficient for sound-on-film, however, for which the standard was established at 24 frames per second. Television in the United States presented a new problem. With a standard frequency of alternating current at 60 Hz, television operates at 60 frames (called fields) per second. If the image of a normal television screen appears in an American motion picture, a black bar will move repeatedly up the screen unless an adjustment has been made. To avoid this problem in films shot primarily for television, cameras run at 30 fps instead of 24. In most of Europe, where the standard frequency is 50 Hz, the motion picture camera runs at 25 fps. In each of the cases conversion is absolutely direct and black bars never appear.

framing shutter *Lighting* A shutter placed in the focal plane of a SPOTLIGHT and adjusted so that it will limit the projected light to a precisely defined area on the stage.

frappé (*frah-PAY*) [French] *Ballet* Literally, struck. Striking the toe of the working foot against the ankle of the supporting leg.

freak show *Circus* A favorite type of SIDESHOW in the early days of the circus, where oddly formed people and animals, *e.g.*, "The Bearded Lady," "The Egyptian Giant" and the "World-Renowned Siamese Twins," were exhibited.

free jazz *Music* A JAZZ style introduced in the 1960s by saxophonists John Coltrane and Ornette Coleman, pianist Cecil Taylor, and others. Its advocates jettisoned traditional forms, harmonic structure, tonalities and the chord sequences of jazz for random and unrestricted group improvisation. This every-man-for-himself approach produced what some historians dubbed a fascinating musical experiment, and others heard as a shapeless mix of wails and shrieks, grunts and groans.

free-theater movement A movement in European theater in the late 19th century, spearheaded by André Antoine in France, Otto Brahm in Germany and J. T. Grein in England, that challenged the socially acceptable repertoire by presenting realistic, sometimes shocking "people's theater" in colloquial language. Examples are Tolstoy's *The Power of Darkness*, Ibsen's *Ghosts* and *The Wild Duck*, Strindberg's *Miss Julie* and Hauptmann's *The Weavers*. The movement spread quickly throughout Europe and America and was a strong influence during the establishment of the MOSCOW ART THEATER where Konstantin Stanislavski worked.

freeze *Acting* To cease movement suddenly and completely and to hold that pose until time to UNFREEZE.

Motion pictures, Television To repeat (i.e., to reprint or rerecord) a single FRAME unchanged for a given length of film time, so that a motionless image shows on the screen.

freeze-frame *Motion pictures, Television* A single FRAME repeated (*i.e.*, reprinted or rerecorded) for a given length of time. Also called a still frame.

French flag *See* GOBO (*Motion pictures*).

French flat *Stagecraft* The entire back wall of the set, made of an assembly of FLATS, often with practicable doors and window units built into some of them, the whole hinged together as a single unit. *Compare* UNIT SET.

French harp *Music* An older name for the HARMONICA.

French horn *Music* *See* HORN.

French School *Ballet* The basic techniques of BALLET developed from the court ceremonies of French royalty, particularly Louis XIV, formalized in 1661 with the founding of the Académie Royale de Musique et de Danse in Paris. The school was esteemed throughout Europe for its emphasis on grace and elegance rather than strength and agility. *See also* RUSSIAN SCHOOL.

frequency *Audio, Broadcasting* The rate of alternation of positive and negative current in an electrical circuit, or of electromagnetic waves in an electronic circuit, expressed as HERTZ (HZ), or cycles per second.

frequency modulation *Broadcasting* A method of transmitting information (such as speech or music) over the air in the form of changes of the FREQUENCY of a continuously emitted carrier wave to avoid interference. Since interference from natural sources such as lighting consists of surges of power, the FM system avoids it by ignoring anything except changes of frequency. *Compare* AMPLITUDE MODULATION.

Fresnel lens *Lighting* Any lens built of concentric prisms. It can be visualized as the top surface of an ordinary, thick plano-convex lens that has been sectioned off in rings and squashed almost flat. The top surface of each ring retains the form of the top of the original lens, and the bottom remains flat, so that the resulting lens is much thinner than the original. This manner of constructing a lens, developed by the French physicist A. J. Fresnel, permits a ray of light to be focused through a thin plate of glass that is much lighter and easier to handle.

fret *Music* A thin ridge, usually made of metal, placed across the fingerboard of a stringed instrument to provide a precise point where the string can be stopped by the pressure of the finger to produce a specific pitch. Instruments with frets include the GUITAR, BANJO, UKELELE, LUTE, BALALAIKA, SITAR and many others.

fricassée (*free-kah-SAY*) [French] *Music* Literally, hash, jumble. A type of largely nonsensical QUODLIBET, dating from the 16th century in France, that drew heavily upon popular and theatrical songs and street cries of the time.

fright wig *Costume* Any wig designed to make its wearer look frightening or absurd.

friska (*FRISH-kah*) [Czech] *Dance* The fast movement of the CZARDAS.

frog *Music* A little block of hardwood with metal or mother-of-pearl fittings at the base of the string player's BOW. It serves as an anchor point for the hairs of the bow, and is mounted in such a manner that it can be moved backward or forward a short distance to tighten or loosen them. Also called the NUT.

from the top *Acting, Music* An instruction to the player(s) to start from the very beginning of the piece or the scene.

front *Stagecraft* 1. The FORESTAGE area in front of the main curtain. 2. The auditorium itself.

front batten *Stagecraft* The BATTEN hung just behind the main curtain. The first batten.

front cloth *Stagecraft* Any cloth drop hung from the FRONT BATTEN.

front lighting Lighting from all the instruments placed in front of the stage, including BEAMS and FOOTLIGHTS. *Compare* FOH LIGHTS.

front liner *Acting* A star or a team who get TOP BILLING.

front of the house *Theater* 1. From the theater owner's point of view, the public entrance and lobby of the theater building. 2. From the lighting designer's point of view, the area within the auditorium in front of the main curtain.

front pipe *Lighting* The first LIGHT PIPE, the pipe hung immediately behind the main curtain.

fronts *See* FRONT LIGHTING.

front scene *Theater* Any scene set far DOWNSTAGE, in front of a DROP, so that the scene behind can be changed.

frost *Lighting* A diffusing filter. *See* SPOT FROST, STARFROST.

frozen frame *See* FREEZE FRAME.

frug *Dance* A very simple, solo ROCK dance in which the dancer does little more than shift weight from one foot to the other. Popular in the early 1960s.

FS *See* FULL SHOT.

f-stop *Motion pictures* The unit of measurement of the aperture of a camera lens, expressed as a ratio of its optical diameter to its focal length.

fugal *Music* In the style of a FUGUE, *i.e.,* with a theme stated by one voice or instrument and answered by another and another, the way a fugue normally begins, but not worked out fully. *See also* CONTRAPUNTAL.

fugato (*foo-GAH-toh*) [Italian] *Music* 1. In the manner of a FUGUE, but not fully worked out. 2. A passage composed in the manner of a fugue within a larger piece.

fugue *Music* A CONTRAPUNTAL composition that begins with a theme (the SUBJECT) stated by one VOICE, which is then answered by others in the same or different KEYS, and contrapuntally developed with frequent restatements and answers. Fugues can be composed of as few as two voices; many have four or five voices, some have six. Some fugal themes are accompanied, in which case the whole piece is called an ACCOMPANIED FUGUE. There are also DOUBLE and TRIPLE FUGUES, with two or three different themes stated and answered together. In its strict academic form, a fugue has many sections, the main ones being the EXPOSITION and various EPISODES. But the great master of the form, Johann Sebastian

Bach, shaped his fugues so differently that these terms hardly can be applied to his music or that of composers who followed him. Mozart composed many fugues, particularly in his large choral works such as the *Great Mass in C minor*, and his *Requiem*. Beethoven composed fugal passages in all kinds of pieces including the famous *Grosse Fuga* in his *String Quartet Op. 133*.

fuguing tune *Music* An 18th-century style of hymn tune that took form first in northern Germany as a demonstration of Lutheran independence from church-imposed chants, then developed into a popular form in Great Britain and eventually spread to the United States. Typically, the hymn began with a chordal section leading to a cadence. This was followed by overlapping entrances by one or more voices in "fugal" style. The hymn concluded with a return to block chords and a cadence. The fuguing tunes of Boston composer William Billings (1746–1800) influenced the composers and publishers of many popular hymn books. Traces can be found in some of the 573 hymns of SACRED HARP MUSIC.

full *Lighting* 1. At full power, *i.e.,* the brightest possible illumination of the scene. 2. At the widest spread of the beam.

full back *Acting* An actor's position facing the back of the stage, with the back toward the audience.

full frame *Motion pictures* Said of any close-up with a subject that fills the frame.

full front *Acting* An actor's position squarely facing the audience.

full house *Theater* An audience that fills all the available seats.

full on *Audio, Lighting* Describing any circuit running at full power.

full score *Music* A SCORE of a large work showing each instrument and voice on its own separate line. The opposite of a CONDENSED SCORE.

full set *Stagecraft* The entire ACTING AREA as defined by the SET.

full shot *Motion pictures, Television* Any shot showing the actors and their essential background completely.

full stage *Stagecraft* The full depth and width of the stage. *See* STAGE AREAS.

funambulist [from Latin] *Circus* A rope walker. An AERIALIST who specializes in HIGH-WIRE ACTS.

functional prop *Stagecraft* Any PROP designed to function in some way on stage, such as a telephone that rings, or a gun that can be fired with blanks.

fundamental *Music* The primary tone that defines any harmony, *i.e.,* the tone in any triadic chord which contains the rest of the tones of the chord as its PARTIALS. Not the same as TONIC.

fundamental bass *Music* A BASS line formed by the FUNDAMENTALS of the chords being sounded by other VOICES.

fundamental tone *Music* The lowest tone of any HARMONIC SERIES.

funk *Jazz* A fusion of BLUES, GOSPEL and HARD BOP. By extension, since the late 1950s, a raw, earthy quality in JAZZ playing, a return to the "old-style" blues feeling and to the original sources of jazz.

funky *Jazz* Having the sensual, earthy characteristics of FUNK.

funky butt *Dance* Probably originating with a jazz tune of the same name, popular in 1900. An African American RAGTIME dance requiring much grinding of the hips and buttocks.

funky Broadway *Dance* In the early 1960s, a solo ROCK dance that combined bending the knees and tapping the feet together.

funnel *Lighting* A cylindrical or square metal hood fitted onto a COLOR FRAME in front of a FLOODLIGHT to eliminate any unwanted spillage of light. *See also* HI-HAT, TOP HAT, SNOOT. *Compare* BAFFLE, BARN DOORS, SPILL RINGS.

furiant (*FOO-ree-ahnt*) [Italian] *Dance* A vigorous Bohemian (Czech) folk dance performed to a strong, irregular rhythm: either the alternation of 2/4 and 3/4 time, or 3/4 time with accented beats creating HEMIOLAS.

furlana (*foor-LAH-nah*), **forlana** (*for-LAH-nah*) [Italian] *Dance* A 16th-century Italian dance based on DOTTED RHYTHMS originally in duple time, later in 6/8. It became popular with Venetian gondoliers in the 1700s.

furniture *Stagecraft* All the chairs, sofas, benches, etc., in the SET.

furniture plot *Stagecraft* The STAGE MANAGER's schedule of all the pieces of furniture that will be needed in each scene of the play, together with any CUES that apply to them.

fusion *Music* 1. The sensation of unity in the experience of hearing many tones sounding together. It may be HARMONY if the tones have harmonious relationships, but fusion can also take place with CLUSTERS and other nonstandard combinations of tones. 2. In popular music, the combining of two styles, such as JAZZ with CLASSICAL, or ETHNIC MUSIC with ROCK, etc.

fustian *Acting* A loud, ranting, bombastic style of acting.

fuzz box *Music* An electronic FEEDBACK circuit, usually built into the equipment used by ROCK AND ROLL players, that can be controlled to cause varying degrees of distortion of the amplified music so that very high-frequency HARMONICS, always discordant when many tones are sounding at once, are amplified out of proportion to their FUNDAMENTALS. This technique results in loud hissing and rasping effects, much favored by the guitarist Jimi Hendrix and his successors, that nearly overwhelm the basic chords being played.

fuzztone *Music* The smudged, rasping tonal effect produced by a FUZZ BOX.

FX *Motion pictures, Television* Short for EFFECTS. *See also* SPECIAL EFFECTS.

ƒ͙z Music Abbreviation for FORZANDO. *See also* SFORZANDO.

G

g *Music* The fifth note of the scale of C, a PERFECT FIFTH above C and a MAJOR SECOND below A. The TONALITY of which the note G is the TONIC. In the FIXED-DO SYSTEM, G is SOL.

gaff *Lighting, Motion pictures* To set up the LIGHTING INSTRUMENTS for a production, connect the DIMMER circuits that will control them and secure the cables and connections so that they will be out of the way and safe for people working on the SET.

gaffer *Lighting, Motion pictures* The head of the stage lighting crew, sometimes the head of the stage crew. The term seems to have originated in England in the time when stages depended upon candles or illuminating gas for light and each fixture above the stage had to be lit individually from below by a person wielding a long pole with a wick burning at its tip. In cockney slang, the pole was a gaff and its handler a gaffer, perhaps a drayman in ordinary life, whom the stage manager called in with his BEST BOY just before curtain time to do this one dangerous job. In the United States the term designates any electrical technician who sets up lights for a production, connects them to their proper DIMMER circuits, fastens all the wires and cables to GRID girders or stage wall conduits or the stage floor, and wraps or covers all exposed connections and fastens cables in place with GAFFER TAPE so that they will pose no danger to actors and stagehands when the power is on.

gaffer grip *See* BEAR TRAP.

gaffer tape *Lighting, Motion pictures* A tightly interwoven cloth tape with an extremely strong adhesive backing, usually 2–3 inches wide, with a black or gray upper surface, liberally used by GAFFERS to bind wires and cables and hold them in safe positions on the stage or a motion picture set, and by GRIPS for many similar jobs, such as to keep a prop in place. It is only superficially similar to industrial duct tape. The best gaffer tape is capable of adhering firmly to almost any surface in a studio or stage, yet can be removed without peeling paint or leaving a residue.

gag *Vaudeville* Any joke.

Gagaku (*GAH-gah-koo*) [Japanese] *Music* Literally, music entertainment. A graceful style of music, imported from Korea before the 7th century, that became a court tradition in Japan. It is characterized by slowly changing, shimmering CLUSTERS of high tones, punctuated by loud and contrastingly soft quick strokes of a drum. It uses pentatonic scales, some with semitones, but has no tonal center in the Western sense, and is somewhat like Western TWELVE-TONE music, though it uses far fewer tones in any given piece. Many pieces

consist of a single voice with instrumental accompaniment. Melodies are performed by a seven-holed FLUTE and a HICHIRIKI, supported by a KOTO, together with a stringed instrument similar to the lute and a drum, both of which play rhythmic accompaniment. Harmonies for certain pieces are supplied by a kind of mouth organ.

gag line *Vaudeville* The last line of a joke, when the turnabout occurs that makes the audience laugh. The PUNCH LINE.

gagman, gagster *Vaudeville* A performer who tells jokes. *See also* STANDUP COMEDIAN.

gag writer *Vaudeville* A writer who writes jokes and funny skits for COMEDIANS.

gain control *Audio* The potentiometer (volume control) that controls the degree of amplification of any audio channel.

gala *Theater* An especially festive performance, sometimes a BENEFIT with many visiting STARS, often the OPENING NIGHT of a new production or the CLOSING NIGHT of a long-running show.

galant, gallant (*gah-LAHN*) [French] *Music* Said of the style of light, pleasant compositions of the period of the mid-1700s when music was moving away from the more formal and contrapuntal style of the BAROQUE with its emphasis on religious use, toward the songs, dances and entertainments of the secular age sometimes called ROCOCO.

gallarda (*guy-YAR-dah*) [Spanish] *Dance* A Spanish dance of the 16th and 17th centuries whose musical accompaniment consisted of continuous variations on a short theme in 4/4 time. The Spanish version of the GALLIARD.

gallery *Stagecraft* The space above the stage containing the GRID and the FLIES. The FLY GALLERY.

Theater The highest balcony, with the cheapest seats, where the GALLERY GODS sit. Also called, in American slang, the PEANUT GALLERY.

gallery gods *Theater* The spectators who occupy the cheapest seats in the highest balcony and are famous the world over for being noisily critical.

gallery hit *Theater* Any show that the GALLERY GODS love.

galliard *Dance* An energetic 16th-century court dance whose rhythms may derive from the BRANLE and the PAVANE, characterized by hopping steps and leaps requiring great agility. *Compare* SALTARELLO.

Music Vigorous music for the dance of the same name, consisting of measures of 6/8 that are predominantly two triple beats per measure, interspersed with measures in which the beat changes to three duple beats. (*See* HEMIOLA.)

galop *Dance* A fast ballroom dance in 2/4 time, extremely popular in the 1900s, danced by couples in the WALTZ position, moving in straight lines. The form appears also in operas, and as the FINALE in ballets.

gam *Vaudeville* Slang for a leg, especially a chorus girl's leg.

gamba [Italian] *Music* Short for VIOLA DA GAMBA.

gamelan *Music* An Indonesian or Malaysian orchestra with from four to forty instruments including various large and small gongs, bronze bars, wooden xylophones, drums, several end-blown flutes, and a two-stringed violin. Its music is characterized by powerful, continuous, interlocking rhythms of the gongs and drums in phrases of very long duration, within which can be discerned a long, deep melodic line in very slow notes and several less deep imitations of that line in faster notes. Traditionally the gamelan plays for ceremonial occasions and for funerals. Several 20th-century composers have been influenced by the gamelan and have composed works in the style. Among the best known is the American composer Lou Harrison.

gamin (*gah-MENH*) (m), **gamine** (*gah-MEEN*) (f) [French] *Acting* An urchin who lives on the streets, a CHARACTER ROLE.

gamut [from Greek] *Music* The whole range of a scale or of an instrument. The word comes from the Greek *gamma* together with the SOLMIZATION syllable *ut*. In medieval musical training it defined the scale whose lowest tone (*ut*) was G (*gamma*).

gang dimmer *Lighting* An array of DIMMERS operated as one by a single mechanical control.

ganged *Lighting* Describing any combination of LIGHTING INSTRUMENTS or DIMMERS that have been connected together so they can be regulated by a single control.

gangsta rap *Music* A form of RAP first created by the group N.W.A. (Niggaz With Attitude) in Los Angeles, California, characterized by boastfulness and glorification of violence against the police and against women. It is distinguished from the New York style by a somewhat slower pace.

gapped scale *Music* A scale, more properly called a MODE, derived from an ordinary acoustically based scale, but missing certain notes. The PENTATONIC SCALE, which leaves out the FOURTH and SEVENTH of the ordinary MAJOR SCALE, is one example.

garage band *Music* A group of very young, inexperienced, would-be ROCK musicians who practice in a suburban garage or basement. By extension, any group incapable of playing more than the simplest chords and RIFFS.

garden border *Stagecraft* Any BORDER painted and perhaps shaped to look like or to suggest foliage and/or flowers.

garden cloth *Stagecraft* A DROP or a FLOOR CLOTH painted to look like foliage and/or flowers.

garden theater A small outdoor theater in a garden setting with WINGS of clipped hedges, perhaps of cypress or ilex, and a floor of turf. Such theaters were common on the grounds of Italian villas of the 17th and 18th centuries and are not significantly different in modern times. Some modern examples, primarily in university settings, have been the site of reconstructions of ancient dramas that were originally performed outdoors.

gargouillade (*gahr-goo-YAHD*) [French] *Ballet* A step similar to a PAS DE CHAT with one and a half or two circular motions of the leg (ROND DE JAMBE) performed in the air in either direction, EN DEHORS or EN DEDANS.

gate *Circus* The gross receipts. Also called the TAKE.

Lighting The frame at the focal plane of an ellipsoidal reflector that holds a GOBO or any other type of masking device.

Motion pictures A pair of plates that guide the film within the focal plane and form the APERTURE through which light passes in a camera or a projector.

gate cut *Circus* A share of the GROSS.

gathering *Dance* A movement of the limbs inward, toward the body. The opposite of SCATTERING.

gauche, à *See* À GAUCHE.

gauze *Stagecraft* A light open-weave fabric that can be used as a SCENE DROP or to cover a window or door opening. It is more transparent than a SCRIM. Its name comes from Gaza, the area along the Mediterranean shore beside Israel. *Compare* BOBBINET.

gavotte *Dance* Originally a French peasant courtship dance, it became a popular court dance in the time of Marie Antoinette. In ballet the steps were more complex and formed the basis for dazzling solo work in the choreography of Maximilien Gardel.

Music A stately dance movement in 4/4 time, frequently occurring in the suites of J. S. Bach, Jean-Baptiste Lully and others of the 17th and 18th centuries. Its most prominent characteristic is a 2-beat ANACRUSIS that introduces its phrases.

Gay White Way *Theater* Broadway, around Times Square in New York City, so called because of the myriad brightly lit, animated signs and theater marquees. The center of the commercial theater district. In the early 1900s all the lights were white.

gazoony *Circus* A laborer hired locally to help prepare the circus ground before the show, pick up trash during the engagement and help dismantle the show afterward. *Compare* ROUSTABOUT.

g-clamp *Stagecraft, Lighting* A special form of the c-clamp, with its screw aimed in toward the center of the clamp instead of straight across. This shape permits a firm grip on a round light pipe, strong enough to bear the weight of a small or medium-size light fixture.

g-clef *Music* The TREBLE CLEF. It takes its form from the old letter *G* that was placed on the STAFF so that its small loop would center on the line representing the note G above MIDDLE C.

G-CLEF

gebrauchsmusik (*geh-BRAUKHS-moo-ZEEK*) [German] *Music* Literally, useful music. A term that came into use in the 1920s in Germany and was made famous by the composer Paul Hindemith, describing music written for ordinary people to play at home, as contrasted with music intended for professional performance in concert.

geek *Carnival, Circus* A SIDESHOW performer who specializes in shocking and gruesome acts, such as biting off the head of a live chicken.

geige (*GUY-guh*) [German] *Music* The German version of the French name for the medieval violin, GIGUE.

geisha (*GAY-sha*) [Japanese] A highly trained professional hostess who provides formal private entertainment and companionship for individual men, including music, dance and poetry.

gel (*jel*) *Lighting* Colored, translucent plastic in sheet or roll form that can be cut to any size or shape to fit into a frame in front of the lens of a stage light, or to cover windows or any other large sources of light in a motion picture set ON LOCATION, altering the color of the light. A COLOR FILTER. Its name comes from the fact that it used to be made of sheets of gelatin.

gel frame, gel holder *See* COLOR FRAME.

gelling *Lighting* The process of installing color filters for a show.

gemshorn (*GHEMZ-horn*) [German] *Music* 1. A type of folk RECORDER made in a number of sizes from the horn of the chamois (an alpine antelope) in medieval times, and later from the horn of the ox, goat or ibex. Its TIMBRE is said to lie somewhere between that of a recorder and a FLAGEOLET. 2. A light-toned organ STOP with conical pipes.

general lighting The nonspecific, mostly shadowless illumination of the set, before any KEY LIGHTS or SPOTLIGHTS are turned on. The opposite of SPECIFIC LIGHTING. Not the same as AMBIENT LIGHT. *Compare* FILL LIGHT.

general manager *Theater* The executive in charge of all business operations of the theater or of a performing company, from accounting to union negotiations.

general understudy *Acting* An actor who stands ready to step into any SUPPORTING ROLE in the production if necessary on a moment's notice.

generation *Recording, Television* The degree of relationship between an original audio or video recording and any of its duplicates. The first generation designates any copy made directly from the ORIGINAL; second generation, any copy made from a first-generation copy, and so on. The term is important in that it suggests how clear a particular copy will be in playback. The more generations it has gone through, the less clear its sound or picture will be.

genny *Lighting, Motion pictures* Short for generator.

genre (*ZHANH-reu*) [French] *Theater* Literally, kind, sort. Any of the stylistic categories of theatrical works, such as TRAGEDY, COMEDY, TRAGICOMEDY, FARCE, MELODRAMA, MUSICAL, KABUKI, NOH, etc.

George Spelvin *Theater* A mythical person whose name appears on playbills now and then to hide the name of an actor who is doubling in an embarrassingly unimportant part. *See also* HARRY SELBY.

German cotillion *Dance* 1. A round dance from the mid-1800s involving complex figures and steps. 2. A social get-together where this is danced. Also called the "German." *See also* COTILLION.

gesso (*JES-oh*) [Italian] *Stagecraft* A mixture of gypsum, plaster of Paris or a similar substance, pigment (often white or black) and oil, used by scene painters to prepare a smooth surface on sized canvas or wooden surfaces on which to paint.

geste (zhest) [French] *Music* Literally, an action or deed. A ballad form developed by TROUBADOURS singing romantic tales of brave deeds. The word comes from the late Latin *gesta*, exploits.

gestic *Dance* Having to do with motions of the body.

gesture *Dance* In the strictest sense, any movement of the body designed to express something. The Italian choreographer and teacher Carlo Blasis divided gesture into two categories: the instinctive, outward expression of feelings through movement, and the gestures created by art as imitation of ideas and objects separate from ourselves.

Gesù *See* DEL GESÙ.

get across *Acting* To project the character's intent and meaning to the audience and have it understood, *i.e.,* to get it across the FOOTLIGHTS.

ghost *Acting* Theatrical slang for paymaster. In old theater tradition, the ghost was an actor who had nothing to do after the first scene in *Hamlet* and could therefore be spared (and trusted) to collect the money taken in at the box office and divide it up among the members of the company. In Elizabethan times, the ghost might also be required to collect the price of admission from the audience, including the GROUNDLINGS who were locked in the PIT until they paid (*see* SCREWED).

Television A dim image still visible on the screen when it should not be there, caused by excessive brightness in a previous shot or slow reaction of the screen.

ghost dance A religious ceremonial dance performed in the late 1800s by several American Indian tribes of the northern plains in honor of the dead.

ghost light *Lighting* A single WORKLIGHT, a bare bulb on a stand left lighted at center stage when the show is over and everybody has gone home, to discourage ghosts from haunting the theater.

ghost trap *Stagecraft* A trap in the stage floor through which an actor may rise into view as a ghost. It is frequently designed to spring open very quickly, with a flash of light and a puff of smoke from a FLASH POT, and may be fitted with a small elevator to lift the actor without requiring a climb. Also called a grave trap.

ghost-walking day *Theater* In old theater tradition, payday. According to the tradition, a certain actor who often played the Ghost in *Hamlet* and therefore was supposed to handle the box office TAKE, refused to walk, *i.e.,* play his part in the opening scene, because there was so little money. When the situation improved the next day he walked, and everybody got paid.

ghost writer *Playwriting* A writer hired to create a SCRIPT under someone else's name.

Gibson girl *Costume* An American style of women's dress and coiffure from the early 1900s, based on the popular illustrations of Charles Dana Gibson. It consisted of an ankle-length full skirt with a tight waist, a light-colored blouse with long sleeves and high puffs at the shoulders, topped off with an upswept swirl of hair.

gig *Music* A short, paid engagement for a small group of musicians or entertainers.

Gigaku (*GHEE-gah-koo*) [Japanese] *Dance, Theater* A Buddhist processional DANCE DRAMA introduced to the Japanese court in the 7th century by a Korean performer. It consisted of a series of scenes with musical accompaniment, enacted by dancers in carved, laquered, wooden masks that covered the entire head. By the 12th century, the form gave way to the more popular BUGAKU court dance. Not to be confused with GAGAKU.

gigot (*zhee-GOH*) [French] *Music* Literally, leg of lamb. In the 12th and 13th centuries a nickname for the REBAB, a predecessor of the violin, that looked like a leg of lamb. The name of the instrument evolved to GIGUE in France and GEIGE in Germany.

gigue (*ZHEEG*) [French] *Dance* A spirited dance of the 1700s, often in rapid 6/8 or 12/8 time.

Music A rapid dance tune, usually in 6/8, with which many German, French and Italian composers from 1650 to 1750 ended their suites of dances. The music was derived from the English JIG, which was also in a rapid triple meter, but had a SCOTCH SNAP built into the first two beats of many of its MEASURES, giving it a much more vigorous, stamping feeling. The term seems to derive not from the Gaelic word *jig*, but from the French nickname for the medieval violin, GIGOT.

gilly, gillywagon *Circus* A wagon or a truck that carries circus equipment from site to site.

giocoso (*joh-KOH-zoh*) [Italian] *Music* Literally, in a joking manner. An instruction to the performer to play in a jocose manner, to lighten the general feeling of the piece, to emphasize its humor.

giraffe *Lighting* A tall stand for lights.

Music Nickname for a type of piano popular in the early 1800s. It had a wing-shaped case rather like that of a grand piano, except that it was built vertically upward from behind the keyboard with a great, decorated scroll at the top, strongly suggesting the neck and head of a giraffe. In that form the instrument took up little floor space in the parlor.

gitana (*hee-TAH-nah*) [Spanish] *See* ALLA GITANA.

gitbox *Music* American slang for the GUITAR.

gittern *Music* A medieval stringed instrument, possibly carved from a single block of wood, with four strings played with a PLECTRUM. It was also called the *guitarra Latina*. Not the same as CITTERN.

giusto (*JOO-stoh*)[Italian] *Music* Literally, just. Precisely in rhythm as written, without variation, or in the appropriate time.

given circumstances *Acting* The fundamental situation of the characters at any moment during a scene. A concept of Konstantin Stanislavski, expressing the totality of all the elements that contribute to the action of a character at a specific moment. These include the background of the character, the plot, dialogue and setting. *See* ACTION (2).

given position *Acting* An actor's position on stage, assigned in the director's BLOCKING.

give position, give the scene, give the stage *Acting* To adjust one's given position with an UPSTAGE turn or a move to one side to allow the FOCUS to shift to another actor.

glam-rock *Music* A ROCK style of the early 1970s having more to do with dress than with music. Performers and fans who embraced the style sported flowing shoulder-length hair, a variety of costumes, furs, peacock feathers and shoes with six-inch high soles. *See also* GLITTER ROCK.

glance-lighting Lighting, particularly of a CYCLORAMA, from such a close, oblique position that much of the light bounces indirectly onto other parts of the set.

glass harmonica *Music* An instrument invented by Benjamin Franklin in 1763 and used by his contemporary Mozart, among others. It consisted of an array of glass bowls in graduated sizes, tuned to the chromatic scale, mounted through their centers on a horizontal axle spun by pedals. The performer played with wet fingers gently touching the etched outer surfaces of the spinning bowls. Its sound has an ethereal, singing, bell-like quality. The instrument for which Mozart composed his *Adagio* (K356) and *Adagio and Rondo* (K617) may have had a keyboard and an action that provided mechanical contact with the bowls and saved the performer's fingertips.

glee [from Anglo-Saxon] *Music* An 18th-century English style of short choral PART SONGS for male voices, composed and performed for fun.

glee club *Music* A gathering, usually of men, who sing together regularly for the fun of it.

gleeman *Music* One of a class of itinerant entertainers who were acrobats, jugglers, jesters and musicians in Northern Europe during the 12th century. These were the English and Saxon counterparts of the JONGLEURS and TROUBADOURS of the 14th century who established the foundation of European secular music.

gliss *Music* Short for GLISSANDO.

glissade (*glee-SAHD*) [French] *Ballet* Literally, a slide. A sliding step used as a connection to another step, beginning and ending with a DEMI-PLIÉ. Glissades are executed DEVANT, DERRIÉRE, DESSOUS, DESSUS, EN AVANT, EN ARRIÉRE, etc.

glissando (*glee-SAHN-doh*) [Italian] *Music* Literally, sliding. A series of adjacent notes, played on the piano by sliding a finger or thumbnail along the keys, or on the harp by stroking across all the strings. It was possible, with the much lighter actions of pianos in the

days of Mozart and Beethoven, to play glissandos in PARALLEL THIRDS and SIXTHS, and even, in Beethoven's *Waldstein Sonata*, OCTAVES. Voices and bowed stringed instruments can also produce a glissando and have the advantage of being able to sound through an infinite number of MICROTONES.

glisser (*glee-SAY*) [French] *Ballet* Literally, to slide. One of the seven basic MOVEMENTS IN DANCE.

glitch *Lighting* Electricians' slang for a brief surge of power in a power line sometimes caused by turning on too much power at once. It makes the stage lights flash brilliantly for an instant, and can blow out bulbs and fuses.

glitter dress, glitter suit *Costume* A spectacular dress or suit covered with shimmering sequins often worn by a star performer in a concert or a special appearance on stage.

glitter rock *Music* A rock style of the early 1970s, similar to GLAM-ROCK in its emphasis on the visual elements of performance, in which some musicians appeared in sequined suits.

glockenspiel *Music* 1. A portable instrument carried by a percussionist in a MARCHING BAND. It consists of an array of steel bars tuned to a high chromatic scale of at least two octaves, mounted within a lyre-shaped frame and played with a steel rod, producing a piercing bell-like sound. 2. An orchestral instrument of the 18th and early 19th centuries consisting of metal bars played by a keyboard. It is featured in Mozart's opera *The Magic Flute*. It differs from the CELESTA, which has a mellower tone.

Gloria *Music* A principal section of the Catholic MASS, subject of many choral masterworks of the 12th through 20th centuries.

glossy *Acting* An actor's black-and-white 8- by 10-inch publicity photograph, ready for instant publication. *Compare* COMPOSITE.

glove puppet *See* HAND PUPPET.

glowtape *Stagecraft* Luminescent tape used to indicate the placement of scenery and props during a change of scene. Its glow is a reaction to the stimulus of stagelights. *See also* L.E.D., SPIKE.

glue sizing *Stagecraft* SIZING made with powdered glue. Scene painters sometimes add pigment to the sizing, though it may eventually cause the underlying fabric to deteriorate.

gobo *Motion pictures* Any screen or mat, usually with a black, nonreflective surface, used to keep bright light from striking the lens of a camera. Usually it is mounted on a stand, but if it is mounted on the camera it is called a French flag. *See also* FLAG.

Lighting Any simple masking device made of heat-resistant material made to slip into the COLOR FRAME of a SPOTLIGHT and designed to cast shaped shadows on the set. It differs from a COOKALORIS in that it casts a shaped shadow rather than shaped or dappled light. The name is a shortened form of "go-between" since the gobo slips into the COLOR FRAME between the lamp and its GEL. *See also* LINNEBACH PROJECTOR.

gobo slot *Lighting* A slot built into the focal plane of an ELLIPSOIDAL REFLECTOR SPOTLIGHT to hold a GOBO.

go down *Acting* To move DOWNSTAGE.

go dry *Acting* To forget one's lines completely while on stage in the middle of a scene.

gods *See* GALLERY GODS.

gofer *Motion pictures, Theater* A person who runs errands; the lowest job in the company, and the level where many a successful actor, producer or director started out.

gogo dancer *Dance* A scantily clad female dancer who occupies a small stage above the heads of patrons in a nightclub or a bar, and dances continuously to recorded music.

Gold record *Music* A registered trademark for an award given by the RECORDING INDUSTRY ASSOCIATION OF AMERICA to a musical artist or group whose recording has exceeded 500,000 in units shipped from the manufacturer. *See also* PLATINUM RECORD.

goliard [Latin] *Music* A wandering ecclesiastical scholar of the late Middle Ages who eked out an existence by composing and performing ballads in late Vulgate Latin. Goliards were influential in the development of music and poetry in their time, and were made famous in modern times with the *Carmina Burana* of Carl Orff, which is based on some of their lyrics.

gong *Music* A bronze bowl, precisely shaped to produce a specific note of the scale, usually in the bass or tenor register, when struck by a wooden mallet. It differs from an orchestral bell primarily in its tone, which tends to be less complex in its harmonics. Because of this limitation, composers prefer to use gongs as specific tones, one by one, rather than in clusters and flourishes where bells would be more expressive. Giacomo Puccini used gongs prominently in his operas *Tosca* and *Turandot* and had a set of thirteen made for that use.

go off *Acting* A CUE to an actor to leave the scene.

go on *Acting* A CUE to an actor to enter the scene.

go out *Acting* A CUE to an actor to leave the scene.

go over *Acting* 1. To reach for and get an appropriate response from the audience. 2. To rehearse a role or a bit of action informally.

gopher *See* GOFER.

gospel *Music* A style of vocal music, mostly choral, characterized by strong swaying rhythms, often in 12/8 time, generally associated with African American church choirs.

go up *Acting* To move UPSTAGE.

gourd *Music* A percussion instrument much used in Latin American dance bands, particularly in the SAMBA. It consists of a large, hollow, natural gourd approximately two feet long,

with parallel grooves cut crosswise into one side. The player holds the gourd in one hand and scrapes across the grooves with a light stick (players tend to prefer a Chinese chopstick) to produce a rasping sound.

grace *Music* Short for GRACE NOTE.

grace note *Music* A brief NEIGHBORING TONE played as an embellishment to a primary tone. It differs from the APPOGGIATURA in that it does not entail a dissonant harmony to be resolved, but is merely a decoration on a single note and its very brief time is deducted from that note.

GRACE NOTE

gracioso (*grah-chee-OH-zoh*) [Italian] *Music* Literally, full of grace. Warmly, gracefully.

Gradual *Music* One of the musical sections of the liturgical MASS, consisting of sentences and responses.

grain *Acting* In the language of the STANISLAVSKI METHOD, the basic ACTION of a character in the play.

graining *Stagecraft* A simulation of wood grain, accomplished by painting a FLAT or a piece of scenery with a partially dry brush.

Grammy *Music* An award given annually since 1957 by NARAS to recording artists in several categories. The award is represented by a small bronze sculpture of an old-fashioned GRAMOPHONE, hence its name.

Gramophone *Music* Trade name for the disk-playing version of the original PHONO-GRAPH invented by Thomas Alva Edison. It consisted of a wooden box with a wind-up motor inside that spun a turntable that supported a recorded disk. A large conical horn mounted on an arm attached to the box had a small disk-shaped membrane that closed its smaller opening. A stylus, firmly cemented at one end to the center of that disk, rode in the grooves of the spinning record and transmitted the resulting vibrations to the membrane, producing sound that the shape of the horn amplified. No electronics were involved.

grand *Music* Short for GRAND PIANO.

grand battement *See* BATTEMENT, GRAND.

grand écart (*granhd ay-KAHR*) [French] *Ballet* Literally, large split. *See* SPLIT.

grand finale *Vaudeville* An extended musical scene with all the cast on stage, dancing and singing, to end the show in a grand manner.

Grand Guignol (*granh gheen-YOL*) [French] *Theater* A small theater of Montmartre in Paris, founded in 1897. It specialized in realistic and gory horror plays, with live actors presenting several short plays each night. It carried to shocking and gruesome extremes the violence of the old PUNCH AND JUDY SHOWS, using stories based on crimes and scandals of the time.

During the 1920s it became immensely popular with some of the social elite and was, under the direction of Antonin Artaud, the showcase of the "theater of cruelty," an exploration of the stark realism typical of many theater movements of the time.

grandioso (*grahnd-YOH-zoh*) [Italian] *Music* In a grand, stately manner.

grand jeté (*granh zheu-TAY*) [French] *Ballet* A big "thrown" step, beginning with a leap from one foot to the other and ending in one of a number of required positions.

grand opera *Music* An opera, usually on a serious subject, with all or most of its text set to music. The term refers most specifically to elaborate works, such as those of Méhul, Halévy, Meyerbeer, Saint Saëns, Wagner and others, in four or five acts, combining the techniques of all the arts, based on historical or epic subjects and produced as lavish spectacles during the 19th century, at the Paris Opèra and other large houses.

grand piano *Music* A PIANO built into a horizontal, wing-shaped case at least 5 feet long, with its strings stretched from front to back behind the keyboard. The CONCERT GRAND PIANO is the standard instrument for concert performance.

grand right(s) *Dance, Music, Playwriting* Right(s) of public performance as or as part of a theatrically staged work, *i.e.,* with actors, dancers and/or singers moving on stage, distinguished from the rights granted for simple concert performance. The distinction has practical importance in that performing rights organizations, such as ASCAP, BMI, SESAC *et al.,* do not manage grand rights, which must always be individually negotiated.

graphic score *Acting* A VISUAL SCRIPT written not in words but in patterns of symbols, and presented to a student actor as a problem to be worked out in improvisation.

Music Any of various types of instrumental and vocal SCORES using symbols in addition to, or other than, the staffs and notes of traditional music, invented independently by several composers of the mid-20th century to satisfy the peculiar requirements of ALEATORY and computer-based composition.

grass cloth *Stagecraft* A green cloth laid on the stage floor to resemble grass for an outdoor scene.

grave (*GRAH-veh*) [Italian] *Music* Literally, serious, grave. Solemnly.

gravel bag *See* BAG (*Motion pictures*).

grave trap *Stagecraft* A TRAP in the stage floor from which an actor may rise as if from the dead. *See also* GHOST TRAP.

gravicembalo (*grah-vee-CHEM-bah-loh*) [Italian] *Music* A 17th-century name for a particularly large HARPSICHORD. The word may be a variation of the word CLAVICEMBALO, meant to imply a larger instrument, one suitable for use with an orchestra in concert. The larger instrument also boasted a bass register an octave below what the normal harpsichord could play, which may also have inspired the name.

gray scale *Television* A diagram showing patches of ten different degrees of gray, lined up in order from white to black. It is used to compare the different levels of brightness that a camera picks up from various images regardless of their original color.

grease, greasepaint *Makeup* The generic name for all varieties of makeup base and pigment used on the skin.

Greater Dionysia *Theater* The great theatrical festivals of ancient Athens. *See* DIONYSIA.

great octave *Music* The second lowest octave of the piano, from C_1 to C. *See* OCTAVE NAME SYSTEM.

greenroom *Theater* A reception room, generally situated backstage, set aside for actors to relax and, often, to meet and mingle with a few selected visitors after a performance. Not many such rooms are actually green. The name may have been derived rather from the fact that green, the traditional color of jealousy, was a color suitable for theater people, just as purple was reserved for royalty.

Gregorian chant *Music* A style of singing first conceived for liturgical use in the time of Pope Gregory I and further developed by church musicians until about the 11th century. It consists of pure, single-line, unaccompanied melodies in CHURCH MODES, set to liturgical texts to be sung by a cantor and a choir IN UNISON. In the centuries since its first appearance, composers have used Gregorian tunes as a basis for POLYPHONIC music. The ancient chant for the *Credo*, for example, appears as the basic theme of the Credo in Bach's great *Mass in B minor*, and traces of Gregorian tunes appear also in many operatic scenes with cathedral settings. *See also* CANTUS FIRMUS.

Gregorian mode *See* CHURCH MODES.

grid, gridiron *Theater* A network of steel bridges and platforms built high above the stage, providing support for FLIES, WINCHES and RIGGING, and the technicians who work on them.

grid plot *Lighting, Stagecraft* The schedule of all the equipment that is to be used and the events that must take place on the GRID during the show.

grind *Dance* In the early 1900s, a ragtime dance characterized by undulating hip movements. *See also* BUMP AND GRIND.

grind house *Vaudeville* A theater devoted to STRIPPERS and others who specialize in continuous performances of provocative dances featuring the GRIND.

grind show *Vaudeville* A show that goes on all afternoon and evening, and features continuous acts with STRIPPERS and dancers who do BUMPS AND GRINDS.

grip *Stagecraft* A stagehand responsible for setting the stage and shifting scenery and props as necessary during a show.

Motion pictures A technician responsible for moving scenery, furniture and props on the SET, and for setting up lights, FLAGS, REFLECTORS, and window GELS as necessary.

grizzly bear *Dance* A ragtime ANIMAL DANCE of the early 1900s, once banned in genteel circles. A loose imitation of the bear's swaying walk, ending in a hug.

groan box *Music* Slang for an ACCORDION.

groaner *Vaudeville* A crooner, particularly one with a BARITONE voice.

groove *See* IN THE GROOVE.

groovy *Music* The condition of being IN THE GROOVE.

gross *Theater* The total amount of money taken in from the sale of tickets, before any deductions are made for costs or taxes. *Compare* NET.

ground, ground bass *Music* 1. A single tone in the BASS, sustained throughout the passage, while other voices play. 2. A short melodic phrase in the bass that repeats without variation throughout the passage or the piece. Not the same as BASSO CONTINUO. *See also* CHACONNE, PASSACAGLIA.

ground cloth *Stagecraft* A painted cloth laid on the floor of the stage to represent any surface, including bare ground, grass, rugs, ice or water.

groundling *Theater* In Shakespeare's time, a member of the audience who stood on the bare ground in front of the stage to watch the play. More affluent patrons sat in covered boxes around the perimeter of the HOUSE. A few others sometimes bought seats directly on the stage.

ground row *Stagecraft* A low FLAT or freestanding piece of scenery, representing a low wall, foliage, waves on the sea, etc., but placed primarily to mask the bottom of a DROP, a STRIPLIGHT or a TREADMILL.

ground row strip *Lighting* A strip of lights on the stage floor behind a GROUND ROW, illuminating the lower part of a CYCLORAMA or a DROP.

groupie *Music* A fan, often a teenage girl, whose dedication to a particular performer or band may include attending every GIG, following the group on tour and providing casual sex.

grouping *See* BLOCKING.

grunge *Music* A ROCK style originating in Seattle, Washington, with groups like Pearl Jam and Nirvana, as a reaction to PUNK. The mood is despondent, the lyrics gloomy, and performers dress in the kind of clothing associated with the homeless.

G-string *Vaudeville* A STRIPPER's very brief covering for the crotch.

guajira (*gwah-HEE-rah*) [Spanish] *Dance* A Cuban folk dance brought to the United States, popular for a short time in the early 1930s.

guaracha (*gwah-RAH-chah*) [Spanish] *Music* A Cuban folk song performed by a solo voice and chorus, in two sections, an introduction followed by faster music, dominated by syncopated rhythms.

Guarneri (*gwah-NEH-ree*) [Italian] *Music* A VIOLIN, VIOLA or VIOLONCELLO made by any one of the famous Guarneri family of violin makers who flourished in Cremona, Italy, during the 17th and 18th centuries. The most famous was Giuseppe Antonio, who was known as Giuseppe DEL GESÙ.

guest artist *Dance, Music* A featured performer, not a regular member of the company, brought in for a particular performance.

guest star *Theater* A performer playing a leading role in the production who is not actually a member of the company.

Motion pictures While the STUDIO SYSTEM prevailed in Hollywood, a STAR borrowed by one studio from another for a single picture. Since that time, the term has lost its meaning and tends to be a variation of TOP BILLING.

guide lines *Motion pictures* Lines, imaginary or actual, extending from the camera to define its viewing area, *i.e.,* the acting area.

guidonian hand *Music* A system devised to aid students in memorizing the tones of the scale and their relationship to each other. It consisted of a visualization of the left hand with the notes of the diatonic scale from G to E^2 arranged in a line starting at the thumb and circling around all the fingers. It came into vogue as a teaching tool in the 13th century, long after Guido d'Arezzo's lifetime, but was named for him because of his development of the SOLMIZATION syllables UT (DOH) - RE - MI - FA, etc., that were its basis.

Guignol *See* GRAND GUIGNOL.

Guild *See* SAG, DGA, THEATER GUILD, WRITERS GUILD OF AMERICA.

guillotine *Motion pictures* In traditional film editing, an editing tool designed to make two kinds of cut: a straight cut precisely along the FRAME LINE of film or an angled cut across a piece of magnetic SOUND TRACK. In either case, the joint is held together by Mylar tape. Unlike a splicing block, the knife of the guillotine is built into the tool.

guillotine curtain *Stagecraft* A curtain hung so that it can be raised or lowered in a single movement without furling in any way. A DROP CURTAIN.

guiro *See* GOURD.

guitar *Music* A stringed instrument closely related to the GITTERN and the VIHUELA, said to have first appeared in Spain in the early 1500s. The modern six-string guitar, outgrowth of many physical changes over the years, has a long FRETTED neck, a hollow wooden body with a flat back, and is shaped somewhat like a VIOLIN but larger

Tuning Sound

GUITAR TUNING

with a round hole in the center instead of F-HOLES. It is played by plucking. The "classical" or "Spanish" guitar associated with concert performers like Andrés Segovia is strung with three gut (or plastic) and three metal-spun silk strings. Used by folk and popular musicians of many nations, particularly in FADO and FLAMENCO, the guitar is also an important instrument in the BLUES and in the rhythm sections of JAZZ bands. Its forms include the ELECTRIC GUITAR, the HAWAIIAN or STEEL GUITAR, the STEEL-STRUNG GUITAR used in folk music, and the TWELVE-STRING GUITAR. Unlike most stringed instruments that are tuned in fourths or fifths, the guitar is tuned as shown in the illustration.

guitarist *Music* A musician who plays the GUITAR.

gun opera *Motion pictures* A WESTERN.

gutbucket *Music* A heavy, raucous style of jazz. *See* BARRELHOUSE.

gut stop *Music* A STOP on the harpsichord that engages the GUT STRINGS, which have a much quieter sound than do the regular wire strings. Also called LUTE STOP. *See also* LAUTENCYMBALO.

gut strings *Music* Strings made of animal gut, once used extensively on stringed (and some keyboard) instruments, replaced on most modern instruments by metal or plastic. Some string players specializing in BAROQUE music believe the tone produced by a gut string is more suitable for music of that period.

guttersnipes *Circus* Circus PAPER pasted on gutters and downspouts of stores and other buildings all around town, to advertise the coming of the circus. *See also* BILLING, BILLING AGENT.

guy *Acting* To improvise during the scene, especially for the purpose of distracting other actors.

Stagecraft A rope or wire firmly attached to part of the SET to hold it in place.

gypsy *Theater* A member of the chorus of a touring show whose bags seem always to be packed, ready for the move to the next town.

gypsy music A vehement, passionate style of music, usually played on a VIOLIN and/or a DULCIMER, characterized by moody shifts from heavy, slow passages to passages of wild abandon, and by the predominance of the GYPSY SCALE.

gypsy scale *Music* A SCALE that probably originated in India. Its most prominent harmonic feature is the melodic interval of an AUGMENTED second that occurs twice, between its third and fourth scale tones and again between the sixth and seventh scale tones.

H

h *Music notation* In German music, the note B-NATURAL.

Habañera (*hah-bah-NYAY-rah*) [Spanish] *Dance* Literally, from Havana. A Creole country dance of Cuba that became extremely popular in Europe and Latin America during the late 19th and early 20th centuries, a direct ancestor of the Argentine TANGO. In its original form it was danced by couples facing each other, moving in slow, stately, shuffling steps with voluptuous movements of the arms and upper body.

Music A musical form based on the dance. There have been many Habañeras composed by Spanish and French composers of the late 19th and early 20th century, including Debussy, Albéniz, Yradier and others. The most famous of all is the provocative aria *L'amour est un oiseau rebelle* that Georges Bizet transcribed from a work by Yradier and inserted in his opera *Carmen*.

hairneedle *See* BODKIN.

hairpin *Music notation* Slang for the symbol for either CRESCENDO or DECRESCENDO.

half apple *Television* A shallow box for a moderately short performer to stand on, half an APPLE.

half broad *Lighting* A 1,000-watt floodlight.

half-hour call, half-hour warning *Acting, Dance, Stagecraft* The STAGE MANAGER's warning to the cast and crew of the show that the curtain will go up in 30 minutes. In many companies, particularly in ballet, it is the critical time when performers must be present, *i.e.,* "signed in," backstage and in the process of preparing costume and makeup.

half-leg drop *Stagecraft* A short, narrow LEG that reaches only partway toward the stage floor, usually to the top of a three-dimensional piece. For example, the leg may be cut and painted to represent the branches and leaves of trees, while the trunks of the trees are constructed in three dimensions below. *See* LEG DROP.

half mask *See* DOMINO.

half note *Music notation* A note having half the duration of a WHOLE NOTE, equal to the duration of two QUARTER NOTES.

HALF NOTE

half plug *Lighting* A special STAGE PLUG designed so that two will fit into one stage POCKET and can therefore be controlled by a single DIMMER.

half step *Music* A SEMITONE.

half toes *See* DEMI-POINTES.

half tone *Music* A SEMITONE.

hall, hall backing *Stagecraft* FLATS placed behind an opening in the set, lighted and painted to give the impression of a hallway leading away from the scene.

Stagecraft An opening in the set with FLATS placed behind it to give the impression of a hallway leading away from the scene.

hallelujah [from Hebrew, *alleluia*] *Music* Literally, praise God. A word that appears within, or at the end of, many Jewish and Christian prayers and frequently serves as text for joyous movements of religious works. One of the most famous is the *Hallelujah Chorus* in George Frideric Handel's ORATORIO *Messiah*.

halo *Costume* A narrow band of cloth fitted inside a hat to secure it on an actor's head.

Lighting A bright corona in the hair around the head of an actor, accomplished by lighting from behind.

ham *Acting* 1. An amateur actor (derogatory). 2. An actor who overdoes actions and emotions on stage. 3. To overdo actions and/or emotions on stage. To "ham it up." *See also* CAMP.

hambo *Acting* Another name for a HAM.

hammer *Music* 1. The part of a piano mechanism that rises to strike the string when a key is depressed. 2. A TUNING HAMMER. 3. To strike the keys of the piano heavily, emphasizing the accents of the rhythm. 4. The beater used to strike the strings of a CIMBALOM.

hammered *See* MARTELLATO.

hammerklavier (*HAH-mer-klah-FEER*) [German] *Music* Literally, hammer keyboard. One name for the piano, used in the early 19th century. Beethoven's *Piano Sonata Opus 106* is subtitled *The Hammerklavier Sonata*.

Hammond Organ *Music* Trade name for an electric organ introduced in the 1930s that produced its sound through a system of magnetic sensors triggered by a set of polygonal steel disks rotating on a common axle. The shape of each disk determined the PITCH of its note. The sensors picked up the different frequencies and, when keyed from the keyboard, sent them along to an amplifier that made them audible as tones. The instrument was limited in that it could not naturally produce different TIMBRES, because the sensors gave only FUNDAMENTAL tones. (*See* SINE WAVE.) Differences of timbre were achieved by adding tones to tones, giving only an approximation of pure HARMONICS. Nevertheless, in the 1940s the Hammond Organ was used as a solo instrument in concert by touring performers such as

E. Power Biggs, and continues to be used in jazz groups, often with the addition of special loudspeakers that create a powerful sound.

hammy *Acting* Having the quality of overdone emotions, like a HAM. *See also* CAMP.

ham up, ham it up *See* HAM.

hand and rod puppet *See* ROD PUPPET.

handbell choir *Music* An ensemble of players of HANDBELLS.

handbells *Music* A set of individual bells, each with a clapper and a handle, designed to be held in the hand and rung by controlled swings. A large set provides a chromatic scale of four octaves, starting with a heavy bell approximately 10 inches high that produces C_1 (below the bass clef), and reaching c^2 (above the treble clef) with the smallest. (*See* OCTAVE NAME SYSTEM.) Most HANDBELL CHOIRs, based in schools and colleges, use about three octaves between those extremes. Handbells are played by a handbell choir, with each member responsible for four bells (and four different notes), one in each hand and two more placed on a felt-covered table within easy reach. When a player's assigned note comes up in a piece of music, the player picks up the appropriate bell, holds it vertically with the clapper upward and makes a careful stroke to make the clapper strike just once, letting the bell ring as long as indicated by the music, then placing it back on the table where the felt covering damps it. Because of the coordination required between individual members of the choir, handbells are excellent for early musical education.

handbill *Theater* A single-page advertisement for a show, intended to be distributed in public places, such as bus stops and shopping malls.

handheld *Motion pictures* A style of camera work accomplished with the camera supported on the operator's shoulder instead of being mounted solidly on a tripod. Its great advantage is its flexibility during the shot. Its great disadvantage is its unsteadiness that is amplified by the camera's normally narrow FIELD OF VIEW and shows up vividly on the screen. Directors often exploit this unsteadiness when it will lend an impression of realism to a scene, making it seem like television news.

handkerchief bit *Acting* Any emotionally moving scene that will cause the audience to weep in sympathy with the characters.

handle *Acting* Any unessential word, like "Well" or "Oh," added to the beginning of a line by the actor to make the line feel more comfortable in delivery.

handler *Theater* An actor's AGENT.

handling line *Stagecraft* 1. *See* OPERATING LINE. 2. A line attached to a piece of scenery to enable stagehands to guide it as it is dropped into position on the stage, or to a COUNTERWEIGHT to help hold it while curtains or scenery are being adjusted. Also called working line.

hand prop *Stagecraft* Any prop that will be carried on stage by an actor, *e.g.*, a fan, a cane, a sword or an umbrella. *See also* CHARACTER PROP.

hand puppet A PUPPET designed to be operated by one hand. It consists of a large, hollow head and a costume that is actually a short sleeve with two miniature sleeves sewn in to represent the arms and hands of the character represented. The puppeteer inserts his hand in the main sleeve with his second and third fingers reaching inside the head, and the thumb and fourth finger slipped into the tiny sleeves as arms. A single traveling puppeteer can set up his tiny BOOTH stage and run a show with two characters, one on each hand. The classic PUNCH AND JUDY were hand puppets. *Compare* FINGER PUPPET, MARIONETTE.

handspring *Circus* A gymnastic movement in which an acrobat falls forward into a HAND-STAND and continues without pause, springing from the handstand to a normal standing position on the feet.

handstand *Circus* A gymnastic position with the hands on the floor and the body inverted, vertical and balanced with the feet in the air.

hang a show *Stagecraft* To rig all the scenery that will be FLOWN for the show.

hanger *Lighting* A short length of pipe mounted on a LIGHT PIPE or stand, to which a lighting fixture may be attached.

Stagecraft A fixture mounted on a batten to provide an attachment point for CURTAINS, DROPS or RIGGING LINES.

hanger iron *Stagecraft* A small, flat piece of iron with a ring at one end, that can be screwed to the frame on the back of a FLAT to hold rigging lines. In a common configuration, hanger irons are installed in pairs, one on the bottom rail of a flat, the other at the top. A rigging line tied to the bottom iron passes through the ring of the top iron up to the batten, supporting the flat in a vertical position. *Compare* CLEAT.

hanging plot *Stagecraft* A drawing showing vertical and horizontal sections of the stage and its SIGHT LINES as they exist with all the pieces shown in place for a specific SET. It provides an opportunity for the set and lighting designers to adjust their plans to take care of otherwise unforeseen sight-line problems.

hanging rail *Puppetry* A strong horizontal rail built across the back of a MARIONETTE stage, against which the puppeteers lean while they are operating marionettes onstage and from which they can hang the controls of those that are temporarily offstage.

hanging unit *Stagecraft* Any BATTEN, curtain, LIGHT PIPE or piece of scenery hung in the flies.

hanging wing *Stagecraft* A WING hung from the GRIDIRON, rather than standing on its own bottom rail.

happening A quasi-theatrical event of the early 1960s, often involving experiments by painters and poets interacting with an audience in a visual and aural environment constructed in an art gallery or studio. At the time, many painters were experimenting with intentionally haphazard techniques such as "action painting" (in which the artist used the body as a brush), poets were playing with dreams and streams of consciousness, and composers were creating ALEATORY music. Individual events gradually grew to include

more than one artist and to attract larger audiences, eventually reaching a climax in New York City with a show combining the work of "artists and engineers" in a large armory, using newly developed ultra-high-speed motion picture film and extreme wide-screen projection. Before long, however, the happening began to resolve into the more composed form called PERFORMANCE ART.

hard bop *Music* An intense, hard-driven JAZZ style that grew out of BEBOP in the mid-1950s, associated with players such as John Coltrane and Sonny Rollins, notable for its ensemble passages of written unison figures, extended solos and splintered effects. Instrumentation seldom varied from a mix of trumpet, tenor or alto sax, piano, bass and drums. Also called neobop.

hard edge *Lighting* Describing any light so accurately focused, or limited by a FUNNEL or a GOBO, that the edges of the lighted area are sharp, making visible shadows rather than diffuse transitions.

hard flat *Stagecraft* A FLAT with a plywood, instead of muslin or canvas, surface. Such a surface can provide support for three-dimensional additions such as a molding around a fireplace.

hard light *Lighting* Any light that produces a sharply focused beam with well-defined shadows. The opposite of SOFT LIGHT.

hard rock *Music* One of the original forms of ROCK AND ROLL created in the 1950s and 1960s, an outgrowth of RHYTHM AND BLUES, notable for its loud, aggressive, intensely masculine style and very strong beat. As the use of electronic effects multiplied and the decibel level increased, it developed into the style known as HEAVY METAL.

hard scenery *Stagecraft* Scenery made with material that has a hard, acoustically reflective surface instead of cloth that tends to absorb sound.

hardware cloth *Stagecraft* Wire screening. It can be formed into almost any shape, covered with fabric, plastic, plaster or PAPIER MACHÉ and then painted to resemble whatever the set designer may want on stage, such as a wall of rough stone or the trunk of a large tree.

hardwire *Audio, Lighting* To join sections of electrical circuits directly and permanently together with soldered or clamped connections rather than with removable plugs and sockets.

Harlequin *See* ARLECCHINO.

harlequinade *Theater* Any fanciful, comic PANTOMIME, skit or play featuring the character Harlequin (ARLECCHINO).

harmonic *Music* 1. Having the quality of concord. 2. Any of the secondary tones generated as an ALIQUOT PART of a FUNDAMENTAL tone. A PARTIAL. *See* HARMONIC SERIES.

harmonica *Music* A MOUTH ORGAN. A hand-size metal box containing a double line of channels with metal REEDS mounted inside that vibrate when air passes through them. The reeds are arranged in pairs facing opposite ways, so that one will sound when the

player exhales through the instrument, the other when the player inhales. By adjusting the position of the mouth to select individual channels, covering unwanted channels with the tongue, and alternating the breathing the player can produce a complete CHROMATIC SCALE, usually covering about two OCTAVES in the TREBLE range. Some instruments are fitted with thumb-operated slides that momentarily redirect the air into alternate reeds to provide other tones. There are one or two concertos for harmonica and orchestra, commissioned and played in the mid-20th century by the most famous of all harmonica players, Larry Adler.

harmonic change *Music* The subjective impression of moving onward that occurs when one chord gives way to another within a piece of music, *e.g.,* when the DOMINANT resolves into the TONIC to create a CADENCE. In general, the impression of movement seems less pronounced when one or two tones of the first chord remain active in the second. It seems more pronounced when all the notes move. These subtleties are the harmonic material with which composers work and they are subject to an infinity of influences and ambiguities. If the effect of harmonic change were reduced to a simple formula, music would cease to be composed. *See* HARMONIC RHYTHM.

harmonic interval *Music* Any INTERVAL consisting of tones that seem CONSONANT when sounded together; a wholly subjective distinction. According to the definition first proposed by the Ionian physicist Pythagoras, intervals that occur lowest in the HARMONIC SERIES, *i.e.,* nearest the fundamental tone, seem more harmonious than those occurring higher up.

harmonic minor scale *Music* A MINOR SCALE with its sixth tone lowered to one SEMITONE above its fifth, and its seventh an AUGMENTED SECOND above that. It is called harmonic because this configuration permits its DOMINANT to be a major chord, with a strong LEADING TONE to the TONIC. Similarly, its SUBDOMINANT chord is minor, which provides a strong resolution toward the DOMINANT chord. In melodic use, however, the interval of an augmented second is often modified as in the MELODIC MINOR SCALE.

harmonic progression *Music* A series of harmonies that establish a change of KEY within a piece of TONAL MUSIC. *See* MODULATION.

harmonic rhythm *Music* RHYTHM produced by patterns of strong and weak changes of harmony. (*See* HARMONIC CHANGE.) Although there may be dancelike patterns of accents or beats in the melodic lines of the music or among the percussion instruments, the psychological sensation of moving onward in a piece of music occurs only when the harmony itself changes. Composers have made extensive use of this ambiguity.

harmonic series *Music* The series of secondary tones, also called OVERTONES or PARTIALS, that exists acoustically when any FUNDAMENTAL tone sounds. The FREQUENCY of each tone above the fundamental is a simple multiple of that fundamental. If the fundamental sounds at 55 Hz (the note A_1: *see* OCTAVE NAME SYSTEM), its overtones are 110 Hz (twice the fundamental, the note A), 165 Hz (three times the fundamental, the note E), 220 Hz (four times, A), 275 Hz (five times, C-SHARP), and so on. The Ionian physicist Pythagoras was the first to measure these relationships by analyzing the sound produced when a taut string vibrated as a whole (the fundamental tone), in two equal parts (second harmonic), three equal parts (third) and

so forth. (*See* ALIQUOT PART.) He found that as the numbers grew larger, the relationship to the fundamental seemed less and less comfortable. Because of this, he declared that any interval in music was harmonious if its tones were in the simplest numerical relationship to each other, as 2:1 (the OCTAVE), 3:2 (the PERFECT FIFTH, measured from the octave of the fundamental) or 5:4 (the MAJOR THIRD, similarly measured from the second octave). Within his analysis are the seeds of the complexity that make music a form of art rather than mathematics; there are many versions of harmonic intervals that conflict with each other, such as the relationship of 6:5, which gives a MINOR SECOND, and 7:6, which gives a different minor second. The major third between the fourth and fifth harmonic has the ratio 4:5. The next major third, between the seventh and ninth, has a ratio of 7:9, and is slightly different in quality (some would say "less major") than 4:5. It is because of these subtle but audible differences that music has its powerful effect, that keyboard instruments with pure tuning are impractical and a system of EQUAL TEMPERAMENT is appropriate. *See also* COMMA OF PYTHAGORAS, JUST INTONATION, PURE TUNING.

harmonious *Music* Having the quality of concord.

harmonium *Music* A small REED ORGAN with one or two keyboards and an array of stops that produce a few different tone colors. It was a popular instrument in private homes during the late 19th and early 20th centuries.

harmonize *Music* 1. To compose chords for the accompaniment of a tune. 2. To sing in harmony with a tune. *See also* BARBERSHOP QUARTET.

harmony *Music* 1. The pleasant relationship of musical tones sounding simultaneously that do not clash. 2. The science of tonal (chordal) relationships.

harness *Puppetry* A strong belt with shoulder straps, worn by a puppeteer to support the weight of a heavy PUPPET operated from underneath the stage.

Theater A set of strong leather straps or nylon webbing worn under the costume and attached to a wire so that an actor can be lifted into the air to simulate the act of flying.

harp *Music* One of the oldest musical instruments, an array of strings stretched taut between two sides of a triangular frame, one of which is hollow, wider than the other and acts as a SOUNDING BOARD when any string is plucked. The earliest known images of harps appear in Mesopotamian reliefs of about 5,000 years ago. The earliest in Europe was the Irish harp, still in use as an accompanying instrument for Irish songs, that can play the notes of a DIATONIC SCALE but cannot modulate between keys. The modern double-action harp has seven strings to each OCTAVE, six and a half octaves in all, and each string can be tuned a SEMITONE up or down from its assigned tone by means of one of seven pedals, making it possible to play in any key and to modulate freely. The player plucks the strings with both hands, producing a sound somewhat like that of the piano but with less percussive quality.

harpist *Music* A musician who plays the HARP.

harp-lute *Music* A small HARP with a frame rising out of a sound box somewhat like the body of a GUITAR. It provided fewer strings than an ordinary harp, but more than the LUTE or the guitar, and had limited use in the 19th century.

harpsichord *Music* A KEYBOARD INSTRUMENT, developed in the 16th century, shaped somewhat like a GRAND PIANO, but smaller and lighter. The keys actuate a mechanism that plucks the strings, rather than striking them as does the action of the piano. 18th-century harpsichords often had two or three keyboards, several pedals or hand STOPS (like those of the ORGAN), and three or four choirs of strings (including those that provide the LUTE STOP), enabling the player to vary the degree of loudness and change the TIMBRE. While the harpsichord blends well with other instruments, its tone is penetrating enough to be heard clearly in contrapuntal music. In wide use until the piano came into its own around 1780, it remains popular with performers specializing in Baroque music and can be heard in a variety of classical and jazz or BIG BAND arrangements.

Harry Selby *Acting* A mythical being whose name appears occasionally in theater programs when an actor doubles in an insignificant role and does not want his own name to appear. Harry is GEORGE SPELVIN's cousin.

hat *Lighting* *See* FUNNEL, HI-HAT.

Music *See* HI-HAT.

hat mute *Music* A MUTE consisting of: 1. A soft hat-shaped felt piece that fits over the BELL of a brass instrument to muffle its sound 2. A metal hat held over, but not touching, the bell of a WIND INSTRUMENT to produce a hollow and remote sound.

hauling line *Stagecraft* A rope or wire attached to a STAGE WAGON so that it can be moved on or off the stage by stagehands or an ENGINE hidden in the wings. *See also* OPERATING LINE.

hautbois (*oh-BWAH*) [French] *Music* Literally, high wood. In English spelled hautboy. *See* OBOE.

haute danse (*oht dahnss*) [French] *Dance* Literally, high dance. Similar to the 14th-century BASSE DANSE, without keeping the feet low. The haute danse called for jumps and hops.

haut, en *See* EN HAUT.

hauteur, à la *See* À LA HAUTEUR.

hava nagila [Hebrew] *Dance* Literally, come let us be merry. A couple dance from Israel based on an old HORA tune.

Havanaise (*hah-vah-NEZ*) [French] *See* HABAÑERA.

have the needle *Acting* To have stagefright; to feel uneasy just before making an entrance on stage.

Hawaiian guitar *Music* A guitarlike instrument developed in Hawaii in the mid-1800s, held in horizontal position across the knees or placed on a table or a stand, with the strings tuned to the pitches of a major TRIAD (slack-key tuning). It is fretted with a bone or metal slide that goes across the strings, enabling the guitarist to play GLISSANDOS, and producing a wailing, ringing sound. *See also* BOTTLENECK GUITAR, STEEL GUITAR.

hay, haye, hey *Dance* A vigorous 16th-century English dance, with dancers in lines facing each other.

hayashi [Japanese] *Music, Theater* Any ensemble of instruments and, by extension, the musicians who play them, accompanying a theatrical performance such as KABUKI or NOH.

hayseed *Carnival, Circus* A spectator at a traveling show, usually in a rural setting, considered naive and gullible by showpeople. *See also* RUBE.

head *Music* 1. Among JAZZ and POP musicians, the original statement of the melody as distinguished from the development section. Because it is short, it can be memorized, allowing the band to pick up a tune quickly, to improvise its harmonization on the spot and develop it in their own way. *See also* HEAD ARRANGEMENT. 2. The stretched membrane(s), whether made of animal skin or plastic, of any drum.

Lighting, Television The top of any stand or tripod that is designed to support a light fixture or a camera.

head arrangement *Music* An ARRANGEMENT that has been worked out by improvisation, is not written down and is played by memory.

header *Stagecraft* A small FLAT hung at the top of a gap in the set to make the opening resemble a doorway or a window.

headliner *Music* The soloist or the band that performs the most important SET(s) and gets TOP BILLING during an evening when several soloists or bands appear.

Vaudeville Any STAR or ATTRACTION that gets TOP BILLING.

headphones *Audio* A tiny pair of audio speakers usually mounted in somewhat soundproof enclosures in a light weight frame that fits on the head and focuses sound into the ears. The wearer can hear messages or other signals, not audible to others, that will not be picked up by microphones in the area or be rendered unintelligible by outside noises. Headphones allow a conductor to hear the music the way it is being recorded, or to hear synchronization cues or a CLICK TRACK while conducting music for a recording for a motion picture. They also let a camera operator hear the director's instructions while shooting.

head rail *Puppetry* *See* HANGING RAIL.

Stagecraft The horizontal piece of framing at the top of a FLAT.

head register *Music* The upper range of a singer's voice, capable of producing a lighter, brighter sound than that of the middle (or chest) REGISTER.

headset *Audio* An assembly consisting of HEADPHONES over the ears and a tiny MICROPHONE held on a light frame in position near the mouth, giving the wearer complete, private, two-way communication, and leaving the hands free to operate a CAMERA, BOOM, or any other equipment in use on the SET.

head shot *Acting* A photographic portrait showing only the head, ready to be submitted to casting directors for their files.

 Motion pictures, Television A shot showing only the head of the subject.

heads out *Audio* Said of audio tape that is wound on a SUPPLY REEL or a HUB, in proper position for immediate recording or playback. The opposite of TAILS OUT.

head spot *Lighting* A SPOTLIGHT with a beam narrowed to illuminate only the head of an actor. *See also* PIN SPOT.

head tone *See* HEAD REGISTER.

heart act *Acting* Any act or scene that is expected to stimulate a deep sympathetic response in the audience.

heat up *Lighting* To turn on a light.

heaven *Theater* The top balcony, with the cheapest seats, where the GALLERY GODS sit to watch the performance. Also called the GALLERY, PARADISE or the PEANUT GALLERY.

heavy *Acting* The VILLAIN. Said of any character of threatening appearance or intent. The opposite of HERO.

heavy lead *Acting* A villain who is one of the LEADS of the play.

heavy metal *Music* A HARD ROCK style dating from the late 1960s, introduced by the British group Deep Purple. It is characterized by heavy BLUES RIFFS, a strong BEAT and a strident, distorted sound created by the use of FEEDBACK, FUZZTONE, REVERB, the WAH-WAH PEDAL and exaggerated amplification, with the instrumental emphasis on GUITARS. Lyrics are nihilistic in tone and include references to the occult. Guitarist Jimi Hendrix (1942–1970), one of heavy metal's greatest exponents, became the nemesis of sound engineers when he regularly ruined LOUDSPEAKERS and burned out amplifiers by using them at full volume in performance. *Compare* THRASH METAL.

heavy name *Theater* A name that carries a lot of weight with audiences and power in the box office.

heavy props *Stagecraft* The furniture and other large movable pieces in the set, as distinguished from HAND PROPS.

heldentenor [German] *Music* Literally, hero-tenor. A TENOR with a powerful voice and a tone quality closer to that of a BARITONE, capable of singing heroic operatic roles such as Siegfried in Richard Wagner's RING CYCLE.

helicon *Music* A BASS instrument of the brass family, similar in range to a TUBA, but with its conical tube shaped in a large loop to be carried over the player's shoulder and its BELL rising in a spiral and opening wide over the player's head. It differs from the SOUSAPHONE only in the shape of its bell.

hemidemisemiquaver *Music notation* British nomenclature for a SIXTY-FOURTH NOTE.

hemiola [Greek] *Music* Literally, one and a half. A two-measure passage written in triple time (*e.g.,* 6/8 or 3/4) in which two beats (i.e., the first and fourth) are accented in one measure, and three beats (*i.e.,* first, third and fifth) are stressed in the other. It appears in many works in all periods of musical history. A good modern example occurs in the choral dance number *America* ("I̲ like to be̲ in A-me̲-ri̲-ca̲") in Leonard Bernstein's score for *West Side Story.*

hemp house *Stagecraft* A theater with rope, rather than wire, RIGGING.

hemp line *Stagecraft* A RIGGING line made of rope instead of wire.

hemp system *Stagecraft* A RIGGING system using rope, instead of wire.

hep *See* HIP.

hero (m), **heroine** (f) *Theater* The most important character of good repute in the cast. The opposite of HEAVY.

heroic couplet *Playwriting* A rhymed pair of lines in IAMBIC PENTAMETER that make an important statement or pose an important question, particularly at the end of a scene, act or play.

heroic drama *Theater* A DRAMA in elevated style of speech and action that tells the story of characters who are larger than life.

heroic tenor *See* HELDENTENOR.

heroic verse *Playwriting* Any style of verse that elevates the general tone of speech to a level appropriate to heroic themes. In Elizabethan theater the appropriate form was rhymed or unrhymed iambic pentameter. In the French of Racine, it was the Alexandrine, which consisted of lines of twelve syllables. Classical Greek drama used dactylic hexameter, six feet (*i.e.,* groups) of three syllables each, one stressed, two unstressed.

Hertz *Electronics* (abbreviated *Hz*) The standard unit of frequency of any electronic wave, equal to one complete cycle of change in one second, named after its German discoverer Heinrich Rudolph Hertz. Only basic power lines carry electric energy in waves of low frequency that are measured in terms of Hz. AM radio frequencies are measured in kilohertz (thousands per second, khz), FM in megahertz (millions per second, mhz), and so on.

herzig (*HEHR-tzikh*) [Austrian German] *Music* Literally, of the heart, lovable. Tender, charming.

hesitation waltz *Dance* An American variation of the VIENNESE WALTZ that may have been created by Vernon and Irene Castle during the 1900s. It involves holding a position for one or two counts of the music during the first part of the two-measure figure of the waltz. Europeans refer to the hesitation waltz as the BOSTON.

hexachord *Music* A scale unit consisting of six steps: two WHOLE TONES, one SEMITONE, two whole tones. In medieval times the hexachord, not the OCTAVE, was the standard unit of the scale.

hey *See* HAY.

hichiriki (*hee-chee-REE-kee*) [Japanese] *Music* A Japanese instrument similar to the oboe, used in GAGAKU.

hi-fi *Audio* Short for HIGH FIDELITY.

high camp *Acting* The ultimate expression of CAMP.

high comedy *Acting, Theater* Comedy with a high level of taste, written and performed with elegance.

high fidelity *Audio* Describing the capability of a good audio system to reproduce sounds with accuracy over the entire audio spectrum.

high flyer *See* AERIALIST.

high frequency *Audio, Broadcasting* Describing the upper range of the electromagnetic spectrum. In audio terms, it generally indicates any level above the general level within which the human ear can identify tones, *i.e.*, from about 5,000 Hz. In broadcasting, the high frequencies, *e.g.*, those reserved for FM, are those measured in MEGAHERTZ.

high hat *See* HI-HAT.

high key *Lighting* Lighting with many gradations of light colors or light grays with no dark shadows. *See also* KEY LIGHT.

Highland fling *Dance* A vigorous national dance of Highland Scotland, composed in duple rhythm with a SCOTCH SNAP. A victory dance with a kick-step in which the performers dance on each leg in turn and fling the other forward or back.

highlight *Lighting* An area of bright light added to the general lighting of a scene to emphasize a particular point within it, such as the place where a particular character stands or a particular doorway where someone appears. The highlight is frequently accomplished with a SPOTLIGHT that is carefully focused and limited by BARN DOORS lest it illuminate the wrong places.

Makeup A small area of much lighter color applied to a part of the face, such as the cheekbones, to improve the three-dimensional MODELING of the face.

High Mass *Music* A liturgical MASS in which not only the main sections, like the CREDO and the GLORIA, but also all the lesser texts are sung.

high-pitched *Music* Of higher range than normal, as in a voice speaking hysterically, or a machine racing out of control.

highs *Audio* The sounds of higher frequency in the audio spectrum, generally from 5,000 to 20,000 Hz, considered as a general range in contrast to the LOWS. During a MIX, for example, if a director wants a voice to sound as if it were coming in over a telephone line, or by radio from outer space, the audio engineer reduces the volume of the lows and increases the HIGHS. *See also* TWEETER.

Music The higher harmonics, as distinguished from those nearer the FUNDAMENTAL. The balance between highs is one of the strongest influences that creates the audible difference between the TIMBRE of one instrument and that of another. Also, a tone that has less audible (*i.e.,* suppressed) highs sounds muffled. A tone with less audible lows sounds tinny.

high wire *Circus* A heavy wire or cable stretched across empty space high over the ground, prepared for an aerialist to perform a death-defying HIGH-WIRE ACT. *See also* FUNAMBULIST, SLACKROPE, TIGHTROPE.

high-wire act *Circus* Any balancing or acrobatic act performed on a HIGH WIRE.

hi-hat *Lighting* A cylindrical baffle attached in front of any lighting instrument to restrict the spread of its beam. *See* FUNNEL, SNOOT.

Music A pair of CYMBALS mounted horizontally through holes in their centers, facing each other and nearly touching at their edges, on a short vertical stand. The upper cymbal is held away from the lower by a spring in the stand. When the player depresses a pedal, it lowers into contact with the lower cymbal and makes a brief clash. The drummer may also play on either cymbal of the hi-hat with sticks or brushes, creating a variety of sounds. Played quietly, it is a basic beat-defining instrument for a dance band. *See also* TOP HAT.

Motion pictures A mounting base for a camera that can be fastened to the top of a TRIPOD or placed on the floor without a tripod to permit the camera to operate from low level.

hillbilly music *Music* A general term once applied to BLUEGRASS and COUNTRY-AND-WESTERN music, now considered lacking in respect.

hip *Music* A JAZZ slang word (originally "hep") with several meanings ranging from wise, aware of what is happening, up-to-date, to broad-minded or self-sufficient. To say "I'm hip" means "I know." *See also* IN THE GROOVE, WITH IT.

hip-hop *Music* A ghetto subculture dating from the 1970s favored by urban teenagers, embodied in graffiti art, BREAK DANCING and RAP.

hippodrome [Greek] *Theater* Literally, horse-racing course. A popular name for a very large urban movie theater in the early part of the 20th century.

hipster *Music* A JAZZ slang word for a musician who is HIP, *i.e.,* aware, knowledgeable and self-reliant.

historical play *See* CHRONICLE PLAY.

histrionic [from Greek] *Acting* Theatrical, having theatrical qualities.

histrionics [from Greek] *Acting* All the artifices of acting somewhat emphasized, including heightened vocal tone and exaggerated gestures.

hit *Theater* A great success with the public.

hitchhike *Dance* In the early 1960s, a solo ROCK dance that loosely imitated the hitchhiker's traditional arm movements.

hit it *Music* In JAZZ and POP, the leader's order to start playing.

hit the back of the house *Acting* A director's suggestion to project the voice so that it bounces off the rear wall of the theater.

"hit your mark" *Acting* A director's instruction to an actor to take a position at a specific point that has been marked on the stage floor.

HO Short for HOLDOVER.

hoedown *Music, Dance* A lively dancing party featuring square dances and country dances, usually accompanied by a FIDDLE, a GUITAR and a WASH-TUB BASS.

hog the scene *Acting* To move and speak in a manner that calls the audience's attention away from the other actors on stage. To STEAL THE SCENE.

hoke *Acting* To exaggerate the emotional qualities of a scene.

hokey-pokey *Dance* A group dance of the 1930s, based on a Cockney song. Called the hokey-cokey in England.

hold *Acting* To pause without losing CONCENTRATION while the laughter fades or the audience reacts, before making the next move or speaking the next line.

hold a scene *Acting* To move and speak on stage in a manner that will support other actors and maintain, or even reestablish, a sense of pace when things seem on the verge of going wrong.

hold over *Theater, Vaudeville* To keep a play open beyond its announced time of engagement, or to retain an act in vaudeville while the rest of the program is changing.

holdover *Theater, Vaudeville* A play or an act that has been retained after its announced engagement.

home key *Music* The KEY in which the piece began. *See* TONIC.

homophonic *Music* Music consisting of a prominent melodic line with a fairly simple chordal accompaniment. The opposite of POLYPHONIC.

homophony *Music* The quality of HOMOPHONIC music.

Hong Kong film *Motion pictures* A style of low-budget film made in quantity in Hong Kong, often focusing on martial arts or crime stories, with outrageous explosive effects and the virtue of not taking itself too seriously.

honkytonk *Music* 1. A cheap bar with a piano (sometimes out of tune), or a small band. 2. A style of music characterized by simple rhythms and the often bawdy lyrics associated with a cheap bar.

honkytonk piano *Music* A style of playing characterized by simple, thumping rhythms played on a piano, particularly a tinny-sounding piano.

honor *Dance* In SQUARE DANCE, to bow. "Honor your partner" means to bow to your partner.

hoofer *Vaudeville* A music hall dancer. The famous American movie actor of the 1930s, James Cagney, began his career on Broadway as a hoofer.

hook *Music* In popular music, a slang term for a musical phrase, rhythmic pattern or group of words that appeals strongly to the listener and stays in the memory. Every successful or HIT song has a hook.

Stagecraft *See* KEEPER.

Vaudeville A long stick with a large half-loop at one end and a determined STAGE MANAGER at the other, used to pull a bad performer off the stage during an amateur show.

hookup *Audio, Lighting* General term for the arrangement of wires, cables and control consoles that have been put together for a show.

Television The arrangement of cameras, transmission equipment and cables or satellites by which a remote FEED is brought into the studio.

hootchy-kootchy *Dance* A suggestive dance, possibly of Turkish origin, performed by women dancers at fairs and carnivals from the late 1800s.

hootenanny *Music* An informal, festive, social gathering of musicians and others for the purpose of playing FIDDLE music, singing songs and sometimes dancing.

hop *Dance* Teenage slang for a social evening of dancing.

hopak *Dance* A vigorous Ukrainian folk dance in duple time, usually performed by men.

hora *Dance* A round dance for mixed couples. It is of ancient European origin, and has formed the basis of several Israeli folk dances and songs such as HAVA NAGILA.

horizon cloth *Stagecraft* A DROP painted to represent the horizon.

horizon light, horizon row *Lighting* A strip of lights placed on the floor of the stage and concealed behind a low FLAT, to illuminate the HORIZON CLOTH or the CYCLORAMA so that it is brightest near the bottom.

horizontal sight line *Stagecraft* A line drawn from the seat at either end of the first row of the theater to the edge of any of the WINGS on the opposite side of the stage, used to establish the limits of what the audience can see and to determine what must be masked by additional scenery or adjustment of the wings.

horn *Music* 1. The French horn. A brass instrument of great range, from F_1 to b^1, with a mouthpiece smaller and deeper than that of a TRUMPET, and with keyed valves that change the pitches of its tones. It has a mellow tone that can be modified by inserting a MUTE into its bell to make it slightly rasping, or by stopping the tone with the player's hand to muffle it. In orchestras of the time of Mozart and Beethoven, there were commonly two horns. Modern orchestras usually have from four to eight horns often playing as a choir. *See also* NATURAL HORN. 2. Among JAZZ and ROCK AND ROLL musicians, any instrument that can be blown.

hornpipe *Dance* An energetic, solo English dance dating from the 15th century, similar to the JIG and accompanied by FIDDLES and BAGPIPES. Although popular throughout the British Isles, it has become particularly associated with sailors and their merrymaking. A classic hornpipe occurs in the first *Watermusic Suite* of George Frideric Handel.

horse opera A WESTERN.

horseshoe *Theater* The first balcony, with the most expensive seats and the boxes, sometimes called the DIAMOND HORSESHOE.

horse trot *Dance* A ragtime ANIMAL DANCE of the early 1900s, notable for its jerky movements.

hortensia (*or-tanhs-YAH*) [French] *Ballet* A style of jump executed by a male dancer with the legs drawn up, one in front of the other, reversing their position in the air several times.

hosanna [Hebrew] *Music* A shout of praise. A section of the GLORIA of the MASS frequently treated by classical composers as a separate piece of music.

hot *Lighting* 1. Said of a wire, cable or PLUG that is actually carrying electrical power and is therefore dangerous to the touch. 2. Describing the appearance of a set that has been illuminated with predominantly "hot" colors, *e.g.*, with intense reds and yellows.

hot circuit *Lighting* A circuit with its power turned on, therefore a dangerous circuit to touch.

hot line *Lighting* A piece of wire connected to a HOT CIRCUIT and therefore dangerous to touch.

hot spot *Lighting* An area of extra brightness within the general area illuminated by a single lamp. It is important in stage or motion picture lighting that the hot spots of the various lights do not unbalance the look of the scene, but are controlled by filtering, defocusing, dimming or re-aiming so that they disappear.

house *Theater* 1. The part of the theater building where the audience sits. 2. The audience collectively. 3. The amount of money the audience has paid to see the show. *See also* BOX OFFICE, GATE, GROSS, TAKE.

house band *Music* The band that works for the theater company, as contrasted with any visiting band present only for a specific show.

house carpenter *Stagecraft* The person responsible for all set construction in the theater, a member of the staff of the company that runs the building, not of a visiting production company.

house charge *Theater* The fee required from a visiting company for their use of the theater. It is usually based on a percentage of the GROSS.

house count *Theater* The number of people actually attending the show, counted by whatever means is available, *e.g.,* counting the number of ticket STUBS left as they came in.

house crew *Theater* The crew responsible for all carpentry, electrical work and stage work in the theater building who are not part of any visiting production company.

house curtain *Theater* The main curtain of the stage.

"house down" *Lighting* A stage manager's order to the appropriate technician to dim the HOUSE LIGHTS in preparation for the opening of the curtain.

house equipment *Theater* Any and all equipment that is the property and the responsibility of the company that runs the theater building and is not brought in only temporarily for a specific production.

house lights *Theater* The lights that illuminate the area in which the audience sits, and are extinguished before the show begins.

house list *Theater* The list of patrons qualified to receive free tickets to the show because of their special relationship with the company that runs the theater.

house main *Lighting* The main switch that supplies power to the auditorium, as distinguished from the STAGE MAIN.

house manager *Theater* The person who manages all functions of the theater building except those specifically concerned with a visiting production company.

"house up" *Lighting* A stage manager's order to the appropriate technician to BRING UP the HOUSE LIGHTS when the act is over.

Huapango (*wah-PAHN-goh*) [Mexican-Spanish] *Dance* A lively Mexican courtship dance for couples that takes its name from the town of its origin.

hub *Audio, Motion pictures* The center core of a tape or film reel. In professional use in each case, the hub can be separated from the flanges of the reel for more efficient storage. For professional use, manufacturers deliver both audio tape and motion picture film on hubs. An editor tends to save spare hubs to hold small segments for easy access during the editing process.

hug the spotlight *Acting* To stand in the brightest light, particularly when another actor is supposed to be there.

hula, hula-hula *Dance* A native Hawaiian dance performed by women with rapid hip swaying and graceful, flowing movements of the arms and hands.

hully-gully *Dance* A solo ROCK dance popular in the early 1960s.

hum *Audio* An unwanted low tone constantly present in the audio system that disturbs the listener and sometimes causes distortion to other sounds. Usually, hum occurs when the alternating frequency of the power line (in the United States at 60 Hz, low B in the musical scale) seeps into the circuit where it is not wanted.

Music To sing quietly, with the mouth closed. *See* BOCCA CHIUSA.

humidifier *See* DAMPIT.

humoresque *Music* A general name for a romantic, pleasant piece of music. Many composers of the 19th century have used the word as a title. One of the best known is by Antonin Dvořák.

hung up *Acting* Stuck on stage during a scene, having completely forgotten what to do or say next or being alone when another actor has missed a CUE and failed to make an entrance.

Stagecraft Said of any rigging in the FLIES that has become snagged in some part of the GRID or among other rigging so that it cannot be moved from below.

hunting horn *Music* A French horn without keys that is limited to the tones it can produce from the natural harmonics of its FUNDAMENTAL TONE. It was the favorite signaling horn for hunters in European forests, because of its looped shape that fitted securely around a rider's shoulder.

hurdy-gurdy *Music* 1. A medieval instrument with tuned strings arranged around a hollow cylinder. Its sound was produced by turning a crank that caused a wheel to rub against its strings. 2. A mechanical organ of the 19th century operated by turning a crank.

hurry-music *Motion pictures* Fast, agitated music chosen or composed to accompany the CHASE.

hustle *Dance* A fast dance performed to the ROCK MUSIC popular in DISCOTHÈQUES in the 1970s, with vigorous breaks and turns adding variety to simple basic steps. Variations include the Latin hustle, Los Angeles hustle (also called the Pasadena line walk) and the New York hustle.

hut *Theater* In the Elizabethan theater, an enclosed booth built high over the stage to contain an actor who would appear on cue as if from heaven or to hide the source of mysterious sound effects like thunder. *See* DEUS EX MACHINA.

hymn *Music* A song for CHOIR or chorus, usually homophonic and with a religious text.

hymnal *Music* A book of hymns.

hymnody *Music* The collection of hymns common to a particular sect.

hyperextension *Dance* Any extension of a joint beyond its normal position.

hypokrites (*hi-PO-kree-tees*) [Greek] *Acting* Literally, an interpreter or one who answers. The Greek word for actor.

Hz *See* HERTZ.

I

iambic pentameter *Playwriting* The verse form of Elizabethan drama. Each of its lines contains five iambs, *i.e.,* five pairs of syllables, each consisting of an unaccented syllable followed by an accented (ICTUS) as in the opening line of Shakespeare's *Twelfth Night*: "If music be the food of love, play on!" or a famous line uttered in a moment of frustration by the great Shakespearian actress Sarah Kemble Siddons: "I asked for water, boy, you've brought me beer!"

IATSE *See* INTERNATIONAL ALLIANCE OF THEATRICAL STAGE EMPLOYEES.

IBEW *See* INTERNATIONAL BROTHERHOOD OF ELECTRICAL WORKERS.

ice *Theater* An extra fee added to the price of a theater ticket sold to a broker (ICEMAN), to which the broker adds another fee at the point of sale to the final buyer.

icebox *Motion pictures* 1. A soundproof booth used in the early days of sound-on-film movies to house the camera and its noisy motor during a shooting session. Its construction was based on the standard walk-in refrigerators used by butcher shops that were heavily insulated and therefore soundproof. It was also uncomfortably hot to work in. Since the booth was huge and immovable, the camera could not shift around—a severe limitation for a medium that was based on motion. In about 1930 attempts were made to mount the icebox on wheels with only moderate success. In 1931 the problem was solved with the invention of the BLIMP. 2. A small, soundproof booth in an old-fashioned movie mixing studio in which an actor or announcer can sit at a desk, isolated from ambient noise, watching the picture that is being projected on a screen outside and recording a NARRATION or a VOICE-OVER. During the 1950s, when business was expanding very quickly, a few small production companies in New York actually purchased second-hand walk-in refrigerators for the same purpose.

ice dancing A style of figure skating developed in England in the 1940s, incorporating elements of ballet and ballroom dancing, usually performed by a couple as part of a competition or an entertainment.

iceman *Theater* A ticket broker who buys blocks of tickets for a show and sells them legitimately at higher prices to theatergoers. *Compare* SCALPER.

ictus *Playwriting* A beat or an accent, especially the heavier accent in a poetic foot. *See also* IAMBIC PENTAMETER.

idiophone [from Greek] *Music* Literally, self-sounding. Any of the class of instruments made of material that produces sound of itself, including percussion instruments such as WOOD BLOCKS, BELLS, GONGS, the XYLOPHONE and MARIMBA, shaken instruments such as the RATTLE and MARACAS, and instruments that are rubbed, such as the GLASS HARMONICA. The SLIT DRUM is an idiophone, but ordinary drums with stretched drumheads are classed as MEMBRANOPHONES.

idiot card *Acting, Television* A large CUE CARD with several lines of script written on it in large letters, held behind the camera where an actor who is ON CAMERA can see it and appear to speak spontaneously while actually reading the lines. *Compare* TELEPROMPTER.

idiot sheet *Broadcasting* A schedule of CUES to be followed by an announcer during a broadcast, with detailed instructions indicating which button to push at which time, *e.g.,* to open a telephone line, play recorded music or run a cartridged advertisement.

idyll *Music* A term borrowed from literature by a few composers to use as a title for a short, pleasant, pastoral piece of music.

Theater A pleasant, sentimental scene or little play on a pastoral theme.

imbroglio (*im-BRO-lee-oh*) [Italian] *Music* Literally, confusion. Within a musical composition, any passage in which different themes are intentionally intermixed to create a brief confusion. An imbroglio may take the form of a simple mixing together of contrapuntal phrases for a few measures near the climax of a FUGUE (*see also* STRETTO). It may also be a mixing of larger forms, as in the famous scene at the end of Act I of the opera *Don Giovanni*, in which Mozart introduces a simple minuet with one small orchestra, then imposes a second orchestra playing in a different rhythm, then a third with music of its own while seven characters sing their rapid-fire individual lines of dialogue.

imitation *Music* The process of restating a musical theme in another VOICE soon after its original statement, while the original continues to develop. Imitation is the basic process by which a composer creates a CANON or a FUGUE. Not to be confused with REPEAT or VARIATION.

imitative *Music* Having the quality of CONTRAPUNTAL imitation.

implied scenery *Stagecraft* Scenery designed to establish a mood rather than a physical place.

impresario *Music, Theater* A person who brings artists together, creates a production company and manages its activities. Similar in business and management functions to a PRODUCER in motion pictures, but the impresario, unlike the producer, is usually the originator of the artistic plan and generally has more personal contact with artists and the theatergoing public.

impressionism *Music* An early 20th-century style of music consisting of improvisatory changes of texture and mood rather than the temporal forms, such as RONDO and SONATA, of classical and romantic music. The name is borrowed from a movement among French impressionist painters that similarly broke away from more formal traditions. Its great proponent among composers was Claude Debussy, who composed many atmospheric pieces, such as the orchestral suite *Images* and the piano prelude *La Cathédrale Engloutie* (The Sunken Cathedral) and made extensive use of the WHOLE-TONE SCALE that avoided the specificity of major and minor scales.

Theater An aesthetic movement in European theater concerned more with the evocation of mood than the excitement of a PLOT. Its chief proponent was the Belgian playwright Maurice Maeterlinck, author of the play *Pelléas and Mélisande* that Claude Debussy used as LIBRETTO for his only successful opera. Since impressionism weakened or actually eliminated most of those elements that Aristotle had shown to be absolutely essential to the structure of drama, the movement was not successful in theater.

impressionistic dance A term loosely applied in the 1930s to a style of MODERN DANCE in which individual mood was more important than logical structure and social consciousness that were characteristic of the time.

impromptu [from French] *Music* Literally, improvised. A term applied to several short piano pieces, mostly by Frederic Chopin and Franz Schubert, that were, in spite of what the name suggests, fully composed.

improv *See* IMPROVISATION.

improvisation *Acting* The process of inventing lines and GESTUREs while acting on stage or in a practice studio. Improvisation is an important part of an actor's technical training, particularly in the STANISLAVSKI METHOD. The instructor sets up a simple situation and gives each participating student one or two specific instructions about the character to be played. The actual working out of the situation is up to the actors who must begin right away, without any preparation, and must maintain the characters they have been assigned no matter what happens during the scene. Improvisation provides meaningful experience in an actor's technique of BELIEF.

Music 1. The process of creating music while playing it. 2. A piece of music that has been composed by its player in the act of playing it. Many of the great solo works by Johann Sebastian Bach, including the great *Musical Offering* based on a theme given to him by the Emperor Frederick the Great, began as improvisations.

improvise *Acting* To invent action and dialogue while acting. To AD LIB.

Music To invent music while playing it.

impulse *Dance* Any ACTION that stimulates movement.

in *Acting* Toward the center of the stage.

Stagecraft Down from the FLIES, *i.e.*, into position in the set.

in alt *Music* High. For a soprano, "C in alt" indicates high C, 2 octaves above MIDDLE C.

in-betweens *Animation* In animated motion pictures, the series of images that creates the illusion of smooth flowing motion between one KEY DRAWING and the next. Typically the originating artist provides a set of finished drawings or paintings showing each significant image in a given scene. In-betweens show the positions of each part of the image as it moves toward its position in the next key drawing. An ANIMATOR calculates the length of time each move should take to look natural, and what path each part of the image should take. If it takes two seconds for a character to lift a hand, there will be a key

drawing showing where the hand starts, another where it stops, and forty-six in-betweens showing all the changes that must occur every 24th of a second along the way. With the advent of sophisticated video animation, such calculations are performed by the computer. The animator's job then consists of telling the computer how to make the move, letting the computer create the in-betweens automatically.

incalzando (*in-kahl-TZAHN-doh*) [Italian] *Music* Literally, warming up. Hurrying, pressing forward.

in character *Acting* For an actor, a condition of complete awareness of, and concentration on, the character being portrayed.

incidental music Music composed for the production of a play, consisting of a series of pieces called for by the script or by the director, as distinguished from BACKGROUND MUSIC. Such music typically includes an overture, various songs and dances indicated in the script, mood music to cover transitional scenes or scene changes and a finale. Shakespeare calls for incidental music in many of his plays, notably in Pericles (". . . but hark! What music? It is the music of the spheres") and in *Hamlet* with many FLOURISHES, songs sung by Ophelia, and, at the end, a DEAD MARCH. One of the most famous pieces of incidental music is Felix Mendelssohn's music for Shakespeare's *A Midsummer Night's Dream*, first performed in 1843. Another is the music for Ibsen's *Peer Gynt* by the Norwegian composer Edvard Grieg.

incident light *Motion pictures* The amount of light coming from the source, as distinguished from the amount of light that reflects from the subject, measured in LUMENS. It is important for all photographers to measure, especially in motion pictures where any movement of the subject may cause a change in the amount of reflected light. To compensate for such continuous changes would not look natural in a motion picture.

inciting action, inciting moment *Acting* The specific dramatic ACTION or event that forces the opening situation of a play into imbalance and sets the PLOT in motion.

incliné, inclinée (*enh-klee-NAY*) [French] *Ballet* Inclined, slanted, as in the *arabesque inclinée*.

independent production *Motion pictures* A term that came into use during the 1930s and 1940s to describe motion picture productions that were not made by the big studios. Most of the pictures nominated for the Academy Awards of 1997 were called independent productions; however, it was notable that, with one exception, they were made by companies wholly owned by big studios; their independence was only relative. The term remains in use, and is also applied similarly to television productions made independently of the big networks.

independent theater movement A movement among IMPRESARIOS of the 1890s away from old traditions and toward a more socially conscious theater. In London, J. T. Grein founded the Independent Theater and put on plays by his contemporaries, Henrik Ibsen, George Bernard Shaw and others. In Paris, André Antoine did the same at the Théâtre Libre, as did Otto Brahm at the Freie Bühne in Berlin.

indeterminate music *See* ALEATORY.

indie *Motion pictures, Television* Short for INDEPENDENT PRODUCTION.

indirect exposition *Theater* The process of giving the audience the background of a PLOT without having a character spell it out in so many words, by using suggestions and hints couched in seemingly natural dialogue.

indirect focus *Acting* BLOCKING that directs attention toward one character or a group, then shifts it to another as the plot develops.

in escrow *Acting* Actor's slang term for being out of work.

infinite baffle *Audio* An enclosure for a LOUDSPEAKER that absorbs most of the sound produced within and behind the speaker itself, while releasing all of the sound produced at the front. This enclosure permits very smooth, undistorted sound at high volume levels. When sound coming around from behind the speaker mixes with sound coming out of the front, the two are slightly out of phase and interfere with each other, resulting in distortion.

infinite cyclorama *Stagecraft* A CYCLORAMA constructed or hung with smoothly curved surfaces so that the audience or the camera will see no edges, corners or sharp changes of light or shadow which would make its size, shape or position definable. *See also* LIMBO SET.

inflection *Acting* An actor's manner of raising or lowering the pitch of spoken words to clarify their meaning.

in four *Acting* Describing the ACTING AREA across the rear of the stage, so called because in many medium-size theaters it is the area under the fourth BATTEN. *See also* IN FRONT, IN ONE, IN TWO, IN THREE.

Jazz An instruction to a player, particularly a BASS player, to play four notes in each MEASURE instead of two.

Music 1. Describing music written in 4/4 time. 2. Describing how the conductor will conduct; with four beats to the measure. It may be necessary for the conductor to be specific when the music is written in some other rhythmic format such as 12/8, which could be conducted in various ways, or even CUT TIME (2/2), when a RETARD or some other change of pace warrants more precision than the TIME SIGNATURE would indicate. *See also* IN ONE, IN THREE, IN TWO.

infringement A violation of the copyright law. To perform a copyrighted play without permission of the copyright owner is an infringement. To alter or arrange a piece of music or to copy a painting or any other copyrighted work without such permission is also an infringement.

in front *Acting* In front of the curtain. *See also* ENTR'ACTE, EPILOGUE, PROLOGUE.

ingénue (*ENH-zhe-nü*) [French] *Motion pictures, Theater* 1. The role of a young and unsophisticated woman. 2. An actress who plays such a role. *Compare* STARLET.

inharmonic *Music* Out of harmony. Not the same as ENHARMONIC.

inharmonious *Music* Relatively DISSONANT, lacking the quality of concord. It is worth noting that some intentional dissonances in music, such as the clashing chords in parts of Igor Stravinsky's *The Rite of Spring*, may be inharmonious in one sense, but require precise tuning in the acoustical sense; they are not "out of tune."

inky *Lighting* A very small incandescent, 250-watt spotlight. *See also* EMBRYO.

inner biography *Acting* A term used in the MOSCOW ART THEATER early in the 20th century to describe the unspoken background of each character (also called inner dialogue) that is essential to establishing the philosophy of the performance.

inner drama *Acting* A term used by the Swiss stage designer Adolphe Appia to describe the underlying motives and tensions that are the genesis of fully integrated theatrical art.

inner proscenium *Stagecraft* A second proscenium, established by a combination of DROPS and BORDERS, or constructed behind the main proscenium to reduce the apparent size of the stage so that it will seem more appropriate for a relatively intimate play. *Compare* DOUBLE PROSCENIUM.

in one *Acting* A phrase designating the acting area that occupies the full width of the stage directly behind the proscenium and in front of the ACT CURTAIN, *i.e.*, under the first BATTEN. Directors often place a scene in one to permit another scene to be set up behind the act curtain without requiring an interruption in the play. *See also* IN FOUR, IN FRONT, IN THREE, IN TWO, STAGE AREAS.

Music Having one beat to the measure. In practice, almost no music is actually written with one beat to the measure. The expression indicates that the conductor will give one beat for each measure when to conduct the number of beats actually written would make the performance drag. A fast WALTZ, for example, is often conducted "in one."

insert *Audio* A segment of recorded sound to be placed between other, previously recorded, segments by the editor. When performers, hearing a playback of a lengthy piece, notice something wrong with a short passage, they may decide to redo only that section, rather than the whole piece. The recording engineer will identify this short segment in his audio SLATE, saying, for example, "Second movement, insert, take one."

Motion pictures A WILD SHOT or a CUTAWAY cut into a sequence, particularly a shot inserted without disturbing the timing of the sound track.

instant theater *Acting* Theatrical improvisation starting with situations suggested by the audience.

Institut de Recherche et de Coordination Acoustique/Musique A facility and faculty devoted to the study of the relationship of computers and music, and to experimentation in composition, development of instruments and presentation of concerts in that field. It was organized by the government of France in 1969 and opened at the "Petit Beaubourg" in Paris under the direction of the composer Pierre Boulez in 1977.

instrument *Acting* An actor's body and voice, considered as a means of DELIVERY.

Lighting Any lighting fixture, together with its lamp and its accessories.

Music The physical device a musician uses to make sound.

instrumental *Music* Said of music composed for instruments, rather than for voices.

instrumentalist *Music* A person who plays a musical instrument.

instrumentation *Music* The selection of musical instruments required to perform a piece of music. *See also* ARRANGEMENT, ORCHESTRATION.

instrument schedule *Lighting* All the LIGHTING INSTRUMENTS required for a show, listed chronologically according to the times within the show when they will be in use.

in sync *Motion pictures* Said of any sound on the SOUND TRACK that is perfectly synchronized with its apparent source in the visual picture.

intendant [German] *Theater* The artistic and managerial director of a German theater company, corresponding to the American PRODUCER.

interconnecting panel *Lighting* 1. In older theaters, a permanent panel containing two parallel arrays of female sockets (STAGE POCKETS) that can be interconnected with various combinations of PATCH CABLES to fit the lighting requirements of a show. 2. In newer installations, a permanent panel containing an array of movable knobs, each of which can be slid into a specific position. Each knob is connected to a specific lighting circuit, each position is similarly connected to a specific dimming circuit. Placing a knob in a specific position connects the lighting circuit with a dimmer, without any need for patch cables. *Compare* PATCH PANEL.

interior *Motion pictures, Theater* Any scene set indoors.

interior monologue *Acting* A spoken monologue that expresses the inner thoughts of a character, usually in the form of what, since James Joyce, has been called a stream of consciousness. A SOLILOQUY.

interior scene *See* INTERIOR.

interlock *Motion pictures* In traditional motion picture POST-PRODUCTION, the test of the final stage of editing a workprint; running the film with all the visual elements in place and all the dialogue, music and sound effects tracks synchronized. For all practical purposes, this test is the last opportunity the director has to make changes in the choice of TAKES, the way they have been cut and/or the order in which they will occur, before going into the MIX.

interlocutor *Vaudeville* In a minstrel show, the actor sitting at the center of the LINE who acts as the general announcer and engages in comic banter with the END MEN.

interlude *Music* A short, relatively calm piece or passage of music between two others of greater intensity.

Theater A short scene between longer scenes providing relief from their intensity. *Compare* ENTR'ACTE.

intermedio (*in-tair-MED-yoh*) [Italian] *Music* An INTERLUDE.

intermezzo (*in-tair-MED-zoh*) [Italian] *Music* Literally, interval (between halves). A piece of music, or a little operatic scene, composed as an INTERLUDE or an ENTR'ACTE.

intermission A period of time between the acts of a play or sections of a concert or ballet performance when the HOUSE LIGHTS come up, and the audience is encouraged to relax and move around before the performance continues.

International Alliance of Theatrical Stage Employees A CRAFTS union organized in 1893. Its original membership expanded with the development of motion pictures to include all branches of stage and motion picture industries.

International Brotherhood of Electrical Workers A labor union that includes television technicians.

international pitch *See* A-440.

internegative *Motion pictures* A print of a completed motion picture in color negative form, together with its separate magnetic sound track, prepared by the laboratory for use as the MASTER from which RELEASE PRINTS of the film will be made. Before the first release print is made, however, an ANSWER PRINT will be run off to make sure that everything is in proper relationship within the picture, and that all the colors are correctly reproduced.

interpolation *Acting* Words or lines added to a script to improve a situation that may have been difficult for an actor without them, or that give an actor an opportunity to surprise the audience.

interpretive dance In contemporary dance, music transformed into movement.

interval *Music* The distance between any two tones of different PITCH. The names of intervals derive from the number of scale steps from one pitch to another, counting the lower tone as one. Hence the interval between C and D is a SECOND, between C and E is a THIRD, and so on. Intervals of the FOURTH, FIFTH and OCTAVE are further described as "perfect." The remaining intervals (the SECOND, THIRD, SIXTH, SEVENTH) are called MAJOR or MINOR depending on the number of whole steps and half steps between them. When a major third, for example, is lowered by a half step, it becomes a minor third. When a perfect or minor interval is similarly lowered, it is called "diminished." Raising a perfect or major interval by a half step makes it an "augmented" interval. *See also* COMPOUND INTERVAL, TRITONE.

Theater In Britain, an INTERMISSION.

in the groove *Music* Said of JAZZ players who are inspired by the music and play unusually well as soloists and as members of the ensemble because of it.

in the round *Stagecraft* Said of any piece of scenery modeled in three dimensions, *e.g.*, a rock that an actor may push around or sit on.

Theater Said of a play produced on an ARENA STAGE.

in three *Theater* In the acting area beneath the third BATTEN, *i.e.*, in the area across the full width of the stage at more than half its depth and less than its full depth. *See also* IN FOUR, IN ONE.

Music In triple time, with three beats to the measure.

in tight *Motion pictures* Said of an EXTREME CLOSE-UP that consists entirely of its subject, without extraneous images around its edges, *e.g.*, a close-up of the face with no hairline or ears showing. *See also* HEAD SHOT.

intimate theater A small theater with few seats and a small stage, frequently an ARENA, that places the actors close to the audience. Good actors can establish AESTHETIC DISTANCE even at such close range.

intonation *Music* A player's or singer's accuracy in PITCH. Good intonation produces tones that are harmonically in accord with each other and/or with the tones of others in an ensemble.

intone *Acting* To speak more slowly than normal and in sustained, somewhat musical tones that may project farther into the theater and with more clarity than ordinary speech. *Compare* SINGSONG.

intro *Music* Short for introduction or introductory passage.

introit *Music* A musical introduction to a religious service, consisting of a quotation from the *Book of Psalms* sung by a CANTOR and/or the CHOIR.

intro number *Vaudeville* A song and/or a dance used as an introduction to a larger PRODUCTION NUMBER.

in two *Acting* In the ACTING AREA across the full width of the stage under the second BATTEN, behind the ACT CURTAIN, *i.e.*, the second quarter of the depth of the stage. *See also* IN FOUR, IN ONE, IN THREE, STAGE AREAS.

Jazz An instruction to a player, particularly a BASS player, to play two tones in each MEASURE instead of four.

Music Having two beats to the apparent MEASURE. A conductor may choose to beat twice in each four-beat measure of a march to make it sound more brisk. Similarly, a confident conductor may conduct a WALTZ that is written in pairs of measures of three beats very gracefully in two, *i.e.*, with a DOWNBEAT for the first measure and an UPBEAT for the second, though it may be (inaccurately) called "in one."

in unison *Music* Playing or singing exactly the same notes, or in octaves, as distinguished from playing or singing different notes in COUNTERPOINT or in harmony.

inversion *Music* 1. An INTERVAL in which one or the other tone has been moved up or down an OCTAVE, putting it in a reversed position in relation to the other. A SIXTH, for example, between C and A, becomes a THIRD when its lower tone is A and its upper is C. 2. A chord not in ROOT POSITION, *e.g.*, a TRIAD with its THIRD or its FIFTH in the bass. *See* FIRST INVERSION, SECOND INVERSION.

Ionian mode *Music* One of the CHURCH MODES, represented in modern terms as equivalent to the SCALE of C MAJOR.

IRCAM *See* INSTITUT DE RECHERCHE ET DE COORDINATION ACOUSTIQUE/MUSIQUE.

iris *Lighting* An adjustable diaphragm constructed of extremely thin sheets of black metal interleaved and mounted within a ring in a fixed frame, in such a manner that an almost circular opening can be made to appear at the center and grow larger or smaller as the ring is turned. If the iris is placed in front of the lens of a SPOTLIGHT or a camera, its opening controls the amount of light transmitted through the lens. If it is in the focal plane of the lens, it controls the diameter of the beam.

Motion pictures 1. An adjustable diaphragm made to fit within the lens of a camera or a projector where it controls the amount of light the lens will transmit. 2. A visual and/or lighting effect in early motion pictures in which a small spot of light showing a portion of the picture on the screen expanded rapidly to reveal the whole scene or, conversely, the edges of the image converged into a small spot of light.

iris curtain *Stagecraft* A special curtain constructed of interleaved sheets of stiff material like the leaves of a mechanical IRIS, that can be drawn in from every direction so that it leaves a circular opening through which the audience can see only the performer's face.

Irish harp *See* HARP.

iris out *Lighting* To dim a focused spotlight by narrowing its beam to nothing. The IRIS, situated at the focal point of the LENS, determines the diameter of the beam. Closing the iris narrows the beam to nothing.

Motion pictures, Television To fade a scene to black by reducing the edges of the FRAME to a circle, and continuing the reduction until the entire screen is black. In motion pictures this can be done only during the final laboratory process of preparing the NEGATIVE from which RELEASE PRINTS will be made. In television, a SWITCHER does it as a WIPE.

iris shutter *Lighting* 1. A shutter shaped and operated like an IRIS. 2. An iris that can be closed completely.

irradiation *Acting* In the STANISLAVSKI METHOD, an actor's subjective feeling of energy radiating outward toward other actors and toward the audience, combined with energy coming from them and being absorbed by the actor.

isolation *Dance* The restriction of the effect of any movement to a single part of the body.

Italian School *Ballet* Associated with La Scala in Milan, the Imperial Dancing Academy was organized in 1812. Its teaching methods, set down in the textbooks of Carlo Blasis who became its director in 1837, are still considered an important part of modern classical ballet training.

itch *Dance* An African American RAGTIME dance of the early 1900s.

ivories *Music* Slang for the keys of the piano—all 88 of them—even though five in every octave are actually made of black wood. The white keys, now covered with white plastic, were originally covered with thin sheets of ivory.

J

jabo (*HAH-boh*) [Spanish] *Dance* A slow Spanish dance in triple rhythm, performed as a solo.

jácara (*HAH-kah-rah*) [Portuguese] *Music* In the 17th century, a comic interlude within a theatrical performance. The jácara became a piece of dance music with variations based on an OSTINATO, somewhat similar to the CHACONNE.

jack *Audio* A female receptacle, built into an audio control panel, that accepts male audio PLUGS to complete an electronic circuit. HEADPHONES, for example, are plugged into the headphone jack of a tape recorder.

Music The part of the key mechanism of a HARPSICHORD that engages and plucks the string to make it sound. *Compare* HAMMER.

Stagecraft A triangular frame hinged to the bottom of the back of a freestanding GROUND ROW. When the piece is in position, the jack is unfolded and weighted with a SANDBAG or fastened with a STAGE SCREW to hold it there and keep it vertical. *See also* BRACE JACK, OUTRIGGER, TIP JACK.

jackknife stage, jackknife wagon *Stagecraft* A platform built on casters in two or more sections, each of which can be swiveled around a stationary pivot to a different position on the stage. Each carries its part of the SET, with all its set pieces, furniture and PROPS in place. In a typical arrangement, each of two sections is pivoted at a downstage corner where it can be swung on or off the stage in a single move. *See also* REVOLVING STAGE, WAGON STAGE.

jaleo (*hah-LAY-oh*) [Spanish] *Dance* An Andalusian dance in triple time performed as a solo to the accompaniment of hand clapping.

jam *Jazz* To play together extemporaneously.

jam session *Jazz* Extemporaneous music-making, usually with a good deal of improvisation, in public or in private. In the 1930s and 1940s the musicians' union frowned upon jam sessions, which were supposed to have no public audiences, because the musicians did not get paid to play but shared whatever the private audience gave, with no portion going to the union. The term is now used to describe the same sort of musical session, one advertised as a special kind of performance at which the musicians do get paid and the union gets a reasonable fee.

Janissary music Turkish military music, characterized by large DRUMS, CYMBALS and other PERCUSSION. The style became very popular among European composers in the 1700s and 1800s. Haydn was especially enamoured of its KETTLEDRUMS and used them in some of his symphonies. Mozart and Beethoven each composed keyboard and instrumental pieces "in the Turkish Style." Mozart's opera *The Abduction from the Seraglio* stemmed from this fascination.

jazz *Music* An improvisational form of popular music that appeared in the last decade of the 19th century, related to early BANJO music, social dance music of that time, RAGTIME and BLUES. It came into its own when musicians such as Joe "King" Oliver and Jelly Roll Morton began to apply more intense SYNCOPATION and the rich harmonies of blues to ragtime improvisations. It was taken up quickly by Sidney Bechet and Louis Armstrong in New Orleans, Jay McShann in Kansas City and others in Chicago, Memphis and New York. A piece of jazz typically began when the leader "stomped off" the beat and the band picked it up, playing the first REFRAIN of a well-known tune in a straightforward fashion. Then a soloist took up the refrain with the pianist or sometimes the whole band backing it up, playing as long as improvisations on the tune developed with increasing inventiveness. Soloist followed soloist until the leader signaled for a final OUT CHORUS with the whole band improvising. By the 1940s, with the expansion of radio and recordings, the styles and proprietary arrangements of individual bands became big business. Many musicians, including Benny Goodman and Duke Ellington—whose backgrounds included formal musical training— became extraordinarily successful. *See also* BEBOP, COOL JAZZ, FREE JAZZ, MODERN JAZZ.

jazz band *Music* A band that plays JAZZ. Early jazz bands were small groups of soloists. When King Oliver's Creole Jazz Band opened in Chicago in 1918, it consisted of cornet, trombone, clarinet, bass, piano and drums. Benny Goodman first became famous in the late 1920s with his quintet. Gradually in the 1930s, jazz bands grew in size and played for social dancing as often as they did for pure listening. Some took up SWING and became BIG BANDS. But as styles became more varied and improvisation became the dominant feature, swing gave way to BEBOP and COOL JAZZ and was performed more often in night spots, jazz bars and concert halls than at dances.

jazz dance A style of dance created around 1917 by African Americans. Based largely on African dance movements, its emphasis was on individually moving parts of the body. It was included in several forms of show business in the 1920s and later combined with modern dance techniques by choreographers such as Jerome Robbins and Alvin Ailey. *See* JITTERBUG, LINDY HOP.

jazz man *Jazz* A musician who plays JAZZ.

jazz-rock *Music* A style created by the great JAZZ musician Miles Davis and his colleagues, blending some elements of ROCK (mainly the use of electronic keyboards and guitars) with COOL JAZZ. An example of FUSION. It culminated in the innovative and highly influential album *Bitches Brew* in 1970.

jazz singer *Jazz* A singer who sings JAZZ. *See also* SCAT.

jazzy *Music* Having the quality and excitement of JAZZ.

jenny *See* GENNY.

jerk *Dance* A solo ROCK dance requiring a snap of the body alternating between the shoulders and pelvis, popular in the early 1960s.

jester *Acting* In Elizabethan and other plays, a court entertainer and CLOWN whose specialties are songs, dances and ironic and satirical commentary. In many of Shakespeare's plays the jester plays an important part in the plot. In *Twelfth Night* the jester, Feste, leads most of the music and provides much of the spice in many scenes.

Jesuit ballet *Dance* As early as the 17th century, Jesuit priests presented ballets on sacred themes that were intended to supplement religious instruction. In spite of some public disapproval, these were performed on formal occasions and at the French court against a background of elaborate and sophisticated scenery.

jeté (*zheu-TAY*) [French] *Ballet* Literally, thrown. A spring from one leg to the other, with the working leg appearing to be thrown forward, backward or to the side. Among the many possible variations is the GRAND JETÉ, executed with a big leap forward.

jeté entrelacé (*zheu-tay anh-treu-lah-SAY*) [French] *Ballet* Literally, interlaced jump. Often incorrectly called *tour jeté* by American dancers. A series of rapid turns, each beginning with a small jump, with the feet quickly exchanging positions.

Jew's harp *Music* A very simple musical instrument that produces a single twanging tone. It consists of a small strip of spring steel mounted at one end inside a horseshoe-shaped metal frame about two inches wide. The player holds it closely in front of his mouth and hums while plucking the spring. Its quality is unique, though it allows very little expression.

jib *Motion pictures* The arm of a studio CRANE or, by extension, the crane itself, fitted to carry a motion picture camera, the camera operator and an assistant at a height above the floor of the studio and to move smoothly and precisely as necessary while the camera is shooting.

jig *Dance* A lively, irregular jumping dance with a SCOTCH SNAP built into many of its MEASURES. It came originally from the British Isles in the 15th century and was known in Europe by the 1600s. The Irish performed it as a STEP DANCE to fiddle or harp and bagpipes. In England a jig was sometimes interpolated into a theatrical performance as a rhymed farce, danced and sung, occasionally used to end a play. The origin of the word is obscure, though its sound contains a suggestion of its basic hopping motion. Although the dance is closely related to the old French GIGUE, the words have no etymological relationship.

jigger *Stagecraft* A narrow board inserted between two of three FLATS hinged together to make a wide, folding unit. The jigger is necessary to make that joint wide enough to accommodate the thickness of the opposite flat in its folded position. Also called a "wooden DUTCHMAN."

jitterbug *Dance* A spectacular style of couple dance to a rapid SWING beat, prevalent in the big-band era of the 1930s and 1940s, characterized by high acrobatic lifts, arm-in-arm spins and improvised steps. Another name for the LINDY HOP.

jive *Music* 1. A name applied to early JAZZ or SWING music, as well as the jargon associated with it. 2. A slang term for insincere, deceptive or nonsensical talk. 3. To dance the JITTERBUG.

jog *Stagecraft* A narrow FLAT built to fill the space between two flats that, when they are in position in the set, are offset from each other. Not the same as a JIGGER.

join *Stagecraft* 1. The vertical line of contact between two FLATS that are lashed or hinged together. 2. A point, marked on the stage floor, where the edges of two adjacent flats are intended to meet. *See also* SCORING LINE.

jongleur (*zhong-GLEUR*) [French] *Music* A professional itinerant musician and entertainer of the Middle Ages (from about 1100). Jongleurs predated the TROUBADOURS.

jota (*HOH-tah*) [Spanish] *Dance* A lively Spanish folk dance for couples, in triple time, accompanied by CASTANETS. It occurs often in BALLETS on Spanish themes and in Spanish theater.

Jubilate (*yoo-bee-LAH-teh*) [Latin] *Music* Literally, rejoice. The first word of Psalm 65 in the Roman Catholic Bible. It is the title of many joyful and ceremonial cantatas composed by Handel and others to celebrate momentous occasions.

jug *Music* Literally a glass or ceramic bottle that becomes a musical instrument when a player in a BLUEGRASS or SKIFFLE band blows gently across its open mouth. Although it can be tuned by adding a little water, it is limited to a single tone or its first PARTIAL.

jug band *Music* An ensemble of several JUGS of different tones that can be played by one or several players to produce a rudimentary melody.

juice *Lighting* Technician's slang for electric power.

juicer *Lighting* Slang for an electrician. *See* GAFFER.

juke box *Music* A large, coin-operated record player, gaudily decorated with lights and shiny internal mechanisms behind plastic panels and set up in a tavern in place of a live band.

juke joint *Music* A public room such as a bar or a hangout for teenagers, with a dance floor and a JUKE BOX.

jump cut *Motion pictures* A CUT that makes the image on the screen seem to jump without smooth transition. An editor may make an intentional jump cut for dramatic purposes by removing a section within a SHOT of a person approaching the camera from a distance; the cut eliminates a portion of the approach, so that the person appears abruptly much closer and larger. The effect may be enhanced by making a series of such cuts, so that the shock occurs several times. An unintentional jump cut, on the other hand, can have a distracting effect, as when the head of a person who is speaking suddenly appears in a new position without any visual justification. The CUTAWAY was devised to solve this technical problem.

jumper *Lighting* A short piece of electrical cable with a male connector at one end and a female at the other, used to make temporary connections between circuits. Not to be confused with PATCH CABLE.

jump lines *Acting* To omit lines either unintentionally because the actor is having trouble remembering them on stage or intentionally in order to TELESCOPE THE SCENE.

justification *Acting* The combination of DRAMATIC ACTION in the scene and an actor's internal understanding of the character that provides a satisfactory logic and MOTIVATION for the next action.

juvenile *Acting* A CHARACTER ROLE portraying a young (teenage) person.

juvenile lead *Acting* The most important JUVENILE role in the play, whether or not there are also adult LEADS.

K

K *Lighting* Kelvin, short for "degrees Kelvin," a measure of the COLOR TEMPERATURE of light, named after the English physicist William Thompson, Lord Kelvin, who also first determined the measure of absolute zero. *See also* KV.

Kabuki (*kah-BOO-kee*) [Japanese] *Theater* Literally, music and dance with style. The popular commercial theater of Japan founded in 1603. Kabuki is performed by male actors in elaborate costumes acting in a highly stylized manner, speaking rhythmically and playing both male and female roles. The plays are in prose and are often based on historical subjects or tales.

Kaddish (*KAH-dish*) [Aramaic] *Music* Literally, holy one. The Jewish liturgical prayer for the dead, often set to music and performed in concerts.

kagura-bue (*kah-goo-rah-BOO-eh*) [Japanese] *Music* In Japanese art music, the largest transverse FLUTE, used mainly in the accompaniment of Shinto ceremonies. It is made of dried bamboo, lacquered inside and out, with six finger holes that produce a PENTATONIC SCALE.

Kalamatianos (*kah-lah-MAH-tee-ah-nohs*) [Greek] *Dance* A slow Greek folk dance of ancient origin from Kalamati in the Peloponnesus region, once performed only by men. The dancers join hands and form a line following a leader at the head of the line who waves a handkerchief in his free left hand and executes complex twists and leaps until exhaustion forces him to stop and let another take his place. Its ancient origin suggests a style of dance that may be related to that of the CHORUS in classical Greek plays.

kalimba *Music* A Central African musical instrument consisting of a shallow sound box with an array of curved tongues of metal (originally of wood) clamped between two horizontal BRIDGES. Generally the tongues are mounted with the longest (of lowest tone) in the center and the rest mounted to the right or the left in descending length (ascending tone). They vibrate like springs and the box resonates briefly when the tongues are plucked by the player's thumb or finger. Each tongue can be tuned by pushing it deeper into or pulling it farther out of the bridges. The range is about two and a half OCTAVES of a G-major scale, but no kalimba has more than seventeen tones available. A close relative to the MBIRA and the SANSA, each of which has a hollow gourd for a sound box. Also called a thumb piano.

Kammermusik (*KAH-mer-moo-ZEEK*) [German] *Music* CHAMBER MUSIC.

Kammerspiele (*KAH-mer-SHPEE-leh*) [German] *Theater* Literally, chamber play. Chamber theater. *See* CHAMBER OPERA, INTIMATE THEATER.

kangaroo dip *Dance* An ANIMAL DANCE of the early 1900s performed to RAGTIME.

Kansas City style *Jazz* A style of JAZZ that developed in Kansas City, Missouri, in the 1930s and was deeply influenced by BLUES. It was made famous by musicians such as pianist Jay McShann. It has less heavily emphasized rhythms than New Orleans jazz, and makes prominent use of RIFFS.

kapellmeister (*kah-PEL-mai-ster*) [German] *Music* Literally, chapel master. The musical director, especially of a church or court choir. Johann Sebastian Bach, in the final years of his life, was kapellmeister of the two largest churches in Leipzig and, at the same time, of the court of the Duke of Weissenfels.

kathak *Dance* A style of Hindu dance-drama from northern India, introduced by Brahman priests called kathaks. The drama includes dance dominated by elaborate foot movements on the ground accompanied by rhythmically spoken syllables and by a TABLA, alternating with passages of PANTOMIME.

katharsis [Greek] *See* CATHARSIS.

kazachok [from Russian] *Dance* A lively Cossack dance for a solo male dancer in rapid DUPLE TIME.

kazoo *Music* A toy instrument consisting of a short tube of sheet metal with a reedlike membrane across a hole in the side of the tube at its midpoint. The player sings through the tube, and the membrane, reacting to the player's voice, distorts the sound making the voice sound rasping, like some outlandish reed instrument or a primitive FUZZ BOX. Also called a bazooka.

keening [from Gaelic] *Music* Intense, formal wailing in mourning for the dead. An Irish folk tradition.

keep alive *Acting* An instruction from the director to maintain the pace and the intensity of emotions in a scene.

Stagecraft To keep set pieces and scenery readily available for use somewhere in the theater, rather than sending them out for long-term storage.

keeper *See* S-HOOK.

Kelvin scale *Lighting* The scale of absolute temperature in degrees Celsius beginning at absolute zero, as determined by William Thompson, Lord Kelvin. *See* COLOR TEMPERATURE, K.

Kentucky running set *Dance* A style of American SQUARE DANCE, popular in the Appalachian Mountains region. It is performed in a large circle (called a big set), or in squares with four couples to the square, who rapidly alternate a heel and toe tap on each beat (see

CLOGGING) to the music of a five-piece string band and the instructions of a CALLER who may also be dancing. The beat is usually much faster than in an ordinary square dance and the accompaniment often consists of a FIDDLE, a BANJO, one or two GUITARS and a DOUBLE BASS or a WASHTUB BASS playing old Southern dance tunes. Also called the Tennessee running set. It is related to the English RUNNING SET.

kettledrum *See* TIMPANI.

kettledrummer *Music* One who plays TIMPANI.

key *Lighting* The average intensity of light on the subject, expressed as HIGH KEY or LOW KEY. *See also* ACCENT, KEY LIGHT.

 Music 1. The general TONALITY of a piece or a passage of music, *e.g.,* "the key of C-MAJOR." 2. The part of the ACTION of a PIANO, HARPSICHORD, ORGAN or any other KEYBOARD instrument, that the player presses to cause the action to engage the sound-producing mechanism. 3. On brass and woodwind instruments, any device operated by a finger that turns a valve, moves a piston or opens or closes a hole to alter the dimensions of the resonant column of air and cause a corresponding change in the pitch of the tone being played.

keyboard *Music* An array of KEYS set horizontally in order of pitch along the front of a PIANO or HARPSICHORD.

keyboard fingering *Music* The method(s) of using the fingers as efficiently and comfortably as possible when playing on a keyboard instrument. Modern fingerings are indicated in printed music by using the numeral *1* for the thumb and *2* through *5* for the remaining fingers.

key drawing *Animation* A drawing showing a complete scene at an important point during the action. There are usually many key drawings for each scene, each showing the exact positions (and shapes and colors) of every detail in the scene as the action progresses. When the key drawings are complete, an ANIMATOR works out the IN-BETWEENS that will provide smooth transitions from one key drawing to the other. Not to be confused with the less precise drawings of a STORYBOARD.

key-fill contrast, key-fill ratio *Lighting* The degree of contrast between the brightness of a KEY LIGHT and the less bright general light that fills the surrounding area.

key grip *Motion pictures, Stagecraft* The chief GRIP.

key light The dominant light that falls on the most important part of the scene, giving it its brightest area of illumination. The key light provides the apparent source of light, *i.e.,* it gives the audience a sense of the direction from which light comes into the set. *Compare* ACCENT, HIGHLIGHT.

keynote *Music* The fundamental note of the key, or any octave of that note. *See* TONIC.

key set *See* UNIT SET.

key signature *Music* In music that has a tonal center, a gathering together at the beginning of each STAFF of the group of SHARPS or FLATS within that staff that determines the KEY in which the music begins. The flats or sharps appearing in the key signature control the pitch of all the indicated notes, or their octaves, that follow until another key signature appears or until a NATURAL sign appears as an accidental to nullify one of them within a single measure. *See also* ACCIDENTAL.

KEY SIGNATURE (EXAMPLE)

keystone *Motion pictures* The slightly trapezoidal shape of the picture on the screen that is produced by a projector set so high in the back of the house that its beam hits the screen at an excessive angle, *i.e.,* more than 15° off a line perpendicular to the screen.

Stagecraft A small piece of plywood nailed over the joint between the STILE and the TOGGLE of a FLAT to hold them firmly at right angles to each other.

keystoning *See* KEYSTONE.

kHz *Audio* Abbreviation for KILOHERTZ.

kill *Acting* 1. To speak a line so badly or with such bad TIMING that it loses its effect. 2. To speak a line while the audience is still clapping for something else.

Lighting 1. To turn off (a light). "Kill that baby!" means nothing more than "turn off that small spotlight." 2. To remove a light from the circuit.

kill a shadow *Lighting* To eliminate an unwanted shadow by adding FILL LIGHT.

kilohertz *Electronics* 1,000 HERTZ.

kinema *See* CINEMA.

kinescope *Television* A motion picture made by shooting the television screen with a motion picture camera. In the 1940s and 1950s before videotape became available, the only way to make a permanent record of a television program was to photograph the screen with a specially synchronized motion picture camera.

kinesphere *Dance* The sphere of motion. According to Rudolf von Laban, who created LABANOTATION, the volume of space in which a dancer moves, limited by the dancer's reach while standing in place.

kinesthetic memory *Dance* A dancer's detailed memory of the physical sensations of a particular movement.

kinesthetic sense *Dance* A dancer's awareness of the physical sensation of motion.

kinetography [from Greek] *Television* The process of recording a television program on motion picture film. *See* KINESCOPE.

Kirov Ballet *See* ST. PETERSBURG BALLET.

kithara (*ki-THAH-rah*) [Greek] *Music* One of the two most important instruments of the Golden Age of classical Greek theater, around the 5th and 4th centuries B.C. The other was the AULOS. Similar instruments were known in Egypt and elsewhere in the Middle East as early as 4,000 years ago. The kithara evolved from the ancient LYRE and consisted of a square wooden SOUND BOX to which were attached two vertical wooden arms with a horizontal bar across their tops. Originally five or six strings were stretched from the bar to the sound box and tuned somewhat like the modern guitar. Other strings were added later not to provide more notes, but to double the existing notes at their OCTAVES. The player held the body of the instrument in one arm and plucked the strings with the other hand. He (kithara players were always men) could raise the PITCH of a string, or of several strings at once, by pressing with a short piece of wood against its lower part. The kithara, the instrument of harmoniousness, was associated with Apollo; the aulos, considered the instrument of emotions, with Dionysius.

klavier (*klah-FEER*) [German] *Music* Keyboard.

klavier-auszug (*klah-feer AUS-tzoog*) [German] *Music* Literally, keyboard extract. *See* REDUCTION.

klezmer [Yiddish] *Music* Originally a professional Jewish folk musician in Poland, now a player in a small band providing music for services in synagogues and entertainment at weddings and social occasions. A klezmer band usually includes a clarinet or flute, trumpet, violin and drum and sometimes a singer. Its style is characterized by extensive improvisation, ornamentation and bending of pitches.

klieg, kliegl *Lighting* Short for KLIEGLIGHT.

klieg eyes *Acting* Fatigue, visible as inflammation and swelling around the eyes of an actor, caused by his or her constant attempt to counteract the intense brightness of stage lights (*e.g.,* KLIEGLIGHTS) without appearing to squint.

Klieglight *Lighting* Trade name for any of a line of stage lights manufactured by the Kliegl Corporation, founded in New York City in 1896.

Knees Up Mother Brown *Dance* A lively English group dance of the 1930s performed to a song of the same name, with the dancers rhythmically running in place.

knell *Music* The mournful sound of a church bell slowly tolling.

"knock 'em dead" *Acting* A whisper of encouragement for an actor to go on stage and outdo every past success. *See also* BREAK A LEG.

Kol nidre (*kol NEE-dreh*) [Hebrew] *Music* Literally, all promises. A liturgical prayer sung at the beginning of the annual service of Yom Kippur, asking forgiveness for the past year.

kolomyka (*koh-loh-MEE-kah*) [Polish] *Dance* A Polish dance from the mountain districts, in quick DUPLE TIME.

komabue (*koh-ma-BOO-eh*) [Japanese] *Music* A Japanese transverse FLUTE, shorter and slimmer than the KAGURA-BUE, used in court music. It came originally from Korea, where it was called the komagaku.

kommos [Greek] *Music* In classical Greek drama, a mournful lamentation sung by a soloist and a chorus.

komos [Greek] *Dance, Music* 1. A merry revel, frequently a festive procession with music and dancing in honor of Bacchus, the god of wine. The word is closely related to COMEDY. 2. The ODE sung during such a festival.

konzert (*kon-ZEHRT*) [German] *Music* A CONCERTO.

kook, kookaloris *See* COOKALORIS.

Korean temple blocks *See* TEMPLE BLOCKS.

kothornus *See* COTHURNUS.

koto *Music* A Japanese stringed instrument consisting of a long, hollow wooden body with an arched top surface, with six to nine silk strings stretched lengthwise and firmly attached to pegs at each end. The player sits on the floor beside the koto and plucks the strings. Before it is played, all the strings must be tuned to the same tone. The arrangement of tones that will be required in the piece is established by setting up bridges at appropriate points under each string before beginning. The koto is used in GAGAKU and as a solo instrument in much nontheatrical music.

kraft (*krahft*) [German] *Music* Literally, power. Vigor, strength.

krummhorn *Music* 1. A DOUBLE-REED INSTRUMENT of the 15th to 17th centuries made of a narrow tube shaped like the letter J, with a covered MOUTHPIECE at the upper (long) end, and seven finger holes along the sides. 2. An ORGAN STOP with a delicate reedlike tone.

KV *Lighting* Kilovolt (1,000 volts), a unit of electric power.

Kyogen (*kee-YOH-ghen*) [Japanese] *Theater* Literally, words of rapture. A genre of short, comic plays in extraordinary and comic language and including music, songs and dances. Kyogen performances alternate with the serious NOH drama on the same stage. *See* NOGAKU.

L

L *Acting* STAGE LEFT. *See* STAGE AREAS.

la *Music* The sixth syllable used in the system of SOLMIZATION. In the FIXED-DO SYSTEM it represents the note A. In MOVABLE-DO it represents whatever tone is the sixth of the scale in use.

Labanotation *Dance* A system of dance movement notation created by Rudolf von Laban. *See also* BENESH NOTATION.

label *See* RECORD LABEL.

labial pipe *See* FLUE PIPE.

laboratory theater *See* STUDIO THEATER.

Lachrymosa (*lah-kree-MOH-zah*) [Latin] *Music* Literally, full of tears. A section of the Requiem, the Roman Catholic funeral MASS.

lacrimoso (*lah-kree-MOH-zoh*) [Italian] *Music* Literally, tearfully, mournfully.

ladder lights *Lighting* Stage lights mounted on a ladderlike series of short horizontal pipes in the WINGS on each side of the stage just behind the main curtain. *See also* LIGHT TREE.

lag *Television* The degree of persistence of an image on the television screen, sometimes the source of GHOSTS.

lai, lay *Music* An elaborate, lyrical song form of medieval France, developed by TROUVÈRES in the 13th century.

l'air, en *See* EN L'AIR.

lake liner *Makeup* 1. A LINER made with any of several pigments combining animal or vegetable colors with a metallic substance. Such a mixture is called *lac*. 2. A crimson LINER used to create the effect of wrinkles and lines of aging.

Lambeth Walk *Dance* A social dance popular in England in the late 1930s, originally created for MUSICAL COMEDY.

lamb's wool *Ballet* Pieces or wads of lamb's wool are used to cushion the inside of POINTE SHOES, or wrapped around the dancer's toes to make the shoes more comfortable.

lament *Music* A mournful funeral piece. In Scotland and Ireland each clan had its own lament, performed with BAGPIPES and TABORS. The earliest known lament, the PLANH, was sung in Aix-la-Chapelle (Aachen) in memory of the emperor Charlemagne in the year 814.

Lamentations *Music* Musical settings of the text of the biblical lamentations of Jeremiah, usually sung in Christian churches during the week preceding Easter.

lamp *Lighting* 1. Any lighting device consisting of an airless glass bulb and a metal base. 2. To install a lamp in a lighting fixture in preparation for lighting the show.

lampblack *Makeup* Black pigment consisting of pure carbon derived from the flame of a candle. It is a black powder, often in stick form, used for black shadows on the cheeks and forehead. In the 19th century it could easily be manufactured in an actor's dressing room by charring a piece of cork over a flame (*e.g.*, of a gaslight).

lamp dip *Lighting* Liquid dye formerly used to color the lamps used as footlights or other lighting fixtures. In present practice, colored lamps have little use (except for STRIPLIGHTS of very low wattage) because of the time and labor required to change colors in a scene. They have been rendered obsolete by color frames into which GELS can be slipped.

lamp down *Lighting* To reduce the amount of light in STRIPLIGHTS by replacing the lamps with others of less wattage.

lamp man *Lighting* Old-fashioned slang, still in use, for a member of the lighting crew.

lampoon *Theater* 1. A sharply focused satire of a person or institution. 2. To ridicule or satirize a person or an institution.

lamp schedule *Lighting* A list of the lighting fixtures, the lamps to be installed in them for the show and the scenes that will require them.

Lancers *Dance* A fast couple dance popular in the 1800s, named for a French regiment and descended from the QUADRILLE. It loosely pantomimed military advances and retreats across the floor, ending in a grand MARCH and a WALTZ.

Ländler (*LEND-ler*) [German] *Dance* A country dance from Upper Austria, in rather slow triple time. In the 1800s it was performed by couples spinning in opposite directions, clapping and stamping to maintain the rhythm. A later version, similar to the WALTZ, became a favorite of the Viennese.

Music Any composition based on the rhythm and spirit of the dance.

landline *Television* A COAXIAL line used as a link between a REMOTE PICKUP location and the main studio. *Compare* AIR LINK, SATELLITE LINK. *See* FEED.

landscape drop *Stagecraft* A DROP with a painted outdoor scene.

landscape format *Motion pictures, Television* General name for the WIDE-SCREEN FORMAT. *See* ASPECT RATIO, LETTERBOX FORMAT.

Langaus (*LAHNG-aus*) [German] *Dance* A wild couple dance popular in Vienna in the late 1700s, in which partners circled the ballroom as fast as possible for as long as possible. As it became more and more popular, police were sometimes called in to contain the violence. Eventually the dance was banned.

langsam (*LAHNG-zahm*) [German] *Music* Slow.

lantern slide *Lighting* In theaters of the 19th century, a transparency that could be slipped into a frame at the focal point of an old-fashioned projector (MAGIC LANTERN) to project the background of a scene on the CYCLORAMA.

lap dissolve *See* DISSOLVE.

lapel mike, lapel microphone *Audio, Television* A small MICROPHONE that can be pinned to a speaker's suit jacket, with its wire hidden under the collar and run over the back so that it will be invisible to the camera during a television broadcast. *Compare* BOOM MIKE, BOSOM MIKE, LAVALIERE.

lapse of time curtain *Theater* A curtain drawn over a scene for a moment, then reopened on the same scene to indicate that a period of time has passed. Changes made while the curtain is closed may suggest just how long the imagined interval is supposed to be.

largando (*lahr-GAHN-doh*) [Italian] *Music* Becoming very slow. *See* ALLARGANDO.

larghetto (*lahr-GHEH-toh*) [Italian] *Music* 1. Somewhat slowly, though not as slow as LARGO. 2. The title of many pieces of moderately slow music.

largo (*LAHR-go*) [Italian] *Music* 1. Very slow and expressive. 2. A descriptive title occasionally used for pieces of very slow, expressive music. One of the most famous is the aria *Ombra mai fù* (Shade never was) from the opera *Serse* by George Frideric Handel.

La Scala *Music* The great opera house of Milan, Italy, built in 1778 on the site of a church dedicated to Regina alla Scala, the duchess of Milan in the 14th century. From the beginning, it has been the leading opera house of Italy, where many of the works of Verdi, Puccini and other great composers had their premieres. The building was destroyed by bombing in World War II, and rebuilt in 1948.

lash *Stagecraft* To tie two flats together by winding a LASH LINE back and forth around their LASH CLEATS.

lash cleat *Stagecraft* A CLEAT attached to a STILE so that it protrudes toward the inside of the FLAT, allowing a LASH LINE to be looped around it when another flat is joined.

lash knot *Stagecraft* A knot made by looping a LASH LINE back and forth around the horns of a CLEAT, with the last loop twisted so that it passes over the long end of the line. As the line pulls taut, the loop presses upon it and prevents it from loosening.

lash line *Stagecraft* Any line used to lash adjoining FLATS together using CLEATS on the STILES. Often a lash line is permanently attached to a cleat at the top of one flat, looped alternately around cleats on the adjacent stiles of both flats and tied off at a bottom cleat.

lassu *Dance* A slow, often melancholy section of the Hungarian CZARDAS.

Laterna Magika *Theater, Lighting* An experimental entertainment invented in the 1950s by the Czech director Josef Svoboda combining live actors and their carefully matched filmed images.

latex [from Latin] *Makeup* Literally, milky liquid. An emulsion made of particles of synthetic rubber in a water base, used to fill hollows and build up areas of the face or to make a mold for casting a mask. The resulting substance remains flexible and can be colored so that it appears quite natural.

lautenclavicymbal *Music* A common but erroneous spelling often used to describe a HARPSICHORD with gut strings that sounds somewhat like a LUTE when plucked. The term has been spelled this way for centuries, even by Johann Sebastian Bach who owned one of the instruments. It has nothing to do with the cymbal. A more plausible spelling would be *lautencembalo*.

lavaliere (in the United States pronounced *lah-vah-LEER*) *Audio* A small MICROPHONE with a comfortable loop that can be worn as a necklace, making it less noticeable than a handheld microphone on television. It was named after the Countess Lavalière (*lah vahl-YEHR*), who lived at the time of the French Revolution and often wore a jewel on a similar loop.

lay *See* LAI.

lay an egg *Acting, Vaudeville* To fail miserably in a performance. The expression was already part of American slang when the weekly theatrical paper *Variety* used it in a headline announcing the collapse of the stock market in 1929: "Wall Street Lays an Egg."

lay down (a line) *Jazz* To establish the chord structure, *i.e.*, the bass line, for a JAZZ improvisation. In a COMBO, this is often the responsibility of the BASS player.

Motion pictures To record a basic sound track on SPROCKETED TAPE as a timed foundation upon which a more complex series of additional musical or EFFECTS tracks can be constructed, as in the expression to "lay down a CLICK TRACK."

lay out *Stagecraft* To draw the fundamental outlines of the appropriate parts of a set on unpainted FLATS preparatory to painting them.

layout *Stagecraft* A floor plan of the SET showing the positions of lighting instruments and the specific areas they will illuminate.

LC *Acting* Abbreviation for LEFT CENTER. *See* STAGE AREAS.

LCE *Acting* Abbreviation for LEFT CENTER ENTRANCE.

lead *Acting* The most important role in the play, the leading role.

leader *Audio* Plastic tape, superficially similar to audio tape (whether sprocketed or not) but either nonrecordable or with no audio signal present. It is used to fill silent periods in an edited audio track, to measure precise periods of time when the track must remain completely silent (*i.e.*, without ROOM TONE) or to provide a visual means of locating a precise beginning point for an audio cue.

Motion pictures 1. A strand of film with no image on it. Film leader is usually white, black or clear, and each has a specific purpose. Clear or white leader is most commonly spliced at the beginning or the end of a reel of WORKPRINT and/or of individual SHOTS within that reel, with each shot's identifying number and name written directly on it with a permanent marker. Black leader is used in the final editing process, when the editor is preparing parallel strands of film with live scenes alternating from one strand to the other so that they can be printed in the laboratory without any visible splices. The black leader keeps the dead strand opaque while the live strand prints. (*See* A & B ROLLS). 2. A strand of film designed to give projectionists a precise timing cue at the beginning of a motion picture reel. It shows symbols and numbers that provide a countdown to the BEEP, followed by two seconds of black after which the first frame of picture appears. The original standard leader, measured for silent films, is called the ACADEMY LEADER. For sound films the SOCIETY LEADER is standard.

Music 1. The person who leads the ensemble. The CONDUCTOR. 2. In Britain, the violinist sitting nearest the audience at the FIRST DESK (or first chair) of the first violins, known in the United States as the CONCERTMASTER. 3. In popular music, often the owner of the band who represents it to the public but is not actually its conductor.

lead-in *Music* An introductory phrase, measure or UPBEAT.

leading lady, leading man *Acting* The actors playing the principal roles in a play.

leading tone *Music* 1. The seventh note (of any scale) that leads to the TONIC. 2. By extension, any tone that demands resolution to another tone in the process of modulating into a new key.

lead sheet *Music* A written copy of the basic melody line of a song and its lyric, without accompaniment and embellishments. In vaudeville, conductors sometimes use lead sheets instead of SCORES, since much of the music they perform consists of standard ARRANGEMENTS of well-known songs. *See also* HEAD ARRANGEMENT.

lead singer *Music* 1. In POP music, ROCK and JAZZ, the principal singer of the band, who generally acts also as its spokesperson at performances. 2. The person who sings the melody or the top voice of an arrangement.

leaning rail *See* HANGING RAIL.

leap *Music* Any melodic movement that exceeds one step of the scale.

leaper *Circus* An acrobat who performs spectacular leaps.

leaptick *Circus* A mattress placed out of sight to protect a clown in a planned fall.

lebendig (*LEH-ben-dikh*), **lebhaft** (*LEHB-hahft*) [German] *Music* Lively.

L.E.D. *Lighting* A light-emitting diode; a very small light powered by an even tinier battery. It is taped to the stage floor to identify the specific spot where a particular part of the SET must be placed by stagehands. It is used in place of glowtape when the set is so dark between scenes that glowtape fails to glow.

ledger line *Music* A short line just above or just below the STAFF, on which an individual note can be written when it is too high or too low in PITCH to fit directly on the staff.

left, left stage *Theater* STAGE LEFT, *i.e.*, to the left from the point of view of an actor facing the audience.

left center *Theater* On stage left, halfway back from the PROSCENIUM. *See* STAGE AREAS.

left center entrance *Theater* An entrance from the WINGS onto the stage on STAGE LEFT, halfway back from the PROSCENIUM.

leg *Stagecraft* A narrow drop, less than stage width. It may have a straight edge or be cut and painted to represent foliage or an architectural shape. Theaters sometimes have two sets of legs and BORDERS, one behind the other, and a full-width curtain behind them to form a downstage acting area. Sometimes, inaccurately, called a LEG DROP. *See also* MASKING LEG.

legatissimo (*leh-gah-TEE-see-moh*) [Italian] *Music* As smoothly connected as possible.

legato (*leh-GAH-toh*) [Italian] *Music* Literally, bound together. Smoothly connected, each tone to the next without any break between. The opposite of DÉTACHÉ and STACCATO. *See also* PORTAMENTO, SLURRED.

leg drop *Stagecraft* A cloth DROP of full stage width with part of its central area removed, leaving a clear acting area. The opening may be irregular to represent foliage and trees, or regular to represent an architectural opening. A BORDER with a leg drop hung from the first BATTEN redefines the proscenium opening. Others, hanging from other battens fulfill the same function for the rest of the stage. *See also* BLACKS, HALF-LEG DROP, PORTAL.

leger line *See* LEDGER LINE.

leggiero, leggèro (*led-JAY-roh*) [Italian] *Music* Light, lightly.

legit *Theater* Short for legitimate, as in LEGITIMATE THEATER.

legitimate theater *Theater* The theater of comedy and tragedy collectively, as distinguished from VAUDEVILLE, BURLESQUE, film, television and OPERA.

legno *See* COL LEGNO.

leidenschaftlich (*LYE-den-SHAHFT-likh*) [German] *Music* Passionately.

leitmotif (*LITE-moh-teef*) [German] *Music* A term derived from the German journalists' word for "leading article" to describe the recurrent use of identifiable musical figures or

phrases associated with specific characters or ideas in the operas of Richard Wagner. The device was in use before Wagner's time, and has been used by many composers since. *See also* MOTIF.

Lekolight *Lighting* Trade name for a line of theatrical spotlights with ellipsoidal reflectors named for two engineers, Levy and Kook, who designed them for the Strand-Century Corporation.

lens, achromatic *See* ACHROMATIC LENS.

lensman *Motion pictures* A camera operator.

lens turret *Motion pictures, Television* A rotatable mounting that carries several camera lenses at once. A typical set-up will consist of a lens of normal focal length (*e.g.,* 50 mm) as well as WIDE-ANGLE and TELEPHOTO LENSES. The operator can turn the mounting to bring any of the lenses into line with the APERTURE at any time during a SHOOT. In out-of-studio situations, such as television news, CINEMA VERITÉ or shooting ON LOCATION, a ZOOM LENS serves several of these functions without burdening the camera operator with a turret.

lentamente (*len-tah-MEN-teh*) [Italian] *Music* Somewhat slowly.

lentando (*len-TAHN-doh*) [Italian] *Music* Relaxing the pace, becoming slower.

lentissimo (*len-TEE-see-moh*) [Italian] *Music* Extremely slowly.

lento (*LEN-toh*) [Italian] *Music* Slow.

leotard *Costume* A skintight suit consisting of a long-sleeved shirt and pants, usually black, worn by dancers during practice. Leotards also appear in performances when a neutral costume is appropriate. It was named after a 19th-century French AERIALIST, Jules Léotard, who is also credited with inventing the FLYING TRAPEZE ACT.

leporello *Music, Stagecraft* A very long strip of paper, folded alternately back and forth (like continuous computer paper) so that it looks like a pad of relatively small sheets. It can be carried unobtrusively on stage, then allowed to drop, fold by fold, until its full length becomes dramatically apparent. It is named for the Don's servant, Leporello, in Mozart's opera *Don Giovanni*, who carries one from which he reads the list of all 1,003 women seduced by the Don.

letterbox format *Television* Wide-screen format, achieved on the ordinary television screen by placing the picture between dark strips across the top and bottom of the scene. The usual placement in television is normal format.

level *Audio* The average volume of sound being recorded, as measured on a VU METER. When a recording is about to be made, the engineer frequently calls for a level check during which the actors or musicians perform as they expect to, giving the engineer an opportunity to adjust the controls so that every sound will be recorded clearly and properly when the recording session resumes.

l.h. *Music* An instruction to the pianist to play with the left hand.

li *Music* A syllable sometimes used in SOLMIZATION when the interval from the sixth to the seventh tone of the scale is a SEMITONE.

liberty horses *Circus* Trained circus horses that perform intricate maneuvers without riders.

library *See* SOUND EFFECTS LIBRARY, STOCK FOOTAGE LIBRARY.

librettist *Music* The author of the text of an opera.

libretto [Italian] *Music* Literally, little book 1. The text of an opera, printed in a small book that can conveniently be carried into the performance by an operagoer. 2. The text of an opera no matter how it may be printed, called *libretto* to distinguish it from the original story, which may have been a novel or a history written by someone else.

lick *Music* A JAZZ slang term for a brief but distinctive phrase or a recognizable chordal sequence that can be inserted at whim within an improvisation. Many players have a stock of licks that are their own or are borrowed from others.

lied (singular)(*LEED*), **lieder** (plural) (*LEE-der*) [German] *Music* Song(s), particularly ART SONG(S).

liederkranz (*LEE-der-krahnts*) [German] *Music* Literally, wreath of songs. The name of several music societies, particularly one in New York City that flourished in the late 19th and early 20th centuries and built a concert hall so famous for its excellent acoustics that the name was appropriated by the Kraft Cheese Company for its best product. Liederkranz Hall, the best recording studio in the city, was still in use in the 1940s for symphony orchestras.

lift *Acting* To add energy to one's DELIVERY to quicken the pace of the scene and lighten its effect.

 Costume 1. An insert in a shoe to add a little height to the performer. 2. A built-up sole and heel designed to add height to the performer. *See* COTHURNUS (2).

 Dance 1. The lifting of a dancer by her male partner. 2. To perform such a lift. *See also* ENLÈVEMENT, PORTÉ.

 Playwriting To plagiarize by borrowing an idea, a characterization, or sometimes a scene from another play.

 Stagecraft An elevator built into the stage floor.

lift jack *Stagecraft* A short wooden plank with a caster near one end on the bottom surface and a hinge on the upper. The hinge is attached near the base of a heavy piece of scenery, so low that when it is in the down position the wheel forces the plank to slant upward, off the floor. When a stagehand steps on the high end of the plank, the wheel acts as a fulcrum and the plank, acting as a lever, raises the piece off the floor so that it can be moved easily. When it is not working, the lift jack is folded up against the piece of scenery, out of the way.

lift stage *See* ELEVATOR STAGE.

light area *Lighting* Any of the individually illuminated areas identified in the LIGHTING PLOT.

light baffle *Lighting* Any piece of any material set up in front of a light to prevent its beam from spreading beyond a predetermined area. *See* BARN DOORS, BOOMERANG, COOKALORIS, FLAG, FUNNEL, GOBO, HI-HAT, SPILL RING.

light batten *Stagecraft, Lighting* A BATTEN or LIGHT PIPE with light fixtures attached.

light board *Lighting* A control board for lights.

light booth *Lighting* A booth containing lighting controls at the back of the HOUSE, the back of a balcony or built into the ceiling of the house, giving the lighting director clear sight of the stage from the audience's point of view and enough isolation from the audience so that communication with backstage will not be heard.

light bridge *Lighting* A catwalk high above the stage behind the main curtain. *Compare* GRID.

light comedy *Playwriting* Any pleasant and amusing comic play. *Compare* FARCE.

light console *Lighting* A CONTROL CONSOLE for lights.

light cue *Lighting* A reminder, usually written into a special copy of a script, often entered into a computer control program, to make a specific preplanned change in lighting at a specific moment during a performance.

light cue sheet *Lighting* A schedule of LIGHT CUES listed by act, scene and cue number, showing the actor's lines or other events that determine their precise timing, together with details of the specific changes required.

light curtain *Lighting* 1. An array of brilliant lights, mounted around the PROSCENIUM opening and aimed directly at the audience. When turned on as the stage goes into a BLACKOUT, the audience, being temporarily blinded, cannot see any change of scene. It is often used in open-air theaters 2. A dense row of high-intensity lights aimed straight down toward the stage floor that catch all the dust particles in the air and create the effect of a curtain of light through which nothing can be seen. The idea is credited to the modern American playwright Jules Feiffer.

light designer *Lighting* The lighting engineer who determines how each scene will be illuminated and specifies the type, power, color and aiming of all the lighting instruments needed to do the job. The result of this work is the LIGHTING PLOT.

lighting The general process of illuminating a stage or motion picture SET. The four basic kinds of lighting are: KEY, FILL, BACK and BACKGROUND.

lighting director The engineer who directs the operation of the lights for a show. Frequently the lighting director is also the LIGHTING DESIGNER. In motion pictures, the person who directs lighting is usually the DIRECTOR OF PHOTOGRAPHY.

lighting plot The lighting plan, showing the basic plan of the stage and SET and indicating the placement of LIGHT PIPES and lights, the types of lights to be used, their colors and intensities, the areas they cover and their schedule of use during any performance. *See* LIGHT CUE.

light leak *Lighting* Any unwanted light on the set. If it comes from stage lights, it is usually corrected by re-aiming the lighting instrument or by careful placement of a small FLAG. If daylight leaks into a motion picture set from outside, it is blocked out with large flags over the windows and doors.

light opera *See* OPERETTA.

light pipe *Lighting* A metal pipe, suspended horizontally in the flies, to which SPOTLIGHTS and other lights can be attached. *See also* LIGHT TOWER, VERTICAL PIPE. *Compare* BATTEN.

light rehearsal *Lighting* A rehearsal of the LIGHT CUES for the production, with or without actors present.

light tower, light tree *Lighting* A vertical LIGHT PIPE either in the WINGS or at the sides of the auditorium in front of the curtain.

ligne (*LEEN-yeu*) [French] *Dance* A dancer's outline during the performance of poses and steps; the degree of beauty in the arrangement of head and body, arms and legs.

lilt *Acting* A light, melodious, somewhat rhythmic manner of speech.

limbo *Stagecraft* A SET with no visible boundaries or corners, establishing a space that seems limitless.

limbo cyc *Stagecraft* A CYCLORAMA with a perfectly smooth, featureless, gently curved surface, stretching beyond the limits of the audience's vision and smoothly curved in to merge with the stage floor so that the line between floor and cyc is imperceptible.

limbo set *Stagecraft, Television* A set designed and illuminated in such manner that neither the audience nor the camera can find edges, flat surfaces or corners that would disclose its true dimensions. The actor seems to stand in an infinite space. *See also* INFINITE CYC.

limelight *Lighting* In old theaters, a very bright light, usually a SPOTLIGHT, whose source is the flame produced when lime is brought to incandescence by means of an oxyhydrogen flame. Also called calcium light. Since modern theatrical lamps do not use lime, the term has become a figure of speech; to be conspicuous in the public eye is to be "in the limelight." It has been supplanted by the ARC LIGHT.

limited engagement *Theater* An engagement with a firmly scheduled closing date.

Lindy hop *Dance* A JAZZ dance whose name may be a tribute to Charles Lindbergh's solo flight across the Atlantic in 1927. In the 1930s it was called the JITTERBUG.

line *Audio* A circuit that connects the CONTROL CONSOLE with a source, such as a MICRO-PHONE, RECORDING or PLAYBACK equipment or an amplifier.

Acting A single phrase or sentence that an actor speaks on stage. *See also* LINES.

Dance *See* LIGNE.

Lighting A lighting circuit, including the control that regulates it, the cable or wire that carries its power and the lighting instrument on stage.

Music *See* STAFF, VOICE.

Stagecraft A length of rope or wire used in RIGGING.

Vaudeville In a minstrel show, a row of players seated on stage with the INTERLOCUTOR at the center, and END MEN at both ends. *See* CHORUS LINE.

linear plot *Playwriting* Any PLOT whose events occur in a chronological or cause-and-effect sequence.

line connector *See* PIN CONNECTOR.

line cue *Acting* A CUE consisting of spoken words.

line grip *Stagecraft* A clamp or similar device that can be attached anywhere along a line of rigging to provide an unmoving attachment point for curtains, other rigging lines, etc. Also called BULLDOG, CLEW, SUNDAY. Not the same as a ROPE LOCK.

line of dance The clockwise or counterclockwise direction of the flow of dancers as they move around a BALLROOM.

line of sight *Broadcasting* A geometrically straight passage through unobstructed space that a television signal follows from the transmitter to a receiver. Ordinary radio broadcasting frequencies pass through space in ever-expanding waves that can travel, for example, beyond the horizon of the spherical earth. VHF (very high) and UHF (ultrahigh) frequencies carrying television signals, however, travel in straight lines like beams of light and cannot be picked up at the surface beyond the horizon.

Stagecraft *See* SIGHT LINE.

line out *See* LINING OUT.

liner *Makeup* Any pigment in pencil form suitable for drawing lines under the eyes or to simulate wrinkles on the face.

line rehearsal *Acting* A rehearsal for the purpose of learning and/or practicing the lines of the show, leaving action and music for another rehearsal. *Compare* SITZPROBE.

liner notes *Music* The text printed on a package containing a published recording, or in the booklet included in such a package, giving the historical and artistic background of the recorded work and of its composer and performer(s).

lines *Acting* All the words an actor speaks while playing a role on stage.

line side *Lighting* That segment of any electrical circuit that carries the main power from the source of power to the control system and/or DIMMERS, as distinguished from the circuitry carrying controlled power the rest of the way to lighting instruments on stage.

lining *Makeup* Lines painted around the eyes or over the eyebrows to make them more visible to the audience, or on the cheeks and forehead to simulate aging.

Stagecraft Lines painted on the surfaces of FLATS to simulate wooden shingles, courses of bricks, etc., in the scenery.

lining out *Music* Leading a hymn. In colonial New England and later in Southern churches where hymn books were hard to come by, the choir leader would "line out" the hymns by speaking a single line ending with the last word of the musical phrase whether it made sense or not. The congregation would sing it, then he would speak the next line, and so on. This led to certain oddities, *e.g.,* when the line ended with the thought unfinished: "The Lord will come and he will not . . ."

Linnebach projector *Lighting* A simple projector consisting of a large reflector with a point source of light, no lens, and a GOBO or a COOKIE mounted on it to cast a simply shaped shadow or light effect over a wide area of the SET. It was conceived by the German stage designer, Adolph Linnebach.

lip-sync *Motion pictures* To synchronize the sound of spoken words with the visual image of the moving lips of the actor speaking. An editor must adjust the DIALOGUE TRACK so that each word spoken by actors precisely matches their lip movements. An actor DUBBING a voice track must watch the picture and synchronize speech sounds with the lip movements of the actor on screen. If the track is in a language different from that of the original picture, synchronization of the new words must be adjusted to avoid obvious misfits, even if a precise match is unattainable.

l'istesso tempo (*lee-STEH-soh TEM-poh*) [Italian] *Music* Literally, the same TEMPO. An instruction to keep the same time duration of beats even though the nominal value of the beat has changed, so that a quarter note in a measure of 4/4 time, for example, will have a time-value equal to a dotted quarter in a measure of 6/8.

literalism *Theater* A style of stage design using SETS that reproduce real-life scenes exactly. A classic example was the complete, detailed reproduction on stage of a Childs Restaurant, including bottles of ketchup on the tables, for a production by Florenz Ziegfeld around 1900.

lithophone *Music* A musical instrument made of stone or ceramic material that resonates when struck with a mallet. Lithophones, a subclass of IDIOPHONES, were added to the vast array of available percussion instruments in the mid-20th century by composers such as Carl Orff and Irwin Bazelon. The orchestral lithophone looks like two overlapping stacks of flat ceramic dishes, mounted on a slanted frame to make a chromatic scale of two octaves, with the "white notes" in one stack and the "black notes" appropriately placed in the other. They produce a brief, but piercing, bell-like sound.

little theater A genre of theater, generally practiced by amateurs and would-be professionals in small HOUSES with little or no budget, before small but dedicated audiences. Little theaters provide a haven for serious young actors and fledgling companies and for the development of new writers and new ideas in the art. Many have spawned actors who later became stars, and a few have also become laboratories for film stars who wish to get back to LEGITIMATE THEATER.

liturgical drama *Theater* From earliest times in the Christian church the MASS, as a reenactment of a symbolic event, suggested dramatic interpretation. Beginning around the 10th century, celebrants reacted to that suggestion for services at Christmas and Easter, improvising embellishments within the responses that formed the INTROITS. At first these responses took the form of questions and answers between celebrants and the congregation. Gradually they became more elaborate; several characters would take part, speaking their lines and interacting. During the 12th and 13th centuries, these interactions became more lengthy interchanges. By the 14th century, formal plays had evolved, based on biblical stories such as Noah and the flood, Daniel and the lion, and St. Nicholas. These plays featured complicated acting, costumes and sets requiring rehearsals and performances separate from the regular church services. In England these and many other subjects were taken out into the open air and performed as MYSTERIES presented annually by the guilds of each town. The tradition that grew out of these religious dramas, which paralleled secular traditions of folk plays and COMMEDIA DELL'ARTE, formed a new basis for European theater.

live *Broadcasting* Said of any performance produced, recorded or broadcast as a complete event in real time by living performers, as distinguished from one that has been recorded in separate segments and edited to simulate a coherent performance.

live house *Acoustics* A theater in all parts of which music and the voices on stage can be heard and understood easily, as distinguished from a DEAD HOUSE in which they are rendered unintelligible by the shape of the house, absorbent materials in the construction and/or by curtains and drapes. A live house can have a long REVERBERATION TIME, which is not good for actors' voices but excellent (up to a point) for music.

Acting A responsive audience.

live line *Lighting* An electrical LINE with power in it, and therefore a line that is dangerous to touch.

live pack *Stagecraft* A stack of flats backstage that will be used during the performance. *Compare* DEAD PACK.

live stage *Theater* A stage with a SET in place.

living picture *Theater* A static moment in a scene, with all the actors present on stage holding a specific pose. Directors have frequently designed these pictures to end an act, with the actors holding the pose until the curtain has closed. *See also* TABLEAU VIVANT.

living theater Theater with live actors, as distinguished from television and motion pictures. *Compare* LEGITIMATE THEATER.

load *Lighting* The total amount of electrical power being carried by a single circuit and, by extension, the equipment that requires such an amount of power.

load connector *See* PIN CONNECTOR.

loading door *Theater* A wide, very high doorway backstage leading to the street or a loading dock, through which scenery can be moved into or out of the theater.

loading gallery *Stagecraft* A bridge high above the stage floor along the side wall where the COUNTERWEIGHTS hang. When a piece of scenery has been attached to rigging lines at the stage floor level, the empty COUNTERWEIGHT ARBOR for those lines hangs at the loading gallery level where stagehands can load the correct number of iron weights (PIGS OR WAFERS) to balance the weight of the scenery. When the scenery is FLOWN, the counterweights slide down through the counterweight channel, and another stagehand at the FLY GALLERY level below engages a ROPE LOCK to hold the counterweight arbor and the scenery in that position.

lobby *Theater* The entrance space outside the auditorium but inside the theater building where the audience gathers before being admitted to the show.

lobsterscope *Lighting* A SPOTLIGHT with a motorized, slotted disk (FLICKER WHEEL) turning in its beam to cause a flickering effect in the set.

location *See* ON LOCATION.

location shot *Motion pictures* A shot made ON LOCATION, *i.e.,* away from the studio.

locking rail *Stagecraft* A horizontal rail built along the FLY GALLERY to hold the ROPE LOCKS that control the FLIES.

locomotor movement *Dance* Any physical movement of the body considered from an anatomical point of view without regard to its significance in dance.

locution *Acting* An actor's particular style of speech, as distinguished from that of other actors.

loft *Stagecraft* The space above the GRIDIRON.

loft block *Stagecraft* A pulley firmly attached to the GRIDIRON, to which a piece of scenery such as a chandelier may be hung.

log *Motion pictures, Recording* 1. A detailed written record of every TAKE during a recording or shooting session, annotated to show which takes are acceptable for consideration by the editor who will assemble the final version. 2. To write a detailed record of each take during a recording or shooting session.

loge [from French] *Theater* 1. A BOX in a balcony. 2. The front section of the balcony, set off from the rest by a rail, and containing the best and most expensive seats.

longa *Music notation* A musical note equal in duration to two BREVES (or four WHOLE NOTES), used in the earliest period of time-based musical notation during the Middle Ages.

long arm *Stagecraft* A CLEARING POLE.

long-playing *Recording* Said of a published recording imprinted in microgrooves on a vinyl disk, to be played back at 33⅓ rpm.

long run *Theater* A run that has no specific closing date or that has been extended for months beyond the usual run of a few weeks. For Broadway theaters, where nearly every show opens with the hope of running forever, a long run is one measured in years.

long shot *Motion pictures* Any shot taken from a distance, showing not only the subject but the environment around the subject. Not to be confused with a WIDE-ANGLE SHOT that may also show some of the environment but is taken from a closer position. *Compare* ESTABLISHING SHOT.

long throw *See* THROW.

longueur (*lonh-GEUR*) [French] *Playwriting* An overlong, boring passage or scene.

longways dance, longways set *Dance* A style of CONTRA dancing in which four or more couples form two lines facing each other and perform figures called by a prompter. Unlike the square dance caller, the contra prompter indicates the movements to be performed with only a few cue words. *See* VIRGINIA REEL.

loop *Audio* A length of recorded tape with its beginning and its end spliced together so that it will run continuously in PLAYBACK. A sound editor makes a loop of an amorphous sound, such as waves washing up against the shore, the murmur of a large crowd, birds chirping or of ROOM TONE, to provide a steady background for a scene.

loose line *Acting* A line of DIALOGUE accidentally left unspoken during a performance until another actor has the presence of mind to pick it up.

Stagecraft *See* SPOT LINE.

lose a light *Lighting* To remove a light from a scene.

lose a line *Acting* To forget a line or a CUE.

lot *Circus* The circus grounds. The open area where the circus sets up its tent for an engagement. It is rented from its owner or from the town by the ADVANCE MAN, then locations within it for various parts of the show are laid out by the TWENTY-FOUR-HOUR MAN.

loudness *Audio* A subjective impression of the volume of sound. The word is used in place of "volume" as the name of a special control that automatically alters the balance of LOWS and HIGHS in the signal to maintain naturalness as it reduces the overall volume.

loud pedal *Music* A misnomer for the SUSTAINING PEDAL on a piano.

loudspeaker *Audio* An electrical device that turns electromagnetic vibrations into physical sound and projects that sound so that it can be heard by an audience. Loudspeakers range from the tiny units in HEADPHONES, pocket radios and tape players to the enormous boxes used in ballparks and circuses.

lounge *See* GREENROOM.

loure (*loor*) [French] *Dance* A French dance of the late 1600s, somewhat like the GIGUE, in moderate triple time.

louré (*loo-RAY*) [French] *See* PORTANDO, PORTATO.

louvred ceiling *Stagecraft* A ceiling within the SET constructed of an array of FLATS suspended horizontally above the set, each slanted downward toward the back of the set so that the array appears to the audience to be a continuous ceiling. The slant provides an opening that allows space for lights hidden above to shine between the flats onto the stage.

low camp *Acting* A style of acting with a touch of humorous obviousness. The opposite end of the scale from HIGH CAMP.

low comedy *Acting* Comedy based on simple, everyday routines and obvious silliness, as distinguished from comedy based on intellectual innuendo and complex incongruities.

lower in *Stagecraft* To lower anything from the FLIES into position in the SET.

lower out *Stagecraft* To lower a DROP or a piece of scenery through a SLOT in the stage floor to remove it from the set.

low key *Lighting* Lighting that is predominantly dark, without bright areas.

low light *Makeup* An area of darker makeup applied to the face, *e.g.*, to simulate hollows in the cheeks.

lows *Audio* The lower frequencies in the audio spectrum. The opposite of HIGHS.

LP *See* LONG-PLAYING.

luftpause (*LOOFT-pau-zeh*) [German] *Music* Literally, light pause. A brief pause.

lullaby *Music* A gentle, melodious piece of music suitable to calm a baby to sleep.

lumen *Lighting* The amount of light emitted by a point source equal in intensity to one standard candle. The unit of measurement of INCIDENT LIGHT.

luminaire (*lü-mee-NEHR*) [French] *Lighting* A lighting instrument.

lundu [Portuguese] *Dance* A Brazilian harvest dance, possibly of African origin.

lusingando (*loo-sin-GAHN-doh*) [Italian] *Music* Caressing.

lustig (*LOO-stikh*) [German] *Music* Cheerful.

lute *Music* A pear-shaped European stringed instrument of the 16th through 18th centuries with a moderately long NECK and a PEG BOARD tipped back at a sharp angle at its upper end. The LUTENIST places it on one knee with its neck against the shoulder and plays it by plucking the strings with one hand and stopping the strings with the other. The 16th-century lute had six pairs (courses) of strings. In the 17th century, four more courses were added in the bass register, requiring an extension to the neck. The six original strings were stretched over FRETS like the strings of the guitar. The BASS strings, however, had no frets and although they could be plucked were unreachable for fingering in any case. They were tuned along with the rest of the instrument to accommodate the KEY the player chose to use. Many of the works of Bach and his contemporaries that are played as keyboard music today were played in that time on the lute.

lutenist *Music* A person who plays the LUTE.

lute stop *Music* A STOP actuated by a lever or pedal on the HARPSICHORD that shifts the action to a rank of GUT STRINGS that produce a gentle lutelike sound in contrast to the more ringing sound of metal strings.

luthier (*LÜT-yay*) [French] *Music* A VIOLIN maker, *i.e.*, a maker and repairer of any of the stringed instruments. The name derives from the time when the primary such instrument was the LUTE.

lux *Television* A unit of measurement of the tiny amount of light that reaches the photosensitive tube of a television camera. One lux equals one LUMEN per square meter. The expression *low lux* indicates the ability of such a tube to register images in very dim light.

lycopodium powder *Stagecraft* Photographer's flash powder used before the invention of photoflash lamps to create, when ignited, any bright flash effect such as lightning.

Lydian mode *Music* The CHURCH MODE represented on the piano as a scale on the white notes from F to F, *i.e.*, a MAJOR SCALE with an AUGMENTED FOURTH.

lyre *Music* A stringed instrument from ancient Greece, consisting of a tortoise shell or a hollow wooden SOUND BOX with an arch made of a single piece of bent wood attached to it. The strings were stretched from the bottom of the tortoise shell to different points on the arch and were played with a PLECTRUM. In the classical period, the lyre evolved into the KITHARA, one of the chief instruments of Greek theater and an ancestor of both the HARP and the GUITAR.

lyric *See* LYRICS

lyrical *Music* Melodious, having the quality of a song.

lyric drama *Theater* Any drama sung, not spoken. *See also* CHORAL DRAMA, OPERA, OPERETTA.

lyricist *Music* One who writes words for songs.

lyric soprano *Music* A SOPRANO soloist whose range is somewhat lower than the COLORATURA, with a lighter, warmer tone quality than that of the DRAMATIC SOPRANO.

lyrics *Music* The words of the songs and choral numbers in a stage play. Frequently the author of the play is not its LYRICIST.

lyric tenor *Music* A TENOR soloist whose voice is lighter and warmer than that of the HELDEN-TENOR, and who specializes in LIEDER and the more tuneful roles in opera.

lyrist *Music* One who plays the LYRE.

lysis (*LÜ-sees*) [Greek] *Theater* Literally, a setting free, a deliverance. Aristotle's term for the resolution of the PLOT that comes after the CATASTROPHE and that must "arise out of the plot itself."

M

M *Theater* Abbreviation for "music," written into a director's script as a CUE.

ma [Italian] *Music* But, as in "allegro ma non troppo"; fast, but not too fast.

machina (*MAH-kee-nah*) [Latin] *See* DEUS EX MACHINA.

machine *Stagecraft* A self-powered piece of scenery, such as a STAGE WAGON with an electric motor under the control of actors. *Compare* ENGINE.

machine play *Theater* A 17th-century term describing a play with spectacular scenic effects involving moving pieces, such as ocean waves or scudding clouds, all operated mechanically by hidden levers and tracks.

macro lens *Motion pictures* Short for macroscopic lens. A lens designed for EXTREME CLOSE-UPS of very small subjects such as the point of a pen as it writes on paper.

Madison *Dance* In the 1950s, a line dance for couples incorporating elements of the JITTERBUG and early ROCK dance steps.

madrigal *Music* A lyrical, unaccompanied PART SONG, usually based on a pastoral and/or amatory text. The form first appeared in Florence, Italy, in the 14th century. It attracted poets and composers who produced some of the most beautiful secular music of the Renaissance including *Mon Coeur se Recommande à Vous*, one of dozens by Orlando di Lasso, and five books of madrigals by Claudio Monteverdi. English composers produced hundreds of examples including *The Silver Swan* by Orlando Gibbons, *April Is in My Mistress' Face* by Thomas Morley, *Adieu, Sweet Amaryllis* by John Wilbye and the many books of madrigals published by William Byrd. The madrigal is to choral music what the string quartet is to the symphony. It is the music of skillful amateur ensemble singers who sing for pleasure. It is still immensely popular. *Compare* MOTET, PART SONG.

madrigal comedy *Music* A musical entertainment consisting of a connected series of madrigals on texts that together form a theatrical comedy. It may have begun as an improvised form used in COMMEDIA DELL'ARTE, later taken over by poets and composers of the late 16th century who developed it more formally as a play composed with madrigals. The earliest famous work of the kind is *L'Amfiparnaso* by Orazio Vecchi, which first appeared in 1594. The form is important as an experiment in musical theater at the same time that Florentine artists were in the process of inventing OPERA. It is an ancestor of CHORAL DRAMA.

madrigalist *Music* A composer or singer of MADRIGALS.

maestoso (*ma-eh-STOH-zoh*) [Italian] *Music* Majestically.

maestro (*ma-EH-stroh*) [Italian] *Music* Literally, master. A term of respect for a conductor.

magamp *See* REACTANCE DIMMER.

maggiore (*mahd-JO-reh*) [Italian] *Music* Major, as in A *maggiore*, A major.

magic lantern *Stagecraft, Lighting* An old-fashioned slide projector once used in theaters for projected backgrounds.

magnetic amplifier *See* REACTANCE DIMMER.

magnetic sound track, magnetic track *Motion pictures* A SOUND TRACK that has been recorded as, or converted into, magnetic impulses imprinted along a strand of magnetic tape or on a strip of ferrous oxide along the edge of a motion picture RELEASE PRINT. It can be reconverted into sound by electromagnetic means during projection. *Compare* OPTICAL TRACK.

magnetic switch *Lighting* A switch designed to regulate large quantities of electrical power, operated by a low-powered circuit that trips it by magnetic means. Also called relay switch. Since magnetic switches are noisy, they are often confined to the basement of the theater.

magnetic tape *Audio* The medium of audio recording, a plastic (usually Mylar) tape coated with ferrous oxide. As the tape runs through a tape recorder, the oxide is magnetized by the electronic signal that represents the sound being recorded. When the magnetized tape is run through PLAYBACK equipment, the signal is reconverted into sound.

Magnificat *Music* A CANTICLE on a text from the Gospels used in Vespers (evening prayer services) in the Roman Catholic and Anglican churches. Many composers have set the text for chorus alone or chorus with orchestra. One of the most notable settings is that of Johann Sebastian Bach.

mag switch *See* MAGNETIC SWITCH.

mahl stick *Stagecraft* A round stick, usually with a pad wrapped around one end, used by a scene painter to provide a steady hand-rest while painting on a wide surface. The painter places the padded end of the mahl stick on a dry or unpainted area, and holds the opposite end up so the stick will not touch the surface. The other hand, holding the brush, can then rest lightly on the stick and draw accurately.

maillot (*ma-YOH*) [French] *Costume* Tights worn by acrobats and dancers in rehearsal. *See also* LEOTARD.

main *Lighting* The main power switch. *See* HOUSE MAIN, STAGE MAIN.

main action *Theater* The principal plot of a play with several subplots.

main curtain *Stagecraft* The front curtain, hung just behind the PROSCENIUM. Not to be confused with the FIRE CURTAIN. *Compare* ACT DROP, HOUSE CURTAIN.

main stem *Theater* Broadway and Times Square, the theater district of New York City.

mainstream *Music* Formerly, a term used to describe a JAZZ style that was neither modern nor traditional. In present-day usage, it describes music that appeals to the largest possible audience.

Main Street *Theater* An out-of-town engagement. *See also* BORSCHT BELT, CHINA CIRCUIT, STICKS.

main switch *Lighting* The switch that controls the entire supply of power for the stage; the COMPANY SWITCH.

maître de ballet *See* BALLET MASTER.

majestätische (*mah-jes-TAY-tish-eh*) [German] *Music* Majestically.

major key *Music* Any key whose THIRD is two WHOLE TONES above its TONIC.

major-major seventh *Music* A SEVENTH CHORD that has in its ROOT POSITION a major THIRD and a major SEVENTH.

major-minor seventh *Music* A SEVENTH CHORD that has in its ROOT POSITION a major THIRD and a minor SEVENTH. If its root is the fifth tone of the scale, it is called a DOMINANT SEVENTH.

major mode *Music* A term loosely applied to those CHURCH MODES of which the third tone is two WHOLE TONES above the TONIC. Strictly speaking, each mode is better identified by its proper name. Those with major thirds include the LYDIAN, MIXOLYDIAN, and IONIAN, which are in other respects quite different from each other.

major scale *Music* Any scale the third tone of which is two WHOLE TONES (*i.e.*, a major THIRD) above its TONIC.

major second *Music* The interval of one WHOLE TONE.

major triad *Music* Any triad whose middle tone in ROOT POSITION is a major third and whose top is a PERFECT FIFTH above its root.

make *Lighting* To make contact, *i.e.*, to close a switch and send power to a light.

make a break *Acting* 1. To cut a line intentionally. 2. To insert a pause, a change of pace or similar change in the script.

make a comeback *Acting, Theater* To return (to performing) successfully after a prolonged absence or series of failures.

make-and-break *Audio, Stagecraft* Said of any push-button switch or relay that establishes an electrical connection when pressed, and disconnects when released. The common doorbell, for example, has a make-and-break button as do the stage manager's cue-signaling devices.

make the nut *Theater* To sell enough tickets to pay for the use of the theater, if not to pay the cast and crew. *See* NUT.

make the rounds *Acting* To visit casting agents and producers, in search of employment.

make the set *Stagecraft* To put up scenery on the stage.

make up *Motion pictures, Television, Theater* To apply the cosmetic materials needed to give an actor the appearance appropriate to a ROLE.

makeup *Motion pictures, Television, Theater* The GREASEPAINT, LINER, LATEX, HAIR and other materials used to give an actor's face an appropriate appearance for a ROLE.

makeup artist One who designs and creates an appropriate face for an actor's role by applying MAKEUP.

makeup box A performer's personal makeup kit, usually contained in a portable box.

makeup pencil A pencil with greasepaint in its center. A pencil-shaped LINER.

Malagueña (*mah-lah-GWAY-nyah*) [Spanish] *Dance* A type of FANDANGO from Màlaga.

 Music An emotional Spanish song improvised to the accompaniment of repetitive minor chords.

male alto *See* COUNTERTENOR.

male impersonator *Acting* A female actor who specializes in male roles. Not to be confused with one who plays a BREECHES ROLE.

mallet *Music* Any of several varieties of short stick with a relatively large spherical end of various degrees of hardness, used by a PERCUSSIONIST to play any of the MALLET INSTRUMENTS. *Compare* DRUMSTICK.

mallet instruments *Music* Any percussion instruments played with mallets. These include the XYLOPHONE, MARIMBA, GLOCKENSPIEL and VIBRAPHONE. Not to be confused with percussion instruments such as TIMPANI, GONGS, BELLS and STEEL DRUMS that are played with beaters or sticks, nor with the DULCIMER and other stringed instruments played with HAMMERS.

mambo *Dance* A fast, Cuban ballroom dance of the mid-1950s combining Latin American and jazz rhythms. In each measure there is one beat on which the dancer takes no step.

M & E tracks *Motion pictures* Music and effects tracks: the strands of sprocketed magnetic tape carrying the sound effects and music (including LEADERS), but not the dialogue, of an entire motion picture.

manager *Theater* 1. The person in charge of business matters for the COMPANY. 2. One who handles business matters for a performer. 3. The person in charge of all the operations of the house, as distinguished from the theatrical operations of the company.

mandolin *Music* A stringed instrument shaped like a pear sliced lengthwise, with a short fretted neck and four pairs of strings tuned like a violin. It is played with a PLECTRUM. The mandolin has a distinctive sound: the player can choose between a single stroke for a tone or, if a tone of longer duration is necessary, strum very rapidly back and forth between the two strings that make up the pair.

mannerism *Acting* Any of an actor's odd or exaggerated personal gestures used habitually for theatrical effect.

Mannheim school *Music* A group of composers who worked at various times in the middle of the 18th century with the orchestra of the court of Karl Theodore, Elector of Pfalzbayern in Mannheim, Germany. Their first conductor was Johann Stamitz, who made many innovations of orchestral style, moving away from the THOROUGH BASS and CONTRAPUNTAL styles of previous decades toward HOMOPHONIC music with crescendos, diminuendos and more varied orchestral effects. This group set the stage for the great symphonic composers who were to follow: Haydn, Mozart and Beethoven.

manual *Music* The keyboard of the HARPSICHORD or the ORGAN, so called to distinguish it from the PEDAL keys.

manual control *Lighting* Direct control by hand, as distinguished from remote control through electrical or electronic circuitry.

manualiter (*mah-noo-AH-li-tehr*) [German] *Music* On the MANUALS of the ORGAN only, *i.e.*, playing only on the keyboards, using no PEDALS.

manual takeover *Lighting* The act of superseding a programmed cue in an automated lighting-control system by manipulating an appropriate hand-operated control, such as a FADER WHEEL. The operator may choose to take over when the scene is moving at a pace quite different from what was planned, *e.g.*, when the planned FADE must happen much more quickly.

manuscript *Music, Theater* Any handwritten copy of a play or a piece of music, as distinguished from a printed copy.

maquette *Stagecraft* A scale model of the SET or of any significant part of it, made as an aid in constructing the real thing.

maraca (*mah-RAH-kah*) [Spanish] *Music* A hollow shell with a wooden handle, usually made from a gourd and filled with dry seeds that rattle when shaken. Often played in pairs, one in each hand, to enhance the rhythm of Latin American dance music.

marcando (*mahr-KAHN-doh*) [Italian] *Music* Literally, marking. *See* MARCATO.

marcato (*mahr-KAH-toh*) [Italian] *Music* Marked, *i.e.*, individually accented.

march *Music* A piece of music composed to accompany anyone who marches, and to help them keep in step.

marching band *Music* A band of WIND INSTRUMENTS and PERCUSSION that specializes in outdoor performances including exhibition marching, sometimes in elaborate patterns, at civic affairs, football games and the like. When perfoming, such a band is usually led by a DRUM MAJOR with or without additional BATON TWIRLERS. The band rehearses, however, with its regular conductor.

mariachi (*mah-ree-AH-chee*) *Music* A small Mexican street band, usually of two or three players who perform for tips. A typical band includes two VIOLINS and one or two GUITARS.

marimba *Music* A tuned PERCUSSION instrument of African origin. Similar to the XYLOPHONE but of mellower tone, it consists of tuned hardwood bars arranged on horizontal rails to make a chromatic scale of six or seven octaves, with resonant tubes mounted below the bars. The player strikes the bars with soft MALLETS to produce a mellow tone of brief duration. An accomplished marimbist may hold two mallets in each hand, and play complex HOMOPHONIC or CONTRAPUNTAL music. The marimba is a major component of the Latin American dance band.

marionette *Puppetry* A PUPPET manipulated from above by means of strings.

mark *Dance* To move through the floor patterns of a dance or a section of it, indicating the steps, positions, jumps and leaps of the dance with simple gestures and words. A technique for outlining a dance and for refreshing the performer's memory of its form, with more detail than a WALK-THROUGH.

Stagecraft To place a MARKER on the stage floor for an actor to find a specific point on stage, or to indicate the exact position of a piece of furniture or a FLAT so that it can be properly and quickly placed there during a scene change. *See* SPIKE, SPOT.

marked *Music* Individually accented.

markers *See* GLOWTAPE, L.E.D., PEG, SPIKE, SPOT.

marking up *Costume* The process of marking the dimensions and placement of seams on a MUSLIN MODEL during the first costume-fitting session. As a general practice, the fitter uses a MARKSTITCH for the purpose.

"mark it" *Lighting* A lighting director's instruction to the operator during a LIGHT REHEARSAL to write down the setting to which a DIMMER has just been moved for a certain cue.

Stagecraft A stage manager's instruction during the preparatory setting up of the stage, to mark the spot where a piece of scenery or a prop has been placed, so that it can be replaced in exactly the same spot during an actual scene change in the show.

markstitch *Costume* A stitch made in a MUSLIN MODEL to indicate the location of a cut or a seam during the first costume-fitting session.

mark up *Acting, Lighting, Stagecraft* To make notes in the SCRIPT of CUES, ENTRANCES and other reminders or instructions.

marqué (*mahr-KAY*) [French] *Music* See MARCATO.

marquee (*mahr-KEE*) [from French] *Theater* A large canopy built out over the sidewalk at the front entrance of the theater, usually with a large sign carrying the name of the show and/or its STARS in bright lights.

martelé (*mahr-teu-LAY*) [French] *Music* Literally, hammered. A technique of BOWING a stringed instrument in short, heavy, quickly released strokes with the bow laid on (not lifted from) the string. Not to be confused with the several methods of bouncing the bow.

martellato (*mahr-tel-LAH-toh*) [Italian] *Music* Hammered, *i.e.*, heavily accented and DÉTACHÉ.

mascara *Makeup* Coloring for the eyelashes and/or eyebrows.

mashed potato *Dance* In the late 1950s, a solo ROCK dance somewhat like the CHARLESTON.

mask *Acting* To block the audience's view of another actor.

 Costume A piece of cloth covering all or part of the actor's face as a disguise. *See* DOMINO.

 Lighting Short for any of a number of devices, such as BARN DOORS, IRISES or other BAFFLES designed to prevent light from spilling into places where shadow is desired. *See* COOKALORIS, FLAG, GOBO.

 Makeup 1. A character's face, considered as a whole image to be achieved with makeup. 2. A complete face, built up with latex and pigments, worn by an actor to represent a character in the play.

 Stagecraft To conceal something from the audience by means of a FLAT, a DROP or a TEASER.

 Theater See MASQUE.

masked ball *Dance, Music* A social gathering for the purpose of dancing, where all participants attend in costume, usually wearing DOMINOS.

masker, masquer *Theater* One who plays in a MASQUE.

masking control *Lighting* Any device such as an IRIS or BARN DOORS, that modifies the shape of a beam of light and can be adjusted by means of handles or knobs.

masking leg *Stagecraft* A LEG hung along the offstage edge of a WING to mask the backstage area that the wing cannot completely conceal.

masking piece *Stagecraft* Any DROP, FLAT or piece of scenery used to mask something on stage.

masque *Theater* An elaborate and aristocratic entertainment of the 16th and 17th centuries. It was usually based on an allegorical subject, with members of the nobility taking prominent parts. The earliest were in pantomime and included dancing. Later poetry, dialogue

and songs were added. In England Ben Jonson, John Milton and other great poets wrote texts for which Thomas Campion and William Lawes provided music. Lawes and his contemporaries introduced the concept of RECITATIF, foreshadowing the development of OPERA, which was being invented in Italy at the same time.

masque tragedy *Theater* Any tragedy in which the performers wear masks, such as the classical tragedies of ancient Greece.

Mass *Music* The central ritual of the ancient Christians still practiced by Roman Catholic, Greek Orthodox and Episcopalian churches, based on a formal reenactment of the last supper of Christ and his disciples. Certain sections were chanted in very early times. By the year A.D. 500 the KYRIE, GLORIA, SANCTUS and AGNUS DEI were adapted as melodies, followed by the CREDO, which was not, in fact, part of the original structure. By 1050 these and other parts of the Mass were being set polyphonically. The 15th and 16th centuries saw the composition of entire Masses by great composers from Dufay to Palestrina. Development continued as the musical Mass expanded into the secular world with the *Mass in B Minor* (1732–1739) of Johann Sebastian Bach, and many by Haydn, Mozart, Beethoven and others. Although these musical pieces are among the world's greatest works of concert and church music, it is important to remember that the Mass began as a dramatization of a mystical event, and its performance even in modern times is shaped as drama. *See also* LITURGICAL DRAMA.

mass drama *Theater* A play in which a group, rather than an individual, is the chief FOCUS.

mässig (*MAY-sikh*) [German] *Music* Moderate, moderately. In much music printed in Europe, the term is spelled with the German double-s: *mäßig*.

mässig bewegt (*MAY-sikh buh-VEHKHT*) [German] *Music* Literally, moderately moved. Moderately fast.

mast *See* CHARIOT AND POLE SYSTEM.

master *Audio* The final perfected tape or disk recording from which copies may be manufactured.

 Lighting Short for MASTER CONTROL.

master carpenter *Stagecraft* The person in charge of building all scenery and furniture for the theater.

master class *Acting, Dance, Music* A class for gifted individual students at the graduate level, taught by an accomplished performer, often in a single session devoted to one scene or work, with other master-level students looking on.

master control *Lighting* 1. A control that determines the total power being sent to other controls in the system. 2. A control that moves other controls to which it is connected.

master controller *See* PRESET.

master crew *Theater* In professional theater, the group of chiefs of the various stage crews, *i.e.*, CHIEF CARPENTER, CHIEF ELECTRICIAN, costume and properties managers.

master dimmer *Lighting* A DIMMER that controls other dimmers.

master dimmer wheel *Lighting* A large wheel that turns the MASTER DIMMER or a set of dimmers to which it is mechanically locked. Its shape is intended to distinguish it from other controls in the busy environment backstage. *See also* PRESET.

master duplicate *Motion pictures* A duplicate of the final, fully edited, CONFORMED ORIGINAL of the motion picture from which INTERNEGATIVES can be made.

master electrician *Lighting* The supervisor of all electrical work on the stage or the motion picture SET. The head of the electrical crew.

mastering *Audio* In recording technology, the process of preparing a master recording from which copies may later be made. Mastering usually involves MIXING several individual tracks made simultaneously during the recording session, and rebalancing them so that their electronic signals will be perfectly reproduced in the MASTER.

master of ceremonies *Vaudeville* The person who introduces the individual acts of a radio, television or vaudeville show.

master prop man, master prop person *Stagecraft* The person in charge of everything to do with the PROPS and SET DRESSING for a show.

mastersinger *See* MEISTERSINGER.

mat *See* TAP MAT.

matinée (*mah-tee-NAY*) [French] *Theater* Literally, morning. A performance given during the afternoon rather than the evening.

matinée call *Theater* Notice to actors and crews to report for an afternoon performance.

matinée idol *Acting* A STAR, especially a young and handsome male whom audiences find irresistible.

matlanchines, los (*lohs MAHT-lan-CHEE-nehs*) [Spanish] *Dance* A Mexican folk dance in which the leader (*matlanchia)* directs the movements of men and women arranged in circles.

mattress *Circus, Vaudeville* A thick pad hidden in the set to soften the impact when a clown pretends to take a disastrous fall.

Makeup A false beard.

maxixe (*mahk-SEEKS*) *Dance* Originally a lively Brazilian folk dance, based on the rhythms of the HABAÑERA combined with movements of the POLKA. It enjoyed great popularity as a ballroom dance in the United States and Europe around 1914.

May dances, maypole dances *Dance* Generic terms for the many forms of round dance based on ancient pagan rites celebrating the coming of spring and regeneration, known in many

countries around the world. In some, particularly in England, dancers moved around a maypole or small tree, a fertility symbol adorned with flowers and sometimes with ribbons that were thought to transmit vigor and virility to the participants. *See also* MORRIS DANCE.

mazurka *Dance, Music* Any of several Polish folk dances for couples, in triple time with a heavily accented first beat in every measure. Also, a CHARACTER DANCE in ballet. The mazurka became popular in the 18th century and has inspired great music by many composers, particularly Frédéric Chopin.

mbira (*um-BEE-rah*) *Music* An instrument from Central Africa and the Congo, of many forms and names, similar to the KALIMBA, with a hollow gourd as its resonant chamber.

MC *See* MASTER OF CEREMONIES.

McCandless method *Lighting* A method of lighting the stage conceived by the lighting designer Stanley McCandless, a professor at the Yale University School of Drama, as a basic plan from which a designer may build an individual style of lighting for a specific play. The acting areas are lighted from both sides with slightly cooler colors on one side and slightly warmer on the other, and from the front with SPOTLIGHTS mounted on light pipes. The upstage area is covered by lights on the first pipe just behind the main curtain, the downstage area from beams in the FRONT OF THE HOUSE. The spots are aimed across the stage from opposite sides and strike the actors at an angle, *e.g.,* 30° to 45° from the stage floor, low enough to illuminate them without unwanted facial shadows, but high enough to avoid visible shadows elsewhere in the set. Their colors and intensities are balanced to enhance the three-dimensional modeling of the scene and bring out its dramatic qualities. *See also* DOUBLE HUNG.

MCU *Motion pictures* Abbreviation for MEDIUM CLOSE-UP.

MD *Theater* Abbreviation for MUSIC DIRECTOR.

meantone temperament *Music* A system for tuning a keyboard instrument so that chords based on most of the tones in the scale will sound well. Since keyboard instruments are limited by practical considerations to a few keys per OCTAVE, musicians discovered in the 16th century that they could not play chords that sounded in tune on all the scale tones of the KEY in which they wanted to play, nor could they play in more than one key. In the course of many years of experimentation, they discovered a way of tuning their instruments by adjusting one note after another in a sequence of FIFTHS, working upward and downward from MIDDLE C. This sequence provided some flexibility, but they found that A-flat was grossly out of tune with the previously established G-sharp. (*See* COMMA OF PYTHAGORAS.) One could play on this keyboard, therefore, with some degree of consonance between the intervals, provided one did not modulate too far from its "mean tone," the original C. To play in other keys, they had to retune the instrument with a new mean tone. During the next century, up to the time EQUAL TEMPERAMENT was conceived, composers tended to write in keys they could tune up with convenience, considering these their safe keys and avoiding others. It was the mathematically minded makers of fine instruments who continued to cope with the problem and to analyze it scientifically. EQUAL TEMPERAMENT was developed in its final form by Andreas Werckmeister around 1700 and Bach celebrated its birth with the forty-eight preludes and

fugues of his *Well-Tempered Clavier*. Meantone temperament survives to this day, however, as the best tuning for pieces that were written for it.

measure *Dance* A slow, dignified court dance from Elizabethan England. A form of BASSE DANSE, mentioned in Shakespeare's plays.

Music A discrete unit of musical time consisting of a number of BEATS and defined by BAR-LINES. A WALTZ is written in pairs of measures of three beats each. A MARCH usually consists of measures of two or four beats each but those beats may be double or triple. In ordinary practice, a measure of music is considered to exist between barlines; according to more rigorous theory, it is defined as the fundamental unit of rhythmic structure consisting of an ANACRUSIS that leads over the barline to the CRUSIS that is followed in turn by the METACRUSIS. Also called a BAR. *See* RHYTHM.

mechanical dimmer *Lighting* Any mechanically operated device that reduces the intensity of a light, such as an IRIS SHUTTER.

mechanical interlock *Lighting* A physical connection between mechanical DIMMERS that permits all to be adjusted by moving one. Usually the connection can be established or canceled with a simple twist of a main interlocking connection, so that the operator can handle the dimming circuits separately during the main part of the scene and connect them for a simultaneous FADE-OUT at the end. *See also* DIFFERENTIAL DIMMING.

mechanical right(s) *Music* The right to reproduce, manufacture and sell copyrighted music in recorded form. These are SUBSIDIARY RIGHTS, implied in the primary right of reproduction under the U.S. Copyright Law of 1978, and generally defined and negotiated individually in any contract.

mechanics *Acting* The initial BLOCKING and general patterns of movement of all the actors in a scene.

mediant *Music* The special name used in harmonic analysis for the third degree of the SCALE.

medium close-up *Motion pictures* A CLOSE-UP taken from a distance that allows a little of the environment to be visible. *Compare* TWO-SHOT, WIDE-ANGLE SHOT.

medium curtain *Stagecraft* A curtain closed at moderate speed at the end of a scene.

medium long shot *Motion pictures* A SHOT taken from a position somewhat distant from its subject, so that the subject appears relatively small on the screen, but not so small that details are lost. *Compare* LONG SHOT, ZOOM.

medium shot *Motion pictures* Any SHOT taken from a few feet away from its subject so that the environment is fully established and recognizable though the subject remains dominant. Not to be confused with a TWO-SHOT.

medium throw *See* THROW.

medley *Music* A piece of music made up of a series of other pieces, with connecting passages between them. *Compare* OLEO.

megahertz *Electronics* 1,000,000 HERTZ.

mel *Music* A technical unit devised by acousticians to measure the human ability to distinguish the difference of pitch between two tones. One mel is the difference of pitch between a tone of 1,000 Hz, and another of 999 Hz.

melisma *Music* A decorative, expressive, melodic improvisation sung on a single syllable. In some styles of music, particularly the music of the Middle East and the Orient, melismas include MICROTONES.

mellophone *Music* A brass instrument similar in appearance to the French horn, of simpler construction and with a shallower MOUTHPIECE like that of the trumpet. Its tone resembles that of a FLÜGELHORN. The mellophone was frequently used in marching bands in place of the French horn, which is more difficult to play.

melodeon *Music* A small REED ORGAN with one (and, infrequently, two) MANUALS, suitable for parlor use. *See also* HARMONIUM.

melodia *Music* The name of an organ STOP of particularly sweet tone that is produced by 8-foot wooden FLUE PIPES.

melodic *Music* Pertaining to melody, as distinguished from HARMONY.

melodic minor scale *Music* In traditional (19th-century) theory, a minor scale that is modified when it is used melodically. Thus, as an ascending scale it has its MINOR THIRD but its sixth and seventh tones are not lowered to their minor positions. As a descending scale, the sixth and seventh are lowered. *Compare* HARMONIC MINOR SCALE.

melodious *Music* Richly melodic, tuneful.

melodrama *Theater* 1. In the 17th and 18th centuries, a play with music. 2. A form of theater in the late 19th and early 20th centuries. A combination of sentimentality and violence accompanied by spectacular stage effects, melodrama enjoyed great success in the United States and England. In a typical plot, a virtuous hero is called upon to protect an innocent heroine from "a fate worse than death" at the hands of a scheming villain. The modern soap operas of radio and television may be an outgrowth of early melodrama. *See also* CAMP, RESCUE OPERA.

melodramatic *Theater* Having the exaggerated quality of a MELODRAMA.

melody [from Greek, "to sing"] *Music* In the strictest sense, an understandable and orderly succession of single musical tones. Subjectively, the impression of movement through a succession of single musical tones to a satisfying conclusion. *Compare* HARMONY.

membranophone *Music* Any DRUM with a head of tautly stretched parchment or plastic.

memory lighting system A lighting system controlled by a computer into which circuit information and light CUES, including intensity, rates of dimming, etc., can be programmed to be operated later, when the cues occur in the play, by simple key strokes.

mending cleat *See* DUTCHMAN.

meno (*MEH-noh*) [Italian] *Music* Less.

meno mosso (*MEH-noh MOS-soh*) [Italian] *Music* Less quickly.

mensural music A term from the 13th century meaning measured music, *i.e.*, time-based, as distinguished from PLAINSONG that derived its timing from the words being sung.

mensural notation *Music* An ancient system of notation developed by Franco of Cologne in 1250. It assigned relative time values to musical notes, making it possible to write POLYPHONIC music with precision, an impossibility when timing depended entirely on the words being sung. It was the foundation of the notational system used today.

menuet *See* MINUET.

merde (*mehrd*) [French slang, "feces"] *Dance, Theater* The word (normally taboo) used by actors and dancers to wish good luck to a performer about to go on stage. *See also* BREAK A LEG, TOY-TOY.

merengue (*meh-REHN-gay*) [Spanish] *Dance* A couple dance in fast 2/4 time from the Dominican Republic, popular in the United States in the 1950s. Accompaniment usually consists of SAXOPHONE, ACCORDION, metal scraper and DRUM, with or without a singer.

merry Andrew *Circus, Theater* A clown.

merry-go-round *Circus* A ride for children and their escorts, consisting of a revolving platform with wooden horses and other animals rising up and down to the music of a CALLIOPE.

messa di voce (*MES-ah dee VOH-cheh*) [Italian] *Music* A vocal technique, part of the 18th-century BEL CANTO tradition, consisting of a gradual CRESCENDO followed by a DECRESCENDO while sustaining a single tone. Singers exercise with it, but do not often employ it during performance. Not the same as MEZZA VOCE.

message play *Theater* A play intended to make a political or didactic point.

messe (*MES-eh*) [German] *See* MASS.

Met, the *See* METROPOLITAN OPERA.

metacrusis *Music* The aftermath of the CRUCIS (principle accent) within a MEASURE of music. In general terms, the unaccented beat(s) after the first beat of a measure of music and ahead of any upbeat to the next measure. *Compare* ANACRUSIS.

metakinesis *Dance* The psychic or nonphysical aspect of movement, described by the American dance critic and writer John Martin as one of the major principles of MODERN DANCE. Others are substance, dynamism and form.

metal *See* HEAVY METAL, THRASH METAL.

metallophone *Music* Any percussion instrument of definite pitch with sound-producing parts made of metal. The class includes BELLS, GLOCKENSPIEL, STEEL DRUMS, GONGS and CROTALES.

meter *Audio* A device that measures the amount of electrical power flowing through a circuit.

Motion pictures A device for measuring the amount of light in a scene to be shot.

Music The fundamental repeating pulse of any piece of music usually indicated by a TIME SIGNATURE, not to be confused with either RHYTHM or TEMPO. The fundamental metric pattern is divided into MEASURES by BARLINES. In traditional music from the 14th century to the present, the basic metric pattern repeats from measure to measure. The metric pattern of the MINUET, for example, consists of measures of three quarter notes each, repeating throughout the piece. RHYTHM is a pattern of long and short durations and accents and nonaccents superimposed on a fundamental meter.

Method *Acting* A formal technique of psychological preparation for acting developed by Konstantin Stanislavski from the practice he and others taught at the MOSCOW ART THEATER and later in Europe. (*See* STANISLAVSKI METHOD.) In the United States this technique is associated with the Actors Studio in New York City, and particularly with Lee Strasberg, one of the studio's founders and its director for many years. Strasberg is thought to have been the first to call Stanislavski's technique the Method.

Music A sequenced program of musical exercises designed to develop instrumental proficiency.

method actor *Acting* An actor who practices the METHOD.

metronome *Music* A clockwork device made famous by Beethoven's acquaintance Johannes Maelzel, but actually invented around 1812 by Dietrich Nicholas Winkel of Amsterdam to help performers understand the correct tempo of a piece of music. It consists of a weighted rod, mounted vertically so that it can rock from side to side in a regular motion like a pendulum, making an audible click with each change of direction. By raising or lowering the sliding weight along the rod, the duration of the swing can be changed. Gradations scored along the rod indicate the number of swings and clicks the rod makes each minute. Modern metronomes do the same job electronically.

metronome marking *Music* An indication of pace or TEMPO, written at the beginning of a piece of music or whenever appropriate within it. Since Beethoven, who was the first to use it, tempo is indicated in beats per minute, with the attribution "M.M.," short for "Maelzel's metronome."

Metropolitan Opera *Music* The great opera house and company of New York City that has flourished under world-famous conductors and with legendary singers since 1883. It occupies one of the grandest opera houses in the world at Lincoln Center.

metteur en scène (*meh-teur anh SEN*) [French] *Theater* Literally, one who places in scene; a DIRECTOR.

mezzanine *Theater* The lowest balcony of a theater, sometimes actually a raised portion at the back of the orchestra seats, sometimes the front section of the first balcony with its own entrances. *See also* DRESS CIRCLE.

mezza voce (*MED-zah VOH-cheh*) [Italian] *Music* Literally, half voice. With restrained vocal energy, producing not only a quieter tone but also a tone of a different, more veiled TIMBRE than the normal voice.

mezzo forte (*MED-zoh FOR-teh*) [Italian] *Music* Medium loud, but less loud than FORTE.

mezzo piano (*MED-zoh pee-AH-noh*) [Italian] *Music* Literally, half quiet, or not as quiet as PIANO.

mezzo-soprano (*MED-zoh soh-PRAH-noh*) [Italian] *Music* A SOPRANO voice of low REGISTER, midway between the soprano register and that of the CONTRALTO.

mezzo-soprano clef *Music* A C-CLEF, not in frequent use, centered on the second line of the STAFF, to permit the notation of most of the range of the MEZZO-SOPRANO voice without requiring LEDGER LINES.

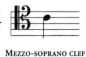

MEZZO-SOPRANO CLEF
(MIDDLE C)

mf *Music* Abbreviation for MEZZO FORTE.

mhz *Audio* Abbreviation for MEGAHERTZ.

mi (*mee*) *Music* The SOLMIZATION syllable sung on the note E in the FIXED-DO SYSTEM, or on the third note of whatever scale is in use in MOVABLE-DO.

mic (*mike*) *Motion pictures* Variant spelling for an abbreviation of MICROPHONE, common in motion picture crafts.

mickey-mouse *Motion pictures* To imitate the movements of an image on the screen with music that precisely matches each move with an accent. The term is derived from animated movies made for children, where musical accents were exaggerated for comic effect.

microphone *Audio* A device that converts physical sound into electronic signals that can be transmitted along a wire to an amplifier or other device. *See also* BOSOM MIKE, LAVALIERE, MOUSE, SHOTGUN MIKE.

microphonics *Audio* FEEDBACK through a microphone. A piercing screech that occurs when a microphone is accidentally placed in line with a loudspeaker on the same live audio circuit. The microphone picks up any sound it hears and sends it through the amplifier to the speaker where it comes out louder. The microphone picks up its own signal through the loudspeaker again and repeats the transmission, then again and again, getting louder each time until in microseconds it becomes unbearable. If not cut off, it will ruin the equipment. *See also* RESONANCE.

microtone *Music* Any interval less than a SEMITONE. *Compare* QUARTER TONE.

middle c *Music* The note C between the TREBLE and BASS clefs.

MIDDLE C

middle line *Acting, Stagecraft* The center line of the stage, perpendicular to the line of the PROSCENIUM.

midrange *Audio* 1. Describing the middle range of the audio spectrum, between the HIGHS and the LOWS. 2. A LOUDSPEAKER that produces only the central portion of the audio spectrum, between the high range of the TWEETER and the low range of the WOOFER.

midway *Carnival, Circus* An area set up like a temporary esplanade between the entrance gate and the BIG TOP, lined with booths and SIDESHOWS providing entertainment, games and food.

mike *Audio* Short for MICROPHONE. 1. To set up a microphone to pick up sound from a specific area or instrument. 2. To attach a BOSOM MIKE, LAPEL MIKE or LAVALIERE to a person's clothing to pick up that person's voice.

miked *Audio* Said of an area where a MICROPHONE has been set up and connected, or a person who is wearing one.

mike fright *Acting* A performer's disabling fear of speaking into a MICROPHONE.

mike placement *Audio* The geometry of the position of the MICROPHONE in relation to the sound it is intended to pick up.

miking *Audio* The process of setting up MICROPHONES for a recording.

milk *Acting* To attempt to elicit a more intense reaction from the audience for a LINE, a piece of BUSINESS or a scene than it deserves.

milonga (*mee-LON-gah*) *Dance* An Argentinian dance of the late 1800s that, combined with the HABAÑERA, became part of the TANGO.

mime *Acting* 1. A performer who specializes in PANTOMIME. 2. To act with facial expression, gesture and movement, but without speaking. 3. In ancient times in Greece and Rome, an entertainment that eventually developed into COMMEDIA DELL'ARTE.

mimesis (*mee-MAY-sis*) [Greek] *Theater* Literally, imitation. In theater, ever since Aristotle used it to describe the fundamental process of drama as an imitation of an ACTION and of life, the term has meant re-creating in action and words a conception of a character, in the context of a dramatic event, that exists only in the mind and is expressed in gesture and word; a fundamentally creative act. It is analogous to the manner in which a MIME creates a character, not merely imitating a familiar person, but inventing gestures, combinations of movements and situations that are both human and suggestive of feelings, creating in the audience's mind someone entirely believable.

mimo drama *Theater* A serious drama in PANTOMIME.

miniature score *Music* A SCORE printed in small size, not to be confused with a SHORT SCORE.

minim *Music notation* In Britain, the name for a HALF NOTE.

minimalism *Music* Part of a late 20th-century movement to emancipate music from its classical restraints by reducing its formal elements as much as possible. Some com-

posers wrote for percussion without pitch, others for harmony without rhythm, still others eliminated order itself by giving different instruments different motifs to play but requiring them to play at different tempos and in different registers without any relationship between them. (*See* ALEATORY MUSIC.) John Cage experimented with all of these possibilities, and also explored silence as an experience for an audience to share. Steve Reich experimented with combinations of phrases of different lengths written for different instruments to play simultaneously, letting their differences work out in automatic fashion. Philip Glass created long periods of static chords with instruments and voices playing repeated figures within the harmonies, changing from time to time to other chords with similar movement within. (*See* TRANCE MUSIC.) Many minimalist works have been composed as accompaniment for stage presentations or motion pictures, where their generally static harmonies match the slowly evolving tableaux.

minimalist One who composes minimalist music.

minimum call *Acting* The least amount of time, and therefore the least amount of pay, for which a member of a performers' union can be hired for a rehearsal or a performance.

miniseries *Television* A SERIES of shows based on a single subject or plot, with two or more segments. The subject may be fictional, historical or documentary.

minnesinger [from German plural *Minnesänger*] *Music* One of a class of aristocratic singers and poets of the 12th through 14th centuries in the courts of Germany. The earliest known was the Tyrolean Walther von der Vogelweide, many of whose LYRICS, but only fragments of his music, have survived. Another was Tannhäuser (13th century), whose legend Richard Wagner celebrated in an opera 600 years later. The minnesingers were in contact with the French TROUBADOURS, but their music developed quite differently, with many devotional songs and narrative ballads and without the shorter song forms of the French. They were the founders of German music.

minor *Music* Said of intervals of the SECOND, THIRD, SIXTH and SEVENTH that are one semitone smaller than the corresponding major intervals, and of any TRIAD whose third is similarly one semitone lower than the corresponding major third.

minor business *Acting* Any BUSINESS of little importance to the plot.

minor chord *Music* Any chord based on a TRIAD of which the THIRD is a minor third above the ROOT.

minor key *Music* Any KEY in which the third tone is a minor THIRD above the ROOT.

minor-major seventh *Music* Any SEVENTH CHORD with a minor THIRD and a major SEVENTH.

minor-minor seventh *Music* Any SEVENTH CHORD with a minor THIRD and a minor SEVENTH.

minor mode *Music* Loosely, any MODE whose third is a minor third above its TONIC. Strictly speaking, each CHURCH MODE is different from every other in other ways besides the position of its third. Those with minor thirds are: DORIAN, PHRYGIAN and AEOLIAN. The term is used also to characterize (loosely) any music written in a minor key.

minor scale *Music* Any scale whose third tone is a semitone above its second. There are many different minor scales. *See* HARMONIC MINOR SCALE, MELODIC MINOR SCALE, RELATIVE MINOR.

minor triad *Music* Any triad whose THIRD is a minor third above its ROOT.

minstrel *Music* 1. One of a class of professional instrumentalists of the Middle Ages in France, descendants of the itinerant JONGLEURS of the 12th century but of a higher social status. In the 14th century minstrels were permitted to form guilds, just like the other professions. *See also* BARD, GLEEMAN, GOLIARD. 2. Any musical entertainer. 3. A member of the cast in a MINSTREL SHOW.

minstrel black *See* BURNT CORK.

minstrel show *Theater, Music* An American entertainment originating with touring troupes in the early 1800s, consisting of songs, tap and soft-shoe dancing, jokes and banter performed usually by white men in BLACKFACE sitting in a row across the stage with END MEN (MR. BONES and MR. TAMBO) at each end and an INTERLOCUTOR in the center. A typical performance began with a parade around the stage, repartee between the interlocutor and the endmen, then a variety show with individual songs and dances by various members of the cast, and ended with an improvised skit. The genre was a staple in VAUDEVILLE and was imitated in comedy routines in films. By the 1900s it had evolved into an entertainment, chiefly by amateurs, members of clubs and local social organizations. It remained popular until the middle of the 20th century.

minuet *Dance, Music* A slow, formal dance for several couples, with three beats to the measure, popular in the courts of England and France in the 17th and 18th centuries.

miracle play *See* MYSTERY.

mirror dancer *Dance* (derogatory) A dancer who performs with an expressionless face and makes no eye contact with others, ostensibly because of concentrating exclusively on solo practice before a mirror.

mirror exercise *Acting* An exercise in IMPROVISATION and quick reaction for two actors facing each other. While one invents gestures and body movements, the other imitates them as if reflected in a mirror.

miscast *Acting* Assigned an inappropriate ROLE in a play.

miscue *Theater* An error on stage caused by a slip of the tongue, the mistiming of a LINE, a light or a sound effect or a failure to react to a CUE.

mise en scène (*MEEZ anh SEN*) [French] *Theater* 1. The art of creating the picture of a play on the stage. 2. The setting of a play in every aspect including the scenery, its lighting and decor, the actors, their costuming, blocking and style of delivery, *i.e.,* everything for which the DIRECTOR is artistically responsible.

Miserere (*mee-zeh-REH-reh*) [Latin] *Music* A penitential psalm (Psalm 51), a major part of the Office for the Dead in Christian liturgy. It has been set to music by many composers

since the Middle Ages, especially as part of a Mass for the Dead, or REQUIEM. Its first line, *Miserere mei Deus* means "Have mercy upon me, God."

missa [Italian] *See* MASS.

miss a cue *Theater* Failure to react on time to a CUE.

missed entrance *Acting* Failure to enter the stage on CUE.

Mr. Bones and Mr. Tambo *Theater, Music* The two END MEN who sit at opposite ends of the line in a minstrel show. Mr. Bones plays the BONES, while Mr. Tambo plays the TAMBOURINE.

mit [German] *Music* With, as in "mit Ausdruck" (with expression).

mix *Audio, Motion pictures* 1. A session during which separate sound tracks are played together simultaneously on synchronized PLAYBACK machines, while the sound editor makes adjustments in their individual volumes and tones, and are then rerecorded onto a single composite track that incorporates all the adjustments. 2. The last stage of preparing the sound track for a motion picture, coming after the INTERLOCK. 3. To make appropriate adjustments in volume and tone of synchronized individual sound tracks during a PLAYBACK session, and rerecord them with those adjustments in a single composite track.

Television To make appropriate adjustments of brightness and color in two or more synchronized video recordings, then rerecord them together with those adjustments onto a single composite video track.

mix-down *Audio, Motion pictures* The process of reducing any number of synchronized SOUND TRACKS to a lesser number of tracks for ease of handling during the editing process.

mixed bill *Vaudeville* Said of any show with two or more different kinds of acts.

mixed media *Theater* A performance that combines live actors and musicians with motion pictures and/or video and prerecorded sound. *See also* HAPPENING.

mixed notices *Theater* Critics' published reviews, some of which are positive and some negative.

mixer *Audio, Motion pictures, Television* The engineer who operates the controls during a mix. If the DIRECTOR is present, the engineer will offer technical advice to the director, who makes all the aesthetic decisions.

mixing *See* MIX.

mixing studio *Audio, Motion pictures* A studio expressly equipped to do a MIX. Typically, it resembles a small movie theater with a few rows of comfortable seats for interested members of the production company, behind which there is a desk and two or three seats for the director, producer and technical advisers, behind which, at a higher level, sit the MIXER and associates at a mixing console. Behind them all is a soundproof wall with openings through which the projector projects the edited WORKPRINT, while sound from all the various synchronized individual sound tracks plays through LOUDSPEAKERS at the front.

Mixolydian mode *Music* A CHURCH MODE, equivalent to the notes between G and G on the white keys of the piano.

mixture *Music* An ORGAN STOP that activates a combination of several different pipes for each note. The different pipes play selected tuned HARMONICS of the principal note, thus creating a more complex sound than that of a simple pipe.

MLS *Motion pictures* Short for MEDIUM LONG SHOT.

M.M., mm *Music* Abbreviation for Maelzel's METRONOME. These initials sometimes appear as part of the TEMPO indication at the beginning of a piece of music. They were first used by Beethoven.

mockup *Stagecraft* A stage set contrived from available pieces of scenery sufficiently appropriate in size and placement to permit the director to start the first stage rehearsals of a play. *See also* MAQUETTE, MUSLIN MODEL.

modal *Music* 1. Said of any melodic composition written within the structure of one of the CHURCH MODES. 2. Having the quality of a mode; said of any piece of music that is primarily melodic, wholly diatonic (*i.e.,* without chromatics) and is not in a major scale. In fact, the major scale is matched precisely in the IONIAN MODE, but is so common in music that only scholars think of it as modal. The Ionian mode was avoided by liturgical composers in medieval times because it was so popular in nonliturgical use. They called it the *modus lascivius*: the lascivious mode.

modal jazz *Music* Jazz in which the harmonic progressions and scales are derived from modes other than the common major or minor scales. Among its best-known practitioners is Herbie Hancock.

mode *See* CHURCH MODES.

modeling *Lighting* The three-dimensional appearance of a well-lighted SET or person on the set, created by careful placement and balance of brightness and color from different sources, the opposite of FLAT lighting.

moderato (*mo-deh-RAH-toh*) [Italian] *Music* Moderately, at a moderate pace, not as fast as ALLEGRO nor as slow as ANDANTE.

modern dance A departure from the traditional structure and movements of BALLET, an attempt to break free from limitations imposed by tradition and create a style more expressive of the dancer's innermost feelings. Isadora Duncan developed INTERPRETIVE DANCE based upon natural rhythms and movements and upon elements acquired in her study of the art of ancient Greece. The dancer, choreographer and teacher Martha Graham confirmed the work of Duncan, Ruth St. Denis and others, focusing mainly on the expression through dance of human emotions and conflicts. Graham also devised a formidable method of body training that calls for a high degree of discipline and virtuosity.

modern dress *Costume* The style of dress in general use at the present time. The opposite of PERIOD COSTUMING.

modern jazz *Music* A stylistic development in jazz beginning in the 1940s, in which the straight 4/4 beat of the bass drum was replaced by a basic time-keeping figure played by the drummer on the HI-HAT (pedal-controlled cymbal), and the harmonic structure of the music was expanded to NINTH CHORDS and beyond. Foremost among its originators were the drummer Max Roach, saxophonist Charlie Parker, trumpeter Dizzy Gillespie, guitarist Charlie Christian and the pianists Bud Powell and Thelonius Monk.

modular lift *Stagecraft* A coordinated system of elevators that controls the height of segments of the stage floor, usually three or four feet square, individually or in combinations. *See* FORESTAGE ELEVATOR.

modular set *See* UNIT SET.

modular stage *Theater* A stage with a floor structurally divided into sections that can be raised or lowered individually or together to various levels.

modulate *Music* To move coherently from one KEY to another within a piece of music.

modulation *Music* A transitional passage that introduces a new KEY. *See also* HARMONIC PROGRESSION.

mogul *Motion pictures* Slang term for any chief of a major American film production studio during the so-called golden age of films, from the 1920s to the 1970s, who made ultimate decisions about what the studio would produce, who would direct, who would be a star and how pictures would be distributed and advertised.

moiré (*mwah-RAY*) [French] *Lighting* A complex, wavelike pattern of light produced by superimposing two patterns, each consisting of many parallel straight lines of light on the same BACKDROP at different angles. The pattern can be changed at any time, or may be kept in constant flux, by moving the light beams. Designers use the moiré frequently to provide a constantly changing backdrop for bands and singers.

moldy fig *Jazz* A derogatory term used by modern and progressive JAZZ players to describe those whom they consider old-fashioned and uninventive.

moll [German] *Music* Minor, as in a MINOR KEY.

molto [Italian] *Music* Very, as in *molto adagio*, very slow.

Momus [from Greek] *Circus, Theater* In ancient Greece, the god of ridicule, hence the god of comedy. A CLOWN.

monaural *Audio* Having a single source of sound, the opposite of BINAURAL or STEREO.

monitor *Audio* 1. LOUDSPEAKERS inside the control booth of a recording studio, set up to permit the engineer to hear either what is going on in the studio during the recording or what is actually being imprinted on the tape. 2. To listen to what is being transmitted through the electronic system during a recording session. An engineer frequently monitors the sound coming directly into the console from the microphones in the studio, and

compares it with the sound that is actually being recorded on the tape, by first monitoring the incoming circuit, then switching to the tape through the studio's PLAYBACK system. If they do not match, the engineer must decide whether to accept it as is or to make changes before continuing.

Television A television picture unit set up in the control room to permit the director and engineers to see what is actually being recorded on the set or in the studio itself so that performers and/or musicians can watch a PLAYBACK to which something new will be synchronized in the SESSION. *See* PRERECORD, POST SYNC.

monobit *See* MONOLOGUE.

monochord *Music* An instrument of one string, used for the analysis of harmonic relationships. In practice the analyst, having established the length and tension of a string that produces a given tone, places movable bridges at various points along the string to change its tone, then compares the change in tone with the difference in length of the sounding portion of the string. By this means, the Ionian physicist Pythagoras discovered that the length of a string that produced an OCTAVE was precisely half the length that produced the FUNDAMENTAL, and so on. In modern times, though the term means one string, acoustic investigators use a more sophisticated instrument with thirteen strings of identical length tuned to the same tone. By placing bridges at different points under all the strings, they can not only make measurements of length but also see graphic curves that represent different scales.

monodrama *Music* A musical drama composed for a single voice accompanied by instruments. *Erwartung* by Arnold Schönberg is a modern example. *Compare* CANTATA. *See also* SCENA.

monody *Music* Music for a single voice with or without accompaniment. *Compare* MONOPHONY.

monologue *Theater* 1. A dramatic work performed by a single actor. 2. An extended speech within a play, such as a prologue or an epilogue, spoken by a single actor with no other actors on the stage. The term usually describes a passage somewhat longer and more complex in subject matter than a SOLILOQUY.

monophonic *Music* Describing music consisting of a single, unaccompanied melodic line. Not to be confused with MONAURAL. *Compare* MONODY.

monophony *Music* Music consisting entirely of a single line, without accompaniment. *Compare* MONODY.

monotone *Acting, Music* Consisting of one unchanging tone, without modulation or expression.

monthly repertory *Theater* A system of scheduling a change of productions once a month.

mooch in *Theater* In theatrical slang, to use one's ability as a professional actor to appear sufficiently important in show business to get into a theater to see a performance without paying for a ticket.

mood *Theater* The emotional atmosphere and general feeling of a play suggested by the look of the SET, the lighting and the general tone of the performance.

mood lighting Lighting designed to establish a mood, rather than a realistic situation.

mood music *Motion pictures* Music, usually fairly soft and without marked accents, chosen as background for sentimental or sad scenes.

mood piece *Theater* A play that emphasizes mood and atmosphere over action. *See also* IMPRESSIONISM.

moonwalk *Dance* A pantomimed walk during which the performer seems to be walking forward while actually moving backward on the stage, performed in music videos and named by the entertainer Michael Jackson, who was inspired by the moves of sneaker-clad street dancers. It resembles a walk performed, often in front of a MOVING PANORAMA, by many famous pantomimists.

morality play *Theater* A didactic, religious folk play of late medieval times based on a biblical story and emphasizing some moral principle, usually (in England) performed as one of a series of plays in an annual PAGEANT. Each play was the responsibility of the members of a craft guild, who built their stage on a wagon so that it could become part of a procession and visit several parts of the town during an appropriate religious festival. Also called miracle play or MYSTERY.

mordent *Music* An ORNAMENT consisting of the alternation of a principal tone with its upper or lower neighbor. It is not usually written out but indicated by a sign over the principal note. The choice between upper mordent and lower mordent, and whether to extend the figure beyond the single motion, is generally left to the performer.

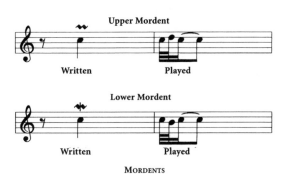

MORDENTS

morendo (*moh-REN-doh*) [Italian] *Music* Dying away.

moresca (*moh-RES-kah*) [Italian] , **moresque** (*moh-RESK*)[French] *Dance* A popular folk dance of the 15th and 16th centuries, performed in Moorish costume with bells on the ankles and the dancers' faces blackened. It became a favorite dance at entertainments during the Renaissance, either as a solo or as a little dramatic scene of battle between Moslems and Christians. Over the centuries many folk dances evolved from the Moresca. One of its descendants is the English MORRIS DANCE.

Morris dance An English folk dance of regeneration. Its origins are in ancient ritual. The name may have come from the Moorish aspect of those dancers who blackened their faces. It is performed by two lines of men adorned in bells, buttons and ribbons, as a lively procession through the streets. Of the many variations on the dances, some remain popular to this day. *See also* MAY DANCES.

MOS *Motion pictures* Without sound. A shot made for visual purposes only, like a CUTAWAY, with no sound being recorded. It is said that a famous film director with a thick German accent working in Hollywood in the early 1930s, when sound was just coming into its own, called for a shot "Mitoudt sound." The assistant cameraman, having no word cue to put on the slate, wrote: MOS. It is sometimes called a mute shot. *See also* WILD SHOT.

Moscow Art Theater A theater company formed in St. Petersburg, Russia, in 1897 by Stanislavski, Meyerhold and others where the STANISLAVSKI METHOD was first developed and refined. *See also* ACTOR'S STUDIO.

moshing *See* MOSH PIT.

mosh pit *Music* The area (without seats) immediately in front of the stage in a hall or a nightclub where ROCK music fans crowd together to dance, shout, push each other around, lift people up and pass them over their heads from one group to another. Musicians on stage sometimes hurl themselves off the stage into the frenzy below, trusting that they will be caught by the crowd before they hit the floor. This activity is called moshing.

mosso [Italian] *Music* Moving along.

motet *Music* A piece of choral music based on a sacred text that first came into being as unaccompanied polyphonic music in the 13th century, and has evolved over 600 years to become one of the most important forms of choral music. It began as a musical interpolation in the expanded cadences of certain liturgical passages. By the 14th century it had grown to become an independent polyphonic form used by composers from Josquin des Prez to the present. In the BAROQUE period, Heinrich Schütz and Johann Sebastian Bach composed many motets, with and without accompaniment, using German texts. A modern descendant of the motet is the English ANTHEM.

motif *Music* A short melodic or rhythmic figure, sometimes only a few notes, that may appear several times in a piece of music as a unifying device. Motifs usually contain recognizable elements of the THEMES.
 Stagecraft A visual element repeated at various locations in the set.

motion choir *Music* A group of singers, usually amateur, who move in simple ways as they sing.

motivated light *Lighting* Any light that exists in the scene for a logical reason spelled out in the script and provides, or seems to provide, illumination from a specific source. A visible reading lamp on a chair-side table is a motivated light, as is the glow that seems to come from a candle but is actually added by a spotlight. *Compare* ARBITRARY LIGHT.

motivation *Acting* An actor's understanding of the reason behind a character's action, an influence that seems present throughout a specific portion of a scene or, more strongly, throughout the play as a whole.

motor-driven transformer *Lighting* A remote-controlled variable transformer that determines the amount of electrical power being delivered to a lighting circuit, and thereby controls the lights' brightness. A transformer controls voltage without most of the residual heat that builds up in an ordinary variable-resistance DIMMER.

Motown, Motown sound *Music* Short for "motor town," a nickname for Detroit, Michigan. It refers to several RECORD LABELS established there in the early 1960s, and to a style of RHYTHM AND BLUES, pop GOSPEL, and pop SOUL music linked with African American vocal groups who performed or made recordings there, such as the Supremes and the Temptations, and with vocalist Marvin Gaye and others.

mount *Motion pictures, Television* Short for camera mount. The steel platform upon which the camera is placed. The mount allows the camera to be fixed in any position. *See also* HI-HAT, PAN/TILT HEAD.

Theater To put a production on stage.

mounting *Lighting* The support for a light fixture that may consist of a specialized clamp or a set of clamps with which the fixture can be firmly attached to a light pipe.

mouse *Audio* A small, omnidirectional MICROPHONE packed inside a thickly padded, protective envelope of dull color, so that it can be placed inconspicuously on the stage floor to pick up performers' voices without also picking up the vibrations of their footsteps.

mouth organ *See* HARMONICA.

mouthpiece *Music* The part of a WIND INSTRUMENT that touches the mouth of the performer, and through which the performer blows to produce sound.

mouth the lines *Acting* 1. To make all the motions of speaking without uttering a sound, usually in a somewhat exaggerated manner so that the audience will be able to guess the words that are ostensibly being kept from other characters in the play. 2. To exaggerate the movement of the lips while speaking in a bombastic manner, adding satirical emphasis to a characterization or to the import of the words. 3. To mumble unintelligibly while the lips are correctly making the motions of words.

movable-do system (*do* is pronounced DOH) *Music* A system of teaching SIGHT-SINGING by which students learn to associate syllables (*do, re, mi*, etc.; *see* SOLMIZATION), with specific notes of the scale in use, as distinguished from FIXED-DO, in which each syllable is restricted to a specific note regardless of the scale being used. Also called SOL-FA, tonic sol-fa.

movement notation *See* BENESH NOTATION, LABANOTATION.

movements in dance *Ballet* The seven basic movements of classical ballet are: ÉLANCER, to dart; ÉTENDRE, to stretch; GLISSER, to glide or slide; PLIER, to bend; RELEVER, to raise; SAUTER, to jump; TOURNER, to turn around.

move off *Acting* A director's instruction to an actor to move away from the center or to leave the stage.

move on *Acting* A director's instruction to an actor to move toward the center or to enter the stage.

movies, the *Motion pictures* 1. The world of motion pictures, as in "She's in the movies." 2. The neighborhood theater, as in "We're going to the movies." *See* NABE.

moving panorama *Theater* A long BACKDROP, gradually unrolled from a vertical axle at one side of the stage and rolled up on a similar axle at the other side, generally painted with a landscape and giving the impression that the actors are making a journey through the countryside. Such a panorama was used by the Venetian COMMEDIA DELL'ARTE troupe, under the direction of Carlo Mazzone at Spoleto in the 1960s for a performance of *The Trip from Venice to Padua*. The actors, all MIMES, faked the act of walking while acting out various scenes of the play. *See also* ENDLESS RUNNER.

moving tracks *Stagecraft* A treadmill set up out of sight behind low scenery to allow an actor to seem to walk naturally without actually moving across the stage. Such a device can be used together with a MOVING PANORAMA, to accentuate the illusion.

Mozarabic chant (*MOH-tsah-RAH-bik*) [Spanish] *Music* The liturgical CHANT of the Christian church in Spain during the medieval period of the 600s and 700s when Spain was under the rule of the Mohammedan Arabs.

mp *Music* Abbreviation for MEZZO PIANO.

ms *Music, Theater* Abbreviation for MANUSCRIPT.

mudra [Sanskrit] *Dance* Any formal gesture of the hand in the classical dancing of India.

mud show *Circus* A small, low-budget traveling circus that follows a day or two behind a larger circus and performs in the same open, presumably muddy, space, hoping to benefit from the advertising and interest generated by the larger show.

muff *Makeup* A false beard.

muff a cue *Acting* To miss a CUE or to react to it incorrectly on stage.

muff a line *Acting* To cut, miss or misspeak a LINE on stage.

mug, mugging *Acting* Overacting, forcing attention to oneself by thrusting the face forward in an exaggerated pose, often with an inappropriate grin or scowl.

mugshot *Acting* An actor's publicity portrait showing the natural face.

Motion pictures Slang for a tight CLOSE-UP of an actor's face.

mule *Stagecraft* A heavy winch mounted on a dolly and used to pull STAGE WAGONS, or to raise or lower heavy DROPS or pieces of scenery, as needed.

multiform staging, multiform theater *Theater* A theater in which the orientation of the audience in relation to the actors can be changed from one show to another. *See also* ARENA, BLACK BOX, THRUST STAGE.

multimedia *Theater* Consisting of elements from different media such as live theater, dance, musical comedy, motion pictures or television. *See also* HAPPENING, LATERNA MAGIKA.

multimetric *Music* Simultaneously having more than one metrical basis as in ALEATORY music. An extreme example is the *Romantic Quartet* of Henry Cowell, in which each instrument plays according to its own beat at a different rate than the beat of any other instrument in the piece. This rhythmic framework made the piece so difficult to play that it waited until long after Cowell's death for its premiere, and then required a carefully made CLICK TRACK to be supplied electronically to each player. Not the same as POLYRHYTHMIC.

multiple control *Puppetry* A single CONTROL that manages the movements of several MARIONETTES.

multiple plot *Theater* Having a main PLOT and one or more SUBPLOTS.

multiscreen *Motion pictures* Said of a motion picture projected on several screens by several synchronized projectors each of which shows only a part of the whole image. Multiscreen technique has been used frequently in trade shows and world's fairs. Two of its most successful American practitioners during the 1940s and 1950s were Charles Eames and Francis Thompson.

multitimbral *Music* Said of electronic SYNTHESIZERS capable of reproducing the sounds of different instruments (*i.e.,* different TIMBRES) playing different lines of music at the same time.

mum *Acting* To act, especially in a MUMMERS' PLAY in disguise.

mummer *Acting* A clown in disguise in a MUMMERS' PLAY or a MASQUE.

mummers' play *Theater* A folk comedy concerned with death and resurrection, performed by amateur actors as stock characters in costume, usually disguised with masks.

muscular memory *Acting* A term invented by Konstantin Stanislavski to describe the memory of superficial things, *e.g.,* how the body moved in an emotional situation, instead of the emotions themselves.

muse In Greek mythology, any of the nine daughters of Zeus (sky) and Mnemosyne (memory) who watched over the arts, including: Calliope (epic poetry), Clio (history), Erato (lyric poetry), Euterpe (music), Melpomene (tragedy), Polyhymnia (religious music), Terpsichore (dance), Thalia (comedy) and Urania (astronomy).

musette *Music* 1. A BAGPIPE with DRONES and two CHANTERS, operated by a bellows that fit under the player's arm. It was popular during the time of Louis XIV (1643–1713). 2. A short piece of music, usually for a keyboard instrument, with a simple dance tune over a GROUND (drone). One of the best known is by Johann Sebastian Bach, from the notebook he compiled for his wife Anna Magdelena.

mushroom *Lighting* Slang for a reflector lamp.

musica ficta [Latin] *Music* Literally, made (*i.e.,* fabricated) music. In musical theory starting around the year 900, any musical tones that did not occur in the DIATONIC SCALE were false tones. Gradually, some became acceptable in practice, beginning with the flatted SEVENTH that appears in GREGORIAN CHANT.

musical Short for MUSICAL COMEDY.

musical adaptation *Theater* A play that has been set to music.

musical comedy *Theater* A modern (20th-century) stage play with music and dancing, a simple plot, usually comic and sentimental, a direct descendant of British music hall comedy and the OPERETTAS of the 19th century. Two famous examples are *Guys and Dolls* (1950) by Frank Loesser, and *The Music Man* (1957) by Meredith Wilson. *Compare* MUSICAL THEATER.

musical conductor *Theater* The leader of the band or orchestra in a MUSICAL COMEDY.

musical director *Opera, Theater* The chief conductor of the company whose responsibility includes the artistic supervision of all musical activities in the organization, and who makes basic musical decisions about new productions, as distinguished from the STAGE DIRECTOR.

musical drama *See* CHORAL THEATER, OPERA.

musicale *Music* A private social gathering for the purpose of listening to music.

musical glasses *See* GLASS HARMONICA.

musicality, musicianship *Music* An innate ability to make music with good INTONATION, a good sense of RHYTHM, fine PHRASING and expressiveness.

musical saw *Music* An ordinary carpenter's crosscut saw held between the knees and played by scraping its back (the nonserrated edge) with a bow. Using the left hand, the player bends the blade to produce different pitches. Also called a singing saw.

musical theater The art of making and presenting plays with music. The term embraces all forms including OPERA, MUSICAL COMEDY, CHORAL THEATER, BALLET and theatrical dance.

music box A mechanical device that produces music. The classic music box was first known in the 18th century. It consisted of a metal cylinder with pins set into its surface. When turned (by clockwork) the pins contacted metal tongues tuned to the notes of the chromatic scale and, by releasing them, produced musical tones. The sound is like tiny bells in a high register. One music box, hidden in a dress owned by Queen Victoria in England in the 19th century, played her national anthem whenever she sat down. A favorite tune for modern music boxes is the "Lullabye" by Johannes Brahms.

music circus *Theater* Summer theater with a high proportion of musical shows, often presented in a large tent.

music copyist A person who copies music from MANUSCRIPT so that it can be read by performers. The typical copyist's job starts shortly before a piece must go into rehearsal, and consists of extracting each vocal or instrumental part from a score and writing it in readable form on its own, separate page. Until the 1990s this was a laborious job accomplished entirely by hand. The modern copyist uses a computer program that speeds up the notation process.

music cue *Motion pictures* 1. A specific FRAME with which a piece of music is to begin. *See also* SYNC POINT. 2. Within a piece of music, a specific moment that is intended to synchronize with a specific FRAME.

Theater 1. A CUE for music. 2. A piece of music intended to be played at a specific time during a scene.

music drama *Opera* A drama in music, an OPERA. The term distinguishes the thoroughly composed works of Richard Wagner and his successors that did not use passages of RECITATIF, from those of Rossini, Verdi and others that did. *See also* CHORAL THEATER.

music hall *Theater* 1. An auditorium designed for concerts. 2. A theater designed for, or specializing in, VAUDEVILLE.

musician One who performs music.

musicology *Music* The study of the theory and/or the history of music.

music roll *See* PIANO ROLL.

music stand A support for an instrumentalist's PART.

music track *Motion pictures* The recorded music of a motion picture that often begins as a strand of AUDIO TAPE, is transferred for editing purposes to strands of SPROCKETED TAPE and becomes, at the end, an OPTICAL TRACK or a magnetized stripe or set of stripes directly on the RELEASE PRINT of the film, beside the VISUAL TRACK.

music video *Motion pictures, Recording* A short video entertainment based on a recorded piece of music. Generally the music video is an extravagant series of montages of members of the band and other persons accompanying a recorded piece of popular music.

musique concrète (*mü-ZEEK konh-KREHT*) [French] *Music* A term coined to describe the music of a few composers of the early 20th century who experimented with sounds produced from hardware and machines. The most notorious of these was *Ballet Mechanique* (1926) by George Antheil, with four (later eight) pianos and two airplane propellers.

muslin fitting *Costume* The first fitting session while costumes have yet to be made. The costume maker creates a MUSLIN MODEL and marks it up to indicate how the final costume should eventually be cut to fit. *See* MARKSTITCH.

muslin model *Costume* A preliminary version of a costume, used in the first costume fitting session to plan the final costume.

mute *Acting* An actor who does not speak or sing. *See also* COMMEDIA DELL'ARTE, MIME, PANTOMIME, SUPERNUMERARY.

Music 1. A small clamp that fits over the bridge of a stringed instrument and modifies its tone, usually making it softer. In Italian, *sordino*. 2. A device that fits into or around the BELL of a wind instrument to modify its tone and make it softer.

mute shot *See* MOS.

Muzak *Music* Trade name for recorded music piped into restaurants, shopping malls, offices or elevators as a soothing background for patrons or workers. The term is frequently used disparagingly to describe continuous, meaningless, boring music. *See also* WALLPAPER MUSIC.

mystery *Theater* 1. A play whose plot features tantalizing questions and the hunt for clues to their answers until the end, when all is revealed as in a detective story. 2. A religious play most often dealing with significant scenes in the life of Christ. *See also* PAGEANT. 3. A secret religious ritual that took place annually at the Bacchic rites at Eleusis in preclassical Greece, from which the Greek arts of comedy and tragedy developed.

mythos (*MEE-thos*) [Greek] *Theater* Literally, myth. Aristotle uses the term in a special sense for a sequence of inchoate ideas that forms the basic structure of the PLOT of a TRAGEDY. He does not require a tragedy to be based on a myth, but uses the word to describe something far less specific and much deeper in human life than a story.

mz *Music* Abbreviation for mezzo, used frequently to designate the MEZZO-SOPRANO line on a musical SCORE.

N

nabe *Motion pictures* Slang for neighborhood theater.

NABET *See* National Association of Broadcast Employees and Technicians.

nachtstück (*NAHKHT-shtük*) [German] *Music* Literally, night piece. *See* Nocturne.

Nagra *Audio* Trade name for a small portable tape recorder with very high fidelity, used to record synchronized sound for motion pictures on location.

nail fiddle, nail violin *Music* A musical instrument invented by Johann Wilde around 1740, consisting of a half-round wooden Soundboard with iron rods of different lengths driven around its rim, played with a violin Bow. The length and size of each rod determines its tuning. When bowed, they produce the tones of the chromatic scale. Having no Vibrato, they have an ethereal effect much like that of the Aeolian Harp or the Glass Harmonica, which were invented in about the same period. In several works of the Avant Garde of the 1970s and 1980s, composers created sounds in the same manner as the nail fiddle, *e.g.,* by using a violoncello bow on the edge of a Cymbal, Marimba block or even a Kettledrum. *Compare* Kalimba.

name act *Theater* An act whose name or the name of its star is well known to the public.

name part, name role *See* Title Role.

name star *Theater* A famous Star.

NARAS *See* National Academy of Recording Arts and Sciences.

narrator *Motion pictures* A person who tells the background story of a motion picture, either On Camera or as a Voice-Over.

Music 1. A speaker who tells the audience the story behind the music and/or comments upon it during the performance. In Stravinsky's *The Soldier's Tale* the narrator describes the soldier and his thoughts as he plods along to the music of a long and intricate march toward a meeting with the devil. 2. A singer who tells the story of the work in Recitatives and/or Arias. Between arias and choruses in the *Passion According to St. Matthew*, by Johann Sebastian Bach, the narrator (called the Evangelist) tells the story of the betrayal and death of Christ.

Theater A character who speaks directly to the audience, telling the story of the plot, commenting upon it or filling in details that are not being represented on stage. In Jean Anouilh's *Lucréce*, while Lucréce and her servants are busy with pleasant chores on stage, two actors (each called Chorus) describe the absent Tarquin mounting his horse and galloping across the countryside onto the cobblestone streets of the city (the sound of which is echoed in the actor's words) on his way to betray her.

narrow beam *Lighting* A SPOTLIGHT focused and limited by an IRIS so that its beam is narrow and the spot it illuminates is small. *See also* BEAM PROJECTOR.

narrow flat *Stagecraft* A special FLAT, narrower than a standard flat, built to fit in between other flats that are offset from each other. *See also* JOG.

National Academy of Recording Arts and Sciences A business association of record producers, distributors and manufacturers who present the annual GRAMMY Awards to recording artists, known as NARAS.

National Association of Broadcast Employees and Technicians A national labor union representing news writers and producers, camera operators, editors, sound mixers and technicans, *et al.,* known as NABET.

National Television Standards Code *Broadcasting* A series of technical protocols drawn up by the National Television Standards Committee to determine, among other things, the specifications of broadcast television including the standard screen with 525 horizontal lines and 60 fields (30 frames) per second using a powerline frequency of 60 Hz, and, when it becomes commercially available, similar standards for high-definition wide-screen television.

natives *Theater* A slightly pejorative term describing a local audience for a touring show.

Nativity play *Theater* A play about the birth of Christ. Nativity plays, mostly by unknown playwrights, were a staple of the English MYSTERY cycles from the 13th to the 16th century. They were performed for the local people by members of local merchant and artisan guilds during the late spring, on Corpus Christi Day, not on Christmas.

natural *Acting* An actor who is perfectly suited to a role, or vice versa.

Music 1. A symbol indicating that the note immediately following is not chromatically altered, *i.e.,* neither sharped nor flatted. *See* ACCIDENTAL. 2. In musical notation, a sign that nullifies the effect of a previous sharp or flat.

NATURAL

Theater A production that is sure to succeed. *See also* ACTOR-PROOF, AUDIENCE-PROOF.

natural harmonics *See* HARMONIC SERIES.

natural horn *Music* A HORN, especially a French horn, with no keys. It produces only the tones that are the natural HARMONICS of a single FUNDAMENTAL tone in its bass register. Since that fundamental is quite low in the bass, its natural harmonics become many and close together above the second octave, so that it is possible for an accomplished player to produce all the tones of the CHROMATIC SCALE in the horn's treble range by "lipping" some of them slightly up or down.

naturalism *Theater* A style of theater that attempts to reproduce life wholly integrated with its environment, without mystical or symbolic significance, expressing this not only in the dialogue spoken by the actors and their way of speaking it, but also in the SETS, costumes and manner of putting the play on stage. Among the plays most often associated with it are Tolstoy's *The Power of Darkness* and several works by Eugene O'Neill. When the style became a movement in theater, in the late 19th and early 20th centuries, the reality sought by the playwrights and actors was that of despair, the bleak world of poverty and political repression.

natural minor scale *Music* A scale with its THIRD, SIXTH and SEVENTH tones lowered one SEMITONE from their positions in the major scale built on the same TONIC. *Compare* HARMONIC MINOR SCALE, MELODIC MINOR SCALE.

neapolitan, neapolitan sixth *Music* The FIRST INVERSION of a TRIAD built on the lowered second tone, *i.e.*, a lowered SUPERTONIC, of the scale (*e.g.,* F - A-flat - D-flat, in the key of C), often used to introduce a DOMINANT in a cadence. It is a characteristic feature of some of the lyrical dance forms of the 17th and 18th centuries, *e.g.,* the SICILIANA.

neck *Music* The narrow extension of any stringed instrument upon which the FINGERBOARD rests, and along which the strings are stretched. The neck of the VIOLIN or similar instrument ends in a SCROLL. The neck of a GUITAR ends in a PEG BOX, that of a LUTE in a PEG BOARD. In every case, the strings are attached to TUNING PEGS set into the sides.

neck roll *Vaudeville* A spectacular acrobatic maneuver discovered by accident when the late 19th-century acrobat Harry K. Morton experienced a severe cramp in his neck during a handstand in a practice session. He lowered himself gently until he could rest one side of his head on the floor, then the rest of the way until his body was nearly horizontal and on the floor, at which point he twisted himself out of the cramp.

negative *Motion pictures* Any photographic film on which colors show up, when the film is developed, as their complementary colors. When printed, the original colors are restored. In motion picture work, the term is also used loosely to designate the ORIGINAL film, whether it is actually negative or not. *See also* REVERSAL.

negative cutter *Motion pictures* In traditional practice, an editor who cuts the ORIGINAL film to conform with the edited WORKPRINT and creates A & B ROLLS. The negative cutter is not concerned with the picture, but with the EDGE NUMBERS printed on the raw film stock by the manufacturer. Those numbers show on the developed original and on the workprint. All the negative cutter has to do is match them exactly. In current practice, this operation is usually performed by an editor using a computer-controlled machine that matches the time codes of the video workprint and the original film.

neighboring tone *Music* A tone immediately adjacent to a principal tone. A trill, for example, is the rapid repeated exchange of a principal tone with the tone immediately above or below it, its upper or lower neighbor.

neo-bop *See* HARD BOP.

neoclassical *Music, Theater* Said of any style that imitates the style of an earlier classical era, *e.g.,* the movement in theater from the 16th to 18th century to re-create the style of classical Greek and Roman drama.

neoromanticism *Theater* A movement in the theater of the late 19th century to recover the lost idealism of romance. One of the great plays of the time was *Cyrano de Bergerac* by Edmond Rostand, which is still produced today.

net *Theater* 1. The total amount of money left over after the NUT and all the expenses of a production have been paid. 2. An open-weave fabric (not a SCRIM) stretched as a low border and decorated to look like an area of natural foliage.

neutral drop *Stagecraft* A cloth DROP of gray or tan color.

neutral stage *Stagecraft* A stage with little or no furniture in a plain SET with a plain background. Shakespeare's Globe Theater had such a stage. The neutrality of the stage enhances the audience's opportunity to imagine a setting far more suggestive than anything that could be designed and built.

New Orleans jazz *Music* A style of JAZZ that originated in New Orleans around the beginning of the 20th century, characterized by strong on-the-beat rhythms, simple harmonies and individual and collective IMPROVISATIONS by every member of the band, often involving the entire group in ecstatic pandemonium. A typical band was small, with a trumpeter, a clarinetist, a trombonist, a bassist and a drummer, all of whom improvised individually or as a group. Sidney Bechet and Louis Armstrong were two of the many great musicians who made the New Orleans style famous with their early recordings and established it as one of the fundamental sources of American jazz. *See also* DIXIELAND, TAILGATE.

new theater A movement of the late 19th and early 20th century to rid the theater of the elaborate visual devices that some thought were obscuring the true strength of theater. Its creators hoped that a unification of word, action and music, set in ritual-like form, would give its audience an intense, spiritual experience. The operas of Richard Wagner were a major part of this movement.

new wave *Motion pictures* In France in the late 1950s, a trend among younger directors such as Jean-Luc Godard, Louis Malle, François Truffaut and others toward a looser, more spontaneous and intimate style of filmmaking. Abandoning the earlier, carefully written forms of the French studio film, new wave directors mixed different styles within the same film and rearranged the chronological structure of plots through lavish use of the FLASHBACK and other devices.

Music Following the PUNK ROCK fad of the late 1970s, a minimalist rock style notable for austere, repetitive arrangements and exaggerated emotional intensity.

Nickelodeon *Motion pictures* A contrived name joining the five-cent coin with the Greek ODEON. The name of a theater that opened in Pittsburgh in 1905, the first of a chain of cheap movie houses all across the country that were little more than converted storefronts. The term has since been used to represent any cheap, popular movie theater. In the 1990s it is the name of a major television cable network.

nine-light *See* BROAD.

ninth *Music* An interval of one OCTAVE and one WHOLE TONE, *i.e.,* nine steps of the scale, inclusively.

ninth chord *Music* A chord of five tones consisting of a TRIAD plus a SEVENTH and a NINTH above the ROOT.

nix *Theater* To veto, forbid or cancel a production or an act.

Nizzarda *Dance* A French couple dance, related to the VOLTA, from the town of Nice (Nizza) in Provence.

No *See* NOH.

nocturne *Music* An evening piece, usually a relatively melodious, meditative piece for the piano. Chopin, who wrote many of them, borrowed the idea from John Field whose nocturnes for the piano were very popular in his time and have been ever since. In German: *nachtstück.*

nod *Theater* A bow to the audience.

nodal point *Music* A motionless point between two opposed and active waves in a taut, vibrating string. In normal conditions, there are many different wave motions going on whenever a taut string is plucked. If, however, one touches very lightly a point that is precisely at the middle of the string, all the existing waves except the wave of that half-length will be damped, making the string sound its second HARMONIC only (without the FUNDAMENTAL), one OCTAVE above its fundamental tone. If one touches the point at one third the length of the string, only the third harmonic sounds, and at one fifth the length, the fifth and so on. By this method of physical experiment, the Ionian physicist Pythagoras discovered the exact relationship of the first seven harmonics to each other. Each involved stopping the string at a precise nodal point.

Nogaku (*noh-GAH-koo*) [Japanese] *Theater* A performance of NOH (serious) plays, alternating on the same stage with KYOGEN (comic).

Noh, No [Japanese] *Theater* Literally, skill. A form of Japanese theater with song, dialogue, music and dance, performed by soloists, a chorus and a small ensemble of instruments. The earliest evidence of Noh dates to the mid-1300s. The art of the actor is its most important feature. A traditional Noh play has two acts, sometimes with a comic interlude. The leading character wears a mask; others do not. The actors sing or speak their lines, the chorus always sings. The basic instruments are a bamboo flute, two hour-glass-shaped drums played with the hands and one barrel-shaped drum played with sticks. The instrumentalists sometimes add a shout as part of their music. The stage for Noh and for other types of theater in Japan is constructed with tightly fitted planks of hardwood to make it resound with the footsteps and intentional stamps of the actors.

noir *See* FILM NOIR.

noise *Audio* Any unwanted signal in an audio circuit that disturbs the clarity of the desired signal. *See also* WHITE NOISE.

noises off *Theater* A stage direction requiring noises from offstage, such as thunder, battle, a crowd mumbling, etc.

noncommercial *Theater* Said of any theater, whether professional or amateur, devoted to the dramatic arts and unmotivated by commercial factors.

nonet *Music* 1. An ensemble of nine instruments. 2. The music played by such an ensemble.

nonharmonic tone *Music* In music theory, any tone that is not part of the harmony of the moment, such as PASSING TONES, which are transitional between harmonic tones, or APPOGGIATURAS.

nonpractical *Stagecraft* Said of any scene unit that looks as if it could be moved, such as a door or a window, but that in fact is unmovable.

non troppo (*nohn TROP-poh*) [Italian] *Music* Not too much, as in *allegro non troppo*: fast, but not too fast.

noodle *Music* To improvise running passages of melody for the pleasure of it, or to warm up. To play in an idle or careless manner.

no-seam *Motion pictures, Television* Very wide, seamless paper used to provide even backgrounds for relatively close shots. It comes in many colors, in rolls that are usually mounted on horizontal pipes above the set and pulled down as needed.

nose paste, nose putty *Makeup* A relatively thick, nonhardening paste used to build up an actor's nose.

notation *Dance* *See* BENESH NOTATION, LABANOTATION.

Music The symbols used for writing music on paper. Modern Western music notation, which came into existence very gradually during the Middle Ages, is based on the idea that a horizontal line may represent a specific PITCH. A NOTE (originally just a small circle or a black shape) placed on that line, above it or below it, indicates a TONE to be sounded on, above or below that pitch. The modern STAFF of five lines, with a CLEF at its head to define one of its lines as a specific pitch of the musical scale, makes it possible to define each of the remaining lines and the spaces between them as scale tones above or below that line. The head and any FLAGS on the stem of the note indicate its relative duration. This system, built on the concept of a vertical scale of definite pitches, has been called harmonic, to distinguish it from other systems in use elsewhere and at other times that are basically melodic, *e.g.,* BYZANTINE NOTATION.

note *Music* A written symbol that indicates the PITCH and duration of a musical tone.

notes *Acting* A DIRECTOR's criticisms and suggestions to the cast after a rehearsal or performance.

note value *Music* The duration of a tone, as indicated by the shape of its note.

notice *Theater* A printed statement from the management of a theater company to the cast and staff informing them that the show will close at a specific time. The rules of ACTORS

EQUITY ASSOCIATION and of the CRAFT UNIONS require such a notice to be posted backstage at least two weeks before the closing date.

notice board *Theater* A bulletin board backstage, usually just inside the stage door, where notices of casting, rehearsal schedules or closings are posted for the cast and crews to see.

notices *Theater* The critics' published or broadcast reviews of a production that appear just after its OPENING.

not in the book *Acting* Said of any interpolated LINE or action not called for in the script of the play.

notturno (*not-TOOR-noh*) [Italian] *See* NOCTURNE.

nouvelle vague (*noo-vel VAHG*) [French] *See* NEW WAVE.

Novachord *Music* Trade name for a small electronic keyboard developed after World War II that could be attached beneath the treble end of a piano keyboard in a position enabling the pianist to play a melody on it with the right hand while keeping up an accompaniment with the other. It produced a violoncellolike sound.

novelty song *Music* In the 1940s and 1950s, a music publisher's category of popular song (as distinct from ballads and rhythm ballads), based on nonsensical words (*e.g.*, "Flat Foot Floogie with the Floy Floy"), comic lyrics or extramusical sound effects such as clapping or STOMPING. Extravagant masterpieces in the sound-effects category were created by Spike Jones and the City Slickers, culminating in their *Musical Depreciation Revue*.

NTSC *See* NATIONAL TELEVISION STANDARDS CODE.

number *Music* A single complete piece of music or of dance. A SET consists of several numbers. A medley is a single number composed of several tunes arranged to be performed in sequence. *See also* PRODUCTION NUMBER, ROUTINE.

number one batten *Stagecraft* The first BATTEN just behind the MAIN CURTAIN.

nun's fiddle *See* TROMBA MARINA.

nut *Music* 1. The short ridge near the TUNING PEGS at the upper end of the FINGERBOARD, over which the strings of a STRINGED INSTRUMENT are stretched. 2. The screw mechanism that tightens the hairs of a violin bow, also called the FROG.

Theater The total cost, per night or per week, of operating a theater, as distinguished from the additional costs required for the production playing in it. It includes costs that must be paid regularly for rent, insurance, staff and maintenance just to keep the theater operating, but not for the cast, crews, advertising, ticket printing, rentals for stage lights, costumes and the like, nor even the extra power required to illuminate the set, all of which are production costs. When a theater company makes a profit, it is said to be off the nut. When things go badly and the company must use some of the money set aside for the nut to pay production expenses, it is on the nut. *See also* OP NUT.

nut act *Vaudeville* A comic act in which plot and lines take second place to coughing, mugging and other funny BUSINESS.

nyckelharpa *Music* An old stringed instrument of Swedish design, with a cylindrical arrangement of strings somewhat like a HURDY-GURDY, played with a BOW.

O

Oakley *Circus* A ticket with a hole punched in it, allowing free admission to the show. Named after Annie Oakley, the sharpshooter of Buffalo Bill's Wild West Show in the 1890s. Her most famous act consisted of shooting a hole in a ticket held in the hand of a willing circusgoer standing some distance away. *See also* COMP.

Oakley holder *Circus* A person who has a free ticket. *See* OAKLEY.

oater *Motion pictures* *See* WESTERN.

obbligato (*ob-lee-GAH-toh*) [Italian] *Music* Literally, required. 1. Originally, when attached to an instrumental part in a SCORE, the term meant the part could not be left out without damage to the overall effect. 2. In modern usage it can mean "optional" as in songs "with flute obbligato," where the flute part may be omitted.

Obie *Theater* An annual award for achievment in OFF BROADWAY production and acting, given since 1956 by the New York weekly newspaper *The Village Voice*.

objective *Acting* In the STANISLAVSKI METHOD, the goal a character strives toward within a "motivational unit" in a scene.

obligatory scene *Theater* A SCENE always expected by the audience, such as a secret meeting between lovers in a romantic play, or a confrontation between enemies in a drama. Called, in French, a *scène à faire*.

oblique flat, oblique scene *Stagecraft* A FLAT or scenery set at an angle to the curtain line of the stage.

oboe *Music* A DOUBLE-REED instrument of treble REGISTER, the highest of a large family of instruments including the ENGLISH HORN and the various BASSOONS. The oboe has a distinctive tone that can be strident and easily heard in the midst of loud orchestral passages, or sweet and flexible in quieter passages and in chamber music. When a symphony orchestra tunes up at the beginning of a concert, the oboe provides the reference tone: A-440.

oboist *Music* A musician who plays the OBOE.

ocarina (*o-ka-REE-nah*) [Italian] *Music* A simple musical instrument made of clay, shaped like a hollow egg, with a hole to blow into and six finger holes to control the PITCH of the tone produced. Its sound is somewhat like that of a flute, usually in a low TREBLE REGISTER. In the United States its common nickname is sweet potato.

octave *Music* 1. A musical INTERVAL consisting of two tones seven scale STEPS apart. In musical nomenclature both tones have the same name. 2. The second HARMONIC (or first OVERTONE) of the HARMONIC SERIES of any FUNDAMENTAL tone, *i.e.,* having exactly twice the FREQUENCY of its fundamental. 3. A unit of the OCTAVE NAME SYSTEM.

octave name system *Music* A system for distinguishing between the seven individual OCTAVES of the audible range represented by the keys of the piano. It consists of seven units. Each unit begins with C as its lowest note and reaches to B, a seventh above. Two slightly different systems are in use today, using capital letters for octaves below MIDDLE C and lowercase letters for the rest. They differ in their designation of MIDDLE C and in their symbols as shown in the illustration. The system used in this dictionary appears as the upper line of letters in the illustration below, and has been chosen because of its logic. The system of names and letters shown on the bottom line has had wide use in academic circles, but mixes subscript numbers with superscript apostrophes, which seems less direct and simple.

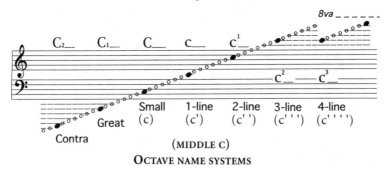

OCTAVE NAME SYSTEMS

octavo (*ok-TAH-voh*)[Italian] *Music* The trimmed size of printed music usually reserved for choral works, equal to one eighth the size of a PRINTER'S SHEET. The publisher generally credited with its first development was Vincent Novello. *Compare* FOLIO, QUARTO.

octet *Music* 1. An ensemble of eight players. *See also* DOUBLE QUARTET. 2. A work of music composed for eight players.

ode [from Greek] *Music* Literally, a song. An extended choral song, usually in praise of something. The CHORAL ODE (in Greek, the STASIMON, an ode with a stationary chorus) was a major component of any play in the classical period in Greece, and appears in several works of more modern times. English poets have used the word as a title for extended lyrical poems, and modern composers have used those poems in extended works for voice and/or chorus and orchestra.

odeon [Greek, properly *odeion*], **odeum** [Latin] *Theater* A place where ODES are sung and therefore, in modern usage, a music hall or a theater.

odic *Music* Having the quality of an ODE.

oeuvre (*EU-vreu*) [French] *Music* Literally, a work. Writers in languages other than French often use the Latin term OPUS.

off *Acting* 1. Offstage. 2. Away from center stage. 3. Not in good psychological shape for acting. 4. Unemployed.

 Music Out of tune, off-key.

off-beat *Music* A secondary BEAT (*i.e.*, accent) within a measure.

Off Broadway *Theater* A loosely organized second tier of professional theaters in New York City that have fewer than 300 seats and therefore operate under special union rules at lower SCALE than the big theaters on Broadway. They function with smaller budgets than the big Broadway houses, charge less for tickets, and produce more artistically challenging works. *See also* OBIE, OFF-OFF BROADWAY.

off-camera *Motion pictures, Television* Said of a person not within the camera's view, particularly one who speaks or makes a sound that is picked up by the microphones and recorded on the sound track.

offertory *Music* A section of the Roman Catholic MASS during which the priest consecrates bread and wine and places them on the altar as a symbolic offering. It has inspired many works of music.

off-line *Television* Said of any process, such as EDITING, performed at leisure, not in real time, *i.e.*, not while broadcasting, thereby allowing the EDITOR time to pause, think, back up and redo as necessary, as distinguished from any process that occurs while on the air, or in any other situation where such interruptions are undesirable.

off-mike *Audio* Said of any performer, or other source of sound, not near enough to a live microphone to be heard clearly.

Off-Off Broadway *Theater* A third tier of theaters operating in New York City, smaller still than OFF-BROADWAY houses, with much smaller budgets, cheaper tickets and even more adventurous programming.

offscreen *Motion pictures* Not on the screen; the movie equivalent of BACKSTAGE.

offscreen space *Motion pictures* The space the audience does not see on the screen but imagines to exist, inhabited, for example, by the gunman to whom the onscreen characters look when the sound track says "Hands up!"

off season *Theater* Any season when no performances are scheduled.

offstage *Acting* Not on stage, *i.e.*, not visible to the audience.

offstage beat *Acting* A subjective feeling of underlying tension or pace in a scene onstage upon which an actor waiting offstage concentrates, thinking of the actions and lines about to be expressed upon entering the scene and preparing the emotional and physical means that enable such expression. Described by Stanislavski and others. *See also* BEAT, METHOD.

offstage cue *Acting, Lighting* Any CUE that originates offstage or is aimed there.

offstage focus *Acting* An intentional focusing of the actors' and, therefore, the audience's attention backstage or into the HOUSE to create the impression that something significant is about to happen out there. Clifford Odets's politically didactic play *Waiting for Lefty* is built upon a setting and a script that make the audience wonder whether there may be union members sitting among them at a tense meeting at which Lefty's nonappearance becomes increasingly ominous.

off the beat *Music* Said of any sound that is regularly not on the main BEAT. *See* SYNCOPATION.

off the book(s) *Acting* During a rehearsal, an instruction to actors to put their SCRIPTS aside and play a scene from memory, to improve their concentration and, perhaps, loosen up the scene.

Music During a rehearsal, an instruction for choral singers to put down their VOCAL SCORES and sing from memory, so that they will be able to listen more closely to each other, sing more freely and, above all, watch the conductor.

off the leg *Ballet* In a bad position, with the body out of proper ALIGNMENT, *e.g.*, with the pelvis not centered over the supporting leg, so that the next step cannot be executed properly.

oldie *Music* A song or other piece of music that has great sentimental value because of its past popularity. Also called a golden oldie.

old-time dancing *Dance* In England, a term that refers to the 19th-century round and square dances like the LANCERS, the POLKA, the VARSOVIENNE and others. These enjoyed a revival in the 1930s among people seeking an alternative to JAZZ DANCING.

Old Vic *Theater* A theater, originally called the Royal Coburg, that opened in London in 1818 and was renamed the Royal Victoria in 1833. Since 1912 it has been the home of several acting companies, reaching a peak in the 1930s and 1940s when John Gielgud, Laurence Olivier and Ralph Richardson each played leading roles there. After World War II, the resident company became the National Theatre, which moved to the new National Theatre space in 1976, leaving the Old Vic to others.

olio *Stagecraft* A painted DROP behind the main curtain providing a background for a scene IN ONE and covering up a scene change that is going on at the same time in the rest of the stage area.

Vaudeville 1. An act performed IN ONE before the painted DROP while the scene behind the drop is being changed. 2. A medley of songs, dances and/or skits performed IN ONE in front of the painted DROP. *See also* AD CURTAIN.

olivette *Lighting* A large, plain FLOODLIGHT with no lens.

ombra scene *Opera* In the earliest operas on mythical subjects, a scene set in the abode of the dead in which a "shade" or ghost appears. *La Favola d'Orfeo* (1607) by Claudio Monteverdi, the first modern opera, has such a scene in which Orpheus goes down to Hades to find his beloved Eurydice among the shades.

omnidirectional mike *Audio* Any microphone designed to pick up sound from all directions. *See also* MOUSE. *Compare* PARABOLIC REFLECTOR MIKE, SHOTGUN.

on *Acting* Onstage, *i.e.,* acting.

 Audio On the air or, by extension, ready to perform.

 Lighting Turned on, live, with electric power in the circuit.

on air *Broadcasting* Said of any program or any performer actively being broadcast at the moment.

on camera *Motion pictures, Television* Said of any performer who is visible to the camera.

ondes Martenot (*ohnd MAHR-te-noh*) *Music* A monophonic electronic instrument with a pleasant tone that can be balanced to sound somewhat like a human voice, developed in the late 1920s by the French composer Maurice Martenot. It consists of a sensitive ribbon connected to circuitry that converts the player's touch into tone which can be heard through loudspeakers. The player determines pitch by placement of the fingers with the help of a dummy keyboard that provides a visual aid. Pitch can vary infinitely. The player can add vibrato or perform a smooth GLISSANDO by moving the finger along the ribbon. Several French composers made use of it in orchestral music during the 1930s and 1940s. Its invention was contemporaneous with the THEREMIN.

one-acter *Theater* A play with a single act.

one-line octave *Music* In the older of the two OCTAVE NAME SYSTEMS, the OCTAVE starting with C above MIDDLE C.

one-liner *Acting* A joke or a quip that requires only a single line. *See also* STAND-UP COMEDIAN.

one-man show, one-woman show *Acting* A show with a single actor who may play more than one character.

one-nighter, one-night stand *Acting, Music* An engagement, usually out of town, for a single performance.

one-quarter position *Acting* A position with the body facing a front corner of the house, at a 45° angle from full front.

one-sheet *Theater* A small-size advertisement requiring only one PRINTER'S SHEET of paper, pasted on a small billboard outside or inside the theater to advertise a show.

one-shot *Motion pictures* A shot with a single actor in it. Not necessarily a CLOSE-UP. *Compare* TWO-SHOT.

one-step *Dance* In the early 1900s, a highly popular RAGTIME dance with a single step on each beat, also called the TURKEY TROT. *See also* CASTLE WALK, PASO DOBLE.

onion ballad *Vaudeville* A very sad song, capable of drawing copious tears from the audience.

onion play *Theater* A very sad play, especially in Yiddish theater, with which the audience can empathize thoroughly. A TEARJERKER.

on-line *Television* Said of any process that must be performed in real time, such as a live broadcast. *Compare* OFF-LINE.

on location *Motion pictures* Away from the studio, shooting in a setting that will be suitable without extensive modification.

on-mike *Audio* Said of any performer or source of sound that is close enough to a live microphone to be heard.

on points *See* POINT.

on spec *Television* Short for "on speculation." It describes the practice of writing or producing a show without pay and without a contract, hoping to negotiate a sale when a potential buyer sees the finished work. *See* PILOT.

on spike *Stagecraft* Said of furniture and other set pieces that have been placed precisely where they belong on the set, *i.e.,* exactly on the MARKERS left for them.

onstage *Theater* In place in the acting area and visible to the audience. *See also* OFFSTAGE, "PLACES."

onstage focus *Acting* The basic tool for attracting and holding the audience's attention in a staged reading, directing it to the readers on stage. Actors accomplish this chiefly by maintaining eye contact among themselves while playing their parts.

on the air *Broadcasting* Actually broadcasting.

on the beach *Acting* A slang term for unemployed.

on the beat *Music* Unsyncopated.

on the boards *Acting* On the stage, *i.e.,* in the acting profession.

on the book *Acting* Said of an actor who is, for the time being, the PROMPTER.

on the road, on tour *Music, Theater* Out of town, traveling.

OP *Acting* Abbreviation for OPPOSITE PROMPT.

op. *Music* Abbreviation for OPUS.

open *Theater* To give the first performance of a new play, new production or new engagement.

open-air *Theater* Open to the weather. Said of any performance space that is out of doors or not under a roof. Shakespeare's Globe Theater had no roof. The music shed at the Boston

Symphony Orchestra's summer location, Tanglewood, has a roof but no side walls. Both are considered open-air performance areas.

open call *Theater* A CASTING CALL that is not restricted to union members.

open circuit *Lighting* A circuit that is not electrically completed and therefore cannot supply power. The switch in such a circuit is open.

open date *Acting* Any date that has not been scheduled for performances or rehearsals and for which the performer is free.

Theater Any date that has not yet been reserved for visiting productions.

opener *Theater, Vaudeville* The first act, the first scene of the show, the introduction.

open fifth *Music* An interval of two tones a PERFECT FIFTH apart sounded simultaneously.

open in *See* OPEN ON.

opening *Theater* 1. The first public performance of a new play, new production or new engagement. *See* OPENING NIGHT. 2. The first event of the show. 3. The introductory scene, the prologue.

opening chorus *Music* The first choral piece of an ORATORIO, CHORAL DRAMA, or OPERA.

opening lighting The lighting designed for the opening scene of the show.

opening night *Theater* The first public (evening) performance of a new production. There may have been out-of-town TRYOUTS and/or PREVIEWS in town and critics may have attended and written about them, but in some cities formal reviews of the production focus on the opening night performance.

opening number *Theater* The first musical number after the show begins, not including the overture (if there is one).

opening situation *Acting* The underlying relationship between CHARACTERS at the beginning of a play that provides the dramatic foundation for the opening scene.

opening time *Theater* The scheduled hour when a show is supposed to start.

open mike *Audio* An active audio circuit that is ready to pick up sounds.

open off *Stagecraft* Said of a door in the scene that opens toward backstage, away from the audience.

open on *Stagecraft* Said of a door in the scene that opens into the scene, toward the audience.

open on a blackout *Acting, Lighting* To open the curtain with the stage dark.

open out *See* OPEN OFF.

open out a speech *Acting* To vary the DELIVERY by changing the pace, adding and/or extending pauses, altogether taking enough time to let the individual meanings of the words and the underlying meaning of the lines be well understood by the audience.

open position *Acting* Any position in which the body faces the audience.

 Dance *See* OUVERT.

 Music 1. The distribution of tones in any CHORD of four voices, in which the upper three are separated from each other by intervals larger than a PERFECT FOURTH. *Compare* CLOSE POSITION. The HARMONICS of tones of a chord in open position tend to agree with each other more than in close position, giving the open chord a particularly clear, almost ringing quality, particularly when it is sung by a chorus A CAPPELLA. 2. The condition of any WIND INSTRUMENT with no keys, valves or finger holes pressed. In open position any such instrument produces one or the other HARMONIC of its natural FUNDAMENTAL tone, *e.g.,* the B-flat trumpet in open position produces B-flat, F, B-flat, D^1 and so on (*See* OCTAVE NAME SYSTEM), depending on the player's lips. They are all harmonics of the fundamental B_1-flat, which is outside the comfortable range of the instrument. *See also* OPEN FIFTH, OPEN STRING.

open rehearsal *Theater* A REHEARSAL that visitors may attend.

open scene *Stagecraft* A freestanding scene on the stage, *i.e.,* not surrounded by painted scenery.

open score *Music* 1. A FULL SCORE. 2. A VOCAL SCORE written with one voice per staff, as distinguished, for example, from one written with female voices together on the upper staff and males together on the lower.

open set *Stagecraft* An interior setting accomplished with WINGS and DROPS, not a BOX SET.

open stage *Stagecraft* 1. A THRUST STAGE with a permanent back and no PROSCENIUM. 2. A stage cleared for BALLET or dance.

open string *Music* Any string, on any stringed instrument, that is not STOPPED, hence a string that produces its FUNDAMENTAL tone. On the VIOLIN, with four strings properly tuned, the open strings produce G, D, A and E.

open turn *Acting* A turn toward the audience.

open up *Acting, Dance* 1. To turn toward the audience. 2. To adjust one's position on stage to give the audience a clear view of another performer.

 Stagecraft To clear the stage of inessential furniture.

open white *Lighting* To turn a light on with no filter in place.

opera *Music* A large staged work of musical theater with sung dialogue, accompanied by instruments. Opera combines all the elements of theater: plot, dialogue, acting, music,

dance, scenery and costume. Although modern opera stemmed from an attempt by a group of Italian composers and poets to re-create the classical Greek drama, which was a synthesis of music with words and action composed by a single author, they actually arrived at an art that is most often the product of a group of creative artists, each working in a different field. Most operas begin with a text adapted from a play or another source, to which a composer adds music. In many cultures across the Middle and Far East, folk rituals from the very earliest periods involved music and movement. Out of such beginnings came the classical Greek and Roman drama. As the tradition expanded into Europe, it divided into two streams: religious and secular drama. Soon there were companies of actors and entertainers among whom were the COMMEDIA DELL'ARTE troupes who flourished in Italy and spread into France in the 15th and 16th centuries. In the late 1500s Italian composers created the genre of MADRIGAL COMEDIES. In the same period, the playwright Molière and the composer Jean-Baptiste Lully were producing ballets for the French court of Catherine de Medici that consisted not only of music and dance, but plots with characters who sang DIALOGUE. With such activities going on everywhere it was perhaps only natural that groups of intellectuals would meet in Florence in the 1590s to see if they could re-create the grand art of classical Greek drama. One such group, meeting at the home of Jacopo Bardi, included the poet Orazio Rinuccini and the composers Jacopo Peri and Giulio Caccini. With texts by Rinuccini, Peri produced *Dafne* in 1597, and Caccini presented *Euridice* in 1602. Each had passages of RECITATIVE with simple chordal accompaniments and both were constructed on the rhythms of poetry rather than on musical principles. The first operatic work in modern form, with ARIAS, SET PIECES and orchestral accompaniment, was *La Favola d'Orfeo* by Claudio Monteverdi with a text by Alessandro Striggio, produced in Mantua in 1607. From that moment on opera has grown to become the largest, grandest, most complicated, most expensive, and certainly most enduring of all serious musical/theatrical forms. Opera today inhabits the best-equipped theaters, with the most thoroughly trained performing and supporting personnel of all the arts and, alone among those arts, maintains an active repertory of works from the most ancient to the most modern. *See also* COMIC OPERA, MUSICAL COMEDY, OPERETTA.

opera ballet A ballet within an opera.

opéra-bouffe (*OH-peh-rah BOOF*) [French], **opera buffa** (*oh-peh-rah BOO-fah*) [Italian] *Music* A comic opera.

opera chair *Music* A comfortable seat in the theater, fully upholstered and with two arms.

Opéra Comique (*OH-pay-rah ko-MEEK*), **Théâtre National de l'** (*tay-AH-treu nah-syo-NAHL deu l'*) [French] *Music* One of the two major opera companies in Paris. Opened in 1715 to present plays with music, called "comic opera," to distinguish them from the more formal court-approved art of serious opera.

opera drape *Stagecraft* A curtain that can be drawn apart at the center into a position where it forms a pleasing edge around the stage opening. *See* AUSTRIAN CURTAIN, BRAILE CURTAIN, CONTOUR CURTAIN.

opera glasses *Theater* Small binoculars suitable for use by an operagoer during a performance.

opera hat *Theater* A tall, formal, collapsible black silk top hat such as that worn by Fred Astaire in many films.

opera house *Theater* A theater built especially for the presentation of operas. Such a building requires many facilities not usually found in other theaters, *e.g.,* a larger orchestra PIT suitable for a full orchestra; more dressing-room space for actors, a chorus and a ballet company; a specially designed stage with ample backstage area that permits complete changes of the SET every night and includes such amenities as a PROMPTER'S BOX in a position where performers can see the prompter. In modern times, any major opera house has elevator stages that permit rapid changes of complex sets between scenes, and is also thoroughly wired for closed-circuit television so that singers backstage can see the conductor. The stage of the Metropolitan Opera in New York City is much larger than the auditorium it serves.

opera seria (*SEH-ree-ah*) [Italian] *Music* Serious opera. The term came into use in the 18th century to distinguish works on classical subjects, myths and so forth, from entertainments which tended to be comic. *See also* GRAND OPERA.

Opéra, Théâtre National de l' *Music* The national opera company of France. It began as the Academie de Musique with a royal monopoly, granted (for a fee) in 1669 to present "operas and dramas with music and in French verse." In 1672 Jean-Baptiste Lully managed to take over the privilege and proceeded to produce operas and ballet at the theater of the Palais Royale in Paris. Lully was succeeded by Rameau in the 1750s, by Gluck in 1774, then by Méhul, Cherubini and others. Always the home of grand opera, it occupied many lesser buildings until the Palais Garnier was built for it and opened in 1875.

operatic *Music* Having the quality of OPERA, *i.e.,* dramatic and having extended ARIAS and ensemble passages of music.

operating gallery *Lighting, Stagecraft* The FLY GALLERY.

operating line *Stagecraft* 1. A continuous loop of rope attached to a COUNTERWEIGHT ARBOR and passing through two SHEAVES, one at the GRIDIRON level, the other below the FLY GALLERY. With the counterweight attached to the rigging that supports the scenery to balance most of the weight, the operating line can be pulled by hand to raise or lower the scenery with ease. Also called the purchase or working line. 2. A continuous loop of rope that opens and closes the ACT CURTAIN. *See also* TRIP LINE.

operating script *Stagecraft* The STAGE MANAGER'S script annotated with all the technical CUES of the production.

operetta *Music* A popular musical play with spoken dialogue, on a sentimental subject. It sprang into existence in the early 19th century and quickly reached a peak with 90 successful works by Jacques Offenbach in Paris, 16 by Johann Strauss, Jr., in Vienna and 14 by Gilbert and Sullivan in England. In the early years of the 20th century, the American composers Victor Herbert, Rudolf Friml and Jerome Kern brought out a series of operettas on American themes that gradually evolved into what we know now as MUSICAL COMEDY.

ophicleide *Music* A brass instrument of BASS REGISTER, with a long conical tube doubled up so that its BELL aims straight up over the player's shoulder. It was used by Felix Mendelssohn

and other composers in the mid-19th century and appeared in many military and concert bands, but has since been replaced by the BARITONE and the TUBA.

op nut *Theater* Short for "operating nut," the minimum budget needed to keep the theater open during a production. *See* NUT.

opposite *See* PLAY OPPOSITE.

opposite prompt *Acting, Stagecraft* In British theaters, the side of the stage opposite the position of the PROMPTER, *i.e.*, STAGE RIGHT. Abbreviated as OP.

opposition *Ballet* A rule by which the position of the arm is opposite to the position of whichever leg is in front; with the left leg in front, for example, the right arm is raised in front and the left held to the side or back.

optical effect *Motion pictures* Any visual EFFECT, such as a FADE or a DISSOLVE, accomplished by optical means in the laboratory during the process of making the MASTER DUPLICATE of the picture.

Stagecraft *See* VISUAL EFFECT.

optical track *Motion pictures* A SOUND TRACK that has been converted into modulations of the density or width of a beam of light and printed along the edge of a RELEASE PRINT. It can be reconverted into sound by optical means during projection. Optical tracks were the first type used in motion pictures and have been largely supplanted by MAGNETIC SOUND TRACKS.

option *Motion pictures, Theater* An agreement made between a studio, a producer or director and an author for a specified period of time, reserving for the producer an exclusive right to produce a specific work of the author in exchange for a fee. This is generally a useful way to give a producer a chance to find financing. It has, however, also been used by certain producers to keep a particular script out of circulation while a similar work is being promoted for financing.

opus, opus number [Latin] *Music* Literally, a work. Catalogs of composers' works (since the time of Beethoven) frequently show opus numbers that take their sequence from the order in which the works were originally published. Often, one number encompasses several works, as in the series of string quartets published by Beethoven as *Opus 59*. In compendious scholarly catalogs of the works of earlier composers, numbers have also been assigned but in a sequence dictated by the particular way the catalog is organized. Many modern composers assign opus numbers to their own works in chronological order of composition.

orangewood stick *Makeup* A slender dowel made of orangewood, used until recently to apply pigment for eyeliners and lines that simulate wrinkles.

oratorio *Music* A large narrative or dramatic work of music on a religious subject, composed for solo voice(s) and/or chorus with organ or orchestral accompaniment, usually performed in concert without scenery or costumes. A CANTATA, though composed for similar forces, is generally smaller and can be on any theme, sacred or secular. *Compare* CHORAL THEATER, MADRIGAL COMEDY.

orchestra *Music* A relatively large ensemble of woodwinds, brasses, percussion and strings, consisting of first and second violins, violas, cellos and basses with several players on each part and, usually, winds and percussion with individual players on each part. An ensemble consisting exclusively of winds and percussion is usually called a BAND.

Theater The main level of the auditorium. The original Greek word indicated the wide, usually circular area in front of the stage where the CHORUS sang and danced. In Roman times, as the chorus waned in importance, the audience moved forward. During the late Renaissance the more affluent members of the audience took seats upon the stage where they could, and did, loudly comment on the actors' performances. After a section was set off for nobility, the rest of the ground level area of Shakespeare's Globe Theater was given over to standees and was called the PIT. By the 17th century, performances had become more genteel, especially in France. Seats were installed on the main floor and many of the gentry took BOXES on a higher level. The area directly in front of the stage then became available for musicians who, because they sat in that space, were eventually called an orchestra, after the original Greek name for the space.

orchestra circle *Theater* A special section of seats in some theaters, in the back of the HOUSE underneath the first balcony.

orchestral *Music* 1. Describing music composed or arranged for an ORCHESTRA. 2. Loosely describing music for other instruments (particularly the piano) that imitates the massiveness and varieties of color that characterize orchestral music.

orchestra leader *Music* In the United States, the conductor. In England, the CONCERTMASTER.

orchestra pit *Theater* The area directly in front of the stage where the orchestra sits during performance. It is generally on a lower level than the main auditorium, so that the players can be heard without blocking the audience's view.

orchestra pit lift *Theater* In a large theater devoted to different kinds of productions, an elevator that raises or lowers the ORCHESTRA PIT from below stage. Normally, it can lift the orchestra's floor high enough to become part of the forestage.

orchestra rail *Theater* The rail between the ORCHESTRA PIT and the main floor of the auditorium, installed to prevent accidental falls in the darkness during the show.

orchestra seats *Theater* The seats on the main floor of the auditorium, called STALLS in Britain.

orchestra shell *Theater* A slightly overhanging, often movable, panelled structure placed behind an orchestra to reflect its sound toward the audience in any situation in which it might otherwise not be clearly heard. Also called BANDSHELL.

orchestra stalls *Theater* In British usage, seats in front of the STALLS, nearest the ORCHESTRA RAIL.

orchestra stand *Music* A MUSIC STAND fitted with a small light that illuminates the player's part during performance.

orchestrate *Music* To convert a piece of music composed for one or several instruments into one that can be played by an orchestra. The process consists of distributing the tones of the original work among the many instruments of the orchestra, without altering their harmonies or melodies. The result is an ORCHESTRATION.

orchestration *Music* 1. A SCORE showing individual lines (STAFFS) for each of the instruments of the orchestra, lined up in parallel so that the conductor can see at all times which instruments are playing what notes. 2. The piece of music itself, considered as an arrangement for instruments.

orchestrion *Music* A 19th-century mechanical instrument that ran by clockwork and reproduced the sound of an orchestra. In the United States there were similar instruments in village gathering places. One, in a drugstore in Fitchburg, Massachusetts, during the 1930s had a piano keyboard, a violin and a set of traps, all operated mechanically with electric motors supplying the power. It served a purpose similar to that of the late 20th-century juke box, but was more fascinating to watch because the keys of the piano keyboard worked, the bow of the violin scraped across the strings, and drums, cymbals and a small bass drum resounded to mechanical drumsticks, all whirling into action at the deposit of a nickel in the slot.

Orff instruments *Music* A set of percussion instruments devised by the German composer Carl Orff to train children in the fundamentals of music. They include various forms of the XYLOPHONE, GLOCKENSPIEL and DRUMS.

Orff method *Music* A method of teaching young children the basics of music, using specially designed ORFF INSTRUMENTS.

organ *Music* A large musical instrument with KEYBOARDS and PEDALS that produces musical sound by directing compressed air selectively into an array of tuned PIPES or, in the case of the electronic organ, by imitating the sounds of pipes. Organs generally have more than one keyboard, and many ranks of pipes, called STOPS, each of which produces a specific TIMBRE. Organ pipes fall into two main classes, FLUE and REED. Each class includes a large number of possible variants, permitting the organist to choose from a palette of many different tone colors. The organ mechanism can be of two types: electrical or TRACKER ACTION. The organ is the chief musical instrument in most Episcopalian and Roman Catholic churches, and is standard equipment in many concert halls. From the late 1920s to the 1940s, a large organ was often a feature in great urban movie theaters, and was played for the audience to sing to between motion picture showings. *See also* HAMMOND ORGAN, WURLITZER.

organ grinder *Music* A street entertainer who operates a mechanical organ on wheels and plays, for tips, any of a small selection of old popular songs by turning a crank on the side of its box.

organic blocking *Acting* BLOCKING conceived by the director after watching the actors move at will during rehearsals, and based upon what they actually did.

organist *Music* One who plays the ORGAN.

organ loft *Music* An area in a church, often high above the main floor, where the ORGANIST plays.

Theater A storage area above the stage floor.

organ pipe *Music* A wooden or metal cylinder designed to produce a musical tone when air under pressure blows through it. There are two types of organ pipe, FLUE PIPES and REED PIPES. Most organs have several ranks of each type, each rank producing a different TIMBRE.

organ screen *Music* An ornamental partition in a church, separating the organist from the congregation.

organ stop *See* STOP.

organum [Latin, from Greek] *Music* A term that refers to POLYPHONIC vocal music composed before the end of the 13th century. In its best-known form, it consisted of music for two voices in parallel, one voice being at the interval of a PERFECT FIFTH above, or a PERFECT FOURTH below, the other.

original *Audio, Motion pictures* The film or magnetic tape that actually passes through the camera or recorder and accepts the audio signal or the visual image. All other strands of tape or film used in the process of editing and releasing the completed work derive, directly or indirectly, from the original. *See* GENERATION.

original cast *Audio, Theater* The CAST who perform in the first production of a play. By agreement between ACTORS EQUITY and the SCREEN ACTORS GUILD, members of the original cast are recognized as creators of their individual roles and are entitled to receive a portion of the royalties from a motion picture made from the play, whether or not they also act in the picture.

original music *Motion pictures, Theater* Music composed specifically for a play or a motion picture, as distinguished from music adapted for use in the play or film but composed for other purposes such as concerts.

original production *Theater* The first production of a play, not its touring production.

ornament, ornamentation *Music* Musical trimmings in the form of TRILLS, MORDENTS, etc. They were considered essential to the performance of lute and harpsichord music, especially in France in the 1600s. Since the tones of lutes and harpsichords were of very short duration, ornaments were applied lavishly to extend tones and keep the melody from sounding disjointed. This largely improvisational practice became less popular in later years among composers and players of polyphonic music, for which ornaments were often written out in full rather than being left entirely to the discretion of the performer. In French the term is *agrément*.

orthicon *Television* Type name for a standard image tube; the sensitive tube inside a television camera that receives the image focused upon it by the lens, and converts it into a coherent signal that can be transmitted electronically. Also called image orthicon.

Oscar *Motion pictures* Trademarked name of a golden statuette given to winners of the ACADEMY AWARD.

ossia [Italian] *Music* Literally, also. A term printed in a musician's PART together with a small section of musical staff showing an alternate version of a figure or ORNAMENT that appears on the main staff.

ostinato (*os-tee-NAH-toh*) [Italian] *Music* Literally, persistent. A tone or a figure in the bass that repeats without change while the rest of the music continues. *See also* GROUND BASS, PEDAL POINT.

ottava (*oh-TAH-vah*) [Italian] *Music* Octave. *See* ALL'OTTAVA, OTTAVA BASSA.

ottava bassa *Music* An instruction to the perfomer to play the next passage one octave lower than written. Abbreviated: 8VB.

oud (*OOD*) [Arabic] *Music* An Arabian stringed instrument similar to the LUTE.

out *See* WAY OUT.

out chorus *Jazz* The final refrain, during which all the soloists may jam (improvise) together.

outdoor theater A theater built out of doors, open to the weather. *See also* AMPHITHEATER, GARDEN THEATER.

outer stage *Theater* The FORESTAGE of the Elizabethan theater, its main ACTING AREA.

out front *Theater* In front of the curtain, in the FRONT OF THE HOUSE.

outlet box *Lighting* A metal box containing electrical sockets into which plugs may be inserted. *See also* PATCH BAY.

outline scenery *See* PROFILE.

out of scene *Acting* During a formal staged READING, said of an actor who sits with the head lowered or turns away from the audience to indicate that the character portrayed is not active in the continuing scene.

out of sync *Motion pictures* Said of any sound on the SOUND TRACK that can be heard before or after, but not precisely at the same time that its corresponding image appears on the screen. The condition is most obvious when the sound of words is not precisely synchronized with the movement of an actor's lips. The time difference may be extremely small, but will be noticed as "something wrong" by the audience. *See also* LIP SYNC.

out on spec *Acting* Unemployed but being considered for a part.

outrigger, outrigger wagon *Stagecraft* A small triangular platform on casters attached to the BOTTOM RAIL of a large FLAT or to a piece of heavy scenery and braced securely to the STILES. It holds the flat vertically, and allows it to be moved easily during a quick scene shift. *See also* TIP JACK.

outtake *Audio, Motion pictures* Any TAKE, or part of a take, not used in the final version of the recording or picture. Editors, especially those involved in DOCUMENTARY recordings or pictures, often catalog and store their outtakes, or deposit them in a STOCK LIBRARY, for possible use in other productions.

ouvert (*oo-VEHR*), **ouverte** (*oo-VEHRT*) [French] *Ballet* Literally, open. An open position of the feet as in the SECOND POSITION or FOURTH POSITION, or an open movement of the legs. The opposite of FERMÉ.

oval beam *Lighting* A FLOODLIGHT with a FRESNEL LENS that casts an oval-shaped beam.

overact *Acting* To express inappropriately exaggerated emotion in the scene. To HAM IT UP.

overblow *Music* 1. To force a WIND INSTRUMENT to make unusual sounds by blowing hard enough to prevent ordinary resonance. 2. To blow across the mouthpiece of the flute to produce a musical tone. 3. To blow with more pressure than normal to force any wind instrument to play the next higher HARMONIC of whatever tone has been keyed. With most instruments, the resultant tone is an OCTAVE higher, but in the CLARINET, which produces only alternate harmonics because of its straight bore, the resulting tone is a major TENTH higher.

overcall *Theater* A new call for investors to put in more money because the show is going over budget.

overcrank *Motion pictures* To run the camera at a speed faster than normal. The effect of overcranking the camera but projecting the image at normal speed is to produce SLOW MOTION on the screen. In the early days the motion picture camera had no electric motor and no mechanical governor. Speed was established by the rate the camera operator cranked. A good operator could maintain a reasonably steady speed as long as necessary, and could start a new scene without perceptible change. *Compare* UNDERCRANK.

overcurve *Dance* Any gesture that results in part of the body curving upward, against gravity.

overdub *Audio* To record additional material over previously recorded material without distorting what was originally recorded. In fact, the procedure consists of rerecording the previous material and the new material simultaneously onto a new strand of magnetic tape. Overdubbing is the common procedure when adding a VOICE-OVER to a motion-picture sound track, or adding BACKUP to a musical recording. Composers who do their work chiefly on synthesizers frequently begin with a basic rhythmic track (or CLICK TRACK) and overdub many other tracks, one by one, to build up what will eventually sound like a simultaneous recording by several voices or instruments.

overhead lighting Lighting from over the heads of the actors, as distinguished from lighting from the front and sides.

overlap *Acting* To speak or move before the preceding line is finished, or before the cue is complete. To CLIP A CUE.

overmodulate *Audio* To broadcast or record a signal at such a high level that it is distorted. *See also* FUZZBOX.

overplay *Acting* To act with an intensity that is inappropriately strong for the scene. To overact.

overtone *Music* Any secondary tone that is produced in addition to the FUNDAMENTAL when a note is played. For numbering purposes the first overtone is equivalent to the second HARMONIC. *See* HARMONIC SERIES.

overture *Music* 1. A piece of music complete in itself composed to introduce an extensive work such as an opera. In many operas the overture includes as many of the themes of the opera as possible, so that the audience will recognize them when they occur in their rightful scenes. 2. A title used by several composers for short orchestral works of descriptive or dramatic character, *e.g.,* the *Academic Festival Overture* of Johannes Brahms and *Fingal's Cave* by Felix Mendelssohn. *Compare* PRELUDE.

overwrite *Playwriting* To write too much for the scene, *e.g.,* to write as dialogue background information that is obvious from the name of the play, the characters involved and/or the setting. Overwriting presents problems of motivation to actors.

P

p *Music* Abbreviation for PIANO (1); soft, softly.

PA *Motion pictures, Television* Abbreviation for PRODUCTION ASSISTANT.

 Theater Abbreviation for PRESS AGENT.

pace *Acting* A subjective feeling of forward progress in a scene, stimulated by the intensity and rhythm of speech and action, and particularly the timeliness with which the actors pick up their CUES. *See* BEAT, OFFSTAGE BEAT.

 Music *See* TEMPO.

pachanga *Dance* A Latin American dance from the Caribbean, popular in the United States in the 1960s.

package *Theater, Vaudeville* A prepared act, entire play or organized group of STARS who can be imported into a theater, particularly a summer theater, as a performing unit.

package board *Lighting* A control board containing a CONSOLE, DIMMERS, MASTERS and PRESETS in a single unit.

package dimmer *Lighting* A dimmer that is part of a PACKAGE BOARD.

package memory board *Lighting* A PACKAGE BOARD with a memory system.

packer *Acting* A popular STAR who can be counted on to PACK THE HOUSE.

packing rail *Stagecraft* A steel beam permanently mounted high on the wall in an out-of-the-way place backstage, against which FLATS may be leaned when not in use. *See also* SCENE DOCK.

pack the house *Theater* To fill the seats with ticket buyers.

pad *Acting* To add LINES or BUSINESS to fill out a role.

 Costume To add padding inside a costume to build it up, especially to create the illusion of a rotund body.

paean (*PAH-yahn*) [Greek] *Music* Literally, a HYMN addressed to Apollo. A hymn of praise.

page *See* CURTAIN PAGE.

pageant *Theater* 1. In medieval England, a stage built on a flat wagon and fitted with appropriate scenery for a MORALITY or MYSTERY play. In many towns, the CRAFT GUILDS got together to celebrate one of the important days of the Anglican calendar, such as the Feast of Corpus Christi, by presenting short plays on biblical stories. Each guild built a stage on a flat wagon, designed and built scenery, rehearsed a CAST of guild members, and put on its play as one part of a cycle of biblical plays in a procession of similar wagons. As each wagon arrived at a place where townspeople had gathered, the guild would put on its play, then move along to the next location. As a result, at each stopping place the townspeople would see the entire cycle of plays during the day. 2. An elaborate outdoor public celebration of an important historical event, often with a procession of allegorical displays and TABLEAUS.

pageantry *Theater* Spectacular display, especially of allegorical subjects.

paint bridge *Stagecraft* A narrow platform suspended from the GRID near the back wall of the theater to carry scene painters working on a painted drop hung from a batten behind the active area of the FLIES. *See also* BOOMERANG.

paint frame *Stagecraft* A wooden frame hung at the rear of the stage and running its full width and height. It is used to stretch large DROPS and hold them securely while scene painters paint them, standing on a BOOMERANG or a PAINT BRIDGE.

PAL *Television* Acronym for Phase Alternating Line, the standard television scanning system prevalent in Europe, producing 625 horizontal scanning lines and 50 fields (25 frames) per second on the screen, using a base frequency of 50 Hz. *Compare* NATIONAL TELEVISION STANDARDS CODE.

palais glide (*PAH-lay*) [French, English] *Dance* A novelty dance for groups, performed in formation to SWING music during the 1930s.

palette *Lighting, Stagecraft* 1. A particular selection of colors chosen for a show. 2. The range of colors generally associated with a particular designer.

palm court music Music identified with the entertainment offered in large hotels and resorts, sometimes in lounges adorned with potted palms, beginning in the 1870s. The repertory included light orchestral works, excerpts from opera and musical comedy, and pieces written or arranged especially for performance by small groups outdoors on piers, bandstands, etc.

palotás [Hungarian], **palotache** [French] (*pah-loh-TAHSH in each language*) *Music* A Hungarian style of instrumental music in duple or quadruple time, taken from the soldiers' dance VERBUNKOS.

pan *Acting* Slang for an actor's face. *See also* DEAD PAN.

 Motion pictures, Television Short for PANORAMA. To turn the camera to scan the scene horizontally while shooting. *See also* SWISH PAN. *Compare* TILT.

Panavision *Motion pictures* A trade name for a system of making and projecting WIDE-SCREEN motion pictures that came into use in the 1960s. Originally it used 70mm film stock, with an aspect ratio of 2.2 to 1. It is more common, however, for such a film to be shot on 35mm stock using an ANAMORPHIC lens, and then blown up to 70mm in the release print for those theaters properly equipped.

pan head *Motion pictures* A camera mounting that permits free horizontal turning movement (panning) of the camera.

panic lights *See* SAFETY LIGHTS.

panorama *Stagecraft* *See* CONTINENTAL CYCLORAMA.

Motion pictures *See* PAN.

panpipe *Music* An ancient musical instrument consisting of a flat bundle of hollow pipes of graduated length, with their tops all in line so that the player can blow across them selectively to play different tones and create melodies. Panpipes, named after the god Pan, have been known since prehistoric times, and were used in ancient theater and dance for centuries. Also called syrinx.

Pantalone (*pahn-tah-LOH-neh*) [Italian], **Pantaloon** *Theater* A stock character in COMMEDIA DELL'ARTE whose name echos that of St. Pantaleone, a 4th-century patron of Venice, and an even more ancient clown from classical Greek times, also called Pantaleone. The commedia character is a lascivious old Venetian merchant in a black cloak, with a red suit and tassle-toed Turkish slippers, head of his family but unable to control his daughter, suspicious of intrigue, but slow to understand when he is being made a fool.

pan/tilt head *Motion pictures* A mounting unit for a motion picture or television camera that supports the camera firmly but allows it to turn both horizontally (PAN) and vertically (TILT).

pantograph *Lighting* An extendable support for a spotlight hung from the FLIES.

Stagecraft A device for copying a drawing in a larger size. It consists of a framelike series of *X*s connected at adjustable joints so arranged that, with one end fixed in place on a workbench, the movement of a pointer mounted at a middle joint produces a corresponding larger movement of a stylus at the other end. The movement of the stylus is in the same proportion to that of the pointer as the distance between them is to the distance from the fixed end to the pointer. When a scene painter traces a working drawing with the pointer, the stylus reproduces it at the desired size.

Television An extendable hanger for a light fixture.

pantomime *Theater* Nonverbal portrayal of actions, emotions and ideas by means of facial expression, gestures and imitative body movements, especially in dramatic form. Not to be confused with charade, which suggests the sounds of words and syllables by means of gesture. In ancient Rome, pantomime was a form of dance-theater combined with a CHORUS. In modern times it is the stock-in-trade of clowns and the famous mimes of theater and motion pictures such as Charlie Chaplin, Buster Keaton, Harpo Marx and Marcel Marceau. *See also* COMMEDIA DELL'ARTE, DUMB SHOW.

pantomime the business *Acting* During rehearsal, to go through the motions of a piece of BUSINESS that involves furniture or props not yet actually present on stage.

pantomimist *Theater* A performer who works entirely in imitative gesture and movement without speaking. Also called a MIME.

pantonal *Music* Describing music in which every tone is considered equal to every other tone, *i.e.,* without inherent harmonic or melodic tensions pulling toward other notes, a description that is slightly more accurate than ATONAL for music written in the TWELVE-TONE SYSTEM.

paper *Circus* To advertise the circus by putting up posters, streamers and banners around the town and distributing FLYERS.

Theater 1. Collectively, the various kinds of advertisement that are printed on paper, including posters, banners, streamers and FLYERS. 2. To post advertising sheets on walls and billboards around the city and in front of the theater. *See* PRINTER'S SHEET. 3. Complimentary tickets. *See* COMP, PAPER THE HOUSE.

papered house *Theater* A HOUSE whose empty seats have been filled by people holding free tickets.

paper man, paper musician *Music* In JAZZ and popular music, a musician who is incapable of improvisation and so must stick to the notes that can be read from the PART. *Compare* B-FLAT MAN.

paper the house *Theater* To fill empty theater seats by giving away batches of free tickets. *See* ANNIE OAKLEY, TWO-FER.

papier-mâché (*PAHP-yay mah-SHAY*) [French] *Puppetry, Stagecraft* Literally, chewed or pulped paper. Paper, such as newsprint, that has been torn into strips and soaked in a mixture of water with a little glue, sometimes used to make lightweight scenery, masks or heads for puppets.

parabasis (*pah-RAH-bah-sees*) [Greek] *Theater* Literally, a turning back. In Greek theater, especially comedy, a set piece in which the CHORUS turns toward the audience and sings an ODE that comments on, or even contradicts the meaning of, the preceding dialogue. The term was gradually appropriated to describe the action of the PROLOGUE, in which an actor would walk on stage, turn away from the other actors toward the audience and introduce the plot.

parable *Theater* A short play, or scene within a play, that tells a story in allegorical fashion.

parabolic flood *Lighting* A FLOODLIGHT with no lens, but with a PARABOLIC REFLECTOR that places the light within a well-defined area. *See also* SCOOP.

parabolic reflector *Lighting* A reflector with a parabolic (*i.e.,* dish-shaped) surface that turns the rays of any lamp placed at its focal point straight out in one direction with little or no spread in the beam, *i.e.,* in parallel.

parabolic reflector mike *Audio* An assembly consisting of a unidirectional microphone and a parabolic (*i.e.*, dish-shaped) reflector, used to pick up voices or sounds from a great distance and, in motion pictures, to avoid using visible microphones in the scene. The microphone faces into the reflector and picks up any sound that arrives from any distant source along its axial focus. Since it ignores sound that comes from points off that axis, there will be little unwanted noise, and the desired signal can therefore be greatly amplified.

parabolic spotlight *Lighting* A spotlight that uses a PARABOLIC REFLECTOR so that the amount of light aimed directly at its target is more brilliant than it would have been with an ordinary SPOTLIGHT with lenses that would absorb some of it.

parade *Ballet* *See* DÉFILÉ.

 Vaudeville A march across the stage by the entire cast to open the show.

paradiddle *Music* A standard drumming figure, a STICKING PATTERN consisting of a rapid series of even strokes.

paradise *See* HEAVEN.

parallel *Stagecraft* A folding platform.

parallel action *Acting* Balanced movement by two actors or two groups, as when one moves DOWNSTAGE and the other moves up.

parallel beam *Lighting* A BEAM PROJECTOR with a parabolic reflector.

parallel motion *Music* Any movement in which two or more VOICES move melodically without changing the harmonic INTERVALS between them. Parallel motion is pleasurable in some musical contexts, but discomfiting in others. In a choral work with individual voices moving melodically, independent of each other, the sudden occurrence of parallel motion weakens that impression of independence, and tends to be disturbing in the CONTRAPUNTAL context. In an impressionistic piano piece, on the other hand, parallel chords add a color that can be musically suggestive. *Compare* CONTRARY MOTION.

parapet *Theater* The facing across the front of the base of the stage that conceals the structure and machinery underneath it.

PAR lamp *Lighting* A PARABOLIC REFLECTOR sealed-beam lamp.

parlando (*pahr-LAHN-doh*) [Italian] *Music* In a speaking manner, as if the notes were words.

parode *See* PARODOS.

parodist *Playwriting* An author who writes PARODIES.

parodos [Greek] *Theater* Literally, an entrance from the side. In classical Greek tragedy, an ode to be sung as the chorus enters from the side of the stage. In Greek comedy, a BURLESQUE coming after the first scene.

parody *Theater* A play or a scene that, while seeming to re-create a serious event or artistic work such as a play, ridicules it.

parquet *Theater* The part of the main floor of an auditorium between the ORCHESTRA RAIL and the seats under the balcony.

parquet circle *Theater* The area of seats at the rear of the main floor of the auditorium and under the first balcony. Also called the parterre.

parquet stage cloth *Stagecraft* A FLOOR CLOTH painted to look like parquet flooring.

part *Acting* The individual role that a specific actor plays. *See also* SIDES.

Music The individual piece of sheet music showing only the line that a specific performer plays, as distinguished from the entire SCORE. *See also* PART BOOK.

part actor *Theater* An actor who specializes in nonleading roles.

part book *Music* A small booklet containing an individual singer's part (plus short cues in small print) for a piece, or several pieces, of choral music. Such books were in common use until the invention of the VOCAL SCORE in the early 1800s supplanted them.

Partch instruments *Music* Any of the instruments invented by the 20th-century American composer Harry Partch and used by him and his associates in concerts and recordings. They were primarily of two types: PERCUSSION and DULCIMER-like stringed instruments. The percussion instruments included various MARIMBAS and XYLOPHONES, some with more than twelve tones to the OCTAVE, some of extreme bass REGISTER, and many varieties of DRUMS, BELLS and CYMBALS made of all kinds of materials including steel (automobile brake drums) and glass ("cloud-chamber" bowls). Several ZITHER-like instruments were designed for MICROTONAL effects with as many as 43 unequal tones within the octave. They frequently had whimsical names such as the Boo (a bamboo marimba), Chromelodeon (a melodion with 43 tones to the octave) and ZOOMOOZOPHONE.

par terre *See* À TERRE, TERRE À TERRE.

parterre *See* PARQUET CIRCLE.

partial *Music* Any tone in the HARMONIC SERIES except the FUNDAMENTAL. An OVERTONE, *i.e.,* a part of a musical tone, in the sense that a musical tone consists of a fundamental and all its overtones.

particello *Music* Describing a musical work originally written in SCORE form that shows at CONCERT PITCH all the musical lines that make up the piece, but without regard to instrumentation. *Compare* CONDENSED SCORE.

participation show *Theater, Television* A show in which actors solicit active participation from the audience.

particolored *Costume* Said of any costume made of panels of contrasting colors arranged in vivid patterns. The typical costume of ARLECCHINO is made of large alternating squares or diamond shapes in red and white.

partita (*pahr-TEE-tah*) [Italian] *Music* Literally, a division. Originally a VARIATION within a piece. The term, which is singular, has been misused by Johann Sebastian Bach and many others as the type-name of a work containing several parts or *partite* (plural).

partition (*pahr-tee-SYONH*) [French], **partitur** (*pahr-tee-TOOR*) [German] *Music* A SCORE.

part music Music composed for several voices, and often written in SCORE form. *See also* PART SONG.

part song *Music* A HOMOPHONIC choral song, as distinguished from one that is, like most madrigals, CONTRAPUNTAL. The term is used particularly to describe choral songs of the late 19th century by English composers such as Hubert Parry, Charles Stanford and Arthur Sullivan.

pas (*pah*) [French] *Ballet* Literally, a step (of the foot). 1. A step involving a transfer of weight. 2. A term that replaces the word *dance* in designating a ballet scene or dance sequence, *e.g.,* PAS DE DEUX.

pas allé (*pahs ah-LAY*) [French] *Ballet* A simple walking step. Unlike PAS MARCHÉ, the whole foot is placed on the floor.

pasamala *Dance* A JAZZ dance of the early 1900s, originating in Tin Pan Alley, performed to RAGTIME music.

pas ballotté (*pah bah-loh-TAY*) [French] *Ballet* A tossed step. *See* BALLOTTÉ.

pas battu (*pah bah-TÜ*) [French] *Ballet* Any step executed with a beat, such as JETÉ, BALLONNÉ, ÉCHAPPÉ, etc.

pas brisé (*pah bree-ZAY*) [French] *Ballet* *See* BRISÉ.

pas couru (*pah koo-RÜ*) [French] *Ballet* A running step in any direction to gather speed for a leap or jump.

pas d'action (*pah dak-SYONH*) [French] *Ballet* A PANTOMIME or dance scene performed between segments of a ballet, to develop the PLOT or express emotion.

pas de basque (*pah deu BAHSK*) [French] *Ballet* A step originating in Basque national dance, adjusted for use in ballet as a sliding step close to the floor (GLISSÉ), or as a jumping step (SAUTÉ). There are many variations.

pas de bourrée (*pah deu boo-RAY*) [French] *Ballet* A step done in three counts (two up and one down), on POINT, usually performed as a transition to another step, in any direction and in many ways, such as COURU, DERRIÈRE, RENVERSÉ, etc. Not the same as BOURRÉE.

pas de chat (*pah deu SHAH*) [French] *Ballet* A catlike step or jump, or a series of movements similar to a cat's leap.

pas de cheval (*pah deu sheu-VAHL*) [French] *Ballet* A step that resembles the movement of a horse pawing the ground, often performed in a series.

pas de ciseaux (*pah deu see-ZOH*) [French] *Ballet* A scissors step, *i.e.*, with the legs straight and the toes pointed down, in which the legs pass each other in midair.

pas de deux (*pah deu DEU*) [French] *Ballet* 1. A dance for two soloists. 2. A classical ballet whose structure includes an ENTRÉE, ADAGIO, separate variations for the DANSEUSE and DANSEUR, and a CODA performed by both.

pas dégagé (*pah day-gah-ZHAY*) [French] *Dance* Literally, a step disengaged. 1. In ballet, pointing the foot, with a fully arched instep, in an open position. 2. To disengage the foot before executing a step.

pas de trois (*pah deu TRWAH*) [French] *Ballet* A dance for three soloists.

pas marché (*pah mahr-SHAY*) [French] *Ballet* A classical walking step, performed (forward) with the toe down first and the instep well arched.

paso doble (*PAH-soh DOH-bleh*) [Spanish] *Dance* Not a two-step as its name suggests, but rather a rapid Spanish ONE-STEP, usually in 6/8 time, popular in Latin America in the 1920s and 1930s.

pass *Acting* *See* PASS AT THE REAR.

Theater A ticket giving admission to the theater, usually free of charge.

passacaglia (*pahs-sah-KAHL-yah*) [Italian] **passacaille** (*pahs-sah-KYE*) [French] *Dance* A slow, stately French court dance in triple time, characterized by gliding movements and crossing of the feet.

Music *See* CHACONNE.

passage *Acting* A path kept open behind the SET to allow actors to cross from one side of the stage to the other without being seen.

Music Any short section of a larger piece. The term is used often to distinguish a moment of transition, as in "the passage between the first and second themes," or of virtuosity, as in "a scale passage" or "a passage of parallel octaves."

passagework *Music* The musical material of a PASSAGE of music, particularly a passage that requires virtuosity in its execution.

pass at the rear *Acting* To go from one side of the stage to the other behind the set or behind a crowd of actors, unnoticed by the audience.

pass check *Theater* A voucher giving permission for a member of the audience to reenter the HOUSE after leaving it for a few minutes.

pass door *Theater* A door between the HOUSE and BACKSTAGE, usually situated unobtrusively at one side of the PROSCENIUM or below stage level.

passé (*pah-SAY*) [French] *Ballet* An auxiliary movement in which the leg is transferred from one position to another.

passé-pied (*pahs-pee-AY*) [French] *Dance* A 17th-century French dance in 3/4 time, a form of BRANLE accompanied by BAGPIPES or singing.

pas seul (*pah SEUL*) [French] *Ballet* A solo dance.

passing note, passing tone *Music* An unaccented note of the scale that fills the gap melodically between two other notes a THIRD apart.

Passion music A musical setting of one of the four biblical stories of the death and resurrection of Christ. Passion settings have been known since the 9th century. The earliest were set in the style of PLAINSONG. Polyphonic settings, and settings in the style of MOTETS, appeared during the Renaissance. The most elaborate, however, were composed after 1700 when librettists felt free to depart from actual biblical texts and write dramatic ORATORIOS. The *Passions* of Heinrich Schütz and George Frideric Handel are famous. Two by Johann Sebastian Bach, one according to St. John, the other to St. Matthew, are considered by many to be some of the greatest dramatic music ever written.

passion play *Theater* A play based on the death and resurrection of Christ. Passion plays were an important part of village culture during the period of the MIRACLE plays in England. In modern times an outdoor production, with townspeople playing all the parts, is revived every ten years in Oberammergau in Bavaria.

passive movement *Dance* Any motion that is the unavoidable result of another motion, *e.g.*, the movement of the upper arm when the lower arm is lifted.

pasticcio (*pah-STEECH-yoh*) [Italian], **pastiche** (*pah-STEESH*) [French] *Music, Theater* Literally, a pastry. A work containing sections created by several different authors or composers.

pastie, pasty *Vaudeville* A decorative rosette glued over the nipples of a topless dancer partly to attract attention, partly to stay within the law in certain strict localities.

pastoral, pastorale *Music* A pleasant, gentle instrumental or vocal work in 6/8 or 12/8 time, similar to the SICILIANO. Pastorales were based on the music typical of Italian shepherds, who could be heard performing on their SHAWMS and PIPES on Christmas Day in the towns.

Theater A pleasant scene in a garden setting that tells a romantic story about shepherds and nymphs, or people acting like shepherds and nymphs. The play-within-a-play of Piramus and Thisbe in Shakespeare's *A Midsummer Night's Dream* is a pastoral, as were some of the entertainments introduced into the French court by Catherine de Medici and expanded by Marie Antoinette.

PA system *Audio* Public address system. In theater use, the backstage system used to give 30-, 10- and 5-minute warnings to the cast and crew.

patch *Audio* 1. A short section of audio cable with a male audio connector at each end, used to connect a MICROPHONE to the proper control circuit, or an output circuit to its proper

recording channel, through a PATCH PANEL that consists entirely of female JACKS. Also called patch cable, patch cord, patch line. A typical patch carries both sides of a stereophonic circuit. 2. A connection made between different sections of an audio channel. 3. To connect a microphone to its proper control circuit, or an output circuit to its proper recording channel, through a patch board.

Lighting 1. A short section of power cable with a male PIN CONNECTOR at each end, used to connect one lighting circuit with another on a patch board. 2. To set up a circuit by connecting a patch between a circuit from the control board and the dimmer it is to control, or between a dimmer and the instrument it will dim.

patch bay, patch board *See* PATCH PANEL.

patch cable, patch line *See* PATCH.

patch panel *Audio, Lighting* An array of female outlets, half of which are connected to individual circuits in a control system, while the other half are connected to circuits leading to instruments, *i.e.,* to MICROPHONES or recording channels for the audio system, or to DIMMERS or lights for the lighting system. An electrician can connect any outlet to any other outlet with a patch cable, making it possible to assign any controls to any instrument the controller wishes and to change that arrangement at any time.

pathos [Greek] *Theater* Literally, a suffering or calamity. The involvement and stress in a play that cause the audience to feel sympathy for the actors, a response created by their emotional reaction to the dramatic situation. In the context of Aristotle's *Poetics*, pathos is the source of the feelings of PITY AND FEAR that are resolved by a CATHARSIS of the emotions in tragedy. The modern conception of sentimentality is not adequate as a definition of tragic pathos.

patron *Theater* 1. A person who buys a ticket to see a show. 2. A person who makes a financial contribution to a COMPANY.

patsy *Acting* A performer used as a scapegoat for everything that has gone wrong in a rehearsal or a performance.

patter *Acting, Vaudeville* Many lines delivered rapidly for comic effect. *See also* PATTER SONG.

pattern *Lighting* A cutout in a MASK in front of the lens of a spotlight, designed to cast a shaped shadow in the set. *See* GOBO, COOKIE.

pattern projector *See* GOBO, COOKIE.

patter song *Music* A simple song with many short STANZAS of a great many words sung so rapidly that its effect is comic. There are many in the works of Gilbert and Sullivan and a very famous one, *Largo al Factotum*, listing all the things Figaro must do in his profession as barber in Rossini's *The Barber of Seville*.

pausa (*PAH-oo-zah*) [Italian] *Music* Literally, pause. A moment of silence, not the same as a FERMATA.

pavane, pavanne (*pah-VAHN*) [French] *Dance* A stately 16th- and 17th-century dance in 2/4 time, sometimes performed with another, faster dance in 3/4 time such as a SALTARELLO or a GALLIARD. The pavane is characterized by curtsies, advances and retreats interspersed with stationary poses.

pavilion *Theater* 1. A building of light, OPEN-AIR design suitable for performances. 2. In the Elizabethan theater, a curtained area on the stage concealing actors who stood ready to perform their scene when the curtains were suddenly drawn aside to reveal them. The pavilion made it possible to shift suddenly from one imaginary setting to another, *e.g.*, from the court to the interior of the queen's chamber.

payoff *Vaudeville* The final phrase that makes a joke funny. The PUNCH LINE.

peak *Circus* The highest point inside a circus tent.

> *Lighting* The lighting angle that provides maximum brilliance from a SPOTLIGHT. The lighting designer may call for a light to be aimed 10° off-peak, for example, to create a desired effect.

peal *Music* A cascade of the sound of bells. *See* CHANGE RINGING.

peanut gallery *Theater* The top balcony, having the cheapest seats. *See also* HEAVEN.

pear-shaped tone *Music* A joke made famous in the title of a work by the early 20th-century French composer Eric Satie, *Three Pieces in the Form of a Pear*. Satie was making fun of the idea that the best vocal tones came when the mouth took such a shape, though the shape destroyed any semblance of understandable DICTION.

peasants *Theater* Slang for any unresponsive audience, as perceived by actors.

peckhorn *Music* Among jazz musicians, an old slang term for the ALTO HORN or MELLOPHONE.

ped. *Music* In piano or organ music, an abbreviation for PEDAL.

pedal *Music* 1. On a PIANO, one of several levers operated by the feet to modify the effect of the KEYBOARD in various ways. *See* SOFT PEDAL, SOSTENUTO PEDAL, SUSTAINING PEDAL. 2. On an ORGAN, a keyboard operated by the feet, used for playing the BASS line of a piece of music. 3. On the HARPSICHORD, a foot-operated device to couple octaves or to actuate different ranks of strings. 4. On a HARP, a set of levers operated by the feet, each of which raises or lowers the tone of a specific note in each octave of the instrument by one SEMITONE.

pedal keyboard *See* PEDAL (2).

pedal point *Music* A single BASS tone of the ORGAN, held during a passage of moving harmonies.

pedal-steel guitar *Music* A guitarlike instrument built on a table or a stand with the strings in horizontal position. (*See* HAWAIIAN GUITAR.) As many as eight attached floor pedals and one to four knee levers change the tuning of the strings. It is played with a STEEL (metal bar) that the player slides up and down the strings. Used mostly by COUNTRY-AND-WESTERN players and occasionally in ROCK music.

pedestal *Television* The wheeled and motorized stand on which a studio television camera is mounted.

peephole *Theater* A small hole in the main curtain that gives the stage manager and others a view of the audience while the curtain is closed.

peep show *Motion pictures* In the early days before movies were routinely projected in theaters, they could be seen in boxlike, coin-operated machines such as Edison's Kinetoscope. The viewer looked through a small aperture to see a minute's worth of a scene in motion. During succeeding decades the term was used to describe titillating shows involving nudity and/or simulated sex.

peg *Music* *See* TUNING PEG.

Stagecraft *See* SPIKE.

peg board *Music* 1. The hardwood board inside a PIANO into which the TUNING PEGS are fitted. 2. A small hardwood board slanting back from the upper end of the neck of a LUTE, holding the tuning pegs.

peg box *Music* A wide hardwood piece at the upper end of the NECK of a GUITAR or similar stringed instrument into which the TUNING PEGS are fitted. *See also* PEG BOARD (2), SCROLL.

penché, penchée (*panh-SHAY*) [French] *Ballet* Leaning forward. In the ARABESQUE penchée, the body forms an oblique line with the head and forward arm low and the extended leg raised.

pencil *Makeup* A slender, hollow wooden applicator for pigments to be used as eyeliner, or to simulate wrinkles on an actor's face.

pennywhistle *See* TIN WHISTLE.

pentameter *Playwriting* A line of five poetic feet. *See* IAMBIC PENTAMETER.

pentatonic scale *Music* A SCALE containing only five tones within every OCTAVE. It consists of two WHOLE-TONE steps, an AUGMENTED second and another WHOLE-TONE STEP, like the black keys of the piano starting on F-sharp. Since it has no SEMITONES, it has a modal effect.

percussion *Music* The class of musical instruments that produce sound when they are struck, as distinguished from instruments that are bowed (strings), blown (winds) or played by means of keyboards. There are two subclasses: instruments with definite pitch and those with indefinite pitch. Instruments of definite pitch include TIMPANI, MALLET INSTRUMENTS, the GLOCKENSPIEL, CELESTA, VIBRAPHONE, tuned BELLS and GONGS. Those with indefinite pitch include all kinds of DRUMS except timpani, various CYMBALS, untuned bells like the cowbell and sleigh bells, ratchets, MARACAS, GOURDS, rattles, etc.

percussionist *Music* A musician who specializes in PERCUSSION. Among percussionists there are additional specialists, particularly TIMPANISTS and MALLET players.

percussion tap dancer *Dance* A tap dancer whose dances emphasize the sounds of tapping feet in intricate rhythms, rather than movements of the body.

percussive movement *Dance* In modern dance a technique associated with Martha Graham, in which the strength of the "attack" or force initiating a movement will seem to take the movement beyond what can be seen.

perdendo (*per-DEN-doh*), **perdendosi** (*per-DEN-doh-see*) [Italian] *Music* Dying gradually away.

perfect cadence *Music* A CADENCE that resolves into a tonic chord in ROOT POSITION with an octave of its root on top.

perfect fifth *Music* An interval that is three whole tones plus one semitone wide, *i.e.,* the inversion of a PERFECT FOURTH.

perfect fourth *Music* An interval that is two whole tones plus one semitone wide, *i.e.,* the inversion of a PERFECT FIFTH.

perfect interval *Music* A pure fifth, fourth or octave. All other intervals are either MAJOR or MINOR. When perfect intervals are lowered by a SEMITONE, they are called DIMINISHED. When they are similarly raised, they become AUGMENTED. Most musicians can agree on the tuning of a perfect interval by listening while adustments are made until the sound seems to resonate most clearly. For any other interval, matters of individual judgment are more difficult to resolve.

perfect pitch *Music* The ability to recall a PITCH without actually hearing it, or to name it precisely after hearing it. *See also* RELATIVE PITCH.

performance art *Theater* A style of theatrical event created on stage in person by the artist, that may contain elements of dance, music, poetry, prose, painting, sculpture, special lighting effects, etc., in various combinations. It developed out of the HAPPENINGS of the 1950s and 1960s as they became more sophisticated and less dependent on audience participation. A piece of performance art differs from a HAPPENING in that it is composed rather than improvised, though it may retain elements of improvisation. It also carries on the basic premise of the happening by featuring a kind of live performance that cannot be adequately experienced in recorded form. The first identifiable works of the genre were experimental productions at Black Mountain College, North Carolina, in the late 1940s, involving actors and dancers, poetry and light, sometimes using projections of moving light on moving bodies. Several innovations in dance by Merce Cunningham with ALEATORY MUSIC of John Cage were the product of these experiments, as were certain productions of experimental theater by others. Performance art developed as an independent form, in which Laurie Anderson became one of the best-known creators, and stimulated both the avant-garde productions of modern playwrights and the highly stylized productions of modern opera and dance.

performance artist *Theater* A creative artist, nominally from any field of art, who creates an original work in performance before an audience.

performance rights *Music* The legal right to perform a copyrighted work in public. This does not include performance as a staged work, which is covered by GRAND RIGHTS. Performance rights are traditionally negotiated separately from MECHANICAL RIGHTS and SYNCHRONIZATION RIGHTS.

performer-in-residence *See* ARTIST-IN-RESIDENCE.

performing arts Any arts that exist only in the actions of live performers before an audience, as distinguished from painting, writing and the like. The chief categories among them are: dance, music and theater. There are many subcategories such as circus, pantomime, puppetry. What they all have in common is the live performer and the audience.

period *Theater* Said of a play or a production conceived in the context of a past age and performed in a setting and in the costumes reminiscent of that time.

periodic *Music* Having a repeating form, as in a rondo, in which the first theme alternates several times with other themes.

period instruments *Music* Instruments of a particular style or construction used in a particular period in the past, including not only instruments that have no modern counterpart, such as the THEORBO or the SERPENT, but also instruments built according to outdated techniques, such as the FORTEPIANO.

peripatetic show *Theater* A show that moves from place to place inside and outside the theater, taking the audience along during the performance. *See* ENVIRONMENTAL THEATER.

peripeteia (*peh-ree-peh-TAY-ah*) [Greek] *Theater* Literally, a sudden reversal. Aristotle's term for the REVERSAL OF CIRCUMSTANCES that leads to the stresses and ENTANGLEMENTS that are the main substance of a DRAMA.

periwig *See* PERUKE.

permanent company *See* COMPANY.

permanent cyclorama *Stagecraft* A cyclorama built of permanent materials as the back wall of the stage. Certain types, such as the INFINITE CYCLORAMA, are often made permanent because their shape is easier to achieve in permanent materials, such as wood and plaster.

permanent set *See* UNIT SET.

perpetuum mobile (*per-PEH-too-um MOH-bee-leh*) [Latin] *Music* Literally, perpetually in motion. A term used to describe music composed in a fast tempo in notes of equal value, with little or no interruption of the pace from beginning to end.

perruquier (*peh-rük-YAY*) [French] *Costume* A wigmaker, particularly one who constructs a PERUKE.

persona (singular), **personae** (plural) *Costume* In Roman times, a theatrical mask that gave the actor the appearance of the character being played. By extension, the image of a character that the actor wishes to project, even without a mask.

personality *Theater, Motion pictures* A STAR whose fame rests chiefly on his/her attractiveness and charm, aside from any artistic ability.

personal prop *Stagecraft* A PROP carried by an actor, as distinguished from a prop placed on the stage. *Compare* CHARACTER PROP.

perspective set *Stagecraft* An architectural SET built with converging, instead of parallel, lines to give an impression of greater depth and height than is actually there.

peruke *Costume* A powdered wig of the 17th and 18th centuries. Also called periwig.

pesante (*peh-ZAHN-teh*) **pesantamente** (*peh-zahn-tah-MEN-teh*) [Italian] *Music* Heavy, heavily.

petits rats (*peu-tee RAH*) [French] *Ballet* Literally, little rats. The children of the ballet school of the Paris Opéra.

pf, pft *Music* Abbreviation for PIANOFORTE.

philharmonic [from Greek] *Music* Music-loving. The term is often used as part of the name of a symphony orchestra.

philharmonic pitch *See* A-440.

phon *Acoustics* In the science of acoustics, a unit of measurement of perception of loudness of sound.

phonograph *Audio* A machine that plays sound recordings, particularly recordings made in grooves on a disk, as distinguished from tape recordings and from digital recordings made on optical disks. *Compare* CD PLAYER. *See also* GRAMOPHONE.

phot *Lighting* A unit of illumination equal to one LUMEN per square centimeter. It defines the amount of light reflecting back from an illuminated surface, not to be confused with the amount of light aimed at the surface.

photo call *Acting* Notice of a meeting called for the purpose of taking individual or group publicity photographs of the CAST, or of particular scenes of the play as staged.

photoplay *Motion pictures* A play written for motion pictures.

phrase *Music* A short series of tones that make up a memorable unit of a melody. A relatively short passage of music that makes up a memorable part of a longer section of the piece.

phrasing *Music* The process of articulating a series of MEASURES of music so that it forms a meaningful and/or beautiful sequence.

Phrygian mode *Music* The MODE based on the third tone of the major scale. On the white notes of the piano, the Phrygian is the mode that has E as its TONIC and B as its DOMINANT.

phylakes (*fee-LAH-kehs*) [from Greek] *Theater* In ancient Rome, jesters who performed their satires and comedies on temporary stages that they could transport from place to place and set up in any town square. These stages were the precursors of the large, permanent theaters of the Roman Empire. *Compare* RAREE.

physical action *Acting* In the vocabulary of the STANISLAVSKI METHOD, the physical means of expressing the emotional content of a role.

physical memory *Acting* In the STANISLAVKI METHOD, an actor's memory of the physical sensations and actions that occurred during a moment of personal emotion, *i.e.,* a memory of reactions that is superficial compared to the actor's memory of the emotions themselves. *Compare* EMOTION MEMORY.

pianism *Music* The totality of the physical act of playing the PIANO.

pianissimo (*pee-ah-NEE-see-moh*) [Italian] *Music* Very softly, abbreviated as ***pp***.

pianississimo (*pee-ah-nee-SEE- see-moh*) [Italian] *Music* As softly as possible, abbreviated as ***ppp***.

pianist *Music* A musician who plays the PIANO.

pianistic *Music* Said of music written in a manner that is comfortable for the hands, avoiding awkward FINGERINGS or unnatural movements on the part of the pianist.

piano [Italian] *Music* Literally, level. 1. Softly, abbreviated as ***p***. 2. Short for pianoforte. A keyboard instrument that produces sound from taut strings, struck by hard felt hammers actuated by the keys; the primary musical instrument in the home and concert hall since the 18th century. It was originally called the pianoforte, because it could play both soft (piano) and loud (forte), which the HARPSICHORD could not. In modern times, pianos have two basic forms, UPRIGHT and grand. The strings of the upright piano are arranged vertically in overlapping layers inside a wooden case behind the keyboard. It takes up less floor space than the GRAND PIANO, whose strings stretch out horizontally away from the back of the keyboard. The upright is common in homes, the grand appears most often in concert halls. *See also* GIRAFFE, SPINET, SQUARE PIANO.

piano dress *Music, Theater* A DRESS REHEARSAL of a musical play to work on acting and technical matters, with a PIANIST substituting for the orchestra.

piano duet *Music* 1. Any piano piece for two players. If the duet is intended for two players sitting at a single piano, it is often referred to as a piece for FOUR HANDS. 2. A team of two pianists who perform together as a unit.

pianola *Music* Trade name for a PLAYER PIANO.

piano-organ *See* BARREL ORGAN.

piano player *Music* A musician who plays the PIANO.

piano quartet *Music* 1. A quartet that includes a PIANO and three STRINGED INSTRUMENTS or WOODWINDS. 2. A piece of music composed for such an ensemble.

piano quintet *Music* 1. An ensemble that includes a PIANO and a quartet of STRINGED INSTRUMENTS or WOODWINDS. 2. A piece of music composed for such an ensemble.

piano roll *Music* A roll of sturdy paper used in performances of music by a PLAYER PIANO. When the paper is pulled across a row of air holes in the playing mechanism, tiny perforations direct air selectively to small bellows that operate individual keys of the piano, making music. In sophisticated systems, other patterns of holes alongside the musical set control the TEMPO and DYNAMICS of the performance and its PHRASING. A few famous pianists of the early 1900s recorded their performances on such rolls, among them Ferruccio Busoni, Maurice Ravel and George Gershwin.

piano score *See* REDUCTION.

piano trio *Music* 1. A TRIO that includes a piano, a violin and a violoncello. 2. A piece of music composed for such an ensemble.

piano wire *Music, Stagecraft* Strong metal wire manufactured for use as strings in the PIANO, but also used in stage construction and rigging where extreme tensile strength and relative invisibility are necessary.

pibroch (*PEE-broch*) [Scottish Gaelic] *Music* A highly ornamented piece of Scottish music, often a DIRGE, played on the bagpipe.

Picardy third *Music* A MAJOR chord played as the final TONIC chord of a piece in a MINOR key. It was common during the 16th century, less common later. The origin of its name is obscure.

piccolist *Music* One who plays the PICCOLO.

piccolo [Italian] *Music* Literally, small. Short for *flauto piccolo*, a small FLUTE with a tone that can be piercing in the range an OCTAVE higher than a normal flute.

piccolo trumpet *Music* A small TRUMPET with a range higher than a normal trumpet, sometimes used in the compositions of Johann Sebastian Bach, most notably in his *Magnificat* and the second of his *Brandenburg Concertos*.

pick *See* PLECTRUM.

pick up *Acting* To reanimate a scene by speaking one's lines in a more lively manner and responding more quickly to cues.

 Lighting To eliminate an unwanted shadow by directing, or increasing, the light on it.

pickup *Audio* 1. Any device that senses signals from a recording and delivers them to the circuitry that converts them into sound. In the PHONOGRAPH, the pickup is a jewel-pointed

stylus. In a tape recorder, it is a tiny electromagnet across which the recorded tape is pulled at a precise rate. 2. A microphone that senses sound directly, rather than as sound waves carried through the air, by being in contact with the sound-producing body. *See* CONTACT MIKE.

Music　The first UPBEAT (ANACRUSIS) of a phrase or a passage of music. The term comes into use chiefly in rehearsals and recording sessions, when it becomes necessary to go back to a given point in the music and replay a passage that begins just before a particular measure or somewhere in the measure, *e.g.,* "pickup to measure 60."

Television　*See* FEED.

pick up a cue *Acting*　To react more quickly to a cue.

pick-up band *Music*　A group of local players hired temporarily to accompany a touring star or act.

pick-up rehearsal *Acting*　An unscheduled REHEARSAL called to make up for one that was missed or canceled by weather or some similar cause, or to brush up unforeseen problems that arose during a scheduled rehearsal. *Compare* BRUSH-UP REHEARSAL.

picture　*See* STAGE PICTURE.

picture rail *Stagecraft*　A rail attached across the back of a FLAT to give hidden support to a picture, a mirror or similar piece hung on its front.

picture screen, picture sheet *Stagecraft*　A DROP prepared for a projected scene or a movie.

piece *Theater*　1. A play. 2. A share in the profits of a production.

Motion pictures　A share in the investor's profits from a production.

Music　A musical composition.

Stagecraft　A unit of scenery.

pièce (*pee-ES*) [French] *Theater*　A play.

pièce d'occasion (*pee-ES doh-kah-ZYONH*) [French] *Theater*　A play or a performance designed for a specific occasion.

pie cut *Stagecraft*　A single segment of a REVOLVING STAGE platform.

pie-in-the-face *Vaudeville*　A BLACKOUT routine wherein comedians throw what appear to be custard pies at each other. The pies are soft and leave a white mess on the face and costume. The pies are usually made from shaving cream.

Pierrot (*pyehr-ROH*) [French] *Puppetry, Theater*　A character in French folk plays, distantly related to a character named Pedrolino in COMMEDIA DELL'ARTE. Pierrot is delicate, gently smiling and slightly melancholy, the eternally misunderstood lover.

pig *Stagecraft* A 40-pound slab of iron, shaped to fit into the frame of a COUNTERWEIGHT ARBOR to adjust its weight to balance the scenery at the other end of the RIGGING LINE. *Compare* WAFER.

pigeon's wings *See* AILES DE PIGEON.

pilot *Television* A single SEGMENT, often the first, of a proposed television SERIES, made on SPEC as a sample to interest potential buyers of the series. Some pilots are made as full-length motion pictures and presented in that market also.

pilot board *Lighting* A control board for remote switches and DIMMERS.

pilot film *See* PILOT.

pin *See* BELAYING PIN.

pin connector *Lighting* An electrical connector used to join a lighting instrument to a cable and the cable to a DIMMER circuit. The LOAD CONNECTOR (male) is attached permanently to the instrument, and has three thick brass prongs embedded in an insulated plastic block. They fit into three corresponding holes in the LINE CONNECTOR of the cable, at the other end of which is another male connector that fits into the female connector, that is usually contained within a STAGE POCKET, of the dimmer circuit.

pinrail *Stagecraft* A horizontal steel pipe located on the FLY GALLERY, drilled with vertical holes to accept BELAYING PINS.

pin spot *Lighting* A SPOTLIGHT that emits an extremely small beam, to highlight a small object on stage, or the eyes or the hand of an actor. Also called HEAD SPOT.

pipe *Music* 1. A simple musical instrument consisting of a tube through which the player blows while selectively closing any of the three or four holes along the side of the pipe to change its note. In France during the Middle Ages, where music of pipe and TABOR was the standard choice for dancing, the player held the pipe in his left hand and played the tabor with his right. *Compare* FIFE, RECORDER. 2. A wooden or metal tube, the sound-producing part of the ORGAN. *See also* FLUE PIPE, REED PIPE.

pipe batten *Lighting, Stagecraft* A horizontal steel pipe hung in the flies primarily to support lighting fixtures but also often to support scenery. *See also* VERTICAL PIPE.

pipe clamp *Lighting, Stagecraft* Any strong clamp used to attach lighting instruments to pipes.

pipe organ *Music* An ORGAN that produces sound by blowing air through pipes. *See also* CALLIOPE.

pipes *Music, Vaudeville* Slang term for a singer's vocal apparatus.

pipe stand *Lighting* A vertical LIGHT PIPE offstage at either side capable of supporting several lighting fixtures to provide light from a lower angle than can be achieved from the overhead pipes.

piqué (*pee-KAY*) [French] *Ballet* Literally, pricked. In ballet, a step directly onto POINT or DEMI-POINTE of the supporting foot, with the other foot raised in a variety of poses. It may be performed BALLONNÉ, DÉTOURNÉ, etc.

piracy *Theater* Any unauthorized publication or performance of a copyrighted theatrical, choreographic or musical work. More plainly known as theft of royalties, it is punishable under the copyright law as a federal criminal offense. The originally weak copyright law in the United States was strengthened partly as the result of outrage over the flagrant piracy of the operettas of Gilbert and Sullivan during the 1890s. A major revision in the 1970s lengthened the term of protection and drastically increased the severity of the punishment for violation. *See* COPYRIGHT.

pirouette *Ballet* One or more turns on one foot, on POINT or DEMI-POINTE, with the impetus for the turn provided by a swing of the arm, often with the point of the working foot against the knee of the supporting leg. The many forms of pirouette include *en* ARABESQUE, EN DEHORS, RENVERSÉE, SAUTILLÉ, etc.

pistolet (*pee-stoh-LAY*) *See* AILES DE PIGEON.

pit *Theater* 1. Short for ORCHESTRA PIT. 2. In an Elizabethan theater, the area on ground level in front of the stage where GROUNDLINGS stood to watch the play.

pitch *Carnival, Circus* 1. The routine used by a BARKER to entice passersby into a SIDESHOW. 2. A publicity theme for a particular show. *See also* BALLYHOO.

Music The apparent position of a musical TONE in the audible range. It is measured in HERTZ. The tones of the musical SCALE have been given two kinds of name: the syllables of the system of SOLMIZATION (DO, RE, MI, etc.), and letters of the alphabet (A through G).

pitch pipe *Music* A small reed instrument that can produce each tone of a single octave when blown like a HARMONICA. The most common type is disk-shaped, with the letter names of each tone inscribed on its surface. The tones are tuned to the CHROMATIC SCALE in EQUAL TEMPERAMENT, with A at 440 Hz. Manufacturers make variations of the pitch pipe to help instrumentalists tune their instruments to standard PITCH. A pitch pipe for the guitarist, for example, produces only the tones to which that instrument's six strings should be tuned.

pit orchestra *Theater* The orchestra, usually small, that plays in the ORCHESTRA PIT during a production.

pity and fear *Theater* Two emotions that Aristotle considered essential to the effect of TRAGEDY. Pity is the sympathy the viewer feels for the characters who are undergoing the stresses of the drama. It turns into empathy, which becomes subconscious fear when the viewer imagines undergoing those same stresses with the PROTAGONIST as the plot develops. The resolution of the play purges these emotional tensions in the process Aristotle calls the CATHARSIS of pity and fear and, because that is a deliverance, he uses the term LYSIS (deliverance, setting free) for the end of the play. *See* ELEMENTS.

più (*PEW*) [Italian] *Music* More, as in *più mosso*, more moving, faster.

pizzicato (*pit-zee-KAH-toh*) [Italian] *Music* 1. For players of bowed STRINGED INSTRUMENTS, it means plucked instead of bowed. 2. A piece, or a passage within a piece, where players of bowed, stringed instruments pluck the strings instead of bowing them.

placeholder *Theater* In the 16th, 17th and 18th centuries, a servant or hireling who went to the theater very early and sat in a particular seat to reserve it for a patron.

placement *See* ALIGNMENT.

"places" *Theater* A directive from the stage manager to the CAST to take their positions on stage or in readiness for the next act of the play.

place, unity of *Theater* The general idea, inaccurately attributed to Aristotle, that the events of a good play should occur in a single place, such as a room or a neighborhood. A capable playwright may define the stage as a place, and yet shift its supposed location in the minds of the audience as Shakespeare does in many plays such as *Twelfth Night,* where one acting area is Orsino's palace, and another the street outside, etc., each established by the words of the actors. The only unity actually discussed by Aristotle in his *Poetics* was that of PLOT.

plagal cadence *Music* A CADENCE initiated by a chord on the SUBDOMINANT followed immediately by the TONIC, as distinguished from an AUTHENTIC CADENCE inititated on the DOMINANT.

plainchant, plainsong *Music* The unaccompanied, monodic CHANT of the Christian church in the early Middle Ages. Plainchant is MODAL, and has no measured rhythm. *See* GREGORIAN CHANT.

planh [French, from Latin *planctus*] *Music* A lament (in the sense of elegy) mourning the death of a great person, a hero or a loved one. The words and music of planhs were composed and sung by TROUBADOURS during the Middle Ages. The earliest known example mourned the death of the emperor Charlemagne in the year 814.

plant *Acting* To place a significant PROP unobtrusively in the set where it can be picked up later to surprise the audience and punctuate the action of the plot. A typical example is for a character in the play to leave at the scene of a crime some seemingly insignificant object that later becomes the evidence convicting the criminal.

 Playwriting To embed, early in the exposition, an idea that will become significant later in the play.

 Theater To place a performer who will later take part in a play among the audience before the play opens. In *Waiting for Lefty*, by Clifford Odets, members of the cast sitting in the auditorium add credence to the theatrical suggestion that all in the audience are union members at a union meeting.

plaster cyclorama *Stagecraft* An INFINITE CYCLORAMA built in plaster on a rigid frame. The plaster is necessary to provide a seamless surface with no fold lines. The rigid frame is necessary to hold the heavy plaster in place. Since a plaster cyclorama cannot be moved, very few theaters have them. They exist in some television studios, particularly for use in filming commercials.

plastic *Stagecraft, Lighting* Having the appearance of three dimensions.

plastic lighting Lighting of different degrees of intensity from more than one direction, to bring out the three-dimensional quality of the set. The opposite of FLAT lighting.

platform *Stagecraft* In the Elizabethan theater, the FORESTAGE.

platform stage *Theater* Any stage with a practical acting area in front of the proscenium. *See* APRON, OPEN STAGE, THRUST STAGE.

platinum record *Music* A registered trademark for an award given by the RECORDING INDUSTRY ASSOCIATION OF AMERICA to a performer or group whose recording exceeds 1 million in unit shipments from the manufacturer. There is also an award, called multi-platinum, for shipments in excess of 2 million. *See also* GOLD RECORD.

platter *Music* Slang term for a published recorded disk. The term came into vogue when recordings were issued on 10- or 12-inch vinyl disks and is still used even though they were later replaced by COMPACT DISCS or TAPES.

play *Acting* To act a role.

Music To perform a piece of instrumental music.

Theater Any verbal theatrical work that has CHARACTERS who act out a PLOT with a beginning, middle and end.

playable *Theater* Said of any script that can be acted meaningfully on stage.

play agent *Theater* A playwright's representative who finds potential producers and negotiates terms for a production of a play.

play back *Audio* To rerun a tape recording in the studio so that the performers can hear what they did.

playback *Audio* The act of rerunning a recorded tape so that its music, dialogue or other sounds may be heard. In a recording studio, the engineer and the director commonly make their final judgements about a recording session only when they hear the playback, because it is, in fact, the sound actually imprinted on the tape. *See also* PRERECORD, POST SYNC.

Motion pictures The technique of playing a prerecorded tape of the sound track in a SHOOT so that actors can synchronize their actions to it. Musical scenes, for example, are often shot to playback in short segments allowing the camera to be shifted in position between shots.

playbill *Theater* 1. A single sheet of paper with an advertisement for a show and a listing of its CAST, schedule and ticket prices. 2. By extension, a printed program given to each member of the audience with details and background information about the show, the playwright, the director and the performers.

playbook *Theater* 1. A printed SCRIPT. 2. In historical research, the original text of an ancient play.

playbroker *See* PLAY AGENT.

play by ear *Music* To play a piece of music by remembering how it sounds, rather than by reading notes off the page.

play doctor *Theater* A person, usually a second playwright, called in when the original playwright is unable or unwilling to rewrite his or her work, to make changes in a script that isn't working well during rehearsals. *See also* DRAMATURGE.

play down *Acting* 1. To reduce the intensity of a role, a scene or a moment within a scene, by deemphasizing its lines and action. 2. To undermine the confidence of other actors onstage by acting in a condescending fashion toward them.

player *Music* One who plays a musical instrument.

Theater An actor.

player piano *Music* A mechanical piano. In the early 20th century, a player piano reproduced music that had been recorded as a system of perforations on a roll of paper, the PIANO ROLL, that was drawn across a cylinder with small openings that released air under pressure to an array of bellows operating the keys. In the 1980s electronically operated pianos came into existence, controlled by signals from a computer disk. Player pianos produce their tone the way a piano does, by striking strings with hammers actuated by keys. Not to be confused with synthesized pianos that produce tones electronically.

play for laughs *Acting* To emphasize those lines and characteristics in a role most likely to elicit laughs from the audience.

playgoer *Theater* A person who regularly attends performances of plays.

playhouse *Theater* A theater, especially one that specializes in plays as distinguished from other types of presentation, such as VAUDEVILLE and OPERA.

playing position *Acting, Dance* The performer's stance on stage, described in terms of the direction the body faces: full front, one-quarter (turned 45°), full profile (90°), three-quarter (135°) and full back.

playing space *Acting* 1. The space an actor occupies in a scene. 2. The acting area available in the entire set.

playing time *Recording* The duration of program material in a recording, expressed in minutes and seconds.

Theater 1. For an actor, the time scheduled for an engagement, expressed in days or weeks. 2. For a performance, the time taken in actual performance including intermissions, expressed in hours and minutes.

play it straight *Acting* To play a ROLE without exaggeration, especially avoiding innuendos that might seem comic or sarcastic.

play opposite *Acting* To play either of two leading roles in a performance. The term suggests that the actor plays opposite a slightly more important actor, with a hint of contrast and/or admiration.

play out *Acting* To play toward the house, *i.e.*, focused toward the audience.

playreader *Theater* One who reads new scripts and makes preliminary recommendations to the producer and/or director for or against production. *Compare* DRAMATURGE.

plays itself *Acting* Said of a play or a scene that needs little effort from actors to succeed on the stage.

play the heavy *Acting* To play the part of a strong, dislikable person.

play the lead *Acting* To play the most important ROLE.

play to capacity *Theater* To perform for a FULL HOUSE.

play to the gallery *Acting* To play a ROLE in a manner that will appeal to the people sitting farthest from the stage.

play up *Acting* To emphasize a specific LINE or piece of BUSINESS.

play up to *Acting* To lend support by giving another actor FOCUS during the scene.

play-within-a-play *Theater* A short play, complete in itself, that takes place during the course of a larger play, *e.g.,* the play of Piramus and Thisbe in Shakespeare's *A Midsummer Night's Dream.* Not to be confused with a SUBPLOT.

playwright *Theater* An author who writes plays.

playwright-in-residence *See* ARTIST-IN-RESIDENCE.

playwriting *Theater* The art of writing plays.

plectrum [Greek] *Music* A small flat, heart-shaped sheet of wood, ivory, tortoise shell or plastic held between the thumb and forefinger of the hand and used to pluck the strings of a GUITAR, MANDOLIN or similar stringed instrument, in function similar to the QUILL of the HARPSICHORD.

plié (*plee-AY*) [French] *Ballet* Literally, bent. Bending the knees, an exercise to loosen muscles and improve balance, considered a crucial element of ballet technique. Executed with the feet turned out and the heels firmly on the floor while the knees slowly bend. As a movement in BALLET, the plié is required in some form for successful performance of turns, jumps, etc.

plot *Theater* 1. The dramatic ACTION underlying any play, whether it be tragic or comic, poetic or musical. The arrangement of the incidents that form the basic structure of a play; a sequence of events that are essential to revealing the story of a play and carrying through from the opening situation to the end. Although such events must occur on stage in a context of time, a plot is not necessarily linear. There are many examples in modern theater in which linear time is either not a factor or is replaced by other relationships between events. According to Aristotle, plot is the most important of the six

formative ELEMENTS of tragedy (*i.e.,* of any drama) and is based on MYTHOS, the fundamental and somewhat symbolic structure of the underlying story. He defines drama, which includes comedy, as an imitation of ACTION, and plot as action that produces a fundamental change in a protagonist's fortunes. In TRAGEDY it arouses PITY AND FEAR in the mind of the viewer. In COMEDY it arouses the confusion of logic and absurdity that makes us laugh. In either case, plot contains a REVERSAL OF CIRCUMSTANCES (a change from one state of things to its opposite) and DISCOVERY (a change from ignorance to knowledge). Discovery is followed by RECOGNITION, which leads to further action leading to a CONFRONTATION WITH FATE and RESOLUTION (LYSIS). Without action, reversal of circumstances and discovery, there will be no plot, and without plot there will be none of the dramatic or comic processes that engage the audience. Aristotle says that a plot must be of some length, but of a length to be taken in by the memory. All these functions are as necessary for comedy as they are for serious plays. *See also* DRAMA, SUBPLOT. 2. A schedule of sequential actions to be taken by technicians and crews during a performance. *See* COSTUME PLOT, LIGHT PLOT, PROP PLOT.

plot action, plot business *Theater* Any BUSINESS required by the plot, such as Don Giovanni's duel with the Commendatore in Mozart's opera *Don Giovanni.*

plot line *Theater* The story of a play.

plot lines *Theater* Lines of dialogue essential to the progress of the PLOT, *e.g.,* in Goethe's *Faust,* when Faust walking with his pupil sees a dog who seems to be circling around him and says to it, "Come with us. Come here." The dog who then follows him home is Mephistopheles in disguise.

plot movement *Theater* The sequential development of the PLOT over time.

plot scene *Theater* A scene required by the progress of the PLOT as distinguished from another scene necessary for background. An example is the scene in Shakespeare's *Othello,* in which Iago steals Desdemona's handkerchief.

plot structure *Theater* The underlying dramatic structure of the play.

plot, unity of *Theater* The telling of a single story through dramatic action, without involvement of prior unrelated events, and without going into other stories after the main story has been told. Aristotle wrote that: "the story must represent one action, a complete whole, with several incidents so closely connected that the transposal or withdrawal of any one of them will disjoin and dislocate the whole" (translation by S. H. Butcher). *See* PLOT, SUBPLOT.

pluck *Music* To make a string produce sound by pulling it with a finger or a plectrum and releasing it. *See also* PIZZICATO.

plug *Acting* 1. To overplay a line intentionally to make sure the audience doesn't miss it. 2. To improvise words that advertise something or carry a message beyond what is necessary for the plot, *e.g.,* an ASIDE in the jail scene of the opera *Die Fledermaus* by Johann Strauss, when the tenor advertises a coming performance by telling the audience he must get out of prison so that he may play another role in it.

Broadcasting An unpaid, informal announcement on the air about an upcoming event, or a commercial product.

Lighting A male connector that fits into a STAGE POCKET for electric power or into a female connector to connect it to a DIMMER.

Stagecraft 1. A small FLAT designed to fit in an opening in a larger flat or between flats, *e.g.,* one that converts a door opening into a window opening (by filling the open space at the bottom), or a fireplace (by filling the open space at the top). 2. A freestanding piece of scenery designed to fit in the open part of a PORTAL.

Theater To mention a new production or a product in the program or the script of the present production.

plunk *Music* Slang for the verb *to strum* as on the GUITAR, implying a movement that will not let the tone resound.

POC *Acting* Abbreviation for POINT OF CONCENTRATION.

pocket *Lighting* *See* STAGE POCKET.

Stagecraft An open-ended seam in the bottom of a DROP into which a smooth BATTEN may be slipped to weight the drop when it is in place in the set.

poco [Italian] *Music* Slightly, a little, as in *poco allegro*, a little fast.

poco a poco [Italian] *Music* Little by little.

podium *Music* A small platform on which the conductor stands while leading an orchestra.

Stagecraft A small platform on which a speaker stands for greater visibility during a speech.

point [English], **pointe** (singular), **pointes** (plural) (*PWENHT*) [French] *Ballet* The tip of the toe(s) as distinguished from DEMI-POINTE, on the ball of the foot. To dance EN POINTE (or on point), a technique used only in BALLET, requires the dancer to create a straight line from the supporting toes through to the hip.

pointe shoe *Ballet* A special satin shoe closely fitted to the foot and strapped to the ankle with ribbons, without a heel and with a toe strongly reinforced with layers of glue and fabric so that it can support the dancer's weight on the tips of the toes, on POINT. Also called a toe shoe.

pointe tendu (*pwenht tanh-DÜ*) [French] *Ballet* Literally, point stretched. A position in which the leg is extended and only the tip of the toe touches the floor, performed with the heel raised and the instep facing outward.

point of concentration *Acting* The point onstage, offstage, or in the memory upon which an actor focuses attention while playing a role. *See also* OFFSTAGE BEAT.

point of focus *Acting* The point onstage where the director wants the audience to look.

point of view *Motion pictures* The direction from which a camera views the scene.

poker face *Acting* An expressionless face. *See* DEAD PAN.

Polacca *See* POLONAISE.

Polaroids *Motion pictures* Still photographs made with a Polaroid camera during a shooting session and developed in the camera so that they are ready for instant reference to see if the shot was correctly set up with actors in correct positions at the end, and to coordinate those positions with the next shot in the sequence. *See* CONTINUITY.

polishing rehearsal *Acting* A rehearsal, sometimes quite perfunctory, called during the run of a show to smooth out any difficulties or errors that have crept into the performance.

polka *Dance* A lively Bohemian round dance in 2/4 time with steps on the first three half-beats and a hop on the fourth. As a ballroom dance it was extremely popular in Europe and the United States in the 1800s. It became the Czech national dance.

Music The music of the dance POLKA. Many composers have written polkas for concert and opera performances. One of the most famous is the polka in Act II of *Die Fledermaus* by Johann Strauss, who also composed many polkas for his own orchestra to play at dances in Vienna in the late 1800s.

polka-mazurka *Dance* A Polish dance in 3/4 time, a variation of the POLKA that became fashionable in Vienna and Budapest in the mid-1900s. Characterized by gliding steps and bending of the knees.

polonaise *Dance* Once a festive PROCESSIONAL, it became a Polish national dance in moderate 3/4 time, often performed at the start of a ball. The polonaise appears in classical ballets such as *Swan Lake* and in modern ballets.

Polyhymnia *Dance, Music* The classical Greek MUSE of music and dance.

polyphonic *Music* Describing music that has more than one melodic line.

polyphony *Music* The style of music with more than one independently melodic line, distinguished from monophonic music that has only one with harmonic accompaniment, or homophonic music in which several voices combine to produce a complex line with unified rhythm and shape.

polyrhythmic *Music* Describing music that has more than one rhythmic pattern going on at a time, though usually with a common metrical basis.

polytonal *Music* Describing music that consists of melodies and harmonies playing simultaneously in different TONALITIES or KEYS. Not the same as POLYPHONIC.

polytonality *Music* The quality of having more than one tonal center. Not the same as POLYPHONY.

pong *Acting* In slang, to invent lines when the right line has been lost during a scene. *See also* AD LIB.

pool of light *Lighting, Stagecraft* An acting area defined by focused light from overhead, and surrounded by darkness.

pop *Broadcasting* A relatively loud sound produced by pronouncing any word starting with a plosive letter such as *P* or *T* too loudly and/or too close to the microphone. It can be reduced by the judicious placement of a pop screen. *See also* WIND SCREEN.

Music Short for POPULAR MUSIC.

pops, pops concert *Music* A concert by a symphony orchestra, frequently staged outdoors in an ORCHESTRAL SHELL, with a program limited to show tunes and lighter classics.

pop screen *See* WIND SCREEN.

pop singer *Music* A singer who specializes in POPULAR SONGS, as distinguished not only from an OPERA or CANTATA soloist, but also from a JAZZ singer.

pop soul *Music* Gospel-oriented SOUL music that has been modified, largely through changes in instrumentation, to appeal to a wider audience. The most notable examples come from MOTOWN records. *See also* CROSSOVER.

popular song *Music* A song composed with the intention of reaching immediately a wide range of listeners. Although many popular songs enjoy only a brief success before they are forgotten, some have endured long enough to become part of the standard repertoire on which dance bands, jazz bands and other groups may base their music. *See also* STANDARD. *Compare* FOLK SONG.

portable board *Lighting* A control CONSOLE that can be moved from place to place.

portal *Stagecraft* Any large, flat scenic structure such as an INNER PROSCENIUM built to frame the entire stage, replacing cloth LEGS and BORDERS.

portamento [Italian] *Music* With the voice or a bowed, stringed instrument, the art of gliding smoothly from one tone to another, passing lightly through the tones in between. Not to be confused with GLISSANDO.

portative organ *Music* A small, portable ORGAN of the 16th through 18th centuries capable of playing only a melodic line.

port de bras (*por deu BRAH*) [French] *Ballet* Literally, carriage of the arms. One or more movements of the arm or arms from one position to another. Also, a series of exercises intended to develop grace and fluidity. *See also* POSITIONS OF THE ARMS.

pose *Dance* An event without motion, a position held for a length of time.

posé (*poh-ZAY*) [French] *Ballet* A movement or step with the knee straight, on to the POINTE or DEMI-POINTE, that can be executed from any position.

positions *Music* 1. On any instrument of the VIOLIN FAMILY, any one of five locations the left hand can take to play different tones. In each position the fingers can cover four notes on each string. In FIRST POSITION, the back of the left thumb touches the base of the SCROLL of the instrument. In addition to the notes of the OPEN STRINGS in that position, the fingers can reach up to four more whole tones (or eight SEMITONES), starting with the semitone above the open string (*i.e.*, G-sharp on the G-string). In second position, the fingers start on the next note (A on the G-string), and so on. In FIFTH POSITION the hand touches the body of the instrument. 2. On the TROMBONE, first position is with the slide pulled in to its home position. The player's lips determine which set of notes will be produced. With each shift away from the home position, the set of lipped tones becomes one semitone lower.

positions of the arms *Ballet* A series of arm positions commonly associated with the five basic POSITIONS OF THE FEET that vary somewhat from one school of ballet to another. One such series appears in the illustration for positions of the feet, below.

positions of the body *Ballet* The directions the body faces in relation to the audience, and the angle it assumes with various positions of the feet, placement of the arms, and the movement the dancer is about to make to execute a particular step. In the CECCHETTI METHOD, the eight basic positions are: (1) CROISÉ DEVANT (crossed in front), (2) À LA QUA-TRIÈME DEVANT (to the fourth front), (3) ÉCARTÉ (separated), (4) ÉFFACÉ DEVANT (shaded), (5) À LA SECONDE (second position), (6) ÉPAULÉ (shouldered), (7) À LA QUATRIÈME DERRIÈRE (fourth back) and (8) CROISÉ DERRIÉRE (crossed in back).

positions of the feet *Ballet* The five basic positions of classical ballet, formulated by Pierre Beauchamps and others in the late 1600s and illustrated for the first time in a book *Maître à Danser* (*The Dancing Master*) by the French queen's dancing master, Pierre Rameau (not the composer), in 1725. *See* FIRST, SECOND, THIRD, FOURTH and FIFTH POSITIONS. *See also* DANSE D'ÉCOLE.

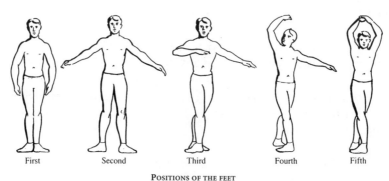

| First | Second | Third | Fourth | Fifth |

POSITIONS OF THE FEET

positiv (*paw-zee-TEEF*) [German] *Music* A small ORGAN in the choir loft, to accompany the choir.

post *See* SOUND POST.

poster *Theater* A large advertisement printed on one or more PRINTER'S SHEETS, intended to be placed on a billboard in the lobby or outside the theater.

postlude *Music* A piece of music composed to be played at the end of a major work, or of a concert.

post-modern dance A movement during the 1970s intended to make dance less formal in its movements, and more directly an expression of emotion.

post-production *Motion pictures* The period during which all the work of finishing a motion picture takes place, after the shooting is complete. The work includes, among many other functions, editing, music recording, mixing, titling and laboratory finishing up to and including the acceptance of an ANSWER PRINT.

post-score *Music, Motion pictures* To compose music for a film that has already been shot and edited. Most feature pictures are post-scored. *Compare* PRE-SCORE.

post sync *Motion pictures* To synchronize music or dialogue to an existing picture by recording it in a studio with the picture playing on monitors so that the actors, conductor and/or musicians can watch it while they record. *See also* DUB (3), LIP SYNC.

post the bond *Theater* To guarantee that actors will be paid for the first two weeks of the show by placing a deposit of the total amount with the Actors Equity Association.

posture master *Circus* Archaic term for a CONTORTIONIST.

pot, potentiometer *Audio, Lighting* An electrical device that controls the amount of power passing through a circuit. Generally the term refers to circuits of low voltage, although a high-voltage DIMMER, strictly speaking, is also a form of potentiometer.

potboiler *Theater* 1. An adequate but not especially exciting play written quickly and in a somewhat offhand manner, merely to make a little money. 2. A disparaging term for a mediocre production presented for the purpose of raising money.

pounce, pounce bag, pounce box *Stagecraft* A porous container holding powder to be sprinkled or tamped over perforated paper patterns to transfer a design to the canvas or a stage FLAT.

pounce wheel *Stagecraft* A little wheel with a handle and spikes around its circumference, used to perforate sheets of paper that will be used with a POUNCE to transfer a design to set pieces.

pound the lines *Acting* To pronounce accented words very heavily.

POV *Motion pictures* Abbreviation for the camera's POINT OF VIEW.

pp *Music* Abbreviation for PIANISSIMO.

PR *Theater* Abbreviation for PRESS RELEASE.

practicable *Stagecraft* Capable of being used or operated on stage as, for example, a door that can be opened and closed as distinguished from the image of a door painted into the set. Often inappropriately replaced by "practical."

practical *Lighting* A light fixture that is part of the set and produces light of seemingly natural intensity, though it may be controlled by a dimmer to achieve that effect. *See also* APPARENT LIGHT SOURCE, MOTIVATED LIGHT.

praxis (*PRAHK-sis*) [Greek] *Theater* Literally, practice, as in the practice of acting. *See* ACTION.

prelude *Music* A short piece in one movement intended to prepare the audience for a larger one. Many composers have used the term as a title for any short piece that is not part of a larger structure.

premier danseur (*prem-YAY danh-SEUR*) [French] *Ballet* The principal or leading male dancer of a ballet company, outranked (in the Paris Opéra) only by the premier danseur étoile (the STAR).

premiere (*prem-YEHR*) [from French] *Ballet, Opera, Theater* The first official public performance of a staged work. Many premieres have been preceded by out-of-town TRYOUTS and PREVIEWS, but the premiere is a gala occasion for which there may be special guests in the audience. It is often the performance that critics review.

première danseuse (*prem-YEHR danh-SEUZ*) [French] *Ballet* The principal female dancer of a ballet company, outranked only (in the Paris Opéra) by the première danseuse étoile (the star). The French equivalent of BALLERINA.

premise *Theater* The basic situation of the plot revealed through dialogue and action during the early scenes of a drama. It is described as the PROTASIS in Aristotle's *Poetics*. *See also* BACKGROUND.

pre-mix *Audio* An audio mix of selected previously recorded sound tracks, *e.g.,* the many separate instrumental tracks that will make up the music track, to reduce the number of tracks that must be dealt with in a final mix.

preparation *Acting* The process of concentrating on the background of the character to be portrayed and on one's personal EMOTION MEMORY before entering a scene. *See* OFFSTAGE BEAT.

Music A composer's technique of softening the effect of a DISSONANCE on the beat by anticipating it, sounding at least one of its tones as a CONSONANT in the preceding chord and holding it into the dissonance. *See* APPOGGIATURA.

Playwriting Background information planted early in the opening scene of a play to prepare the audience to understand what happens later, or to work up anticipation for the entrance of a significant character in the scene.

prepared piano *Music* A PIANO that has been modified by attaching any of a vast number of devices to its strings so that it produces a wide variety of tones and sound effects. The American composer John Cage was the first to make consistent use of the idea. He attached bolts to some strings, thin rattling pieces of metal to others and so on, making his music an interesting study in percussive effects with only hints of musical tone within them.

prerecord *Motion pictures* To prepare a sound track before shooting the picture to match it. Many a musical scene is shot to PLAYBACK, so that the musical performance can be recorded under ideal conditions without the distractions, delays and physical problems that normally occur in a shooting session. Many a scene with a STAR singing must be pre-

recorded with a professional singer because the star has an inadequate singing voice. The technique is standard in ANIMATION. The editor makes a LOG of the sound track, marks each of its significant beats and prepares a FRAME COUNT from which a STORYBOARD, and eventually a series of KEY DRAWINGS can be made. The ANIMATOR prepares the IN-BETWEENS and the camera operator shoots the picture to the frame count.

prerelease screening *Motion pictures* A test screening for a selected audience to determine if any changes may be needed in the picture before it is released to the general public.

prescore *Music, Motion pictures* To compose music for a film before the film is shot and edited. Most animations are prescored, because the animator can then use the music track as a base for synchronizing the picture.

presence *Audio* The sense of nearness and realism in the sound of voices or instruments that occurs when MICROPHONES are well placed to pick them up and the audio system transmits without interference. When microphones are placed badly, they pick up other sounds in the area that, when transmitted along with the desired sounds, produce an unreal effect.

Acting The audience's sense of an actor's emotional contact with the other actors in the scene, starting from the moment the actor enters.

preset *Lighting* A control that can be set ahead of time to produce a specific dimming operation, allowing the operator to work out the degree and duration of the dimming along with its terminal setting during rehearsal without the pressure of doing it in real time on CUE. When the cue actually arrives in the scene, the operator sets the process going automatically and has time, thereby, to set up the next cue. Presets for an entire scene are often arrayed in a bank, and can be arranged to be operated by a single MASTER FADER. *See also* MEMORY SYSTEM.

preset board *Lighting* A control board that can handle several PRESETS at once.

preset sheet *Lighting* A CUE sheet for the lighting operator, showing in proper order the settings for each detail of each PRESET together with its cue.

press book *Theater* A book containing copies of all the press releases, announcements, advertisements and published interviews, together with the critics' reviews of the show.

press list *Theater* A list of critics who are to be given free tickets for opening night.

press pass *Theater* A card or a special free ticket giving a reporter or a critic free access to the theater to see the show.

press roll *Music* On the SNARE DRUM, a rapid, restless DRUMROLL requiring both sticks, used mostly in DIXIELAND music.

prestissimo (*pres-TEE-see-moh*) [Italian] *Music* As fast as possible.

presto (*PRES-toh*) [Italian] *Music* Very fast, faster than ALLEGRO.

preview, prevue *Motion pictures* A brief selection of SHOTS taken from a new movie and made into an advertisement for it, to be played in theaters in the weeks ahead of its arrival.

Theater A performance of the play given to a limited audience before the official opening as a means of ironing out any difficulties in the production before the critics see it.

pricksong *Music* A 16th-century term for music on paper (pricked on with a quill-pointed pen, or printed) to distinguish it from music learned from oral tradition only.

prima ballerina (*PREE-mah bah-leh-REE-nah*) [Italian] *Ballet* In a ballet company, the first principal female dancer. The French equivalent is *première danseuse d'étoile.*

prima donna (*pree-mah DON-ah*) [Italian] *Opera* 1. The most important female singer in the company. 2. By extension, any female singer whose feeling of self-importance has made her extremely difficult to work with.

prime *Music* 1. The TONIC note of any scale. 2. An interval of no steps, *i.e.,* UNISON.

prime time *Television* The hours between 8:00 and 11:00 P.M. weekdays and Saturdays, and between 7:00 and 11:00 P.M. Sundays, when the television audience is presumed to be most numerous and advertisers pay the highest rates.

primo (*PREE-moh*) [Italian] *Music* The first. The term frequently is used to designate the treble player in a FOUR-HAND (piano) duet, the other being SECUNDO.

principal *Acting* The leading role.

Music A four-foot open stop on the organ.

printer's sheet A standard sheet of paper used by printers for music, newspapers, playbills or large posters. Theatrical posters and billboards are usually printed on one or more standard sheets, *e.g.,* ONE-SHEET, THREE-SHEET, TWENTY-FOUR-SHEET. Programs, music and LIBRETTOS are printed with two to eight pages on each side of a standard sheet, *e.g.,* FOLIO, OCTAVO, QUARTO.

"print it" *Audio, Motion pictures* An instruction by the director during a SHOOT or a RECORDING SESSION to make a work print of the TAKE for editing and, conversely, not to bother with printing other takes. Although an audio recording is not printed, directors continue to use the term to indicate takes that are acceptable for editing.

print-through *Audio, Television* A recorded echo offset by several seconds from its initiating signal. It arises when the original signal is recorded at too high a level and the tape, being wound tightly on a reel, allows the overmodulated signal to migrate from layer to layer, causing an echo earlier or later than the proper sound.

processional *Music* A solemn MARCH composed as an accompaniment for a procession such as a line of priests, acolytes and choir entering the church to perform a service. The processional is often an accompanied hymn, sung by the choir as they march.

processional cycle, processional play, processional staging *See* PAGEANT.

process shot *Motion pictures* Any shot, *e.g.,* a DISSOLVE, that requires work in an optical laboratory to complete.

produce *Motion pictures* To gather together the entire creative and technical team that will design and finish the production, determine its budget, provide the money, hire the cast, supervise scheduling, logistics and expenditure throughout both production and post-production phases until the picture is released.

Music To gather together the performers and technical personnel for a recording, arrange for and supervise the studio session, any necessary editing, mixing and/or mastering.

Theater To put together the entire creative and technical team that will design and rehearse the production, determine its budget, arrange for financing, rehearsal space and the theater they will use, and supervise the management of all the technical, professional and business matters that may arise, including tours.

producer *Motion pictures, Theater* The person ultimately in charge of a production. In the United States, the person who wields day-to-day financial control, though not the same as a business manager. *See also* INTENDANT.

Music In recording, the person ultimately responsible for the way a piece of music is recorded and marketed. Frequently the producer works very closely with the featured musicians, selects the engineers, the studio and sometimes even some of the SIDEMEN who will take part, and exercises influence in the style of recording and MIXING the many TRACKS.

production *Motion pictures* 1. The total creative and technical activity of making a motion picture. 2. A specific motion picture, as distinguished from any others that may have been made from the same book or play.

Opera, Theater 1. The total creative and technical activity of putting a theatrical work or an opera on stage. 2. A specific performance version of a theatrical work.

production book *Theater* The stage manager's annotated copy of the script, showing details of BLOCKING and CUES as they were specified for the particular production. *See also* PROMPT BOOK.

production crew *Theater* All the backstage technicians and assistants who create, design and handle SETS, lights, costumes and PROPS for a production.

production house *Motion pictures, Television* A business firm that produces motion pictures or videotaped programs on contract for others, usually at its own facilities.

production manager *Theater* The supervisory person ultimately responsible for all technical and business matters in a production.

production notes *Theater* All the information added to the script in the stage manager's PRODUCTION BOOK.

production number *Motion pictures, Theater* Any elaborate and complete musical event within a play or a motion picture that fills the stage or screen and involves all or most of the cast. By extension, the term is used to describe any large, expensive scene in a screenplay.

production stage manager *Theater* The STAGE MANAGER for a particular production. There may be one for the original production, another for a touring production.

proem [from Greek] *Theater* A PROLOGUE.

professional matinée *Theater* A MATINÉE to which professional members of other productions are invited.

profile, profile board *Stagecraft* A FLAT with one or more edges shaped irregularly to represent foliage, clouds, waves, or an architectural shape. *See also* GROUND ROW, SILHOUETTE.

profundo (*proh-FOON-doh*) [Italian] *Music* Deep, as in BASSO PROFUNDO, deep bass.

program *Broadcasting* *See* SEGMENT.

 Music The story underlying a piece of PROGRAM MUSIC.

 Theater *See* PLAYBILL.

programmatic *Music* Having or suggesting the quality of PROGRAM MUSIC.

programming panel *Lighting* The section of a memory CONTROL CONSOLE that carries the electronic controls with which the lighting director can prearrange all the PRESETS for a show in every detail so that the show can be run by cue number.

program music Music that attempts to depict an extramusical image or story, *e.g., Don Quixote* (1898) by Richard Strauss, as distinguished from ABSTRACT MUSIC.

progression *Music* An orderly movement of harmonies within a piece of music, particularly a sequence of harmonies that follows a perceptible pattern, as in the CYCLE OF FIFTHS.

 Playwriting The forward movement of the PLOT.

progressive jazz *Music* A term whimsically invented by Stan Kenton in 1947 as a name for a new band and its first album. Although the album to which he referred contained several arrangements in his style of that time, including the melodious *Theme to the West*, the term soon took on new meaning as a style of jazz more suitable for concert than for dancing. *See also* COOL JAZZ, MODERN JAZZ.

progressive rock *Music* In the 1960s, a trend in ROCK music toward the use of new electronic instruments, distortion effects, synthesizers, etc.

project *Acting* To speak clearly and resonantly in rhythms that are natural to the words and their significance, and to match the speech with appropriate stance and action so that it carries with all its meaning to the entire audience.

projected scene *Motion pictures, Stagecraft* A scene created by projection onto a suitable surface on the SET, projected from behind the set onto a translucent SCREEN or SCRIM. *See also* REAR PROJECTION.

projection *Acting* The process of delivering the significance and meaning of the play across the footlights to the entire audience.

Lighting The process of throwing focused, shaped light on a specific surface from a distance.

Motion pictures The process of placing the focused motion picture on a large screen in a theater.

projection booth *Theater* A booth at the rear of the HOUSE, sometimes above a balcony, from which light or a motion picture can be projected onto the stage.

projectionist *Motion pictures* The operator of a motion picture projector.

projection screen *See* SCREEN.

projector *Lighting* Any light that casts its beam in a single direction and can be focused accurately. A projector must have either a lens or a parabolic reflector to focus the beam.

prologue *Theater* 1. An introductory speech or scene, usually performed in front of the main curtain to secure the attention of the audience. 2. The performer who speaks the introductory speech. *See also* WARMUP.

promenade *Dance* 1. In ballet, a slow turn on one foot, with the dancer holding a specific POSE. In a PAS DE DEUX, the female dancer holds her pose on POINT and is turned by her partner. Also called *tour de promenade*. 2. In SQUARE DANCE, to march forward as a couple, arm in arm around the dance floor.

promenade, en *See* EN PROMENADE.

promo *Television* Short for promotional announcement. A brief message broadcast along with COMMERCIALS to announce an upcoming program or film on the same channel.

promotion *Theater* The announcements, press releases, personal appearances, interviews, newsletters, advertisements, souvenirs and other marketing devices used to attract an audience to a show. *See* BALLYHOO.

prompt *Acting* 1. In British theaters, the side of the stage where the prompter sits, *i.e.*, STAGE LEFT. *See also* OPPOSITE PROMPT. 2. To speak the cues or supply missing words to an actor in rehearsal or quietly from the wings during a performance.

prompt board *Theater* The board or panel to which are attached the PROMPTER'S telephone and intercom, signal buttons and, in some theaters, a closed-circuit television monitor, installed in the PROMPT CORNER, giving the prompter instant communication with the stage manager, music director and others during the show.

prompt book *Theater* The copy of the play used by the PROMPTER in a particular production, marked up with cues and blocking information, all of which may be preserved as archival material. *Also called* PRODUCTION BOOK, STAGE MANAGER'S BOOK. *Compare* REGIEBUCH.

prompt corner *Theater* The place backstage where the prompter sits during the show. It is often at STAGE LEFT (the audience's right) just behind the proscenium.

prompter *Dance* In some CONTRA dances, including the LONGWAYS SET, a person who indicates the figures to be danced by calling a few cue words at appropriate times. *Compare* CALLER.

Opera, Theater The person who sits on the stage out of sight of the audience, follows the SCRIPT (or the SCORE) during a rehearsal or performance and supplies CUES and/or missing words to the performers and cues to technical operators as needed.

prompter's box *Opera* A covered booth, usually placed among the FOOTLIGHTS at center stage, in which the PROMPTER sits with a SCORE, out of sight of the audience but visible to the actors. In a modern opera house, the prompter's box is equipped with a telephone, an intercom, signaling buttons and one or more closed-circuit television monitors, so that the prompter can see the CONDUCTOR or an assistant conductor backstage and can communicate with the stage manager and others as needed. *Compare* PROMPT CORNER.

prompt script *See* PROMPT BOOK.

prompt side *Theater* The side of the theater where the PROMPTER sits. Actors and stage managers, particularly in British theaters, use the term in their scripts to mean STAGE LEFT.

prompt table *Theater* A table in the PROMPT CORNER on which the prompter places the PROMPT BOOK.

prompt wing *Theater* The WING behind which the prompter sits.

prop *Theater, Motion pictures* Abbreviation for PROPERTY, but the term is most common in its short form. Any easily portable object of some significance in the play carried or used by actors in a scene. *See also* CHARACTER PROP, PERSONAL PROP.

prop crew *Theater, Motion pictures* The backstage team responsible for providing and managing all the PROPS throughout a production.

property *Motion pictures, Television* The complete rights to an original story that will be made into a motion picture or a television program.

Stagecraft See PROP.

prop list *Motion pictures, Theater* A complete list of all the PROPS that will be used in a production.

prop man, prop person *Motion pictures, Theater* A person who handles PROPS backstage during the show, gets them ready for use as called for in the script and retrieves them after use so that they will be ready for the next performance.

prop master, prop mistress *Motion pictures, Theater* The person in charge of PROPS, their handling backstage and their storage. Often also the person who finds or purchases appropriate props for the show.

proportional dimming *See* DIFFERENTIAL DIMMING.

prop rehearsal *Acting* A rehearsal called for the purpose of learning how to handle the PROPS in the show.

prop shop *Theater* The room backstage where PROPS are kept and, in larger houses with shows in repertory, where many are made.

proscenium *Theater* An architectural, framed opening through which the audience sees the play. The proscenium is the permanent wall between the auditorium and the stage and has a wide opening that defines the limits of the visible acting area behind it. Its outer surface may be elaborately decorated or plain. An APRON or a THRUST STAGE extends in front of the proscenium toward the audience. An ARENA STAGE has no proscenium at all.

proscenium batten *Stagecraft* A BATTEN directly behind the PROSCENIUM, in front of the main curtain of the stage.

proscenium lights *Lighting* Stage lights mounted on vertical pipes in the wings directly behind the proscenium. Also called LADDER LIGHTS.

proscenium stage *Theater* A stage with a permanent proscenium. *Compare* APRON, ARENA STAGE, FORESTAGE, THRUST STAGE.

proscenium theater A theater with a PROSCENIUM, as distinguished from an arena theater.

proscenium wall *Theater* The architectural wall pierced by the PROSCENIUM opening.

prosody *Music* The art of matching the natural rhythms and sounds of words to vocal music. Words sung in rhythms that are grossly different from their natural rhythms are harder to understand. Vowel sounds held for a long time, or spread over many notes, tend to lose their individual characters, and dipthongs may be completely destroyed. Also, not every vowel sounds natural in every vocal range. The sound of "ee" is often indistinguishable from "ah" if it must be sung in the singer's top REGISTER or, for that matter, in the lowest register. A composer who is sensitive to words, and who wants them to be understood by the audience must take these subtleties into account when composing vocal lines.

protagonist [Greek] *Theater* Literally, first contestant. The leading ROLE in a play, *i.e.,* the role of the character who goes through the sudden REVERSAL OF CIRCUMSTANCES that Aristotle defined as a requirement of drama. *See also* ANTAGONIST.

protasis (*pro-TAH-sees*) [Greek] *Theater* Literally, something put forward. *See* PREMISE.

protection copy *Recording, Motion pictures* An exact duplicate of the ORIGINAL negative or RECORDING that is put aside and preserved, to be retrieved if anything happens to the original.

prothalamion (*pro-thah-LAH-mee-on*) [from Greek] *Theater* An ODE in celebration of a betrothal. The term was coined from Greek as the title of a poem by Edmund Spenser in the 16th century. The Greek playwrights composed odes in celebration of marriage, for which their word was *epithalamion,* "upon the marriage."

provinces *Theater* A slightly disparaging term for anywhere "out of town." In the United States this term is often used to describe any place outside of New York City.

psalm [Hebrew] *Music* A sacred song, particularly one of the 150 songs whose words have been preserved in the Old Testament Book of Psalms.

psalmody *Music* The songs preserved in the Old Testament, considered collectively.

psaltery *Music* A plucked stringed instrument of biblical times, like the modern ZITHER.

P-side *Stagecraft* Abbreviation for PROMPT SIDE.

PSM *Theater* Abbreviation for PRODUCTION STAGE MANAGER.

psychodrama *Theater* Nontheatrical plays improvised and performed by psychiatric patients for therapeutic reasons during their treatment. Not to be confused with psychological plays, that are theatrical plays with an emphasis on psychological characterizations.

public rehearsal *Theater* Any rehearsal to which members of the public are admitted. *Compare* PREVIEW, TRYOUT.

pub rock *Music* In the early 1970s, an unpretentious style of ROCK music performed in London pubs by bands clad in workshirts and jeans, perhaps in reaction to the overdressed adherents of GLAM-ROCK.

puff *Theater* A small item of publicity planted in a program or press release.

Punch and Judy show *Puppetry* A traditional puppet show for children played for centuries by itinerant puppeteers in the villages and towns of Europe. There are two main characters, Punch and his wife Judy, both HAND PUPPETS and both somewhat grotesque, with exaggerated facial features. The script is improvised by the puppeteer and always contains great noisy fights between the two characters. *See also* GRAND GUIGNOL.

Punchinello [Italian] *Puppetry* The prototype of Mr. Punch.

punch line *Vaudeville* The last line of a joke, the line that makes it funny.

punk, punk rock *Music* Originating in New York City in the mid-1970s, a ROCK style of music and dress designed to provoke both bourgeois society and the rock establishment, later typified by the British group the Sex Pistols. Lyrics were insolent, abusive and nihilistic, against a background of aggressively overamplified music.

punster *Vaudeville* A STAND-UP COMEDIAN who specializes in puns.

pup *Lighting* Slang term for a 500-watt spotlight.

puppet Any articulated model of a human being or an animal used in a theatrical situation. The term "puppet" is usually taken to mean HAND PUPPET. A puppet on strings is more frequently called a MARIONETTE. There are also puppets controlled by rods from below the

stage and Asian SHADOW PUPPETS that play in silhouette on translucent screens, also controlled by rods from below. *See* BUNRAKU, PUNCH AND JUDY SHOW.

puppeteer *Puppetry* One who operates a PUPPET or a MARIONETTE.

puppetry The art of presenting plays and skits by means of PUPPETS or MARIONETTES.

puppet show *Puppetry* A show that uses PUPPETS or MARIONETTES.

purchase line *See* OPERATING LINE.

pure-tuned music Music in which all the intervals, whether melodic or harmonic, are tuned precisely at pitches that are in simple arithmetic relationships to each other, *e.g.*, 2:3, 1:2, 5:4, etc. It is impossible for a piece of music to maintain pure tuning at any length, because these relationships force the piece to move to new ranges that strain the voices or exceed the capabilities of the instruments. In practice, therefore, A CAPPELLA choirs and others who attempt pure tuning make constant melodic adjustments as they progress from one harmony to the next, concentrating their efforts on keeping the individual chords harmonically pure. Pure tuning is an ideal against which all systems of tuning are judged. *See* EQUAL TEMPERAMENT, MEAN-TONE SYSTEM.

putty *Makeup* Any soft, pliable material that can be applied to the face to build up cheekbones and other prominences required to define a CHARACTER in a play.

Pythagorian scale *Music* A SCALE devised by the Ionian physicist Pythagoras (c. 550 B.C.), by tuning each tone at the interval of a PERFECT FIFTH from the last, or, for reasons of practicality, from the lower octave of the last and then bringing them together in stepwise order. To do this, Pythagoras and his associates must have used some version of a MONOCHORD. The Pythagorean scale was the first attempt in history to arrive at an understanding of acoustical relationships. *Compare* MEAN TONE SYSTEM.

Pythagorian third *Music* A major THIRD with its two tones in the harmonic relationship of 5:4. It is a wider third than any in the equal-tempered system. It comes into practical use, though many do not recognize its origin, when a choral director asks his choir to sing the LEADING TONE, the third of the dominant chord, "as sharp as possible" to give it an intense cadential effect.

Q

Q *Lighting* In the lighting director's script, the abbreviation for CUE.

quad box *Lighting* An electrical connection box with four outlets. *See also* DUPLEX, SPIDER, THREEFER.

quadrille *Dance* 1. A SQUARE DANCE for four couples, originally in five sections, popular in France and England during the first half of the 19th century and later brought to the United States where it was in vogue in New Orleans during the early years of jazz. Elements of the quadrille became part of the American square dance. 2. In the Paris Opéra, a group of dancers equivalent in rank to the CORPS DE BALLET.

quadruple counterpoint *Music* A style of COUNTERPOINT in four voices with at least two themes, in which the upper theme is lowered or the lower theme raised an octave from time to time. A form of INVERTIBLE COUNTERPOINT. Not the same as a QUADRUPLE FUGUE.

quadruple fugue *Music* A four-voice FUGUE with four different SUBJECTS woven together. The last, unfinished section of Johann Sebastian Bach's *Art of the Fugue* is a quadruple fugue.

quadruplet *Music notation* A sequence of four notes to be played in the time allotted to three. *See* TUPLET.

quadruple time *Music notation* Any metrical pattern that can be divided into four regular beats. *See* TIME SIGNATURE.

quantity *Music notation* The duration of a note.

quartal harmony *Music* A system advocated by modern scholars for the analysis of the structure of Gregorian chant, based on TETRACHORDS with two tetrachords forming the octave.

"quarter" *Theater* A stage manager's WARNING to the cast and crew of a show 15 minutes before the curtain rises.

quarter note *Music notation* A note having the time value of one quarter of a WHOLE NOTE.

QUARTER NOTE

quarter position *Acting, Dance* A performer's position, standing with the body facing 45° away from the audience, *i.e.,* halfway between full front and profile position, facing either DOWNSTAGE CORNER.

quarter tone *Music* A musical INTERVAL equal to one-half a SEMITONE. Although much ETHNIC MUSIC makes use of MICROTONES, particularly in the Middle East and Asia, most must be considered MELODIC styles, with little emphasis on HARMONIC structure. European, American and a few contemporary Japanese composers have explored both the melodic and harmonic possibilities of microtones, using strings, fretless guitars, etc. Among these was the 20th-century American composer Harry Partch, who devised several stringed and dulcimerlike instruments with 43 tones to the octave. But the tones he used were not evenly distributed quarter tones. Those experimental composers who wished to use quarter tones with precision devised various keyboard instruments, some with two standard keyboards ranked one above the other in a single instrument, some with 24 split keys to the octave. One of the few successful works in the quarter-tone genre, and certainly one of the earliest to be composed, is *Three Quartertone Pieces*, composed by Charles Ives for two pianos tuned a quarter-tone apart.

quartet *Music* 1. Any ensemble of four singers or instrumentalists. 2. A piece of music composed for such an ensemble. 3. An ensemble of four strings: two violins, viola and violoncello, also referred to as a string quartet. *Compare* PIANO QUARTET, BARBERSHOP QUARTET.

quarto *Theater* Literally, a quarter (of a sheet). One of the sizes in which plays were printed in Shakespeare's day. The printer impressed four pages on each side of a standard PRINTER'S SHEET folded in half once, then once again, to produce eight pages. *See also* FOLIO, OCTAVO.

quartz-iodine lamp *Lighting* A small bulb that produces light at 3,200 to 3,400 K (degrees Kelvin).

quatrième (*kah-tree-EM*) [French] *Ballet* Literally, fourth, as in FOURTH POSITION.

quaver *Music notation* The British term for QUARTER NOTE.

queer someone's act *Acting* To spoil the TIMING of another actor's scene by anticipating or delaying CUES, moving in unexpected ways on stage or failing to react to another's lines.

quick-change artist *Acting* A performer who specializes in very rapid changes of character or of costume.

quick-change room *Stagecraft* A special dressing room located close to the stage, where an actor can change from one costume to the next in the least possible time. On occasion, a temporary quick-change room may be constructed by lashing several FLATS together backstage.

quick cue *Acting* A CUE to be taken up without a pause.

quick curtain *Stagecraft* A curtain closed as quickly as possible after the final action or word in a scene. *Compare* MEDIUM CURTAIN, SLOW CURTAIN.

quick march *Music* A MARCH at a fast tempo. *See* CUT TIME.

Quickstep *Dance* An English version of the "quick time" FOXTROT of the 1920s, executed with gliding steps and turns. Slow steps are held for two beats each, and quick steps for one beat.

quick study *Acting* Said of an actor who learns lines quickly.

quick time *See* CUT TIME.

quinte *Music* 1. An organ STOP having a prominent third HARMONIC. 2. German name for the FIFTH.

quintet *Music* An ensemble of five voices and/or instruments. In practice, the term usually indicates a group of similar instruments, such as five strings, five winds or five brasses. Sometimes, however, it is modified with an instrument name, as in viola or violoncello quintet, to indicate a string group made up of a standard STRING QUARTET with an additional viola or violoncello. *See also* PIANO QUINTET.

quintuplet *Music notation* A sequence of five tones to be played in the time of four (in passages of duple beats), or three (in passages of triple beats). *See* TUPLET.

quodlibet [Latin] *Music* Literally, what pleases. A humorous little piece of music made up of familiar tunes or fragments, frequently with words that mix with comic or ribald effect when they coincide unexpectedly as the tunes are sung together. The improvisation of quodlibets was a favorite pastime around the Bachs' supper table, where father, mother and several of the children were exceptional musicians. Perhaps the most famous of all quodlibets occurs in the last section of Johann Sebastian Bach's *Goldberg Variations*, where he mixed "I've been so long away from you" with "Cabbages and turnips have driven me away."

quonk *Audio* An onomatopoeic name for the sound of any unwanted bump against an open microphone.

R

R *Theater* STAGE RIGHT.

raccourci (*rah-koor-SEE*) [French] *Ballet* Literally, shortened. A position in which a bent leg is raised, with the pointed toe of the WORKING LEG touching the knee of the SUPPORTING LEG. *See also* RETIRÉ.

race music *Jazz* A term used in the 1920s and 1930s for a style of music based closely on the BLUES, characterized by a heavily accented beat and intended for a mostly African American audience. Records of such music were referred to in the recording industry as race records.

rack *Lighting* 1. A steel framework attached to the wall of the stage, or in the basement, to support an array of DIMMERS activated by remote control. 2. In older theaters, a steel rack built in front of the front rail of a balcony to hold lights.

racket *Music* A DOUBLE-REED INSTRUMENT of medieval times. It consists of a short wooden cylinder that can be held in the hand, with an arrangement of parallel tubes inside, each connected to another to form a single long, folded tube. The player blows through a little curved pipe inserted into the top of the cylinder and closes or opens various holes in the side of the cylinder with the fingertips to determine pitches.

radical theater A style of theater that came into existence in the 1930s, emphasizing social and political subjects in satirical and comic form. In some cases the productions closely imitated the style of Italian COMMEDIA DELL'ARTE.

rag *Music* Short for RAGTIME.

Stagecraft Slang for MAIN CURTAIN.

raga *Music* A classification of types of melodies in the music tradition of India, in use since the 4th century. Since music has always been considered an integral part of the structure of the universe in Hindu philosophy, individual ragas have always been associated with colors, moods and spiritual elements. Even today, performers are careful not to play some ragas on a stage with, for example, predominantly blue curtains, if they have not traditionally been associated with blue.

rag doll *Stagecraft* A scrap of canvas soaked in paint, then rolled over the surface of a FLAT to give it a rough look.

rag show *Vaudeville* A show presented under canvas.

ragtime *Music* A style of music introduced around the turn of the 20th century by the pianist and composer Scott Joplin. His music is characterized by relaxed but persistent syncopation, making "ragged time."

rail *Puppetry* *See* LEANING RAIL.

 Stagecraft Either the top or the bottom piece of the frame of a FLAT. *See also* TOGGLE.

rail iron *Stagecraft* A length of strap-iron fitted along the bottom of any heavy FLAT to make the flat easier to slide along the stage floor during scene changes and to provide structural stiffness, especially if the flat has a door or a fireplace built into it that would require the wooden bottom rail to be eliminated. *Compare* SADDLE IRON.

rail jump *Theater* Actors' slang for a trip by train to the next town on a TOUR.

rail lights *See* BALCONY BEAMS.

rainbow wheel *See* BOOMERANG.

rain box *See* RAIN DRUM.

rain check *Circus, Theater* A re-entry ticket giving free admission at a later date to members of the audience of an outdoor show that has been canceled because of a RAINOUT. By extension, free re-entry for patrons of any show canceled for any reason.

rain drum *Stagecraft* A round box partially filled with dried peas, beans or lead shot that produce a sound like rain when the box is tilted and slowly rotated.

rainout *Circus, Theater* Any outdoor show canceled because of rain.

rain pipe *Stagecraft* A perforated water pipe suspended horizontally above the stage floor through which water can be pumped to simulate rain on the stage. *See also* RAIN TROUGH.

rain trough *Stagecraft* A concealed trough on the stage floor directly under a RAIN PIPE where it will catch the water that falls as rain from the pipe.

rake *Theater* The DOWNSTAGE slope of the stage floor in older theaters, sometimes constructed in modern sets for special effects or to improve SIGHT LINES.

raked stage *Theater* A stage with a raked floor, *i.e.,* slanted DOWNSTAGE.

raking flats *Stagecraft* FLATS set at an angle to the audience, not parallel to the line of the main curtain.

raking piece *Stagecraft* Any small, triangular piece of wood shaped to close a gap between a RAKED STAGE floor and the bottom of a FLAT.

rallentando (*rah-len-TAHN-doh*) [Italian] *Music* Relaxing the pace and the intensity of the music.

R and B *See* RHYTHM AND BLUES.

random light *Lighting* A stage light with no apparent source, *i.e.,* an ARBITRARY LIGHT.

range *Acting* The gamut (compass) of an actor's voice, the extent to which the voice can reach up or down in pitch.

Music The total compass in musical pitch, from lowest to highest, throughout which a given voice or instrument can produce musical tone. *See also* REGISTER.

rank *Music* An array of organ pipes of the same TIMBRE, controlled by a single STOP.

rank theater A theater with separate sections of seats reserved for people of different social classes, as in Britain from the 16th to the 18th centuries.

rap *Music* A form of urban African American music based on street language that developed in the late 1970s, borrowing from a New York disk jockey's technique of talking over an instrumental BACKING TRACK. Rap lyrics are strongly rhythmic and tend toward confrontational social commentary. The accompaniment is usually supplied by a DRUM MACHINE or RHYTHM SECTION. *See also* REGGAE.

rapper *Music* One who performs RAP.

raree *Theater* 1. A street show, particularly one that promises "rarees" (rarities). 2. In Elizabethan times and later, a show carried around in a box, *i.e.,* a very early form of PEEP SHOW. *Compare* PHYLAKES.

raster *Television* The chaotic mass of horizontal lines on a television tube that appears when no transmitting signal has been tuned in. It is produced by random NOISE within the fundamental scanning circuit of the receiving set. When a transmitted signal comes in, the noise disappears.

rat *Ballet* *See* PETITS RATS.

Theater *See* SCALPER.

ratamacue *Music* A nonsense word that imitates the sound of and designates a DRUM figure.

rataplan (*rah-tah-PLANH*) [French] *Music* An onomatopoeic word in French, imitating one of the sounds of a DRUM.

ratatat *Music* An onomatopoeic word in English, imitating one of the sounds of a drum. *Compare* PARADIDDLE.

ratchet *Music* A wooden device that can be cranked or whirled with the hand to produce a loud clacking or whirring noise for a sound effect in a piece of orchestral music.

rattle *Music* A PERCUSSION INSTRUMENT used for its sound effect, made with a number of pieces of wood or metal loosely attached to a handle, that rattles when shaken by the percussionist.

rave *Theater* An extremely enthusiastic and positive review of a performance. In the British press the term once had precisely the opposite meaning when a critic raved in disgust about a performance.

raw stock *Audio, Motion pictures, Television* New motion picture film, videotape or audio tape as it arrives from the supplier, with no recorded signal of any kind.

RC *Theater* Abbreviation for STAGE RIGHT, center. *See* STAGE AREAS.

RCE *Theater* Abbreviation for STAGE RIGHT, center entrance.

re (*RAY*) *Music* The second syllable in the Guidonian scale, *i.e.,* in the system of SOLMIZATION. In the FIXED-DO SYSTEM, it represents the note D. In MOVABLE-DO, it is the second tone of the SCALE in use.

read *Acting* 1. To audition for a ROLE. 2. To play a role with script in hand, reading the lines, as in the first rehearsal. 3. To read a play to evaluate it before it is considered for production. 4. Said of a scene or piece of business that carries, or (if it "doesn't read") fails to carry, meaning to the audience.

read downhill *Acting* To read a line, or lines, with the voice growing less and less audible, letting it die.

reader *Theater* One who evaluates scripts for consideration for production. Also called a PLAYREADER. *Compare* DRAMATURGE.

reader's fee *Theater* A fee charged by a production company to a playwright who has submitted a script for the company's consideration.

readers' theater An association of actors who present plays on stage, sitting in chairs and reading their parts with limited movement and, usually, not in costume. Sometimes called theater of the mind. In the 1940s, the Reader's Theater, Inc., of New York City specialized in staged readings.

read for a part *Acting* To demonstrate one's capabilities in an audition by reading the part on stage with limited improvised action.

reading *Theater* 1. A meeting of the cast of a new production, gathered to hear the playwright read the play for the first time. 2. A preliminary rehearsal of a production, with the cast reading their lines from their scripts. *See also* READ-THROUGH. 3. A presentation of a new play by a seated cast, with limited or no stage movement or effects. *See also* READERS' THEATER. 4. An actor's particular style of performance of a specific role. 5. An AUDITION.

Music 1. A performance with little or no REHEARSAL to give a new work a hearing. 2. A particular performance version of a work of music, as compared with another version.

Opera *See* SITZPROBE.

reading edition *Theater* A published edition of a play intended for general reading, as distinguished from an ACTING EDITION.

reading fee *Theater* A fee sometimes charged by a playwright for a reading of a play when no performance has been scheduled.

read-through *Theater* A preliminary rehearsal of a play, with the actors seated, reading their parts and getting a general understanding of their individual roles as part of the whole.

realism *Theater* A style of theater designed to represent real life, as in the works of Henrik Ibsen, Anton Chekhov and Arthur Miller among others.

realism of the soul *Acting* Konstantin Stanislavski's term describing a character's psychological truth. *See* STANISLAVSKI METHOD.

realization *Music* An arrangement of a FIGURED BASS for keyboard and, if appropriate, other instruments.

realize *Music* To arrange a FIGURED BASS for modern players using modern instruments, *i.e.*, to replace the figures with musical notes.

rear pit *Stagecraft* A depression in the stage floor at the rear of the stage of some older German theaters, to conceal lights focused on the CYCLORAMA.

rear projection *Motion pictures, Lighting, Stagecraft* Projection from the rear onto a translucent SCREEN or SCRIM. *See also* BOUNCE LIGHT, SILHOUETTE.

rear screen *Motion pictures, Lighting, Stagecraft* A SCREEN designed for REAR PROJECTION.

rear stage *Theater* 1. A curtained acting area at the rear of a stage, especially in the 17th and 18th centuries. It can be opened by actors to reveal what is going on within. 2. An acting area that can be opened behind the main stage to create an effect of great depth. It is used often in scenes requiring that a procession come from a distance, as does the chorus of pilgrims in Wagner's opera *Tannhäuser*.

rebec *Music* An ancient instrument like a VIOLIN but with fewer strings and shaped like an elongated pear. During the Renaissance and later, it was the substitute instrument of French street musicians who were forbidden to play the violin. It was a descendant of a similar two-stringed Arabian instrument called the *rabab* that was brought into Spain during the Moorish conquest and a direct ancestor of the GIGOT.

rebop *See* BEBOP.

rebroadcast *Television* A transmission of a program that has been shown previously.

recall *Acting* 1. Another CURTAIN CALL. 2. A second AUDITION. *See* CALLBACK.

recap *Music* Short for RECAPITULATION.

recapitulate *Music* To repeat a THEME heard previously, albeit in a different KEY or with minor variations.

recapitulation *Music* A section in a piece of music, particularly in a FUGUE or in SONATA FORM, that repeats the first section of the piece, perhaps with minor variations, and generally leads back to the original key.

recast *Theater* To replace an actor in a particular ROLE.

recessional, recessional hymn *Music* A HYMN sung at the end of a church service as the celebrant and the choir leave. *See also* PROCESSIONAL.

recit (*reh-SEET*) *Music* Short for RECITATIVE.

recital *Dance* A performance by a single dancer or, in the United States, by a group of students.

Music A performance of one or several pieces of music by a soloist, with or without an accompanist.

recitalist *Acting* *See* DISEUR, DISEUSE.

Music A musician who presents a recital.

recitatif (*reh-si-tah-TEEF*) [French], **recitative** (*reh-si-tah-TEEV*) [English] **recitativo** (*reh-chee-tah-TEE-voh*) [Italian] *Music* A passage in an ORATORIO or an OPERA in which a soloist tells part of the story or introduces an aria or a chorus, in a musical style that imitates narrative prose. In opera, recitative began with the attempt by Giulio Caccini and others in the early 1600s to revive the classical Greek drama, with SET PIECES for soloists or chorus separated by narrative sections, somewhat like the ancient liturgical practice of chanting a story from the Bible and completing it with a more musical setting of a psalm. Composers of the 17th century wrote recitatives for both operas and oratorios, and developed the idea to the point that some recitatives, especially in the larger works of Bach and Handel, contained florid melodic and harmonic passages and complex orchestral accompaniments, though they were always imitative of ordinary speech. The style with the least musical embellishment is called DRY RECITATIVE, and can be heard in many operas by Haydn, Gluck and Mozart. Its opposite is the "endless melody" of narrative, as in Richard Wagner's operas. Composers up to the present time suit the style of their recitatives to the occasion.

recitativo accompagnato (*reh-chee-tah-TEE-voh ah-kom-pahn-YAH-toh*) [Italian] *Music* Accompanied RECITATIVE, *i.e.*, with melodic and harmonic embellishment as distinguished from DRY RECITATIVE.

recitativo secco (*reh-chee-tah-TEE-voh SEH-koh*) [Italian] *Music* Literally, DRY RECITATIVE.

recitativo stromentato (*reh-chee-tah-TEE-voh stroh-men-TAH-toh*) [Italian] *Music* Literally, RECITATIVE with instruments.

recognition *Theater* One of the essential events of drama, the ANAGNORISIS described by Aristotle in his *Poetics*, when the PROTAGONIST recognizes the truth (though not yet its entire meaning) that will inevitably lead to a downfall. It is the immediate cause of the REVERSAL OF

CIRCUMSTANCE (PERIPETEIA) that leads through further development (EPITASIS) and dramatic and emotional stress (AGON and PATHOS) to the CONFRONTATION OF FATE (CATASTASIS). Aristotle cites the scene in *Œdipus Rex*, by Sophocles, when a messenger comes to bring Œdipus the good news that he need no longer fear the oracle's prediction that Œdipus would murder his father, because the messenger knows that Œdipus was found as a baby abandoned in the mountains and could not possibly be the son of the previous king who was murdered by a stranger on the road. Œdipus, discovering this truth, recognizes that he has already fulfilled the prediction and was, in fact, the murderer. In a single speech by the messenger the king has discovered who he really is and recognized the significance of that fact. The circumstances of his life have been reversed. He must now contend with his fate. *See also* ELEMENTS.

record *Audio* A DISK containing analog or digital information that can be translated electronically into the sounds of a previously recorded performance. Although a magnetic tape can contain the same information, it is generally called a TAPE or, if so contained, a CASSETTE. If the disk contains several different pieces of music, it may be called an ALBUM.

Audio, Television To reproduce sounds or images in an electronically retrievable form. In the 1990s, the form may be analog or digital information imprinted on magnetic tape or optical disk. In motion pictures, the preferred term is "shoot" or "film" rather than record.

record changer *Music* A record player of the mid-20th century with a built-in mechanism that replaces a completely played disk with another.

recorder *Audio* An electronic device that makes a RECORDING.

Music Any of several wooden WIND INSTRUMENTS with a conical bore that has a MOUTHPIECE with a FLUE at one end (in contrast with the side-blown or transverse FLUTE) into which the player blows air to produce a sweet, flutelike sound. Pitches are determined by the selection of finger holes in the side of the tube that the player covers with the fingertips. There are five sizes in general use, each with a range of slightly more than two octaves: sopranino, soprano, alto, tenor and bass. Of these the alto, with approximately the range of a high soprano voice, has been most popular for solo work and chamber music since the 17th century. Antonio Vivaldi composed concertos for the sopranino, and Johann Sebastian Bach composed the sinfonia *Sheep May Safely Graze* for two alto recorders and a small orchestra.

recording *Audio* A performance that has been fixed in electronically retrievable form on a RECORD.

Recording Industry Association of America A trade organization representing the recording industry in the United States, based in Washington, D.C. Since 1958 the RIAA has recognized recording artists by awarding GOLD and PLATINUM RECORDS.

recordist *Audio* An engineer who makes an audio recording.

record label *Audio, Music* Any company that produces and sells RECORDS.

redowa (*REH-doh-vah*) [Polish] *Dance* A folk-dance from Bohemia, somewhat like the MAZURKA, popular in the mid-1800s, in which couples advance the length of the room with one partner moving backward.

reduction *Music* An ARRANGEMENT for piano of a work originally composed for other instruments. The piano part under the voices in a VOCAL SCORE may be a reduction of the work's original instrumental SCORE, to make the book small enough for choristers to hold in hand while singing.

reed *Music* 1. A short, relatively flat strip made of cane (for WIND INSTRUMENTS) or metal (for the HARMONICA, ACCORDION or ORGAN) with a very thin edge that vibrates when it is properly mounted and air blows across its thin edge. Its vibration causes the resulting column of air to produce a musical tone that can be adjusted to various PITCHES (on a wind instrument) by pressing the instrument's KEYS. 2. A wind instrument whose sound is produced by the rapid stopping and releasing of the flow of a column of air as it blows across the edge of a reed. SINGLE-REED instruments include the CLARINETS and SAXOPHONES, in which the MOUTHPIECE, reed and ligature (the clamp that holds the reed in place) combine to channel the airstream across the reed to the rest of the instrument's pipe. DOUBLE-REEDS are the OBOE, ENGLISH HORN and BASSOON, in which the mouthpiece is a bundle of two reeds bound back to back with their thin edges almost touching. In either type, the player blows into the space defined by the thin edge(s) and the resulting vibration makes a sound that can be changed into a musical tone by the resonance of the rest of the instrument's pipe, and changed in pitch by manipulating the instrument's keys. 3. A STOP on the organ that produces a tone with a reedy quality.

reed organ *Music* A small ORGAN with single metal reeds in individual wind channels instead of pipes. *Compare* HARMONIUM.

reed pipe *Music* One of two classes of ORGAN PIPE. The other is the FLUE PIPE. A reed pipe is made of metal with a slightly curved brass tongue that fits over a narrow slot. When air is blown into the reed chamber, it causes the tongue alternately to close and open the passage, making the air column vibrate. The PITCH of the resulting musical tone is determined by the length of the pipe into which the reed allows the air to pass.

reel *Dance* 1. An energetic dance from Scotland and Ireland for two or more couples, in 2/4 or 4/4 time, with many different figures. *See also* HIGHLAND FLING. 2. In the VIRGINIA REEL, the second of three parts.

reflector drop *See* BOUNCE DROP.

refrain *Music* In a song, an unvarying STANZA that alternates with other, variable stanzas. In modern popular song, it is also called the CHORUS. *See also* BURDEN.

regal *Music* A portable REED ORGAN with a single, short KEYBOARD, used in the 16th and 17th centuries.

reggae *Music* A style of popular music originating in Jamaica in the 1960s that combines elements of CALYPSO, BLUES and ROCK with vocalized social and political commentary. The tradition of talking (rather than singing) against a musical/rhythmic background, called toasting, may have inspired the RAP performers of the 1970s. Typically the second and fourth beats of the measure are strongly accented.

regiebuch (*reh-ZHEE-bookh*) [German] *Theater* The director's annotated SCRIPT, containing BLOCKING, STAGE DIRECTIONS and other information. *Compare* PROMPT BOOK.

regional *Theater* Any permanent, professional theater company that performs year-round away from any large theatrical center like New York City, that draws its audience from, and is influential in, an extensive region of the country. Regional theaters exist in many parts of the United States.

regisseur (*reh-zhee-SEUR*), **regisseuse** (*reh-zhee-SEUZ*) [French] *Dance* The stage director or stage manager who supervises a revival of a BALLET that is in the repertory but has not had a recent performance, or who supervises the MISE EN SCÈNE of a work in a new theater on tour where the new stage may require slight changes from standard performances. *See also* BALLET MASTER, METTEUR EN SCÈNE.

Motion pictures, Theater The director of a production.

register *Acting* To portray an emotion with gestures and expressions of the face.

Music 1. A particular tonal quality of the voice, *e.g.*, HEAD REGISTER, CHEST REGISTER, etc. The differences between different registers are apparent to the singer and listener, but the specifics of how they are achieved, or whether they result from anything that can be firmly associated with their descriptions is a matter of controversy among vocal teachers. 2. A segment of the PITCH range considered in relation to the total range of a particular voice or instrument, *e.g.*, high register, low register. 3. Any STOP on the organ and the array of organ pipes associated with it.

registration *Music* The art of selecting organ STOPS for a particular performance.

rehearsal *Music, Theater* Any learning or practice session in preparation for a performance.

rehearsal call *Music, Theater* A notice to performers giving the time and place of a REHEARSAL and listing the ROLES that will be involved.

rehearsal copy *Theater* Any copy of the script prepared for and/or marked up at a rehearsal. *See also* ACTOR'S SCRIPT, PROMPT BOOK, REGIEBUCH, SIDES.

rehearsal lights *Lighting* A few lights, often a single FLOODLIGHT, temporarily hung for use in early rehearsals.

rehearsal props *Stagecraft* Any objects that can be used temporarily before the actual PROPS are ready for use.

rehearsal room *Theater* Any room large enough to substitute for the stage during early REHEARSALS of a performance.

rehearsal scene *Acting* A segment of a play or part of a scene selected for rehearsal purposes, not necessarily designated in the script as a scene. It generally begins with a character's entrance and ends with an exit, and is conveniently short for the relatively intense work of early rehearsals. Also called a French scene.

rehearsal stage *Theater* An area fitted with a few lights and SET PIECES to substitute during early rehearsals for the stage that will finally be used.

rehearse *Music, Theater* To practice a work in preparation for its performance.

l-ghen) [German] *Dance* An ancient German round dance.

...hting 1. To replace burnt-out bulbs. 2. To replace lamps of a given wattage with of higher or lower wattage, particularly in BORDERS and FOOTLIGHTS.

rela... major, relative minor *Music* Since the 16th century, a relative KEY is one that uses the same notes as another key, but has a different TONIC. The relative major of any minor key is the major key that begins on the third of the minor key. The relative minor of any major key is the minor key than begins on the sixth of the major, *i.e.,* a minor THIRD below the major. The relative minor key is often called NATURAL MINOR.

relative pitch *Music* 1. The pitch of any tone in relation to that of another tone, not the same as ABSOLUTE PITCH. 2. The ability to hear and accurately reproduce any tone defined as being at a specific INTERVAL from a known tone. A singer who can sing in tune may not have absolute pitch but is said to have good relative pitch.

release *Acting* *See* CLEARANCE.

Dance To relax a CONTRACTION.

Motion pictures To issue a finished motion picture to a distributor for public exhibition. *See* RELEASE PRINT.

Music In popular music and JAZZ, the B section of any melody having an ABA or an AABA form.

release line *See* CUT LINE.

release print *Motion pictures* A print, made from the MASTER or the INTERNEGATIVE, that will be distributed to theaters for public showing.

relevé (*reu-leu-VAY*) [French] *Ballet* Literally, raised, lifted. Starting with the entire foot on the floor (À TERRE) and springing lightly onto POINTE(S) or DEMI-POINTE(S); or, in another version from the same starting position, rising onto pointes in one smooth motion.

relief *Stagecraft* A freestanding piece of scenery with one edge cut in a profile such as foliage or architectural shapes, set up with other similar pieces to create the impression of a vista opening to some distance behind the scene.

Theater A comic role in a heavily dramatic play, *e.g.,* the role of the servant Leporello in Beaumarchais's play (and Mozart's opera) *Don Giovanni. See also* COMIC RELIEF.

relief stage *Theater* A style of directing tried in the Munich Artists' theater in Germany in the early 1900s, with the cast performing in the foreground in relief against a flat background. (*See* IN ONE.)

remake *Motion pictures* 1. A new motion picture made on the same subject as an old production. *State Fair* with Will Rogers (1933) was remade in 1945 with Dana Andrews, then again in 1962 with Pat Boone. The musical *Silk Stockings,* however, with Fred Astaire and Cyd Charisse was an ADAPTATION of *Ninotchka,* an earlier film starring Greta Garbo. 2. To produce a motion picture on a story that has been used before for another production.

remaster *Audio* To remix a recording from its original separate tracks. When the recording industry converted from the manufacture of LPs to CDs, older recordings that were still popular were remastered to convert them from ANALOG to DIGITAL format restoring their full range of sound.

remembered emotions *See* EMOTION MEMORY.

remote *Audio, Lighting* Any controlling unit that operates at a distance from whatever it controls.

Television See REMOTE PICKUP.

remote control board *Lighting* A control board that operates DIMMERS and other circuits located elsewhere in the building.

remote pickup *Television* A transmission to the broadcasting studio from a distant location, as in a news broadcast. *See* AIR LINK, FEED, LANDLINE, SATELLITE LINK.

rendition *Acting, Music* A performance considered as a version of a written work.

rent party *Music* In the early days of JAZZ, a JAM SESSION with the announced purpose of collecting contributions to help musicians pay the rent on their homes.

renversé, renversée (*ranh-vair-SAY*) [French] *Ballet* Literally, reversed, overturned. Applied to a turn during which the body bends from the waist, sideways and backward, upsetting the normal balance but maintaining equilibrium.

rep *Theater* 1. Short for REPERTORY. 2. Short for REPRESENTATIVE. *See also* AGENT.

repeat *Music* A passage that is repeated in a piece of music.

repeat bar *Music* A left-facing symbol indicating that the player must go back to the beginning of the piece or to a similar right-facing symbol at the beginning of the section, and repeat the music in between the symbols.

REPEAT BAR

repeater *Theater* A play popular enough to be held over or kept in repertory.

repertoire (*reu-pehr-TWAHR*) [French], **repertory** *Dance, Music, Theater* A group of complete works kept ready for performance at all times.

repertory company, repertory *Theater* A theater company that keeps a selection of several plays ready for performance and presents them on alternate days or weeks. Such a theater is said to be "in repertory."

répétiteur (*ray-pay-tee-TEUR*) [French] *Opera* A rehearsal pianist or vocal coach in an opera company.

répétition générale (*ray-pay-tee-SYONH zhay-nay-RAHL*) [French] *Theater* A private dress rehearsal just before opening night.

reprise *Music* 1. A repeat of a section of a piece of music, particularly of its REFRAIN or CHO-RUS. 2. In musicals, to repeat an entire song in the hope of making it familiar to, and pop-ular with, the audience. *See* RELEASE.

Requiem [from Latin] *Music* A MASS for the dead, one of the important musical forms in church liturgy.

rerecord *Audio, Motion pictures* To play back previously recorded material and modify it electronically as it is being recorded on another MAGNETIC TAPE. The basic process of a MIX, and of REMASTERING.

rerun *Television* A rebroadcasting of a program that has been aired before. *See also* SYNDICATION.

rescue opera *Music* Any OPERA on a subject that consists, in the main, of a rescue, *e.g., Fide-lio* by Beethoven (1805).

resident company *Ballet, Theater* A company of performers based in a particular theater, *e.g.,* the Arena Stage in Washington, D.C.

residual *Broadcasting, Television* A periodical payment due to a performer under union rules for any reuse of a filmed or recorded performance.

resin, rosin *Dance* A powder made from pine pitch, used on the soles of dancers' shoes to prevent slipping on the stage floor.

Music A small solid block of pine pitch, used by string players who rub it against the hairs of their BOWS to increase the friction that produces tone from the strings.

resolution *Motion pictures* The power of a lens to distinguish two neighboring pinpoints of light as separate coherent images.

Music The relaxation of a dissonant chord or note as it moves into a closely related con-sonance, *e.g.,* the resolution of a DOMINANT SEVENTH to the TONIC.

Theater The final outcome of a drama, after the complications and entanglements of the plot have been brought to a CLIMAX and tension dissolves. The knitting up of all the elements of the plot that were torn apart by the climax. The release that Aristotle calls LYSIS, a deliverance.

resolve *Music* To move from a dissonance into its closely related consonance, *e.g.,* to resolve a DOMINANT SEVENTH chord into its TONIC.

resonance *Acting* The tonal richness of the speaking voice.

Acoustics An echo in any enclosed space.

Audio A state of continuous echo within an electronic circuit, occurring when the fre-quency of the incoming signal precisely matches the natural frequency of the circuit. This is the condition that underlies the essential functions of an electronic circuit, such as mod-ulation and amplification. *See also* MICROPHONICS.

Music A quality of tonal richness in any musical instrument. The PIANO, HARP and HARP-SICHORD have SOUNDING BOARDS that are designed to enhance resonance. The GUITAR and

other plucked stringed instruments are built with resonant bodies and have round holes in their top surfaces to release the sound into the air. The instruments of the VIOLIN FAMILY, although they have TABLES and BACKS designed to resonate and a SOUND POST to transmit resonance between them, also have F-HOLES in their top surfaces to quell their resonance somewhat. DRUMS and the like have different qualities of resonance for different purposes.

resonant *Acting, Music* Having a naturally rich tone. A voice is resonant when the vocal cords and the laryngial chambers seem to be completely in tune with each other, like ORGAN PIPES in a church of the right size. Just how this can be accomplished by a singer is a matter of constant exploration.

resonate, resound *Acoustics, Music* To echo repeatedly at a definite rate while diminishing in strength. To reverberate. Resonance is the function that determines the PITCH of a musical tone when air is blown under pressure into an ORGAN PIPE or any WIND INSTRUMENT. The REED (or the lips) through which the air blows sets up a wave of pressure that bounces back and forth at a specific rate (the speed of sound in air) within the instrument and against the still air outside its outlet. The length of the tube (wavelength) determines how fast it bounces, *i.e.,* what the frequency of the bounce will be, and thus establishes the pitch of the resulting tone. Much the same thing occurs with the vibration of a string, whose length also determines the frequency of the wave with which it visibly moves.

response *Audio* The measure of an audio system's capability to reproduce sound of a given strength at all levels of frequency.

response curve *Audio* A line on a graph representing the relative strength of an electronic signal at every level of frequency.

rest *Music notation* A symbol written on the staff in place of a NOTE to indicate silence for a specific period of time.

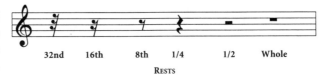

32nd 16th 8th 1/4 1/2 Whole

RESTS

resting *Acting* Unemployed.

Restoration *Theater* The period in English history beginning with the overthrow of Oliver Cromwell, whose Puritan government suppressed theater, and the reestablishment of the monarchy in the person of Charles II, who encouraged the establishment of new theater companies. The new companies he fostered brought innovative ideas that altered the fundamental character of what had been Elizabethan theater. Thus the term indicates a significant change in the history of theater and an entirely new GENRE. In 1674 the Restoration triumphed with the opening of the theater designed by Christopher Wren in DRURY LANE. Wren's theater was not open to the sky, as the Elizabethan theaters had been, but was roofed in. It had an APRON in front of the PROSCENIUM, its sets consisted of standard-size FLATS that could be changed for different plays, and performances were lighted with candles. The most profound innovation of all was the introduction of women as actors, the most famous of whom was Nell Gwyn.

resultant tone *See* COMBINATION TONE.

retake *Audio, Motion pictures* A new TAKE to replace one that was considered unsatisfactory.

retard *Music* 1. A slowing of the TEMPO. 2. To slow the tempo.

retardando (*reh-tar-DAHN-doh*) [Italian] *Music* Holding back, slowing.

retire *Acting* To leave the FOCUS of the scene but remain quietly on stage.

retiré (*reu-tee-RAY*) [French] *Ballet* Literally, withdrawn. A position with the thigh raised, the knee bent and the pointed toe resting in front of, to the side of or behind the knee of the supporting leg. Similar to RACCOURCI.

retombé (*reu-tom-BAY*) [French] *Ballet* Falling back to return to the original position.

retrograde *Music* Moving backward, from the last note to the first. A favorite device of composers since the 14th century, particularly in small pieces like the CRAB CANON that Haydn composed on the text of the first of the Ten Commandments, and the MINUET in his *Symphony No. 47*. Paul Hindemith composed a larger work for piano, *Ludus Tonalis* (*Tonal Game*, 1943), the last POSTLUDE of which is the retrograde and inversion of its PRELUDE.

return *Stagecraft* A dark, or black, FLAT or drape placed at the side of the stage, behind the TORMENTOR and in line with a normal flat that is part of the scenery, to mask the backstage area that would otherwise be visible to the audience.

reveille (*reu-VAY-eu*, anglicized as *REH-veh-lee*) [French] *Music* A military signal played on a BUGLE at the beginning of the day to wake the troops.

reverb *Audio* Short for REVERBERATION. 1. A degree of delay artificially introduced into a signal as it passes through electronic circuitry to produce the effect of echo. 2. The name of a special electronic circuit that produces a variable degree of echo in the system.

reverb circuit *See* DELAY LINE.

reverberation *Audio* Echo that persists at gradually diminishing strength within a performance space or recording system. *See* RESONANCE.

reverberation time *Acoustics* A measure of the persistence of an echo in an enclosed space. Acoustic engineers measure the reverberation of an auditorium in terms of the number of seconds it takes a sound of a given pitch to diminish to one millionth of its initial volume. Typically, the sound in a good hall echoes for a second or two. If the time is too short, the theater seems dead. If too long, the sounds of speech and/or music may overlap each other and become unintelligible. A theater satisfactory for spoken plays generally requires less echo than one designed for music. One of the practical reasons for the long melismatic passages on single syllables in Gregorian chant was the fact that the great stone churches of the Middle Ages echoed and re-echoed, so that words spoken at ordinary tempo became mush.

Audio The persistence of an echo in an an electronic circuit. Engineers adjust the DELAY TIME in their circuitry to create the effect of acoustical echo in the sound being transmitted

or recorded, *i.e.,* they add PRESENCE by creating the illusion that the sound originated in a resounding space. The effect is not restricted to music, but is used commonly in motion pictures to establish a realistic atmosphere for a scene in a tiled shower, for example, or an airport waiting room. Conversely, voices recorded in a room with no reverberation sound as if they were recorded outdoors.

révérence (*ray-vay-RANHS*) [French] *Ballet* 1. A formal bow or curtsey, with one foot extended ahead, the other leg in DEMI-PLIÉ and the body bent forward with arms CROISÉ. 2. The formal bow, curtsey or combination of steps performed at the end of a ballet class as a gesture of appreciation to the teacher.

reversal *Motion pictures* A type of motion picture color film that shows pictures in their natural colors, rather than in NEGATIVE. Before the advent of video tape it was used for filmed news coverage, where it saved the time that would ordinarily be spent making a print from a negative. It is not so useful in work where the original film must go through several processes to make multiple prints later. *See also* NEGATIVE.

reversal of circumstances, reversal of fortune *Theater* One of the essential actions required of a PLOT, called PERIPETEIA in Aristotle's definition of TRAGEDY. It is the moment when the fundamental situation of the life of the PROTAGONIST changes irrevocably. It is the result of the DEVELOPMENT of the plot and leads to the CONFRONTATION OF FATE.

review *Theater* A published critique of a performance. Not the same as REVUE.

reviewer *Theater* A journalist who attends a play and publishes a critique shortly thereafter.

revival *Theater* A new production of an old play or MUSICAL, especially when it copies the style of the older production.

revival meeting *Music* A lively meeting, often held outdoors during the late 19th and early 20th centuries with hundreds in attendance, in which a charismatic preacher preaches, and the people sing gospel hymns, or a GOSPEL CHOIR sings. Several American plays and movies have featured such scenes, *e.g., Down in the Valley* by Kurt Weill and Stephen Sondheim.

revoice *See* VOICING (2) and (3).

revolving stage *Stagecraft* A stage with a TURNTABLE built into its floor. When mounted with two or more sets back to back, one remains on view to the audience while the others are turned out of sight. *Compare* ELEVATOR STAGE, JACKKNIFE STAGE.

revue *Vaudeville* A show featuring a mix of songs and dances together with STAND-UP COMEDIANS and other light entertainments.

rewrite *Playwriting* 1. To edit and revise the text of a play extensively. 2. A scene or a play that has been thoroughly edited and revised, usually by someone other than the original playwright. *See* PLAY DOCTOR.

rh *Music* Abbreviation for the right hand.

rhapsodic *Music* Having the expressive warmth and enthusiasm of a RHAPSODY.

rhapsodist [from Greek] *Music, Theater* Literally, one who sews songs together. A singer of songs. The epic poems of Homer were originally performed by rhapsodists who wandered from place to place and sang their heroic stories with a walking staff in hand, using the staff as a character in the story by singing to it or pretending to listen to it. The rhapsodist is considered to be the first actor in what became, when others in later centuries joined to answer the rhapsodist as a CHORUS, Greek DRAMA.

rhapsody *Music* Any piece of music that has great warmth and expressiveness, particularly in BALLADE form. The term has been used by many composers in titles of piano fantasies, especially when they are based on Middle-European dance rhythms. Franz Liszt composed a series of *Hungarian Rhapsodies*; George Gershwin's *Rhapsody in Blue* is one of his most famous works.

rheostat *Lighting* A type of DIMMER that works by varying the electrical resistance of a lighting circuit. In such a circuit, electrical resistance converts into heat, making it necessary in some theaters to keep the dimmers away from the stage in a place where heat can be regulated, thus requiring that they be remotely controlled.

rhythm *Music* The feeling of movement in music. Patterns of movement in music expressed as accents and/or long and short durations of tones that occur within the MEASURES of a musical composition; in some forms and styles these patterns provide much of its feeling of physical dancelike movement. Rhythm is not to be confused with METER, which is the underlying regular structure of musical measures. The rhythms of the WALTZ and the MAZURKA, for example, each occur in measures of three beats, as do the MARCH and the GAVOTTE in measures of four or six, but they are all unmistakably different patterns. *See also* EURYTHMICS, HARMONIC RHYTHM.

rhythm and blues *Music* A style of popular music or JAZZ that grew out of RACE MUSIC, continuing the emphasis on simple structure and heavy accented bass accompaniment. It inspired the ROCK music that emerged in the 1960s.

rhythmic, rhythmical *Music* Having pronounced rhythms.

rhythmic pattern *Music* Any repeating sequence of accents and of long and short durations in music.

rhythmics *Music* The study of rhythms. *Compare* EURHYTHMICS.

rhythmist *Music* One who creates and works with RHYTHMS.

rhythm section *Music* The group of instrumentalists in any ensemble who provide the accents and patterns of rhythm. In JAZZ the rhythm section includes drums, piano, bass and guitar. In dance bands of the mid-1900s, it also included the BANJO. Even the HARPSICHORD and the PIANO have been used as rhythm instruments.

RIAA *See* RECORDING INDUSTRY ASSOCIATION OF AMERICA.

Rialto (*ree-AHL-toh*) [Italian] *Theater* Literally, the name of a bridge across the Grand Canal of Venice, upon which people have met daily for hundreds of years to exchange news and

gossip. Shakespeare mentions it in *The Merchant of Venice* with the line "What news of the Rialto?" In modern theater argot, it is the theater district of any city. Metaphorically, the unpublished news and gossip that everybody in the theater world knows, though none knows the real source.

ribs *Music* The narrow, wooden sides of the violin, viola, violoncello and double bass, to which the TABLE and the BACK are glued. The ribs form the BOUTS of the instrument.

rice powder *Makeup* A fine white face powder used as a toner to eliminate shine.

ricercar (*ree-chehr-KAHR*), **ricercare** (*ree-chehr-KAHR-reh*) [Italian] *Music* Literally, research. A musical composition, no matter what its basic musical form, that a composer develops out of a probing analysis of its initial musical ideas. Similar to an ÉTUDE or a FANTASIA.

ricky-tick, rinky-tink *Music* Imitative slang for an American style of old-fashioned popular music with jaunty 2/4 rhythms played on tinny-sounding instruments such as an out-of-tune piano. By extension, corny or outdated music.

riddle canon *Music* A CANON in which the instructions necessary to its proper execution are hidden within its text. Riddle canons appear in works of some of the great composers of the early Renaissance.

ride-a-bike *Dance* In the early 1970s, a solo dance performed to Jamaican REGGAE music.

ride cymbal *Jazz* A single cymbal mounted on a stand and used for the basic continuing beat patterns of the piece. *Compare* CRASH CYMBAL. *See also* HI-HAT, SIZZLE CYMBAL.

rider *See* EQUESTRIAN.

ridiculous theater *See* THEATER OF THE RIDICULOUS.

ridotto (*ree-DOT-oh*) [Italian] *Theater* Literally, foyer. In the 18th century, a public ball-room or music hall where patrons sometimes attended a performance wearing DOMINOS.

rifacimento (*ree-fah-chee-MEN-toh*) [Italian] *Music, Theater* Literally, a REMAKE. *See also* REVIVAL.

riff *Jazz* A musical phrase or melodic figure repeated, with or without alterations, over changing chord patterns. Typically it is built on the harmonies of that section of the piece being played, and may be an ensemble passage backing up a solo. The riff developed from the BLUES practice of filling in with improvised figures in contrasting rhythms at the end of any phrases where the voice was silent.

rifle *Audio* Slang term for an extremely directional microphone, also called a SHOTGUN.

rigaudon (*ree-goh-DONH*) [French], **rigadoon** *Dance* A 15th-century courtship dance from Provence in the South of France. It was performed at court in the 17th century to the accompaniment of brisk music in 2/4 or 4/4 time, by dancers who danced side by side without holding hands.

rigger *Stagecraft* A grip or a STAGEHAND who sets up the RIGGING and hangs the scenery for a show or works in the FLY GALLERY.

rigging *Stagecraft* The system of ropes and/or cables and counterweighted lines by which all the FLOWN units of scenery are lowered to the stage or raised into the FLIES, including any accessory lines used to control their horizontal positions, as well as the sheaves and pulleys attached to the GRID through which all the lines pass, and the PINS in the PINRAIL to which they are attached. A system consisting of ropes is HEMP RIGGING. One with wires and cables is WIRE RIGGING.

rigging line *Stagecraft* Any rope or wire used to raise or lower scenery.

rigging loft *See* FLIES.

rigging plot *Stagecraft* A STAGE MANAGER's schedule showing the rigging that will be necessary from scene to scene throughout a play. Also called HANGING PLOT.

right, right center *Theater* STAGE RIGHT, *i.e.*, to the right from the point of view of an actor facing the audience. *See* STAGE AREAS.

right center entrance *Theater* An entrance at STAGE RIGHT, halfway between the MAIN CURTAIN and the BACKDROP.

rights *Dance, Music, Theater* The various legal rights reserved exclusively to the copyright owner of a work of art by the 1978 Copyright Law of the United States. The primary rights of a copyright owner are: reproduction, distribution, derivative rights (the right to derive other works from it), performance and display. *See also* GRAND RIGHTS, MECHANICAL RIGHTS, STATUTORY RIGHT, SUBSIDIARY RIGHTS.

rig lights *Lighting* To set up lights for a show and connect them through CABLES and PATCH BOARDS to appropriate CONTROL CIRCUITS.

rim *Music* The wooden or metal ridge around the edge of a DRUM.

rim-lighting Back lighting that produces a bright area around the edges of a piece of scenery.

rim-shot *Music* A single very sharp, loud DRUMBEAT accomplished by striking the head and rim of a snare drum at the same time. There are several different kinds, accomplished in different ways, *e.g.*, by striking the rim and the center of the drumhead simultaneously with one stick, or by placing one DRUMSTICK quietly against the rim with its head resting in the center of the drumhead and striking it heavily with the other stick. Also called a stick shot.

rinforzando (*rin-fort-ZAHN-doh*) [Italian] *Music* Reinforced, *i.e.*, a single note or chord somewhat accented.

ring *Circus* The stage of a circus, consisting of a sand-filled circle within which the animal acts, acrobats and clowns perform. The great circuses have up to three rings, all active throughout the show.

Lighting 1. A halo around the head of an actor, created by back-lighting. 2. A metal hoop around a candle on stage. *See also* SPILL RINGS.

ring control *Puppetry* A CONTROL for a marionette with rings that fit on the controller's fingers for certain moves.

Ring Cycle *Opera* A tetralogy containing a prologue (*Das Reingold*) and three operas (*Die Walküre, Siegfried* and *Götterdämmerung*) by Richard Wagner based on a traditional folk tale, *The Ring of the Nibelungs*.

ring down *Theater* To lower the curtain.

ringer *Music* A professional singer or instrumentalist brought in to fill out a sparse chorus or orchestra.

ring master *Circus* A performer who stands in the RING and announces each act.

ring up *Theater* To raise the curtain.

ripieno (*reep-YAY-noh*) [Italian] *Music* 1. A passage for all the instruments, in a CONCERTO with other passages for soloists. 2. The whole orchestra, as distinguished from a smaller group of soloists (CONCERTINO) engaged in the performance of a CONCERTO GROSSO.

rise *Ballet* A smooth raising of the body onto POINTS. *See* RELEVÉ.

Theater *See* AT RISE.

rise and sink *Stagecraft* A special quick-change effect used in older vaudeville houses. It consisted of two wide drops or panels situated behind the main curtain, one of them hanging in the flies, the other held in a trough below the stage floor. When a number ended, the upper panel was lowered and the lower one raised to meet it, the performers of the outgoing scene moved aside and those of the new scene took their places. When the panels were withdrawn, the new scene was magically ready to go.

riser *Music* A multilevel platform section, usually 6 feet wide, of one to four steps, each of which stands 6 to 8 inches above the one below and is from 18 inches to 2 feet deep, used to support rows of CHORISTERS so that they can all see and be seen by the CONDUCTOR and the audience during performance.

Stagecraft A short section of a platform of any height, from a few inches to a foot or two above the floor, installed in the set to provide an acting area higher than the rest of the stage. Single risers, at whatever height, are often 3 feet wide and 6 feet long. By lashing together several risers of graduated heights, a stage of many levels can be created. *See also* STEP UNIT.

rising action *See* EPITASIS.

Risorgimento (*ree-sor-gee-MEN-toh*) [Italian] *Dance, Music, Theater* The great period of upheaval in Italy (1750–1870) that resulted in the unification of the country and a corresponding expansion of artistic and theatrical creativity. *Compare* RESTORATION.

rit *Music* Abbreviation for RITARDANDO.

ritardando (*ree-tahr-DAHN-doh*) [Italian] *Music* Gradually slowing the pace. Similar to RALLENTANDO.

ritenuto (*ree-teh-NOO-toh*) [Italian] *Music* Immediately held back.

ritornello (*ree-tor-NEL-loh*) [Italian] *Music* A little piece of instrumental music, often occurring as the conclusion of a larger piece, sometimes as an introduction or interlude.

ritual *Theater* A prescribed procedure consisting of speech and action repeated at specific times for religious purposes. Ritual is the basis of all formal drama.

ritual theater Theater that emphasizes the ritual, rather than the narrative aspect of drama. During the 20th century, playwrights and students of theater began to apply their knowledge of the multicultural history of theater to modern productions. Many of the various movements that resulted from this development were based in some way on the idea that theater, like ritual, is a repetition of prescribed actions, a process that actors and audience must go through together for a meaningful emotional or spiritual experience. From such ideas grew the theaters that embraced abstract sets and others that explored antirealistic or superrealistic styles, but always maintained the fundamental structure of ritual. Samuel Beckett's play *Waiting for Godot* sprang from this source. Modern productions of Monteverdi's opera *La Favola d'Orfeo* have emphasized the fundamental ritual of rebirth that is implicit in its story.

rivoltade (*ree-vol-TAHD*) [French, from Italian] *Ballet* A turning step performed by a male dancer as he jumps, in which one leg passes over the other before he lands facing the opposite direction.

road *See* ON THE ROAD.

road board *Lighting* A portable CONTROL BOARD that travels with a touring company. Sometimes called a PACKAGE BOARD.

road box *Stagecraft* Any crate built to contain the materials needed on a tour.

road card *Theater* A special membership card issued to a member of ACTORS' EQUITY ASSOCIATION, validating membership while on tour so there will be no difficulties with local companies.

road company *Theater* The CAST, CREWS and management of a show on tour, as distinguished from the cast that opened the show or is still performing it at its original site. Sometimes a road company consists only of those playing leading ROLES and a stage manager, the rest being picked up and rehearsed wherever the road company mounts a performance.

road house *Theater, Vaudeville* An out-of-town theater that routinely imports productions for short engagements and has no resident company.

road shoe *Stagecraft* A piece of strap iron attached along the bottom rail of a FLAT, especially a flat used by a touring company, to protect it.

road show *Theater* A touring production.

roady *Circus* Any member of the company, since they all must travel.

rock, rock and roll, rock 'n' roll *Music* A style of popular music originating in the 1950s that combines American country music and RHYTHM AND BLUES, notable for its frenetic and heavily accented beat, its openly expressed sexual energy and its overall flouting of conventional lyrics and dress. Rock has enjoyed extraordinary commercial success with stars like Elvis Presley and bands like the Beatles and the Rolling Stones, and has undergone many changes and revivals. *See also* ACID ROCK, GRUNGE, HARD ROCK, HEAVY METAL.

rockabilly *Music* In the 1950s, a style of popular music that grew out of RHYTHM AND BLUES, a forerunner of ROCK AND ROLL with elements of BLUEGRASS and a strong swinging beat. Instrumentation usually consisted of electric guitars, rhythm guitar and DOUBLE BASS or an ELECTRIC BASS GUITAR.

rocker bar *Puppetry* A pivoted crosspiece on a marionette CONTROL, to operate any part of the marionette that works in alternating movements, *e.g.,* the knees while walking.

rock steady *Dance, Music* In the mid-1960s, a Jamaican music and dance style that later developed into REGGAE.

Rococo *See* GALANT.

rod puppet *Puppetry* A PUPPET supported on and controlled by rods from below the stage. The puppeteer, standing underneath the stage, may operate the puppet's head with one hand and its hands and feet with the other. If the puppet is large and heavy, it may be supported by a harness worn by the puppeteer. The technique is common in Japanese puppet theater and is fundamental to performances of the SHADOW PUPPETS of Java. Rod puppets have existed in many cultures but are best known in Asia.

Roger de Coverly, Sir *See* SIR ROGER DE COVERLY.

rogue's march *Music* A brisk tune that originated in England as a special QUICK MARCH to be played when a malefactor was drummed out of the army.

role *Acting* The part an actor plays on the stage or in a motion picture. The character represented by an actor.

roll *Circus* *See* NECK ROLL.

 Music *See* DRUMROLL, PIANO ROLL.

 Motion pictures 1. An uncut strand of film wound around a HUB. Film stock comes from the manufacturer in rolls of 100, 400, 1,000 feet or more. 2. A SCROLL OF CREDITS. *See also* A & B ROLLS, M & E ROLLS.

 Stagecraft *See* CONTINENTAL CYCLORAMA.

roll ceiling *Stagecraft* A large cloth DROP attached to a frame like a FRAMED DROP, but painted and rigged to become the ceiling of a BOX SET. Its frame consists of stage-width BATTENS to which the drop is permanently attached, with removable spreaders (also called STRETCH-ERS) between them. For transportation, the spreaders can be removed and the drop rolled up on its battens. *Compare* BOOK CEILING.

roll curtain *Stagecraft* A curtain that is raised into the FLIES by rolling its BATTEN. It is usually flown right behind the main curtain, *i.e.,* IN ONE. *See also* OLIO CURTAIN.

roll drop *Stagecraft* A cloth DROP anywhere on the stage except IN ONE, where it is called an ACT DROP or an OLIO CURTAIN.

roll drop hook *Stagecraft* A strong hook or clamp used to hold a BATTEN in position when its cloth DROP has been partially unrolled.

roller *Stagecraft* 1. A caster on a scenic unit. 2. A BATTEN that can be rolled.

rolling *See* RAG DOLL.

rolling bass *Jazz* A repeating figure or accompaniment provided by the pianist in the lower part of the keyboard with the left hand, imitating the sound of train wheels.

rolling cyclorama *See* CONTINENTAL CYCLORAMA, PANORAMA.

rolling in, rolling out *Dance* Tilting the foot toward or away from the center line of the body, an undesirable position often caused by attempting to force the legs into a TURNOUT.

rolling stage *Stagecraft* A stage that can be rolled into position for a scene or rolled back to be replaced by another. A WAGON STAGE. *See also* ELEVATOR STAGE.

"roll it" *Audio* A recording director's order to start the recording machine. The audio engineer's response is the audio SLATE for the recording, *e.g.,* "Introduction, take three, SPEED."

romance *Music* A title often used for a pleasant tuneful piece of instrumental music, especially for a solo instrument and piano, or piano alone.

Theater A pleasant fanciful play about love.

romantic acting *Theater* Acting with intense emotional expression and with unstudied gestures.

Romantic Ballet A style that emerged in the late 19th century that emphasized mood or feeling rather than order or structure, and strongly suggested the contrast between reality and the ideal or fantastic.

romantic drama *Theater* A drama of high adventure and romance, with exotic settings, characterized by personal idealism; the drama of Goethe and others that was particularly popular in theaters during the period from the French Revolution until the 1850s. Edmond Rostand's *Cyrano de Bergerac* is a later example.

rondeau (*ron-DOH*) [French] *Music* A form of song and poetry of the 13th century in France, consisting of STANZAS of eight short lines with a strict pattern of repeating phrases within them.

rond de jambe (*ronh deu ZHAHMB*) [French] *Ballet* A circular motion of the working leg with many variants, including À TERRE, EN L'AIR, EN TOURNANT, etc.

rondeña (*ron-DEH-nyah*) [Spanish] *Dance* A FANDANGO from Andalusia in Southern Spain.

rondo *Music* A piece of music that consists of a THEME and several EPISODES, with the theme returning after each episode.

room tone *Audio, Motion pictures* The ambient noise always present in a quiet space, *i.e.,* outdoors or in a recording studio when no one speaks and nothing moves. Such so-called silence is actually alive with sound. If the room tone under any scene is interrupted or changes for any reason, listeners will be distracted. Editors must therefore have extra footage of room tone to insert whenever they intercut between shots. For that reason, sound engineers always take time during any shooting session to record the tone while all the people working on the scene remain silently in position.

root *Music* The FUNDAMENTAL tone of any chord.

root position *Music* The position of any chord in which the ROOT is the lowest note. *Compare* FIRST INVERSION, SECOND INVERSION.

rope lock, rope clamp *Stagecraft* One of an array of steel clamps mounted along the FLY GALLERY along one side wall of the stage. When a stagehand raises or lowers a piece of scenery into position on stage or in the FLIES, the rope lock is engaged to hold the OPERATING LINE firmly in that position.

rope system *See* RIGGING.

ropewalker *Circus* An acrobat who walks along ropes stretched high above the ground and performs daring feats. A FUNAMBULIST. *See* HIGH WIRE, SLACKROPE, TIGHTROPE.

rosin *See* RESIN.

rosin box *Dance, Stagecraft* A shallow box placed conveniently in the WINGS, where dancers can rub the soles of their shoes to eliminate slipperiness before they go on stage. *See also* WATERING CAN.

rostrum, rostrum camera *Motion pictures* An ANIMATION STAND and its camera, used in the preparation of feature films for titling and simple special effects. The term is of British origin.

Rototom *Music* Trade name for a type of TOMTOM that can be tuned almost instantly during a performance throughout a bass range of one octave, by rotating it on its stand. Rototoms usually appear in sets of six or more, mounted on a single stand.

rough cut *Motion pictures* In traditional editing, the result of the first phase of the editing process, after the director and the editor have selected the TAKES they want to use from

the DAILIES. In the rough cut those takes, together with their synchronized sound tracks, have been spliced together in proper sequence and cut to approximately correct lengths, giving the director and the editor their first opportunity to see a segment of the picture in form required by the screenplay. They can then refine their plans for the rest of the editing. In modern practice, the same process is accomplished electronically on videotape by using digital coding.

rough out *Stagecraft*　To put up a temporary approximation of the set to establish the positions of doors, etc., and to work out preliminary action and BLOCKING for the play.

roulade (*roo-LAHD*) [French] *Music*　A highly ornamented melodic passage in vocal music, sung to a single syllable. *Compare* MELISMA.

round *Music*　A CANON that can be repeated over and over, with each voice picking up the first note in its turn until all decide to end it. Also called a perpetual canon.

　Theater　A wave of applause.

round actor *Theater*　A living actor as distinguished from an image on the movie screen.

round dances　Ancient group dances, performed around a totem or object of reverence, that later evolved into country dances in a circular (rather than square) formation. The term is applied also to couple dances of the 19th and 20th centuries in which the partners turn constantly. *See* POLKA, WALTZ, FOXTROT.

roundel *Lighting*　1. Any round frame used to hold a color GEL or MASK in front of a light. 2. A round COLOR FILTER, especially one made of glass.

roundelay (English pronunciation of the French word *rondelet*) *Dance*　A folk dance of many countries, in which the dancers hold hands and form a circle.

round figure *Puppetry*　A three-dimensional figure, as distinguished from a profile.

round of parts *Acting*　The roles played by an actor during a season in REPERTORY.

roustabout *Circus*　A laborer, often an employee of the circus company, who works at caretaking jobs on the circus grounds and helps put up and take down the circus tent. *Compare* GAZOONY.

route sheet *Circus, Theater*　An information sheet showing the route a traveling production will take, and its schedule.

routine *Acting, Dance, Vaudeville*　A particular performance pattern that forms the basis for an act or dance, *e.g.*, steps, DIALOGUE, bits of BUSINESS.

row *Stagecraft*　A low, freestanding FLAT used as a scenic unit, and/or to hide lights or machinery such as a treadmill placed on the stage. *See also* GROUND ROW.

Royal Ballet　*See* SADLERS WELLS.

royale (*rwah-YAHL*) [French] *Ballet* Literally, royal. A CHANGEMENT DE PIEDS named in honor of Louis XIV of France, who performed it, in which the calves beat together and the feet change position before landing. Also called *changement battu*.

Royal Opera *See* COVENT GARDEN.

royalty A fee due to the originator and/or copyright owner of a creative work, to be paid by the performer(s) or producer(s) of a performance. Royalties are often calculated as a percentage of the GROSS for live performances, of the producer's profit for motion pictures, or are set for radio or television broadcast by performance-licensing organizations such as ASCAP, BMI or SESAC. *See also* RESIDUAL.

rub-a-dub *Music* A sound imitative of a miltary DRUM. *See also* PARADIDDLE, RATAMACUE, RATAPLAN.

rubato (*roo-BAH-toh*) [Italian], **tempo rubato** *Music* Literally, robbed. A term used to indicate freedom from strict rhythmic regularity in performance, as in a WALTZ when the performers prolong the first beat of the measure and shorten the next two ever so slightly to enhance its swinging feeling. Properly and artistically executed, the slowing down or speeding up of part of a musical phrase will be corrected later on by a corresponding speeding up or slowing down, so that the basic pulse remains intact. To be convincing, the adjustment must sound natural; exaggerated rubato can produce a disjointed effect.

rube *Carnival* A naive and/or gullible person in the audience of a SIDESHOW. *Compare* HAYSEED.

 Theater A farmer as a stereotypical character.

ruche *Costume* A strip of pleated material, usually lace, used as decorative edging for period costumes.

rudiments *Music* Any of a series of 26 standard two-handed practice figures for drummers in marching bands. The list, consisting of various STICKING PATTERNS, FLAMS and ROLLS, was established by the National Academy of Rudimentary Drummers in the early 20th century as a standard for teaching drummers in marching bands. *See also* RUFF.

ruff *Music* A drummer's specific term for a FLAM containing more than one grace note before a principal note.

rug *Makeup* Slang for a hairpiece or a large wig.

rühig (*RÜ-ikh*) [German] *Music* Calmly, restfully.

ruin the audience *Acting, Vaudeville* To present a spectacularly good act, making things very difficult for any act that follows. *Compare* STOP THE SHOW.

ruling passion *Acting* The major emotional motivation of a character in a scene, *e.g.*, Othello's susceptibility to jealousy.

rumba *Dance* An African-Cuban ballroom dance in fast 2/4 or 4/4 time, characterized by syncopated, broken rhythms and very complex steps. It first became popular in the United States in the late 1920s.

rumble box, rumble cart *See* THUNDER BOX.

run *Theater* 1. A series of performances in one theater. 2. The length of time a show stays active. 3. The PLAYING TIME of a show. 4. To rehearse a lengthy section of the play without stopping for corrections and changes. *See* RUNTHROUGH.

Lighting To operate a control board.

run a flat *Stagecraft* To move a flat across the stage by sliding it relatively quickly along the line of its base rail. Also called SHOOT A FLAT, SKATE A FLAT, WALK A FLAT.

runner *Stagecraft* 1. A strip of carpet laid backstage to silence actors' footsteps as they cross back and forth. 2. The track from which a curtain hangs.

running crew *See* BACKSTAGE CREW.

running gag *Vaudeville* A joke that serves as the foundation for a series of funny moments in a skit.

running lights *Stagecraft* Dim lights in strategic places BACKSTAGE to help actors find their way in safety during the show.

running order *Vaudeville* The schedule of NUMBERS in a show.

running set *Dance* A lively English folk dance in 2/4 or 4/4 time, usually accompanied by fiddle music, that has survived in the Appalachian Mountains of the United States where it evolved into the KENTUCKY or TENNESSEE RUNNING SET.

running tabs *Stagecraft* Wheeled hangers for a DRAW CURTAIN. They support the curtain every foot or so and run in a special steel channel built into the BATTEN that supports the main curtain.

running time *Motion pictures* The duration of a motion picture expressed in hours, minutes and seconds.

runout *Music* Any individual performance at a distant site of a concert that has already been rehearsed and played at the organization's regular place of performance. In summertime, many symphony orchestras do runouts of their less weighty concerts in public parks or at schools.

run the pack *Stagecraft* To move several flats at once into or out of the SCENE DOCK.

runthrough *Theater* A rehearsal of a complete play or, sometimes, of a long section of a play, in proper sequence, usually without interruptions. Not the same as a DRESS REHEARSAL. *Compare* READING, SITTING REHEARSAL, SITZPROBE, TECHNICAL RUNTHROUGH, WALK-THROUGH.

runway *Theater* An extension of the stage floor projecting over the footlights toward the audience, sometimes actually out among the seats. Actors may use it in the show, and directors sometimes use it during rehearsals for easier access to the stage.

rushes *See* DAILIES.

Russian School *Ballet* A ballet school founded in 1738 in St. Petersburg by French dancers and based on techniques of the FRENCH SCHOOL. Later it was influenced strongly by the brilliant and virtuosic style of Italian ballet masters like Enrico Cecchetti. In the 1920s, the Russian ballerina Agrippina Vaganova continued the development of French and Italian techniques and created the system of ballet instruction still considered essential in the countries of the former Soviet Union.

S

SA *Vaudeville* Abbreviation for sex appeal.

SACEM *Music* The French Société des Auteurs, Compositeurs et Editeurs de Musique, founded in 1851 to handle the performance-licensing affairs that stemmed from the principles of copyright protection promulgated in 1791 during the time of the French Revolution. SACEM was the first such organization in the world. ASCAP was formed much later in the United States for similar purposes.

sackbut *Music* The medieval predecessor of the TROMBONE. Even in medieval times, when other wind instruments with few keys could play only a limited selection of tones that were harmonics of a single FUNDAMENTAL, the sackbut had a slide that made its tube longer or shorter and, by that means, allowed it to produce every note of the chromatic scale within its baritone range. Because of its soft, warm tone quality, it was frequently chosen for accompaniments of vocal music. Its name comes from an old French word roughly translated as "pull-push."

sack puppet *See* HAND PUPPET.

SA come-on *Vaudeville* A performer's ability to suggest sex appeal through choices of song and lyrics, and the manner with which they are presented.

Sacred Harp *Music* A vigorous style of communal singing practiced since the mid-19th century in rural areas in the South, based on *The Sacred Harp*, a book of hymns harmonized for four voices in SHAPE-NOTE notation published in Georgia by F. F. White in 1840. During the 19th century, a tradition of community meetings developed for the sole purpose of singing hymns from the book. To this day, at seasonal meetings in Alabama, Georgia and other states, the singers arrange themselves in a hollow square, one VOICE to a side, and sing the hymns through almost without interruption for most of a day. Their singing style is plain, unrefined, loud and enthusiastic. The original book has undergone many refinements and improvements since its original publication. Its musical style has its roots in the Northern European Protestant movement, where the common people rejected the tradition of being sung to by priests and cantors, preferring to sing for themselves in their own way. From this stemmed the hymnology of Martin Luther that influenced so many great composers including Heinrich Schütz and Johann Sebastian Bach (who composed 371 homophonic chorales for the congregation to sing in his many church pieces). The American composer William Billings retained the homophonic style and vigorous marching rhythms. Some of the Sacred Harp hymns are called FUGUING TUNES, a term that Billings used for many of his titles.

saddle iron *Stagecraft* A thin but strong iron strap with a pair of short vertical tabs welded at each end. It replaces the bottom rail of a FLAT with a door (or fireplace) opening, where a wooden rail would be visible to the audience, stiffens the flat and protects it when it is being moved. Also called a sill iron.

Sadlers Wells *Music* A theater in London, built in 1753 on the grounds of an older "pleasure garden" for the presentation of plays and operettas. It was the home of the premier opera and ballet companies in England that have since become the Royal Ballet and the English National Opera.

Sadlers Wells Ballet A school and ballet company originally based at the Sadlers Wells theater in 1931. It grew out of a school and a company both founded by Ninette de Valois in 1926. It was chartered as the Royal Ballet in 1956.

safety *Audio* In the days when audio recordings were made directly on master disks, the safety was a duplicate cut at the same time the original was being cut, for protection in case anything should go wrong with the cutting mechanism. As the industry moved into tape systems, the term remained in use but described any duplicate of any TRACK made at any time during the editing process, up to and including the final MIX.

safety chain *Lighting, Stagecraft* A short, extra length of chain attached to a lighting fixture at one end and its BATTEN or LIGHT PIPE at the other, for safety in the event that the clamp holding the light becomes loose.

safety curtain *See* FIRE CURTAIN.

safety lights *Theater* Battery-powered emergency lights that turn on automatically if the main power line shuts off, providing enough light to help players and audience leave the theater.

safety rope clamp *See* ROPE LOCK.

SAG *See* SCREEN ACTORS GUILD.

saint play *Theater* A MIRACLE PLAY based on the life of a saint.

Saint Vitus's Dance A dancing mania, probably caused by popular fears about the disease called *chorea* that afflicted many Europeans in the 14th century. Its victims sought a cure by dancing to the shrine of St. Vitus, patron saint of *chorea* sufferers.

salon music Light, entertaining music, suitable for social occasions in a private mansion. *See also* PALM COURT MUSIC.

salsa (*SAHL-sah*) [Spanish] *Dance* Literally, sauce. A lively ballroom dance originally from Puerto Rico, with the first beat of each measure accented. Similar to the MAMBO.

Music A modern style of Latin American popular music that combines elements of JAZZ and ROCK with Cuban dance rhythms.

saltando, saltant *See* SALTATO.

saltarello [Italian] *Dance* A lively folk dance of Italian and Spanish origin characterized by leaps and hopping, known since the 14th century. *Compare* BASSE DANSE, ESTAMPIE, GALLIARD.

saltato (*sahl-TAH-toh*), **saltando** (*sahl-TAHN-doh*) [Italian] *Music* A BOWING technique consisting of very short, rapid, bouncing strokes using the middle of the bow. Generally, the strokes bounce higher than in the SPICCATO.

samba *Dance* 1. An African-influenced folk dance from Brazil, in 2/4 time, characterized by fast shuffling steps and notable for its complex rhythms. 2. A couple dance known as the samba-carioca, that evolved from the MAXIXE, with simple steps performed in 2/4 time. 3. A song form based on the dance.

samisen, shamisen *Music* A Japanese stringed instrument of three strings stretched along a long neck and across a rounded-square sound box with wooden sides and stretched catskin for its top and bottom. It is played with a PLECTRUM, and produces a sound reminiscent of the banjo. The samisen is used as an accompanying instrument in Japanese puppet theater (BUNRAKU) and in KABUKI.

Samoiloff effect *Lighting* An effect developed in the early 20th century by the designer Adrian Samoiloff who experimented with monochromatic light of various colors projected on stage SETS that had areas painted in different mixed colors. As colors projected upon them varied, the painted areas would undergo surprising changes before the eyes of the audience.

sand *Dance* A dance step popular among African Americans in the late 1930s and 1940s, probably based on a turn-of-the-century vaudeville routine.

sand bag *Lighting, Stagecraft* A weight used for many purposes backstage, *e.g.,* dropped against the bottom rail of a FLAT or the bottom of a light stand to keep it from moving, or hung on a rigging line to help balance the weight of scenery attached to the other end.

sand cloth *Stagecraft* A FLOOR CLOTH painted to represent sand or dirt.

s. and d. *Vaudeville* Slang abbreviation for song and dance.

sandwich batten *See* DOUBLE BATTEN.

sansa *Music* One of the many names for the MBIRA. *See also* KALIMBA.

saraband, sarabande *Dance* Originally a wild Spanish dance of the 16th century, considered indecent. It evolved into a dignified court dance in 3/4 time of the 17th and 18th centuries, performed by a man or woman as a solo.

 Music A standard movement of an instrumental or keyboard SUITE, in slow 3/4 time.

sardana *Dance* A Catalan folk dance in rapid 6/8 time, performed in a circle with a pipe and a drum for accompaniment, similar to the FARANDOLE. It is the national dance of Catalonia.

sarod *Music* A stringed instrument of Hindu India that can be either plucked or bowed. It is roughly the size and shape of a MANDOLIN, though it has a hollow gourd at its upper end for resonance. Its range is similar to that of the VIOLA.

sarrusophone *Music* A double-reed instrument invented in the 1850s by a French band leader named Sarrus. Although there were sarrusophones in every range from SOPRANINO down, only the double-bass instrument remains in use in a few bands as an alternative to the CONTRABASSOON.

sashay *Dance* 1. A square dance step consisting of quick, small, gliding steps to the right or left with the man holding his partner's right hand in his left, and her left hand in his right. 2. To move or glide as in a dance.

satellite link *Television* A transmission system for a REMOTE PICKUP from a location too far from the main studio to permit an AIR LINK. It uses a high-frequency radio signal directed to a satellite in earth orbit and rebroadcast from the satellite to the base. *See* FEED.

satire *Theater* 1. The use of imitation, irony, ridicule, sarcasm and humor to deride anything or anybody. 2. A play or skit using those means for such a purpose. The term derives from the Greek SATYR PLAY. Many of the plays that developed out of COMMEDIA DELL'ARTE are satires, *e.g.*, *The Marriage of Figaro* (1784) by Beaumarchais, and *Volpone* by Ben Jonson.

satirical *Theater* Having the quality of SATIRE.

saturation *Stagecraft* A measure of the purity of a color, expressed in percentage as the reciprocal of the ratio of white contained in it, *e.g.*, in paint, a 90 percent saturated color contains 10 percent white pigment.

Lighting Brilliant lighting of the entire stage, often used during an outdoor performance when the show opens before the sky has become dark, so that the audience is less liable to be distracted by things that occur offstage.

satyr chorus *Theater* In classical Greek comedy, a chorus costumed as satyrs in a SATYR PLAY.

satyr play *Theater* A vigorous, licentious, pastoral COMEDY that was presented by torchlight in the evening, after a trilogy of TRAGEDIES (often by the same author) presented that day during the great festivals in Greece during the 4th and 3rd centuries B.C. Satyr plays were named for the mythical attendants of Bacchus, who were half goat and half human, represented by the chorus. *See* DIONYSIA.

saunter *Dance* An English version of the FOXTROT.

saut (*soh*) [French] *Ballet* A jump off both feet, landing in the same position.

saut de basque (*soh deu BAHSK*) [French] *Ballet* A jumping, traveling step performed while turning in the air, with one foot touching the knee of the other leg.

sauté, sautée (*soh-TAY*) [French] *Ballet* A term designating a movement executed while jumping, such as ÉCHAPPÉ *sauté*.

sauter (*soh-TAY*) [French] *Ballet* To jump. One of the seven basic MOVEMENTS IN DANCE.

sautillé (*soh-tee-YAY*) *See* SALTATO.

SA value *Vaudeville* Short for sex-appeal value.

Savoyard *Opera* 1. A member of the original company that presented all the OPERETTAS of Gilbert and Sullivan at their Savoy Theatre in London. 2. Since about 1900, when the operettas of Gilbert and Sullivan began to appear all over the world, a member of any company presenting them.

saw *See* MUSICAL SAW.

sax *Music* Short for SAXOPHONE.

saxhorn *Music* Any of the family of brass wind instruments designed in the mid-1800s by the Belgian band master Adolphe Sax. They were all held upright, had valves and mouthpieces like those of the trumpet or tuba, and ranged from soprano to bass register. Not to be confused with SAXOPHONES, also invented by Sax.

saxophone *Music* Any of the family of metal, SINGLE-REED, WIND INSTRUMENTS designed around 1840 by the Belgian band master Adolphe Sax. Its MOUTHPIECE is similar to that of the clarinet but, unlike the clarinet, the saxophone is constructed of brass and has a conical bore that gives it a distinctive tone quality. It is a transposing instrument. Music for all saxophones is written in the treble clef, and they all have the same fingering patterns. The family covers the entire orchestral range in eight registers (transpositions indicated in parentheses): sopranino (E-flat), soprano (B-flat), alto (E-flat), tenor (B-flat), baritone (E-flat), bass (B-flat), contrabass (E-flat), subcontrabass (B-flat). Many composers have used alto and tenor saxophones as solo instruments in orchestral compositions. Some have also composed for saxophone quartets. Because saxophones have such a variety of tonal qualities, they have been prominent in dance and JAZZ bands since the 1890s.

scab *Stagecraft* A small scrap of cloth glued over a tear or a small opening in the canvas of a FLAT. Also called a scrap patch. *Compare* DUTCHMAN.

Scala, La *See* LA SCALA.

scale *Motion pictures* A schedule of minimum rates of pay for performers, technicians and crews, established for actors by the ACTORS' EQUITY ASSOCIATION and SCREEN ACTORS GUILD, for directors by the DIRECTORS GUILD OF AMERICA and for technicians and crews by other CRAFT UNIONS.

Music 1. A graduated series of musical tones related to each other by TUNING. Every DIATONIC scale begins with its TONIC and rises through its SECOND, its THIRD, etc., through its SEVENTH after which it repeats an OCTAVE higher. A CHROMATIC scale rises by SEMITONES. *Compare* GAPPED SCALE, MAJOR SCALE, MINOR SCALE, MODE, PENTATONIC SCALE. 2. A schedule of minimum rates of pay for musicians, established for instrumentalists by the AMERICAN FEDERATION OF MUSICIANS and each of its local affiliates, and for singers

by the AMERICAN FEDERATION OF TELEVISION AND RADIO ARTISTS and AMERICAN GUILD OF MUSICAL ARTISTS.

Television *See* GRAY SCALE.

Theater A schedule of minimum rates of pay for performers, technicians and crews, established for actors by ACTORS' EQUITY, for musicians by the AMERICAN FEDERATION OF MUSICIANS and AMERICAN GUILD OF MUSICAL ARTISTS, and for technicans and crews by INTERNATIONAL ALLIANCE OF THEATRICAL STAGE EMPLOYEES and other unions.

scale step *Music* A single degree of the SCALE.

scale the house *Theater* To establish different ticket prices for seats in different parts of the HOUSE.

scalp *Circus, Theater* To buy tickets from the box office at normal rates and sell them on the street illegally for inflated prices.

scalper *Theater* One who SCALPS. Also called a RAT.

scandoll *Vaudeville* A female dancer in a fantastic costume, often with elaborate headdress, in the chorus line of a REVUE of the early 20th century.

scanning lines *Television* The horizontal lines across the television screen that carry the lights and colors of the image. *See also* RASTER.

scare wig *See* FRIGHT WIG.

scat *Jazz* To sing a jazz tune in the style of SCAT SINGING.

scat singing *Music* A jazz style of singing first practiced in the 1920s by the bandleaders Cab Calloway and Louis Armstrong, and expanded into a personal style by the jazz singer Ella Fitzgerald. It consists of a stream of nonsense syllables sung in rapid rhythmic figures in imitation of the highly decorative melodic improvisations of jazz instrumentalists.

scattering *Dance* Moving the limbs outward, away from the body. The opposite of GATHERING.

scena (*SHAY-nah*) [Italian] *Music* An operatic scene in the form of an extended solo with recitatives, often extracted from an opera and performed in concert as a complete work on its own.

scenario *Motion pictures* An outline of the story of a motion picture, scene by scene, establishing the basic dramatic structure, style and timing of the picture. In practice, the scenario is often worked out from a TREATMENT, and provides the basis from which writers create the SCREENPLAY.

Theater An outline of the plot for any play, especially one that is to be improvised, such as COMMEDIA DELL'ARTE.

scenarist *Motion pictures* One who creates the SCENARIO of a motion picture.

scene *Theater* 1. A discrete unit of a play, shorter than an ACT, occurring in a specific setting and with a beginning, middle and end. *See also* REHEARSAL SCENE. 2. The locale in which any portion of a play is imagined to occur, represented by suggestive or realistic scenery.

scène à faire (*sehn ah FEHR*) [French] *See* OBLIGATORY SCENE.

scene board *Theater* In Elizabethan theater, a large board put up at one side of the PROSCENIUM at the beginning of a scene announcing its SETTING. It may also appear in a revival of a 19th-century MELODRAMA for its comic effect.

scene change *Theater* A break between scenes during which the setting is changed. Often the change occurs while another scene is playing IN ONE in front of a SCENE DROP. Also called scene shift. *See also* A VISTA SCENE CHANGE.

scene cloth *See* SCENE DROP.

scene curtain *Stagecraft* A curtain lowered from the SECOND BATTEN to be the background for a scene IN ONE and, often, to conceal a simultaneous SCENE CHANGE. *Compare* SCENE DROP.

scene designer *Theater* The artist who designs the SETS for a production.

scene dock, scenery dock *Stagecraft* 1. A location backstage where a SCENE PACK can be stored safely, with all its FLATS leaning against each other in a suitable recess. 2. An open frame of pipes built on a low platform that can be moved around backstage on casters. The frame holds many flats, separated into manageable groups, for temporary storage. Also called a stacking rack.

scene drop *Stagecraft* A cloth DROP, usually painted and used as BACKDROP for a scene.

scene frame *Stagecraft* A frame built on a chariot to hold different pieces of scenery in 17th- and 18th-century theaters where the CHARIOT AND POLE SYSTEM was in use.

scene headings *Theater* The letters and/or numbers that appear in SCRIPTS and printed programs to identify each scene.

scene in one *See* IN ONE.

scene intermission *Stagecraft* A brief break, with the SCENE CURTAIN closed to allow a quick change and the house lights dim or dark.

scene master *Lighting* A master DIMMER that controls all the dimmers in use in a scene and makes it possible to dim everything with one move. *See also* PROPORTIONAL DIMMING.

scene muslin *Stagecraft* Heavy muslin, used instead of canvas to cover FLATS.

scene pack *Stagecraft* Any set of flats stored in a SCENE DOCK.

scene picture *Theater* 1. The look of a scene, with the actors in costume and in their places. 2. A TABLEAU at the end of a scene, with the actors frozen in position and IN CHARACTER as the curtain closes. *See also* TABLEAU VIVANT.

scene plan *Stagecraft* The floor plan of the SET.

scene plot *Stagecraft* A list of all the scenes in a play, together with details about scenery and scene shifts, more common in the 19th century than later.

scenery *Stagecraft* The FLATS, DROPS and constructed pieces that make up the SETTING of a production.

scenery chewer *Acting* An actor who overdoes actions and emotional reactions to a ridiculous degree. A HAM.

scenery wagon *See* CHARIOT AND POLE SYSTEM. *Compare* WAGON STAGE.

scene shift *See* SCENE CHANGE.

scene shop *Stagecraft* A carpenter's workshop where scenery is constructed and painted.

scene sketch *Playwriting* The playwright's suggestions to set designers and directors about the SETTING of the play and, sometimes, its BLOCKING.

scene stealer *Acting* An actor in a minor role who distracts the audience from the LEAD players.

scenographer *Stagecraft* The set designer.

schematic *Lighting* A technical plan of the wiring of circuits for a production, showing, with standard symbols, LIGHTING INSTRUMENTS, PATCH BAYS, DIMMER BANKS and CONTROL CONSOLES together with the circuitry that connects them.

schematics *Makeup* A set of outlines of an actor's head with its surfaces divided into sections, annotated to show the colors and types of makeup to be used to create the face of a character that actor will portray at every performance.

scherzando (*skehrt-ZAHN-doh*) [Italian] *Music* Literally, joking. In a lighthearted, humorous manner.

scherzo (*SKEHRT-zoh*) [Italian] *Music* Literally, joke. A humorous or playful composition, an alternative to the minuet, frequently part of a STRING QUARTET or a movement of a SYMPHONY.

Schillinger System *Music* A system to aid composers, which was published by Joseph Schillinger in the 1940s, and taught in his school, the Schillinger House, in Boston (later the Berklee School of Music). The system lists hundreds of combinations of rhythms, chords and melodic fragments according to a system of numbers. It promotes the idea

that by reordering the numbers, a composer can produce new musical ideas. A fundamental of the system is Schillinger's concept of musical tension and release. Some composers and arrangers of music for films found it useful, presumably because it saved them time and effort.

schleppend (*SHLEP-ent*) [German] *Music* Dragging heavily.

schmachtend (*SHMAHKH-tent*) [German] *Music* Languishing.

schmerzlich (*SHMEHRTS-likh*) [German] *Music* Literally, painful. Sorrowful.

schnell (*SHNEL*) [German] *Music* Quick, quickly.

schola cantorum (*SKOH-lah kahn-TOH-rum*) [Latin] *Music* A name taken by several modern choral organizations, after the Papal Choir founded in Rome in the time of Gregory the Great, in the 6th century.

schottische (*SHOT-tish*) [German] *Dance* Literally, Scottish. A German round dance in duple time, also called the German polka, popular in the mid-1900s in England and the United States. It is characterized by WALTZ-like turns and hopping and gliding steps. It has also been used as a stage dance. Not the same as ÉCOSSAISE.

schuhplattlertanz (*SHOO-plat-ler-TAHNZ*) [German] *Dance* Literally, flat-shoe dance. A lively Bavarian folk dance similar to the ländler, in which dancers slap their knees and the soles of their shoes while dancing.

schwa *Music* The indeterminate sound of an unstressed vowel in English, *e.g.*, the A in balloon, E in skillet, I in handily, O in gallon, U in circus. A term much used by choral conductors and diction coaches.

schwer (*shvair*) [German] *Music* Literally, heavy, difficult. In a heavy manner.

schwindend (*SHVIN-dent*) [German] *Music* Disappearing, dying away, as a DIMINUENDO.

sciopticon *Lighting* A SPOTLIGHT with a slide or a special color filter, sometimes motorized, to provide effects such as ripples when projected onto the stage.

scissors cross *Acting* 1. A simultaneous crossing of the stage from opposite sides by two actors. 2. An awkward movement by an actor who intends to cross the stage but starts with the wrong leg (*i.e.*, opposite the turning direction) which must then cross in front of the other leg.

scissors lift *Stagecraft* A mechanical lifting device similar to an automobile jack but much larger, with a platform on top that stays level at whatever height the lift reaches. It can support any large scenery unit on which actors must stand, such as a platform at the top of a wide staircase.

scolion [Greek] *Music, Theater* A song sung at banquets in the Archaic period (7th to 5th centuries B.C.) in Greece. It was sung by one carousing guest after another, each sup-

plying or improvising new verses and variations, to the accompaniment of a LYRE. Its name comes from a word meaning crooked, bent or twisting, presumably because of the variety of improvisations that were sung, especially if the guests had had too much wine.

scoop *Lighting* Slang word for a large FLOODLIGHT (*e.g.,* 18 inches in diameter) with a matte finish reflector and no lens. It is often used on location in motion pictures or television, to provide general light for the scene. *See also* NINE-LIGHT.

scooping *Lighting* The practice of lighting the stage with SCOOPS.

Music Said of a singer's sliding from one note to another in an exaggerated manner.

scordatura (*skor-dah-TOO-rah*) [Italian] *Music* The practice of tuning one or more strings of a stringed instrument to a fundamental tone different from normal tuning, to permit certain passages to be played with fingering that would have been impossible otherwise. The notes written on the staff then represent not the actual tones to be played, but notes to be fingered that will automatically become transposed as the correct tones. The technique was used by Johann Sebastian Bach, in his fifth suite for unaccompanied violoncello and in several other works. Also used by modern composers to alter the tonal effect, or to increase the range of the instrument slightly.

score *Music* 1. A complete written or printed version of a musical composition displayed on a system of STAVES, each showing the notes to be played by a single voice or type of instrument. Each staff is synchronized with the others vertically, so that the first MEASURE of the piece appears in each instrument in the same column. In modern orchestral practice, the top section of the score contains the WOODWINDS, next the BRASSES, then PERCUSSION, HARP, VOICES and other optional parts, with STRINGS at the bottom. *See also* MINIATURE SCORE, OPEN SCORE, PARTICELLO, SHORT SCORE, VOCAL SCORE. 2. To ARRANGE for many instruments or voices a piece originally written for only a few.

Theater 1. The music composed or arranged for a particular production. 2. To count the box office receipts. 3. To succeed spectacularly with the audience. Said of a play or an actor in it; to score is to be a HIT.

scoring line *Stagecraft* A line marked on the stage floor to identify the point where the JOIN of two flats, lashed together, is to be placed.

Scotch snap *Music* A vigorous rhythmic figure, appearing often in Scottish dances, consisting of a short note on the beat followed by a long one before the next beat, *i.e.,* usually, a SIXTEENTH followed by a DOTTED EIGHTH.

SCOTCH SNAPS

scrap patch *See* SCAB.

scratch company *Theater* An acting company put together at the last moment with whatever actors are available at the time.

scratch wig *Costume* A messy wig worn for comic effect.

screen *Motion pictures, Theater* Any surface upon which slides or a motion picture can be projected as scenery or for viewing. A screen for viewing generally hangs from a BATTEN and is stored, when not in use, in the FLIES. A screen for projection of scenery is usually translucent, for REAR PROJECTION, and built into the SET to conceal its edges.

Stagecraft See also SCRIM.

Screen Actors Guild *Motion pictures* The national union of motion picture actors, founded in 1933. Its jurisdiction parallels that of AMERICAN FEDERATION OF TELEVISION AND RADIO ARTISTS in television and radio and ACTORS' EQUITY in live theater.

screening *Motion pictures* A private showing of a motion picture to an invited audience.

screenplay *Motion pictures* The SCRIPT of a motion picture, with lines to be spoken, acting directions and detailed descriptions of moods and attitudes for the performers, together with general suggestions for the DIRECTOR OF PHOTOGRAPHY.

screen test *Motion pictures* A short film showing an actor, who may be a candidate for a particular role, playing that role in a significant scene for casting purposes.

screenwriter *Motion pictures* One who specializes in writing SCREENPLAYS, often a member of the staff of a production company who begins work with a TREATMENT prepared by others.

screw *See* STAGE SCREW.

screw base *Lighting* A light-bulb base that screws into a socket like any household bulb, as distinguished from a BAYONET BASE. Most low-wattage bulbs are screw-based.

screwed *Theater* In late Elizabethan times and up to the 18th century, the condition sometimes experienced by GROUNDLINGS who bought standing space in the PIT; when the play opened, the doors to the pit were fastened together with screws so that none could escape the collection of the admission price, which is said to have been taken (often by the GHOST) during the INTERVAL.

scribe *Theater* A slang term for a critic who writes for print media.

Stagecraft To draw the outlines of large shapes on unpainted flats, preparatory to painting them.

scrim *Lighting* A metal screen placed in front of a light to reduce its intensity without diffusion or change of color.

Stagecraft A heavy cloth of open weave used as a DROP. When the scene in front of the scrim is illuminated, but the acting area behind the scrim is not, the scrim, which can be painted, seems opaque and serves as a BACKDROP. When the ACTING AREA behind the scrim is illuminated and the scrim is not, the scrim and its painting seem to disappear allowing the audience to see the previously concealed stage. This property permits the lighting designer to effect a DISSOLVE between two scenes. Scrim is heavier and less transparent than THEATRICAL GAUZE.

scrimming *Stagecraft* Using a SCRIM, *e.g.,* to fill a window opening in a FLAT.

script *Theater* The actors' lines, descriptions of settings and costumes, and stage directions of a play. The script is the basis for the various schedules needed by the STAGE MANAGER, TECHNICAL DIRECTOR and PROMPTER in a production. *Compare* ACTOR'S SCRIPT, SIDES.

Motion pictures 1. The actors' lines, descriptions of scenes and costumes, stage directions and general suggestions for camera operation for a motion picture. It is the product of the SCREENWRITER, and is often written after the story has been worked out first in a TREATMENT and then in a scenario. From the script, the DIRECTOR and/or DIRECTOR OF PHOTOGRAPHY work out the SHOTLIST. 2. A generic title in the CREDITS of a motion picture for the assistant who was once called the SCRIPT GIRL.

script clerk, script girl *Motion pictures* A person present during every shoot who follows the script as the actors perform, makes note of every verbal deviation or addition that occurs and of any CUES missed or handled differently than the script indicates, and reports them to the director before the shot can be WRAPPED UP. *Compare* CONTINUITY CLERK. In motion picture credits, this gender-specific job title is often replaced by the single word *script.*

script reader *Theater* A person who reads SCRIPTS and prepares a preliminary evaluation upon which a PRODUCER will base a decision to produce the play or not. *Compare* DRAMATURGE.

scriptwriter *Motion pictures, Theater* 1. One who writes SCRIPTS, particularly motion picture scripts. 2. One who prepares an ADAPTATION of a story for stage or motion picture production.

scroll *Motion pictures* A display of introductory information or of CREDITS that begins at the bottom of the screen and proceeds upward, disappearing at the top. It is the vertical version of a CRAWL.

Music The carved extension at the upper end of the NECK of a stringed instrument, into which the TUNING pegs fit.

sculptural lighting Any lighting that brings out the three-dimensional quality of the SET. The opposite of FLAT lighting.

scumbling *Stagecraft* Casually rubbing or smearing over a painted surface with a different pigment using a dry or damp brush and allowing the pigment to fall spottily, having the effect of lightening (with white or light color) or darkening (with darker color) the original surface.

SD *Theater* Abbreviation for STAGE DOOR or STAGE DIRECTOR.

sea cloth *Stagecraft* A cloth DROP painted to look like the sea.

sea drum *Stagecraft* A round box or drum in which large round shot or pebbles can be rolled about to simulate the sound of the sea. *Compare* RAIN DRUM.

searchlight technique *Lighting* The technique of spotlighting different areas as action occurs here and there on a dark stage. It was used most dramatically on a wharf at the Pearl Harbor naval base during World War II, when Maurice Evans and two other actors traveling

the war zones put on Shakespeare's *Hamlet*. There was no scenery, the actors wore LEO-TARDS, and ACTING AREAS were defined by pools of light from enormous aircraft searchlights mounted high above the wharf at opposite ends of an aircraft carrier.

sea row *Stagecraft*　A GROUND ROW painted to look like the sea. In some theaters of the 17th and 18th centuries, the sea was represented by two or more ground rows with wave-shaped profiles, moved alternately back and forth by means of levers from below the stage.

season　The annually recurring period of weeks or months during which a producing or performing organization remains busy and for which it schedules productions (usually at least a year in advance). Many organizations have no specific season, or operate all year round. Others, such as some symphony orchestras, have a winter season at one location, and a summer season at another. *See also* SUMMER STOCK.

season ticket　*See* SUBSCRIPTION.

seating *Theater*　The arrangement of seats for the audience. *See* AMERICAN PLAN SEATING, CONTINENTAL SEATING.

seating chart *Theater*　A chart, often displayed in the lobby of the theater for the benefit of ticket buyers, showing the floor plan of the HOUSE with the positions of the rows and seat numbers.

seat strap *Music*　A short cloth strap, laid across the bassoonist's chair, with a cloth or leather cup attached at one end to fit over the butt of the BASSOON and support its weight during performance.

SECAM *Television*　Système Electronique Couleur avec Mémoire, the system that determines the technical standards for French television, which differ from American standards in that the French frequency standard for alternating current is 50 Hz (the American is 60 Hz), and French television broadcasts 625 horizontal lines per frame of picture (the American standard is 525) at 25 frames (50 fields) per second. *See also* PAL.

secco (*SEH-koh*) [Italian] *Music*　Dry, *i.e.,* without decoration. *See* RECITATIVO SECCO.

second *Music*　The interval between any two adjacent SCALE tones.

"second act" *Acting*　A stage manager's WARNING to actors to take their places for Act II.

secondary accent *Music*　A beat stressed less than the main accent of a MEASURE, but more than its unstressed beats. The term is important in describing the rhythmic shape of a measure in COMPOUND TIME, in which the secondary accent can be on different notes creating different rhythmic patterns.

secondary emphasis *Theater*　A director's choice in BLOCKING, with the actors grouped on stage so that there will be two points of FOCUS.

secondary plot　*See* SUBPLOT.

second banana *Vaudeville* A STAND-UP COMEDIAN who ranks just below the TOP BANANA.

second border *Lighting, Stagecraft* A BORDER on the second BATTEN, *i.e.*, IN TWO.

second chair *Music* The secondary position, *i.e.*, farther from the conductor than the first chair, at any DESK in the string section of an ORCHESTRA.

second company *Theater* A company, usually consisting of a complete CAST and its own STAGE MANAGER and LIGHTING OPERATOR, hired to go on tour with a show or to mount a second production in another city.

seconde, en *See* EN SECONDE.

second ending *Music* The final ending that replaces the FIRST ENDING after a repeating passage has been played the second time.

second hand *Stagecraft* A subordinate member of the stage crew.

second inversion *Music* An inversion of a TRIAD with its FIFTH as its lowest note. A C-major triad in second inversion becomes G-C-E. *Compare* FIRST INVERSION, ROOT POSITION.

second lead, second man, second woman *Acting* The actor or role next in importance to the LEAD.

secondo (*seh-KON-doh*) [Italian] *Music* Of two pianists performing a PIANO DUET on a single piano, the one playing the lower part, sitting to the left of the center of the keyboard. *See also* PRIMO.

second position *Ballet* A basic position with the balls of the feet turned out to form a straight line, as in FIRST POSITION, but with a space of about 12 inches between the heels. One of the five basic POSITIONS OF THE FEET.

 Music See POSITIONS.

second production *Theater* A second company organized to take the show on tour while the first company continues in town.

section *Music* 1. Any part of an orchestra consisting of instrumentalists playing the same kind of instrument, *e.g.*, woodwinds, brasses, strings or percussion. 2. Any of the voice groups in a chorus, *e.g.*, sopranos, altos, tenors or basses.

sectional rehearsal *Music* A rehearsal of one SECTION of the orchestra or chorus.

secular drama *Theater* Any nonliturgical play.

segment *Television* A single show from a SERIES.

segment stage *Stagecraft* A stage divided into removable sections on casters. *See also* MODULAR STAGE.

segno (*SEN-yoh*) [Italian] *See* DAL SEGNO.

segue (*SEH-gway*) [Italian] *Music* Literally, to follow. To continue without pause into the next section or the next page of the piece.

seguidilla (*seh-gwee-DEE-yah*) [Spanish] *Dance* A Spanish dance with many variations, known throughout the Spanish-speaking world. The most popular version is a couple dance in 3/4 time with GUITAR and vocal accompaniment.

selah [Hebrew] *Music* A word of unknown meaning appearing frequently in the Hebrew texts of the Book of Psalms, and left there by all the translators of the Bible. There are many theories, some suggesting that it indicates a change of voice or of loudness. Perhaps the most plausible theory is that it indicates an instrumental or dance interlude between STANZAS of the song.

Selby *Acting* *See* HARRY SELBY.

selective realism *Theater* A style that mixes realism with partial realism, as in EPIC THEATER, in which the vast scope of the subject may be represented symbolically, but the personalities of the characters are realistically portrayed.

sellout An absolutely FULL HOUSE, with every seat sold.

semi-arena *Theater* A theater with the audience seated in a half-circle or on three sides facing a wide stage that has no PROSCENIUM. *See also* AMPHITHEATER, ARENA, THRUST STAGE.

semibreve *Music notation* A scholarly term for a WHOLE NOTE, half the duration of a BREVE.

semichorus *Music* 1. Half, or any smaller portion, of the full CHORUS. 2. The music specifically designated for a small portion of the chorus to sing. A modern chorus is frequently divided into a large group and a smaller one to perform ANTIPHONAL music in an ordinary concert hall; the difference in group size makes up for the lack of multiple stages from which to sing.

semiquaver *Music notation* British term for an EIGHTH NOTE.

semitone *Music* 1. Half a WHOLE TONE, *i.e.,* one twelfth of an OCTAVE. 2. An interval between two tones a half-step apart. In the system of EQUAL TEMPERAMENT, all semitones are equal at 100 CENTS.

semplice (*SEM-plee-cheh*) [Italian] *Music* Literally, simple. With simplicity.

sempre (*SEM-preh*) [Italian] *Music* Literally, always, as in *sempre pianissimo*, always very quietly.

senior *Lighting* A 5,000-watt SPOTLIGHT. Also called a "five."

sennet *Music, Theater* A FANFARE or short piece of music called for in several Elizabethan plays. To be distinguished from a FLOURISH, which is much shorter. The word may be a corruption of *sonata.*

sense memory *See* PHYSICAL MEMORY.

sentimental comedy, sentimental drama *Theater* Any play in which sentimental ideas and nostalgia predominate over action.

sentito (*sen-TEE-toh*) [Italian] *Music* Literally, felt or heard. Expressively.

senza (*SEND-zah*) [Italian] *Music* Without, as in *senza sordino*, without MUTE.

separation *Motion pictures* The general difference of color and sharpness between an image and its background. The degree to which the image in the foreground "stands out" against its background.

septet *Music* 1. An ensemble of seven players. 2. A piece of music composed for such an ensemble.

septuplet *Music* A melodic figure of seven notes intended to be played smoothly, without internal accents, during the time normally allowed for fewer notes, *e.g.*, in a piano piece, a decorative figure of seven sixteenth-notes in the right hand, to be played freely against two eighths in the left. Sometimes spelled *septolet*. *See also* TUPLET.

sequel *Motion pictures* A motion picture with a story line that continues the story of a previous picture.

sequence *Motion pictures* Any series of SHOTS showing closely related actions in the plot. A typical sequence might consist of three shots showing a person coming out of a door, walking down steps and climbing into a vehicle that then drives away.

Music A passage of music in which a phrase repeats, not necessarily exactly, at a different PITCH.

sequence dancing *Dance* An English term designating ballroom dances that are composed of steps performed in a prescribed order, so that couples make the same movements at the same time.

sequence player *Lighting* A memory lighting system that prepares the next CUE as soon as the previous cue has been accomplished.

sequential staging *Theater* Staging of several scenes on several PAGEANT wagons, arranged so that the scenes arrive at each show place at different times in the proper order.

serenade, serenata [Italian] *Music* 1. A melodious evening song, frequently a love song, *e.g.*, the lovely *"Deh vieni alla finestra"* (O come to the window) in Mozart's *Don Giovanni*, or the ironic *"Vous qui faites l'endormie"* (You who pretend to be sleeping) sung by Mephistopheles to Marguerite in Gounod's *Faust.* 2. An instrumental work intended for an evening performance. Among the most famous is Mozart's *Eine Kleine Nachtmusik* (A Little Night Music). Another, though intended to be played in the morning, is the *Siegfried Idyl*, composed by Richard Wagner to surprise his wife on her birthday. *See also* NOCTURNE. *Compare* AUBADE.

serial *Motion pictures, Theater* 1. In the 19th century, plays produced in installments, like many novels of the period. 2. In the first half of the 20th century, a movie produced and distributed in (often weekly) segments. In the late 20th century, these evolved into television SERIES.

serial music, serial technique *Music* A structural method for composing music that avoids the stresses and resolutions that occur in traditional harmonies. It seeks to impose a system of rules that require the composer to base the music on a series of notes that do not form a melodic or harmonic structure in the traditional sense. It is commonly associated with music composed on a TONE ROW and is often called the twelve tone system, but many composers who have practiced it have deviated from such a strict limitation. Serial music proved to be a valuable tool for freeing the composer from the limitations of tradition, but it also made the music difficult for the audiences of the 1960s and 1970s to follow. *Compare* ALEATORY MUSIC.

series *Music* *See* TONE ROW.

Television A succession of television programs appearing at regular intervals based on related stories about a permanent cast of characters. Some series present a complete story within each program, as did the long-running *M*A*S*H*, with its setting in an American hospital unit near the front line of the Korean War. Others present an epic like *The Forsyte Saga*, based on the novels by John Galsworthy and produced by the British Broadcasting Company. It follows one family over several generations in 18 episodes, each 50 minutes long. *Compare* MINISERIES.

seriocomic *Theater* Describing a play or a scene on a serious theme with comic details.

serious drama *Theater* Any drama that is not on a frivolous subject.

serious music An unsatisfactory term used by licensing organizations such as ASCAP, BMI and SESAC to categorize music composed for concert and to distinguish it from popular music, which those organizations call STANDARD, and from JAZZ, ROCK, BEBOP and other types.

serpent *Music* A wind instrument of the 16th century, developed as a BASS version of the older wooden CORNETT (not to be confused with the brass CORNET). It consisted of a long wooden tube with six finger holes. Because the holes had to be far apart to accomplish correct tuning, the instrument was bent into a reverse curve, which gave it its name. In later years it was further developed and eventually became a bass horn of velvety tone used by Wagner, Rossini and other composers as late as the 19th century.

serrando (*seh-RAHN-doh*) [Italian] *Music* Literally, pressing. Becoming faster.

SESAC *See* SOCIETY OF EUROPEAN SONGWRITERS, AUTHORS AND PUBLISHERS.

session *Music* 1. A period of time set aside for musicians to get together and play, as in a nightclub or a JAM SESSION. A session may consist of one or more SETS. *See also* GIG. 2. A period of time during which musicians meet in a studio to record music. In union terms, a long recording period is considered as a number of standard sessions, each defined in terms of playing and resting time and the pay scale that applies.

set *Motion pictures* 1. Specifically, a portion of a studio prepared with furniture, props and scenery or background for a shooting session. 2. Loosely, any area, whether in the studio or ON LOCATION, that has been selected and prepared to become the visible setting for a scene.

Music 1. A series of musical numbers played consecutively as one program unit by a single BAND, usually with little breaks for introductory remarks, during a concert, a variety show or a GIG in a nightclub. After a set, the band takes an intermission, then reappears or is replaced by another band for another set. *See also* HEADLINER. 2. A group of pieces of dance music.

Stagecraft The scenery, platforms, BACKDROPS, PROJECTIONS, TRIM PROPS and furniture that appear on stage during a scene.

set designer *Theater* An artist who designs the sets for a production.

set dresser *Stagecraft* A designer and/or technical person who selects furniture and TRIM PROPS for each scene of a play and designates their placement in the set.

set dressing *Stagecraft* All the FURNITURE and TRIM PROPS needed to complete the set for each scene of a play.

set lights *Lighting* To put lighting fixtures in position, aim and focus them for each scene of a play.

set of lines *Stagecraft* A group of RIGGING LINES that operate together to raise or lower a heavy piece of scenery in the FLIES.

set piece *Stagecraft* Any large three-dimensional unit of scenery that stands alone on the stage floor or is part of a larger constructed scene, *e.g.*, the grand staircase in the coronation scene in Mussorgsky's opera *Boris Godunov*.

Theater A formal scene in a play or an opera, *e.g.*, the arrival of Tarquin to betray Lucrece in Jean Anouilh's play (and Benjamin Britten's opera) *The Rape of Lucrece. Compare* PRODUCTION NUMBER.

set the scene *Theater* To establish the scene both visually, with each actor taking position on the set, and dramatically, with each actor properly prepared to play a role.

set the stage *Stagecraft* To put all the scenery, furniture and PROPS in position on the stage.

setting *Motion pictures* The visual environment of the scene.

Theater The environment of the play as suggested by the scenery.

setting line *Stagecraft* An imaginary line marking the DOWNSTAGE limit of the SET.

set-up *Lighting* The arrangement of lights for a scene and of the circuitry and CONTROL BOARD that will operate them.

Motion pictures The position(s) of the camera(s) and lights, ready to begin a specific SHOT.

seven movements *See* MOVEMENTS IN DANCE.

seventh *Music* 1. An interval one step less than an octave. 2. The seventh tone of a SCALE, also called the LEADING TONE.

seventh chord *Music* A chord consisting of a FUNDAMENTAL tone and its THIRD, FIFTH and SEVENTH. *See also* DOMINANT SEVENTH.

Sevillana (*seh-vee-YAH-nah*) [Spanish] *Dance* A version of the SEGUIDILLA, from Seville in Andalusia.

sextet *Music* 1. An ensemble of six instruments. 2. A piece of music composed for such an ensemble.

sextuplet *Music* A melodic figure containing six tones that are to be played smoothly and without internal accents in the time normally allotted to four of the same value, *e.g.,* six EIGHTH NOTES, intended to be played simultaneously with two QUARTER NOTES (the equivalent of four eighths). Sometimes called sextolet.

sextuple time *Music* A musical METER containing six beats, usually considered as two beats of three notes each, or three beats of two notes each.

sf *Music* Abbreviation for SUBITO FORTE.

sfogato (*sfoh-GAH-toh*) [Italian] *Music* Literally, vented. Lightly, easily.

sforzando (*sfort-ZAHN-doh*) [Italian] *Music* Literally, strengthening. Forcing or accenting a note or a chord strongly. It is represented by the symbol *sfz*.

sfp *Music* Abbreviation for sforzando piano, suddenly loud, then immediately quiet.

SFX *Motion pictures, Television* Abbreviation for SOUND EFFECTS or SPECIAL EFFECTS.

sfz *Music* Abbreviation for SFORZANDO.

shade *Costume* Slang term for a mask.

shader *Television* An engineer who controls contrast and picture quality in the video signal during a video broadcast or recording.

shading *Makeup* The art and process of suggesting sunken areas on an actor's face using SHADOW MAKEUP.

Television The process of controlling contrast and picture quality in a video signal.

shading colors *Makeup* Pigments used to create highlights, shadows, lines, wrinkles, etc., on an actor's face.

shadow box *Lighting* Any boxlike SHIELD built into a strip of border lights to prevent light SPILL.

shadow graphs *Theater* Images that look like familiar animal shapes, created on a screen by a performer's fingers in projected light.

shadow makeup Makeup in dark shades used to suggest hollows in the face. *See* SHADING.

shadow play *Puppetry, Theater* A play, often in pantomime, presented in silhouette on a backlighted screen by actors or SHADOW PUPPETS working behind the screen.

shadow projector *See* COOKIE, COOKALORIS, GOBO, LINNEBACH PROJECTOR.

shadow puppet *Puppetry* A two-dimensional articulated ROD PUPPET operated close behind a backlighted screen so that its shadow shows through to the audience.

shag *Dance* A lively hopping dance of the 1940s, a form of JITTERBUG performed to strongly syncopated rhythms.

shake *Dance* 1. A jazz dance popular in the first 30 years of the 20th century. 2. In the mid-1960s, a dance requiring much shaking of the hips, performed to Jamaican RHYTHM AND BLUES. *Music* Another name for TRILL. Not to be confused with VIBRATO except as a description of tremulousness in the natural voice.

shakuhachi [Japanese] *Music* A Japanese FLUTE made of bamboo, held vertically and blown through its top, used as a solo instrument by Buddhist monks. It has only four finger holes in front and another in back.

shanty *See* CHANTEY.

Shape-note music *Music notation* A system set forth in 1801 in *The Easy Instructor* by the American singing teachers William Little and William Smith, to make it easier to read hymn music. They gave the head of each note of each half of the scale an individual shape—triangle, square, circle and inverted triangle—to help the singer recognize the different scale steps from one note to the next. Their book was very successful in the southern United States and became the basis for several popular books of hymns, the most important of which was *The Sacred Harp* (*See* SACRED HARP), published in Georgia in 1840 and still in use (with revisions) in the 1990s. There is, to this day, a national organization of shape-note singers who hold annual meetings, broadcast and make recordings.

sharp *Music* 1. High in PITCH. 2. At a pitch higher than it should be. 3. A symbol indicating a pitch one SEMITONE higher than the written note.

SHARP (G-SHARP)

shawm *Music* The highest in PITCH of a family of double-reed wind instruments used in the 14th to 18th centuries, ancestors of the modern OBOE.

sheave *Stagecraft* A pulley, set inside a BLOCK through which a RIGGING LINE can be passed to aid in hoisting scenery into the FLIES.

sheet *Theater* A sheet of stiff paper, printed with the seating plan of the theater, upon which box-office clerks can mark off the locations of seats that have been sold so that they and the remaining ticket buyers can see what is left.

sheet music Unbound published music, particularly music of only a few pages, such as popular songs. By extension, the term has come to include all printed music, as distinguished from published recordings.

shell *See* BANDSHELL.

shellac *Music* Slang term for a cheap disk record of the 1920s and 1930s, which ran at 78 rpm.

Stagecraft A form of varnish used to protect painted surfaces in the set.

sheng [Chinese] *Music* An ancient WIND INSTRUMENT consisting of a cluster of PIPES of different sizes mounted in holes arranged in a circle on top of a hollow gourd. The player holds the instrument cupped in two hands and inhales (more often than exhales) through a MOUTHPIECE on one side of the gourd while STOPPING the holes of various pipes with the fingers to produce CHORDS.

shield *Lighting* Any device designed to cut off stray light from a lighting fixture. *See* BARN DOORS, FUNNEL, SHADOW BOX, SPILL SHIELD.

shift *Music* On any stringed instrument, to move the left hand from one POSITION to another.

Stagecraft To remove one stage SET and replace it with another. *See also* STRIKE.

shill *Circus* An employee of the circus posing as a passerby who stands among the audience outside a SIDESHOW and makes remarks calculated to convince others that the show is worth buying tickets to see.

shim *Stagecraft* A thin slab of wood or iron, used as a leveling device under the corner of a piece of scenery.

shimmy, shim-sham-shimmy *Dance* An African-based jazz dance popular in the 1920s, involving shaking of the shoulders and body, and turning in the knees and feet as in the CHARLESTON.

shindig *Dance* A large, noisy party with dancing. Perhaps derived from shin + dig, a blow on the shin.

shivaree *See* CHARIVARI.

shock rock *Music* In the 1970s, a ROCK music performance style typified by spectacular displays of violence and eroticism on stage. Elements included the smashing or burning of amplifiers, guitars and microphones, topless dancing and the blowing up of assorted objects. Shock rock came into existence in the pop music world at the same time PERFORMANCE ART was taking place in concert halls and theaters.

shoestring production *Theater* Any production put together and presented with little or no money.

shofar, shophar [Hebrew] *Music* A ram's horn used as a musical instrument in biblical times during important Jewish religious and public ceremonies, still used in many congregations for Rosh Hashanah and Yom Kippur.

S-hook *Stagecraft* A flat iron strap bent alternately in four places to form a squared *S*. One end can slip over the TOGGLE of a flat, leaving the other end in position to support a STIFF-ENER. Also called a keeper.

shoot *Motion pictures* 1. Short for shooting session. 2. To take moving pictures.

shoot a flat *Stagecraft* To slide a flat rapidly across the stage floor. *See also* RUN A FLAT.

shooting script *Motion pictures* A script expanded to show each SHOT of a motion picture as a separate item, annotated with details about the position and operation of the camera. It has been prepared from the basic script by the DIRECTOR and the DIRECTOR OF PHOTOGRAPHY, and serves as the basis for the preparation of a SHOTLIST.

shop *Stagecraft* The scene shop, or carpenter's shop, where scenery is constructed.

shop manager *Costume* The head of the costume shop, responsible for making costumes according to the designer's drawings, fitting them to actors, and cleaning, repairing and storing them as necessary.

short score *See* CONDENSED SCORE.

short subject, short *Motion pictures* A brief motion picture, once used to entertain the audience in a continuously running movie house while patrons who have seen the main attraction leave and others arrive. Shorts appear in modern times as filler between FEATURES on cable television stations that specialize in movies.

shot *Motion pictures* A single operation of the camera and, by extension, the piece of film or videotape that is its record. Also called CUT. A shot begins when the camera starts rolling and ends when the camera stops. It consists of FRAMES, 24 for each second. A SEQUENCE is made up of shots. It is not necessarily the same as a TAKE. A shot can be defined in a shooting script, but it may require several takes during a shooting session to accomplish the shot the way the director wants it.

shot bag *Stagecraft* A heavy weight, consisting of a bag full of lead shot, used, for example, to hold the bottom rail of a flat in place. *See also* SAND BAG.

shotgun, shotgun microphone *Audio* A special microphone used when other microphones cannot be close to the subject without being seen in the picture. It is a long tube with one end open, a microphone built into the other end and screened vents along its sides. The operator points the open end at a distant source of sound, *e.g.*, an actor standing on the other side of the street. The sound coming directly in line with the tube goes straight to the microphone. Other sounds, coming from sources not in line with the tube, come partly through the side vents and partly through the tube, so that they tend to cancel out. *See also* PARABOLIC REFLECTOR MICROPHONE.

shotlist *Motion pictures* A numbered, annotated list of all the SHOTS planned for a motion picture, prepared from the shooting script by the DIRECTOR and the DIRECTOR OF PHOTOGRAPHY. One purpose is efficiency; to shoot each shot in the order in which it will appear in the picture can require a new SET-UP for every shot taken. With a shotlist, however, the DP can reorganize all the shots so that wherever two or more will use the same SET-UP, they may be shot together.

shoulder sit *Ballet* A step in which the male dancer lifts his partner to his shoulder where she sits, *e.g.*, with the outer leg extended forward (*en attitude devant*), the other knee bent and one or both arms raised.

shout, shout gospel *Music* A type of SPIRITUAL that vigorously and loudly expresses religious fervor or elation.

show bill *Theater* A single-sheet advertisement for a show. *See* ONE-SHEET.

show biz *Theater* Short for SHOW BUSINESS.

showboat *Theater* A large boat, particularly one like the Mississippi River steamboats of the 19th century, that traveled from city to city giving shows, with a theater in its main cabin and accommodations in other cabins for actors and stage crews.

show business *Theater* The world of theater and, by extension, television and motion pictures.

showcase *Dance, Theater* 1. A presentation, sometimes a short RUN, to display a new play, dance or performer. 2. To introduce a new play, dance or performer before an audience in a single presentation or a short run.

show cloth, show curtain *Stagecraft* A DROP hung directly behind the main curtain, painted with the title of the show or other advertising material. *See also* AD CURTAIN.

show folk *Circus, Theater* The professional people in show business.

showgirl *Vaudeville* A female dancer/singer in the chorus line.

showman *Circus, Vaudeville* 1. A MASTER OF CEREMONIES. 2. A producer or theatrical manager.

showmanship *Theater* The ability to engage the audience in any event on stage, a combination of PRESENCE and TIMING.

show people *See* SHOW FOLK.

show-stopper *Theater, Vaudeville* Any ACT or NUMBER that wins tremendous applause from the audience, demanding bows before they will allow the performance to continue.

show tape *Theater* An audio tape recording of passages of music and sound effects, edited into the order in which they will occur in the production, with annotated WHITE LEADER between segments to assist the operator in setting up each CUE when its time comes. In highly sophisticated sound systems, the individual cues may be electronically marked so they can be called up by a computer keyboard.

show the act *Vaudeville* To give a presentation of an act before a potential producer.

show town *Theater, Vaudeville* Any town where a show is, or could be, scheduled for a successful engagement.

show tune *Music* A dance tune or a song composed for, and closely associated with, a MUSICAL COMEDY. A hit song from a musical comedy.

show-wise *Theater* Said of a sophisticated audience.

shroud *See* FUNNEL.

shrubbery *Makeup* Slang term for a beard.

shtick [Yiddish] *Vaudeville* A performer's personal style of DELIVERY or standard ROUTINE on stage.

shuffle *Dance* A slow JAZZ dance from the American South, performed to strongly syncopated music.

Music In jazz, a style of playing in which each measure of 4/4 time is divided into EIGHTH NOTES. On the piano, four eighths in the TREBLE follow in succession another four eighths in the bass, moving step-wise.

shutter *Motion pictures* A spinning disk between the lens and the film of a camera or a projector, with a slotted segment that allows light to pass through for part of its cycle. The width of the slot can be adjusted to increase or decrease the amount of time allowed.

Lighting A light-proof device made of two or more thin leaves of metal, painted black and fitted between two parallel channels, which in turn can fit in a COLOR FRAME in front of a light fixture. By sliding the leaves apart or together, it can be opened or closed very quickly. In its open position it lets all the light through. When it is closed, no light reaches the stage.

shwa *See* SCHWA.

si (*see*) *Music* The seventh syllable in the standard system of SOLMIZATION. In the FIXED-DO system, the note B or B-flat. In MOVABLE-DO, the seventh note (LEADING TONE) of whatever scale is in use. It is sometimes replaced by TI.

sibilant *Acting* The hissing sound of the letter S.

Siciliana, Siciliano (*see-chee-lee-AH-nah, see-chee-lee-AH-noh*) [Italian] *Dance* A Sicilian pastoral dance of the 17th and 18th centuries in DOTTED RHYTHMS in a moderately slow 6/8 or 12/8 meter, characterized by a gently swaying effect, soft melodies and harmonies, often with a NEAPOLITAN SIXTH in its CADENCES.

Music A dancelike section occurring in keyboard sonatas of the 17th and 18th centuries, including some by Johann Sebastian Bach and Arcangelo Corelli, or a piece composed to accompany pastoral scenes in operas and cantatas of the period.

sicilienne *See* SICILIANA.

sickle, sickling *Ballet* A technical fault in which the dancer's foot turns in or out from the ankle, thus breaking the straight line of the leg. *See also* ROLLING IN, ROLLING OUT.

side *See* SIDES.

sideman *Music* Any member of a dance or JAZZ band other than the leader.

sides *Acting* An actor's LINES and CUES extracted from the SCRIPT and printed on a series of single sheets that can be held in the hand, ideally with plenty of room for the actor's notes.

side scenes *Stagecraft* Scenery painted on FLATS placed as wings on each side of the acting area.

sideshow *Circus* An individual show in its own BOOTH STAGE on the MIDWAY of a large circus, or among the many rides and attractions that make up a CARNIVAL. Typically, it is small, perhaps not much more than a FREAK SHOW, a magician, SWORD-SWALLOWER, EXOTIC DANCER or a similar ACT. It is set up with a BARKER and often a SHILL out front to lure passersby on their way to the main show.

side slot *Lighting* A vertical opening in the side wall of the auditorium through which SPOT-LIGHTS may be focused onto the stage without being in view of the audience.

siesta *Acting* Slang for a short period of unemployment.

sight act *Circus, Vaudeville* Any act that requires little or no speech, *e.g.,* ACROBATICS or JUG-GLING. It can go on as the first number in the show while the audience is still noisy. *See also* SIGHT GAG.

sight cue *Acting* Any silent CUE, such as an actor's gesture, a stage manager's (or prompter's) finger pointing from behind the wings, or another visual event.

sight gag *Vaudeville* Any GAG that makes its comic point visually, *e.g.,* when a circus clown attempts to sweep up a pool of light on the floor.

sight line *Stagecraft* Any of several imaginary boundary lines between which the audience can see actors on the stage, and outside which they cannot. The positions of the lines are determined by the placement and shapes of scenery and by the PROSCENIUM and any BOR-DERS, DROPS or WINGS that may be in use.

sight-read *Music* To read and play music simultaneously, at first sight, without previous rehearsal or the memory of past reading. The ability to sight-read depends on special techniques and talents. To sight-read an instrumental SCORE, where many of the individual instruments may be TRANSPOSED so that their sound is not directly represented by the written notes, is particularly complex, but it is a necessary skill for a competent conductor.

sight-singing *Music* The process of reading a vocal line and singing it without previous rehearsal. It requires familiarity with INTERVALS and RHYTHMS of every sort, and an ability to

coordinate with others in an ensemble, abilities that can be acquired through intensive training and practice in SOLFÉGE, or solfeggio, and RHYTHM.

sign *See* DAL SEGNO.

signature *See* KEY SIGNATURE, TIME SIGNATURE, SIGNATURE TUNE.

signature tune *Music* A piece of music popularly associated with a particular performer, especially such a piece played at the beginning or end of every performance.

signed *Acting* 1. Booked for an engagement or contracted for a role in a production. 2. Translated into American Sign Language for deaf people in the audience by an interpreter standing offstage but in view of the audience.

sign-off *Broadcasting* The special routine with which a radio or television program ends.

silent *Motion pictures* A movie made without sound, particularly any FEATURE made prior to the development of SOUND-ON-FILM.

silent cue *See* SIGHT CUE.

silent keyboard *Music* A small dummy KEYBOARD designed for exercise or practice, that produces no sound and that can be carried easily.

silhouette *Stagecraft* 1. The shadow of the profile of a performer or of a piece of scenery projected on a backlighted, translucent screen. It is named after Étienne de Silhouette, a minister in the court of Louis XVI just before the French Revolution. 2. Any flat piece of scenery with an irregular profile cut to resemble foliage or an architectural shape. *See also* GROUND ROW, PROFILE BOARD.

silk *See* BUTTERFLY.

silkscreen *Stagecraft* A technique for reproducing identical painted images, *e.g.,* architectural details, on several FLATS. Using any impermeable substance like paint or plastic sheeting, a negative copy of the image is applied to the printing screen. The scene painter then places the screen in position on the flat and brushes it with color that passes through the open mesh of the screen but is blocked by its impermeable areas, thus leaving a positive imprint on the flat.

sill iron, sill rail *See* SADDLE IRON.

silver screen *Motion pictures* Popular term for the world of motion pictures.

simple interval *Music* Any interval of an OCTAVE or less. Intervals beyond an octave are called COMPOUND.

simple time *Music* Music with either two or three BEATS to the measure, as distinguished from music in COMPOUND TIME. Strictly speaking, 4/4 is not simple time, because it can be construed as two pairs of two beats each.

simulcast *Television* A process for broadcasting the SOUND TRACK of any television program on an FM radio channel IN SYNC with the video broadcast. The technique came into use in the 1970s, primarily to satisfy opera lovers who disliked the scrawny sound of the loud-speakers built into most television receivers.

simultaneous cross *Acting* The action of two or more actors who cross the stage in opposite directions at the same time. *Compare* SCISSORS CROSS.

simultaneous staging *Theater* A set that displays several different scenes or ACTING AREAS that are visible all at once. A multiple setting. Some sets for religious dramas in the late Middle Ages displayed the spiritual life of mankind in a single set containing at least three environments: heaven at one end, life on earth in the center and hell at the other end.

sine wave *Acoustics* The wave form characteristic of a tone with no HARMONICS. In nature it consists of smoothly alternating pulses of higher and lower pressure that can be represented in a two-dimensional diagram as a continuous, smooth curve rising above and falling below a horizontal line. *See* SOUND WAVE.

sinfonia (*sin-foh-NEE-ah*) [Italian, from Greek] *Music* Literally, sound(ing) together. The Italian term for SYMPHONY. Composers often use it as part of a title of a purely instrumental piece that has no specific dance or aria form, as an interlude within a series of dances or within a cantata providing a meditative moment between dramatic portions. Johann Sebastian Bach called his *Three-Part Inventions*, which were short pieces for keyboard, sinfonias.

sinfonia concertante (*sin-foh-NEE-ah kon-chehr-TAHN-teh*) [Italian] *Music* A symphonic work with two or more solo instruments.

sinfonietta (*sin-fohn-YET-tah*) [Italian] *Music* A small symphony, often a symphonic piece for a small orchestra.

sing *Music* 1. A gathering of amateurs to sing together for pleasure. 2. To make music with the voice. 3. To produce musical tone beautifully, like the human voice.

singer *Music* A musician who sings.

singing actor *Theater* An actor with a good voice, trained as a singer.

single-color system *Lighting* A technique of lighting the set with one tint from one side and another tint from the other. *See also* McCANDLESS METHOD.

single-reed instrument *Music* Any wind instrument that produces its sound by blowing air under pressure through a MOUTHPIECE that is alternately stopped and opened by the vibration of a single thin, flexible REED. Such instruments include CLARINETS and SAXOPHONES. REED ORGANS are not considered single-reed instruments even though they meet the technical qualification, because it makes more sense to classify them among keyboard instruments. *Compare* DOUBLE-REED INSTRUMENT.

single-system *Motion pictures* The system originally developed to record sound on the same strand of film that photographs the image, as distinguished from DOUBLE-SYSTEM, which

records the sound on a separate strand using different, though synchronized, equipment. Since both sound and picture exist on the same strand, neither can be edited separately. Because of this, single-system is no longer in general use.

sing out *Music* To sing (or speak) loudly.

singsong *Acting* A style of speaking with the voice rising and falling in a monotonous manner that has little to do with the natural rhythms of the words being spoken, and therefore tends to deride those words.

singspiel (*ZING-shpeel*) [German] *Music* A play with many musical passages; an OPERETTA, as distinguished from both OPERA and MUSICAL COMEDY.

sink and fly *See* RISE AND SINK.

sinking curtain *Stagecraft* A stage curtain that can be dropped into a slot in the stage floor and, usually, rolled up on a BATTEN below.

sinking stage *See* ELEVATOR STAGE.

siren *Music* 1. A signaling device that produces a piercing tone that gradually rises and falls in pitch. It has been used in many musical works as a SOUND EFFECT and in some, notably the works of Edgard Varèse, for its musical quality.

Sir Roger de Coverly *Dance* An English COUNTRY DANCE from the 16th century, ancestor of the VIRGINIA REEL, that often served as a closing dance in 19th-century BALLS.

sirtos *See* SYRTOS.

sirvente (*seer-VANHT*), **sirventois** (*seer-vanh-TWAH*) [French] *Music* In medieval France, a song on a heroic or satirical subject, with words and melody composed and sung by a TROUBADOUR.

sissonne (*see-SON*) [French] *Ballet* Named for its creator, a jump executed from both feet onto (in most cases) one foot, with many possible variants.

sissonne fermée (*see-SON fehr-MAY*) [French] *Ballet* A SISSONNE close to the floor, ending on two feet with the working foot sliding into a DEMI-PLIÉ in FIFTH POSITION.

sister act *Vaudeville* An act played by two or more women, who may or may not actually be sisters.

sistrum *Music* A percussion instrument of ancient Egypt, consisting of a U-shaped frame with wooden crossbars and metal disks suspended between its arms. The disks rattled when the instrument was shaken.

sitar *Music* A large metal-stringed instrument similar to a LUTE with an onion-shaped body and a long, broad neck; one of the principal instruments of the classical music of India. Brass FRETS curve above the surface of the neck to allow space underneath for eleven SYM-

PATHETIC STRINGS. There are four "playing" strings for the main melodic line as well as three others that are usually struck or strummed together, all of which pass over the frets.

sitcom *Television* Short for situation comedy: 1. A comedy based on a state of affairs that is inherently funny and permits characters to exploit odd and comic relationships. 2. Generally, a television SERIES with a permanent cast who, in each SEGMENT, find themselves in a comic and sometimes bizarre situation that resolves by the end of the program.

sitting on their hands *Theater* Said of an audience that fails to applaud a performance.

situation *Theater* 1. The status of the PLOT and of the relationships between characters at a particular moment, *e.g.,* at the opening of a scene. *See also* GIVEN CIRCUMSTANCES. 2. The physical positions of all the actors on stage at any given moment, *e.g.,* at the opening of a scene.

situation comedy *See* SITCOM.

sitzprobe (*ZITS-proh-beh*) [German] *Theater* A sitting rehearsal. A rehearsal, common in opera productions, with most of the performers present but seated with their scripts or scores in hand rather than moving about the stage. *See also* READING.

six-five chord, six-four chord, six-three chord *See* FIGURED BASS.

six-sheet *Theater* A poster made of six PRINTER'S SHEETS pasted together on a medium-size outdoor billboard, advertising a show.

sixteenth, sixteenth note *Music notation* A note that is one-sixteenth the value of a WHOLE NOTE, or one quarter the value of a QUARTER NOTE. It has two FLAGS.

SIXTEENTH NOTE

sixth *Music* 1. The sixth tone of the scale in use. 2. A musical interval six scale notes wide.

sixth chord *Music* A TRIAD in FIRST INVERSION, *i.e.,* with its THIRD as its lowest note and its ROOT on top, *e.g.,* in the key of C: E-G-C. Also called a SIX-THREE CHORD, in FIGURED BASS terminology, because the two upper notes (reading down from the top) are a SIXTH and a THIRD above the lowest.

sixty-fourth note *Music notation* A note that is one sixty-fourth the value of a WHOLE NOTE, or one sixteenth the value of a QUARTER NOTE. It has four FLAGS.

SIXTY-FOURTH NOTE

size *Stagecraft* To prepare canvas for painting, using SIZING.

sizing *Stagecraft* A heated mixture of glue and water (or synthetic resin) used to fill the pores of any cloth surface in preparation for painting, *e.g.,* to prepare FLATS and pieces of scenery to be painted. Sizing does not provide a fine-grained smooth surface as does GESSO. Its purpose is to prevent direct contact between canvas and pigment which would eventually rot the canvas.

sizzle cymbal *Music* A large CYMBAL, mounted horizontally on a vertical stand, with a series of rivets loosely placed in 10 or 12 evenly spaced holes around its rim. When the cymbal is

struck, the rivets add a high-pitched rattling sound. A drummer can create a similar effect by attaching a short length of light metal chain to the stand and letting it drape across a cymbal.

ska *Dance* A dance from Jamaica, also called the blue beat, typified by vigorous hip movements to a strong, rapid, offbeat rhythm.

Music A predecessor of REGGAE, based on rural Jamaican music and RHYTHM AND BLUES, with simple melodies and LYRICS that tend toward social commentary and protest, introduced in the 1960s. *See also* ROCK STEADY.

skald *Music* A poet of ancient Iceland, one who sang his own words.

skate a flat *Stagecraft* To slide a FLAT across the stage floor on its BOTTOM RAIL. *See also* RUN A FLAT.

sked *Theater* Short for schedule.

skeleton play *Theater* A scenario for IMPROVISATION.

skeleton script *Acting* A script for the SUPPORTING CAST, minus the major speeches of the LEADS (except for the last lines of every speech that are needed as CUES).

skeleton set *See* UNIT SET.

sketch *Vaudeville* A brief comic play with two or three actors, complete in itself, often used as a centerpiece in a comic routine or an interlude between musical numbers.

Stagecraft A rough drawing of the SET or of a costume.

skiffle *Music* 1. A style of JAZZ derived from BLUES and RAGTIME, often using cheap ACOUSTIC GUITARS and nonstandard, homemade instruments, popular in the 1920s. 2. A style of music popular in England after World War II, using hillbilly instruments such as the WASHBOARD and the JUG, later known as British ROCKABILLY.

skiffler *Music* One who plays in a SKIFFLE band.

skins *Music* Jazz slang for DRUMS.

skin show *Vaudeville* Any show with nude or nearly nude performers.

skip *Dance* Any lightly leaping step in which the dancer lifts the body in a little leap from one foot, then touches that foot to the floor again before the weight shifts to the other foot.

Music A musical figure of two notes, one accented, the other not, imitating the dancer's movement. *See also* DOTTED RHYTHMS, SCOTCH SNAP.

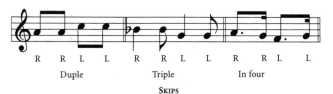

R R L L R R L L R R L L
Duple Triple In four

SKIPS

skit *See* SKETCH.

skull *See* TAKE (*Acting*).

skull a line *Acting* A slang expression for concentrating intently to understand the character's motivation for a line.

sky batten *Stagecraft* The batten that supports the SKY DROP.

sky border *Stagecraft* A BORDER painted to represent sky.

sky cloth *Stagecraft* Any DROP or BORDER hung to represent the sky.

sky cyclorama *Stagecraft* A CYCLORAMA painted or lighted, *e.g.*, with a projection, to look like the sky.

sky drop *Stagecraft* Any DROP intended to look like the sky.

sky pan *See* SCOOP.

SL *See* STAGE LEFT.

slack-key tuning *See* HAWAIIAN GUITAR, BOTTLENECK GUITAR.

slack off *Stagecraft* To loosen the ropes and/or relax the hoisting speed of the RIGGING when the item being hoisted is about to reach the desired height.

slackrope, slackwire *Circus* A rope or wire suspended, but not taut, between two elevated points so that it forms an arc in the air. A slackrope walker walks or rides a unicycle from one attachment point to the other while performing breathtaking feats high above the ground. *See also* HIGH-WIRE ACT, ROPE WALKER. *Compare* TIGHTROPE.

slamdancing *Dance* In the late 1970s a style of dancing seen in nightclubs and discothèques, involving a lot of jostling and violent body contact, usually performed to PUNK ROCK and THRASH METAL music. *See also* MOSH PIT.

slancio, con (*kon SLAHN-choh*) [Italian] *Music* With dash, impetuously.

slap-bass, slapping *Music* 1. A DOUBLE BASS player's technique of literally slapping rather than plucking the string, by bringing the right hand down hard from several inches above the string to produce both the tone and the percussive effect of the string hitting the fingerboard. 2. A bass player's PIZZICATO technique in which the string is drawn across or away from the fingerboard and abruptly released, an effect used often in the BIG BAND music of the 1930s and 1940s.

slapping and popping *Music* A rhythmic technique used widely by players of the ELECTRIC BASS GUITAR in FUNK and ROCK music in the 1970s. It involves SLAPPING, using the thumb to strike a lower string, then vigorously pulling ("popping") a higher string away from the fingerboard with the tips of the fingers. It produces a hollow, twangy, percussive effect.

slapstick *Circus, Vaudeville* 1. Two thin wooden slats, bound together at one end so that they are slightly separated along their length, with which one clown can beat another violently making loud smacks without actually hurting the victim. Not to be confused with CLAP-STICK. 2. A style of comedy that depends heavily on wildly physical humor. By extension, any boisterous comic routine. *See also* PUNCH AND JUDY SHOW.

slate *Audio* 1. An oral indentification for a segment of recorded sound, spoken by the recording engineer and recorded onto the tape just before the performers begin so that the editor will know which TAKE is which. It includes a working title for the material being recorded, the section about to be performed, the take number and the word *speed* to indicate that the machines are running, *e.g.,* "Beethoven, adagio, take two, speed." *See also* INSERT. 2. To label a specific take in a recording by imprinting a spoken description and TAKE number, such as "Schumann, First Symphony, third movement, take one" or, more simply, "Scherzo, take one." The term derives from the use of a slate in motion pictures. It can also be accomplished automatically with computer-based information in the tape-recording system.

Motion pictures, Television 1. A small board held in front of a camera at the beginning of any SHOT so that the editor will know which take is which. It is usually black, annotated in white chalk with information identifying the SCENE, shot and take, and usually includes a CLAPSTICK mounted on its top edge. 2. The image of the slate and its corresponding information on the film, and/or the sound of its CLAPSTICK on the sound track. 3. To label a shot or a take by imprinting identifying numbers and other information directly in the recorded image or sound. In traditional motion picture practice this is accomplished by holding the slate in front of the camera (usually at the beginning of the shot) and shooting it for a few seconds so that the editor will know later which take is which. In documentary work, where it is sometimes impossible to slate the shot before events happen, it is slated "at the tail." In modern technique, the slate is also accomplished electronically by imprinting similar information on both the visual and audio tracks with a computer signal.

"slaughter them" *Acting* An actor's encouragement to another who is about to go on stage, particularly in comedy, to overwhelm the audience with brilliance. *See also* BREAK A LEG.

sleeper *Motion pictures, Theater* Said of any play or film, particularly a low-budget production, that has unexpected success.

sleigh bells *Music* A SOUND EFFECT used in the percussion section of an orchestra. It consists of a cluster of little spherical bells hung on strings and shaken up and down by a percussionist.

slice of life *Theater* A style of play that imitates ordinary life in every detail.

slide *Music* 1. In string playing, a change in position of the left hand that takes place between two notes some distance apart. The resulting "slide" can be performed discreetly, with the transition barely audible, or more noticeably as an expressive effect. *Compare* GLISSANDO, PORTAMENTO. 2. *See* STEEL.

Lighting, Stagecraft A transparency that can be slipped into a SLIDE PROJECTOR or mounted in a COLOR FRAME so that it can be placed in front of a SPOTLIGHT to produce an image, *e.g.,* of a city street, a grand interior, or a sky with fluffy clouds, as background for a scene. *See also* CUT-OUT, DIAPOSITIVE.

slide guitar *Music* *See* STEEL GUITAR, HAWAIIAN GUITAR, BOTTLENECK GUITAR.

slide trombone *See* TROMBONE.

slide whistle *Music* A TIN WHISTLE without finger holes, with a sliding stopper that determines the pitch of its note, controlled by a bent wire at the bottom end. It has been used in a few light orchestral works and novelty songs to provide loud shrieks and other comic sounds.

sliding stage *Stagecraft* A segment of a stage floor built as a platform on tracks on which it can be slid into or away from the acting area. Usually, when such a segment has been removed, a BRIDGE rises like an elevator from below to fill the gap. *Compare* WAGON STAGE.

sliphorn *Music* Slang for TROMBONE.

slip stage *See* WAGON STAGE.

slit drum *Music* A hollow log with a slit in its top. It produces a brief tone when struck with a beater.

sloat, slote *Stagecraft* An arrangement of slanted guide rails and a small elevator within a TRAP by which an actor or a piece of scenery can be lifted into view on the stage. Also called a hoist.

slop print *Motion pictures* A secondary print made from a WORKPRINT when the editor needs a duplicate of a shot but has no time to get the original out of the vault for a new workprint.

slot *Stagecraft* An opening across the ceiling or vertically in the side walls of the auditorium, through which lights can be focused on the stage without being in view of the audience. *See also* LOUVERED CEILING.

slow burn *Acting* A character's angry reaction established by the actor at an artificially low level of intensity, then allowed to grow gradually until it interrupts the scene with an outburst of indignation.

slow clap *Theater* Rhythmic clapping by a dissatisfied audience, kept up until somebody does something to correct the objectionable situation that caused it.

slow curtain *Theater* A curtain closed slowly after the end of a scene.

slow motion *Motion pictures* A visual effect in which action on the screen moves along at a much slower pace than could have been possible in real life. It is accomplished by OVER-CRANKING.

slow night *Theater* A night when fewer than normal tickets are sold.

slow study *Acting* Said of an actor who learns lines laboriously.

slow take *Acting* A comic reaction allowed to develop very slowly, reaching its climax long after its stimulus in the scene has passed by. *Compare* SLOW BURN. *See also* TAKE.

slur *Music notation* A phrasing mark; an arc written over several notes or an entire phrase. Generally, the shorter arc over a few notes indicates they are to be played LEGATO. A long arc defines the limits of a phrase that may contain other phrasing marks within it. If two notes under a short arc are of the same pitch, it is not a slur but a TIE.

SM *Theater* Abbreviation for STAGE MANAGER.

small octave *Music* A name frequently applied to the octave below MIDDLE C. *See* OCTAVE NAME SYSTEM.

small-time *Acting, Theater* A disparaging term for any theater company or theatrical career that has not achieved considerable fame. *Compare* BIGTIME.

smash, smash hit *Theater* A tremendous popular success.

smear *Makeup* Slang term for greasepaint.

smoke generator, smoke machine *Stagecraft* A box containing a chemical mixture that produces smoke and a fan to blow the smoke onto the stage. *See also* FOG MACHINE, STAGE EFFECTS.

smoke pocket, smoke pot *Stagecraft* A metal container, hidden backstage or in the set, filled with a chemical mixture that can be ignited by an electrical heater or spark to produce smoke that drifts into or rises up within the set.

smorzando (*smort-ZAHN-doh*) [Italian] *Music* Dying away.

SMPTE *See* SOCIETY OF MOTION PICTURE AND TELEVISION ENGINEERS.

snake dance 1. A Hopi Indian religious dance using live snakes, usually as a prayer for rain. 2. By extension, the celebration of a special event in which people move in "Indian file" in a serpentine path. Snake dances often form spontaneously within very large, celebrating crowds.

snap cue *Lighting* A signal to turn a light on or off with a switch, rather than to DIM it.

snap hook *Stagecraft* Any strong hook with a rope or chain attached to a ring at its base and a spring closure across its open end. It can be snapped quickly to a BATTEN, the GRID or another rope and released equally quickly by pressing its spring back.

snap line *Stagecraft* A length of strong string drawn taut between two points several feet apart on the stage floor, or on a surface to be painted. When the line is rubbed with chalk or powdered pigment, then pulled up a few inches at its center and allowed to snap back, it leaves a straight line on the surface between the two anchor points to give the scene painter a straight reference line to work with. A portable snap line consists of a string drawn taut between two anchor points at the ends of a two- or three-foot wooden stick.

snare, snare drum *Music* A small military drum about 14″ in diameter and from 6½″ to 7¼″ deep, with 8 to 12 wire-wound plastic cords (snares) stretched taut across the bottom head. In marching bands, the drum hangs from a shoulder strap, slanted in front of the

player. In dance and jazz bands, it is mounted on a stand. The snares can be disengaged with a lever on the bottom rim, giving the drum a tom-tom-like effect.

snatch basket *Stagecraft* Any small basket a PROP PERSON can carry while quickly picking up loose props around the stage during a scene shift.

snatch block *Stagecraft* A SHEAVE, or pulley block, with one of its sides open so that a stagehand can flip a RIGGING LINE into it and over its pulley without having to thread it through.

snatch chain *Stagecraft* A length of chain attached to a counterweighted BATTEN, ready to be attached at the other end to any FLOWN object.

snatch line *Stagecraft* 1. A short length of rope attached to a BATTEN, ready to be tied to a FLOWN object so that stagehands can swing it into position. 2. A length of rope attached to a FLOWN object so that it can be guided into position by a stagehand.

sneak *Acting* To move from one place to another on stage without being noticed.

sneak in *Audio* To introduce a SOUND EFFECT, such as wind or rain, so gradually that the audience is not aware when it begins.

Lighting To bring up a light gradually, so that the audience will not detect the change.

Music To begin playing so softly that the audience will not hear the change, then gradually increase the volume of sound.

sneak out *Lighting* To reduce the brightness of a light to nothing so gradually that the audience hardly notices the change.

sneak preview *Motion pictures* Originally, a preview not announced to the public in any way but played after a regularly scheduled show for whatever audience happens to be in the theater at the moment. The term has become meaningless in the 1990s, with theaters advertising "Sneak preview Wednesday night!" in enormous letters in the Sunday paper.

snello [Italian] *Music* With agility, nimbly.

sniper *Carnival, Vaudeville* A person who puts up show posters surreptitiously all over town in places that are not supposed to have any, especially on walls marked "Post No Bills."

snoot *See* FUNNEL.

snorkle *Motion pictures* A periscope constructed to fit over the lens of a camera and reach almost to the floor, with internal mirrors that allow the camera to shoot from that low position. With a camera so fitted and mounted on a motorized dolly, the operator can, for example, follow a small child through the rooms of a house showing the furnishings and grownups as the child sees them.

snout *See* FUNNEL.

snow *Television* A continual storm of little white spots on the television screen, caused by interference, mistuning of the receiver, or problems with the antenna.

snow bag, snow trough *Stagecraft* A bag or trough hung above the stage, often IN ONE, filled with little white flakes of paper (or soap flakes) that can be spilled gradually by rocking the bag or the trough to simulate a snow shower on the stage.

snow drum *Stagecraft* A drum made of wire mesh with an axle running through it, hung from a BATTEN. It can be filled with bits of paper or other chaff that will slowly fall away from it when the drum revolves.

snow machine *Stagecraft* A motor-driven machine with a hopper that drops chaff onto an endless belt which carries it in front of a fan that blows the chaff like gently wafted snow onto the stage.

snub line *Stagecraft* A short piece of RIGGING anchored to the GRID and tied to a COUNTER-WEIGHT to keep it from falling while stagehands are attaching the scenery that will balance it.

soap, soap opera *Television* A melodramatic serial program chronicling the lives and loves of its characters from one day to the next. So-called because many are sponsored by companies that manufacture soap and detergents.

soap, soap over *Stagecraft* To render a mirror incapable of reflecting stage lights by rubbing its surface with soap.

social comedy *Theater* Any comedy based on the foibles of society, particularly one set in a drawing room, such as *Present Laughter* by Noel Coward.

social drama *Theater* Any drama based on social problems, such as Ibsen's *An Enemy of the People.*

social realism, socialist realism *Theater* A heavily propagandistic style of theater of the 1920s and 1930s, intended to expose the misery of the lower classes. *Compare* SLICE OF LIFE.

society drama *Theater* Any drama on a theme having to do with the relationships between people in the higher echelons of society.

society leader *Motion pictures* A LEADER approved by the Society of Motion Picture and Television Engineers for use in sound films running at 24 frames per second. *Compare* ACADEMY LEADER.

Society of European Stage Authors and Composers A performance-rights management organization for European music, similar to the American ASCAP, founded in 1931. Currently it is known by its acronym, SESAC.

Society of Motion Picture and Television Engineers An organization of technicians that was founded in 1916 for motion pictures only, and later expanded when television became viable.

sociodrama *Theater* A technique for studying social interactions in which students in university classes play roles taken from real-life situations as a means of studying social psychology.

sock chorus *Vaudeville* A chorus NUMBER so exciting that it stops the show every time.

sock cymbal *See* HI-HAT.

socko *Theater* An exclamation describing the effect of a SHOW-STOPPER.

sock play *Theater* A play that is a big HIT with the audience.

sock puppet *See* HAND PUPPET.

sock vaudeville *Vaudeville* A fast, exciting, tremendously successful show.

soffit *Stagecraft* A special BORDER or FLAT hung beneath an architectural piece of the SET to give it thickness.

soft focus *Motion pictures* A quality of image that is in focus but has soft edges, produced by adding a filter with frosted edges in front of the lens, out of the focal plane.

soft lighting Diffuse, low-contrast lighting with no sharp edges or shadows. Soft light provides better modeling of the subject than HARD LIGHT. It is produced by using unfocused lights where possible, and by bouncing strong lights off diffusing reflectors such as UMBRELLAS and BUTTERFLIES.

soft pedal *Music* A pedal on the GRAND PIANO that reduces the volume of sound across the keyboard by shifting the entire key mechanism a fraction of an inch to one side, so that each HAMMER strikes only one of the two or three strings that make up each note. On an UPRIGHT piano, depressing the soft pedal moves all the hammers closer to the strings to achieve the same effect. *See* UNA CORDA.

soft shoe dance Similar to the TAP DANCE, but performed in soft-soled shoes without metal TAPS.

sol *Music* The SOLMIZATION syllable that indicates the note G in the FIXED-DO SYSTEM, or the fifth tone (the DOMINANT) of whatever scale is in use in the MOVABLE-DO SYSTEM.

sold out *Theater* An ideal condition for a performance, with every seat sold. *See also* SRO.

soleares (*soh-lay-AH-rehs*) [Spanish] *Dance* An older form of Spanish FLAMENCO.

sol-fa *Music* Short for Tonic Sol-fa, a British system of SOLMIZATION. *See* MOVABLE-DO.

solfége (*sol-FEZH*) [French], **solfeggio** (*sol-FEH-joh*) [Italian] *Music* A system of teaching and practicing SIGHT-SINGING, advocated by composers and teachers since the 17th century, using syllables that identify each note of the scale. At the outset, the syllables used were vowel sounds because they were easy to sing at any tempo. These were supplanted later with SOLMIZATION syllables, *do, re, mi* etc. The exercises themselves are called VOCALISES, and

many have been composed by great composers from Alessandro Scarlatti to Sergei Rachmaninoff. The traditional methods of teaching solfége were fundamentally expanded in the 20th century by Émile Jaques-Dalcroze into a holistic system of studying music through physical experience and improvisation integrated with EURHYTHMICS.

soli [Italian] *Music* Plural for SOLO.

soliloquy *Acting* A meditative speech to be spoken by a single actor, alone on stage. One of the most famous is Hamlet's, which begins "To be or not to be, that is the question."

solmization *Music* General name for several systems of teaching SIGHT-SINGING, using syllables instead of texts, the earliest known being that of the schools for actors in the classical Greek theater of the 5th to the 3rd centuries B.C. The syllables in general use since about 1600 are the first syllables in each line of a prayer that may have been composed for the purpose by the great 11th-century music teacher Guido d'Arezzo: <u>Ut</u> queant laxis <u>Re</u>sonare fibris, <u>Mi</u>ra gestorum <u>Fa</u>muli tuorum, <u>Sol</u>ve polliti <u>La</u>billi reatum, Sancte Johannes. By the 18th century, the syllable *ut* was replaced by *do*, which seemed easier to sing. Later, *si*, which may have been devised from the initials of Guido's last two words, was added to represent the seventh, or leading tone. *See* FIXED-DO, MOVABLE DO, SOLFÉGE.

solo *Dance* 1. A VARIATION in which one dancer performs individually within a scene. 2. To perform alone, or as an individual dancer in a group of not more than four.

Music 1. A piece or a passage of music for a single performer. 2. The main melodic line of any work for a single voice or instrument with accompaniment. 3. In band music, the main melodic line of the trumpet, trombone, French horn or clarinet section. 4. To perform alone, with or without BACKUP.

soloist *Dance* A dancer, not necessarily a BALLERINA or a PREMIER DANSEUR, who performs alone or in a group of not more than four.

Music One who plays a SOLO.

somersault, somerset *Circus* A complete forward revolution of the body, performed by an acrobat. The performer begins by bending forward, putting head and hands on the ground, curling the body, rolling forward in a continuous motion and coming up to a standing position.

sonata *Music* A composition for an instrumental soloist with or without accompaniment, consisting of several movements such as an ALLEGRO, an ADAGIO, a MINUET or SCHERZO and a FINALE. In many sonatas written for a single instrument accompanied by harpsichord or piano, the "solo" and keyboard parts are considered equally important. *See also* SONATA FORM.

sonata da camera *Music* A 17th-century piece of music for a soloist or a very few instruments composed specifically for performance at court or in a church.

sonata form *Music* A musical form first established by Franz Joseph Haydn and continually developed by later composers. In Haydn's works, it generally consists of three sections: EXPOSITION, DEVELOPMENT and RECAPITULATION, based on contrasting tonalities set out in separate sections of the piece. In the exposition, the composer states a theme or

several themes in different, frequently contrasting tonalities. Often a second theme has a more lyrical character than the first. The development section expands upon elements in the exposition, working in the DOMINANT or other keys away from the tonic. The closing section recapitulates the exposition with its conflicts resolved and returns to the tonic key. Composers since Haydn have modified and expanded the concept to the point where the term sometimes applies in only the most general sense. Later composers have worked with less definable divisions of the music into sections, approaching a variation of BINARY FORM that consists of an exposition that becomes a development and moves into a new key, then further development that expands upon the ideas of the first and moves back to the original key with a less sharply defined recapitulation.

sonatina *Music* A smaller, shorter SONATA.

sone *Acoustics* A subjective unit of loudness of sound equal to the perceived loudness of a tone of 1,000 Hz at 40 DECIBELS.

song *Music* A short, simple piece of music for SOLO voice on a poetic text, with or without accompaniment, the oldest of all musical forms. *See also* PLANH, CAVATINA.

song and dance man *Vaudeville* An old term for a performer of the early 1900s whose act consisted of a few jokes, perhaps a little skit with a song or two and a dance routine.

songbird *Vaudeville* Slang for a female singer.

song cycle *Music* A series of individual songs on related texts, intended for performance as a group.

songfest *Music* An informal community gathering for the pleasure of singing, popular especially in the American Midwest during the late 19th and early 20th centuries before the development of amplification.

song plugger *Music* A music publisher's salesman during the early 1900s who played and sang new songs for visiting performers to help them choose numbers for their acts. The American composer George Gershwin began his professional career as a song plugger. *See* TIN PAN ALLEY.

songster, songstress *Music* 1. A COMPOSER of songs. 2. A singer who specializes in songs.

songwriter *Music* A COMPOSER and/or a LYRICIST of songs.

sonorous *Acting, Music* Having a resonant tone of voice.

soot black *Makeup, Stagecraft* Pigment made of pure carbon. *See also* BURNT CORK.

sopranino (*soh-pra-NEE-noh*) [Italian] *Music* Describing instruments of the highest TREBLE register, *e.g.*, the sopranino RECORDER or SAXOPHONE.

soprano *Music* 1. The highest female voice, with a RANGE of nearly two octaves from MIDDLE C. *See also* COLORATURA, DRAMATIC SOPRANO, LYRIC SOPRANO, MEZZO-SOPRANO. 2. Describing

an instrument (in a family of instruments) that covers the range of the soprano voice, *e.g.,* soprano saxophone.

soprano clef *Music* The TREBLE CLEF. *See* G-CLEF.

sordino, con (*kon sor-DEE-noh*) [Italian] *Music* To be played with a MUTE.

sospirando (*sos-pee-RAHN-doh*) [Italian] *Music* Literally, sighing. Plaintive.

sostenuto (*sos-teh-NOO-toh*) [Italian] *Music* Literally, sustained. In instrumental music, slowing down or extending the normal duration of a phrase.

sostenuto pedal *Music* On some PIANOS, the middle pedal, capable of sustaining a (usually BASS) note or a chord while other notes or harmonies are played on another part of the keyboard. It affects only those notes that have been struck and held before the middle pedal is depressed. Not to be confused with the SUSTAINING PEDAL.

sotto voce (*SOT-toh VOH-cheh*) [Italian] *Acting, Music* Literally, under voice. Speaking or singing with very quiet tone, not to be confused with whispering.

soubresaut (*Soo-breu-SOH*) [French] *Ballet* Literally, sudden leap. A springing jump performed upward and forward, from FIFTH POSITION, with the knees extended and toes pointed, landing in fifth position on both feet.

soubrette *Acting* 1. A female character who is young, pretty and vivacious, frequently sly and manipulative, often a lady's maid in a comedy. 2. An actress who plays such a role.

Opera A role for a light soprano voice, characterized by saucy charm, *e.g.,* the role of Zerlina in Mozart's opera *Don Giovanni.*

soul, soul music *Music* A term used loosely to describe a style of African American popular music based on the BLUES and GOSPEL singing. Soul music is generally more melodic than rhythmic, and it is more often associated with singers such as Aretha Franklin than with instrumental groups. It is characterized by warmth, conviction and great emotional expressiveness.

soundboard *Music* A resonant hardwood surface inside a PIANO or HARPSICHORD over which the strings are stretched. *See also* SOUND HOLE.

Theater Any hard-surface paneling built into the set, intended to reflect sound toward the audience. *See also* BAND SHELL.

sound booth *Broadcasting, Theater* 1. A CONTROL BOOTH in which audio engineers sit, watching performers through a soundproof window and listening on LOUDSPEAKERS to the sounds produced on stage or in the studio while they control the way those sounds are being recorded. 2. A soundproof booth in a theater where engineers can watch events on stage and provide the sound CUES called for in the script.

sound box *Music* The hollow, resonant body of any plucked string instrument, *e.g.,* the GUITAR, KITHARA, LYRE, etc., or the KALIMBA, MBIRA or SANSA.

sound check *Broadcasting, Music* During a recording session or before air-time for a broadcast, a brief run-through of the loudest portion(s) of a piece of music to allow the engineers to adjust volumes to the proper levels. Musicians playing in nightclubs with amplified instruments also go through a sound check before beginning their sets.

sound console *Audio* A CONTROL CONSOLE for audio circuits. It often includes an array of controls for each of 24 or more CHANNELS. Each channel consists of a line from a single microphone, an array of controls for balancing volumes at many different pitch levels, controls that modify the character of the incoming sound, and controls that send it along to the recording machine.

sound control *Theater* The CONSOLE that controls all the sound for the theater, and its operator.

sound cue *Acting, Audio* A signal to produce a sound effect. *See also* START CUE, STOP CUE.

sound effect *Audio* Any sound designed to convince an audience that something specific is happening when, in fact, it isn't. Most sound effects consist of previously recorded sounds that can be played on CUE from a tape player. A few, such as sleigh bells, gunshots, rain or doors closing, may be produced by stagehands backstage.

sound effects library *Audio, Motion pictures* An archive of recorded sounds, indexed with many descriptive references to make it possible for an editor to find a selection of possible sounds to fulfill specific needs. When the desired sound has been found, it is DUBBED onto sprocketed audio tape for use in the editing room.

sound film *Motion pictures* A completed motion picture with synchronized sound imprinted on the same strand of film as the visual element.

sound head *Audio* 1. The magnetic transducer that rides against a moving magnetic tape and either imprints sound or reads what has been previously imprinted. 2. The optical device inside a sound-on-film motion picture projector that reads the OPTICAL TRACK from one edge of the film that is passing through the sprockets.

sound hole *Music* Any of various specially shaped holes carved into the SOUNDBOARD of a keyboard instrument, or into the top surface of a stringed instrument to allow the wooden plates that make up the body of the instrument to resonate. In the violin, viola, violoncello and double bass, these are referred to as F-HOLES because of their shape, a shape that has never been improved for those instruments in spite of exhaustive study and experimentation. In other instruments, *e.g.,* the GUITAR or HARPSICHORD, the sound holes are generally round.

sounding board *See* SOUNDBOARD.

sound lock *Theater, Television* A vestibule separating the theater or studio from the ambient noises outside.

sound man *Motion pictures, Music* One who operates sound equipment.

sound motion picture A motion picture with synchronized sound.

sound-on-film *Motion pictures* The process by which a motion picture and its synchronized SOUND TRACK are imprinted on the same strand of motion-picture film.

sound operator *Theater* One who operates sound equipment.

sound plot *Theater* A schedule of CUES for sound effects and music as they will be required, scene by scene, throughout a performance.

sound post *Music* A small wooden dowel placed inside the body of a stringed instrument to hold the back and front surfaces of the instrument at the proper distance from each other and to distribute the vibrations of sound between them evenly.

sound speed *Motion pictures* A FRAME SPEED of 24 frames per second (fps) in the United States, or 25 fps in Europe.

sound stage *Motion pictures* A soundproof motion picture studio equipped for shooting sound pictures.

sound technician *Motion pictures* A technician who installs, maintains and operates sound equipment.

sound track *Motion pictures, Television* 1. Since the early days of sound movies, a ragged white line contained within a narrow black stripe running alongside the picture whose varying width (or varying optical density) represents sound. A photo-sensitive cell inside the projector reads the signal and converts it into electronic form which is then amplified in the theater. Also called an OPTICAL TRACK. 2. In modern times, a narrow magnetic stripe running alongside the picture carrying the sound signal. On wide-screen films, the magnetic stripe often carries up to six channels of sound. Also called a MAGNETIC SOUND TRACK. *See also* M & E TRACKS.

sound-track album *Music* The music, and sometimes dialogue, of a play or a motion picture that is made available to the general public on a recording.

sound truck *Television* 1. A truck or van containing LOUDSPEAKERS, public address and playback equipment, for playing sound and making announcements to the public on the street. 2. A truck or a van containing all the equipment necessary for recording the sound of a motion picture or television program while on LOCATION.

sound wave *Audio* A succession of differences of pressure moving through air that impinge upon the ear causing the sensation of sound. A sound wave is represented on paper as the longitudinal profile of a wave moving from left to right. It is carried electronically as a similarly continuous change of electrical strength moving in time. *See also* SOUND TRACK.

sourdine (*soor-DEEN*) [French] *See* MUTE.

sousaphone *Music* A brass WIND INSTRUMENT of the same range as the orchestral TUBA, but with a conical tube shaped in a large loop to be carried over the player's shoulder with its BELL rising in a spiral and opening wide over the player's head. It differs from the HELICON only in the shape of the bell. It is named after John Philip Sousa, "the March King," who suggested its design.

soutenu (*SOOT-nü*) [French] *Ballet* A drawn-out or sustained movement, such as a BATTE-MENT *soutenu*, or a *soutenu* turn.

sp *Music* Abbreviation for SUBITO PIANO.

space music *See* TRANCE MUSIC.

space stage *Stagecraft* In its ultimate form, a bare stage that depends entirely upon lighting for its scenery. In practice it is a stage with an INFINITE CYCLORAMA, a SET consisting of the least possible scenery that suggests rather than displays the environment of the play, and highly specific lighting on the actors. *See also* ABSTRACT SET.

spare *Acting* An UNDERSTUDY.

spasm band *Music* A small street band that plays JAZZ in a simple style on homemade, non-traditional instruments fashioned from crates, jugs, washtubs, etc. *Compare* SKIFFLE.

spattering *Stagecraft* The process of applying texture and color to the surface of a FLAT or a piece of scenery by flicking pigment from the hairs of a brush at it from a short distance.

speak at concert pitch *Acting* To speak more intensely than normal, and with clear diction, as if speaking to a large crowd.

speaker *Audio* Short for LOUDSPEAKER.

 Acting, Music One who speaks, as a DISEUR, DISEUSE, or NARRATOR.

speaking choir *Music, Theater* A CHOIR that speaks lines instead of singing them.

speaking part, speaking role *Theater, Opera* A role that requires speaking and little or no singing. The Sheriff in Gershwin's *Porgy and Bess* is a speaking part.

spear-carrier *Acting, Opera* A SUPERNUMERARY who may or may not actually carry a spear or another CHARACTER PROP. *See* WALK-ON.

spec *See* ON SPEC, SPECTACLE, PILOT.

special effects *Motion pictures, Television* Scenes, events and sounds prepared artificially by ANIMATION or other means, and inserted into the picture as if they were real. Special effects have been around a long time, since 1902 when Georges Méliès concocted *Le Voyage dans la Lune*, showing 30 scenes of people traveling to the moon in his version of a spaceship.

special light *Lighting* A light illuminating a special area in the scene, *e.g.*, a small spotlight that shines on a writing desk, or a small FLOOD behind a door flat illuminating the area outside. *See also* BABY, INKY.

specialty artist *Vaudeville* A performer whose act is his/her exclusive specialty, *e.g.*, a BLUES singer with a highly personal style.

specialty dance In a MUSICAL, a solo or duet dance often created by the soloists themselves rather than by the production's choreographer.

specialty number *Vaudeville* A song and/or dance that is not part of the regular show.

specific lighting Lighting that emphasizes individual acting areas; the opposite of general lighting.

spectacle *Theater* Any show considered as a visual public event.

speech *Acting* 1. An actor's manner of speaking. 2. Any lines spoken as a single unit by an actor that form a discrete part of the dialogue of the play. *See also* MONOLOGUE, SOLILOQUY.

speech cue *Acting* 1. A verbal CUE. 2. A cue to speak.

speech prefix, speech title *Acting* The name of a character printed in the script ahead of each speech that character will say.

"speed" *Audio* Ready to record. A recording engineer's report over the intercom that the tape is running at the proper speed. The term is a relic of the early days of recording, when master disks were cut directly and the lathes (record-cutting machines) required two or three seconds to reach the right speed. When the director called "Roll it," the engineer would turn on the machine and reply "Rolling," and after a moment, "Speed." At that point, the musicians could begin to play.

Spelvin *See* GEORGE SPELVIN.

spiccato (*spee-KAH-toh*) [Italian] *Music* A technique of BOWING a stringed instrument in which the player, using a loose wrist and the middle section of the bow, bounces the bow on the string. Similar to SALTATO. Not to be confused with STACCATO.

spider *Lighting* Any multiple connector, *e.g.,* one that provides power for the lights on music stands in the orchestra pit. Also called DUPLEX, QUAD BOX, THREEFER, etc.

spiel (*shpeel*) [German] *Acting* Literally, play, game. An actor's speech or routine.

 Circus A BARKER'S sales pitch.

spieloper (*SHPEEL-oh-per*) [German] *Music* A word coined in Germany in the 19th century to describe an opera with spoken dialogue. *See* OPERETTA.

spike *Stagecraft* 1. Any method used to mark a spot on the stage floor where a specific item in the set or its furnishings is to be placed. 2. To mark a spot on the stage floor where an item of scenery is to be placed. *See* PEG, SPOT.

spill *Lighting* An area of unwanted light in the set that should have been properly cut off with SPILL RINGS, BARN DOORS or a FLAG, or controlled by more accurate focusing.

spill rings, spill shields *Lighting* Concentric sheet metal rings or louvers mounted in front of a spotlight to prevent light from spilling to the side.

spinet *Music* 1. An early keyboard instrument, smaller than the HARPSICHORD but with a similar sounding mechanism. 2. A type of square piano. The term has been applied in modern times as a stylish name for the smallest UPRIGHT pianos.

spiniato (*speen-YAH-toh*) [Italian] *Music* Smoothly, evenly.

spinto [Italian] *Music* Literally, pushed. A lyric voice, most often a TENOR or SOPRANO capable of enough power to sustain the more dramatic elements in a song or operatic role.

spirit gum *Makeup* A type of liquid adhesive used to fasten bits of hair to the face, as for a mustache or a beard.

spiritoso (*spee-ree-TOH-zoh*) [Italian] *Music* With spirit.

spiritual *Music* A religious song, especially in the tradition of African American singers of the 19th century.

splashing *Stagecraft* A technique of painting with thin paint, allowing it to spill beyond where the brush actually places it.

splice *Audio, Television* 1. A firm jointure between two strands of magnetic tape. The splice consists of a taped joint between two segments of tape that have been cut on a slant. The slant prevents the cut itself from being heard in the recording. 2. To join two pieces of magnetic tape together so they will run without interruption through the mechanism of the recording machine.

Motion pictures 1. A firm jointure between two strands of motion picture film. A traditional editing splice is made by cutting both the outgoing and incoming shots precisely on frame lines, and joining them with adhesive Mylar tape across the cut. A negative (the ORIGINAL) is cut the same way, but each shot is cemented to black leader (*See* A & B ROLLS). The cut always occurs precisely on the frame line so it cannot be seen on screen when the film is finished. 2. To join two pieces of motion picture film together so that they will run through editing and projecting equipment without tearing.

split *Dance* An acrobatic movement with one leg extended straight out in front and the other in back, with both at right angles to the torso. Also called the *grand écart*.

split key *Music* A special key on the KEYBOARD of a PIANO or similar instrument, split into two mechanisms so that it will engage either of two differently tuned strings. By such a means, musicians in the late 18th century were able to cope with MEANTONE temperament, which demanded that certain notes, *e.g.*, A-flat and G-sharp, change pitch slightly in different harmonic contexts.

split plug *Lighting* An electrical plug half the thickness of a standard STAGE PLUG, designed to fit as one of two such plugs into an ordinary STAGE POCKET.

split screen *Television* A technique of showing two pictures at once on a television screen, *e.g.*, an interviewer shown in the studio, and the interviewee shown at the same time on the Capitol steps.

split stage *Stagecraft* A stage showing two or more scenes in full view at the same time.

split week *Theater* 1. A week during which the company will give a few performances at one location, then move quickly to perform more in another. 2. A week during which one show will be replaced by another in the same theater.

sponging *Stagecraft* The process of applying color to a surface using a sponge instead of a brush.

spoonerism *Acting* An error in speech, when the speaker has interchanged the consonants of two syllables, as in "oonerspism." Named for a 19th-century English prelate, W. A. Spooner.

spoons *Music* A homemade percussion instrument consisting of two tablespoons held together (belly to belly) and struck against each other, against the surface of a table, or on various parts of the player's body to create a RHYTHM.

spot *See* SPOTLIGHT.

Stagecraft 1. To mark the position of any movable object on stage so that it can be replaced precisely whenever the stage is reset for its specific scene. Stagehands sometimes drive tacks into the floor or place bits of white tape or luminous markers there to fix the positions, for example, of the legs of a chair. 2. Similarly, to mark a specific position for an actor to take during a scene.

Vaudeville A position on the SHOWBILL.

spot block, spot sheave *Stagecraft* A pulley hung from the GRIDIRON, ready to support a piece of scenery such as a chandelier. A LOFT BLOCK.

spot border *Lighting* SPOTLIGHTS hung just behind the PROSCENIUM or mounted on a vertical LIGHT PIPE in the WINGS.

spot down *Lighting* To make the beam of a floodlight narrower, by adjusting its lamp rearward, *i.e.,* increasing its focal length. *See also* DIAPHRAGM, IRIS.

spot frost *Lighting* A translucent, frosted FILTER, with a bright clear spot in its center. It produces a soft-edge beam. *Compare* STAR FROST.

spotlight *Lighting* 1. Any bright stage light that can be focused precisely. *See also* BABY, BALCONY SPOT, BEAM, ELLIPSOIDAL REFLECTOR, FOLLOW-SPOT. 2. To focus a spotlight on a person or object in the scene.

spotlight booth *Lighting* A booth at the back of the house or on a balcony, from which large SPOTLIGHTS can be aimed onto the stage. *See* FOLLOW-SPOT.

spotlight chaser, spotlight hog *Acting* Any performer, especially in vaudeville, whose chief preoccupation seems to be to get into the SPOTLIGHT whenever possible.

spot line *Stagecraft* 1. A rope hung from a specific point on the GRIDIRON to support a piece of scenery, *e.g.,* a chandelier that must hang at that point in the scene. 2. A line, visible to stagehands, drawn on the stage floor to indicate the exact position to which a FLAT or a STAGE WAGON must be moved for a scene. *See also* SPOT BLOCK.

spotted *Stagecraft* Said of any piece of scenery or furniture whose exact position has been marked on the stage floor. *See* SPOT.

spotting *Dance* A method of avoiding dizziness during rapid turns, while appearing to keep the face forward. A head movement in which the dancer's eyes fix on a spot in front as the turn is made. The head turns faster than the body, and the eyes return always to the same spot.

spreader *Stagecraft* A wooden shaft placed between BATTENS to hold them a specific distance apart, as for supporting a CEILING FLAT. *See also* TOGGLE.

spread the house *See* WEED THE HOUSE.

spread the part *Acting* A director's suggestion to an actor to play the part more broadly.

sprechgesang (*SHPREKH-geh-sahng*), **sprechstimme** (*SHPREKH-shtim-muh*) [German] *Music* Literally, speech song, speech voice. A formal, composed style of DELIVERY that is partly singing, partly speaking. It was used in an opera by Englebert Humperdinck in 1897, in *Pierrot Lunaire* by Arnold Schönberg in 1912 and by Alban Berg in his two major operas, *Wozzeck* (1931) and *Lulu* (1937).

springdans *Dance* A Norwegian "leaping dance" in 3/4 time.

spring foot iron *Stagecraft* A piece of strap iron, hinged near the bottom of the frame of a FLAT with a spring to hold it in folded position except when the flat has been moved into place on stage and the strap can be fixed to the stage floor with a STAGE SCREW.

sprocketed magnetic tape *Audio, Motion pictures* Magnetic tape manufactured to be an exact match for motion picture film in every dimension including SPROCKET HOLES. It is used for editing synchronized SOUND TRACKS.

sprocket holes *Motion pictures* A line of tiny square holes along the edge of a piece of motion picture film designed to engage the mechanism of a camera or projector so that the film can be stopped for an instant (*e.g.*, a fiftieth of a second) directly in line with the lens. It was the invention of this device in 1887 by William Dickson, an engineer working for Thomas Edison, that made the entire art and industry of motion pictures possible.

square dance Any American folk dance performed by groups of two or four couples facing each other (the square), particularly a dance with intricate figures following the instructions of a CALLER. Many rural American square dances are based on QUADRILLES and CONTRAS of earlier times. *See also* KENTUCKY RUNNING SET.

square piano *Music* A type of parlor PIANO built in the early 1800s, with the strings parallel to the keyboard.

square set *Dance* An American square dance performed by four couples. *See also* KENTUCKY RUNNING SET.

square wave *Acoustics* A sound wave that has no smooth slope, but looks square when it appears on analytical instruments. In theory it is a wave that contains all its HARMONICS

at equal intensity. It is best represented by the harsh sound of a loud buzzer, or by a particularly harsh REED STOP on the organ. *Compare* SINE WAVE.

squeeze box *Music* Slang for the ACCORDION.

squib *Theater* A small advertisement placed in the newspaper or the program at the last minute to promote a show.

squillante (*skwee-LAHN-teh*) [Italian] *Music* Literally, blaring. Harshly.

SR *Theater* Abbreviation for STAGE RIGHT.

SRO *Theater* Abbreviation for STANDING ROOM ONLY.

Stabat Mater [Latin] *Music* Literally, the mother stands. A 13th-century prayer of the Roman Catholic Church that has been used for important choral works by many composers ever since.

stacc. *Music* Abbreviation for STACCATO.

staccato (*stah-KAH-toh*) [Italian] *Music* With separated notes, cutting each note off before it has reached its full indicated duration. Indicated with a dot or wedge-shaped sign over the note. Not the same as SALTATO or SPICCATO.

stacking rack See SCENE DOCK.

staff *Music notation* A group of five horizontal lines, close together and parallel, providing a matrix that defines the PITCHES of any musical notes written on or between them. It was probably invented in the early 11th century by Guido d'Arezzo, one of the greatest of all innovators in music, who also developed the first surviving system of SOLMIZATION. In music, the plural of staff is staves.

Theater The nonperforming members of a theater company.

stage 1. A platform upon which performances take place. In practice, the stage includes not only the platform, but also the lights that light it, the machinery and rigging with which scenery and curtains are manipulated, and the dressing rooms, rehearsal rooms and storage spaces necessary in its operation. *See also* ARENA STAGE, ELEVATOR STAGE, PROSCENIUM STAGE, THRUST STAGE. 2. Metaphorically, the world of the performing arts, especially theater as distinguished from concert arts.

stage action *Acting* The physical movement of the cast in a scene, as distinguished from the DRAMATIC ACTION that may not be manifest in physical movement.

stage actor *Acting* An actor who specializes in, or is best on, the stage, as distinguished from another who works in motion pictures.

stage areas *Acting, Lighting, Stagecraft* Specific areas of the standard PROSCENIUM STAGE floor, designated according to a standard system by which UPSTAGE (U) indicates away from the audience, DOWNSTAGE (D) toward the audience, STAGE LEFT (L) and STAGE RIGHT

(R) are named from the point of view of an actor facing the audience. C indicates Center. The diagram shows the standard area designations for small (a "six-area stage"), medium ("ten-area") and large ("fifteen-area") stages. *See also* IN ONE, IN TWO.

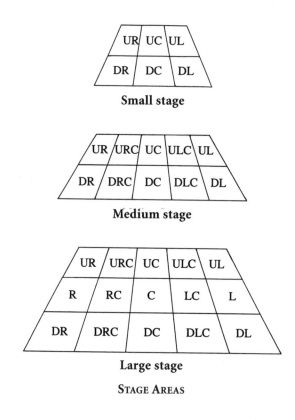

Small stage

Medium stage

Large stage

STAGE AREAS

stage audience *Theater* A part of the audience seated on the stage. This was a common situation in Elizabethan theater, and the audience of the privileged class who took advantage of it sometimes engaged in banter with the actors during the play.

stage band *Music* 1. A band playing on stage as part of a scene or act along with other performers, as distinguished from a larger orchestra playing in the ORCHESTRA PIT. 2. In many colleges, a group that plays for dances or performs at functions for which a larger concert band or marching band would be inappropriate.

stage blocking *See* BLOCKING.

stage brace *Stagecraft* A wooden shaft of adjustable length that can be placed diagonally behind a FLAT to hold it firmly in vertical position on the stage. A U-shaped hook at the upper end of the brace fits into a BRACE CLEAT on the back of the flat. A STAGE SCREW through a hole in a short iron strap at the bottom fastens the brace to the floor.

stage brace cleat *See* BRACE CLEAT.

stage business *See* BUSINESS.

stage cable *Lighting* A heavy three-conductor CABLE designed to provide power to various parts of the set. It is flexible, tough, and fully insulated so that there is little possibility of accidental electrical contact.

stage call *Acting* A special meeting of the CAST on stage to discuss the production, have pictures taken, rehearse, etc.

stage carpet *Stagecraft* A carpet spread on the stage floor to complete the scene and/or to soften the sound of an actor's footsteps.

stage ceiling *Theater* The top of the stage, above the GRIDIRON. *See also* BOOK FLAT, BOX SET, CEILING DROP.

stage center *Acting, Stagecraft* 1. The acting area at the center of the stage. 2. In a PROSCENIUM STAGE the area of the stage on the center line and halfway between the proscenium and the BACKDROP.

stage cloth *See* FLOOR CLOTH.

stage clothes *Costume* Clothes worn only in performance on stage, as distinguished from STREET DRESS.

stage convention *See* THEATRICAL CONVENTION.

stagecraft *Theater* The technical aspect of theatrical presentation, especially the specifics of stage design and management, set construction, lighting, costume, etc.

stage crew *Theater* All the people who operate stage equipment and work with scenery and props on or behind the stage during rehearsals and performances, including STAGEHANDS, ENGINEERS, DRESSERS, etc.

staged *Music, Theater* Said of any BALLET, OPERA or PLAY that has been prepared for performance on the stage.

stage depth *Theater* The distance from the SETTING LINE to the backstage wall.

stage designer *See* SET DESIGNER.

stage direction *Acting* 1. Any instruction written into the SCRIPT, to direct movements on the stage. The term is also used loosely to include background information about the characters, their motivations and interactions, plus the playwright's costuming suggestions and descriptions of the setting. 2. Directing the performers in a play, an opera or any other staged piece, as distinguished from directing the orchestra (in opera or musical productions) or the camera crew (in motion pictures or television).

stage director *Opera, Motion pictures, Television, Theater* A director whose specific responsibility is to interpret the script and direct actors and/or singers in its presentation, as distinguished from the director of the orchestra in opera or of camera operations in motion pictures or television. Not the same as STAGE MANAGER.

stagediving *Dance* One of the more extreme forms of self-expression, in which ROCK musicians or fans throw themselves from the stage into the audience, hoping to be caught before they hit the floor. *See also* MOSH PIT, THRASH METAL.

stage door *Theater* The door by which performers enter from the street into the backstage area. It is often guarded by a STAGE DOORKEEPER and typically opens into a small lobby where a notice board holds information for the cast and technicians. Not to be confused with the LOADING DOOR.

stage door Johnny *Theater* A fan who is obsessed with one of the cast and waits outside the stage door to get a glimpse of her, possibly even a glance of interest. *Compare* GROUPIE.

stage doorkeeper *Theater* An employee of the theater who sits inside the STAGE DOOR, receives and distributes messages and mail for the actors, allows members of the company in, but keeps the general public out.

stage effect *Stagecraft* Any effect that occurs on stage, especially those such as rain and lightning that are created by special equipment.

stage entrance *See* STAGE DOOR.

stage fall *Acting* An actor's controlled fall that looks convincing to the audience but does not hurt the actor.

stage floor *Theater* The softwood permanent surface of the stage. It is not always the acting surface but may sometimes support WAGON STAGES, TURNTABLES or other special surfaces.

stage fright *Acting* A disabling fear of inadequacy that may come over a performer before going out on stage to perform.

stage grip *See* STAGEHAND.

stage grouping *See* BLOCKING, FOCUS, MISE EN SCÈNE, SECONDARY FOCUS, STAGE PICTURE, TABLEAU.

stagehand *Stagecraft* Any person who works with scenery and furniture on the stage, setting up each scene, shifting from one scene to the next, etc. *See also* GRIP, KEY GRIP.

stage hog *Acting* A performer who tries always to be in the center of the stage for maximum exposure to the audience. *Compare* SCENE STEALER, SPOTLIGHT HOG.

stage imagery *Theater* The visual means of communicating ideas theatrically, using actors, scenery and lighting.

stage left *Acting, Stagecraft* To the left, from the point of view of an actor facing the audience. *See* STAGE AREAS.

stage level *Theater* The vertical distance between the floor at the FRONT OF THE HOUSE (ignoring the orchestra pit) and the floor of the stage.

stage loft *Theater* The space above the stage where the GRIDIRON is situated and where the FLIES hang.

stage machinery *Stagecraft* The COUNTERWEIGHT system, elevators and WAGON STAGES used in stage productions in a specific theater.

stage main *Lighting* The main switch that controls all the power to the stage. *See also* COMPANY SWITCH.

stage makeup *Theater* The type of makeup used on stage, as distinguished from the street makeup of daily life.

stage-manage *Theater* 1. To manage and direct the crews who work backstage and all the activities backstage that are made necessary by the DIRECTOR'S instructions during rehearsals. 2. To manage the entire production after the first night, when the director, having completed the creation of the production, leaves.

stage manager *Theater* The person, subordinate only to the DIRECTOR, in charge of everything that occurs on the stage. During rehearsals the stage manager is chief of all the crews who work on a production, and assistant to the director in matters affecting entrances, exits and CUES. During the run of the show, after the director's job has been completed, the stage manager is in charge of every performance in every detail, from the way actors handle cues to the timing of curtain openings and closings, as well as CURTAIN CALLS.

stage manager's station *Stagecraft* The place the stage manager occupies while running the show, usually behind the PROSCENIUM at STAGE LEFT. It often includes a small desk, telephones, an intercom connected to various parts of the theater such as the box office, the orchestra pit and several places backstage, and (in larger theaters) a closed-circuit television monitor.

stage money *Stagecraft* Simulated money for use on stage.

stage mother *Theater* The mother of any young performer, in constant attendance to protect the rights of her child, sometimes to the consternation of the professionals in the company.

stage movement *Acting* Any physical movement of actors on stage, especially those movements that accomplish the BLOCKING that the director has decided upon for each scene.

stage name *Acting* A pseudonym adopted by a performer for use in publicity and performance.

stage peg *See* STAGE SCREW.

stage picture *Theater* The look of the SCENE at any important moment, with actors in costume as the director has placed them. *See also* MISE EN SCÈNE, TABLEAU VIVANT.

stage plug *Lighting* A male electrical CONNECTOR consisting of a fiber block with copper contacts wrapped around two sides, shaped to fit into a STAGE POCKET. Because their live contacts are dangerously exposed, stage plugs have been replaced in theaters by PIN PLUGS, or TWIST-LOCK CONNECTORS. They are still in use, however, on motion picture sets where power requirements are very high and nontechnical personnel can be kept away from them.

stage pocket *Lighting* An insulated metal box, recessed in the stage floor, with electrical receptacles to accommodate STAGE PLUGS by which lights or electrical devices can be connected through hidden power lines to a backstage PATCH PANEL.

stage position *Acting* The actor's place on the stage at any significant moment in a scene.

stage presence *Acting* An actor's innate ability to establish an intangible but firm bond with the audience from the stage. It is nourished by sensitivity to the audience's reactions, the ability to adjust instantly to subtle cues and, above all, excellent timing.

stage prop *Stagecraft* Any PROP that is part of the set, as distinguished from other props carried by actors. *See* TRIM PROP.

stage rehearsal *Theater* Any rehearsal on the stage itself, as distinguished from a rehearsal in another space. Not to be confused with a TECHNICAL REHEARSAL.

stage right *Acting* To the right, from the point of view of an actor on stage facing the audience. *See* STAGE AREAS.

stage screw *Stagecraft* A small, sharp augur with a T-shaped handle, that can be screwed by hand through the hole in the bottom cleat of a STAGE BRACE to hold it in place on the stage floor.

stage seat *Theater* A seat on the stage itself for a member of the audience, often provided to fops and dandies in the 18th century who wished to be seen while watching and heckling performers. In modern times, stage seats are frequently sold for musical recitals.

stage setting *Stagecraft* The scenery of a play in place on stage.

stage step *Stagecraft* A scenery unit consisting of one or more steps, used as stairs in the set or as graduated platforms on which actors can stand. *See also* RISER.

stagestruck *Theater* A state of fascination with the glamour and excitement of life in the theater to which young people seem vulnerable.

stage technician *Lighting, Stagecraft* Any person who specializes in operating electrical, mechanical or electronic equipment on stage.

stage technique *Acting* The vocal, physical and psychological technique an actor uses on stage.

stage trap *Stagecraft* A TRAP DOOR in the stage floor.

stage trick *Stagecraft* Any illusion used on stage, especially those that seem almost magical, *e.g.,* changing the scene by dimming the light on a scrim, or having an actor disappear by hiding in a crowd and then slipping offstage behind it.

stage turn *Acting* An OPEN TURN, *i.e.,* any turn from an open position toward UPSTAGE that maintains an open position as long as possible before facing the back of the stage.

stage version *Theater* The acting edition of a play, with PRODUCTION NOTES included, as distinguished from a literary version without them.

stage wagon *Stagecraft* A low platform on small wheels or AIR BEARINGS, designed to carry scenery and/or actors into the acting area. Some stage wagons are elaborate affairs, built to carry entire stage sets and to move smoothly with little noise so that scenes can be changed very rapidly by exchanging stage-size wagons. Not to be confused with the wagons used in PAGEANTS.

stage wait *Theater* Any delay that stops the show temporarily during a performance.

stage walk *Acting* Any special way of walking on stage, from a style intended to convey the attitude of a character to an illusion intended to look like walking while the actor remains in place. The latter was and is a favorite device of COMMEDIA DELL'ARTE and of pantomimists of all times. *See also* MOONWALK.

stage wandering *Acting* Moving aimlessly around the stage for no dramatic purpose.

stage weight *Stagecraft* A counterweight. *See also* SAND BAG.

stage whisper *Acting* A loud whisper that the audience can hear. *See also* ASIDE, THEATRICAL CONVENTION.

stage width *Theater* The distance from one side wall of the stage to the other. Not the same as the width of the PROSCENIUM.

staggered seating *Theater* A seating plan whereby the center lines of the seats of one row are in line with the arms of the seats in the row behind it, so that viewers behind can see the stage without obstruction by viewers immediately in front.

stair unit *See* STEP UNIT.

stall *Theater* A British term for an upholstered theater seat with arms, placed in the main floor of the HOUSE.

stand *Costume* A dressmaker's dummy.

Lighting A light stand.

Theater 1. A theatrical engagement, as in one-night stand, three-week stand. 2. A theatrical poster, in place where the public can see it. *See* SHEET.

standard *Music* A term used loosely by musicians to categorize all music of enduring value and to distinguish it from the newest hits and novelties that have not yet won respect. Among performance-licensing organizations and musicians, "standard" generally refers to a popular tune that is played and/or recorded by many different organizations in many different arrangements.

standard pitch *See* A-440, CONCERT PITCH.

"stand by" *Television* A warning from the technical director to all personnel in the studio that the COUNTDOWN is about to start.

stand-by *Acting* An UNDERSTUDY.

standee *Theater* A member of the audience who has no seat to sit in. *See* GROUNDLING, STAND-ING ROOM ONLY.

stand-in *Motion pictures* A person who takes the place of a member of the cast temporarily to allow the regular cast member some rest during the often long periods of time required to set up a SHOT and make technical adjustments to the set, to lighting or to cameras. The major qualification for a stand-in is resemblance to the regular cast member in stature and general coloring. *See also* STUNT MAN.

standing flood *Lighting* A FLOODLIGHT on its own stand, often with casters.

standing room only *Theater* A notice posted in front of the theater to let potential ticket buyers know that all the seats have been sold, leaving only a few tickets for STANDEES who will have to stay in back of the seated audience. Abbreviated as SRO.

standing set *Stagecraft* A SET that remains on stage for the entire run of the show.

stand-up bass *Music* Among jazz and dance-band musicians, the acoustic DOUBLE BASS that is held vertically with its pin resting on the floor, and is not to be confused with the ELEC-TRIC BASS GUITAR, which hangs on a strap from the neck of the player.

stand-up comic *Vaudeville* A COMEDIAN who specializes in solo performances in nightclubs.

Stanislavski method, Stanislavski system *Acting* Named for its creator, Konstantin Stanislavski, director of the MOSCOW ART THEATER, a method of focusing attention on EMOTIONAL MEMORY and other inner truths to enable an actor to perform believably on stage in a natural style. A principal concern was the psychological difficulty of repeating the expression of emotional experience night after night without losing spontaneity. When repetition begins to be based on remembering physical actions and tones of voices, which Stanislavski considered superficial, it loses credibility. But to dredge up the memories of emotions consciously reestablishes the original stimulus and restores spontaneity to their reenactment. Stanislavski searched for "a conscious path to an unconscious creativity." In the United States, his system is commonly referred to as The Method and was taught and further developed by Lee Strasberg and others at the ACTORS STUDIO. *See* METHOD.

stanza *Playwriting* Any single set of lines forming a coherent division of a lyric poem set apart from similar sets. *See also* STROPHE.

Theater 1. One act of a play. 2. A single engagement of one or a few weeks, as distinguished from a LONG RUN.

star *Theater* 1. The most important performer in any show. A star gets TOP BILLING and in big theaters often has a special dressing room, larger than those of other actors, with a star-shaped emblem on the door. 2. To play the most important role in a production.

star billing *Theater* A privilege accorded to STARS giving their names the best position on advertisements above the title of the play, in larger letters than the names of lesser members of the cast.

star cloth *Stagecraft* A dark cloth with tiny holes in it, through which bright white light shines to represent the stars in the night sky.

stardom *Acting* The glamorous world inhabited by stars. The highest level of recognition in most actors' careers.

star dressing room *Theater* A special dressing room near the stage where a STAR may entertain reporters and other guests after the show. It is usually larger than other dressing rooms, equipped with its own toilet facilities and often has a star-shaped emblem on the door.

star entrance *Acting* The star's first entrance in the show, preceded by BLOCKING that focuses the audience's anticipation so that there can be a show-stopping round of applause when the star appears.

star frost *Lighting* A light filter that is translucent around the edges, but has a jagged hole cut out of its center so that its pattern in the set will be much brighter at the center, without revealing telltale edges.

starlet *Motion pictures* A young female actor who is being promoted by her AGENT and the studio she works for as a potential STAR. *Compare* INGÉNUE, SOUBRETTE.

star part *Television, Theater* A role especially appropriate, sometimes actually written for a specific STAR.

star play *Television, Theater* A play with a role in it that is especially appropriate for a specific STAR. Sometimes a play written for a star.

star quality *Acting* The impressive appearance, personal magnetism and powerful public presence that make an actor suitable for the promotion and advertising that create a STAR.

starring vehicle *Television, Theater* A play chosen or created for the specific purpose of providing a SHOWCASE for a particular STAR.

star-studded *Television, Theater, Vaudeville* Said of a production with several famous STARS playing.

star system *Motion pictures, Theater* An informal system of choosing VEHICLES for stars and vice versa. In summer theaters and in opera, for example, it is common practice to put together a permanent supporting cast for the whole season and bring in stars to take the most important roles in each production. In motion pictures, especially during the 1930s through the 1980s, when big studios held sway, the first consideration of the studio was to provide vehicles to keep their stars in the public eye, which had little to do with choosing subjects that would make great movies.

start *Acting* An actor's sudden movement, instantly frozen, when the character has been startled.

start cue *Audio, Lighting* A CUE to begin dimming lights or to start a sound or music effect, and to continue the increase (or decrease) until a STOP CUE.

start mark *Motion pictures* A mark that appears well before the first frame of a motion picture and is matched precisely by an audio signal on the corresponding sound track, so that the two may be brought into SYNC before they are INTERLOCKED.

star turn *Vaudeville* A featured act by a star.

stasimon (*STAH-zee-mon*) [Greek] *Theater* Literally, a continuing song, from a root meaning standing or stationary. A CHORAL ODE in a classical Greek tragedy, coming after the first EPISODE of the play. In a formal presentation, the chorus marches to the center of the stage, turns to face the audience and sings the ode, commenting on the meaning of the situation in the plot without further mass movement.

statutory right *Music* A specific right defined in the Copyright Law of the United States permitting any performing organization to record a musical work that has been previously recorded for commercial distribution, without negotiating with the copyright owner, as long as royalties stipulated by law are paid.

staves The plural of STAFF.

stay *Stagecraft* 1. A STAGE BRACE long enough to hold a high scene unit in place. 2. A thin slip of wood stuffed into the gap between two adjacent flats that have been lashed together to stiffen the joint.

stay in character *Acting* To maintain concentration while the action of a scene has been disrupted by applause, a missed cue or any other distraction.

Steadicam *Motion pictures* Trade name for a frame carried by a camera operator, using shoulder pads and a back brace, built to support a motion picture camera and to dampen sudden movements and/or vibrations. There are gyroscopes mounted in the frame to keep it steady. With the camera, batteries and other required paraphernalia, the camera operator bears a heavy load.

steal *Acting* 1. To steal the audience's attention. 2. To sneak from one place to another on stage without being noticed. 3. To cheat on a profile position by turning the head a little toward the audience.

steal the scene *Acting* To take the attention of the audience away from other actors by moving to a dominant position on the stage, speaking with more intensity than others in the scene, or otherwise distracting them from the main FOCUS.

steal the show *Acting* To play the part so brilliantly that the audience tends to ignore other actors in the show.

steam curtain *Stagecraft* In an outdoor theater, a curtain created by a line of steam jets across the front of the stage, brilliantly lighted on the audience's side so that it is effectively opaque.

steam pipe *Stagecraft* A PIPE that carries steam into the SET where it creates a visible mist.

steel *Music* A metal or glass sleeve that fits over a guitarist's finger, or a piece of flat metal used to fret, or hold down, the strings. *See* STEEL GUITAR, BOTTLENECK GUITAR.

steel band *Music* A band whose players play on STEEL DRUMS. Originally Jamaican, such groups have become popular in urban America. Their musical capabilities include all styles, but they are at their best with CALYPSO and the MERENGUE.

steel drum *Music* A Jamaican musical instrument made from half a 50-gallon oil drum. The maker hammers dents into the top surface from underneath, creating raised areas that, when struck with heavy padded drumsticks, play specific tones of the CHROMATIC SCALE. The player must memorize which note comes from which dent, because one drum does not always match another. The sound produced is similar to that of the MARIMBA, and can be extremely loud.

steel guitar *Music* A type of guitar that developed in the early 20th century from the Hawaiian guitar. It has a raised nut that holds the strings higher off the fingerboard than on a normal instrument, and is held against the body rather than in a horizontal position. A steel bar is used to fret the strings, for slide playing and GLISSANDOS. Also called the slide guitar. *See also* BOTTLENECK GUITAR.

steel string guitar, steel-strung guitar *Music* A six-string GUITAR played with a PLECTRUM to produce a sound that is particularly bright because of its steel strings. The neck and fingerboard are somewhat narrower than those of the classical guitar, making the instrument easier to play. Also called a folk guitar. Not to be confused with the STEEL GUITAR.

Steinway *Music* A piano manufactured by Steinway & Sons, a New York firm founded in Germany that has been making instruments since 1835. Prized for its fine tone quality and durability, the Steinway is widely used in concert performance and in the home.

step *Dance* A shifting of weight from one leg to the other, a connecting movement.

Music A single move, up or down, from one note of a scale to the next. *See* SEMITONE, WHOLE STEP.

step-dancing *Dance* Since the late 1800s, a form of lively solo dance in which complex foot movements are of primary importance, sometimes executed with the hands in the pockets. In more modern times, it has been performed in a line pattern. *See also* TAP DANCE.

step on a laugh, step on a line *Acting* To move or speak too soon when the audience is about to laugh, or directly after another actor's line so that the audience is distracted and fails to react.

stepped lens *Lighting* A lens that has the optical qualities of a simple (plano-convex) lens but has been manufactured as a series of concentric rings. Each ring is a prism (*i.e.*, a section of a lens) making a much thinner unit that can be handled more easily than a thick lens. A FRESNEL lens.

step unit *Stagecraft* A scenery unit consisting of one or more practicable steps, like a short flight of stairs. *See also* RISER.

stepwise *Music* Describing a melodic or harmonic passage that rises or descends one SCALE STEP at a time.

sterbend (*SHTEHR-bent*) [German] *Music* Dying away.

stereo *Audio* Short for STEREOPHONIC.

stereophonic *Audio* Said of an audio system that simulates the effect of sound in a three-dimensional space by producing two channels of sound, each recorded by its own microphone, recorded in its own channel and emitted by its own loudspeaker. *Compare* BINAURAL.

stereopticon *Theater* Old name for a SLIDE PROJECTOR that had two parallel optical systems, so that it could effect a DISSOLVE between two scenes.

stet finale *Theater* A final scene that duplicates the opening scene of the play.

stick *See* DRUMSTICK, MALLET.

sticking pattern *Music* Any of several patterns used by drummers to accomplish different types of drumbeat, *e.g.,* the various patterns of the PARADIDDLE. *See* RUDIMENTS.

sticks *Music* *See* DRUMSTICKS.

Theater Slang for the rural countryside, *i.e.,* the trees. To be far out of town is to be "in the sticks." A famous headline that once appeared in *Variety*, the journal of show business, read "Stix Nix Hick Pix," which could be translated to mean "The people outside New York City reject motion pictures that deal with a country person in a disparaging way."

stiffener *Stagecraft* 1. Any piece of wood or metal attached to the frame of a FLAT to make it more rigid. 2. A long piece of wood held in place with S-HOOKS across the backs of two or more flats, to keep them in line with each other.

still *Motion pictures, Theater* A single photograph, as distinguished from motion pictures. *See also* CONTINUITY, POLAROIDS.

still frame *See* FREEZE-FRAME.

still photographer *Motion pictures, Theater* A photographer who takes STILLS for advertising in print media. During motion picture production, stills are also needed to record the exact appearance of the set and actors at the end of each SHOT so that any subsequent shot made in the same location and intended to have CONTINUITY will be set up with the same props and people in the same positions, wearing the same makeup and costumes.

stilts *Circus* A pair of stiff sticks with handles at their tops and footrests at some height above their bottoms, designed to be extensions for the legs of an acrobat who will then appear extremely tall.

stimmungs musik (*SHTIM-oongs moo-ZEEK*) [German] *Music* Mood music, BACKGROUND MUSIC.

sting *Music* A sharp chord or a very brief musical sequence composed and recorded for placement at a dramatic moment in a film or play, to startle the audience or to emphasize an event.

sting cymbal *Music* A single CYMBAL made of specially tempered metal that produces a very hard tone.

stippling *Stagecraft* Applying color and texture to the surface of a FLAT by touching it lightly all over its surface with a brush or a sponge.

stock *Motion pictures* Film stock, unexposed motion picture film as it comes from the manufacturer. There are different kinds of film stock used for different purposes, *e.g.,* black-and-white or color stock for the ORIGINAL, various cheaper stocks for the WORKPRINT, and special stocks for INTERNEGATIVES and different kinds of RELEASE PRINTS. *See also* SPROCKETED MAGNETIC TAPE, STOCK FOOTAGE, STOCK SHOT.

Theater Short for SUMMER STOCK.

stock company *Theater* A company of performers equipped and prepared to present performances of plays in repertory on tour or on a temporary basis away from their home base. A stock company may consist of actors who will play supporting roles, with STARS on contract to join the company at specific times and places to take leading roles in certain plays. *See also* BORSCHT BELT, REPERTORY, SUBWAY CIRCUIT, SUMMER STOCK, TOURING COMPANY.

stock footage *Motion pictures* Archives of uncut original film organized according to subject matter and used as background material or CUTAWAYS in new films. An editor goes to the vaults, a STOCK FOOTAGE LIBRARY or to another company to find historical material or a plausible background necessary for the film being produced. *See also* STOCK SHOT.

stock footage library *Motion pictures, Television* An archive of STOCK SHOTS.

stock play *Theater* A play kept in readiness to be put on stage at short notice when an open date becomes available or when another play must be taken off the schedule.

stock setting *Stagecraft* An all-purpose setting with standard items of scenery and furniture, such as a SKYDROP, and a set of FLATS with a door or two in convenient places, all of which can be quickly brought out of storage and placed on stage to serve as a background for any PLAY.

stock shot *Motion pictures* A single shot from an archive of ORIGINAL film. A stock shot may show various versions of ordinary events, *e.g.,* crowds cheering at a ball game, or old-fashioned automobiles in city traffic. It may also provide backgrounds that can be processed into a film, *e.g.,* a magnificent sunset over the prairie or a storm-tossed sea. The editor can and will often make adjustments in the film being edited to coordinate its scenes with a good stock shot.

stock shot library *See* STOCK FOOTAGE LIBRARY.

stomp *Dance* A JAZZ or SWING style probably based on African folk dances in which the barefoot dancers stamped to lively rhythms.

Music 1. A cheerful, energetic JAZZ tune, especially of the early 1900s, characterized by heavy accents on the BEAT, *e.g.,* Jelly Roll Morton's *King Porter Stomp.* 2. To stamp the feet heavily on every accented beat of the measure of a jazz dance tune.

stooge *Vaudeville* An actor who feeds straight lines to a comedian for GAGS or another who sits among the audience and pretends to be a heckler, similarly in support of the comedian on stage.

stop *Music* 1. A mechanism, usually actuated by a knob or a lever, by which an organist engages a specific RANK of organ PIPES, *i.e.*, a group of pipes that produce a specific tone, such as the trumpet stop, the flute or the bassoon. 2. By extension, the rank of pipes that the mechanism controls and that produce the desired TIMBRE. 3. A similar mechanism on the HARPSICHORD that engages a specific rank of strings, *e.g.*, the LUTE STOP. 4. To place a finger firmly on a string of any stringed instrument to change the pitch of the note that string produces. *See also* DOUBLE STOP. 5. To place a fingertip on any finger hole of any flutelike instrument to change the pitch that the instrument produces.

Stagecraft See STOP CLEAT.

stop beat *See* STOP CHORUS, STOP TIME.

stop chain *Stagecraft* A chain attached between the GRIDIRON and a BATTEN holding a DROP, to stop the drop when it reaches the correct height off the floor of the stage.

stop chorus *Music* A STOP TIME accompaniment played late in a JAZZ arrangement, when the tune and its treatment have been so well developed that the chorus will be "heard" even though only the first note or two of each measure are actually played. Perhaps the most extreme example of this occurs in Glenn Miller's arrangement of *Little Brown Jug* (for live performances only) in which the trombonists firmly establish a pattern of dramatic physical positions with their horns aimed upward in a different direction for each four-measure phrase as the piece becomes quieter and quieter until, in the next to last chorus, not a sound can be heard from the band but the trombones are still pantomiming their act and the dancers go right on jitterbugging as if they can hear it. Needless to say, the silent passage does not succeed in an audio recording.

stop cleat *Stagecraft* A CLEAT attached so that it projects a bit beyond the edge of a FLAT to create a flush jointure with an adjacent flat, or to provide a stop for a neighboring hinged unit such as a door.

stop cue *Audio, Lighting* A cue to stop dimming lights, or to stop increasing or decreasing a sound or music effect that began with a START CUE.

stop gap *Stagecraft* A narrow FLAT made to close the gap between two other flats that do not quite meet.

stopped pipe *Music* Any ORGAN PIPE with a closed upper end.

stopper *Puppetry* A plug inserted in the body of a HAND PUPPET to prevent the puppeteer's hand from slipping too far into the puppet's head.

stopping *See* STOP (3).

stop the show *Acting* To perform with such excellent effect that the audience applauds for a long time, temporarily preventing the show from continuing. *See* SHOW STOPPER.

stop time *Music* A term probably coined by trumpeter/singer Louis Armstrong in the 1920s. In JAZZ, it means the band will play together only the first chord or the first few notes of every measure, then "stop time" all at once to allow the soloist to fill in the gaps. The same technique is used often in accompaniment for TAP DANCERS.

story *Theater* The sequence of ACTIONS of the characters that form the basis for the PLOT.

storyboard *Motion pictures, Television* An outline in drawings of any animated film, a television commercial or any short film where the visual relationship between scenes is of primary importance. A storyboard shows each significant moment in each scene as a picture sketched within the shape of the frame, with a short note below indicating what is going on in the story at that moment. When it is complete, in a live-action film the ESTABLISHING SHOT for each of these moments can be planned, or in an animated film the KEY DRAWINGS.

story line *Theater* The sequence of actions of the characters in the play that are the basis of the PLOT.

Storyville *Music* The red-light district of New Orleans known for the bands that made the NEW ORLEANS STYLE of jazz famous.

stovepipe *Lighting* 1. *See* FUNNEL. 2. A simple SPOTLIGHT made of materials available in any hardware store, such as a length of galvanized sheet-metal pipe painted black, a MOGUL socket, some wire, a plug and a bulb.

St. Petersburg Ballet The premier ballet company in Russia, the official resident ballet company at the Marinsky Theater in St. Petersburg, known for its innovative programming. It was formerly known as the Kirov Ballet.

str. *Music* Abbreviation for strings, written in a PIANO REDUCTION to indicate that the passage was originally scored for stringed instruments, and should therefore be played with that fact in mind.

Strad *Music* Short for a STRADIVARIUS instrument.

Stradivarius *Music* A violin, viola or violoncello made by Antonio Stradivari of Cremona, Italy. Authenticated instruments by Stradivari are the most prized of all and sell for hundreds of thousands of dollars. It is believed that regular use keeps the glue of their joints supple and maintains their extraordinary tone quality. For this reason, several matched sets of instruments kept in museums are brought out frequently for concerts. *See also* AMATI, DEL GÈSU.

straight *Acting* 1. Not eccentric, as in "play the scene straight." 2. Seriously, as distinguished from comically or satirically. *Compare* PLAY FOR LAUGHS.

straight cross *Acting* Crossing the stage in a straight line, without moving either DOWNSTAGE or up.

straight cut *Audio* A cut made straight across the tape or magnetic film, as distinguished from a DIAGONAL CUT. It can often be heard as a click when the TRACK is played back.

Motion pictures A CUT from one shot to the next without overlap, as distinguished from a DISSOLVE, which requires overlapping.

straight line *Vaudeville* A line spoken by a STOOGE or a STRAIGHT MAN to set up a GAG for a comedian.

straight makeup Makeup that preserves a natural look of the face under stage lights.

straight man *Theater* A comedian's foil, an actor who helps set up a comedian's jokes or comic routines by speaking seemingly serious lines.

straight mute *Music* A MUTE placed inside the bell of a brass instrument that allows much of the tone to pass directly through but modifies part of it by reducing most of its LOWS and emphasizing most of its HIGHS, thus providing a much quieter, but more silvery, piercing tone.

straight play *Theater* Any play, comic or tragic, with no extensive musical passages.

strainer *Lighting* A perforated sheet of metal fitted into a COLOR FRAME (not in the light's focal plane) along with a GEL to reduce the brilliance of the light without changing its color (as determined by the gel) as dimming would.

strap *Stagecraft* 1. A standard form of iron, ⅛" by ¾" in cross section, used to make CLEATS, SADDLE IRONS, etc. 2. A flat piece of iron attached across a joint between two FLATS to make it strong.

Music *See* SEAT STRAP.

Strathspey *Dance* An ancient (now national) Scottish dance in 4/4 time related to, but slower than, the REEL, and notable for its dotted rhythms. *See also* SCOTCH SNAP.

straw hat *See* SUMMER STOCK.

stray light *See* SPILL.

street backing *Stagecraft* A FLAT placed behind a window or an open doorway, painted and lighted to provide an impression of what is imagined to be outside.

street dress *Costume* The clothes ordinarily worn outside the theater considered as realistic costumes for the stage.

street makeup The makeup ordinarily worn outside the theater that is unsuitable for the stage because of the way stage lights change its colors and shadowing. To achieve a natural look, stage makeup is necessary.

street-piano *See* BARREL ORGAN.

street theater *Acting* A theatrical presentation on the pavement or on a flat-bed truck in a public street, usually in the manner of an improvisation. *Compare* COMMEDIA DELL'ARTE, PANTOMIME, RAREE.

stress *Acting* An accent on a syllable.

stretch *Broadcasting* To improvise during a broadcast to fill time when the planned material is running short.

stretcher *Stagecraft* 1. A horizontal crosspiece in the framework of a FLAT. Also known as a TOGGLE RAIL. 2. A removable crosspiece in the frame of a large ROLL DROP, *e.g.*, of a CEILING DROP.

stretta, stretto [Italian] *Music* Literally, drawn together. A passage in which the themes previously stated and developed in the piece are restated in closer succession so that each overlaps the next. *See also* IMBROGLIO.

stride piano *Music* A dynamic style of JAZZ piano playing that became popular in the 1920s, made famous by James P. Johnson and his student Thomas "Fats" Waller. The left hand strikes a single bass note on the first and third beats and a chord on the second and fourth beats, creating a "striding" effect. *See also* WALKING BASS.

strike *Stagecraft* 1. To take the set down and remove it from the stage. 2. To remove a specific object from the set, as in "Strike that chair." 3. To turn off a specific light in a scene and remove it from the LIGHT PLOT.

strike crew *Stagecraft* The crew who strike the SET. If there will be a new show the following night, the strike crew also installs its scenery.

strike night *Theater* The night of the last performance of a show, when the set will be taken down. After a significant RUN, strike night is also the time of the closing-night party.

strike the set *See* STRIKE (1).

string bass *See* DOUBLE BASS.

stringed instrument *Music* Any musical instrument whose sound is produced by bowing or plucking strings, except the HARPSICHORD, which is primarily a keyboard instrument.

stringendo (*strin-JEN-doh*) [Italian] *Music* Literally, squeezing. *See* ACCELERANDO.

stringing stand *Puppetry* A stand to hold a MARIONETTE and its CONTROL while the strings are attached.

string orchestra *Music* An orchestra consisting only of stringed instruments, usually VIOLINS (firsts and seconds), VIOLAS, VIOLONCELLOS and DOUBLE BASSES.

string player *Music* A musician who plays a bowed STRINGED INSTRUMENT.

string quartet *Music* 1. A composition written for two VIOLINS, a VIOLA and a VIOLONCELLO. 2. The group of players of those instruments.

string quintet *Music* 1. A composition written for a STRING QUARTET with an additional stringed instrument, usually a viola or violoncello. 2. The group of players of those instruments.

strings *Music* The bowed STRINGED INSTRUMENTS of the orchestra, collectively.

Theater The RIGGING in the FLIES.

string sextet *Music* 1. A composition written for a STRING QUARTET with two additional stringed instruments, usually a viola and a violoncello or double bass. 2. The group of players of those instruments.

string trio *Music* 1. An ensemble consisting of three stringed instruments, usually a violin, viola and violoncello. 2. A piece of music composed for such an ensemble.

striplight *Lighting* An array of lights contained in an open trough that serves as a reflector and SPILL SHIELD, used as FOOTLIGHTS behind a GROUND ROW, or as BORDER LIGHTS.

strip out *Lighting* To widen the beam of a BALCONY SPOT or a FOLLOW-SPOT until it illuminates the entire stage.

stripper *Stagecraft* A DUTCHMAN in the form of a narrow strip of cloth used to conceal the joint line between two adjacent FLATS.

Vaudeville A performer who gradually removes his/her clothes while dancing provocatively.

strip show *Vaudeville* Any show with STRIPPERS.

striptease *Vaudeville* The act of the STRIPPER.

strobe *Lighting* Short for STROBE LIGHT.

strobe light *Lighting* A special gas-filled tube, controlled by circuitry that causes it to flash repeatedly and brilliantly for a specific time in microseconds between measured periods of complete darkness. It is sometimes used in vaudeville and in dance numbers to make smooth movements look like a rapid series of still pictures.

strobing *Motion pictures, Television* A rapid flashing of part of the image caused by some item in the scene moving just far enough between FRAMES so that there is a gap between its position in one frame and the next. It occurs often in shots of carriages or automobiles that seem to show spoked wheels turning backward while the vehicle is moving forward. It also occurs when the camera scans across anything in stripes, such as a golfer's shirt, making it seem to flash on and off very rapidly. In animation, strobing can be prevented by making sure that the apparent distance any series of lines or stripes seems to shift from one frame to the next on the screen does not exceed the width of one of those stripes.

stroll *Dance* In the late 1950s, a solo ROCK dance similar to the CAMEL WALK.

strong curtain *Theater* An ending of a scene or an act that brings the play to a vigorous close.

strophe (*STROH-feh*) [Greek] *Theater* Literally, a turn or a twist. In the classical Greek drama, the first of a pair of STANZAS in a CHORAL ODE, followed by an ANTISTROPHE. Some theorists believe that the ancient chorus turned to the right during the strophe, to the left during the antistrophe, then faced center for the ending. Judging from the character of Greek dances known to have been popular in those days, it seems likely that they performed inventive variations on that basic plan. The term is used in modern times merely to describe any stanza in a lyrical poem.

strophic *Theater* Having STANZAS similar to the form of a Greek CHORAL ODE.

structuralism *Theater* An analytical approach to drama in the 1960s in which the essence of theater was considered to be the relationship between the different scenes or segments of the play (*i.e.*, structure), not the actions of the characters themselves.

structural scene *Acting* A REHEARSAL SCENE, *i.e.*, one that begins with a particular character's entrance, and ends with the same character's exit, thus providing a convenient unit for rehearsal.

structural setting *Stagecraft* Any scenery unit that stands on its own in three dimensions, as distinguished from one consisting of FLOWN units, and DROPS.

strum *Music* To play any stringed instrument by stroking with the fingers or with a pick (PLECTRUM) across all the strings, as distinguished from plucking specific strings individually.

strut *Acting, Dance* To walk with high, exaggerated steps, to walk with a swagger.

 Stagecraft A STAGE BRACE.

stub *Theater* Short for ticket stub. The small piece of the ticket that the ticket taker at the door tears off, leaving the patron with the larger portion. The management uses the stub for bookkeeping purposes and to prove attendance in any contract-fulfillment reports and tax returns.

studio *Audio* A soundproof space designed for recording. A small studio will be big enough for seven or eight musicians. An average studio will have enough room for an orchestra. A very large one will be big enough for a full symphony orchestra plus a chorus. All will have soundproof CONTROL ROOMS, electronic circuitry for recording in many CHANNELS and for PLAYBACK, plus closed-circuit television for those occasions when music or voice must be synchronized with previously produced motion pictures or video-tapes.

 Motion pictures 1. A SOUND STAGE. 2. A motion picture company with a staff of creative and technical people in continuous production, usually in facilities it owns. For most of the middle of the 20th century, film production in the United States was dominated by a few large studios that had their own writers, directors and actors on iron-bound contracts. Only after World War II did smaller, independent studios make significant inroads into the market.

studio production *Motion pictures, Television* Any production produced by a studio, using its own stable of writers, directors and actors, as distinguished from those produced by INDEPENDENTS using talent hired for the occasion.

studio theater　A theater, usually a small one, devoted to training actors and to experimentation in nonstandard plays and styles of presentation.

study　*See* FINGER EXERCISES.

stunt *Motion pictures*　Any feat considered too difficult or risky for most actors, such as acrobatics, leaps from buildings, falls through windows, street fights, etc., performed by a specialist dressed and made up to resemble the actor's character.

stunt man, stunt woman, student double *Motion pictures*　A specialist who takes the place of a member of the cast to perform a STUNT.

Sturm und Drang (*SHTOORM oont DRAHNG*) [German] *Theater*　Literally, storm and stress. An extremely expressive style of literature and theater usually associated with Johann Wolfgang von Goethe, characterized by untraditional plots, impetuous romanticism, the exaltation of the individual, and utter devotion of the hero to nationalistic ideals. The style got its name from the title of a play by F. M. Klinger produced in 1776.

style　The mode and manner of an artistic presentation, as distinguished from its content. In theater and motion pictures, style is often made manifest in the language of a play, the actors' diction and manners of speech, the director's blocking and, most immediately, the set and its decor.

style galant　*See* GALANT.

stylization *Theater*　The emphasis of form and manner of presentation over content, sometimes used to facilitate AESTHETIC DISTANCE. Theater itself is a stylization of life. Within theater, such modes as PANTOMIME and HIGH CAMP are stylizations, as is the production of a play by Shakespeare in modern dress. *See also* ABSTRACT SET, CONVENTION.

stylize *Theater*　To modify the style of a production.

stylus *Recording*　1. A needle used to cut a groove in a blank recording disk to imprint vibrations of sound that are delivered to it through the circuitry of the recording machine.　2. A similar needle, used in a similar way, to pick up those imprinted vibrations and send signals back through the recording circuitry as a PLAYBACK of the recorded material. These processes have been largely eliminated by the development of magnetic recording.

sub *Music*　To substitute for another musician in a performance.

subbass *Music*　The lowest BASS REGISTER of any instrument or family of instruments.

subdivide *Music*　To divide a BEAT into its component parts, *e.g.*, to divide a QUARTER-NOTE beat into two EIGHTH-NOTES. A conductor may subdivide a slow 6/8 measure to clarify whether it consists of three duple beats, or two triples. The practice is frowned upon by some conductors and teachers, particularly Herbert von Karajan who once shouted at a master class, "*Never* subdivide!"

subdivision *Music*　The division of a BEAT into its smaller parts.

subdominant *Music* 1. The fourth degree of the SCALE, one WHOLE TONE below the DOMI-NANT. 2. The TRIAD built upon the fourth degree of the scale.

subito (*SOO-bee-toh*) [Italian] *Music* Immediately, suddenly.

subito forte (*SOO-bee-toh FOR-teh*) [Italian] *Music* Suddenly loud. Its symbol is *sf*. *See also* SFORZANDO.

subito piano (*SOO-bee-toh pee-AH-noh*) [Italian] *Music* Suddenly quiet. Its symbol is *sp*.

subject *Music* The main theme of a piece of music, especially of a FUGUE. Also called a statement.

submediant *Music* 1. The sixth degree of the SCALE, also known as the superdominant. 2. A triad built upon the sixth tone of the scale.

subplot *Theater* A secondary story in a theatrical work, such as the plight of Bottom the Weaver, who is magically given the head of an ass in Shakespeare's *A Midsummer Night's Dream*.

subscriber *Theater* A person who buys tickets for a series of performances or for a season.

subsidiary rights *Music, Theater* Any subordinate RIGHTS inherent, but not explicit, in the primary rights defined in U.S. copyright law. These include, for example, the MECHANICAL RIGHT, SYNCHRONIZATION RIGHT, PERFORMANCE RIGHT, and the right to make and sell merchandise using material from the copyrighted work, etc.

substage *Theater* The space below the main stage. The cellar or basement.

substitute *See* UNDERSTUDY.

subtitle *Motion pictures* A strip of text imprinted across the bottom of the frame of a motion picture, providing additional information, such as a translation of foreign language. *Compare* SUPERTITLE.

subtonic *Music* The seventh degree of the SCALE, next below the tonic. Also known as the LEADING TONE.

subway circuit *Theater* The theaters of New York City, collectively.

suite *Music* A series of compositions, usually based on dance forms, considered as a single performing unit. Many were composed for keyboard (particularly HARPSICHORD) soloists in the BAROQUE period in the 18th century, before the SONATA developed. A typical suite by Johann Sebastian Bach contains an ALLEMANDE, COURANTE, SARABAND and GIGUE.

sujet (*sü-ZHAY*) [French] *Dance* In French ballet companies, a soloist.

sul tasto (*sool TAH-stoh*) [Italian] *Music* On the FINGERBOARD. Designating notes to be bowed close to or just over the fingerboard of the instrument. Placing the bow at such a distance from its normal location tends slightly to reduce the strength of the LOWS in the tone of the instrument and bring out the HIGHS, and produces a softer tone without the damping effect of a MUTE.

summer stock, summer theater *Theater* Any theater company operating usually in a countryside location for the summer, producing a play a week, sometimes with imported STARS.

summer tryout *Theater* A series of public performances of a new production in a summer theater to give the cast some experience with public reactions and allow the producer to change things if the audience seems displeased or half-hearted.

Sunday *Lighting* A large looped knot in a power cable placed to prevent the formation of a kink in the line.

Stagecraft A knot in a RIGGING LINE to provide an unmovable location to tie a SAND BAG.

sun gun *Lighting* A bright, portable floodlight.

sunk up *Motion pictures* An editor's slang term to describe any picture and/or track that has been properly synchronized.

sunspot *Lighting* A strong SPOTLIGHT shining outside a window or a door in the set, simulating bright sunshine.

super *Acting* 1. Short for SUPERNUMERARY. 2. To act as a supernumerary.

Motion pictures 1. A word, a symbol or a diagram superimposed on a SHOT after editing. A super usually provides information otherwise lacking in the shot, such as a price for some object shown for sale in a commercial, or the name of someone who appears in the shot during an interview. *See also* CAPTION, TITLE, CRAWL, SCROLL. 2. To superimpose words or diagramatic material on the picture. *See also* BURN IN.

Television *See* CHARACTER GENERATOR.

superdominant *See* SUBMEDIANT.

supernumerary *Acting* A costumed person, not necessarily a professional actor, who appears on the set solely to lend color or authenticity to the scene by means of costume and simple action. *See also* SPEAR-CARRIER, EXTRA, DRESS EXTRA, WALK-ON.

Motion pictures An EXTRA.

superobjective *Acting* In the STANISLAVSKI SYSTEM, the ultimate objective of the plot or of any character.

supertitle *Opera, Theater* Words projected across the top of the PROSCENIUM where the audience can see them during performance, providing a translation of the text of the play or opera. At the Metropolitan Opera House in New York City supertitles have been transferred to tiny screens built into the backs of seats, to make them easier for a patron to read and less disturbing to those who don't want to see them.

supertonic *Music* The second degree of the SCALE.

supply reel *Audio* The reel containing an audio tape ready to be used in recording or playback. It is the opposite of the TAKE-UP REEL. *See also* HEADS OUT, TAILS OUT.

support, supporting cast *Acting* The secondary level of the cast, below the LEADS.

supporting leg *Dance* The leg that supports the weight of the body while the WORKING LEG remains free to move.

supporting role *Acting* A secondary but important role.

surface noise *Audio* An unwanted hissing, rumbling or scratchy sound in the PLAYBACK of a disk recording, produced by the STYLUS rubbing against the bottom of the groove, or by dust or other obstructions on the surface of the disk. By extension, the term also is used to describe a similar sound in a magnetic recording, caused by a maladjustment of the bias signal in playback.

surf box *Stagecraft* A box made of metal screening with dried peas or BB shot that roll around inside when the box is tipped, making a sound like distant surf.

sur le cou-de-pied *See* COU-DE-PIED, SUR LE.

sur les pointes (*sür lay PWENHT*) [French] *Ballet* On the tips of the toes. *See* POINT.

sur place (*sür PLAHS*) [French] *Ballet* Literally, on the place, in place. Designates a step performed without moving away from the spot where the dancer stands.

surprise pink *Lighting* A pale lavender COLOR FILTER that produces a light flattering to the actors on stage. The effect is a warm pink rather than lavender.

surrealism *Theater* A movement of the 1920s and 1930s to remove the idea of ordinary realism from theater and replace it with the notion that reality resides in the unconscious mind. One of the most famous surrealistic plays was the satiric farce *Ubu Roi* (Ubu the King) by Alfred Jarry, first performed in 1896, long before the movement it inspired actually got started. More recent examples are the early film works of Luis Buñuel and others.

surround *Stagecraft* A CYCLORAMA made of drapery, providing not only the background of the set but also part of each side. *See also* BLACKS.

surround sound *Audio* A multichannel system in motion picture theaters, providing sound that is not only STEREOPHONIC, but also directional from any part of the room or theater.

Susie Q, Suzy Q *Dance* A SWING dance created in the mid-1930s at the Cotton Club in Harlem.

suspension *Music* A tone sounded and held, while a chord of which it is not a harmonic part is played, then resolved by moving into harmony with the chord. *See* APPOGGIATURA.

suspension of disbelief *Theater* The process of putting present reality out of the mind and accepting the imaginary reality of a play in progress. It is the essential process that allows theater to become a moving experience.

sustain *Music* To maintain a tone at its initial strength (as nearly as possible) for its indicated duration.

sustaining pedal *Music* A pedal actuated by the player's right foot that disengages all the DAMPERS of the piano mechanism at once, so that the tones of whatever keys have been activated will continue to resound until the pedal is released or they die away. Also called the damper pedal. Not to be confused with the SOSTENUTO PEDAL.

swab *Music* A piece of soft cloth, usually cotton, that can be pulled (by a string) through the tube of a wind instrument to clear the tube of excess humidity. *See also* COTTON ROD.

Stagecraft To wipe a torn area of the surface of a flat with thin glue and cover it with a patch of canvas. *See also* DUTCHMAN.

swag curtain *Stagecraft* A curtain pulled up into a fancy series of loops. *See also* BRAIL CURTAIN, VENETIAN CURTAIN.

swan song *Theater* Slang for a performer's final performance.

swazzle *Puppetry* A REED or a TIN WHISTLE held in the mouth to alter the sound of speech during a performance.

sweep *Stagecraft* The curved part of an arch in the SET.

sweeps *Television* A reviewing process conducted by television monitoring agencies annually in November, February, May and July, to determine the relative popularity of serial programs, as part of the process of establishing their value to advertisers.

swell *Music* A CRESCENDO in organ music, accomplished by opening the SWELL BOX.

swell box *Music* A wooden enclosure with slats that can be progressively opened or closed, built around one or more ranks of ORGAN PIPES. When the swell box is closed, the sound of the pipes is muted. When it opens, the sound grows louder.

swing *Music* A JAZZ-based style of popular dance music that enjoyed great success from the mid-1930s through the 1940s and has had revivals of popularity since. Performed by BIG BANDS and various COMBOS, it is normally written in 4/4 time but the beats are often subdivided into a pattern similar to 12/8 or syncopated variations of it, with a loose feeling that matches the swinging movement of dancing couples and gives the style its name. *See also* JITTERBUG.

swing joint *Lighting* A device built into the supporting frame of a light fixture so that the light can be turned in any direction without moving its support.

swing stage *Stagecraft* A pivoted stage that can be swung out of the way. *See also* ELEVATOR STAGE, WAGON STAGE.

swish pan *Motion pictures* A very rapid horizontal movement of the camera that produces a blurred image of whatever it scans. Used for an effect of great speed. *See* PAN.

switch *Costume* A hairpiece but not a full wig.

switchboard *Lighting* A generic term for CONTROL BOARD.

switcher *Television* 1. An electronic system that controls the selection of pictures and sound from all the cameras in operation in the studio, performs various modifications to them, *e.g.,* FADES, WIPES, DISSOLVES, and sends the final result on to the broadcasting transmitter or the videotape recorders. 2. The engineer, often the TECHNICAL DIRECTOR, who operates such a system.

switching *Television* The process of selecting and modifying the audio and video signals from many cameras and delivering the result to broadcast or to the videotape recorder.

swoop *Music* Slang term for an unfortunate sliding of the singing voice from one note to another.

sword dance *Dance* Dating from 1350, a dance with many variants performed often at Christmas and Shrovetide by a group of dancers wielding swords, or by a solo dancer. Steps were sometimes intricate, with the swords used to form vaults and patterns. In the British Isles and parts of Europe the dance was accompanied by buffoon characters, grotesques or performers dressed as historical figures.

sword swallower *Circus* A performer whose act consists of gradually sliding a sword down his own throat and withdrawing it without any ill effects.

symbolic gesture *Acting* Any theatrical gesture the meaning of which is instantly recognized by the audience, *e.g.,* scratching the head to indicate thinking, or clenching the fists to indicate a desire to punch someone in the nose.

symbolism *Theater* A movement in the late 19th and early 20th century to emphasize mood and symbol in theater and to work with the material of legends, as in the plays of Maurice Maeterlinck.

sympathetic strings *Music* Strings that vibrate when other strings, of the same pitch or any octave lower, are sounded. Among the instruments that have such strings built into them are the modern TWELVE-STRING GUITAR, the 17th-century LUTE and the Hindu SITAR. The effect also can be produced on the PIANO by holding down several keys with the right hand and striking their lower OCTAVES briefly.

sympathetic vibration *Music* The vibration of any sounding object when tones of the same PITCH (or of any pitch that would produce the tone as a HARMONIC) pass over them.

symphonette *Music* A term occasionally used for a small orchestra, especially one that plays SALON music.

symphonia *See* SINFONIA.

symphonic *Music* Having the quality of a SYMPHONY.

symphonic ballet A term designating BALLETS of the 1930s and early 1940s that were choreographed to symphonic works and that attempted to fit the moods and forms of the dance to those of the music. One of the most successful is George Balanchine's ballet choreographed to Georges Bizet's *Symphony in C.*

symphonic drama *Music*　A DRAMA accompanied by a symphony orchestra, presented in concert form.

symphonic poem *Music*　An orchestral work based on themes that suggest characters and events in an underlying story. (*See* PROGRAM MUSIC.) Richard Strauss composed several, including *Till Eulenspiegel's Merry Pranks*. Also called a tone poem.

symphonie concertante　*See* SINFONIA CONCERTANTE.

symphonist *Music*　A composer who writes symphonies.

symphony *Music*　A large work for a full orchestra, usually in SONATA FORM, often in three or four movements. The first master of the form and its principal inventor was Haydn. *Compare* SINFONIA.

symphony orchestra *Music*　A large orchestra, in modern times often numbering more than one hundred instrumentalists, typically with flutes, oboes, clarinets, bassoons, French horns, trumpets, trombones, tuba, harp, percussion, timpani, first and second violins, violas, violoncellos and double basses.

sync *Motion pictures*　Short for SYNCHRONIZATION. *See also* IN SYNC.

sync generator *Motion pictures*　An electronic device used by the camera crew during a SHOOT to maintain precise SYNCHRONIZATION between camera(s) and sound recorder(s). It produces a precise timing signal that controls the camera and sound recorder mechanisms through cables.

synchronization *Motion pictures*　The process of aligning a sound track precisely with a motion picture scene so that every event on screen is exactly matched by its appropriate sound.

synchronization right(s) *Motion pictures*　A legal right to match a copyrighted piece of music or of spoken words to a motion picture. Since this is a SUBSIDIARY RIGHT under United States copyright law, it is traditionally negotiated separately from the right to play that sound as part of the motion picture, which copyright owners negotiate as a PERFORMANCE RIGHT.

synchronize *Motion pictures*　1. To control the pace of cameras and/or tape recorders so that they run exactly alike, with each FRAME taking the same amount of time (a twenty-fourth or a thirtieth of a second) on each device. 2. In the editing process, to line up picture and sound on their separate TRACKS so that their frames match absolutely and stay in step as the shot runs.

Synclavier *Music*　Trade name for a professional-quality musical SYNTHESIZER.

syncopate *Music*　To create a RHYTHM in which a strong tone, often a tone of longer duration, falls on a weak or normally unaccented BEAT.

syncopated *Music*　Said of any music that emphasizes the OFF-BEATS.

syncopation *Music* The process of emphasizing OFF-BEATS by placing tones of longer duration or stronger harmonic changes on them.

sync point *Motion picture* A specific FRAME in a shot with which something else, normally a sound, is to be synchronized, *e.g.,* the frame that shows the impact of a cup falling on the floor, which must be synchronized with the sound of that impact that has been previously recorded on its separate strand of magnetic tape. *See also* CUE, MUSIC CUE, START MARK.

sync pulse *Motion pictures* An electronic pulse created by a SYNC GENERATOR and fed to the cameras and recorders to keep them IN SYNC with each other. *See also* CRYSTAL SYNC.

syndication *Television* A marketing system by which companies acquire distribution RIGHTS for television programs that have run their course as a first-run series, for rental to individual broadcasting stations.

synthesis *Theater* The fundamental merging of all the arts of theater in the initial creative process, an ideal sought particularly by Richard Wagner in his operas, and by Edward Gordon Craig, Adolphe Appia and other modern playwrights and composers. Although any theatrical production is the result of combining elements of visual, verbal and temporal (*e.g.,* musical) art by the time the work goes on stage, the idea of fundamental synthesis requires that they come from a single source at the outset, and are composed as a single entity.

synthesizer *Music* An electronic device with one or more KEYBOARDS like the piano, and complex circuitry that can produce tones of any conceivable TIMBRE in a signal that can be recorded or fed to LOUDSPEAKERS. Many theatrical, recording and motion picture producers use synthesizers to avoid the expense of live musicians. Many rock bands use synthesizers to provide harmonic background material. Some modern composers use them in conjunction with computers to notate and, sometimes, record or perform their music.

syrinx *See* PANPIPE.

syrtos (*seer-TOHS*) [Greek] *Dance* A lively Greek group folk dance from Epirus in quick 4/4 time, performed in a line with each dancer's arms interlocked over the shoulders of the next in line on each side. The whole line moves on the beat without leaping three steps to one side, kicks to that side with the free leg on the fourth beat, then three steps to the other side, kicking the opposite way, and so on. The syrtos was known at least 2,000 years ago and is still popular. It provides a hint of the kind of dance that may have been performed on stage in classical times. *See also* TSAMIKOS.

system *Acting* *See* STANISLAVSKI SYSTEM.

Music A single array of several STAVES in a SCORE, bound together by a vertical line at the left. This arrangement allows a score for a few voices or instruments to be written in the upper part, then continue in the lower part of a page, not only saving paper but also saving the composer and musicians the disturbance of having to turn pages as often as they otherwise might.

T

tab *Stagecraft* A narrow DROP hung at the sides just inside the PROSCENIUM to establish the width of the proscenium opening and to mask the backstage. *See also* TORMENTORS.

tab backing *Stagecraft* A DROP hung behind the TABLEAU CURTAIN to mask the rest of the stage.

tab curtain *See* CONTOUR CURTAIN.

tabla *Music* A small cylindrical wooden hand drum from India. The top and bottom heads are bound by a system of thongs woven from one to the other around the circumference of the drum. The top head is actually two layers of skin, one of which has a large hole cut into it. The other skin is a circular patch glued from underneath to fill that hole. The patch, in turn, is filled with a smaller circular area of a tarry mixture pasted in its center. The expert tabla player can produce up to 16 different tones by pressing on the heads of the drum and striking it in various ways with his fingers.

tablature *Music notation* Any system of musical notation with letters, numerals or other symbols representing the positions of fingers on strings rather than musical notes that represent tones in a scale. Although tablatures were once common in music during the 15th to 17th centuries, in modern times they appear as chordal fingering maps for the GUITAR or numbers for fingers on a special staff that represents the strings of the BANJO. *Compare* FIGURED BASS.

table *Music* The top surface, which acts as a sounding board, of any instrument of the VIOLIN FAMILY, upon which the bridge stands. The table is symmetrically pierced by two holes, called F-HOLES because of their shape.

tableau (*tah-BLOH*) [French] *Dance, Theater* *See* STAGE PICTURE, TABLEAU VIVANT.

tableau curtain *Stagecraft* A two-section BRAIL CURTAIN divided at the center of the stage, with its lifting cords passing through diagonal lines of rings reaching from the center-stage corner of each side to the corresponding upper corner of the PROSCENIUM. When the lines are pulled, the two sections separate at the bottom center and form decorative looping folds that converge at the upper corners of the proscenium. *Compare* AUSTRIAN CURTAIN, CONTOUR CURTAIN, VENETIAN CURTAIN.

tableau vivant (*tah-BLOH vee-VANH*) [French] *Theater* Literally, living picture 1. A moment of silence and stillness on stage, with all the performers in costume and in characteristic positions. Directors sometimes use such a STAGE PICTURE to establish a mood or end a scene.

2. A private entertainment popular in the late 1800s, particularly in England, in which costumed performers or invited guests attempted to reproduce a famous statue, painting or scene of historical interest, by striking and holding the appropriate poses.

table music *See* TAFELMUSIK.

table part *Acting* A ROLE played behind a table, *e.g.,* as a salesperson or a magician.

table stage, tabletop *Motion pictures* A technique of making an ANIMATION, using small constructions for a set, with articulated models or flexible plastic figures for characters, all placed on a table so that they will be at a convenient height for shooting. The film *A Close Shave,* that won the Academy Award for an animated subject in 1995, was a tabletop production. The battle scenes in *Return of the Jedi* were an elaboration of the technique, combining shots made on miniature stages with others in full life. Many technical and scientific films use tabletop to simulate strange environments, such as the surface of the moon.

Theater A revolving stage. *See* TURNTABLE.

tabloid theater A small theater that specializes in condensed versions of PLAYS, MUSICALS or other entertainments.

tabor, taboret (*tah-bo-RAY*), **taborin** (*tah-bo-RENH*) [French], **tabret** [Middle English] *Music* A small DRUM known since the Middle Ages, played with the hand as accompaniment for a PIPE. *See also* TAMBOURINE.

tab show *Theater* A traveling show designed to be played for carnivals and small-town audiences, using either original material or abridged versions of Broadway revues or musical comedies.

tacet (*TAH-chet*) (plural, **tacent**) [Latin, Italian], **tacit** (*TAH-sit*) [English] *Music* Silent, to be silent.

taconeo (*tah-koh-NAY-oh*) [Spanish] *Dance* Literally, noise of heels. The heal-tapping technique of FLAMENCO dance.

ta-da *Theater, Vaudeville* A word that imitates a very short fanfare.

tafelmusik (*TAH-fel moo-ZEEK*) *Music* Music, including several instrumental suites by Georg Philipp Telemann, composed for entertainment at a banquet.

tag, tag line *Acting* 1. The last line(s) of a scene, an act or a play. In Elizabethan theater, the tag was often a rhymed couplet. 2. The last act of a variety show.

Music In JAZZ, POP and ROCK, the equivalent of the CODA in classical music; an expansion of the last part of the number meant to emphasize the ending.

tailgate *Music* A term applied around 1910 to a style of JAZZ or RAGTIME trombone playing associated with New Orleans in the early 1900s, when brass bands were sometimes driven in parades in wagons or advertising trucks. To allow use of the slide to its full length

without hitting other musicians, the trombonist stood at the rear of the truck where he was forced on occasion to pull the slide in quickly; the resulting violent swoop became a characteristic feature of the style.

tailgater *Music* A jazz musician, especially a TROMBONIST, who plays in the TAILGATE style.

tail slate *Audio* An audio SLATE recorded at the end of the TAKE, rather than at its beginning. Tail slates are necessary, for example, when recording a documentary event, when the recordist does not know what will be on the tape until after the recording has been made. They are necessary also when recording ROOM TONE, in addition to a routine slate at the beginning, lest the editor fail to notice later when room tone turns into DEAD AIR.

tails out *Audio* Said of a reel of tape that has not been rewound, *i.e.,* the head (the beginning of the recording) is at the center of the TAKE-UP REEL (on the hub), and the tail (the end of the recording) is outside. Engineers often prefer to store recordings in this fashion, just as they wind up during a real-time playback, because the tape, having been wound slowly, is less likely to be loose. The opposite of HEADS OUT. *See also* HUB.

take *Acting* Any of four kinds of gesture of surprise: (a) skull, a sudden look (also as a verb, to skull); (b) DOUBLE TAKE, two looks separated by a pause; (c) BODY TAKE, a double take with the whole body; and (d) SLOW TAKE, contrasting with the action of the scene. *See also* SLOW BURN.

Audio, Motion pictures, Television 1. A single completed and successful operation of the camera or the recorder. 2. The resulting piece of film, or audio or videotape. On film different takes are identified by SLATES. A single take may or may not satisfy the requirement of a given SHOT and may therefore be retaken (*e.g.,* "Shot 3, take 1" or "Shot 3, take 2" and so forth) until that requirement has been met. When at last a take is satisfactory, the director may say, "That's a take!"

Circus, Theater The gross amount taken in at the box office for ticket sales at one performance.

take a count *Acting* To time a pause; to pause and count (*e.g.,* to five), then go on. It may be a slow or a fast count.

take an encore *Vaudeville* To repeat the NUMBER.

take a prompt *Acting* To listen to the PROMPTER for the line.

take down (a light) *Lighting* To reduce the intensity (of a light).

Stagecraft To STRIKE the show.

take five, take ten *Music, Theater* To take a five- or ten-minute break during a rehearsal or a recording SESSION.

take in *Stagecraft* To lower (*e.g.,* a DROP) into the set.

"take it away" *Stagecraft* A stage manager's instruction to open the curtain or raise a DROP.

Vaudeville A MASTER OF CEREMONIES cue to performers to begin their act.

take-off *Vaudeville* A BURLESQUE.

take out *Lighting* To DIM OUT or turn off (a light).

> *Stagecraft* To raise (*e.g.,* a DROP) into the flies.

take the boards *Acting* To enter the acting profession.

take the cake *See* CAKEWALK.

take the scene, take the stage *Acting* To move into a dominant position in the scene, to take the FOCUS of the scene away from someone else.

take up *Lighting* To increase the intensity of a light.

take up a cue *Acting* To recognize and react appropriately to a CUE.

take-up block *Stagecraft* A SHEAVE underneath a COUNTERWEIGHT, to guide the operating line that controls it.

take-up reel *Audio, Motion pictures* The reel upon which the tape winds up (*see* TAILS OUT) after running through the tape recorder, camera or projector. The opposite of the SUPPLY REEL.

taking date *Lighting, Stagecraft* The day that charges begin to accrue for rented equipment, *i.e.,* the day on which the equipment is picked up from the rental company.

takings *See* TAKE (*Circus, Theater*).

talc *Makeup* Short for talcum powder.

talent *Motion pictures* Generic term for performers.

talent scout *Motion pictures* In the heyday of the big Hollywood studios during most of the 20th century, an employee of the studio who searched for people who might become candidates for careers in the movies, a function now performed by professional casting offices.

talent show *Theater, Vaudeville* A show made up of individual acts by aspiring amateur or student performers. *See also* SHOWCASE.

talkie *Motion pictures* A term popular in the 1930s for a motion picture with synchronized sound. *See* SOUND-ON-FILM.

talking picture *See* SOUND-ON-FILM.

talking single *Vaudeville* An act by a single performer who tells jokes and stories.

tall grass, tall timber *Theater* Any place far out of town, beyond the STICKS. *See also* BOONDOCKS.

tally light *Television* A tiny red light on the front plate of a video camera just above the lens mount, bright when the camera is actually ON THE AIR or actively recording on tape, and dark when it is not.

Tambo *See* MR. BONES AND MR. TAMBO.

tambour (*tahm-BOOR*) [French] *Music* A DRUM.

tambourin (*tamh-boo-RENH*) [French] *Dance* A lively dance from Provence in 2/4 or 4/4 time. Its style and rhythms were taken up by a number of 18th-century French composers.

tambourine (*tamh-boo-REEN*) [French] *Music* A small shallow DRUM with a single parchment HEAD and with pairs of metal jingles set into its sides. The player, often a Spanish dancer, holds the instrument in one hand, strikes it with the other and frequently shakes it to make the jingles sound.

tambura (*tahm-BOO-rah*) [Hindi] *Music* A lutelike instrument of India with four strings, a very long neck without FRETS, and a round sounding body at its lower end. The player plucks the strings, which reverberate for a relatively long time, providing a dronelike accompaniment for the SITAR in Indian music.

tampon (*tahm-POHNH*) [French] *Music* A DRUMSTICK with a single padded head.

tampon double (*tahm-ponh DOOBL*) [French] *Music* A DRUMSTICK with two padded heads, one at each end, held at its middle in one hand and shaken by twisting the wrist rapidly back and forth to create a ROLL on the BASS DRUM.

tampur *See* TAMBURA.

tam-tam *Music* A very large bronze disk hammered to thinness like a CYMBAL, with a rounded edge but no dome-shaped indentation in its center. When struck with a padded MALLET it produces a very low tone of indefinite pitch. When it is struck hard, it produces a crashing sound that, because of its size and its hammered condition, changes TIMBRE as it resounds, with an effect that no other instrument can duplicate. A large tam-tam appears in the opening shot, before the title, of every film made by the J. Arthur Rank organization in England during the 1930s and 1940s. Another large tam-tam can be heard being played very softly at the climax of Tchaikovsky's *Symphonie Pathétique*.

tanbur *See* TAMBURA.

tangent *Music* The tiny metal contact at the end of the key of a CLAVICHORD that rises up, strikes and presses against the string when the key is depressed. It consists of a short metal shaft with one end hammered to a dull, chisel-like edge. When it strikes the string it not only causes the string to vibrate but also, by pressing against it, determines the length of the string that will vibrate, thus establishing its PITCH. This fact makes it possible, by varying the pressure on the key, to cause the string to alter its pitch slightly to accommodate pitch differences that may be required for a particular harmonic figure, or to produce a kind of vibrato effect. *See* MEANTONE TEMPERAMENT.

tango *Dance* A ballroom dance based on Caribbean and Argentine elements that enjoyed great popularity in France, England and the United States in the early 1900s. In slow 2/4 time, it combines aspects of the HABAÑERA and BOLERO, and has a variety of steps, turns and dips.

tank town *Theater* Any small town far out in the countryside, a metaphor for the bleak prospects of a touring theatrical troupe. The term derives from the days of steam locomotives that used a great deal of water. A large tank was built beside the tracks in a desolate spot where engines could stop and replenish their supply. *See also* BOONDOCKS, STICKS, TALL GRASS.

tanto (*TAHN-toh*) [Italian] *Music* As much, so much, too much. A modifier, as in *allegro non tanto*: allegro, but not too much.

tap *Dance* 1. A small metal plate attached to the toe and/or heel of a tap dancer's shoe that makes a sharp click when struck against the floor. 2. To perform as a TAP DANCER.

tap cue *Lighting* A CUE for a very slight change in intensity, which the operator accomplishes by gently tapping a DIMMER control.

tap dance, tap-dancing Based on the popular JIG and CLOGGING dances of Great Britain and the United States, a stage dance that emerged in the late 1800s, characterized by rapid, rhythmic tapping of the toes and heels on the floor, performed in shoes with metal plates (TAPS) fitted to them. Tap-dancing enjoyed success in vaudeville, music halls, stage shows and motion pictures largely due to the virtuosity and inventiveness of performers such as Bill "Bojangles" Robinson, Fred Astaire and Ray Bolger. Also called step-dancing. *Compare* SOFT-SHOE DANCE.

tap dancer *Dance* One who performs a TAP DANCE. *See also* PERCUSSION TAP DANCER.

tape *Audio, Television* 1. A long plastic ribbon coated on one side with a layer of ferrous oxide that will accept a magnetizing signal when the tape runs through a recording machine, and will play it back on command. Audio tape is normally ¼ inch, ½ inch or ¾ inch wide. Videotape is ½ inch, ¾ inch or 1 inch wide. For motion picture work, audio tapes are also manufactured as SPROCKETED TAPE in 16mm and 35mm widths to match the motion picture film with which they are to be synchronized. 2. A recording imprinted on magnetic tape. 3. To record on magnetic tape.

tape deck, tape machine *Audio* Any recording or PLAYBACK machine that uses magnetic tape.

tape player *Audio* A PLAYBACK machine that plays, but does not record, magnetic tapes.

tape record *Audio* To make a recording on magnetic tape.

tape recorder *Audio* An audio recording machine that uses magnetic tape. *See also* VIDEO RECORDER.

tape recording *Audio* A recording made on magnetic tape. *See also* VIDEO RECORDING.

taping, taping session *Audio, Television* 1. The process of making an audio or videotape recording. 2. A recording session for an audio or video program.

tap mat *Dance* A portable mat, often made of thin, parallel wooden slats, held together by a cloth backing. It can be carried rolled up, and unrolled on any floor to provide a suitable surface for a tap dancer.

Taps *Vaudeville* The drummer in a minstrel show.

Music A particular tune used as a military signal for the end of the day, also known as "Retreat" or "Lights Out," usually played on a BUGLE but also, in concert, on a TRUMPET. It is heard frequently at the most solemn moment of a military funeral. *See also* TATTOO.

taqueterie (*tah-keh-TREE*) [French, from *taqueté*] *Ballet* Literally, pegged. A term applied to a number of small rapid steps on POINT, with the points tapping the floor in a staccato manner. Some taqueterie steps are PAS DE BOURRÉE, PIQUÉ, etc.

tarantella *Dance* A fast Italian folk dance in 6/8 time, known as early as the 17th century, performed by two women or by a man and a woman. The name may have come from the seaport of Taranto, or from the tarantula spider, whose poisonous bite was said to be cured by vigorous dancing. It appears in ballets such as Petipa's *Swan Lake* and Massine's *La Boutique Fantasque*. *See also* SALTARELLO.

Music A musical form based on the dance, in fast 6/8 time, often using the technique of PERPETUUM MOBILE to great effect.

tardo (*TAHR-doh*), **tardamente** (*tahr-dah-MEN-teh*) [Italian] *Music* Gradually slowing down.

tarogato *Music* 1. An ancient Hungarian military wind instrument, similar to the modern BUGLE. 2. A wooden SAXOPHONE with a clarinet mouthpiece. Its tone is mellower than the brass saxophone.

Tartini's tone *See* COMBINATION TONE.

tasto (*TAHS-toh*) [Italian] *Music* The FINGERBOARD of any instrument of the VIOLIN FAMILY. *See* SUL TASTO.

tattoo *Music* A military signal played by BUGLES and/or DRUMS at the end of the day. Often known as "Retreat." *See also* TAPS.

taxi dancer *Dance* In the 1930s and 1940s, a woman working in a dance hall or cabaret where customers paid a small fee for the privilege of dancing with her.

Taylor Trunk *Acting* Trade name for a trunk that was popular among touring actors during the early 20th century.

TD Abbreviation for TECHNICAL DIRECTOR.

team *Circus, Vaudeville* Any group of two or more performers who travel and perform together regularly.

teapot style *Acting* A style of acting with exaggerated diction, characterized by a basic stance with one hand on a hip and the other hand held up and out from the body with the palm upward, like the spout of a teapot.

tearjerker *Theater* A very sentimental play or motion picture that is sure to make the audience cry.

tear sheet *Theater* An entire page of a newspaper or magazine containing a theater advertisement, torn from the paper by its publisher and sent to the theater management as a proof that it was properly published.

teaser *Stagecraft* 1. A short horizontal FLAT hung behind the main curtain and in line with the TORMENTORS. It sets the height of the stage opening and masks lights of the first LIGHT PIPE. Together with the tormentors it defines the stage opening as designed by the set designer for a particular show. 2. A short cloth DROP that fulfills the same purpose. 3. Any small cloth drop or flat designed and placed to conceal a light. *See also* BOX TEASER. *Compare* BORDERS.

teaser batten *Stagecraft* The BATTEN that holds a TEASER.

teaser position *Stagecraft* The first light pipe. *See* FIRST ELECTRIC.

teaser spotlight *Lighting* A SPOTLIGHT on the first LIGHT PIPE hidden by a TEASER.

teaser striplight *Lighting* A STRIPLIGHT on the first LIGHT PIPE hidden by a TEASER.

techie, tekkie *Stagecraft* Nickname for TECHNICIAN.

technical *Theater* Describing any theatrical function except performing, directing or business management.

technical director *Theater* During the preparation of the SET, the person ultimately in charge of SCENERY, PROPS, LIGHTS, SOUND, etc. Often the same as the MASTER CARPENTER.

Television A technician or engineer who monitors the electronic signal coming from the camera(s), adjusts it for color balances, and operates or supervises the operation of the SWITCHER.

technical rehearsal *Theater* A rehearsal of the technical processes that are to take place during a performance. In a technical rehearsal, actors may or may not take part, depending on the complexity of the situation.

technical runthrough *Theater* A RUNTHROUGH of a play for the purpose of checking all the technical factors such as lighting and sound cues, set changes and the like that have previously been rehearsed. In a technical runthrough, actors usually take part to provide proper timing and precise cues for the technical crew. They may not, however, be required to play those scenes or speak those lines that do not involve technical events.

technical script *Motion pictures, Television* A complete, annotated script showing all the technical events that will take place during the show. *See also* LIGHT PLOT, PROP PLOT, SCENE PLOT.

technician *Theater* Any person in the theater company who operates electrical or electronic systems.

tedesca, alla *See* ALLA TEDESCA.

Te Deum (*teh DAY-oom*) [Latin] *Music* Literally, thou Lord. A Christian hymn of thanksgiving of the 6th century, expanded by many composers into a major work for chorus and orchestra, often to celebrate an event of national importance.

telecast *Television* Short for television broadcast.

telecine (*TEL-leh-SEEN*) *Television* A department of a television studio where previously recorded audio and videotape segments and motion pictures originate and are fed into a television program.

telephoto lens *Motion pictures* A long lens designed to pick up images from a great distance. *Compare* ZOOM LENS.

teleplay *Television* A play written for television.

Teleprompter *Television* Trade name for a device that displays the lines to be spoken by a speaker. Frequently the lines are projected from below onto a pane of glass slanted toward the podium, so that the speaker can see the words but the audience cannot, giving the illusion that the performer is speaking without notes. The lines displayed are stored as computer information, transmitted and converted into visible words by the system.

telescope the scene *Acting* 1. To speak all at once, with the lines of several actors overlapping each other. 2. To shorten the playing time of a scene by dropping inessential words or phrases and abbreviating actions and reactions where possible.

telethon *Television* A public-service program in which many performers and celebrities take part to raise funds for a good cause. The term is a shortened form of *television marathon*.

televise *Television* To broadcast, *e.g.*, a news event, via television.

television 1. The process of broadcasting and receiving sound (audio) and images (video) electronically. 2. The world of audio/video broadcasting.

telharmonium *Music* The earliest known musical instrument that generated its tones electrically, invented by Thaddeus Cahill in 1904.

tema (*TAY-mah*) [Italian, Spanish] *Music* A musical theme, especially the SUBJECT of a FUGUE.

temperament *Music* A mode of tuning a KEYBOARD instrument to permit playing in any KEY and modulating from one key to another during performance. As soon as keyboard instruments were developed, musicians discovered that they could not play in more than one key without producing some chords that sounded grossly out of tune. Attempts to remedy this situation were successful only up to a point. By the 16th century, it was common practice to tune the notes of the scale according to the MEANTONE TEMPERAMENT, by which a musician tuned the instrument by ear, upward and downward around a single note (usually E), but making most of the intervals slightly smaller than they would be if they were mathematically correct. The listener could not normally detect the impurity as long as the music stayed fairly close to

the fundamental key. The player could not, however, modulate to distant keys. The idea of EQUAL TEMPERAMENT was conceived as early as the 16th century, both in Europe and in China. By 1700, the system had been worked out, at least in approximations, by several theorists including Andreas Werckmeister, a German organist. Bach's *The Well Tempered Clavier*, 48 preludes and fugues in all, may have been composed before Bach actually knew the system.

tempered *Music* Modified in pitch according to a system of TEMPERAMENT.

tempestoso (*tem-pes-TOH-zoh*) [Italian] *Music* Tempestuously.

template *Lighting* Any opaque sheet, of a size and thickness to fit inside the COLOR FRAME of a light, with a shaped cut-out that will allow certain areas of light to pass through. If the cut-out shape is designed to cast a lighted image, the template is called a COOKIE. If it is designed to cast a shaped shadow, it is called a GOBO. *See also* LINNEBACH PROJECTOR, WHITE SHADOW.

template bench *Stagecraft* A workbench designed to facilitate the construction of stage FLATS. Wooden flanges are attached to the benchtop to hold the several parts of the frame in place while CORNER BRACES and KEYSTONES are placed over the JOINS and nailed down. Metal plates, set into the benchtop at appropriate places, automatically crimp nails as they are driven through the frames.

temple blocks *Music* A musical instrument consisting of a row of hollow, almost spherical, blocks with deep slots cut into them. It has been said that a temple block looks like a "pot-bellied herd bell, or the head of a fish." They are usually lacquered in brilliant red and fastened in groups of four or more to a horizontal bar on a stand. They are of graduated sizes, and produce different, though untuned, pitches when struck with a drumstick. Also called Chinese or Korean temple blocks. *Compare* WOOD BLOCKS.

tempo [Italian] *Music* Literally, time. The pace at which a piece of music is to be performed. Composers indicate tempo with words such as ANDANTE, ALLEGRO, LENTO and LARGO, or with METRONOME indications that are more precise.

tempo giusto (*TEM-poh JOO-stoh*) [Italian] *Music* 1. Strictly in TEMPO. 2. At the "just" or appropriate pace.

tempo primo (*TEM-poh PREE-moh*) [Italian] *Music* At the TEMPO indicated at the beginning of the piece.

tempo rubato *See* RUBATO.

temps (*tanh*) [French] *Ballet* 1. A moment when the weight does not shift. Part of a movement or step (*pas*) performed without shifting the weight from one foot to another, unlike a *pas* in which the weight is transferred. 2. A term that may also refer to a complete movement or step, as in TEMPS LEVÉ.

Music French, the musical BEAT, indicated by the TIME SIGNATURE.

temps de cuisse (*tanh deu KWEES*) [French] *Ballet* Literally, thigh movement. A compound step with several variations that begins with a BATTEMENT DÉGAGÉ and ends in a SISSONNE FERMÉE.

temps de poisson (*tanh deu pwah-SONH*) [French] *Ballet* Literally, fish movement. A jump, usually performed by a male, with the body arched (like the curve of a leaping fish), the legs extended to the side and back and the pointed feet crossed to suggest a fish's tail. *Compare* FISH DIVE.

temps développé *See* DÉVELOPPÉ.

temps levé (*tanh leu-VAY*) [French] *Ballet* Literally, time raised or a raising movement. 1. A jump or hop, usually starting with DEMI-PLIÉ in FIRST POSITION and returning to demi-plié. 2. A jump from one foot with the other raised in any position.

temps lié (*tanh lee-AY*) [French] *Ballet* Literally, connected movement. An exercise involving steps and arm movements, designed to develop balance and control in the transfer of a dancer's weight from one position to another smoothly and rhythmically. Based on the FOURTH, FIFTH and SECOND POSITIONS.

tendu (*tanh-DÜ*) [French] *Ballet* Held or stretched (as in BATTEMENT TENDU).

tenebroso (*teh-neh-BROH-zoh*) [Italian] *Music* Literally, full of shadows. Darkly.

"ten minutes" *Theater* A stage manager's WARNING to cast and crew that the next act will begin in ten minutes.

Tennessee running set *See* KENTUCKY RUNNING SET.

tenor *Music* 1. The highest normal register of the male voice. *See also* COUNTERTENOR. 2. Short for TENOR SAXOPHONE.

tenor clef *Music notation* 1. A C-CLEF centered on the fourth line of the staff. 2. A TREBLE CLEF with the subscript numeral 8, defining the second line as the G below MIDDLE C.

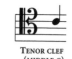

TENOR CLEF
(MIDDLE C)

tenor horn *Music* 1. The BARITONE (considered as a tenor TUBA). 2. Jazz slang for the TENOR SAXOPHONE.

tenor saxophone *See* SAXOPHONE.

ten percenter *Theater* An AGENT.

tenth *Music* A musical INTERVAL equal to one OCTAVE plus a THIRD. It can be MAJOR or MINOR, depending on its third.

tent show *Circus, Music* Any show performed in a tent. Tent shows were popular for summertime entertainment, especially in the Midwest, during the late 19th and early 20th centuries. A variation of this idea survives today in the form of "musical tents" presenting popular concerts and musicals at summer resorts.

tenuto (*teh-NOO-toh*) [Italian] *Music* Held, sustained. In practice, held for the full indicated value of the note, *i.e.*, resisting the tendency to release a note just before attacking the next one.

ternary form *Music* A three-part musical form in which each section is complete in itself. The middle section, often in a different key from the first, is composed of musical material that contrasts with that of the other sections. Not the same as SONATA FORM. *Compare* BINARY FORM.

ternary skip *Music* Any SKIP based on a three-part beat, *i.e.,* with its first part twice as long as its last.

terpsichorean *Dance* 1. A dancer. 2. Having to do with the art of dance. In ancient Greek mythology, Terpsichore (*tairp-SEE-ko-reh*) was the muse of dance and choral song.

terpsichorine *Vaudeville* A chorus girl, a slang corruption of TERPSICHOREAN.

terre, à *See* À TERRE.

terre à terre (*tehr ah tehr*) [French] *Dance* 1. In ballet, a term indicating steps to be executed on the ground, with the feet barely rising above the floor. 2. Said of a dancer who lacks ELEVATION.

tessitura (*teh-see-TOO-rah*) [Italian] *Music* The average placement of PITCHES in a melody within the total range of the voice singing it, without concern for one or two very high or very low pitches that may also be present. Two melodies may each have an absolute range of an octave and a half with the same highest and lowest notes, but one may have more notes in the higher part of the range and fewer in its low part than the other, and be considered therefore to have a higher tessitura.

test pattern *Television* A pattern of vertical and horizontal lines on the screen, with various measurements indicated along them, designed to show technicians precisely how accurately the system is reproducing images during transmission. *See also* COLOR BARS.

tetrachord *Music* In the musical teaching of ancient Greece, a sequence of four scale tones that repeats to comprise an octave.

tetralogy [from Greek] *Theater* A group of four related plays.

texture *Stagecraft* The simulation of roughness or smoothness on a surface, accomplished by various painting techniques including SCUMBLING, SPATTERING, SPLASHING, SPONGING, STIPPLING.

theater 1. A structure with a stage and space for an audience. 2. Metaphorically, the world of drama and dramatic presentation as distinguished, *e.g.,* from the world of dance or motion pictures.

theater-in-the-round *See* ARENA THEATER.

theater of cruelty *See* GRAND GUIGNOL.

theater of the absurd A mid-20th-century avant-garde style of theater that ignores conventional theatrical principles of logic and order and explores human feelings of isolation and the irrational, on the premise that life is essentially meaningless, human beings are

unable to communicate and any rational action is absurd. It has influenced many modern playwrights, including Samuel Beckett, whose plays *Waiting for Godot* and *Endgame* are classics that evolved from the genre.

theater of the ridiculous A late 20th-century farcical style of theater that satirizes life with grotesque sets and costumes, clowning, nudity and other intentionally outrageous effects, mocking all ideals. Charles Ludlam's Ridiculous Theater Company of the 1980s is one example.

theater people The professional producers, directors, performers and technicians who work in the theater.

theatrical 1. Having to do with the theater. 2. Exaggerated as in the theater.

theatrical agent *See* AGENT.

theatrical coach *Acting* One who teaches and advises a performer in the practice of the arts of theater, *e.g.,* singing, dancing, fencing, speaking, pronunciation.

theatrical cold cream *Makeup* A cream applied to the face before putting on theatrical make-up, to protect the face and to make it easy to remove the makeup after the show.

theatrical convention *Theater* Any gesture or manner of speech the meaning of which is instantly understood by the audience, though it may not seem natural outside the theater, *e.g.,* the unnaturally loud speech that actors use on stage to make their lines intelligible to the audience. The whole idea of singing the dialogue of an opera is a theatrical convention. Also called stage convention.

theatrical family *See* SHOW FOLK.

theatrical gauze *See* GAUZE, SCRIM.

theatrical hardware *Stagecraft* STAGE SCREWS, ROPE LOCKS, CLAMPS, etc., used in the theater.

theatrical net *Stagecraft* Any strong fabric with a very wide, open weave, suitable as a base for interwoven leaves, etc., to simulate foliage on the stage. Not to be confused with GAUZE or SCRIM.

theatrical speech *See* DELIVERY.

theatrics 1. The collective arts of theatrical presentation. 2. Any pattern of gestures or vocal mannerisms that are exaggerated beyond the intensity of ordinary life and are appropriate to the stage.

thematic *Music* Having to do with themes, as in thematic MOTIFS.

theme *Music* A musical idea that forms the starting point for an extended musical work.

theme song *Music* A song usually associated with a particular performer or performing group and repeated at the beginning or end of its musical programs.

theorbo *Music* A large LUTE in the high bass register.

theremin *Music* The first internationally successful electronic musical instrument, with a sound somewhat like that of a fine VIOLONCELLO. It consists of a box with two chromium-plated rods mounted on top. One rod is vertical and straight, the other forms a closed hoop. To sound notes of a specific pitch, the player moves the left hand up or down near the vertical rod without actually touching it. Since there are no keys, frets, nor indicators of any kind, controlling the pitch requires great skill and experience. Finger motions help supply the attacks and separations that make each note discrete. To control dynamics, the player moves the other hand into the center of the space within the hoop. The more space the hand takes up within the hoop (never touching it) the louder the tone of the instrument. It was invented by the Russian physicist and amateur cellist Leon Theremin in 1920, and was brought to the United States in 1930. Its most prominent performer was the violinist Clara Rockmore, who gave the first performances of several concertos written for the instrument.

thesis play *Theater* Any play of ideas, designed to expose problems and propose solutions for them.

Thesmophoria *Theater* A theatrical festival in ancient Greece in honor of women and in particular of Demeter, goddess of the family and of agriculture. It was the occasion of the production of one of the more outrageous comedies of Aristophanes: *Thesmophoriasuzae.*

thespian [from Greek] *Acting* An actor. The word may be related to the Greek word for oracle, though it is commonly assumed to come from Thespis, the name of a dramatist and poet of preclassical Greece.

thespian maids *See* MUSE.

thickness piece *Stagecraft* A small FLAT, a narrow board or a stiff piece of fabric placed against the edge of scenery pieces, *e.g.,* inside the frame of a door or a window, to simulate the thickness of a wall. *See also* SOFFIT.

thief *Acting* A SCENE STEALER.

thimble *Stagecraft* A pear-shaped steel ring tied at the end of a line of RIGGING that substitutes for a loop in the line, providing a tying point that protects the line from chafing.

thinking part *Acting* Slang term for a role with no lines.

third *Music* Any interval in which the upper and lower tones are separated by two SCALE steps.

third banana *Vaudeville* A STOOGE or a COMEDIAN who is a supporting player and FALL GUY for the TOP BANANA and SECOND BANANA.

third batten *Stagecraft* The batten in the third position back from the PROSCENIUM.

third border *Stagecraft* The border hung from the THIRD BATTEN.

third business *Acting* A supporting role two levels below the lead.

third position *Dance* One of the five basic POSITIONS OF THE FEET in ballet: with the feet completely turned out, in parallel, one foot in front of the other, and the heel of the front foot against the instep of the back foot.

Music *See* POSITIONS.

third stream *Music* In the 1960s, a style that combined elements of CLASSICAL MUSIC and JAZZ. The American composer Gunther Schuller, who coined the term, was one of its main practitioners. The bassist/composer Charles Mingus also experimented with the style. *Compare* FUSION.

"thirty minutes" *See* HALF-HOUR CALL.

thirty-second note *Music notation* One thirty-second of a WHOLE NOTE, written with three FLAGS.

THIRTY-SECOND NOTE

thorn *Music* A needlelike PLECTRUM glued to a JACK in a HARPSICHORD, which engages the string and releases it to make sound. In most older instruments, it is made from a crow's quill.

thorough bass *See* FIGURED BASS.

thorough-composed *Music* Fully composed, without repeated passages. Music, particularly songs, that has continuous development rather than, for example, repeating stanzas. The term came into general use in the 19th century to describe certain art songs, such as *Der Erlkönig* by Franz Schubert. Recently its meaning has been extended to include symphonic and operatic compositions of composers such as Richard Wagner, Giacomo Puccini, Paul Hindemith and others whose works tended to avoid STROPHIC FORM.

thrash metal *Music* In the 1980s and 1990s, a form of HARD ROCK that encourages its fans to participate in SLAMDANCING and STAGEDIVING, characterized by an extremely fast beat, repetitive bass lines, loud and aggressive solos and lyrics shouted into microphones. *Compare* HEAVY METAL.

three *See* IN THREE.

three-dimensional lighting *See* PLASTIC LIGHTING.

three-dimensional trim *Stagecraft* Any surface of the SET that includes trim that has been built in three dimensions rather than painted, *e.g.,* moldings, fireplaces, door knobs.

threefer *Lighting* A single power outlet that can accommodate three circuits. *See also* DUPLEX, QUAD BOX, SPLIT PLUG.

three-fold *Stagecraft* A set of three flats, hinged together to make a single unit of scenery with a JIGGER widening the space between two of them and DUTCHMANS covering the hinged edges. *See also* TWO-FOLD.

three-four time *Music* A musical meter consisting of measures of three QUARTER NOTES each.

three-light system *Lighting* Any style of stage lighting that illuminates the actors from three directions. It is necessary, for example, in an ARENA STAGE, with light on the acting area from three sources placed 120° apart. Some designers use four sources for the arena, with lights 90° apart. *See also* McCANDLESS METHOD.

three-line octave *Music* The octave that begins at c^2, two octaves above MIDDLE C. *See* OCTAVE NAME SYSTEM.

three-quarter position *Acting, Dance* A standing position on stage, facing an UPSTAGE corner, 45° from a full back position.

three-quarter time *See* THREE-FOUR TIME.

three-riser *Stagecraft* A single six-foot-wide RISER unit with three levels, built for members of a chorus to stand on during performance. *See also* STEP UNIT.

three-row-vision sequence *Theater* A seating plan in a theater having a RAKED house floor, with the seats of the second row set one-third their width to the side of the center line of the seats in the first row, the seats of the third row another third and so on, to improve the view of the stage from the audience. *Compare* AMERICAN PLAN SEATING, CONTINENTAL SEATING.

three-sheet *Theater* A theatrical poster made of three standard PRINTER'S SHEETS, to be pasted in a showcase outside the theater to advertise a show.

three-step unit *Stagecraft* A RISER with three levels above the stage floor.

three unities *See* UNITIES.

threnode, threnos [Greek], **threnody** *Music* A lament for the dead, a dirge.

thriller *Theater* A play of exciting suspense, often a murder mystery.

throat microphone *Audio* A small MICROPHONE hidden in the front of a collar so that it fits comfortably but snugly against the speaker's throat and can pick up speech sounds without also picking up background noise.

throaty *Acting, Music* An overly rich quality of vocal sound.

throne *See* DRUMMER'S THRONE.

through bass *See* FIGURED BASS.

through-composed *See* THOROUGH-COMPOSED.

throw *Lighting* The distance from which a light can adequately illuminate a given area. The throw is limited by a lighting director's subjective measurement of the intensity of its illumination on the surface of the SET. A BALCONY SPOT must have a long throw. A BABY SPOT, which has only a short throw, would not be adequate on the balcony.

throw a cleat *Stagecraft* To join two FLATS by lashing them together.

throw a line *Acting* To give another actor a cue.

throwaway *Acting* A line spoken at a level that is audible, but only barely so, to the audience.

 Vaudeville A line or a short routine that is only incidental to the show and can be played at the beginning while the audience is noisy and inattentive, when nothing essential will be lost.

throwaway ending *Music* A phrase or phrases of a piece of music that end the piece, usually gently, abruptly and quietly, to surprise and delight the listener without any of the traditional closing devices such as the codas and cadences upon cadences that would alert the listener to an imminent conclusion.

throw-line *Stagecraft* A rigging line thrown over a PIPE or into an open SHEAVE, rather than one attached to the pipe or fed through a regular sheave. *Compare* LASH LINE.

thrum *Music* To STRUM idly and amateurishly on the strings of a guitar or similar instrument.

thrush *Vaudeville* Slang term for a female vocalist.

thrust, thrust stage *Theater* 1. A stage with a large APRON that reaches out into the audience in front of the PROSCENIUM. 2. An open stage with a BACK WALL, no proscenium, and seating on three sides. *Compare* ARENA STAGE, TRANSVERSE STAGE.

thumb-piano *See* KALIMBA, MBIRA.

thunder barrel, thunder box *Stagecraft* A SOUND EFFECTS device consisting of a wooden barrel or box filled with heavy stones that rumble when it is slowly turned over.

thunder cart *Stagecraft* A wooden cart with wooden wheels, weighted so that it rumbles when rolled across the stage floor, serving the purpose of a THUNDER RUN but from the back of the stage instead of overhead.

thunder channel *See* THUNDER RUN.

thunder drum *See* THUNDER BARREL.

thunder machine *See* THUNDER BARREL, THUNDER RUN, THUNDER SHEET.

thunder run *Stagecraft* A large trough built of heavy boards above the ceiling of the HOUSE, and arranged so that it can be tilted slightly from end to end. When large round stones in the high end rumble and tumble to the lower end they make a sound that seems to move across over the heads of the audience, just like natural thunder. There are still theaters with thunder runs in the United States and Europe.

thunder sheet *Stagecraft* A SOUND EFFECTS device consisting of a large sheet of steel, hung vertically off the backstage floor. When a stagehand grasps the bottom end and shakes it, or strikes it with a padded mallet, the sheet produces a sound much like thunder.

ti (tee) *Music* A variant for the SOLMIZATION syllable SI.

ticket stub *See* STUB.

tie *Music* An arc drawn to connect two notes, indicating that the second note should not be played but held over to continue or sustain the sound of the first. Not the same as a SLUR.

Lighting To connect two circuits in parallel to a single dimmer.

tie cord, tie line *Stagecraft* A short cord used to tie drapery to a BATTEN.

tie off *Stagecraft* To complete any rigging or lashing operation by tying the rigging line to a cleat or a pin.

tie-off cleat (or **hitch, pin, rail** or **screw**) *Stagecraft* A point at which a LASH LINE can be tied. On a FLAT, it is usually the cleat on the BOTTOM RAIL.

tier *Circus, Theater* A balcony or a section of seats at a different level from other sections.

tierce (*tee-EHRS*) [French] *Music* 1. An INTERVAL of a THIRD. 2. An ORGAN STOP that sounds two OCTAVES and a MAJOR third above the key played.

tierce de Picardie *See* PICARDY THIRD.

tight *See* IN TIGHT.

tight close-up *Motion pictures* Any close-up in which the subject utterly fills the frame, with no background visible. *See* IN TIGHT.

tightrope, tightwire *Circus* A strong rope or wire stretched between two small platforms above the ground to support an AERIALIST doing a HIGH-WIRE ACT. *Compare* SLACKROPE.

tightrope walker *Circus* An AERIALIST who performs spectacular feats while balancing without other support on a TIGHTROPE. *See also* HIGH-WIRE ACT.

tights *Dance* A tight-fitting, stockinglike garment that covers the body from the waist down, or from under the bust down. A modern dancer's tights cover the hips and legs but leave the feet bare. *See also* LEOTARD.

tilt *Motion pictures* To turn a camera vertically to shoot a subject that is at, or is moving at, a sharp angle upward or downward. This motion requires a camera mounting that can operate on two axes, so that it can both pan and tilt. *See* PAN/TILT HEAD.

tilt shot *Motion pictures* Any shot that requires the camera to be tilted up or down on its mount. *See also* PAN/TILT HEAD.

timbales (*tim-BAH-lehs*) [Spanish] *Music* A pair of very small TIMPANI of African-Cuban origin used for basic rhythm in Latin American music, serving the purpose that SNARE DRUMS serve in an American dance band. They have hard skins tuned a FOURTH or a FIFTH apart and are played with light sticks.

timbral [English] *Music* Having to do with TIMBRE. This is a modern usage that fulfils a need when discussing the wave-form functions of an electronic synthesizer that can produce simultaneous sounds imitative of different instruments. *See also* MULTITIMBRAL.

timbre (*TENHM-breu*) [French] *Music* The characteristic sound of any instrument, without regard to its pitch or loudness. The OBOE's reedy timbre is in sharp contrast with the smooth, mellow, dark timbre of the low register of the clarinet. Timbre results from the specific balance of intensities in the HARMONIC SERIES of the tones produced by the instrument. In the clarinet, for example, a few odd-numbered harmonics tend to predominate, whereas the basic shape of the tone of a FLUTE, visualized on an oscilloscope, is that of a pure SINE WAVE with no harmonics. The oboe, in contrast, has a nearly SQUARE WAVE that produces most of its harmonics at equal intensity, and therefore has more that are actually audible. *See also* MULTITIMBRAL.

time *Music* Loosely, the meter of a piece of music, as in THREE-QUARTER TIME, or CUT TIME.

Theater The period in history, the season or the time of day in which the play and its parts are imagined to be set.

time code *Motion pictures, Television* A code of four pairs of digits showing the elapsed time (since the beginning of the segment) in hours, minutes, seconds and FRAMES, electronically coded in the video signal of a video WORKPRINT, giving the editor precise synchronization information throughout the editing process.

time cue *Lighting* A CUE that requires a specific amount of time to complete. A "30-second dim to black" is a time cue. Dimming the lighting to simulate a sunset, starting at a certain line in the script and ending as the scene ends, is another.

time-lapse *Motion pictures* Short for time-lapse cinematography, the process of shooting individual frames of a motion picture at long, evenly spaced intervals under the control of a timekeeping device to visualize a process that is otherwise too slow to be perceptible. By means of time-lapse, for example, a cinematographer can show the progress of a plant bud opening to become a flower.

timer *Motion pictures* A laboratory technician who measures the densities of individual colors in every shot of a CONFORMED ORIGINAL and produces a TIMING TAPE that will control the printing process, shot by shot as the original passes through the machines, so that the colors will be correctly exposed and will look natural in the ANSWER PRINT and the INTERNEGATIVE.

time sheet *Stagecraft* A stage manager's record of exact playing time, including audience responses and intermissions.

time signature *Music* A display of two numbers, one above the other, at the beginning of each STAFF. The lower number defines the basic pulse within the measures that follow. The upper number indicates how many such beats occur within the measure. If the music is composed in COM-

TIME SIGNATURE

POUND TIME, two or more upper figures of the time signature represent the different subdivisions of the measure, and the digit below indicates whatever note is most appropriate as the unchanging pulse.

time, unity of *Theater* The general idea, somewhat inaccurately inferred from Aristotle's *Poetics,* that the apparent time that passes in the plot of a play should be a period the audience can keep in the back of the mind easily during the performance, a time such as one day or the duration of one comprehensible event. *See also* PLOT.

timing *Acting* An actor's ability to play upon the rhythms of speech, the reactions of other actors and of the audience so that every word and every gesture happens exactly when it will achieve the strongest effect.

Motion pictures The color-correcting process. *See* TIMER.

timing tape *Motion pictures* The record of the decisions made by the TIMER during the timing process. In past years it was a punched paper tape that ran through a special machine that controlled exposures in the printer. Nowadays, it is digital information on a computer disk.

timp *Music* Short for TIMPANI. A single drum of the family of timpani. The proper singular, in Italian, is timpano. American musicians, however, often prefer the term TIMP for a single drum.

timpani (plural) *Music* A family of large, bowl-shaped metal drums with an overall range of just under two octaves, from D_1 to MIDDLE C, covered by four sizes of drum with diameters ranging from 29 inches for the deepest tone to 23 inches for the highest. Each drum consists of a large copper bowl covered with a calfskin or plastic sheet wound over a ring that stretches it taut over the rim. The HEADS can be tuned during performance by various mechanisms. Timpani first came to European attention during the Crusades, when they were carried in pairs, slung over the backs of horses and played by Islamic warriors on the march. Haydn was the first to use them in a significant way in several works, including the famous *Surprise Symphony* of 1791. Not to be confused with TYMPANUM.

tin beard *Makeup* Slang term for a badly made false beard, *e.g.,* too stiff or with lumps of hair sticking out in the wrong places.

tin ear *Music* A disparaging slang term, describing someone who has trouble understanding music and cannot sing in tune. *See also* TONE DEAF.

tin hat *See* FUNNEL.

tinny *Music* A disparaging description of the sound of an instrument, particularly an out-of-tune piano, that has plenty of HIGHS but few LOWS in its characteristic tones.

Tin Pan Alley *Music* In the 1920s, the block of West 28th Street between Fifth and Sixth Avenues in New York City where many publishers of popular music set up their offices, just a few steps away from the big theaters clustered at that time along Broadway around Herald Square. It was a meeting place where musicians could exchange gossip and job information, and where vaudeville entertainers could listen to new tunes played and sung by SONG PLUGGERS. In those days, if a vaudevillian took a new song to feature in a cross-country tour, the publisher could count on massive sales of its sheet music. During the 1930s, as the theaters began to expand into Times Square, the music

stores and publishers followed, occupying the block between Sixth Avenue and Broadway on West 47th Street. There are now many musical instrument stores in this area, but there are few publishers and no song pluggers at all.

tinsel town *Motion pictures* Nickname for Hollywood, California, and its neighborhood, where the big motion picture production companies flaunted their taste for gaudy excess during the 1920s and 1930s.

tin whistle *Music* A toy whistle, also called a pennywhistle, consisting of a short tube with a FLUE mouthpiece and four or five finger holes. It has been used in audience-participation works including one by the English composer John McCabe. *Compare* SLIDE WHISTLE.

tip jack *Stagecraft* A folding frame with wheels, hinged to the back of a large flat piece of scenery. When the scenery is in place and held there by a STAGE BRACE, the jack can be folded up against its back, out of the way. When the piece must be moved, the jack is let down until its wheels touch the floor and the piece tilted back onto it. When the scenery is heavier than an ordinary FLAT the tip jack sometimes forms the bottom part of a permanent frame built out from the back, rather than simply being hinged. *See also* OUTRIGGER.

tirare (*tee-RAH-reh*) [Italian] *Music* Literally, to pull or draw out. In string playing, a term indicating the DOWNBOW.

tire-bouchon, en *See* EN TIRE-BOUCHON.

tiring room *Theater* In Elizabeth theaters, the actors' dressing room.

title *Motion pictures* 1. The title of the film. 2. Any words, including CREDITS, superimposed on the picture. *See* CAPTION, SUPER.

title role *Acting* The role of a character whose name is in the title of the opera, play or motion picture.

titles *See* SUBTITLES, SUPER, SUPERTITLES.

title song *Motion pictures, Theater* A song with the same title as the play or motion picture to which it is attached.

toasting *See* REGGAE.

Toby *Theater* 1. A character in old MELODRAMAS who is always the butt of jokes or the gullible one who is swindled. 2. The dog in a PUNCH AND JUDY SHOW.

toccata (*toh-KAH-tah*) [Italian] *Music* Literally, touched. A brilliantly expressive composition in free style for a keyboard instrument, with contrasting sections of full chords, running counterpoint and fugal passages.

toe dance A ballet performed on POINT, *i.e.*, on the tips of the toes, in reinforced shoes.

toe-dance To perform a dance on POINT.

toe dancer *Dance* A dancer who performs on POINT.

toe shoe *See* POINTE SHOE.

toggle bar, toggle rail *Stagecraft* The horizontal bar across the center of the frame of a FLAT. *See also* RAIL.

toggle iron *Stagecraft* A flat piece of metal nailed over the joints between the TOGGLE BAR and the STILES of a FLAT, to keep them at right angles to each other. *Compare* KEYSTONE.

toll *Music* To sound repeatedly at equal slow intervals of time, like a church bell.

tombé, tombée (*tom-BAY*) [French] *Ballet* Literally, fallen. A movement in which the dancer falls forward, backward or sideways, from one leg to the other or from both feet to one foot, ending in a FONDU on the WORKING LEG.

Tom show *Theater* A production of *Uncle Tom's Cabin*, based on the 1852 novel by Harriet Beecher Stowe. It was a very popular play for touring companies in the period around the American Civil War.

tom-tom *Music* 1. An American Indian DRUM of indeterminate pitch made of wood with stretched skin or plastic heads at each end, bound together with thongs. 2. A modern drum of similar shape, but with a cylindrical plywood body designed to produce a deep, resonating tone quite different from that of the somewhat similar SNARE DRUM. They come in several sizes and are often mounted in arrays of up to four or five different pitches, the largest producing the deepest tone. *See also* ROTOTOMS.

tonadilla (*toh-nah-DEE-yah*) [Spanish] *Music* A short Spanish comic opera of the late 1700s and early 1800s originally composed to be an ENTR'ACTE, but later treated as an independent work. Unlike the earlier and more elaborate ZARZUELA, a tonadilla has only a few characters who act and sing only one or two songs, and occasionally a chorus.

tonal *Music* A general characterization of music that has a TONAL CENTER and whose melodies and harmonies relate to each other in some variant of a traditional system. The opposite of ATONAL.

tonal center *Music* The principal tone of a mode or scale that serves as a reference point for the harmonic structure of a piece of music, also called the TONIC.

tonal light *Lighting* General light surrounding active acting areas, designed to supply the tone of the scene.

tonalist *Music* A composer who works within a TONAL structure.

tonality *Music* 1. The general structure of music that has a TONAL CENTER to which all its melodies and harmonies are in some way related. 2. Any of several systematic structures derived from HARMONICS, *e.g.,* major and minor keys. *Compare* ATONALITY, MODALITY, POLYTONALITY.

tone *Music* 1. A continuous musical sound of definite PITCH. 2. The quality of any sound. *Compare* TIMBRE. *See also* HARMONICS.

Lighting, Stagecraft A consistency of colors in a scene.

tone arm *Audio* A short, pivoted support that carries part of the weight of a STYLUS and its cartridge mount as it tracks a groove in a recorded disk. The vibrations picked up by the stylus are converted within the cartridge into electrical impulses that are carried through wires inside the tone arm to the amplifying circuitry of the PLAYBACK machine, which reconverts them into audible sound.

tone cluster *Music* A DISSONANT mass of many musical tones, each a SEMITONE or a tone from the next, sounded simultaneously like a chord. Tone clusters first became noticeable in the piano music of Henry Cowell who performed them with his whole hand, a fist, or even a forearm pressed on the keys. They have since become a feature of music in several forms, set often for choirs of brasses or of human voices. Outstanding examples are the *Music for Brass Choir* by Wallingford Riegger (1950), and Thea Musgrave's *The Last Twilight*, a choral drama for double chorus and brass (1980).

tone color *Music* The difference of TIMBRE of tones produced by different instruments. The tone of the French horn, for example, is sometimes said to have a darker color than that of the trumpet.

tone control *Audio* An electronic control that alters the balance of HIGHS and LOWS in signals passing through an amplifying circuit. *See also* EQUALIZER.

tone-deaf *Music* Unable to hear or reproduce vocally the differences between musical tones of different pitches.

tone poem *See* SYMPHONIC POEM.

tone row *Music* A row of musical tones. In modern practice, a phrase of (usually) twelve notes, one of each tone of the chromatic scale with no repeats, used as the thematic basis for a work of SERIAL MUSIC. For centuries composers have been aware that the tones of the scale seem to pull upward or downward toward other tones, depending on how they are combined in a matrix of sound, *i.e.*, in chords and in harmonic passages. To some this seemed to impose a limitation on the composer's freedom to write. In the early 20th century, Arnold Schönberg and others experimented with the idea that each of the 12 tones of the chromatic scale, in the context of EQUAL TEMPERAMENT, could be considered "equal" to every other tone, that they should be heard as individual tones having no inherent influences to move in any particular way, allowing the composer complete freedom. *See* SERIAL MUSIC.

tonette *Music* A very simple wind instrument of small range, somewhat like a primitive flute, blown through the end. *Compare* SLIDE WHISTLE, TIN WHISTLE.

tongue, tonguing *Music* A wind player's technique for articulation between notes. The player stops the breath with the tip of the tongue pressed to the spot just above the teeth, to the pursed lips or to the reed of the instrument, as if speaking the sound "t," then releases it as a sharp start for the tone as in the audible syllable *ta*. *See also* DOUBLE-TONGUE, FLUTTER-TONGUE, TRIPLE-TONGUE.

tonic *Music* The fundamental tone of a SCALE, that gives the scale its name.

tonic sol-fa *See* MOVABLE-DO SYSTEM.

toning lights *See* TONAL LIGHT.

tonometer *Music* General name for any instrument used to measure the pitch of an audible tone. In modern times tones are measured with an electronic oscilloscope, to which the simple term *tonometer* is almost never applied.

tonsil test *Acting* Slang term for a vocal audition.

tonsure wig *Makeup* A special wig with a simulated bald spot on top, in imitation of the way monks traditionally cut their hair.

Tony *Theater* An award for distinguished achievement in theater given annually by the American Theater Wing in memory of the actress Antoinette Perry, who was the organization's president during the 1940s. The award was established in 1946 to honor the best play or musical on Broadway and the best performers, directors, authors, composers, choreographers and designers of the year.

toomler [Yiddish] *Vaudeville* The chief entertainer in a hotel or a resort in the BORSCHT CIRCUIT. The term is derived from *tumult-macher* (tumult-maker).

toon *Motion pictures* 1. Short for CARTOON. 2. A character in a cartoon.

toot *Music* 1. A single, brief sound played on a wind instrument. 2. To make a single, brief sound on a wind instrument.

tooth enamel *Makeup* A tinted substance that can safely be applied to an actor's teeth to alter their natural color or, if it is black, to simulate a missing tooth.

top *Acting* 1. The beginning of a scene. 2. To outdo a previous event.

Music The beginning of a scene or a piece of music, *i.e.,* at the top of the page or the piece. *See also* FROM THE TOP.

top a laugh *Acting* To outdo the effect of the previous GAG or comic BUSINESS and get more of a laugh from the audience.

top a line *Acting* To outdo the effect of a previous line by speaking the next line with more intensity or at a higher pitch than the last.

top banana *Vaudeville* The most important comedian in the show.

top billing *Theater, Vaudeville* Placement of the name of a performer, director or producer at the top of the advertisements for the show, above its title. *See also* STAR BILLING.

top drop *Stagecraft* Any BORDER.

top hat *Costume* A tall, cylindrical and collapsible black silk hat designed for formal occasions. The hat worn by Fred Astaire in the film *Top Hat* (1935) with Ginger Rogers.

Lighting *See* FUNNEL.

Motion pictures *See* HI-HAT.

Music A style of MUTE for the trumpet, shaped like a top hat and made to fit over the bell of a trumpet or trombone to mellow its tone. *Compare* HAT MUTE.

topical songs *Music* American folk or popular songs that focus on contemporary social problems or injustices, or songs designed to arouse interest in a common cause. Examples range from those of William Billings that date from the American revolution, to the *Dust Bowl Ballads* of Woody Guthrie and songs about the labor movement, etc.

top light, top lighting *See* DOWNLIGHT, DOWNLIGHTING.

topliner *See* HEADLINER.

topper *See* TOP HAT.

top rail *Stagecraft* The top crosspiece in the frame of a FLAT.

torch singer *Music* A singer, especially a woman, with a voice of heavy, dusky quality, who specializes in the BLUES and similarly sad and passionate popular songs.

torch song *Music* The BLUES or any other deeply passionate, unhappy, popular song. The term was common parlance in the 1930s.

tordion *Dance* A lively 16th-century court dance similar to the GALLIARD, in triple time, often performed as the last section of a BASSE DANSE.

tormentor pipe *Lighting* A light pipe just behind the TORMENTORS.

tormentors *Stagecraft* A pair of narrow structures or drapes hung close behind the MAIN CURTAIN at the edges of the PROSCENIUM opening to define the width of the stage, as required by the set designer for a particular show, and to conceal its side areas from the view of the audience. Tormentors remain in place for the entire show and do not change with scene changes. *See also* BORDER, BLACKS, TEASER, WINGS.

tormentor tower *Lighting* A vertical light pipe just behind the TORMENTORS.

tormentor wing *Stagecraft* A wing placed close to the PROSCENIUM to serve the purpose of a tormentor, but painted to become part of the scene on stage.

torms *Stagecraft* Short for TORMENTORS.

tornare, tornando (*tor-NAH-reh, tor-NAHN-doh*) [Italian] *Music* To return, returning.

Totentanz (*TOH-ten-tahnts*) [German] *See* DANCE OF DEATH.

touch *Music* 1. The degree of resistance of the PIANO keys to the pressure of the player's fingers. 2. The manner in which the player actuates the keys: heavily, lightly or anything in between those extremes; varied or unvaried; using pressure from the fingers and wrists alone, or from the shoulders, arms and fingers, etc.

touch dancing *Dance* Ballroom dance in which couples hold each other, as in the FOXTROT or CHA-CHA, in contrast to the many rock dances (FRUG, HUSTLE, MASHED POTATO) executed as solos.

toupée tape *Makeup* A short piece of flesh-colored tape used to hold a hairpiece on an actor's head so that it will be secure throughout a performance. The tape can be covered with makeup to conceal its edge.

tour *Theater* 1. The itinerary of a traveling theater company performing in several towns and cities away from its base. 2. To travel, giving a series of performances in a circuit of distant towns and cities.

tour de promenade *See* PROMENADE.

tour de rôle (*toor deu ROHL*) [French] *Acting* A series of performances in which an actor plays each of the roles he or she has in repertory.

Ballet A policy that calls for alternating one principal dancer (not an UNDERSTUDY) with another in a specific role.

tour en l'air (*toor enh LEHR*) [French] *Ballet* A turn or PIROUETTE in the air, usually executed by a male dancer. The dancer leaps vertically off both feet from a DEMI-PLIÉ, makes one or more complete turns and lands in FIFTH POSITION with the feet reversed.

touring cast *Theater* The cast of a touring company, as distinguished from another cast that continues performing where the play opened.

touring company *Theater* A theater company that tours. Some touring companies consist of an ADVANCE MAN, an entire CAST, a skeleton CREW and all the scenery and PROPS needed for performances. They hire local STAGEHANDS in each town. Others consist of only a few actors who play leading parts. They pick up local actors and rehearse them for minor parts and use local people for their crews. *See also* BORSCHT BELT, STOCK COMPANY, SUMMER STOCK.

touring staff *Theater* Depending on the type of production and the budget for a TOUR, the staff may consist of advance people who make logistical arrangements and do promotion, a touring STAGE MANAGER who directs the entire tour, and a chief carpenter and chief electrician who hire local technicians to work with them.

tour jeté (*toor zheu-TAY*) [French] *See* JETÉ ENTRELACÉ.

tournant, en *See* EN TOURNANT.

tourner (*toor-NAY*) [French] *Ballet* To turn around. One of the seven MOVEMENTS IN DANCE.

towel *Theater* To close (a failing show), to "toss in the towel."

tower *Audio* *See* AUDIO TOWER.

Lighting 1. A vertical light pipe, especially one at either side of, and outside of the PROSCE-
NIUM. *See also* LIGHT TREE. 2. A tall structure at each side of the proscenium of an out-
door theater, carrying the lights that illuminate the entire stage.

tower lights *Lighting* The lights mounted on a LIGHT TOWER.

tower operator *Audio* An audio technician who operates the sound system in an audio tower
at an outdoor concert or show.

Lighting A technician stationed in a LIGHT TOWER to operate its lights, including any
FOLLOW-SPOTS, during the show.

tower speakers *Audio* The loudspeakers mounted in the AUDIO TOWER.

toy-toy *Dance, Theater* An essentially meaningless word used by European dancers to express
good luck to a performer about to go on stage. *See also* BREAK A LEG, MERDE.

tr. *Music* Abbreviation for TRILL, placed above a note to be trilled. Often followed by a wavy
line to indicate the duration of the trill.

track *Audio, Motion pictures* The recorded sound for a motion picture.

Stagecraft The metal channel through which the little wheeled hooks that hold up a stage
curtain travel while it is being opened or closed.

track bracket *Stagecraft* A bracket that supports the channel that supports a curtain.

tracker action *Music* A wholly physical mechanism operated by the KEYS and STOPS of an
ORGAN that actuates the valves allowing compressed air to flow to the pipes. Named for
one of its parts; a long stick connecting the key in the console with the valve mechanism
among the pipes. It is distinguished from other actions that may be operated by electrical
means.

tracking shot *Motion pictures* A SHOT made by a camera mounted on a DOLLY that rolls along
special tracks, laid in place by GRIPS, following the actors.

trade fours, trade eights, etc. *Music* In jazz, to improvise a passage together with another
soloist, each playing four, eight or more bars and each, having heard the other's work,
inventing new variations in implied competition. *See also* CUTTING CONTEST.

tragedian, tragedienne *Theater* One who performs or writes tragedies.

tragedy [from Greek, *tragos* + *ode*, "goat song"] *Theater* In modern thinking, tragedy is a
drama in which the main character suffers a change of fortune that leads inevitably to a
downfall. In many works, the irreversible downfall is interpreted as death, though death is
only one of its possible manifestations. In the elaborate definition by Aristotle in his *Poetics*,
tragedy is never limited to plays with sad outcomes. He called it an imitation (MIMESIS) of
an ACTION (PRAXIS) in life. Whether its outcome is happy or sad, it must have a PLOT, CHAR-

ACTERS, thought and meaning, language, beauty and spectacle, and in the plot there must be a REVERSAL OF CIRCUMSTANCES that leads to a completely new situation for the characters, for better or worse. All this unfolds in ritual form. The origin of the word *tragedy* is a matter of uncertainty, but it surely has to do with very ancient rites involving the goat (*tragos*) and song (*ode*) that were practiced by goatherds on the rocky heights that eventually became the Acropolis at Athens. Gradually taking on more elaborate form (*see* DIONYSIA), these rites may well have developed into formal drama. From a theoretical point of view, all drama has ritual form. Aristotle defines the final effect of tragedy on the viewer as "a CATHARSIS of pity and fear." In the course of time the classical conception of PITY AND FEAR has lost some of its specific roots, particularly the implied context of supernatural fate. Nevertheless, the process of tragedy remains a ritual process; the spectator goes through the procedure of a drama knowing all the time that it will be resolved in the end, but becomes emotionally involved nevertheless. A modern spectator becomes a participant, emotionally involved in the tragic situation (*see* SUSPENSION OF DISBELIEF), transfixed by its crisis, and transformed in mind and being by its resolution, finally arriving at a new realization in life from which a return to the former condition of innocence is not possible. It is as irreversible a process for the viewer as for the characters in the play, and it remains true to the ancient definition. *See also* COMEDY, ELEMENTS.

tragic *Theater* Having the quality of TRAGEDY, *i.e.*, leading irrevocably to a DOWNFALL.

tragic flaw *Theater* Something inherent at the outset of a TRAGEDY, but of unrecognized significance until it is revealed and becomes the cause of the protagonist's DOWNFALL. Faust's insatiable greed to reexperience youth, for example, is the tragic flaw that leads him to sell his soul to the devil.

tragic irony *Theater* The underlying significance of some factor in the PLOT of a TRAGEDY that becomes paramount and causes an eventual downfall.

tragic muse The muse Melpomene, one of the nine daughters of Zeus (sky) and Mnemosyne (memory) in classical Greek mythology.

tragicomedy *Theater* Any play that is both tragic in form and outcome, but comic in many of its scenes.

trailer *Motion pictures* Any very short film that is spliced to follow a FEATURE, especially one that advertises a coming attraction for the theater. In modern practice, trailers frequently precede the feature, rather than follow it.

Stagecraft A narrow WING with a curtain attached behind it.

trance music A meditative style of music, also called space music, that consists of long-sustained quiet chords and repetitive melodic phrases creating an atmosphere of serenity and dreaminess. Tempos are usually slow, with little rhythmic activity. Composers or improvising musicians rely heavily on SYNTHESIZERS and electronic instruments to add to the otherworldly effect.

tranquillo (*trahn-KWEEL-loh*) [Italian] *Music* Peacefully, with tranquillity.

transcribe *Music* To rewrite in another form without changing the content, *e.g.,* to rearrange the notes of an instrumental work so that it can be played on a piano. A transcription is similar to an arrangement, but usually is more faithful to the original material. *See also* ORCHESTRATE.

transcription *Music* An old work written in a new format without change of basic content.

transformation *Music* The gradual process of modifying a theme during the DEVELOPMENT section of a work. Not the same as VARIATION.

transformation scene *Stagecraft* A scene that changes into another as if by magic in full view of the audience. Such changes were popular in 17th- and 18th-century theaters where they had to be accomplished by devices such as an array of vertical wooden prisms, carefully aligned, that could be turned simultaneously by a connecting mechanism under the stage floor. In each of its three positions the prisms presented a smooth, flat surface on which a scene was painted. Scene A suddenly became scene B when the prisms were turned partway, and then scene C when they were turned again. They were used in the classical Greek and Roman theaters and were called *periaktoi* (in demotic pronunciation: *peh-ree-AHK-tee*). The same technique is used today to lure travelers' attention to similarly equipped, mechanized billboards.

transformer *Lighting* An electrical device, shaped like a large metal box, that converts electrical power as it is delivered from the high-voltage lines in the street, to a lower voltage usable in the circuitry of the theater.

transient *Audio, Lighting* A brief unwanted surge in power that shows up in an audio circuit as a click, or in a lighting circuit as a sudden brilliance. It can occur, for example, during a thunderstorm when lightning strikes a nearby power line, and can ruin equipment.

transition *Music* A passage that forms a bridge between two different sections of a work of music.

Theater A scene providing a bridge between two usually more important scenes.

transparency *Lighting* A clear plastic sheet on which an image has been painted or imprinted photographically so that it can be projected into the set or on the CYCLORAMA as part of the scene.

transpose *Music* To play or rewrite a passage or a piece of music in a KEY different from that in which it was originally written.

transposing instrument *Music* Any instrument whose actual sound is systematically different from the written notes the player reads. The written note MIDDLE C on the GUITAR, for example, sounds one octave lower, as C (*see* OCTAVE NAME SYSTEM). A SAXOPHONE player reading the note G, will hear the ALTO SAX produce B-FLAT below it, or the TENOR produce F. The system is useful because the scale that uses the simplest fingering for each type of instrument occurs at a different pitch level. That scale is considered to be its C scale, like the natural scale of the white keys of the piano, even though its actual sound occurs at a different pitch than written.

transposition *Music* The technique of playing or rewriting a passage of music in a different KEY than that in which it was originally written.

transverse flute *See* FLUTE.

transverse stage *Theater* A stage placed between two sections of audience facing one another. *Compare* ARENA, THRUST STAGE.

transvestite *Acting* An actor wearing the clothes of the opposite sex.

trap, trap door *Stagecraft* A covered opening in the stage floor through which actors or scenery may rise into the acting area or descend out of it. *Compare* ELEVATOR STAGE. *See also* GHOST TRAP, VAMPIRE TRAP.

trap cellar *Stagecraft* The area under the stage where actors prepare to ascend to stage level through TRAPS.

trapeze *Circus* A short horizontal bar suspended at each end by vertical ropes attached to a structure high above the floor. AERIALISTS swing on the trapeze, sometimes from one trapeze to another, performing daring maneuvers in the air.

trapeze artist *Circus* An AERIALIST who performs in the air using TRAPEZES.

traps *Music* A complete set of DRUMS, CYMBALS and other PERCUSSION INSTRUMENTS arranged for a single player in a JAZZ or dance band.

traurig (*TRAU-rikh*), **traurigkeit**, (*TRAU-rikh-kait*) [German] *Music* Sad, sadness.

traveler, traveler curtain *Stagecraft* 1. A stage curtain that opens horizontally from its center. A DRAW CURTAIN. 2. The track that carries such a curtain.

traveling cyclorama *See* MOVING PANORAMA.

traveling stage *See* WAGON STAGE.

travel shot *See* TRUCK SHOT.

travestie, en (*onh trah-ves-TEE*) [French] *Ballet* A term applied to a female dancer in male dress and performing a male part, or to a male dancer in female costume.

travesty *Theater* A grotesque farcical parody of a serious play or story intended to make the original work seem ridiculous. The term derives from the same root as TRANSVESTITE, since many such parodies place men in women's roles and vice versa for added comic effect.

tray *Lighting* A metal pan hung underneath a spotlight, especially a BALCONY BEAM, to catch anything that might accidentally fall, such as an overheated GEL.

treadmill stage *Stagecraft* A low platform with a continuously moving belt upon which an actor may walk without actually moving out of position. It is often hidden behind a GROUND ROW. Also called an endless runner.

tread the boards *Acting* To appear on stage as an actor. To take up the profession of acting.

treatment *Motion pictures* A brief one- or two-page description of a proposed motion picture, giving both its plot and a general idea of how it is intended to be shot and how it will look on the screen. It may have been written as part of an original proposal by a freelance author or as a reworking of another's story in film terms by a member of the production company's staff who specializes in treatments. Once a treatment has been accepted by a PRODUCER, the next step is usually a SCREENPLAY.

treble *Music* 1. The high range of music, roughly the octave and a half above MIDDLE C. 2. The highest choral voices, the soprano and mezzo-soprano.

treble clef *Music notation* G-CLEF.

treble staff *Music notation* The staff defined by the presence of a G-CLEF at its beginning.

tre corde (*treh KOR-deh*) [Italian] *Music* Literally, three strings, *i.e.,* without using the SOFT PEDAL. *Compare* UNA CORDA.

tree *Lighting* A vertical LIGHT PIPE with horizontal bars attached at appropriate levels to hold lights. *See also* TOWER.

tree border *Lighting* A vertical LIGHT PIPE placed in the wings of the stage.

tree tab *Stagecraft* A short DROP painted to simulate the leaves of a tree that hangs only partway down from the FLIES, terminating at a scene unit representing the trunk of the tree.

tremolant *Music* An organ STOP that causes air to pulsate rapidly as it enters the pipes, causing the tones of the pipes also to pulsate.

tremolo *Music* 1. A rapid pulsation of the tone of a stringed instrument, accomplished by rapid up-and-down bowing. Not to be confused with VIBRATO. 2. A variable pulsation of the tone of a VIBRAPHONE. 3. An ORGAN STOP that produces a TREMOLANT on selected ranks of pipes.

trepak (*TRAY-pahk*) [Russian] *Dance* A Ukrainian folk dance in fast 2/4 time, typified by vigorous squatting steps and big leaps, performed by men. A fine example is the Russian Dance in Marius Petipa's ballet *The Nutcracker.*

trescone (*treh-SKOH-neh*) [Italian] *Dance* Literally, a REEL. An Italian country dance of the 16th century in duple time, once performed at wedding celebrations by four couples in round or square formations.

trestle, trestle stage *Stagecraft* A portable stage.

triad *Music* A three-note chord consisting of a ROOT, its THIRD and its FIFTH, *e.g.,* C - E - G. Triads are named according to their roots. *See also* FIRST INVERSION, ROOT POSITION, SECOND INVERSION.

trial set-up *Stagecraft* Scenery tentatively placed for a full stage rehearsal of a show with most of the units in place but not necessarily in their final state, ready to be adjusted as necessary and SPOTTED.

triangle *Music* A PERCUSSION INSTRUMENT consisting of a light steel rod bent twice to form an open triangle with sides of about 10 inches, suspended freely from a stand. The player strikes it with a smaller, straight steel rod to produce a brilliant bell-like tone of very high pitch.

triangle play *Theater* Any play involving the relationship of three lovers.

triangular movement *Acting* A simultaneous movement of three actors in different areas.

trick line *Stagecraft* A strong black string or wire, invisible to the audience, used from off-stage to move or to actuate something on stage.

trick wire *Stagecraft* A strong wire, *e.g.*, PIANO WIRE, invisible to the audience and used to suspend an actor or a piece of scenery in the air during a scene. *See* FLYING.

trihoris *Dance* A 16th-century dance from Brittany, a type of BRANLE.

trill *Music* 1. An ornament in music consisting of a smooth, continuous and usually rapid alternation between a tone and its upper NEIGHBORING TONE. 2. To perform a trill on a specified note.

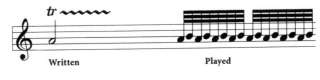

Written Played

TRILL

trilogy *Theater* A series of three plays by one author telling three stories about the same subject, *e.g.*, *Œdipus the King*, *Œdipus at Colonus* and *Antigone*, all written by Sophocles. *See also* TETRALOGY.

trim *Stagecraft* To adjust everything on the stage, especially if the stage is RAKED, to make the set look right.

trim chain *Stagecraft* A short length of chain between a BATTEN and its wire RIGGING LINE that helps support a heavy DROP and allows precise adjustment of its level.

trim mark *Stagecraft* A marker tied or clamped to an OPERATING LINE as a cue to the operating technician to stop and lock the line in the position at which the scenery or curtain at the other end will be in the right place.

trim prop *Stagecraft* A stage PROP that is part of the set, such as flowers in a vase, not carried by actors. *Compare* PERSONAL PROP.

trim rail *Stagecraft* A rail underneath the PIN RAIL backstage where all the operating lines for scene units, which have been wound around pins on the pin rail, can be tied off when the units are in the right positions.

trio *Music* 1. An ENSEMBLE consisting of three instruments or voices. 2. A piece of music written for such an ensemble. *See also* PIANO TRIO, STRING TRIO.

triolet *See* TRIPLET.

trio sonata *Music* A piece of contrapuntal music of the BAROQUE period composed in three parts, the lowest of which is a FIGURED BASS. It was commonly performed by four players, *e.g.,* two violins, a violoncello and a keyboard instrument, the latter two playing the figured bass. Bach composed six pieces for the organ that he called trio sonatas because each consisted of three CONTRAPUNTAL lines for the single instrument.

trip-cyclorama *Stagecraft* A CYCLORAMA that folds to smaller dimensions when it is raised, *e.g.,* a very high cyclorama with both top and bottom fitted with battens; while the top is being raised normally, the bottom can be raised twice as much until the entire surface folds to half its former vertical dimension and is out of sight in the flies.

triple bill *Vaudeville* Three different acts in one showing.

triple concerto *Music* A CONCERTO for three soloists and orchestra.

triple counterpoint *Music* A species of COUNTERPOINT having three parts.

triple fugue *Music* A FUGUE with three SUBJECTS that may be treated separately at first and then combined in a complex simultaneous counterpoint.

triplet *Music* A sequence of three notes intended to be played in the time of two of the same value. It is notated with a slur or a bracket over the three notes and the numeral 3.

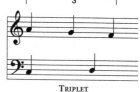

TRIPLET

triple time *Music* Any meter that can be subdivided into threes, *e.g.,* 3/4, 3/8, 6/8, 9/8 or 12/8.

triple-tongue *Music* With a wind instrument, to sound every note three times in rapid succession, by moving the tongue, as though pronouncing ta-ka-ta, ta-ka-ta. Not the same action or effect as FLUTTER-TONGUE. *Compare* DOUBLE-TONGUE.

trip line *Stagecraft* A secondary OPERATING LINE used to raise or lower the bottom BATTEN of a heavy DROP into or out of the FLIES.

tripper *Vaudeville* Slang term for a dancer.

tripping *Stagecraft* The process of FLYING a heavy DROP from two BATTENS, one at its top, the other at its bottom. When the drop is flown, both battens are drawn up into the FLIES.

tritone *Music* Any interval the width of three whole tones, *e.g.,* C - F-sharp or F - B. The tritone, which appears in the HARMONIC SERIES as the interval between the fifth and seventh HARMONICS (a DIMINISHED FIFTH), or the seventh and the tenth (an AUGMENTED FOURTH), seems to demand resolution either inward from the diminished fifth to a major or minor third, or outward from the augmented fourth to a major or minor sixth. It is this harmonic tension that gives the DOMINANT SEVENTH CHORD, for example, its special quality.

troisième (*TRWAHZ-yem*) [French] *Dance* Literally, third. In ballet, the THIRD POSITION, one of the basic POSITIONS OF THE FEET.

tromba marina *Music* A stringed instrument of the Middle Ages, frequently associated with nuns and sometimes called a nun's fiddle. It had a hollow neck as much as six feet long, a single string that could be bowed outside, an array of sympathetically tuned strings inside and a bridge with one loose leg that drummed audibly on the face of the soundbox when the instrument was played. The player touched the outside string lightly at certain points and bowed above the touching point, sounding harmonics instead of fundamental tones. In spite of its name, it had nothing to do with the sea, though it could sound a bit like an ancient trumpet.

trombone *Music* Also called slide trombone, a BRASS INSTRUMENT larger than the TRUMPET and of baritone or bass range, with a cup-shaped MOUTHPIECE and a sliding portion built into its cylindrical tube instead of keys or valves. The player controls pitch by a combination of lip position, which determines the general range, and placement of the SLIDE, which gives the specific note. With this capability, the trombonist, like the violinist, has infinitely fine control of pitch. Chords sounded by two or more slide trombones in tune with each other can create a resonance that is unique in the orchestra. The family of trombones includes the alto, tenor and bass. *See also* VALVE TROMBONE.

trompe l'oeil (*tromp LEU-ee*) [French] *Stagecraft* Literally, deception of the eye. A term applied to illusions such as a perspective view of a deep architectural space painted in two dimensions on a backdrop.

troop *See* TROUPE.

troppo [Italian] *Music* Too much, as in *allegro non troppo*, fast, but not too fast.

troubadour (*TROO-bah-dooer*) [French] *Music* A poet and musician of 12th- and 13th-century Southern France, devoted to the composition and performance of songs of chivalrous love, *e.g.*, SIRVENTES and PLANHS. Troubadours were the first major group of artists in Europe to compose songs exclusively in the vernacular. One of the most famous, some of whose poems survive, was Bernart de Ventadorn. The troubadours were contemporaneous with the professional JONGLEURS and were the predecessors of the TROUVÈRES of France and the MINNESINGERS of Germany.

trough *See* FOOTLIGHT TROUGH, RAIN TROUGH, SNOW BAG, THUNDER RUN.

troupe *Circus, Theater* The performing company as a whole.

trouper *Circus, Theater* A performer with a great deal of experience and dedication.

trousers part *Acting* A role for a woman wearing a man's clothes. The role of Viola in Shakespeare's *Twelfth Night* is typical. *See also* BREECHES ROLE, TRANSVESTITE, TRAVESTIE.

trouvère (*troo-VEHR*) [French] *Music* A poet and musician of 12th- and 13th-century Northern France who, perhaps in imitation of the TROUBADOURS of the South, composed and sang songs of love and adventure. Their songs were more STROPHIC in form; many were

BALLADS. The most famous trouvère was Adam de la Hale who also composed a dramatic PASTORAL, *Le Jeu de Robin et Marion*, which is still performed from time to time.

truck (verb), **truckin'**, **trucking** (noun) *Dance* Originally a slang term for a stroll or strolling. A popular JAZZ dance introduced in 1933 at the Cotton Club in Harlem, performed to a SHUFFLE rhythm.

trucking shot, truck shot *Motion pictures* A SHOT made from a moving DOLLY, sometimes actually from a car or truck, preceding or following moving actors. Generally, a truck shot is distinguished from a DOLLY SHOT by its speed and the distance it moves, for example, following two people galloping away across the prairie on horseback. A dolly shot usually moves slowly over a distance of a few feet.

truck stage *Stagecraft* A WAGON STAGE.

trumpet *Music* A brass wind instrument of treble register. It has a cup-shaped MOUTHPIECE and a long cylindrical tube folded into a convenient size to be held in the hand, and widening to a bell at its outlet, like a BUGLE. It differs from the bugle in having a set of three valves that divert the flow of air into three short CROOKS to change the pitch whenever a valve is pressed down. It is a TRANSPOSING INSTRUMENT, usually in B-flat. A fourth crook can be adjusted to change the transposition to C (*i.e.*, no transposition at all) when the TESSITURA of the work to be played is higher than normal, as in some of works of the Baroque period. There have been slide trumpets, like miniature slide trombones, but the three-valve version is standard. *Compare* CORNET, FLUGELHORN.

trumpeter *Music* A musician who plays the trumpet.

trumscheit *See* TROMBA MARINA.

tryout *Theater* A performance of a play, either a new play or a new production, either out of town or for an invited audience to make sure it is fully acceptable before the official opening date becomes firm. Not to be confused with a PREVIEW, which occurs in the theater where the opening will also occur.

tsamikos (*TSAH-mee-kos*) [Greek] *Dance* A Greek line dance to a moderately slow 4/4 beat; the performers are linked together with their arms over each others' shoulders as in the SYRTOS. The basic dance consists of relatively slow steps of the whole line, moving to the left, then to the right with each step. With each step, one leg swings across the other, heel down, then forward with the toe down, then back. The leader performs graceful elevations, knee bends and partial turns in each measure. Like many Greek folk dances of ancient origin, the tsamikos suggests a style that may have been used on the classical stage. During the war of Greek independence the dance was commonly associated with partisan guerillas who tried to outdo each other as leaders. It remains universally popular among Greeks today.

tub *Music* A metal washtub that sometimes substitutes, in SQUARE DANCE and similar music, for a DOUBLE BASS. The tub is turned bottom-up, with a thick string pulled upward through a hole at its center and held taut at the upper end of a stout stick that the player holds in the hand; the bottom end of the stick presses on the rim of the tub. The player plucks the string and controls its pitch, in a general sense, by pulling back on the stick to make it more taut. The tone is so low that the audience cannot really tell when it is or isn't in tune.

tuba *Music* A BRASS INSTRUMENT of the BASS register, with a large funnel-shaped MOUTHPIECE and a swirl of tubing that widens into a large bell. It has three to five valves that control pitch, much like the valves of a trumpet. It is a transposing instrument. There are three types: the TENOR in B-flat, the BASS in E-flat or F, and the CONTRABASS in B-flat an octave below the tenor (sometimes called the BB-flat bass tuba). *See also* BOMBARDON, HELICON, SOUSAPHONE.

tubs *Music* A jazz slang term for DRUMS.

tucket *Music, Theater* A brief military signal on the trumpet, called for frequently in Elizabethan plays.

tumble *Circus* To perform gymnastic feats such as somersaults, leaps, handstands and handsprings on stage.

Stagecraft To roll a DROP.

tumbler *Circus* An ACROBAT who performs gymnastic feats on stage.

tumbler batten *Stagecraft* A BATTEN on which to roll DROPS before they are placed in storage.

tumbling *Circus* The art of gymnastics.

tune *Music* 1. A MELODY, especially a simple one. 2. To adjust the PITCH of any musical instrument to bring its parts into harmony with each other and the instrument into harmony with others. *See also* TEMPERAMENT.

tuner *Music* A technician who specializes in tuning keyboard instruments to the particular type of TEMPERAMENT required.

tunesmith *Music* Slang for a composer of popular songs.

tungsten light *Lighting* The light produced by any bulb with a tungsten filament, as contrasted with that produced by a CARBON ARC, a mercury metal diode or a halogen-filled bulb. Tungsten is warmer in color than any of the others, which must be taken into account when a lighting designer chooses GELS for their color effect.

tuning *Music* 1. The act of adjusting the PITCH of any instrument to bring it into harmony with others. 2. The particular TEMPERAMENT to which any keyboard instrument is tuned.

tuning fork *Music* A U-shaped steel bar, with an extension at the bottom of the U that serves as a handle, that produces a specific musical pitch, such as A-440. A musician holds the handle and strikes the upper end of the tuning fork on an elbow or any fairly hard object that will not harm it, then touches the handle to a flat surface where it will produce audible tone to which the musician's instrument can be tuned.

tuning hammer *Music* The tool, actually a special form of socket wrench, that the tuner uses to twist the TUNING PINS of a piano or other keyboard instrument to establish the degree of tension on the string that will produce the correct pitch when the key is struck.

tuning pegs *Music* A set of pegs fitted tightly into holes in the upper part of the neck of a stringed instrument. Each is shaped with a flat surface or wings to make it possible to twist the peg. To each peg one string is attached, its other end being anchored on the body of the instrument. The player tunes the instrument by tightening or loosening each tuning peg until its string produces the desired PITCH.

tuning pins *Music* An array of thick steel pins with one square end, the other round and fitted tightly into a line of holes in the SOUNDING BOARD near the keys of a KEYBOARD instrument. To each pin, one string of the instrument is attached, the other end being anchored at the far end of the sounding board. The player or TUNER uses a TUNING HAMMER to tighten or loosen the pins to achieve the degree of tension that will produce the correct pitch for each string.

tuning rod *See* COTTON ROD.

tuning slide *Music* A metal sleeve fitted at the top of an organ FLUE pipe, used to shorten or lengthen the pipe to adjust its PITCH.

tuplet *Music* Generic name for the class of DUPLETS, TRIPLETS and the like. The term has come into more general use among composers and arrangers who use various computer programs for the notation of music.

turkey *Theater* Slang term for a play that fails badly at the box office.

turkey trot *Dance* A simple ragtime dance, also known as the one-step, characterized by flapping the arms and keeping the feet wide apart. Very popular in the early 20th century, it was considered unsuitable in polite society. *See also* ANIMAL DANCES, BUZZARD LOPE.

turn *Music* An ORNAMENT in which the melodic line performs a flourish around the principal note, engaging both its upper and its lower neighbor. Turns normally occur off the beat, and enhance the feeling of leading into the following beat.

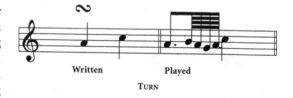

Written Played

TURN

turnaround *Stagecraft* An overnight change from one show to the next.

turnaway *Theater* A SELLOUT.

turn in *Acting, Dance* A turn toward center stage.

turning point *Theater* The moment of crisis in a play. *See also* CONFRONTATION OF FATE, REVERSAL OF CIRCUMSTANCES.

turn out *Acting, Dance* A turn away from center stage.

Ballet Considered a basic principle, the dancer's ability to turn out the feet and legs from the hip joints to form an angle of 90° or more from a forward-facing line. The English equivalent of EN DEHORS.

turnout *Theater, Circus* The gathering of people in the audience, as in "a large turnout."

turntable *Recording* A revolving metal disk that supports and turns an audio RECORD during recording or playback.

Stagecraft A circular platform, filling part or most of the stage area, that can be turned on its center with SET and/or actors in place upon it. It is used most often to provide a method of shifting the scene quickly, with a back wall for one scene that fills half the turntable, concealing another scene already set up in back. When the turntable turns 180°, the other scene comes into view and the first scene can be changed. Also called a disk. In some theaters, the stage is equipped with two turntables, each containing half of each set. *See also* ELEVATOR STAGE, JACKKNIFE STAGE, REVOLVING STAGE.

turret *See* LENS TURRET.

tutti (*TOO-tee*) [Italian] *Music* Literally, all. Describing a passage with all the instruments playing, as distinguished, *e.g.*, from a RIPIENO passage for the ensemble of soloists in a CONCERTO GROSSO.

tutu *Dance* The standard classical ballet skirt, in lengths that vary from midcalf to above the knee or shorter. It is made of many layers of net or tarlatan.

twang *Acting* A nasal tone of the speaking voice, often used as part of the CHARACTERIZATION of a farmer or hillbilly.

tweeter *Audio* A tiny loudspeaker tuned to project the highest tones in the audio spectrum. The extreme opposite of a WOOFER. *See also* MIDRANGE.

twelve-note row, twelve-tone row *See* TONE ROW.

twelve-string guitar *Music* A steel-strung GUITAR with double strings, *i.e.*, two strings tuned in unison for each of the single strings of the standard guitar. The player stops both strings of each pair with the fingers of the left hand, and plucks them both with the right hand, producing a larger, richer sound than the standard instrument. It was the instrument of choice for the 20th-century American folk-musician Huddie Ledbetter ("Leadbelly").

twelve-tone technique *See* SERIAL MUSIC.

twenty-four-hour man *Circus* A management employee of the circus who goes out one day ahead of the traveling show to make the physical preparations that will be required, *e.g.*, putting up arrows at street corners to direct circus trucks to the LOT, placing markers on the ground to outline the locations of the MIDWAY and the tent, ordering hay for elephants and horses, and making arrangements for circus people to park their vans and campers. Not to be confused with ADVANCE MAN or BILLING AGENT.

twenty-four-sheet *Theater* A very large theatrical poster made of 24 standard PRINTER'S SHEETS and pasted on a large highway billboard to advertise a show.

twirler *See* BATON TWIRLER.

twist, the *Dance* A solo ROCK dance introduced by the singer Chubby Checker in 1961, characterized by twisting movements of the hips, feet and shoulders. It was taken up enthusiastically by young people and by patrons of fashionable nightclubs and resorts.

twist-lock connectors *Lighting* Electrical connectors, male and female, that must be twisted in opposite directions to lock after they have been matched, so that they cannot accidentally separate and become dangerous on the set.

two *See* IN TWO.

two-beat, two-beat jazz, two-beat music *Music* In JAZZ, an emphasis or accent on two of the four beats in every bar, usually associated with DIXIELAND and older jazz styles.

two-fer *Lighting* A single electrical power outlet that accepts two circuits. *See also* DUPLEX.

Theater A ticket that admits two people for the price of one.

two-fold *Stagecraft* A pair of flats permanently hinged together with a DUTCHMAN concealing the hinged edge. *See also* THREE-FOLD.

two-four time *Music* A musical meter with two-beat measures in which the QUARTER NOTE is the BEAT.

two-line octave *Music* An old designation for the octave between c^1 and c^2. *See* OCTAVE NAME SYSTEM.

two-riser *Stagecraft* A single RISER unit having two levels, built for members of a chorus to stand on during performance.

two-sheet *Theater* A small theatrical poster made of two standard PRINTER'S SHEETS to be pasted on a small billboard either outside the theater or in the lobby to advertise a show.

two-shot *Motion pictures* Any MEDIUM CLOSE-UP showing two people together on the screen.

two-spot *Vaudeville* The second spot on a playbill and in order of appearance during the show.

two-step *Dance* A ballroom dance in duple time, with two sliding steps to each beat, first performed around 1890.

two-step unit *See* STEP UNIT.

tympanum [from Greek via Latin] *Music* A large drum, similar to the BASS DRUM. Not to be confused with TIMPANI.

type *Acting* Any standard characterization, *e.g.,* the stalwart hero, the crotchety old man.

typecast *Acting* Cast in a particular role because it matches an actor's normal personality and physical appearance. For an actor to be typecast can be a trap, reducing his or her chances of taking on a variety of roles that might be more interesting.

typing *Acting* The practice of TYPECASTing.

U

U *Acting* Abbreviation for UPSTAGE. *See* STAGE AREAS.

UC *Acting* Abbreviation for UPSTAGE CENTER. *See* STAGE AREAS.

U.C. *Music* Abbreviation for UNA CORDA.

UE *Acting* Abbreviation for UPSTAGE ENTRANCE. *See* STAGE AREAS.

uillean pipe (*oo-EEL-yan*) [Gaelic] *Music* The Irish BAGPIPE.

ukelele, uke *Music* A small, GUITAR-shaped instrument with four strings and a fretted finger-board. Associated with Hawaii, it became popular in the United States in the 1930s, especially with amateur singers who could strum simple chords for their own accompaniment with almost no training.

UL *Acting* Upstage left. *See* STAGE AREAS.

ULC *Acting* Upstage left center. *See* STAGE AREAS.

ultraviolet light *Lighting* Light that is invisible to the human eye though it is dangerous if aimed directly into it. It is produced by a CARBON ARC or a mercury metal diode lamp and is used in a blacked-out scene to make certain objects glow mysteriously with various colors. Also called black light.

umbrella *Lighting* A light reflector with a silver or white surface shaped like, and of the same size as, an ordinary umbrella, used to bounce and soften the light in motion picture CLOSE-UPS.

umstimmen (*OOM-shtim-men*) [German] *Music* To change the tuning of TIMPANI.

una corda (*OO-nah KOR-dah*) [Italian] *Music* Literally, one string. A directive to pianists to press the pedal on the left, the SOFT PEDAL.

uncover *Acting* To move away from a position that blocks the audience's view of another actor.

underact *Acting* To play a scene less expressively than its words or its circumstances would normally indicate.

undercrank *Motion pictures* To run the motion picture camera slower than normal so that the images later projected seem to move faster than normal. The term came into use in the early 1900s when movie cameras were cranked by hand. The opposite of OVERCRANK.

underdress *Costume* A second costume worn under the first, to facilitate a quick change.

underimage *Acting* An underlying mental image that helps an actor's conceptualization of a scene.

underplay *Acting* To UNDERACT.

underplot *See* SUBPLOT.

underscore *Motion pictures, Music* To compose a musical accompaniment for a motion picture.

understudy *Acting* An actor who is fully rehearsed and stands ready to substitute for another immediately in any emergency.

understudy rehearsal *Acting* A special rehearsal with understudies playing their assigned roles.

under the big top *Circus* A metaphor for performing, or having a career, in the circus.

unemphatic curtain *Stagecraft* A slightly delayed closing of the curtain, after the scene has ended.

unemphatic prop *Stagecraft* A PROP that exists on stage solely to complete the general effect of the scene. *Compare* PERSONAL PROP, SET DRESSING, TRIM PROP.

unfreeze *Acting, Motion pictures* To reestablish normal movement in the scene, after having stopped for a FREEZE in position on stage or a FREEZE FRAME in a motion picture.

unidirectional microphone *Audio* A microphone designed to pick up sound coming from one direction only and to suppress sound from any other direction. *See also* SHOTGUN, PARABOLIC REFLECTOR MIKE.

unison *See* IN UNISON.

unit *Motion pictures* A complete production team consisting of camera operators, sound technicians, lighting technicians, set, costume and makeup people, and all the GRIPS and assistants necessary to shoot ON LOCATION.

unitard *Costume* A body stocking, a LEOTARD in one piece.

unities *Theater* A conception, inaccurately attributed to Aristotle by Renaissance scholars, that a drama must always have unity of time, place and action. In fact, Aristotle discussed only UNITY OF PLOT, barely suggested unity of time, and said nothing whatever about unity of place.

unit set *Stagecraft* 1. A SET consisting of a number of FLATS, platforms and set pieces that can be decorated differently or easily rearranged to serve as scenery for all the scenes of a play. 2. A set built in movable modules so that it can present different arrangements for different scenes without new construction. *See also* ABSTRACT SET.

unity of plot *See* PLOT, UNITY OF.

unlocalized scene *Theater* A scene that has no specified locale, but is necessary to the plot, *e.g.,* as a transition between other scenes. This kind of scene occurs frequently in Elizabethan and other plays performed in ABSTRACT SETS.

unmusical *Music* Lacking in naturalness and beauty of rhythm, phrasing and intonation. Sometimes a performer may play all the notes correctly and speed up or slow down in the right places, but without the natural flexibility that would make the performance musical. Another performer may miss notes here and there but perform with such natural sweep that it sounds musical.

un poco più (*oon poh-koh PYOO*) [Italian] *Music* A little more.

unruhig (*oon-ROO-ikh*) [German] *Music* Uneasy, restless.

unstopped *Music* 1. Said of an OPEN STRING of any stringed instrument. 2. Said of any ORGAN PIPE that has an open end.

untempered *Music* Not tuned according to any of the systems of TEMPERAMENT. *Compare* PURE TUNING.

unvoiced *Acting* Said of any consonant uttered with no vowel sound, or a word whispered.

up *Theater* UPSTAGE. The term derives from the days when most stages were steeply RAKED, *i.e.,* sloped upward from the curtain line.

up and down unit *Stagecraft* A unit of the SET that is oriented on a line perpendicular to the curtain line.

upbeat *Music* 1. An unaccented beat that leads to the next DOWNBEAT, or the first accented beat of the MEASURE. 2. The first note(s) leading to the first downbeat of a piece of music. *See* ANACRUSIS. 3. Fast, as in "an upbeat arrangement," *i.e.,* an arrangement with a fast beat.

Theater A slang term meaning peppy, happy or hopeful, as in "an upbeat ending," *i.e.,* a happy ending.

upbow *Music* In stringed-instrument playing, a stroke starting with the tip of the bow, moving toward the FROG.

UPBOW

up center *Theater* Upstage center, abbreviated as UC. *See* STAGE AREAS.

updo *Makeup* An upswept arrangement of hair.

up left *Theater* Upstage left, abbreviated as UL. *See* STAGE AREAS.

up left center *Theater* Upstage left center, abbreviated as ULC. *See* STAGE AREAS.

upper stage *Theater* On the Elizabethan stage, an acting area on the upper level above the main acting area.

up right *Theater* Upstage right, abbreviated as UR. *See* STAGE AREAS.

up right center *Theater* Upstage right center, abbreviated as URC. *See* STAGE AREAS.

upright piano *Music* A PIANO whose strings and soundboard are placed in a vertical plane behind the keyboard, to save floor space. Uprights are made in three sizes: the spinet (about 36 inches high), console (about 42 inches) and studio (44–51 inches).

upstage *Acting* To steal FOCUS by moving UPSTAGE to force another actor, who is speaking, to turn away from the audience.

Theater Toward the back of the stage, away from the PROSCENIUM. The term derives from the days when stage floors were RAKED (slanted upward from the front). *See* STAGE AREAS.

UR *Theater* Upstage right. *See* STAGE AREAS.

URC *Theater* Upstage right center. *See* STAGE AREAS.

urtext (*OOR-tekst*) [German] *Music, Theater* A text that represents the author's work without any editorial changes or interpolations.

usher (m), **usherette** (f) *Theater* A member of the HOUSE staff who shows patrons to their seats.

ut *See* SOLMIZATION.

utility actor *Acting* A member of the company who can fill any supporting role or, if necessary, do technical work backstage.

utility character, utility role *Acting* Any character or role that is not essential to the main plot, but serves to lend authenticity to the scene.

UV *See* ULTRAVIOLET LIGHT.

V

Vaganova School of Ballet The premier ballet school of Russia, associated with the St. Petersburg Ballet, the outgrowth of a school of ballet founded in 1738 by Jean-Baptiste Landé, and renamed the Vaganova School in 1957.

valance *See* BORDER, TORMENTOR.

valse [French] *See* WALTZ.

value *Music* *See* NOTE VALUE.

 Motion pictures, Stagecraft A measure of brightness or darkness of color.

valve *Music* A mechanism in a brass instrument that diverts the column of air through one or the other CROOK, thus increasing the instrument's effective length and lowering the fundamental PITCH of the tone it produces by one or more SEMITONES. Because brass instruments use the first few HARMONICS of their FUNDAMENTAL TONES, any change of valve position also lowers all its playable OVERTONES. A trumpet has three valves, a French horn three or four, and a tuba up to six.

valve trombone *Music* A TROMBONE that uses VALVES and a selection of CROOKS instead of a slide to produce different pitches. Since each crook has a specific length that, though it can be set for tuning, cannot be altered while the instrument is being played, the valve trombone lacks the slide trombone's capability of PURE TUNING and cannot perform a GLISSANDO.

vamp *Acting* The role of a seductive female who corrupts her lover, derived from VAMPIRE.

 Music 1. A phrase or figure that can be repeated again and again as an introduction or a BRIDGE (2) while the instrumentalist waits for the singer or the actor to start the next song or verse. 2. To play such a figure or a phrase, expressed often in the phrase "vamp until ready." 3. An improvised or written accompaniment of simple chords in JAZZ. 4. To improvise an accompaniment for a jazz soloist with simple chords in a repeating pattern. The term has nothing to do with vampires; it has its roots in Old English and has been used in the musical sense for centuries.

vampire, vampire part *Acting* A stock VILLAIN's role in plays about supernatural beings who take human form by night and must have warm blood for nourishment.

vampire trap *Stagecraft* A TRAP in the stage floor often fitted with a SMOKE POCKET and garish lighting from below, to produce an eerie effect when an actor rises from a coffin in character as a VAMPIRE or a ghoul.

vamps *Vaudeville* Double doors with spring hinges used for sudden entrances of featured actors.

vamp up *Stagecraft* To improvise changes and improvements in a set to make it useful in a new show.

vanilla *Theater* Derogatory adjective for an utterly bland play or performance.

Variac *Lighting* Trade name for a variable transformer used as a DIMMER. It raises or lowers the voltage of the circuit, producing less heat than does a variable resistance dimmer.

variant *Music* A version of an ORNAMENT, a FIGURED BASS, DYNAMICS, FINGERING or a REPEAT that is different in other editions of a work, especially an old work whose original is lost or not completely readable.

Theater A version of a word, a line or a stage direction in one edition of a play that is different from that in other editions. The many different interpretations of the various early FOLIOS and QUARTOS of the plays of Shakespeare were collected in the late 19th century in a very large set of volumes called *The Variorum Edition.*

variation *Dance* A short solo dance within the context of a dance scene.

Music 1. A passage that recapitulates the melody or harmonic structure of another, but with alterations of ornamentation and/or a change of mood, *e.g.,* from major to minor. 2. A piece of music based on the harmonic and melodic structure of a THEME stated at the beginning that restates it with noticeable alterations in ORNAMENTATION, RHYTHM, TEXTURE and PHRASING. Among the most elaborate sets for keyboard instruments are Bach's *The Goldberg Variations,* Beethoven's *The Diabelli Variations* and, for orchestra, the *Variations on a Theme of Haydn* by Brahms.

variazione (*vah-ree-aht-see-OH-neh*) [Italian] *Music* VARIATIONS.

variety, variety night, variety show *Vaudeville* A show with several different kinds of acts.

variety turn *Vaudeville* Any song and dance routine, skit or other act in a VARIETY SHOW.

variorum *See* VARIANT.

varsity drag *Dance* A dance that was popular in the late 1920s, similar to the CHARLESTON. It was created for the musical comedy *Good Times.*

Varsovienne [French], **Varsoviana** [Italian] *Dance* Literally, (a person) from Warsaw. A couple dance of the mid-1800s in slow 3/4 time, combining elements of the MAZURKA and POLKA, often with an accent on the DOWNBEAT of every other measure.

vaudeville *Theater* 1. A popular entertainment consisting of a variety of individual comic acts and skits, songs and dance numbers. This usage of the term is peculiar to the United States. The British call such entertainment "music hall." 2. A simple love song of the 16th century that evolved gradually to become a popular song, frequently one that was already familiar as a tune but with a new satirical text. Early collections called the original love songs *vau de ville*, a French term that may have derived from *voix de ville* (voice of the town) or, in the opinions of some historians, *vau de vire* (from the valley of the Vire, in the Calvados region of France).

vaudevillian *Vaudeville* One who performs any of the various specialties of American vaudeville, *e.g.*, a comedian, a dancer, a singer. *See also* BANANA, CHORINE, HOOFER, STAND-UP COMEDIAN, STRIPPER.

VCR *Television* Short for video cassette recorder.

vegetable actor *Acting* In the 1800s, an actor who specialized in VILLAIN'S roles, whom the audience would pelt with tomatoes, rotten fruit and eggs. Such an actor usually appeared behind a protective net, which added to the fun.

vehicle *Theater* A production designed especially to display the talents of a STAR.

veleta *Dance* A sequence dance of the early 1900s that combines gliding steps with the WALTZ.

velours, velvets *Stagecraft* A standard setting consisting of draperies with BORDERS, LEGS and a BACKDROP, always made of velour or velvet.

Venetian curtain *Stagecraft* A CONTOUR CURTAIN that can be drawn up so that its lifting cords move at different speeds proportionally related to each other causing the looping drapes between the lifting cords to form a symmetrical arched opening. *Compare* AUSTRIAN CURTAIN.

ventriloquism *Vaudeville* A technique of concealing lip movements and other visual cues so that the voice seems to come from a source other than the person speaking, *e.g.*, from a PUPPET or a wooden doll whose lips are moved from behind by the performer's hand.

ventriloquist *Vaudeville* A performer who practices VENTRILOQUISM. In the mid-20th century the entertainer Edgar Bergen used his talents as a ventriloquist to create the famous and much-loved "dummy" characters of Charlie MacCarthy and Mortimer Snerd, who appeared in many radio and television shows and in movies.

verbunkos [Hungarian] *Dance* An 18th-century soldier's dance from Hungary, performed to gypsy music, designed to entice men to join the army. It was divided into slow and fast sections somewhat like the CZARDAS.

Music A form based on the dance, used by several Hungarian composers.

verismo (*veh-REEZ-moh*) [Italian] *See* CINÉMA VERITÉ.

verse play *Theater* A play written in metrical lines or rhymed couplets. *See also* ALEXANDRINE, IAMBIC PENTAMETER.

verset *Music*　A short piece of music for the organ, composed expressly to alternate with a spoken or sung verse of a PSALM.

vertical pipe *Lighting*　A vertical steel support for lighting fixtures, often installed in the WINGS, behind the PROSCENIUM or in recesses in the side walls of the auditorium from which its lights can illuminate the stage. *See also* LIGHT TREE.

vertical sight lines *Stagecraft*　Imaginary lines drawn from all the corner seats in the house to the lower edges of BORDERS, TEASERS and FLOWN scenery, to determine whether any of those items need adjustment to conceal the FLIES and backstage areas. Also called elevation sight lines.

vespers *Music*　Music composed to be sung at the vespers (sunset) service in a Catholic or Anglican church. In the history of music, the vespers service is important as the only church service in which non-Gregorian music was admitted. Therefore, since medieval times, composers have written their most innovative works for it. The vespers of Monteverdi, Mozart and Rachmaninoff are frequently performed to this day.

vestibule *Theater*　An enclosed space between the outer and inner entrance doors of the auditorium providing a buffer between the dark, quiet, comfortable theater and the brightness, noise and discomfort of the outdoors.

vibes *Music*　Short for VIBRAPHONE.

vibraphone, vibraharp *Music*　A modern percussion instrument similar to the XYLOPHONE, but with metal bars and individually tuned resonating tubes mounted vertically beneath each of them. In each tube there is a small disk on an axle near the top. By means of a pedal that actuates a variable-speed motor, the player can cause these disks to rotate at any relatively slow, steady speed to produce a subtle TREMOLO. In addition to the tremolo control, there is another that damps all the bars by pressing a felt-covered rail against them. The result is an instrument of supple, velvety tone that has become a major instrument for orchestral and JAZZ percussionists, including the famous Lionel Hampton.

vibration　*See* HERTZ.

vibrato (*vee-BRAH-toh*) [Italian] *Music*　A variable, fairly rapid fluctuation in the pitch of a musical tone. In stringed instruments, it is produced intentionally by the motion of the left hand while a note is being played. In the human voice it begins as a natural TREMOLO but can develop, especially with age, to become an undesirable wobble in pitch. Wind-instrument players produce it by breath control.

video *Television*　The visual portion of the television signal, as distinguished from the AUDIO.

video disk *Television*　A digital recording of a television program imprinted on an optical disk.

videotape *Television*　1. A strand of magnetic tape, almost always contained within a protective cassette, suitable for the recording and playback of a television program. In the 1990s videotape comes in cassettes compatible with home video cameras and players (½-inch tape), industrial cameras and players (½- or ¾-inch tape), and broadcast equipment (½- or 1-inch tape).

vidicon *Television* Generic name for the electronic tube on which the video camera's lens focuses the picture.

Viennese waltz *Dance, Music* An elegant style of couple dancing to a rather fast WALTZ tempo, characterized by whirling turns, with a slight anticipation of the second beat of the measure. The dance and its music became popular with the orchestras of Johann Strauss (both Sr. and Jr.) in the ballrooms of Vienna in the mid- and late 1800s. *Compare* HESITATION WALTZ.

viertel (*FEER-tel*) [German] *Music* Quarter, a QUARTER NOTE.

vignette *Stagecraft* An inner acting area, only partially visible to the audience through an opening in the SET.

Theater A short scene providing a bit of character background or a detail of the plot among larger scenes.

vihuela (*vee-WHAY-lah*) [Spanish] *Music* A Spanish instrument of the 16th century physically similar to the GUITAR but tuned like a LUTE.

villain *Acting* The evil character in a melodrama. Loosely termed the ANTAGONIST, though in other theatrical forms an antagonist is not necessarily a villain.

villancico (*vee-yahn-SEE-koh*) [Spanish] *Music* An idyllic song of the 15th and 16th centuries in Spain. Many were composed for solo voice and VIHUELA, others for several voices. It gradually evolved in the 17th century to become a more elaborate form for chorus and organ or other instruments, to be performed in the church.

villanelle *Dance* A rustic dance in quick 6/8 time, developed in the 19th century from a 16th-century type of satirical madrigal.

Music A jovial style of vocal music that became popular in Italy in the 16th century as a sophisticated reaction against the politeness of the MADRIGAL. It spread rapidly to northern Europe, where it developed into drinking songs and jests and became refined again, though no less fun, with the secular works of composers of the late Renaissance, such as the Belgian Orlando di Lasso. It was taken up again in the 19th century by many composers in instrumental dance music.

villotta (*vee-LOT-tah*) [Italian] *Music* A popular type of Italian street song from the 16th century, similar to the VILLANELLE.

vina (*VEE-nah*) [Hindi] *Music* A melodic stringed instrument of India consisting of a long, thick stick that is actually a fretted fingerboard, over which four strings are stretched and to which two large, hollow gourds are attached for resonance.

viol *Music* A family of stringed instruments popular in the 16th and 17th centuries, ancestors of the modern VIOLIN FAMILY. Most have fretted fingerboards, six strings instead of four, flat backs and deeper bodies than modern instruments, and their tone is more delicate and soft. Flatter, less arched BRIDGES enable them to produce chords of up to four notes. Many modern DOUBLE BASS instruments retain some of the characteristics of viols, and their strings are tuned in fourths, like the rest of the viol family.

viola *Music* The tenor voice of the violin family, larger than the standard VIOLIN, but played in the same manner. Its strings are tuned in FIFTHS beginning with C.

viola clef *Music* The C-CLEF, centered on the middle line of the staff.

VIOLA CLEF
(MIDDLE C)

viola da braccia (*vee-OH-lah dah BRAH-chah*) [Italian] *Music* Old name for an instrument of the violin family that is held by the arm, like the modern VIOLIN or VIOLA, rather than between the knees like the VIOLA DA GAMBA or the VIOLONCELLO.

viola da gamba (*vee-OH-lah dah GAHM-bah*) [Italian] *Music* A 16th-century solo instrument of the VIOL family, with six strings tuned like a GUITAR starting on D, a whole tone above the modern VIOLONCELLO. Its name indicates that it is held between the player's knees. Along with the LUTE it was a primary solo instrument in Europe until the mid-1700s. Bach composed three sonatas for it, and used it in his *St. Matthew Passion.*

viola d'amore (*vee-OH-lah dah-MOH-reh*) [Italian] *Music* An instrument of the VIOL family, but played like a modern violin (instead of being held between the knees). Stretched underneath the bowed strings are sympathetically tuned wire strings that give it a silvery resonance. There are many collections of solo pieces for the instrument, including some by Haydn. It has also been used by more modern composers, including Giacomo Puccini in his opera *Madama Butterfly* (1904) and by Paul Hindemith, a violist himself, who composed two sonatas for it.

violin *Music* The principal stringed instrument of Western orchestral music. It has a relatively short neck ending in a pegbox and a carved SCROLL, attached to a hollow rounded wooden body with a narrow waist. The body has a domed upper surface called the TABLE and a similar lower surface called the BACK, joined by vertical sides called the RIBS which form the upper, middle and lower BOUTS. The table and the back are held apart by a wooden peg inside called the SOUND POST. The table is pierced by two elongated holes, each shaped like an elegant letter *f*. At its center, nearly over the sound post, stands a small wooden bridge that holds four strings, stretched from the scroll to the lower bout and tuned in FIFTHS, starting with G below MIDDLE C. It is played with a BOW. The violin, a descendant of an ancient instrument called the REBEC, is related to the VIOL. The great violin makers, Niccolò Amati, Antonio Stradivari and Giuseppe Guarneri, working in Cremona, Italy, perfected the instrument. Many of the violins they made are still in daily use all over the world and are greatly prized.

violin clef *Music* The G-CLEF.

violin family *Music* The VIOLIN, VIOLA, VIOLONCELLO and DOUBLE-BASS. *Compare* VIOL.

violinist *Music* One who plays the VIOLIN.

violin maker *Music* A maker and repairer of instruments of the VIOLIN FAMILY, also known as a LUTHIER.

violino piccolo *Music* A small VIOLIN, tuned a FOURTH above the standard violin, and used by Johann Sebastian Bach in his first *Brandenberg Concerto* and *Cantata No. 140.* Not to be confused with the modern smaller-size violins that are made for children.

violist *Music* One who plays the VIOLA.

violoncellist *Music* One who plays the VIOLONCELLO.

violoncello *Music* A bass-stringed instrument of the VIOLIN family, similar in shape and construction to the violin but much larger. A steel peg supports the instrument off the floor while the player holds it in a nearly vertical position between the knees. Usually referred to as the cello, it is tuned in fifths, one octave below the VIOLA.

violone (*vee-oh-LOH-neh*) [Italian] *Music* Literally, big VIOL. A name variously applied to the VIOLA DA GAMBA and the DOUBLE BASS VIOL.

virelai (*vee-reu-LAY*) *Music* A 13th-century French form of poetry and music probably of Spanish or Arabian origin, consisting of a series of three STANZAS separated by a REFRAIN. It is related to the later Italian BALLATA and the Spanish VILLANCICO.

virginal *Music* An early 16th-century form of the HARPSICHORD, consisting of a short keyboard and a single rank of strings contained in a small oblong wooden box that could be placed on a table. The origin of its name is obscure, though *virga* is the Latin name for the JACK of the harpsichord.

Virginia reel *See* SIR ROGER DE COVERLY.

virtuoso *Music* A performer with a prodigious technical command of an instrument.

vision cloth *Stagecraft* A DROP with a relatively large opening covered with theatrical gauze through which, when the lights behind the drop become bright, the audience can see an imaginary being, *e.g.*, the Queen of the Night in Mozart's opera *The Magic Flute*.

visual comedy *Motion pictures, Television, Theater* Any comedy that depends for its comic effect entirely on what can be seen by the audience. The comedy of silent movies had to be entirely visual, as does that of PANTOMIMISTS.

visual cue *See* SIGHT CUE.

visual effect *Lighting, Stagecraft* Any stage effect that depends primarily on light, *e.g.*, a sunset created on a CYCLORAMA by a subtle series of changes of light. Sometimes, if special projections are involved, it can be called an OPTICAL EFFECT.

visual track *Motion pictures* The portion of a strand of film that carries the images, as distinguished from its SOUND TRACK.

Vitascope *Motion pictures* Trade name for the early motion picture projector developed at the Edison factory following its invention by William Dickson.

vite (*veet*) [French] *Music* Quickly.

vivace (*vee-VAH-cheh*) [Italian] *Music* Quick and lively.

VO *See* VOICE-OVER.

vocal *Music* 1. Having to do with the voice. 2. In popular music and vaudeville, the voice line of a song. 3. A song as distinguished from an instrumental piece.

vocalise (*voh-kah-LEEZ*) [French] *Music* An extended melody for voice, a song with vowel sounds but without words. In training, the vocalise is an exercise in vocal tone. In POLY-PHONIC music of the period between the 13th and 15th centuries, there are passages without text to be sung by the TENOR, or another voice, as a vocalise while others sing words. There are modern vocalises, such as *Bachianos Brasilieros Number 5* for mezzo-soprano and 18 cellos (1939), by the Brazilian composer Heitor Villa-Lobos, and several by Sergei Rachmaninoff.

vocalization *Music* The physical process of singing, particularly using exercises for the voice.

vocalize *Music* To exercise the voice by singing ARPEGGIOS, SCALE PASSAGES and melodic lines.

vocal part *Music* Any part of a piece of music written for voices.

vocal score *Music* A score showing the vocal parts of a piece of music with the accompaniment, if there is any, represented as a keyboard REDUCTION from an orchestral SCORE. The modern vocal score in OCTAVO size was invented by the British music publisher Vincent Novello in 1811. Before that time, choral music was written in separate PART BOOKS, based on the composer's complete score, just as orchestral parts are today, making practice extremely difficult for singers, who need to know all of what everyone is singing. A vocal score for an unaccompanied choral work often includes a keyboard reduction of the vocal parts to provide support during rehearsals.

voice *Acting* The characteristic tone of a role, a vague and subjective quality made of the kinds of words and phrases used, as well as implications of the identity of the character.

Music 1. The human voice and, by extension, the characteristic sound of any instrument. 2. Any melodic line, whether for human voice or instrument. 3. To modify the sound of an instrument by adjusting the parts that produce its sound. A PIANO is voiced by altering the angle and velocity with which its hammers strike the strings and by altering the texture of its hammers or the material of its strings. A PIPE ORGAN is voiced by making alterations in its pipes. Voicing is not the same as TUNING.

voice box *Music* The human larynx.

voice-leading *Music* The art of assigning notes in music to different VOICES so that the individual vocal or instrumental lines are melodious.

voiceless *See* UNVOICED.

voice-over *Audio, Television* A commentary or narration, not part of the SOUND TRACK of a film, recorded as a separate sound track to be synchronized with the picture and superimposed on whatever other sounds occur.

voice part *See* VOCAL PART.

voicing *Music* 1. The manner in which melodic lines or the tones of a chord are distributed among the various voices, or among the instruments of an orchestra. 2. *See* VOICE (3). 3. The organ tuner's operation of modifying the shapes of the various FLUES and REEDS of the organ to get the proper TIMBRES.

volante (*voh-LAHN-teh*) [Italian] *Music* Flying, lightly and swiftly.

volé, volée (*voh-LAY*) [French] *Ballet* Literally, flown, flying. A movement executed in the air, as a BRISÉ VOLÉ.

volkslied (*FOLKS-leed*) [German] *Music* A folk song.

volta *Dance, Music* A lively popular dance in 6/8 time for couples in the early 17th century, with the men sometimes lifting their partners high in the air at the ends of phrases.

volti (*VOL-tee*) [Italian] *Music* An instruction to the player to turn the page quickly lest the next note be late.

volume *Audio* 1. The intensity of sound produced by LOUDSPEAKERS. 2. The control on a control board that determines the intensity of sound produced by loudspeakers. Not the same, in audio terms, as LOUDNESS.

voluntary *Music* A contrapuntal piece for ORGAN, often IMPROVISED, played at an Anglican church service.

vorspiel (*FOR-shpeel*) [German] *Music* A PRELUDE or an OVERTURE.

vox angelica *Music* An organ STOP of sweet tone.

vox humana *Music* An organ STOP that produces a tone somewhat like the human voice.

voyagé (*vwah-yah-ZHAY*) [French] *Ballet* For a specific pose, usually an ARABESQUE, the term indicates a series of traveling steps or small jumps on the supporting foot, forward or backward, ending in a DEMI-PLIÉ on the same foot.

VTR *Television* Short for videotape recorder.

VU meter *Audio* The initials stand for volume unit. A measuring device that displays the strength of the output of an amplifier. It is usually calibrated in terms of attentuation from maximum power in DECIBELS.

W

wafer *Stagecraft* A 20-pound weight that fits into a COUNTERWEIGHT ARBOR to adjust the balance of scenery attached to the other end of the RIGGING. *Compare* PIG.

waffle *Acting* To mumble and speak unclearly to cover up a memory slip onstage.

wagon *See* SCENERY WAGON, WAGON STAGE.

wagon stage *Theater* A low platform that moves into or out of the acting area on tracks carrying a full stage SET. Also known as a slip stage. *See also* CHARIOT AND POLE SYSTEM, ELEVATOR STAGE, PAGEANT.

wah-wah mute *Music* A type of trumpet or trombone MUTE, popular in the 1920s and 1930s, that closes the BELL with a metal cup but allows some of the sound to pass through a central port. The player controls the timbre of the sound by closing and opening that port with a free hand while playing. The name of the mute represents its sound.

wah-wah pedal *Music* On some electronic SYNTHESIZERS, a foot-operated control that alters the pitch of the notes slightly, producing an effect like the sound of the term. There are electronic variations of this device that similarly introduce variable amounts of DISTORTION into the music.

wail *Music* In JAZZ, to perform in an outstanding manner or with great expressiveness. By extension, to do something well and with great flair.

wait *Acting* The period between onstage appearances during a performance.

Music In the 15th and 16th centuries, a member of a band of street musicians who played Christmas music in front of important town houses. Also spelled *wayte*.

Theater The intermission between acts.

walk-across *Vaudeville* A FLOOZIE or a VAMP who walks across the stage, UPSTAGING the comedian in a comic skit. She utters a teasing line or two, then does a little BUMP AND GRIND and leaves.

walk a flat *Stagecraft* To move a FLAT during a scene shift by sliding it across the floor on its bottom rail. *See also* RUN A FLAT, SHOOT A FLAT, SKATE A FLAT. *Compare* WALK DOWN, WALK UP.

walk a part *Acting* To go through one's lines and actions at less than performance level, for practice or to BRUSH UP.

walkaround *Vaudeville* A parade of the entire company around the stage, strutting, swinging their canes and singing or dancing as they go.

walk a scene *Acting* To do a WALK-THROUGH.

walk down *Stagecraft* To lower a large flat gently to the floor by blocking its bottom rail against a wall, someone else's foot or any immovable object, and walking backward, supporting the flat hand over hand on the wooden STILES as it comes down. *Compare* FLOAT DOWN.

walker *See* FOLEY WALKER.

walking bass *Music* 1. On the DOUBLE BASS, a style of JAZZ playing with one (usually) plucked note to each beat, "marching" in a steady and continuous melodic line. Also, a bass line consisting of the ascending and descending notes of a chord, played in eighth notes. 2. In jazz piano playing, an accompanying line or series of notes in the bass arranged in broken octaves, very popular with BOOGIE-WOOGIE pianists of the 1930s. *See also* STRIDE PIANO.

walking lady, walking man, walking part *Acting* A WALK-ON.

walk-on *Acting* A role requiring only an appearance, but no speech or significant action. It can be played by a SUPERNUMERARY.

walk the curtain *Stagecraft* To walk across the stage behind the curtain, to pull its opposite edges together when it reaches the closed position. This is usually the assignment of a CURTAIN PAGE.

walk-through *Acting* A rehearsal of the general stage movement of a scene, with the actors moving from area to area, following the director's BLOCKING, to smooth the flow of the scene and, *e.g.*, on a TOUR, to make adjustments for a different stage. Ordinarily, the actors will speak only their CUE LINES, for the sake of continuity. Not the same as a RUNTHROUGH.

Dance A rehearsal of all the basic floor patterns of a dance piece or any scene requiring coordinated movement around the stage, in proper sequence, without detail of its steps and without interruptions, for the purpose of understanding its placement on stage as a whole and making any adjustments that may seem necessary. It is particularly useful when a dance company on tour is preparing to perform on an unfamiliar stage. Not the same as RUNTHROUGH. *See also* MARK (*Dance*).

Television A preliminary rehearsal of a scene with actors, but without cameras.

walk up *Stagecraft* To raise a FLAT by blocking its BOTTOM RAIL against the wall (or someone else's foot), lifting its TOP RAIL overhead and walking forward, supporting it hand-over-hand on the wooden STILES until it is upright.

wallpaper music *Theater* Relatively quiet, featureless music continuously playing in the background, having nothing to do with the scene.

wall pocket *Lighting* An electrical outlet mounted on the side wall or back wall of the stage. *See also* FLOOR POCKET.

waltz *Music* A ballroom dance in 3/4 time for couples, characterized by turning movements while in each other's embrace. It developed from the Austrian LÄNDLER around 1800, and became popular in Vienna around 1823 with the success of Johann Strauss Sr., who composed more than 150 waltzes for his orchestra and played them all over Europe until he died in 1849. His son, Johann Strauss Jr., formed his own orchestra in 1845, then took over his father's and went on to tour an even wider section of the world, including fourteen concerts in Boston and four in New York in 1872.

wankend (*VAHN-kent*) [German] *Music* Wavering, shaking.

warble *Music* A wide VIBRATO in the pitch of a singer's voice, usually undesirable.

warbler *Vaudeville* Slang term for a singer.

wardrobe *Theater* 1. A department of a theater company responsible for the creation and upkeep of costumes and the fittings and alterations necessary for their use on stage. 2. The collective costumes and wigs for a show. 3. The room where costumes and wigs are stored.

wardrobe keeper, wardrobe manager, wardrobe master, wardrobe mistress *Theater* The person in charge of costumes.

warhorse *Theater* 1. Slang term for a production that has been in the repertory for years without significant changes other than the CAST, and can be expected to be popular for years to come. 2. A role that has been played by many actors over many years, but never fails to engage the audience, *e.g.*, Hamlet. 3. An experienced performer who can and does play many roles, always successfully.

warm *Lighting* 1. To brighten (a light). 2. To narrow the focus of a SPOTLIGHT, thus brightening its beam. 3. To change color(s) in a scene by replacing GELS with warmer colors.

warm colors *Lighting, Stagecraft* Any colors in the red, orange and yellow portion of the spectrum.

warmers *See* CURTAIN WARMERS.

warm key *Lighting* A key light with a GEL of a WARM COLOR.

warm up *Acting* To exercise the body and sometimes the voice prior to going on stage. *See also* OFFSTAGE BEAT.

Music 1. To tune an instrument and practice on it for a short while in preparation for a performance. It is essential, particularly with wind instruments, to let them adjust to the temperature of the hall so that they can be accurately tuned, then to warm them up by playing for a while. 2. For singers, to sing quietly and limber up both the body and the voice before a performance.

Vaudeville To entertain the audience and focus their attention on the stage prior to the main show.

warmup *Music* A brief series of vocal and breathing exercises for a chorus before going on stage for a concert.

warn *Stagecraft* 1. To alert the cast before an act is to begin. 2. To alert an operator or a crew member before a CUE occurs.

warn and go, warning and go *Lighting, Stagecraft* A pair of CUES often combined into one, instructing an operator to set up controls, then immediately to initiate the action.

warning *Theater* 1. A STAGE MANAGER'S notice to the cast that the act will begin in 15, 10 or 5 minutes. 2. A signal in the theater lobby that the audience should now take their seats.

warning cue *Lighting, Stagecraft* A signal or specific LINE in the scene that alerts an operator to be ready for the next CUE, which will occur shortly.

war paint *Acting* Slang for an actor's makeup.

wart *Stagecraft* Slang term for a small DUTCHMAN.

wash *Lighting* 1. Light of a particular tint and tone that provides the general illumination for the entire scene. *See also* FILL. 2. General, even light over the whole area of a CYCLORAMA.

wash and key *Lighting* The combination of general and specific lighting that illuminates the scene.

washboard *Music* An instrument made of an old-fashioned scrubbing board, *i.e.*, a ribbed board that delivers a loud rasp when rubbed with the point of a stick. Popular with SKIFFLE bands.

wash light *Lighting* The FILL LIGHT that illuminates a wide area.

washtub *Lighting* Slang term for a BEAM PROJECTOR.

washtub bass *Music* An instrument consisting of an overturned cylindrical metal washtub, with a stout string attached to the center of its bottom (on top when it is overturned) and to the top end of a broomstick. Holding the tub down with one foot, the player presses the bottom end of the broomstick firmly near the edge of the tub and pulls back to make the string taut. When the string is plucked, the tub gives out deep bass tones at pitches vaguely determined by the tension of the string. It appears in SKIFFLE bands and sometimes in urban street bands.

water black *Makeup* Mascara, for eyelashes.

water curtain *Stagecraft* 1. *See* DELUGE CURTAIN. 2. A special use of a RAIN PIPE in an outdoor theater to create a sheet of water that can act as a stage curtain.

watering can *Dance* The ROSIN supply, so called in earlier times when dancers used to sprinkle water on their shoes to prevent slipping.

wattage *Lighting* The amount of electrical power required to illuminate a light, expressed in watts.

Watusi *Dance* In the early 1960s, a popular ROCK dance performed individually or by lines of dancers facing each other. It involved wiggle-kick-clap movements.

wa-wa *See* WAH-WAH MUTE.

wave machine *Stagecraft* Any machine designed to create an effect of ocean waves on the stage. In 18th-century theaters, some stages were fitted with a series of GROUND ROWS shaped and painted to represent waves, that could slide back and forth in grooves in the upstage floor. By pushing and pulling them in alternating sequence from the wings or from below, stagehands could produce the effect of waves. In modern theaters, a projection on the CYCLORAMA can do the same thing much more easily.

wave movement *Dance* A basic body movement conceived by Isadora Duncan in imitation of ocean waves, which she considered the fundamental movement of all life and, therefore, of modern dance.

way out *Jazz* A complimentary slang expression meaning unconventional, extremely dissonant or adventurous.

wayte *See* WAIT (*Music*).

weed the house *Theater* To spread the audience around, to make a sparse audience cover more space. Also called spreading.

weekly rep *Theater* A repertory schedule with a new play every week.

week stand *Theater* An engagement for one week only.

weeper *Theater* A sentimental play guaranteed to make the audience weep. A TEARJERKER.

wehmütig (*VAY-mü-tikh*) [German] *Music* Sadly, with a sense of melancholy.

weight *See* COUNTERWEIGHT, PIG, WAFER.

weight the lines *Stagecraft* To tie small sandbags on the upper ends of unused rigging lines so that they will not get stuck in the FLIES but will come down if their other ends are detached from the PINRAIL.

well-tempered *Music* Describing a keyboard instrument that has been tuned by EQUAL TEMPERAMENT. Bach used the term in the title of *The Well-Tempered Clavier*.

West Coast jazz, West Coast school, West Coast sound *Music* The COOL JAZZ style associated with musicians such as Shorty Rogers, Shelly Manne, Art Pepper and others at the Lighthouse Jazz Club in Hermosa Beach, California. Notable for the use of instruments not usually heard in jazz, such as the FLUTE and OBOE, and for the occasional use of COUNTERPOINT.

West End *Theater* The theater district in London.

western *Motion pictures* A motion picture about cowboys, Indians, horses, cattle rustlers and renegades, filmed in the western United States. Also known as a HORSE OPERA.

wet rouge *Makeup* An underlayer of rouge.

wheeled stage *See* CHARIOT STAGE.

whiffle *Music* A FIFE used to accompany an old English Morris dance.

whip *Stagecraft* A stage sound-effect device consisting of two thin plywood slats, slightly separated and mounted on a handle. When a stagehand thrashes a soft object with it backstage, it cracks like a whip. *Compare* SLAPSTICK.

whirling dervish *Dance* A monk of Islam dedicated to mystical practice in the form of a dancelike series of repetitive, slow, whirling movements in more or less erect posture. Often the arms are raised, with the right palm turned upward and the left turned downward. The ritual is performed by a group of men costumed in long, wide skirts that bell out as they turn. The effect is graceful and serene.

whisker *Acting* Slang term for a slip of the tongue on stage.

white balance *Television* A technique used in video recording to adjust the color balance of the video camera before using it. The operator focuses the camera on a white surface, then adjusts the balance control until the image in the viewfinder appears to have the same whiteness.

white cake, white cream, white face powder *Makeup* Whiteners for the face.

white leader *Audio, Motion pictures* LEADER that can be written on with a permanent black marker, to identify the sound or the image that follows it.

white noise *Acoustics, Audio* Noise, like the sound of a jet engine, that includes all frequencies. Derived from the concept of white light that contains all wavelengths of the visible spectrum. White noise tends to obliterate all coherent signals in any electronic system. *See also* SNOW.

white-note music Derisive term to describe music wholly devoid of chromatics, which can be played entirely on the white notes of the piano. *See also* DIATONIC.

white shadow *Lighting* An image cast by a COOKIE. The opposite of a SILHOUETTE.

White Way *See* GAY WHITE WAY.

whiting *Stagecraft* Powdered chalk used in scene painting.

whizzer *See* BULL ROARER.

who-done-it, whodunit *Theater* A murder mystery.

whole note *Music notation* A note equal to four quarter notes. Called a
SEMIBREVE in Britain.

WHOLE NOTE

whole rest *Music notation* A REST equal in duration to a whole note.

whole tone *Music* 1. A scale step equal to two half-tones. 2. As an interval, a MAJOR
SECOND.

whole-tone scale *Music* A scale consisting entirely of whole tone steps. There are only two:
C, D, E, F-sharp, G-sharp, A-sharp, C; and C-sharp, D-sharp, F, G, A, B, C-sharp.

wide-angle lens *Motion pictures* Any lens that accepts an image wider than one accepted by
a normal lens. Not the same as an ANAMORPHIC LENS. The wide-angle lens is used sometimes
not only to take in a wider view but to create a type of distortion that makes short distances
seem large. A tight CLOSE-UP front view of a face with a wide-angle lens will, for example,
make the nose look huge and the ears tiny. A person walking away from the camera in a
WIDE-ANGLE shot will seem to move much more quickly than normal.

wide-angle shot *Motion pictures* A shot taken with a WIDE-ANGLE LENS.

wide-screen *Motion pictures* Describing any format of film or video projection that has an
ASPECT RATIO greater than 1.33 to 1. A common wide-screen ratio is 1.85 to 1. *See also* CIN-
ERAMA, CINEMASCOPE, LETTERBOX FORMAT.

wiegenlied (*VEE-gen-leed*) [German] *Music* A cradle-song, a lullabye.

wig *See* PERIWIG, PERUKE.

wig band *Costume, Makeup* A thin, narrow adhesive band placed across the forehead at the
base of a wig and concealed with makeup.

wig lace *Costume* Hair-colored (or flesh-colored) lace used to fill out a hairdo or to pro-
vide something to which a hat can be fastened.

wig line *Makeup* The boundary between a wig and the flesh of its wearer.

wigmaker *Costume* A person who makes wigs. In French, a PERRUQUIER.

wig paste *Costume, Makeup* A special paste somewhat like greasepaint used to secure a stage
wig.

wig plot *Costume* The wardrobe manager's schedule of wigs that will be used in a show.

wild shot *Motion pictures* A SHOT not called for in the SCRIPT nor on the SHOT LIST but
requested by the director or the director of photography for use as a CUTAWAY. It will be
shot silent, *i.e.*, without recording any sound. *See also* MOS.

wild sound *Motion pictures* Sound not called for in the SCRIPT but needed, *e.g.,* as ROOM TONE, or for other eventualities in the editing process.

Wild West show *Circus* A type of traveling show popular in the United States during the late 1800s, consisting of the standard characters of western folklore, the cowboys and Indians of legend, performing acrobatic feats on their horses, and staging simulated battle scenes, together with sharpshooting demonstrations and the like. The largest and most famous was that of Buffalo Bill (William J. Cody), one of whose stars was the sharpshooter Annie Oakley.

wind band *Music* A relatively large ensemble of wind instruments.

windchest *Music* The container that holds the air supply of an ORGAN and distributes it to the PIPES.

wind instrument *Music* Any instrument that requires a player to blow through it to produce tones. *See also* BRASS INSTRUMENT, REED INSTRUMENT.

wind machine *Stagecraft* A device that imitates the sound of wind. Since the 19th century, such a machine consists of a wooden drum turned by a hand crank, that pulls a continuous roll of heavy cloth across a stationary wooden cylinder. Friction makes the sound; the cranking speed determines its pitch and intensity. *See* SOUND EFFECTS.

window flat *Stagecraft* A FLAT with a large, uncanvassed opening built into it to serve as a window. For a very wide window, a stage designer may designate two flats hinged together, each one serving as half the window opening. The opening may be filled with theatrical gauze to represent the glass, or be braced to support a fully operable WINDOW UNIT.

window unit *Stagecraft* A practicable window in its frame built to fit into the opening of a WINDOW FLAT.

wind quartet, quintet, sextet, etc. *Music* 1. An ensemble of four, five, six, etc., players of WIND INSTRUMENTS. 2. Music written for such an ensemble.

wind screen *Audio, Motion pictures* 1. A soft, porous covering placed directly over a microphone to prevent breezes from making noise that will show up in the recording. 2. A round, flat screen of sound-absorbent mesh placed in front of a studio microphone to break up any plosive sounds (as when pronouncing a word beginning with the letter *P*) made by speakers or singers who are recording close to the mike. Also called a pop screen.

wing *Stagecraft* A panel or a narrow DROP that faces the audience, parallel to the curtain line at the side of the stage, and conceals the backstage or side-stage area, permitting an actor to make entrances or exits conveniently. Generally there are two to four wings set up parallel to the curtain on each side of the stage. They may be constructed as PROFILE FLATS when the scene requires it, *e.g.,* for an architectural scene, a forest or a garden. *See also* FLAT.

wing flat *Stagecraft* 1. A FLAT placed and used as a WING. 2. A set of three flats lashed together like a standing screen.

wing flood *Lighting* A FLOODLIGHT on its own stand located in the wings.

wing hand *Stagecraft* A STAGEHAND who stands in the wings, *e.g.,* to receive props from the acting area during the show, to hand props to actors as they go on stage or to produce sound effects.

wing it *Acting* To improvise lines, perhaps with help from someone in the wings, when something has gone wrong during a performance.

wing lights *Lighting* All the lights installed in the WINGS, collectively.

wings *Stagecraft* The hidden areas at the sides of the stage.

wing space *Stagecraft* The area offstage between and behind the WINGS.

wipe *Television* A change of scene created by any of various sliding motions across the screen that simultaneously erase the outgoing picture and replace it with the incoming picture. At first, wipes were simple straight-line shifts created during post-production by the editor and the laboratory. With the advent of computer controls in television, wipes can take any imaginable form and are accomplished either during live shooting or in post-production by the person who operates the SWITCHER.

wire act *See* HIGH-WIRE ACT.

wire dancer *See* AERIALIST.

wireless mike *Audio* A self-contained system consisting of a MICROPHONE and a radio transmitter that sends signals to a receiver connected to an audio or recording system. The microphone may be handheld or concealed in the costume of the performer. With no wires to cause difficulties, the performer can move anywhere on the stage while speaking or singing through the mike.

wire walker *See* AERIALIST.

with books *Acting* Reading from the script. *See* READING (2).

within *Acting* In an Elizabethan play, the small area at the rear of the stage, often curtained. *See* REAR STAGE.

without books *Acting* In a rehearsal, speaking the lines from memory. *See also* OFF THE BOOK(S).

wohltemperierte (*vohl-tem-peh-REAR-teh*) [German] *Music* Well-tempered, as in *Das Wohltemperierte Klavier* (*The Well-Tempered Keyboard* [1709]) by Johann Sebastian Bach. *See* EQUAL TEMPERAMENT.

wolf *Music* 1. Any unpleasant deviation from normal tone quality on one or two notes of a stringed instrument, that is not attributable to bad playing. In the violin it happens near the C-sharp on the A string. In a violoncello it is likely to occur near the F-sharp on the

D string. The cause is not usually a defect of construction, but is inherent in the design of the instrument, because no design can create an instrumental body that will resonate with the same quality to every pitch. 2. The discrepancy between G-sharp and A-flat in a keyboard instrument tuned by the MEANTONE SYSTEM. *See also* BREAK (*Music*, 1), COMMA.

wood blocks *Music* 1. A PERCUSSION INSTRUMENT consisting of a set of hardwood blocks, each shaped like an ordinary brick, with deep slots cut into each narrow side for resonance. When struck by DRUMSTICKS or wooden MALLETS, a block produces a dry, penetrating whack of high or low tone, depending upon its size. In orchestras and dance bands, up to four blocks are generally mounted together on a stand so that the player may create rapid patterns of different tones as if playing a XYLOPHONE. Not to be confused with TEMPLE BLOCKS. 2. In a dance band, a pair of cylindrical wood blocks, mounted on top of the bass drum. Each is partially hollowed out from one end, and each produces a tone different from the other when struck with a drumstick.

wood border *Stagecraft* A border with large openings and its lower edge cut in profile to represent foliage.

wood cuts *Stagecraft* Framed DROPS with large openings through which the audience can see the actors, as if looking through the trees of a forest.

wooden dutchman *See* JIGGER.

woodshed *Music* A slang term meaning to practice on one's instrument, intensely and in private.

woodwind *Music* Any flutelike or reed instrument that requires a player to blow through it to produce musical tones. The class includes all the FLUTES, OBOES, BASSOONS, CLARINETS and SAXOPHONES.

woodwind quartet, quintet, sextet, etc. *Music* 1. An ensemble of four, five, six, etc. instrumentalists who play WOODWINDS. 2. Any piece of music composed or arranged for such an ensemble.

woofer *Audio* A LOUDSPEAKER that produces only the lowest tones of the audio spectrum. *Compare* MIDRANGE (2), TWEETER.

word rehearsal *Acting* A rehearsal for practice in LINES.

work a show *Circus, Theater, Vaudeville* To do one's job as performer, musician or craftsperson in a show.

workbook *Stagecraft* The STAGE MANAGER's annotated copy of the SCRIPT.

work downstage *Acting* To move gradually DOWNSTAGE during the scene.

working leg *Dance* The leg that remains free to move while the SUPPORTING LEG carries the dancer's weight.

working line *See* OPERATING LINE.

working script *Theater*　The prompter's annotated copy of the script.

working side *Theater*　The side of the stage where the PROMPTER sits and the stage manager and the curtain puller stand by.

working title *Motion pictures*　A title that may not be the final title of the motion picture but will serve to identify scenes marked up on the slate and cans of exposed film, etc., until the final title has been selected.

work left *Acting*　To move gradually toward STAGE LEFT during a scene.

worklight *Theater*　A bare light bulb on a stand or hung from the FLIES, to provide enough light to see by while working on the stage. *See also* GHOST LIGHT.

workprint *Motion pictures*　1. In traditional movie editing, a print made directly from the ORIGINAL footage and then used for editing. The workprint shows not only the images that have been shot, but also the EDGE NUMBERS that were previously imprinted on the original film by the manufacturer. The editor works exclusively with the workprint, cutting and splicing it at will until the film is complete and has been MIXED. At that point a negative cutter takes the edited workprint, matches its edge numbers precisely to those on the original film and makes the CONFORMED ORIGINAL. *See also* SLOP PRINT. 2. In modern editing, the workprint is a time-coded video duplicate of the original. The editor works exclusively with the video copy, then sends it to the laboratory where the original is cut automatically, using the TIME CODE.

work right *Acting*　To move gradually toward STAGE RIGHT.

work upstage *Acting*　To move gradually UPSTAGE during a scene.

world music　A term, created shortly after the birth of REGGAE in Jamaica, that refers to popular music from non-Western cultures or a hybrid of Western and foreign styles and sounds, as well as the newer multiracial groups. It includes an increasing number of ROCK bands, Celtic and other FOLK MUSIC ensembles and POP groups from Eastern Europe, the Middle East, West Africa, South Africa, Japan, etc.

wow *Theater*　1. A great success, or a very exciting ending. 2. An encouragement for an actor to outdo every past success, to "knock 'em dead."

wrangler *Motion pictures*　An animal trainer and handler who specializes in working with large animals, *e.g.,* horses, camels or elephants.

wrap *Motion pictures*　The completion, especially of a film shooting session. Generally spoken by a director whose announcement "It's a wrap" indicates that shooting has concluded at least for the day; the actors may then remove their makeup, the camera operators may seal up their exposed film (the only item, probably, that will actually be wrapped up, so they can send it to the laboratory) and the crews and craftspeople may shut down the lights, strike the set and do whatever else may be necessary before going home.

"write it" *Lighting* The lighting director's instruction to the CONTROL BOARD operator to enter the set-up of a particular CUE into the memory system.

Writers Guild of America A national association of television and screenwriters.

Wurlitzer *Motion pictures, Music* A major manufacturer of theater organs, particularly famous as the maker of "the Mighty Wurlitzer" that was always the "largest, most magnificent and most costly organ ever made" in any large urban motion picture theater worthy of the title "Palace."

X

X *Acting* An actor's shorthand CUE (penciled into the script) for a move across the stage.

Xota (*HOH-tah*) [Spanish] *See* JOTA.

xylophone *Music* A PERCUSSION INSTRUMENT of definite pitch, consisting of a double row of hardwood bars mounted loosely on felt pads in two ranks across a metal frame. Their arrangement on the frame resembles the keys of the piano: the "white notes" form an unbroken series on one level near the player, the "black notes" are placed on a slightly higher level, farther from the player, and spaced exactly the way they are on the piano. The player strikes the bars with two or four special MALLETS of various degrees of hardness to produce piercing tones of almost no duration in the three highest octaves of the musical range. Because of its peculiar sound, it has become a favorite instrument to represent skeletons dancing, as in the famous *Danse Macabre* (1875) of Camille Saint-Saëns. *Compare* MARIMBA, VIBRAPHONE.

Y

yack, yock, yuck *Vaudeville* A loud laugh. By extension, a funny joke.

yaller girl *Vaudeville* An alluring female character in an early 20th-century MINSTREL SHOW played by a man.

yellow card *Stagecraft* A memo from the chief carpenter of the show to the management of a theater where the company will appear on tour, providing all necessary information about physical preparations that must be made, as well as specifying how many union STAGEHANDS will be needed to do the job.

yodel *Music* To sing with moments of rapid alternation between normal voice and FALSETTO, in imitation of the style of Swiss mountaineers who practiced the technique so their voices would carry across great mountain valleys.

yoke *Lighting* The U-shaped frame that holds a lighting instrument so that it can be tilted up or down. The yoke itself pivots horizontally in its base, so that the light can be aimed in any direction.

yoke clamp *Lighting* A large clamp shaped to provide a mounting for a stage light and to be fastened to a LIGHT PIPE.

yokel *Theater* A disparaging term for any theater patron from out of town. *See also* HAY-SEED, RUBE.

youth choir *Music* A choir made up of young people.

youth orchestra *Music* An orchestra made up of young people.

yo-yo zoom *Motion pictures* An almost sickening visual effect of flying violently toward a subject and just as violently away from it (or vice versa) with no pause in between, accomplished by moving the zoom control of a zoom lens rapidly back and forth while shooting.

Z

zambra (*ZAHM-brah*) [Spanish] *Dance* A Spanish FLAMENCO dance of Moorish origin, known since the 14th century, performed by women to the accompaniment of recitation or song.

zanni (*TZAH-nee*) [Italian] *Theater* A general name for the taunters and tricksters in the earliest period of COMMEDIA DELL'ARTE, who later took on individual names, *e.g.*, ARLECCHINO.

zapateado (*zah-pah-tay-AH-doh*) [Spanish] *Dance* A Spanish FLAMENCO dance performed by men, usually without musical accompaniment, typified by rhythmic stamping and staccato heel tapping.

zarzuela (*zahr-ZWAY-lah*) [Spanish] *Music* An important style of Spanish opera that originated in the 1600s in fiestas in the Palace of La Zarzuela in Madrid, still popular in the 20th century. It is similar to OPERETTA in that it has spoken dialogue, and is usually based on intensely romantic tales of passion. *Compare* TONADILLA.

ziemlich (*TSEEM-likh*) [German] *Music* Rather, as in *ziemlich lebhaft*, rather lively.

zinc white *Makeup* A white pigment for stage use made of zinc oxide, formerly used in MAKEUP.

zingaro, zingara (*ZIN-gah-roh, ZIN-gah-rah*) [Italian] *Music* A gypsy. *See* ALLA GITANA, ALLA ZINGARESE.

zip cord *Lighting* A very flexible type of two-conductor electrical cord, similar to the type commonly used in the household.

zither *Music* 1. A Central European folk instrument consisting of a sound box with two sets of strings, five for the melody stretched over a FRETTED FINGERBOARD, the remaining twenty or more for the accompaniment, individually tuned across the body of the instrument. For the melody, the player uses a PLECTRUM attached to the thumb of the left hand and stops the melody strings with the fingers of that hand. The accompaniment is played on the remaining strings by the fingers of the right hand. The zither provided the music for Carroll Reed's famous motion picture *The Third Man*. 2. A family of instruments, each consisting of a set of tuned strings played with the fingers or with mallets. They include the PSALTERY, the VINA, the Hungarian CIMBALOM and the Japanese KOTO. *See also* ZOOMOOZOPHONE.

zithern, zittern *See* CITTERN.

zoom *Motion pictures* 1. An apparent movement of the camera toward or back from the subject, similar to a DOLLY SHOT but accomplished with a ZOOM LENS. 2. To change the image seen by the camera smoothly from a LONG SHOT to a CLOSE-UP, or vice-versa, using a ZOOM LENS.

zoom lens *Motion pictures* A lens of variable focal length. In operation the lens simulates movement toward or away from the subject by simultaneously narrowing or widening the angle of view and proportionately enlarging or reducing the apparent size of the image within that view. The effect simulates a DOLLY SHOT but is fundamentally different, because all parts of the image remain in the same relationship to each other throughout the zoom. Zoom lenses are sometimes used on projectors, to maintain a certain screen size while changing the area of coverage in the slide.

zoomoozophone *Music* A zitherlike instrument constructed by Harry Partch, with forty-three tones to each of five octaves. *See* PARTCH INSTRUMENTS.

zurückhaltend (*tzoo-RÜK-hahl-tent*) [German] *Music* Holding back.

zydeco *Music* Dance music originating in the French-speaking areas of Louisiana and East Texas, based on CAJUN MUSIC and BLUES. A strongly rhythmic style that uses mainly fiddle, guitar and accordion.

Appendix
People Mentioned

A

Adler, Larry	American harmonica player	1914–
Aeschylus	Greek dramatist	525–456 B.C.
Ailey, Alvin	American dancer, choreographer	1931–1989
Albéniz, Isaac	Spanish pianist, composer	1860–1909
Allman, Duane	American rock guitarist	1946–1971
Amati, Niccolò	Italian violin-maker	1596–1684
Anderson, Laurie	American composer, performance artist	1947–
Anderson, Maxwell	American dramatist	1888–1959
Andrews, Dana	American film actor	1909–1992
Anouilh, Jean	French dramatist	1910–1987
Antheil, George	American pianist, composer	1900–1959
Antoine, André	French theater manager, actor	c. 1857–1943
Appia, Adolphe	Swiss stage designer	1862–1928
Aristophanes	Athenian dramatist	c. 448–c. 380 B.C.
Aristotle	Greek philosopher	384–332 B.C.
Armstrong, Louis "Satchmo"	American jazz trumpeter, singer	1900–1971
Astaire, Fred	American dancer, choreographer	1899–1987

B

Bach, Carl Philipp Emanuel	German composer	1714–1788
Bach, Johann Sebastian	German composer	1685–1750
Balanchine, George	American dancer, choreographer	1904–1983
Barnum, Phineas Taylor (P.T.)	American showman	1810–1891
Barrymore, John	American actor	1882–1942
Bartók, Béla	Hungarian composer	1881–1945
Basie, Count (William)	American jazz pianist, bandleader	1904–1984
Bazelon, Irwin	American composer	1922–1995
Beauchamps, Pierre	French dancer, educator	1636–1705
Beaumarchais, Pierre Augustin	French dramatist	1732–1799
Bechet, Sidney	American jazz clarinetist, saxophonist	1897–1959
Beckett, Samuel	Anglo/French dramatist	1906–1989
Beethoven, Ludwig von	German composer	1770–1827
Belasco, David	American dramatist, theater manager	1859–1931
Benesh, Rudolf	English painter, dance theoretician	1916–
Berg, Alban	Austrian composer	1885–1935
Bergen, Edgar	American entertainer, ventriloquist	1903–1978
Berlioz, Hector	French composer	1803–1869
Bernstein, Leonard	American composer, conductor	1918–1990
Biggs, E. Power	British/American organist	1906–1977
Billings, William	American composer	1746–1800
Bizet, Georges	French composer	1838–1875

Blasis, Carlo	Italian choreographer, teacher	1795–1878
Bolger, Ray(mond) Wallace	American dancer	1904–1987
Boone, Pat (Charles Eugene Boone)	American popular singer	1934–
Borodin, Alexander	Russian composer	1833–1887
Boulez, Pierre	French composer, conductor	1925–
Brahm, Otto	German theater director, critic	1856–1912
Brahms, Johannes	German composer	1833–1897
Brando, Marlon	American stage and film actor	1924–
Brecht, Bertolt	German poet, dramatist	1898–1956
Britten, Benjamin	English composer	1913–1976
Buffalo Bill (William J. Cody)	Frontiersman, entertainer	1846–1917
Busoni, Ferruccio	Italian/German pianist, composer	1866–1924
Byrd, William	English composer	1543–1623

C

Caccini, Giulio	Italian composer	c. 1550–1618
Cage, John	American composer	1912–1992
Cagney, James	American entertainer, actor	1904–1986
Cahill, Thaddeus	American inventor	EARLY 20TH CENTURY
Calloway, Cab	American jazz singer, bandleader	1907–1994
Calvé, Emma	French soprano	1858–1942

Campion, Thomas	English poet, composer, librettist	1567–1620
Caruso, Enrico	Italian tenor	1873–1921
Castle, Irene	American ballroom dancer	1893–1969
Castle, Vernon	American ballroom dancer	1887–1918
Cecchetti, Enrico	Italian ballet dancer, teacher	1850–1928
Chabrol, Claude	French film director	1930–
Chaplin, Charlie	British comedian, film director	1889–1977
Charisse, Cyd	American dancer, film actress	1923–
Charles II	King of England	1630–1685
Checker, Chubby (Ernest Evans)	American popular singer	1941–
Chekhov, Anton	Russian dramatist	1860–1904
Chopin, Frédéric	Polish composer, pianist	1810–1849
Christian, Charlie	American jazz guitarist, blues singer	1916–1942
Cocteau, Jean	French author, dramatist	1889–1963
Congreve, William	English dramatist	1670–1729
Corneille, Pierre	French dramatist	1606–1684
Corsi, Jacopo	Florentine patron of the arts	1560–1602
Cotton, James	American blues guitarist	1935–
Cowell, Henry Dixon	American composer	1897–1965
Craig, Edward Gordon	British stage designer, actor	1872–1966
Cromwell, Oliver	Lord Protector of England	1599–1658
Crosby, Bing	American popular music singer	1901–1977

D

Damrosch, Walter	German/American conductor	1862–1905
Davis, Miles	American jazz trumpeter	1926–1991
Debussy, Claude	French composer	1862–1918
Delsarte, François	French theater director	1811–1871
Descartes, René	French philosopher, scientist	1596–1650
Diaghilev, Sergei	Russian ballet impresario	1872–1929
Dickson, William	American inventor, associate of Edison	EARLY 20TH CENTURY
Dorsey, Tommy	American trombonist, bandleader	1905–1956
Dryden, John	English poet, dramatist	1631–1700
Duncan, Isadora	American dancer	1878–1927
Dvořák, Antonin	Czech composer	1841–1904
Dylan, Bob (Robert Zimmerman)	American folksinger, songwriter	1941–

E

Eames, Charles	American designer, architect	1907–1978
Edison, Thomas Alva	American inventor	1847–1931
Ellington, Edward Kennedy ("Duke")	American pianist, composer, bandleader	1899–1974
Esterhazy, Prince Nicholas IV	Hungarian prince, patron of Haydn	1765–1833
Euripides	Greek dramatist	c. 480–406 B.C.
Evans, Gil	Canadian jazz pianist, arranger	1912–1988

F

Feiffer, Jules	American, cartoonist, dramatist	1929–
Fender, Clarence Leo	American musical instrument maker	1909–1991
Fergusson, Francis	American director, author, teacher	1904–1986
Field, John	Irish pianist, composer	1782–1837
Fitzgerald, Ella	American jazz singer	1918–1996
Flagstad, Kirsten	Norwegian soprano	1895–1962
Flaherty, Robert	American explorer, filmmaker	1884–1951
Foley, Jack	American film/sound editor	1891–1967
Franco of Cologne	Musical theorist	c. 1250–c. 1280
Franklin, Aretha	American soul singer	1942–
Franklin, Benjamin	American statesman, scientist, writer	1706–1790
Frederick II (The Great)	King of Prussia, flautist, composer	1712–1786
Fresnel, A. J.	French physicist	1788–1827
Friml, Rudolf	American operetta composer	1879–1972

G

Galilei, Vincenzo	Italian composer, writer on music	1520–1591
Galsworthy, John	British novelist, dramatist	1867–1933
Galway, James	Irish flautist	1939–
Garbo, Greta	Swedish/American film actress	1905–1990
Gardel, Maximilian	French choreographer	1741–1787

Garrick, David	English actor, dramatist	1717–1779
Gassner, John	American director, educator	1903–1967
Gaye, Marvin	American R & B singer	1939–1984
Gaynor, Janet	American film actress	1906–1984
Gershwin, George	American composer, pianist	1898–1937
Gibbons, Orlando	English composer	1583–1625
Gibson, Charles Dana	American illustrator	1867–1944
Gielgud, Sir John	British actor, director	1904–
Gilbert, William Schwenk	British dramatist, director	1836–1911
Gillespie, John Birks ("Dizzy")	American jazz trumpeter, composer	1917–1993
Gluck, Christoph Willibald von	German composer	1714–1787
Godard, Jean-Luc	French film director	1930–
Goethe, Johann Wolfgang von	German poet, dramatist, philosopher	1749–1832
Goldoni, Carlo	Italian poet, dramatist	1707–1793
Goodman, Benny	American clarinetist, band leader	1909–1986
Gorelik, Mordecai	Russian director, dramatist	EARLY 20TH CENTURY
Graham, Martha	American modern dancer, choreographer	1894–1991
Gregory I (The Great)	Pope	590–604
Gregory, Lady Augusta	Irish dramatist	c. 1859–1932
Grein, Jack Thomas	Dutch-born dramatist, theater manager	1862–1935
Grieg, Edvard	Norwegian composer	1843–1907
Guarneri, Giuseppe Bartolomeo	Italian violin maker	1698–1744

Guido d'Arezzo	French-born music theoretician	c. 995–(?)
Guthrie, Woody	American folk singer, songwriter	1912–1967

H

Hagen, Uta	German/American actress	1919–
Hale, Adam de la	French poet, musician, composer	1240–1287
Halévy, Jacques François	French composer	1799–1862
Hampton, Lionel	American jazz vibraphonist	1913–
Handel, George Frideric	German-born English composer	1685–1759
Handy, William Christopher	American jazz musician, composer	1873–1958
Harrison, Lou	American composer	1917–
Hauptmann, Gerhart	Polish/German dramatist	1862–1946
Hawkins, Coleman	American jazz saxophonist	1904–1969
Haydn, Franz Josef	Austrian composer	1732–1809
Helmholtz, Hermann von	German scientist	1821–1894
Henderson, Fletcher	American jazz musician	1898–1952
Hendrix, Jimi	American rock singer, guitarist	1942–1970
Herbert, Victor	Irish/American operetta composer	1859–1924
Hertz, Heinrich Rudolph	German physicist	1857–1894
Hindemith, Paul	German composer, violist	1895–1963
Hodges, Johnny (John Cornelius)	American jazz saxophonist	1906–1970
Hoffman, Dustin	American actor	1937–

Homer	Greek epic poet	8TH CENTURY B.C.
Humperdinck, Engelbert	German composer	1854–1921
Humphrey, Doris	American modern dancer, choreographer	1895–1958

I

Ibsen, Henrik	Norwegian poet, dramatist	1828–1906
Ionesco, Eugène	French dramatist	1912–1994

J

Jackson, Michael	American rock singer	1958–
James, Elmore	American blues guitarist	1918–
Jannings, Emil	German actor	1885–1950
Jaques-Dalcroze, Émile	Swiss composer, educator	1865–1950
Jarry, Alfred	French dramatist	1873–1907
Johnson, James P.	American jazz pianist	1891–1955
Johnson, Robert	American blues guitarist	1911–1938
Jones, Robert Edmond	American stage designer	1887–1954
Jones, Spike (Lindley Armstrong)	American bandleader	1911–1965
Jonson, Ben	English poet, dramatist	1573–1637
Joplin, Scott	American ragtime pianist, composer	1868–1917
Josquin des Prez	Flemish composer	c. 1440–1521

K

Karajan, Herbert von	Austrian-born conductor	1908–1989
Kaye, Danny	American comedian, actor	1913–1987
Kean, Edmund	English Shakespearean actor	1789–1863
Keaton, Buster	American clown, film director	1895–1966
Kelly, Emmett	American clown	1898–1979
Kelvin, William Thompson, Lord	English physicist	1824–1907
Kenton, Stanley Newcomb	American jazz composer, bandleader	1912–1979
Kern, Jerome	American composer	1885–1945
King, Albert	American blues guitarist	1923–
Klinger, Frederich Maximilian von	German dramatist	1752–1831
Kodály, Zoltán	Hungarian composer, teacher	1882–1967

L

Laban, Rudolf von	German dance theoretician	1879–1958
Landé, Jean Baptiste	French dancer in Russia	EARLY 18TH CENTURY
Landini, Francesco	Italian instrumentalist, composer	1325–1397
Lassus, Orlandus (Orlando di Lasso)	Netherlandish composer	1532–1594
Lawes, William	English composer	1602–1645
Lawrence, Jerome	American dramatist	1915–

Ledbetter, Huddie ("Leadbelly")	American folksinger, guitarist, composer	1885–1949
Lee, Robert Edwin	American dramatist	1918–
Lehmann, Lotte	German soprano	1888–1976
Leinsdorf, Erich	Austrian/American conductor	1912–1993
Léotard, Jules	French aerialist	1830–1870
Lindbergh, Charles A.	American aviator	1902–1974
Linnebach, Adolph	German stage designer	1886–1963
Liszt, Franz	Hungarian composer, pianist	1811–1886
Lope de Vega	Spanish dramatist	1562–1635
Ludlum, Charles	American director, playwright	1943–1987
Lully, Jean-Baptiste	French composer	1632–1687

M

MacMurray, Fred	American film actor	1908–1991
Maelzel, Johannes	German developer of the metronome	1772–1828
Maeterlinck, Maurice	Belgian dramatist	1862–1947
Malle, Louis	French/American film director	1932–
Manne, Shelly	American jazz musician	1920–1984
Marceau, Marcel	French mime	1923–
Marlowe, Christopher	English dramatist, poet	1564–1593
Martenot, Maurice	French composer, inventor	1898–1980
Martin, John	American dance critic	1893–1985

Marx, Julius ("Groucho")	American comedian	1894–1977
Massine, Leonid	Russian-born dancer, choreographer	1895–1925
Mazzone-Clementi, Carlo	Italian mime, teacher	1923–
McCandless, Stanley	American stage designer, educator	1897–1967
McShann, Jay	American jazz pianist, bandleader	1909–
Medici, Catherine de	Queen of France	1519–1589
Méhul, Étienne-Nicolas	French composer	1763–1817
Méliès, Georges	French filmmaker	1861–1938
Mencken, Henry Lewis	American editor, author, critic	1880–1956
Mendelssohn-Bartholdy, Felix	German composer	1809–1847
Meyerbeer, Giacomo	German composer	1791–1864
Miller, Arthur	American dramatist	1915–
Miller, Glenn	American trombonist, band leader	1904–1944
Milton, John	English poet	1608–1674
Mingus, Charles	American jazz musician, composer	1922–1979
Molière (Jean-Baptiste Poquelin)	French dramatist	1622–1673
Monk, Thelonius	American jazz pianist, composer	1917–1982
Monteverdi, Claudio	Italian composer	1567–1643
Morley, Thomas	English composer	1557–1602
Morton, Ferdinand Joseph ("Jelly Roll")	American jazz pianist, composer	1885–1941
Morton, Harry K. Sr.	Acrobat	1856–1919
Mostel, Zero (Samuel Joel)	American actor, singer	1915–1977
Mozart, Wolfgang Amadeus	Austrian composer	1756–1791

Musgrave, Thea	Scottish composer	1928–
Mussorgsky, Modeste	Russian composer	1839–1881

N

Novello, Vincent	English music publisher	1781–1861

O

Oakley, Annie	American sharpshooter, entertainer	1860–1926
Odets, Clifford	American dramatist	1906–1963
Offenbach, Jacques	German composer	1819–1880
Oliver, Joseph ("King")	American jazz cornettist, bandleader	1885–1938
Olivier, Sir Laurence	English actor	1907–1989
O'Neill, Eugene	American dramatist	1888–1953
Orff, Carl	German composer, educator	1895–1982

P

Paisiello, Giovanni	Italian composer	1740–1816
Palestrina, Giovanni Pierluigi da	Italian composer	c. 1525–1594
Parker, Charlie ("Bird")	American jazz saxophonist	1920–1955
Parry, Hubert	English composer	1848–1918

Partch, Harry	American composer	1901–1974
Pepper, Art	American jazz saxophonist	1925–1982
Peri, Jacopo	Italian composer`	1561–1633
Perry, Antoinette	American actress	1888–1946
Petipa, Marius	French ballet dancer, choreographer	1822–1910
Piscator, Erwin	German director, teacher	1893–1966
Powell, Earl ("Bud")	American jazz pianist	1924–1966
Presley, Elvis A.	American rock singer	1935–1977
Prokofiev, Sergei	Russian composer	1891–1955
Puccini, Giacomo	Italian composer	1858–1924
Purcell, Henry	English composer	c. 1659–1695
Pythagoras	Ionian physicist	c. 582–500 B.C.

R

Rachmaninoff, Sergei	Russian composer, pianist	1873–1943
Racine, Jean	French dramatist	1639–1699
Rameau, Jean Philippe	French composer	1683–1764
Rameau, Pierre	French balletmaster	EARLY 18TH CENTURY
Rank, J. Arthur	English film executive	1888–1972
Ravel, Maurice	French composer	1875–1937
Reed, Sir Carol	English film director	1906–1976
Richardson, Sir Ralph David	English actor	1902–1983

Riegger, Wallingford	American composer	1885–1961
Rimsky-Korsakov, Nicolai	Russian composer	1844–1908
Rinuccini, Ottavio	Italian poet	1562–1621
Robbins, Jerome	American choreographer, director	1918–1998
Robinson, Bill ("Bojangles")	American tap dancer, actor	1878–1949
Robinson, Edward G.	American film actor	1893–1973
Rockmore, Clara	American violinist, thereiminist	1910–1998
Rogers, Ginger	American dancer, actress	1911–1995
Rogers, Milton ("Shorty")	American jazz trumpeter, band leader	1924–
Rogers, Will (William Penn Adair)	American actor, lecturer	1879–1935
Rossini, Gioacchino	Italian composer	1792–1868
Rostand, Edmond	French dramatist	1868–1918
Rouget de Lisle, Claude-Joseph	French composer	1760–1836

S

Saint Saëns, Camille	French composer	1835–1921
Sax, Adolphe	Belgian bandmaster, inventor	1814–1894
Scarlatti, Alessandro	Italian composer	1659–1725
Schillinger, Joseph	American composer, musician, teacher	1895–1943
Schönberg, Arnold	Austrian composer	1874–1951
Schubert, Franz	Austrian composer	1797–1828
Schuller, Gunther	American composer	1925–

Schumann, Robert	German composer	1810–1856
Schütz, Heinrich	German composer	1585–1672
Seneca the Younger	Roman dramatist, statesman	c. 3 B.C.–A.D. 65
Shakespeare, William	English dramatist	1564–1616
Shaw, George Bernard	Irish dramatist, critic	1856–1950
Sheridan, Richard Brinsley	English dramatist	1751–1816
Siddons, Sarah Kemble	English actress	1755–1831
Silhouette, Étienne de	French statesman, reformer	1709–1767
Skelton, Red	American comedian	1913–1997
Sondheim, Stephen Joshua	American composer, lyricist	1930–
Sophocles	Greek tragic poet, dramatist	c. 496–406 B.C.
Sousa, John Philip	American bandmaster	1854–1932
Spenser, Edmund	English poet	1552–1599
Spooner, William Archibald	English prelate, educator	1844–1930
St. Denis, Ruth	American dancer	1877–1968
Stamitz, Johann	German composer	1717–1757
Stanford, Charles Villiers	Irish-born English composer	1852–1924
Stanislavski, Konstantin	Russian actor, director, teacher	1863–1938
Stanwyck, Barbara	American actress	1907–1990
Stowe, Harriet Beecher	American author	1811–1896
Stradivari, Antonio	Italian violin maker	c. 1644–1737
Strasberg, Lee	American theater director, teacher	1901–1982
Strauss, Johann, Jr.	Austrian violinist, composer, conductor	1825–1899
Strauss, Johann, Sr.	Austrian violinist, composer, conductor	1804–1849
Stravinsky, Igor	Russian-born composer	1882–1971

Striggio, Alessandro	Italian lutenist, composer	c. 1535–1592
Strindberg, Johan August	Swedish dramatist, novelist	1849–1912
Sullivan, Sir Arthur Seymour	English composer	1842–1900
Synge, John Millington	Irish dramatist	1871–1909

T

Tartini, Giuseppe	Italian violinist, composer	1692–1770
Tchaikovsky, Piotr Ilyich	Russian composer	1840–1893
Telemann, Georg Philipp	German composer	1681–1767
Terence	Roman dramatist	c. 190–c. 159 B.C.
Theremin, Leon	Russian inventor	1896–1994
Tolstoy, Leo	Russian novelist	1828–1910
Toscanini, Arturo	Italian conductor	1867–1957
Travolta, John	American film actor	1954–
Truffaut, François	French film director	1932–1984

V

Vaganova, Agrippina	Russian ballerina, educator	1879–1951
Vakhtangov, Eugene	Russian actor, theatrical producer	1883–1922
Varèse, Edgard	French composer	1883–1965
Vecchi, Orazio	Italian composer	1550–1605
Ventadorn, Bernart de	French troubadour	1127–1195

Verdi, Giuseppe	Italian opera composer	1813–1901
Villa-Lobos, Heitor	Brazilian composer	1887–1959
Vivaldi, Antonio	Italian composer	1675–1741
Vogelweide, Walther von der	German minnesinger	c. 1170–c. 1230

W

Wagner, Richard	German opera composer	1813–1883
Waller, Thomas ("Fats")	American jazz pianist	1904–1943
Waters, Muddy (McKinley Morgenfield)	American blues singer, guitarist	1915–1983
Weill, Kurt	German/American composer	1900–1950
Werckmeister, Andreas	German organist, theorist	1645–1706
Wilbye, John	English composer	1574–1638
Wilder, Thornton	American novelist, dramatist	1897–1975

Y

Young, Lester Willis	American jazz saxophonist	1909–1959
Yradier, Sebastián de	Spanish composer	1809–1865

Z

Ziegfeld, Florenz	American theatrical producer	1869–1932

Dictionary *of the* Performing Arts

FRANK LEDLIE MOORE
and MARY VARCHAVER

CB

CONTEMPORARY BOOKS

Library of Congress Cataloging-in-Publication Data

Moore, Frank Ledlie.
 Dictionary of the performing arts/Frank Ledlie Moore and
Mary Varchaver.
 p. cm.
 ISBN 0-8092-3009-7 (cloth).—ISBN 0-8092-3010-0 (paper)
 1. Performing arts—Dictionaries. I. Varchaver, Mary.
II. Title.
PN1579.M66 1999
791'.03—dc21 98-49884
 CIP

Cover design by Kim Bartko
Cover illustration copyright © 1996 Daniel Aubry/The Stock Market
Interior design by Point West, Inc.

Published by Contemporary Books
A division of NTC/Contemporary Publishing Group, Inc.
4255 West Touhy Avenue, Lincolnwood (Chicago), Illinois 60646-1975 U.S.A.
Copyright © 1999 by Frank Ledlie Moore and Mary Varchaver
Printed in the United States of America
International Standard Book Number: 0-8092-3009-7 (cloth)
 0-8092-3010-0 (paper)
99 00 01 02 03 04 BC 18 17 16 15 14 13 12 11 10 9 8 7 6 5 4 3 2 1